THE MUSEUM

THE MUSEUM
A Reference Guide

Edited by
Michael Steven Shapiro
With the Assistance of
Louis Ward Kemp

GREENWOOD PRESS
New York • Westport, Connecticut • London

Library of Congress Cataloging-in-Publication Data

The Museum : a reference guide / edited by Michael Steven Shapiro
 with the assistance of Louis Ward Kemp.
 p. cm.
 Includes bibliographical references.
 ISBN 0–313–23686–0 (lib. bdg. : alk. paper)
 1. Museums—Bibliography. I. Shapiro, Michael Steven. II. Kemp,
Louis Ward.
 Z5052.M93 1990
 [AM5]
 016.069—dc20 89–26022

British Library Cataloguing in Publication Data is available.

Library of Congress Catalog Card Number: 89–26022
ISBN: 0–313–23686–0

First published in 1990

Greenwood Press, 88 Post Road West, Westport, CT 06881
An imprint of Greenwood Publishing Group, Inc.

Printed in the United States of America

∞

The paper used in this book complies with the
Permanent Paper Standard issued by the National
Information Standards Organization (Z39.48–1984).

10 9 8 7 6 5 4 3 2 1

For my Parents
Jack and Charlotte
who always took me to museums
and
For my Children
David and Rebecca
who sometimes agree to go to museums

CONTENTS

ACKNOWLEDGMENTS

The need for a critical bibliography in museum studies first became clear to me as an associate professor of American civilization at the George Washington University, where I directed the Graduate Program in Museum Studies. With one foot in each world, I wanted to share with my colleagues in American civilization my excitement about the new opportunities for interdisciplinary research in museum studies and to encourage my students to think critically about the museum as a civic institution in American culture.

In order to accomplish these objectives, I recognized that the university, in cooperation with museums, must take the initial steps in organizing and evaluating the literature on museums. I owe thanks to Henry Solomon, dean of the Graduate School of Arts and Sciences, the George Washington University, for facilitating this effort by providing an environment congenial to research. I am also indebted to Avery D. Andrews, associate dean of the Graduate School, for urging me to enrich the curriculum of graduate students at every possible opportunity. My colleague and friend Joseph Zeidner provided wise counsel and needed encouragement whenever the project bogged down. With good cheer (even without the benefit of a word processor), Gillian Norton typed and proofread the first draft of the manuscript.

Law firms, not unlike universities and museums, are collections of creative people, many with uncommon interests. Weil, Gotshal & Manges is such a firm, and I am indebted to management for allowing me to pursue my interests by providing the resources for retyping the manuscript and to members of the Word Processing Center for their efforts. I also thank Robin Mason and Anne Kienlen for proofreading parts of the manuscript.

INTRODUCTION

Although the museum has emerged as an important civic institution in American life, the literature on museums has not received the critical attention it deserves. Part of the explanation appears to be that books about museums traditionally have been written by and for a relatively small group of people. Directors, curators, and scholars with close personal and professional ties to the museum community have written memories, reminiscences, and commemorative histories for a limited readership. The small list of authoritative works on museums has in the past attracted a devoted readership among aspiring museum directors but few others. Although this canon has now been supplemented by a rapidly growing body of technical writing, the literature on museums has remained substantially disorganized and unevaluated, thereby making it less accessible to general readers.

The contributors to this book, drawn from both the museum and university communities, were asked to identify and evaluate works that introduce general readers, museum studies students, and beginning professionals, to the history and functions of museums. I asked the authors to strike a balance, appropriate to their topic, between historical narrative and bibliographical detail because framing and answering questions about museums requires both specific data and a general context to evaluate such information. Thus, each chapter consists of an introductory historic narrative, a survey of sources, and a bibliographic checklist that contains cited and additional sources.

The initial task proved deceptively simple, for it required selecting books and monographs from hundreds of texts. Assessing the value of individual

books and the coherence of groups of works raised even more difficult questions, for it required the evaluation of works written for diverse purposes and audiences. Alert to the need to relate the literature to the problems of contemporary museums, the authors were also forced to reconsider familiar episodes in American museum history. At other junctures in the project, contributors were asked to challenge the assumptions underlying the literature—what Dominick LaCpra has recently called the "noncanonical reading of canonical texts."

This book begins with Charlotte M. Porter's review of the literature on natural history museums, for almost from the first moment of exploration, naturalists were fascinated by the wonders of the New World. Dismissing the view that the natural history museum became an inactive storehouse during the nineteenth century, Porter reconstructs its place as an important nineteenth-century scientific institution that not only stored collections but also helped to disseminate information essential to research. Mindful of the importance of private philanthropy to museums, the author describes the ways in which natural history museums attracted resources from an industrial economy, occasionally incorporating its competitive ideals.

Edith A. Tonelli portrays the development of art museums on a much vaster canvas. The literature of the art museum, Tonelli argues, is deeply imprinted by the larger debate in Western civilization between elitism and utilitarianism. In particular, she contends that the writings about art museums reflect the ongoing struggle of American museums to define both the nature and the content of fine arts collections in a democratic society. By analyzing the writings of the directors of the great American art museums, Tonelli demonstrates how these works can be used to learn more about the choices they made in guiding arts institutions between the conflicting demands of vocal constituencies.

In contrast to the art museum, books about museums of science and technology until recently have rarely attracted much attention outside the museum field. According to historian Bernard S. Finn, this lack of attention was well deserved, for the older literature was often dry and inward looking. Nonetheless, Finn shows how the reawakening of public interest in science and technology (roughly contemporaneous with the rise of space exploration and the growth of popular science centers) has revitalized the science museum literature. Pioneers in such museum innovations as computer-assisted exhibits, science and technology museums found themselves at the center of a wider, lively debate over the functions of the museum in contemporary society.

History museum literature has always raised basic questions about the way Americans confront their past. According to Scott T. Swank, two groups—antiquarian and academic historians—have played significant roles in preserving and interpreting the materials that comprise what the author calls the American "national collective memory." Although these historians began their work with common intellectual assumptions, they became es-

tranged by the turn of the century. Looking out upon an American past from differing institutional perspectives, they increasingly used different sources and often reached conflicting conclusions. Nonetheless, Swank shows how collaborative projects undertaken during the bicentennial celebrations of American independence and the Constitution provided a basis for reconciliation.

In her essay on the American folk museum, Elizabeth M. Adler also stresses the heightened awareness of preserving and interpreting aspects of everyday life in the American past. She shows how American folk and history museums, borrowing from European traditions, made research the foundation for the preservation and interpretation of regional cultures. The principles of fidelity to research and innovation in interpretation, Adler demonstrates, were gradually absorbed into general American museum practice.

While Kenneth A. Yellis agrees that the practice of museum education and interpretation has been exemplary in the field, he finds that the literature on museum education reveals an embarrassing lack of meaningful themes. Part of the problem, Yellis argues, is that educational posturing has too often gotten in the way of the development of a more useful body of theory. Even early visitor research, Yellis notes, often led to the accumulation of data but not insight. Still, he finds hope for museum educators in the findings of more recent visitor surveys and leisure studies. Such research, which focuses on the ways museum visitors derive meaning from visits by relating them to their own experiences, holds out the promise of providing a new theoretical framework for museum education.

In his chapter on exhibition literature, Wilcomb E. Washburn identifies a persistent tension between the exhibit as a form of entertainment and as a form of instruction. Bringing the reader behind the scenes, Washburn candidly discusses some of the conflicts that may arise as directors, curators, designers, and educators each assert their own view of the purpose of the exhibition. Thus, Washburn argues that the making of an exhibition is from its inception a process by which competing visions of the museum are temporarily reconciled. The basic dilemma of the museum—developing an effective idiom of communication without sacrificing the museum's standards of scholarship—is never, however, fully or permanently resolved.

Although few persons today question the proposition that museums should expend scarce resources on public programs, the precise origin of this pervasive commitment to public service is less clear. In his chapter on the museum and the public, Michael S. Shapiro attempts to reconstruct past attitudes about museum visitation and museum audiences by examining changes in the norms of visitor behavior and accepted canons of taste. Understanding these changes, Shapiro argues, helps to explain which groups visit modern museums and which do not, thus providing a useful point of departure for reexamining the policies of contemporary museums.

Invisible to the public are the spaces in which the vast majority of museum

objects are stored. Collections management experts Philip Spiess and Kath-
erine Spiess take readers on a tour of these hidden rooms, explaining some
of the principles and practices by which museums select, acquire, care for,
treat, and organize collections and collections-related information. Although
they make no attempt to survey the field of conservation, a subject requiring
a separate book, due attention is given to the day-to-day practices by which
museums seek to ensure the long-term survival of the collections entrusted
to their care. In the process, the authors illuminate the complex web of
relationships among curators, conservators, registrars, and museum admin-
istrators. Among other topics, the authors also address the new challenges
posed by maintaining extensive collections records and the alluring, yet
elusive, promise of the computer.

Louis W. Kemp's chapter on museum biographies is a refreshing departure
from operational imperatives, offering students, visitors, or patrons a fasci-
nating new entrée to museums. Eschewing the traditional hagiographic treat-
ment of museum founders and directors, Kemp nonetheless finds these
biographies instructive as a group, arguing that the imprint of forceful per-
sonalities continues to loom over many museums and galleries. Further, he
demonstrates how biographies can be used to illuminate the interactions of
museums, the surrounding communities, and prevailing intellectual trends.

J. Lynne Teather's concluding chapter on professionalism and the museum
recasts many of the questions implicitly raised in other chapters. The author
begins by identifying questions central to all professions. Is there a common
body of knowledge? Are the boundaries clearly defined? Is the work force
subject to internal or external discipline? Are training standards commonly
shared and recognized by others? Although Teather finds that profession-
alization is a favorite topic among writers on museums, she contends that
the subject is rarely discussed with the rigor it deserves, a condition she
believes itself reflects the contradictory pressures in the museum field.

Three appendixes serve as guides to readers searching for additional ma-
terials on museums. First is a bibliography of museum directories, an an-
notated list of 200 such directories, organized geographically. This eclectic
list contains entries ranging from world compendiums of museums to guides
to local or specialized collections. To assist readers in quickly identifying
relevant museums, this literature has been divided into three groups: world
directories, national-multinational directors, and regional, state, and local
directors. An index is provided to allow access by location and subject matter.
The second appendix covers museum archives and special collections. This
noncomprehensive guide to the more significant museum depositories is
intended to serve as an entrée to non-published materials on museums. The
last appendix is a selective list of museum periodicals.

1

THE NATURAL HISTORY MUSEUM

Charlotte M. Porter

HISTORIC OUTLINE

According to some authorities, the spectacular gardens of Montezuma that Cortés and his companions saw in Mexico provided the unique impetus for the rather rapid development of living collections of natural history—the large-scale menageries and gardens of exotic species of southern Europe. Certainly it is true that during the first one hundred years that followed the discovery of the New World, fanciful medieval bestiaries and herbals gave way to the finely illustrated books of natural history organized by authors of the scientific Renaissance like Leonard Fuchs (1501–1566) and Conrad Gesner (1516–1565), who attempted to observe nature directly and to record species on the basis of collected specimens. Before the close of the sixteenth century, European collectors had established cabinets of curiosities open to visitors that typically included objects of natural history, American Indian novelties, Chinese porcelain, Roman coins, and other relics. By the mid-seventeenth century, these "cabinets of the curious" had become the prototype for private museums, and the room of Ole Worm's museum in Copenhagen, for example, displayed stuffed quadrupeds and fish, antlers, miscellaneous "animalium partes," shells, roots, mineral salts, and many dried marine creatures in the midst of bows and arrows, paddles, and sundry footwear from around the world.

Although the study of natural history was not yet guided by strictly scientific principles, the presentation of plants and animals for public viewing assumed a more monumental format in the hands of artists than those eclectic

arrays arranged by amateurs. On a sophisticated visual level, the idea of the *Wunderkammer*, or collection of natural and artificial curiosities, inspired a magnificent series of tapestries called "Les Indes," which were woven for Louis XIV at the Gobelins factory in 1687, just five years after the French acquisition of Louisiana. One hundred and seventy years earlier, the great master Raphael had painted species of American birds in the Logetta of Cardinal Bibbiena at the Vatican. The sense of wonder and beauty that natural history inspires has traditionally motivated collections and justified their expense. Yet however lovely, artificial arrangements can give false lessons from nature, and in more recent times, policies of collection and exhibition have been shaped by considerations other than aesthetics, particularly in the United States. Perhaps museum visitors of the twenty-first century will be able to enjoy exhibits that reflect the ideals of the early bird collector, Alexander Wilson, who urged his fellow Americans in 1808 to "examine better into the operations of nature [so that] our mistaken opinions, and groundless prejudices will be abandoned for more just, enlarged and humane modes of thinking."

Although camels and elephants were listed among the wonders of the New World, early travelers were most impressed by its feathered prodigies, the remarkable birds—turkeys, hummingbirds, toucans, and parrots. Not surprisingly, the development of natural history museums followed the progress of the science of birds (ornithology), as well as the study of large fossil animals (paleontology). Indeed, for more than a century, the discovery and accumulation of exotic birds and giant bones, later combined with the Victorian taste for big game hunting, characterized the museum history of the United States. In early American cities, public museums preceded the large private collections typical of European development, and in 1773, the Charleston Library Society opened the first American museum devoted to natural history. Charles Willson Peale's (1741–1827) more ambitious Philadelphia Museum followed in 1786 and became the first commercial gallery to use overhead lighting. An early ticket, which sold for twenty-five cents, shows nature as an open book and reads, "The Birds and Beasts will teach thee!" Located in the Philosophical Hall of the American Philosophical Society from 1794 to 1802, Peale's museum eventually exhibited more than 243 birds and 212 mounted quadrupeds, as well as fish, shells, rocks, and insects.

During the late eighteenth century, the grand voyages of circumnavigation that France, Britain, and Holland launched created the foreign study collections that eventually gave rise to the science of ornithology. The National Museum in Paris, perhaps the finest in the world, contained only 463 bird specimens in 1793, and although that number increased by 3,000 within the decade, neither the brandy nor the embalming spices used to transport and store birdskins warded off destructive insects after they were stuffed. On this side of the Atlantic, Peale surmounted these problems and worked out basic methods for taxidermy and exhibit dioramas that had long-term con-

sequences for museums as permanent scientific repositories of public inter-
est. Apprenticed as a saddlemaker in his youth, Peale studied painting briefly
in London. After the American Revolution, he settled down in Philadelphia
to the life of a portrait painter until one summer day in 1784, when a Hessian
officer brought the artist some massive bones to sketch. Peale began to plan
a natural history collection in conjunction with his portrait gallery and, with
Thomas Jefferson's endorsement, undertook the management of the first
public collections with national, rather than regional, emphasis.

Departing from European custom, Peale displayed bird specimens in
glass-fronted cases backed by naturalistic views or habitats painted by his
artistic children. His effective arsenic method for treating specimens was
imitated by others, and returning to his early training in saddlemaking, he
stretched animal skins over wooden forms to restore lifelike attitudes. Often
he hand-carved the internal limbs for these mounts and even molded the
glass eyes. About fifty of Peale's mounted birds exist today at the Museum
of Comparative Zoology, in Cambridge, Massachusetts, where after almost
two hundred years, the colorful Chinese pheasants Peale obtained from
George Washington are still on display.

By 1816, Peale's annual gross receipts of $11,924 indicated a paid atten-
dance of nearly 48,000 people. Peale's sons attempted to start similar en-
terprises in Baltimore and New York, where Peale's efforts were being
imitated unsuccessfully by Delacoste's museum and other less serious cab-
inets of curiosities. Many of Peale's visitors preferred his animal displays to
his paintings, but Peale's creativity was not to be so easily discouraged, and
he used his museum space for magic lantern shows and musical presenta-
tions. Certainly the message of his "Dirge for Aldrovandus who founded the
first Museum" in Bologna but "spent his final days in the alms house" was
not veiled. Peale's undeniable triumph, and the one that brought him a
modicum of commercial gain, was the exhumation of mammoth bones from
a swamp in Orange County, New York. Peale mounted the entire skeleton
in his museum in 1801 and, with the aid of his sons, toured a second skeleton
in Europe. This mastodon, the first complete fossil reconstruction, made
the mammoth a household word and established the sine qua non for natural
history museums worldwide.

Given the long gallery and tower in present-day Independence Hall rent
free after 1802, Peale provided other naturalists and artists with specimens
to study and draw and also with an audience eager to buy their works.
Regarding his own motivations, he concluded that "the gratification which
every new object produced in the mind of an enthusiastic man is all pow-
erful." Personal dedication aside, however, Peale realized that the key to
posterity was the establishment by Congress of a national museum. Although
his museum failed to realize that goal, the family institution became a source
of employment for the proprietor's many sons and daughters, former slaves,
numerous in-laws, and the city's overflow of talented bank-note engravers.

The imaginative displays that resulted instructed more than a generation of visitors before the museum was acquired by P. T. Barnum in 1849–1850. In particular, Peale's bird collections permitted the production of Alexander Wilson's splendid bird book, and Wilson's landmark publication (1808–1814), in turn, inspired a group of Philadelphians to found the Academy of Natural Sciences in 1812 in order to achieve intellectual "independence" from that city's botanically oriented Linnaean Society.

From its humble beginnings in John Speakman's apothecary shop, the Academy of Natural Sciences organized natural history in the direction of zoology, and by the mid-nineteenth century, the academy's bird collections, first curated in 1817 by Peale's youngest son, Titian, were the largest in the world. During the nineteenth century, other outstanding public institutions established for the promulgation of natural history also focused upon the various sciences of animals, including humans. In contrast to the National Museum of the Smithsonian Institution or the American Museum of Natural History, no botanical collection emerged as a lasting national herbarium, despite the fact that American botany quickly developed as an organized pursuit after the publication of Linnaeus's *Systema Naturae* in 1735.

There were good reasons for this patriotic interest in animals by the end of the eighteenth century. Linnaeus and the scientific polymath, Buffon, had died within a decade of each other, and quite quickly, the Parisian zoologist, Georges Cuvier, filled the position of authority they had shared within natural philosophy. By the turn of the century, Cuvier had identified fossil bones on both sides of the Atlantic as the remains of exotic animals whose past existence posed profound questions about nature and creation. As one tourist remarked upon seeing Peale's mounted mastodon, "Perhaps we ought to imagine if Noah found it too large and troublesome to put in the ark, and therefore left the poor animal to perish." On a more serious level, these big bones also attracted the attention of Thomas Jefferson, and it is no accident that the early government expeditions he organized exercised stringent control over vertebrate collections even though the botanical materials were often more valuable to the medical profession and usually arrived in better condition.

Although Peale's Long Room with its dioramas and fossils was the prototype of the modern natural history museum, his museum idea was waylaid by two problems. The first he correctly identified as the need for reinterpretation of the Constitution so that federal funds could be used to support national collections. Although his museum was used as the national repository for collections made on government expeditions to the West, Peale was not given official sanction. In fact, the best of the Lewis and Clark collections went directly to Jefferson, who maintained them privately as part of his Poplar Forest estate. Peale received the unwanted items—infested antelope skins and rowdy grizzly bear cubs. Congress did not give serious attention to the management of federal collections until after 1842 when

animals, plants, and geological specimens from the U.S. Exploring Expedition to the South Seas arrived in the nation's capital.

The second obstacle to the development of natural history museums in the United States was the location of type specimens, those specimens first given their scientific names and descriptions in press. Many of the type specimens for North American species (with the notable exception of birds) were housed abroad or, in the case of invertebrates, were dispersed across the country in poorly curated private collections, which were usually destroyed after the owner's death. At the same time that Peale's museum began to meet serious financial troubles, the vigorous intellectual climate that followed the War of 1812 encouraged American studies and fostered the growth of lyceums. In some cities, scientific societies that attempted to consolidate private holdings almost achieved true museum status. For example, the Academy of Natural Sciences in Philadelphia opened its museum to the public in 1828, and, by mid-century, its collections numbered 150,000 specimens.

Having been impressed by Philadelphia's venerable American Philosophical Society founded by Benjamin Franklin, Daniel Drake (1785–1852) organized the Western Museum Society in the frontier city of Cincinnati. He hoped to support the collection of specimens in the Ohio Valley and to offer local instruction in natural history. One of Drake's first preparators was the then-unknown bird painter, John James Audubon. Another bird painter, Peale's son Titian, visited Drake's museum in 1819, but by 1823 economic depression forced the Museum Society to shut down.

The more successful New-York Historical Society established a cabinet of natural history and a lecture program in New York City in 1816. Through the common, but deplorable, practice of snipping plant specimens, the society received valuable duplicates of Linnaeus's personal collection, but the membership eventually suppressed scientific directions in favor of history and art. The New York Lyceum of Natural History was founded two years later on the model of the Philadelphia Academy of Natural Sciences, but despite the promise of its metropolitan location, it did not gain the stature of its sister organization, and the New York Academy of Sciences assumed the older lyceum's archives after a fire destroyed its collections in 1866. Furthermore, the 1836 inauguration of the estate's natural history survey in the new capital upstate led to the location in 1843 of the survey's Cabinet of Natural History in Albany. The Museum of Scientific and Practical Geology and General Natural History followed in 1870, and the architecturally dynamic New York State Museum in Albany is the present beneficiary of these former survey headquarters.

The city of Albany had a relatively long history of informal private museums, which on the popular level justified such developments. In 1809, John Scudder announced his intention to establish a city museum in Albany, but the only project to become a reality that year was the Henry Trowbridge

Museum, which first occupied the Old City Hall. Having extended his displays through the purchase of the so-called New Haven Museum and other collection, Trowbridge designated his establishment as the State Museum in 1821 and declared it second only to Peale's Philadelphia museum. Fire damaged the museum in 1838, and in 1855, a press report claimed that the collections were to form a floating museum on the Mississippi River.

In 1871, a former taxidermist for the State Survey, James A. Hurst, opened his Albany Free Museum but, faced with competition from P. T. Barnum's Great Traveling Museum (which owed what little dignity it had to Peale's collections), the Great Eastern Menagerie, and Murray's Great Railroad Circus, Hurst was forced to close three years later. Of elaborate Victorian design, Hurst's displays are noteworthy. Like his 1870 stereoscopic slide of a "Gorilla from Africa, supposed to be our next of kin," they represented an early effort to exhibit human evolution. In fact, the ape Hurst showed was a baboon, for the gorilla was still a novelty, having been first described in 1847 in the *Boston Journal of Natural History*.

Like similar organizations in other cities, the Boston Society of Natural History struggled to maintain collections. This precarious financial existence changed after 1860, when the Boston Society received the first of a series of large gifts. A land grant from the state legislature that followed enabled the society to reopen to the public in 1864. The new Museum of the Boston Society of Natural History drew heavily on the local medical community of professors and students, but even under the leadership of F. W. Putnam and Alpheus Hyatt, both students of the renowned Louis Agassiz (1807–1873), the society's collections were dwarfed by the facilities of nearby Harvard College: the Geological Museum, Gray Herbarium, Arnold Arboretum, Peabody Museum of American Archaeology and Ethnology, and Agassiz's museum. The writing was on the wall. In an age when scientific lectures, institutes, and summer programs were in vogue, the charismatic Agassiz was able to influence a far wider public than his circle of students.

Like Peale, Agassiz advised his public to "read Nature," and like the energetic Philadelphian, he considered museum collections to be an indispensable asset to institutions of higher learning. In 1859, he managed to coordinate considerable private, state, and university support to found the Museum of Comparative Zoology (MCZ). Although his dictatorial leadership has been criticized, Agassiz was the first research biologist to run a permanent museum in the United States. Nevertheless, with the notable exceptions of the avian anatomist Frederick Lucas and James Chapin, the MCZ staff included no other properly trained curators before 1930. Agassiz thought of the MCZ as a storehouse of nature. Through his network of contacts, he attempted to establish synoptic collections for beginners and experts alike to bring under one roof scattered private collections and the miscellaneous holdings of defunct organizations. Eventually the MCZ acquired the collec-

tions of the Boston Society of Natural History, which included some of Peale's well-traveled artifacts.

In 1865, Agassiz organized the famous Thayer Expedition to determine the distribution of fish in Brazil and to test Darwin's ideas about speciation, but despite the carefully made collections, a complete report was never published. In addition to its role in Agassiz's heated public campaign against Darwinism, the MCZ stimulated outstanding museum protégés—A. S. Bickmore, Spencer Fullerton Baird, George Brown Goode, and Henry A. Ward, founder of Ward's Natural Science Establishment in Rochester, New York. In the twentieth century, the museum employed brilliant ornithologists, including the evolutionist and recent director, Ernst Mayr. The museum's fifteen-volume *Checklist of Birds of the World* is a work in progress unequaled for any other group of organisms.

The fruitful path that eighteenth-century collections followed in Great Britain from regional societies to national museums had no successful counterpart in American cities. In the nation's new capital of Washington, D.C., former Secretary of War Joel Poinsett (for whom the poinsettia flower is named) organized the National Institution for the Promotion of Science as a private receivership for the Pacific collections sent back by the Wilkes Expedition from 1838 to 1842. Poinsett and other members hoped that the National Institution could grow into the role of a much-needed national museum of natural history. Following the unprecedented bequest of James Smithson, a British chemist who in 1826 left $508,318.46 worth of gold sovereigns to the United States, Congress did not agree but, after much debate in 1846, established the Smithsonian Institution with Joseph Henry (1797–1878) as its secretary. Henry, the leading American scientist of his day, emphasized pure research and resisted investing the Smithsonian income (then $30,000 a year) in museum services. By 1876, however, the mushrooming growth of government-sponsored collections sent back by Lieutenant W. H. Emory's Military Reconnaissance (1846–1847), the Gadsden Boundary Survey (1854–1855), the Pacific Railroad Surveys (1853), and F. V. Hayden's Geological Surveys of the Territories (1869–1878) necessitated the organization of a distinct natural history museum within the Smithsonian Institution.

After Spencer Baird (1823–1887) succeeded Henry as secretary, Congress established the U.S. National Museum in 1879 and provided a new building for the collections, now the Smithsonian's Arts and Industries Building. Under Baird's youthful supervision, the National Museum's collections, especially the birds, rapidly achieved a status not since surpassed. Baird, in turn, employed a young ichthyologist named George Brown Goode (1851–1896) to arrange the Smithsonian and U.S. Fish Commission exhibits for the Philadelphia Centennial Exposition of 1876, and Goode soon became the foremost American museum professional of his day. In charge of the National

Museum after 1887 until his death, Goode expanded its purview to include all aspects of American culture. Reflecting his views, the "nation's attic" (as the Smithsonian museums are affectionately known) now contains more than 65 million objects, 80 percent of them natural history specimens.

In 1869, A. S. Bickmore (1839–1914) founded the American Museum of Natural History in New York City. In contrast to his teacher, Agassiz, Bickmore wanted a democratic museum with learning opportunities for children, and his idea gained loyal support from city magnates, including Theodore Roosevelt, Sr., Benjamin A. Field, Robert Colgate, William E. Dodge, and later J. Pierpont Morgan. The state of New York chartered the museum, which the commissioners of then new Central Park housed on the upper floors of the park's Arsenal Building. In 1871, the museum wisely joined the Metropolitan Museum of Art and, with the aid of Boss Tweed, secured the still-standing agreement with the city to provide buildings, maintenance, and security. The cornerstone for the museum's first birthday at its present location on Central Park West was laid in 1874.

In 1881, multimillionaire banker Morris K. Jesup became president of the museum. Jesup attracted funds, appointed scholarly curators, and personally financed expeditions, including Robert E. Peary's trek to the North Pole. Later Jesup and his widow left $6 million to the museum, a sum that has grown to 20 percent of the present endowment. Jesup supported the beautiful bird habitat groups developed by Frank M. Chapman for the Hall of North American Birds, Birds of the World, and the Whitney Hall of Birds. Although Chapman (1864–1914) had no college education, he rose from an assistant position in 1888 to head of the museum's ornithology department in 1908. Chapman, in turn, encouraged the fine bird painter Louis Agassiz Fuertes and discovered the talented museum artist Francis Lee Jaques. Indeed, it had been said that because of Chapman's vision, the American Museum has had a more profound impact on the development of American ornithology than any other institution in recent times. With almost 1 million bird specimens and 250,000 mammals, the collections are second only to those of the National Museum.

After the Civil War, Americans settled 430 million acres west of the Mississippi River. The territorial surveys mapped western regions, determined mineral resources, and assessed land use. Although only nine dinosaurs were known, fossil finds made by the Nebraska Survey in 1847 and presented to the Academy of Natural Sciences in Philadelphia demonstrated the opportunities federal surveys provided collectors and created intense competition among private museums. For example, after 1870, Othniel C. Marsh (1831–1899), professor of paleontology at Yale University and the first director of the Peabody Museum, conducted a series of Yale expeditions that uncovered the first skeletons of *Brontosaurus*, *Stegosaurus*, *Diplodocus*, and *Triceratops*. These spectacular fossils were displayed with much fanfare in Yale's Peabody Museum of Natural History, established in 1866 by Marsh's uncle, George Pea-

body. In addition to eighty new dinosaurs, Marsh described the first cretaceous toothed birds, early marsupials, and his famous fossil horse series, including specimens of thirty American species. Through Marsh's efforts, the Peabody Museum's collection of Mesozoic mammals became the finest of its kind in the world and was cited by both Charles Darwin and Thomas Henry Huxley as "the best support to the theory of evolution."

Not to be outdone, between 1891 and 1910, the trustees of the American Museum of Natural History spent over $110,000 on fifty-two expeditions to western bone quarries. Materials from Bone Cabin, Wyoming, alone filled two railroad cars supplied by J. P. Morgan, an uncle by marriage to the museum's curator of vertebrate paleontology, Henry Fairfield Osborn (1857–1935). In total, four major quarries yielded 493 specimens of Jurassic mammals. Furthermore, in 1895, the trustees used $35,000 from a secret fund of Morgan to buy the collections of Marsh's bitter rival, Edward Drinker Cope (1840–1897), a veteran of earlier government surveys led by F. V. Hayden over 1870–1873 and 1875–1879. Cope, the nation's authority on fossil fish, had also described fifty-six new dinosaurs, and the museum's splendid Hall of the Age of Mammals still displays fifty-seven of his discoveries, including twenty-eight type specimens from the John Day beds and other locations. Many more remain in their packing cases.

The American Museum of Natural History now owned the largest vertebrate paleontological collections in the world, and Osborn recognized the great public appeal of these fossil giants. As president from 1908 to 1932, he supervised artists Charles Knight, R. Bruce Horsfall, and Erwin S. Cristman, whose murals of prehistoric creatures have shaped the popular imagination of millions of visitors. Furthermore, through the museum's powerful trustee, Osborn was able to organize a series of exclusive hunting clubs that were responsible for the bagging of the exotic species used in the magnificent and unequaled dioramas constructed under his presidency. Even at the height of the Great Depression, Osborn managed to meet the costs of these life groups, which ranged from $10,000 to $35,000 apiece. By 1927, through his emphasis on the museum arts and interpretation, Osborn had, despite his controversial statements on race and eugenics, given his term *museology* real application. But Osborn did not stop here. Between 1922 and 1930, he raised $1 million and charged Walter Granter with the largest privately endowed land expedition ever to leave the country, this time for the Gobi Desert. Osborn's methods worked. In one year alone, the much-publicized find of a clutch of fossilized dinosaur eggs attracted contributions of $284,000. However, the dinosaur wars had not ended in complete victory for New York, for the great industrialist and philanthropist, Andrew Carnegie, joined the fray shortly after the establishment of his Museum of Natural History in Pittsburgh in 1896.

Impressed by Osborn's department of vertebrate paleontology, Carnegie ordered the museum's director, W. J. Holland, to procure Pittsburgh's first

dinosaur for $10,000, and field collectors were sent West in 1898. Following the discovery in Wyoming of "Dippy," an almost complete 10–ton *Diplodocus*, A. S. Coggeshall designed a system for mounting dinosaurs still used today, and Carnegie undertook a program of fossil replicas for museums in Austria, Russia, Argentina, and Germany. In 1909, Earl Douglass found the unusually rich site at present-day Dinosaur National Monument, Utah, and the Carnegie Museum began to amass one of the world's outstanding collections of Mesozoic reptiles, which, with Carnegie's donations of over $250,000, continued to grow until his death in 1919. Today the museum owns approximately 500 catalogued dinosaur specimens, including five type specimens. Also in 1903 Carnegie purchased the famous collection of Baron Ernest de Bayet of Brussels for $20,500. The result of forty years of collecting, the Bayet collection was one of Europe's largest private fossil collections and includes superb Jurassic invertebrates from southern Germany and eleven pterosaurs, rarely found winged reptiles.

Before the turn of the century, two more major museums were founded: the first children's museum in Brooklyn, New York, in 1899 and the Field Museum of Natural History in Chicago. By 1893, Marshall Field's gift of $1 million had created the Field Museum on the basis of the Colombian Exposition and newly acquired natural history collections. Field hired the master preparator, Carl Akeley, whose first habitat group of muskrats done in 1892 is still displayed at the Milwaukee Public Museum (established in 1882). Akeley mounted many animals for the Field Museum, including the pair of elephants in the Great Hall. (A formidable fieldworker as well, Akeley is said to have saved himself in Africa by strangling an aggressive leopard.) Osborn, meanwhile, maintained a polite balance of power with Field. In 1909, he convinced Akeley to leave the Field Museum to create dioramas for the hall at the American Museum of Natural History, which bears his name. Osborn was also willing to share his staff talent with Field and permitted the artist Charles Knight to paint prehistoric humans for the Chicago museum. Osborn, in turn, expected the Field Museum to provide him with casts of the unusual series of bronze sculptures of modern primitive peoples made by Malvina Hoffman.

Other museums imitated Osborn's exhibition approach. Thousands of animals for life groups at the Natural History Museum of Los Angeles County (established 1910) were gathered by two wealthy supporters, Maurice A. Machris and T. A. Knudsen. They were accompanied in East Africa by sixty animal trackers, professional hunters, drivers, and cooks, as well as the museum's senior taxidermist, George Adams, who helped select specimens. In addition to big game trophies, the museum received entire families of chimpanzees and monkeys, birds, insects, and even plants. In recent years, the zealous collection policies of the turn of the century have been reevaluated, and as natural habitats are disturbed worldwide and many organisms face extinction, American natural history museums are fast becoming valu-

able repositories of destroyed ecosystems. In this regard, the National Park Service took an important step in 1921 by opening its first site museum at Yosemite National Park. Other interpretation centers followed the growth of the park system and explain the significance not only of objects but also of particular natural communities in situ.

Throughout the development of natural history museums in the United States, no other branch of inquiry has attracted more attention than ethnography, the study of human races. During the eighteenth century, the brisk China trade permitted Charles Willson Peale to assemble some of his earliest acquisitions—articles of clothing, weapons, and utensils from around the world. Peale, like other Enlightenment thinkers, was particularly interested in "the Noble Savage," the North American Indian, and he hoped tribal delegates would visit his museum, where he displayed their artifacts with the hope of peaceful relations. Peale also collected human skeletons of various types (as well as skin samples). Subsequent museums followed his lead, including Harvard's Peabody Museum of Archaeology and Ethnology in Cambridge, which was founded in 1866 and acquired more than one thousand of Peale's artifacts through a generous bequest in 1899.

Although the Philadelphia Academy of Natural Sciences possessed perhaps the largest phrenological (skull) collection in the world by 1840, prior to the advent of Darwinism, most ethnographic collections were eclectic assemblages reflecting the travels of local benefactors. The idea of evolution, however, changed ethnography from the traditional documentation of customs and languages to the study of human speciation, and contrary to the earlier dogma of Cuvier, the discovery of human fossil remains was eagerly anticipated on both sides of the Atlantic. By the end of the century, debate about possible land bridges and the origins of Indians in the New World climaxed in the Jesup North Pacific Expedition organized by the trustees of the American Museum of Natural History and funded by a grant of $16,240 from Jesup.

The Jesup Expedition was the brainchild of Franz Boas, the outspoken pioneer of cultural anthropology in the United States. Boas hoped that the cultural exchange among the disappearing groups of the Northwest Coast would yield clues to their early histories. The expedition's busiest years, 1897 and 1898, were followed by an investigation of the peoples of Siberia, when competition with the Field Museum of Chicago became a problem. Added to the older Bishop and Emmons collections, the Jesup materials account for about 90 percent of the museum's Northwest Coast artifacts and, together with the holdings of the Heye Museum of the American Indian established in New York City in 1916, form a preeminent resource for understanding material cultures of historic North American Indians. In 1989, the Heye Foundation and the Smithsonian Institution entered into an agreement under which the bulk of the Heye Collection would be establish a National American Indian Museum within the Smithsonian.

Although Osborn's promotion of the museum's Hall of the Age of Man (1924) and his role in the famous Scopes trial jointly formed the single most effective campaign to integrate prehistoric and primitive peoples into the larger framework of animal evolution, Osborn was no friend to the new science of anthropology. Boas, for example, bitterly opposed Osborn's racist perspective on modern human groups and became an early advocate of scholarship and a public museum devoted to the Negro, both ideas ahead of their time. Today native cultures continue to survive, often in different forms than may be expected, and within the North American Indian Museum Association (established 1978), there are more than one hundred museums operated by native Americans. The largest American ethnographic collection is owned by the Smithsonian Institution, and taken as a group, ethnographic collections at natural history museums have indeed demonstrated the value of what Boas described in 1899 as the application of "inductive methods to the study of social phenomena."

SURVEY OF SOURCES

Despite the intrinsic interest of natural history museums, no single work or identifiable group of works treats the history of natural history museums in a comprehensive way. In general, with regard to museums in the United States as well as museums in Mexico, the Soviet Union, and Southeast Asia, more authors have examined that special branch of natural history, ethnology, than any other discipline. See, for example, *The National Museum of Anthropology; Mexico* (1968) by Pedro Ramírez Vázquez and others; *National Museum of Anthropology, Mexico City* (1970) by Carlo Ludovico Ragghianti and Licia Ragghianti Collobi; *The Mexican National Museum of Anthropology* (1973) by Ignacio Bernal and others; "Mexico, Museum Country" (1976) by Iker Larrauri; *The Museum of Anthropology and Ethnography Named after Peter the Great* (1970) by T. V. Stanyukovich; and "Museums of Anthropology: Their Role in East, South and Southeast Asia" (1976) by Grace Morley. No doubt this comparatively intense scholarly interest reflects the intellectual ferment created by the study of past human cultures and present-day races in the political climates of these nations. All the same, only works that discuss ethnographic or anthropological collections as parts of large natural history museums will be discussed here. Works such as Percy Madeira's *Men in Search of Man* (1964), which treat museums like the University of Pennsylvania's University Museum or Harvard University's Peabody Museum of Archaeology and Ethnology, will not be mentioned again.

In the absence of definitive monographs, the best sources for case studies are museum archives, the manuscripts of their leaders, and newspaper collections. Although such repositories provide the eager scholar with the joys of working with primary documents, museum archives, unlike their collections, are often tedious to use, poorly curated, and/or closed to general use.

Increased demand by researchers and students in the growing field of museum studies might well change access policies. Max Meisel's masterwork, A *Bibliography of American Natural History* (1924–1929), is an invaluable reference guide to locating rich stores of nineteenth-century materials, but this tome needs to be updated for the twentieth century by an equally dedicated author. (A list of museum archives and special collections appears as appendix B.)

Besides Charles Willson Peale and Ambroise M. F. J. Palisot de Beauvois's A *Scientific and Descriptive Catalogue of Peale's Museum* (1796), a number of other works reflect the desire of early, gifted thinkers to integrate the history of American art and nature museums. Not surprisingly, many of these authors were, like Peale, museum directors. George Brown Goode, in such representative works as "The Beginnings of Natural History in America" (1901) and "The Genesis of the U.S. National Museum" (1901), used the publications of the Smithsonian Institution to give his thoughtful ideas wide currency among museum professionals, researchers, and general readers. Later A. E. Parr reexamined the development of American museums in *Mostly About Museums* (1959). His efforts to place museum history well within cultural history include "Museums and Museums of Natural History" (1962), "Civilization and Environment" (1963), and "On Museums of Art and Nature" (1980). Parr's works span twenty years during which time natural history museums found their place as chapters in a number of studies like the chatty work by Alvin Schwartz, *Museum: The Story of American's Treasure Houses* (1967); the nicely written, reflective essays by Dillon Ripley, *The Sacred Grove* (1969); and the more scholarly volume by Whitfield Bell, Jr., and others, A *Cabinet of Curiosities* (1967).

Two works written by experienced museum professionals for others entering the field, George Ellis Burcaw's *Introduction to Museum Work* (1975) and Edward Alexander's more recent *Museums in Motion* (1979), have become staples of basic museology courses at universities, and both offer good, brief introductions to the natural history museum. Burcaw's thumbnail sketches put natural history museums into a museological perspective, while Alexander offers a short history and inventory of contemporary issues in the natural history museum. This thesis received larger treatment by Kenneth Hudson in his A *Social History of Museums* (1975), an ambitiously titled, but earnestly intended, work in a much-needed area of museum studies. In general, the urban growth of natural history museums in the United States merits comparison with their sister organizations of living natural history, or zoos, on the one hand [L. Harrison Matthew's "The Zoo" (1976) and Helen Horowitz's "Seeing Ourselves Through the Bars" (1981)], and botanic gardens on the other [C. Stuart Gager's "Botanic Gardens in Science and Education" (1937)].

Unlike the ubiquitous appeal of the British Museum, described in Sir William Flower's *Essays on Museums and Other Subjects Connected with*

Natural History (1898) and more recently in *That Noble Cabinet* (1974) by Edward Miller, American museums of natural history have been of primary concern only to American scholars of recent decades. With the exception of the Charleston Museum, which has thus far received only brief treatment by Laura Bragg in "The Birth of the Museum Idea in America" (1923), the best-documented museums in the United States are the oldest ones, and perhaps no other museum has attracted more scholarly attention than Charles Willson Peale's Philadelphia Museum. The colorful appeal of his enterprise seems to have lent this large number of publications a lively character that deserves imitation. The popularity of Peale's Museum as a subject of research also reflects the fact that his institution defined many future directions—mounted birds, big bones, and western exploration—and the corpus of Peale scholarship, climaxing in the recent, lavish volume by Edgar Richardson, Brooke Hindle, and Lillian Miller, *Charles Willson Peale and His World* (1983), certainly provides a well-rounded model for other museum studies.

Next to Peale's own *Discourse Introductory to a Course of Lectures on the Science of Nature* (1800), Peale's ideas have received their greatest dissemination in *Charles Willson Peale* (1947), the work of his talented descendant and definitive biographer, Charles Coleman Sellers. Indeed, for many years, Peale Museum research was a family affair. Seller's early description of this institution, entitled "Peale's Museum" (1953) and published in the *Transactions of the American Philosophical Society* (which owns Peale's manuscripts), was based in part on the early "Biographical Sketch of Charles Willson Peale" (1830) and accounts of such relatives as Harold Sellers Colton in "Peale's Museum" (1909).

Sellers's exhaustive search through museum collections along the eastern seaboard not only culminated in his comprehensive history of the museum, *Mr. Peale's Museum* (1980), but also stimulated a number of fruitful efforts by other authors. John Greene, in "The Founding of Peale's Museum" (1966), reexamined Peale's scientific and personal motivations for the museum; Jessie Poesch's *Titian Ramsay Peale* (1961) and Richard Ellis's "The Founding, History, and Significance of Peale's Museum in Philadelphia" (1966) followed the museum's later history after the founder's death in 1827; and James Flexner's delightful chapter in *The Light of Distant Skies* (1954) breathed life into Peale's spectacular stagings. To these works has been added the considerable scholarship of Lillian Miller, author of "The Peale Family" (1979) and editor of *The Collected Papers of Charles Willson Peale and His Family (1735–1885)* (1980). These studies owe much to Sellers's painstaking tracking down of artifacts and Walter Faxon's identification of extant specimens from Peale's collections in "Relics of Peale's Museum" (1915), as well as the published accounts of museum tourists and artistic cohorts, including William Blane's *Travels through the United States and Canada* (1828) and

William Dunlap's *History of the Rise and Progress of the Arts of Design in the United States* (1834).

Thomas Jefferson's nationalistic goals for American natural history with regard to organized exploration of the western regions have been mentioned by Donald Jackson in *Thomas Jefferson & the Stony Mountains* (1981), and the particulars of Jefferson's contributions to Peale's museum idea can be found in their correspondence concerning the specimens of the Lewis and Clark Expedition, as contained in Jackson's edited volume, *Letters of the Lewis and Clark Expedition, with Related Documents* (1978). The unexpected destiny of these artifacts, Barnum's American Museum, is discussed briefly by John Perry in "P. T. Barnum's American Museum" (1976) and at more length by Neil Harris in his valuable contribution to nineteenth-century cultural studies in the United States, *Humbug* (1973). Finally, Hans Huth's *Nature and the American* (1957) has addressed the role of Peale's museum and other, later institutions of natural history in his description of popular American attitudes about nature during the last century.

In addition to essays by former directors and the aftermath of Peale studies, historians of science have provided many of the best analyses of museums within the context of other emerging organizations of natural history. For the colonial period, the classic study is the richly detailed volume by Raymond Stearns, *Science in the British Colonies of America* (1970), which, when combined with such studies of Sir Hans Sloane and the Royal Society as Hermann Braunholtz's *Sir Hans Sloane and Ethnography* (1970) and Gavin De Beer's *Hans Sloane and the British Museum* (1953), furnishes a good picture of corresponding naturalists. This transatlantic circle created the foundation for collections of North American specimens in Britain and dissemination in the colonies of the Linnaean classification of living things.

Dirk Struik's *Yankee Science in the Making* (1962), often overlooked in an era of conservative scholarship, offers a refreshing examination of paths that did not lead to lasting institutions of science and the difficult careers of idiosyncratic naturalists and collectors both in and out of "yankee" society. A good litmus test for many of Struik's more critical remarks is an influential contemporary assessment made by a political author with natural history interests, Governor De Witt Clinton of New York, in his "Introductory Discourse" (1815). Having investigated American natural history after 1830, George Daniels gives mixed reviews of its achievements in *American Science in the Age of Jackson* (1968). His conclusion that U.S. natural history was at best Baconian, or cumulative in purpose, gives some clues to the prolonged congressional debates concerning the philosophical interpretation of Smithson's will and its application to scientific collections.

Since U.S. museums of natural history founded during the nineteenth century have emphasized the animal sciences, another useful discussion is Wesley R. Coe's overview of zoology in the centennial volume by Edward

Dana and others, *A Century of Science in America* (1918). More specifically, Erwin Stresemann's *Ornithology from Aristotle to the Present* (1975), a comprehensive history of the study of birds, contains a seminal epilogue by the noted evolutionary biologist Ernst Mayr, who points out the close relationship between bird collections and the development of technical systematic ornithology in the United States. Furthermore, in a rather unusual article, "The Development of Taxidermy and the History of Ornithology" (1977), Paul Farber outlines the practical advances in preparing birdskins that made stable collections possible. George Simpson has given these works their counterpart in one of the best-written, most knowledgeable monographs in the field, "The Beginnings of Vertebrate Paleontology in North America" (1942). Simpson's article is the place to begin for an understanding of large fossil collections in the United States. Taken as a group, these works have been updated on occasion, but they have not been surpassed, and they provide museologists with essential background in the history of natural history and valuable detailed bibliographies.

In addition to the history of internal developments within natural history, museums more than any other natural history organization reflect the external or sociopolitical factors outside science that shape growth and often determine directions and even objectives. Historians of science in the United States have taken the lead in careful case studies of scientific societies, the foci of organized natural history and its public interface. Here the role for scientific institutions as unfulfilled museums has long been a source of controversial interpretation and the subject of unsigned articles since 1826. Ralph Bates's *Scientific Societies in the United States* (1965) was among the first attempts at an overview, and, in this regard, the bicentennial volume edited by Alexandra Oleson and Sanborn Brown, *The Pursuit of Knowledge in the Early American Republic* (1976), has become without question the definitive source for the histories of early urban and frontier societies of science. Particularly valuable are the chapters on the Boston Natural History Society by John C. Greene and the Philadelphia Academy of Natural Sciences by Patsy Guerstner.

Because of its self-conscious beginnings, perhaps, no other society dedicated to the promulgation of natural history in the United States has received more scholarly attention than the Philadelphia Academy, described in Maurice Phillips's "The Academy of Natural Sciences of Philadelphia" (1953). The academy's museum now as, then, has major national standing, eliminating the need for a civic counterpart in one of the nation's oldest cities. As the academy's earliest historian and corresponding secretary for many years, S. G. Morton provided for the periodical press a *Notice of the Academy of Natural Sciences of Philadelphia* (1831) and a "History of the Academy of Natural Sciences of Philadelphia" (1841), both of which include valuable descriptions of not only collections but also their arrangements and modifications over time. A generous benefactor, Herman Fairchild, served a

similar function for the New-York Lyceum of Natural History, and his account, *A History of the New York Academy of Sciences* (1887), used some primary sources no longer extant. Sally Kohlstedt has emphasized the role of the educated amateur in these societies (particularly the Boston Society for Natural History) in another bicentennial volume edited by Gerald Holton and William Blanpied, *Science and Its Public* (1976). In addition, selected writings edited by Henry Shapiro and Zane L. Miller in *Physician to the West* (1970) reveal Daniel Drake's pivotal role in the short-lived museum endeavor in Cincinnati. Last, and perhaps most important, a sense of both the enthusiasm and the rarely met expectations natural history societies and the opening of their cabinets generated on the local level can be found in F. W. P. Greenwood's "An Address Delivered before the Boston Society of Natural History" (1834) and John W. Francis's *A Discourse: Delivered Upon the Opening of the New Hall of the New-York Lyceum of Natural History* (1841).

Besides the development of the scientific disciplines within natural history and the organization and promulgation of its pursuits by societies, the growth of museums in the United States paralleled geographical interests, namely state and federal appropriations, not for collections per se but for a wide variety of surveys. The state surveys led the way with North Carolina in 1823 and South Carolina the next year, but federal undertakings were more various. Ranging from the simple mission of exploration characteristic of Jefferson's day to the gargantuan U.S. Geological Surveys of the Gilded Age, they helped to create major American museums with some of the largest natural history collections in the world. William Goetzmann, in *Exploration and Empire* (1966), delineates the role of mid-century western military reconnaissances, boundary surveys, and railroad expeditions in the genesis of East Coast collections, particularly those of the National Museum of the Smithsonian Institution. Goetzmann was also one of the first authors to emphasize the later role of photography and landscape painting as congressional ploys that mightily assisted the rise of the U.S. Geological Survey and provided a much-needed boost to the career of John Wesley Powell. Powell, a geologist, later managed the powerful Bureau of American Ethnology in Washington, D.C., which is treated at length by Neil Judd in *The Bureau of American Ethnology* (1967). In *Contributions to a History of American State Geological and Natural History Surveys* (1920), G. P. Merrill, one of the most literate historians of geology the nation has produced, attempted an early evaluation of the contributions of natural history surveys at the state level. In the case of New York, the survey spun off a major public state museum and also the minor, but interesting, private Hurst enterprise described by Robert Hatt in "James A. Hurst, New York's First State Taxidermist" (1976). Merrill's writings merit reevaluation and continuation for those U.S. territories that are now states with their own museum collections.

Although it is almost inconceivable to twentieth-century museum visitors,

government support of museum collections required almost half a century of congressional deliberation and legislative and constitutional amendments, as A. Hunter Dupree has so ably explained in his *Science in the Federal Government* (1957). At every turn, the evolution of the U.S. National Museum of Natural History was punctuated by debate, for policymakers were not prepared to receive so large a cash gift as Smithson's bequest, and by 1836, different members of Congress had conflicting ideas about how the British chemist's money could best be used to "increase and diffuse" knowledge. Melville Grosvenor's "How James Smithson Came to Rest in the Institution He Never Knew" (1976) provides a brief account of Smithson's intentions, and M. E. Pickard's "Government and Science in the United States" (1946) has given a thought-provoking introduction to the issues surrounding the utilization of the bequest for a scientific institution of learning that was at once both a library and laboratory but not a school or museum. In "A Step Toward Scientific Self-Identity in the United States" (1971), Sally Kohlstedt, one of the most prolific historians on the subject of scientific institutions, has shown the failure of the National Institute in 1844 as a nascent museum or national organization. Despite a rather fortuitous location in Washington, D.C., the institute's influential membership lost its advantage when it lost custody of the substantial collections of the U.S. Exploring Expedition. George Brown Goode has discussed at length the details of the true genesis thirty years later of a permanent national caretaker of federal natural history collections, the U.S. National Museum, and Curtis Hinsley, Jr., has focused upon the Smithsonian Institution's role in the development of anthropology from 1846 to 1910 in *Savages and Scientists* (1981). His book deserves companion volumes for the sciences of ornithology and ichthyology as well. Geoffrey Hellman has assembled a handy, popular history of the institution—its directors, detractors, and acquisitions—in *The Smithsonian: Octopus on the Mall* (1967).

It has been claimed that the sometimes adversary relationship between science and government that gave the mission of the Smithsonian Institution its particular place in American life had its counterpart in the university museum and nineteenth-century college. In *Science and the Ante-Bellum American College* (1975), Stanley Guralnick has examined the role of the various branches of science, including natural history, in liberal arts curricula before the Civil War and has concluded somewhat surprisingly that, although natural history was rather poorly represented on many college campuses, it was not discouraged as an intellectual pursuit, even at denominational colleges where study of the classics prevailed.

Laurence Vail Coleman has written a useful description of the often neglected resources of campus museums, *College and University Museums* (1942). With the notable exception of the Florida Museum of Natural History, established by the state legislature in 1917 but now organized as a college within the University of Florida, these university museums perform a func-

tion, by virtue of their academic status, quite distinct from the large private and/or civic museums with more popular concerns. Their histories show an interesting shift in American life. During the twentieth century, city museums have provided both leaders and national spokesmen for not only natural history museums but also all other types of museums, as a review of founders and presidents of the American Association of Museums will demonstrate. In contrast, during the nineteenth century, as excellent short essays in *The Lazzaroni* (1972) by Lillian Miller, Frederick Voss, and Jeannette Hussey reveal, academically prominent scientists exerted considerable effort to promote the development of an intellectual climate in Washington, D.C., favorable to the formation of museums and the use of public monies to support them. In particular, Edward Lurie's *Louis Agassiz: A Life in Science* (1960) provides the definitive biography of perhaps the most controversial of these "campus" intellectuals, and Ralph Dexter's "Contributions of the Salem Group of Agassiz Zoologists to Natural Science Education" (1976) patiently follows the dissemination of Agassiz's ideas through his group of Harvard students to outlying communities.

Besides the constitutional interpretation necessary for federal support of museums in the United States and the broad-based interest in natural history necessary to sustain them, historians have pointed out that the establishment of lasting museums with ongoing curation freed from the vicissitudes of public sentiment required cultivation of private philanthropy on an unequaled scale. Indeed, until after the Great Depression, Osborn's place in New York circles of wealth, along with Field's role in Chicago and Carnegie's self-made financial empire, formed a powerful museum triangle, a virtual triumvirate that diverted substantial funds from other agencies and curried favoritism in high places for such things as special travel visas and the importation of exotic species. Author of *The American Museum of Natural History* (1911), Osborn remains the most prolific and also the most biased historian of the civic institution he almost single-handedly reshaped into a world giant.

In *Dollars for Research* (1970), Howard Miller has examined general questions of scientific research and patronage just prior to Osborn's career at the American Museum of Natural History. With regard to natural history museums per se, John Kennedy investigated perhaps the classic example for his doctoral dissertation, "Philanthropy and Science in New York City: The American Museum of Natural History, 1868–1968" (1968). Although Kennedy's work remains unpublished, his thesis appears in a somewhat modified form for the general reader in Geoffrey Hellman's popular, colorful history of the same institution, *Bankers, Bones & Beetles* (1969). Helen McGinnis has carefully examined Carnegie's personal tactics in acquiring world-class collections for Pittsburgh in *Carnegie's Dinosaurs* (1982), and both Edwin Colbert, in *Men and Dinosaurs* (1968), and Elizabeth Shor, in *The Fossil Feud Between E. D. Cope and O. C. Marsh* (1974), have elaborated on the expensive "fossil feuds" that gave rise to the major vertebrate

paleontological collections in the United States. In the case of Chicago, Donald Collier has briefly examined the contributions of the Colombian Exposition to the birth of Field's museum idea in "Chicago Comes of Age" (1969), and a somewhat longer contemporary view, focusing upon the establishment of the museum's department of anthropology, is found in George Dorsey's "The Department of Anthropology of the Field Colombian Museum" (1900), written only six years after the fact.

The literature treating the history of natural history museums in the United States pales before both the volume and intellectual fervor of works devoted to the history of their anthropological collections, qualities that may well derive from the intense personal animosity between Osborn and Boas. In "The Rise to Parnassus" (1983), Charlotte Porter has shown that Osborn, basically an evolutionary mammalogist, viewed early humans as a special case of fossil history, subject to the same laws as any other fossil forms, except that Osborn's interpretation was clouded by deep-seated racism. The halls he built did not permit the cultural understanding of primitive peoples, past or present, that Boas demanded as a foundation for the modern science of anthropology. Like Osborn, Boas was an ardent historian of his own cause in such works as "Advances in Methods of Teaching: Anthropology" (1899), *Materials for the Study of Inheritance in Man* (1928), and *Anthropology and Modern Life* (1932). His career has also attracted scholarly attention by John Buettner-Janusch in "Boas and Mason" (1957) and more recently by Curtis Hinsley, Jr., and Bill Holm in "A Cannibal in the National Museum" (1976). Boas was really demanding a revolution in thought with regard to the modern human races both as subjects of study and social interaction, and from the days of the painter George Catlin's traveling "Indian Gallery" (William Truettner's *The Natural Man Observed* [1979]) to Heye's Museum of the American Indian (George Pepper's "The Museum of the American Indian" [1916] and V. Vincent Wilcox's "The Museum of the American Indian" [1978]), no one who has attempted large-scale anthropological displays has done so without controversy.

The special relationship in the United States between the growth and direction of anthropology and museum collections has been repeatedly examined in a number of publications, including "The Role of Museums in American Anthropology" (1954) by Donald Collier and Harry Tschopik, Jr., and "Anthropology and the Museum" (1967) by Frederick Dockstader. Hermann Frese, in *Anthropology and the Public* (1960), has addressed the function of museums in the public perception of science. Marcus Goldstein, in "Anthropological Research, Action, and Education in Modern Nations" (1968), and James Kellers, in "On Museums and the Teaching of Anthropology" (1970), have taken a bold look at the problems museum collections can present, and William Fenton has addressed some of the difficulties with continuity faced by researchers in his "Field Work, Museum Studies, and Ethnohistorical Research" (1966). In a prescient article, "Problems and Pro-

cedures in Modernizing Ethnological Exhibits" (1955), John Ewers discussed what would, during the turbulent civil rights movement of the 1960s, become a thorny issue of modernizing ethnological exhibits to meet the social expectations of an ever changing American public, and Gert Nooter's "Ethics and the Collection Policy of Anthropological Museums" (1972) examined the even more difficult ethics of collecting as some cultural groups wish to reclaim articles of religious significance while others face material impoverishment. For fellow members of the museum profession, "Finders Keepers?" (1973), by James Nason and others, rather pointedly questioned whether "finders" should be "keepers" in the acquisition process described by Karl Meyer in *The Plundered Past* (1973).

In general, collection policies for all museums have undergone scrutiny as preservation techniques have been reevaluated and methods of display improved. Ernst Mayr and Richard Goodwin were among the first to review biological materials in museum collections in *Biological Materials*, part 1 (1956). Volume 2 of *The Preservation of Natural History Specimens* (1955–1968), edited by Reginald Wagstaffe and J. Havelock Fidler, and the 1968 symposium of the Biological Society of Washington, D.C., entitled "Natural History Collections, Past, Present, Future" (1969) and arranged by Daniel Cohen and Stanwyn Shetler, were also devoted to examination of past procedures and anticipated preservation challenges to be faced by curators of natural history materials. Such review has and will continue to have a profound impact on the care and the understanding of natural history collections. Certainly both natural history curators (Donald Squires's "Schizophrenia: The Plight of the Natural History Curator" [1969]) and museum directors alike (Thomas Nicholson's "NYSAM Policy on the Acquisition and Disposition of Collection Materials" [1974]) have become more self-conscious about their research, collection, and exhibition decisions as they and their public become more cognizant of the social biases of their times. As a result, museums of natural history in the United States have without question become the first as a national group to incorporate worldwide conservation objectives into the fabric of their acquisition policies.

BIBLIOGRAPHIC CHECKLIST

Abbott, Shirley. *The National Museum of American History*. New York: Harry N. Abrams, 1981.

Alexander, Edward P. *Museums in Motion: An Introduction to the History and Functions of Museums*. Nashville, TN: American Association for State and Local History, 1979.

Bates, Ralph S. *Scientific Societies in the United States*. 3d ed. Cambridge, MA: MIT Press, 1965.

Bell, Whitfield J., Jr., Clifford K. Shipton, John C. Ewers, Louis Leonard Tucker, and Wilcomb E. Washburn. *A Cabinet of Curiosities: Five Episodes in the*

22
The Museum

Evolution of American Museums. Charlottesville: University Press of Virginia, 1967.

Benjamin, Marcus. "Memories of the Smithsonian." *Scientific Monthly*, 4 (May 1917), 461–72.

Bernal, Ignacio, Román Piña-Chán, and Fernando Cámara-Barbachano. *The Mexican National Museum of Anthropology*, translated by Carolyn B. Czitrom. Rev. ed. London: Thames and Hudson, 1973.

Betts, John Rickards. "P. T. Barnum and the Popularization of Natural History." *Journal of the History of Ideas* 20 (June-September 1959), 353–68.

[Titian Ramsay Peale]. "Biographical Sketch of Charles Willson Peale." *Cabinet of Natural History and American Rural Sports* 1 (1830), 1–7. Reprinted in *The Cabinet of Natural History and American Rural Sports*, edited by Gail Stewart. Barre, MA: Imprint Society, 1973.

Blane, William Newnham. *Travels through the United States and Canada*. London: Baldwin, 1828.

Boas, Franz. "Advances in Methods of Teaching: Anthropology." *Science*, January 20, 1899, 93–96.

———. *Materials for the Study of Inheritance in Man*. New York: Columbia University Press, 1928. Reprint. New York: AMS Press, 1969.

———. *Anthropology and Modern Life*. Rev. ed. New York: W. W. Norton, 1932.

Bragg, Laura M. "The Birth of the Museum Idea in America." *Charleston Museum Quarterly* 1 (1923), 3–13.

Braunholtz, Hermann Justus. *Sir Hans Sloane and Ethnography*. London: British Museum, 1970.

Buettner-Janusch, John. "Boas and Mason: Particularism versus Generalization." *American Anthropologist* 59 (April 1957), 318–24.

Burcaw, George Ellis. *Introduction to Museum Work*. Nashville, TN: American Association for State and Local History, 1975.

Clinton, DeWitt. "Introductory Discourse." *Transactions of the Literary and Philosophical Society of New-York* 1 (1815), 19–184.

Cohen, Daniel M., and Stanwyn Shetler, eds. "Natural History Collections, Past, Present, Future." *Proceedings of the Biological Society of Washington* 82 (1969), 559–762.

Colbert, Edwin H. *Men and Dinosaurs: The Search in Field and Laboratory*. New York: E. P. Dutton, 1968.

Coleman, Laurence Vail. *College and University Museums: A Message for College and University Presidents*. Washington, DC: American Association of Museums, 1942.

Collier, Donald. "Chicago Comes of Age: The World's Colombian Exposition and the Birth of the Field Museum." *Field Museum of Natural History Bulletin* 40 (May 1969), 3–7.

Collier, Donald, and Harry Tschopik, Jr. "Wenner-Gren Foundation Supper Conference: The Role of Museums in American Anthropology." *American Anthropologist* 56 (October 1954), 768–79.

Colton, Harold Sellers. "Peale's Museum." *Popular Science Monthly* 75 (September 1909), 221–38.

Crook, James Mordaunt. *The British Museum*. London: Penguin Press, 1972.

Dana, Edward Salisbury, and others. *A Century of Science in America, with Special*

Reference to the American Journal of Science, 1818–1918. New Haven: Yale University Press, 1918.

Daniels, George H. *American Science in the Age of Jackson.* New York: Columbia University Press, 1968.

Darnell, Regna. "The Emergence of Academic Anthropology at the University of Pennsylvania." *Journal of the History of the Behavioral Sciences* 6 (January 1970), 80–92.

De Beer, Gavin Rylands. *Sir Hans Sloane and the British Museum.* London: Oxford University Press, 1953.

De Borhegyi, Stephan F. "A New Role for Anthropology in the Natural History Museum." *Current Anthropology* 10 (October 1969), 368–70.

Deloria, Vine, Jr. "Largest Collection of Indian Items Is Put on Display." *Smithsonian* 9 (August 1978), 58–65.

Dexter, Ralph W. "Frederic Ward Putnam and the Development of Museums of Natural History and Anthropology in the United States." *Curator* 9 (June 1966), 151–55.

———. "Putnam's Problems Popularizing Anthropology." *American Scientist* 54 (September 1966), 315–32.

———. "The Role of F. W. Putnam in Founding the Field Museum." *Curator* 13 (March 1970), 21–26.

———. "Contributions of the Salem Group of Agassiz Zoologists to Natural Science Education." *BIOS* 47 (March 1976), 25–30.

———. "The Role of F. W. Putnam in Developing Anthropology at the American Museum of Natural History." *Curator* 19 (December 1976), 303–10.

Dixon, Roland B. "Anthropology, 1866–1929." In *The Development of Harvard University Since the Inauguration of President Eliot, 1869–1929*, edited by Samuel Eliot Morison. Cambridge: Harvard University Press, 1930.

Dockstader, Frederick J. "Anthropology and the Museum." In *The Philadelphia Anthropological Society: Papers Presented on Its Golden Anniversary*, edited by Jacob W. Gruber. Philadelphia: Temple University Publications, 1967.

Dorsey, George A. "The Department of Anthropology of the Field Colombian Museum—A Review of Six Years." *American Anthropologist* 2 (April-June 1900), 247–65.

Dunlap, William. *History of the Rise and Progress of the Arts of Design in the United States.* 2 vols. New York: George P. Scott, 1834. Reprint. New York: Dover Publications, 1969.

Dupree, A. Hunter. *Science in the Federal Government: A History of Policies and Activities to 1940.* Cambridge: Belknap Press of Harvard University Press, 1957.

Dwyer, Jane Powell, and Edward Bridgman Dwyer. *Traditional Art of Africa, Oceania, and the Americas.* San Francisco: Fine Art Museum, 1973.

Edelson, Zelda. "The Peabody Museum." *Discovery* 12 (Fall 1976), 3–16.

Ellis, Richard P. "The Founding, History, and Significance of Peale's Museum in Philadelphia, 1785–1841." *Curator* 9 (September 1966), 235–58.

Engström, Kjell, and Alf Gunnar Johnels, eds. *Natural History Museums and the Community: Symposium Held in October 1969 at the Swedish Museum of Natural History (Naturhistoriska riksmuseet) in Stockholm.* Oslo: Universitetsforlaget, 1973.

Evans, J. W. "Some Observations, Remarks, and Suggestions Concerning Natural History Museums." *Curator* 5 (1962), 77–93.

Ewers, John C. "Problems and Procedures in Modernizing Ethnological Exhibits." *American Anthropologist* 57 (February 1955), 1–12.

Facklam, Margery. *Frozen Snakes and Dinosaur Bones: Exploring a Natural History Museum.* New York: Harcourt Brace Jovanovich, 1976.

Fairchild, Herman LeRoy. *A History of the New York Academy of Sciences, formerly the Lyceum of Natural History.* New York: Published by the author, 1887.

Farber, Paul Lawrence. "The Development of Taxidermy and the History of Ornithology." *Isis* 68 (December 1977), 550–66.

Faxon, Walter, "Relics of Peale's Museum." *Bulletin of the Museum of Comparative Zoology* 59 (July 1915), 117–48.

Fenton, William N. "Field Work, Museum Studies, and Ethnohistorical Research." *Ethnohistory* 13 (Winter-Spring 1966), 71–85.

Fisher, James. *Zoos of the World: The Story of Animals in Captivity.* Garden City, NY: Natural History Press, 1967.

Flexner, James Thomas. *The Light of Distant Skies, 1760–1835.* New York: Harcourt, Brace, 1954.

Flower, Sir William Henry. *Essays on Museums and Other Subjects Connected with Natural History.* New York: Macmillan, 1898. Reprint. Freeport, NY: Books for Libraries Press, 1972.

Francis, John W. *A Discourse: Delivered Upon the Opening of the New Hall of the New-York Lyceum of Natural History.* New York: H. Ludwig, 1841.

Freed, Stanley A. "The American Museum of Natural History: Department of Anthropology." *American Indian Art Magazine* 5 (Autumn 1980), 68–75.

Frese, Hermann Heinrich. *Anthropology and the Public: The Role of Museums.* Leiden, Netherlands: E. J. Brill, 1960.

Gager, C. Stuart. "Botanic Gardens in Science and Education." *Science*, April 23, 1937, 393–99.

Girouard, Mark. *Alfred Waterhouse and the Natural History Museum.* New Haven: Yale University Press, 1981.

Goetzmann, William H. *Exploration and Empire: The Explorer and the Scientist in the Winning of the American West.* New York: Alfred A. Knopf, 1966.

Goldstein, Marcus S. "Anthropological Research, Action, and Education in Modern Nations: With Special Reference to the U.S.A." *Current Anthropology* 9 (October 1968), 247–54.

George, George Brown. "The Beginnings of Natural History in America." In *Annual Report of the Board of Regents of the Smithsonian Institution . . . 1897. Report of the U.S. National Museum*, pt. 2. Washington, DC: Government Printing Office, 1901.

———. "The Genesis of the U.S. National Museum." In *Annual Report of the Board of Regents of the Smithsonian Institution . . . 1897. Report of the U.S. National Museum*, pt. 2. Washington, DC: Government Printing Office, 1901.

Greene, John C. "The Founding of Peale's Museum." In *Bibliography and Natural History*, edited by Thomas R. Buckman. Lawrence: University of Kansas Libraries, 1966.

Greenwood, F. W. P. "An Address Delivered Before the Boston Society of Natural History." *Boston Journal of Natural History* 1 (May 1834), 7–14.

Grosvenor, Melville Bell. "How James Smithson Came to Rest in the Institution He Never Knew." *Smithsonian* 6 (January 1976), 30–37.

Guralnick, Stanley M. *Science and the Ante-Bellum American College.* Philadelphia: American Philosophical Society, 1975.

Hahn, Emily. *Animal Gardens.* Garden City, NY: Doubleday, 1967.

Harris, Neil. *Humbug: The Art of P. T. Barnum.* Boston: Little, Brown, 1973.

Hatt, Robert T. "James A. Hurst, New York's First State Taxidermist." *NAHO* 9 (Spring 1976), 3–17.

Hediger, Heini. *Man and Animal in the Zoo: Zoo Biology.* New York: Seymour Lawrence/Delacorte Press, 1969.

Hellman, Geoffrey Theodore. *The Smithsonian: Octopus on the Mall.* Philadelphia: Lippincott, 1967. Reprint. Westport, CT: Greenwood Press, 1978.

———. *Bankers, Bones & Beetles: The First Century of the American Museum of Natural History.* Garden City, NY: Natural History Press, 1969.

Hinsley, Curtis M., Jr. *Savages and Scientists: The Smithsonian Institution and the Development of American Anthropology, 1846–1910.* Washington, DC: Smithsonian Institution Press, 1981.

Hinsley, Curtis M., Jr., and Bill Holm. "A Cannibal in the National Museum: The Early Career of Franz Boas in America." *American Anthropologist* 78 (June 1976), 306–16.

Holton, Gerald, and William A. Blanpied, eds. *Science and Its Public: The Changing Relationship.* Dordrecht, Netherlands: D. Reidel Publishing Co., 1976.

Honour, Hugh. *The New Golden Land: European Images of America from the Discoveries to the Present Time.* New York: Pantheon Books, 1975.

Horowitz, Helen Lefkowitz. "The National Zoological Park: 'City of Refuge' or Zoo?" *Records of the Columbia Historical Society of Washington, D.C.* (1973–1974), 405–29.

———. "Animals and Man in the New York Zoological Park." *New York History* 56 (October 1975), 426–55.

———. "Seeing Ourselves Through the Bars: A Historical Tour of American Zoos." *Landscape* 25 (1981), 12–19.

Hudson, Kenneth. *A Social History of Museums: What the Visitors Thought.* Atlantic Highlands, NJ: Humanities Press, 1975.

Huth, Hans. *Nature and the American: Three Centuries of Changing Attitudes.* Berkeley: University of California Press, 1957. Reprint. Lincoln: University of Nebraska Press, 1972.

International Seminar on Museums and Anthropological Research in the Service of Development. Dar es Salaam. *Museums and Anthropological Research in the Service of Development: Report on the Seminar, Tanzania, 1 to 18 October 1968.* Berlin-Tegel: German Foundation for Developing Countries, 1968.

Jackson, Donald D., ed. *Letters of the Lewis and Clark Expedition, with Related Documents, 1783–1854.* 2d ed. Urbana: University of Illinois Press, 1978.

———. *Thomas Jefferson & the Stony Mountains: Exploring the West from Monticello.* Urbana: University of Illinois Press, 1981.

Judd, Neil M. *The Bureau of American Ethnology: A Partial History.* Norman: University of Oklahoma Press, 1967.

Kellers, James. "On Museums and the Teaching of Anthropology." *Current Anthropology* 11 (April 1970), 175.

Kennedy, John Michael. "Philanthropy and Science in New York City: The American Museum of Natural History, 1868–1968." Ph.D. dissertation, Yale University, 1968.

King, Duane H. "History of the Museum of the Cherokee Indian." *Journal of Cherokee Studies* 1 (1976), 60–64.

Kohlstedt, Sally Gregory. "A Step Toward Scientific Self-Identity in the United States: The Failure of the National Institute, 1844," *Isis* 62 (September 1971), 339–62.

———. "From Learned Society to Public Museum: The Boston Society of Natural History." In *The Organization of Knowledge in Modern America, 1860–1920*, edited by Alexandra Oleson and John Voss. Baltimore: Johns Hopkins University Press, 1979.

———. "Henry A. Ward: The Merchant Naturalist and American Museum Development." *Journal of the Society for the Bibliography of Natural History* 9 (April 1980), 647–61.

Larrauri, Iker. "Mexico, Museum Country: Extracts from a Conversation with Iker Larrauri, Director of Museums, National Institute of Anthropology and History, Mexico City." *Artes Visuales* 11 (July-September 1976), 11–12, 36–37.

Lurie, Edward. *Louis Agassiz: A Life in Science*. Chicago: University of Chicago Press, 1960.

Madeira, Percy Chester. *Men in Search of Man: The First Seventy-five Years of the University Museum of the University of Pennsylvania*. Philadelphia: University of Pennsylvania Press, 1964.

Martin, Edwin Thomas. *Thomas Jefferson: Scientist*. New York: Henry Schuman, 1952.

Martin, Lynne. *Museum Menagerie: Behind the Scenes at the Nature Museum*. New York: Criterion Books, 1971.

Matthews, L. Harrison. "The Zoo: 150 Years of Research." *Nature*, May 27, 1976, 281–84.

Mayr, Ernst, and Richard Goodwin. *Biological Materials, Part 1. Preserved Materials and Museum Collections*. Biology Council, National Research Council Publication, no. 399. Washington, D.C.: National Academy of Sciences National Research Council, 1956.

McGinnis, Helen J. *Carnegie's Dinosaurs: A Comprehensive Guide to Dinosaur Hall at Carnegie Museum of Natural History, Carnegie Institute*, edited by Martina M. Jacobs and Ruth Anne Matinko. Pittsburgh: Board of Trustees, Carnegie Institute, 1982.

Meisel, Max. *A Bibliography of American Natural History; The Pioneer Century, 1769–1865; The Role Played by the Scientific Societies; Scientific Journals; Natural History Museums and Botanic Gardens; State Geological and Natural History Surveys; Federal Exploring Expeditions in the Rise and Progress of American Botany, Geology, Mineralogy, Paleontology and Zoology*. 3 vols. Brooklyn: Premier Publishing Company, 1924–1929.

Merrill, George P., ed. *Contributions to a History of American State Geological and Natural History Surveys*. Smithsonian Institution, U.S. National Museum Bulletin, no. 109. Washington, DC: Government Printing Office, 1920.

Meyer, Karl Ernst. *The Plundered Past*. New York: Atheneum, 1973.

Miller, Edward. *That Noble Cabinet: A History of the British Museum*. Athens: Ohio University Press, 1974.

Miller, Howard S. *Dollars for Research: Science and Its Patrons in Nineteenth-Century America.* Seattle: University of Washington Press, 1970.

Miller, Lillian B. "The Peale Family: A Lively Mixture of Art and Science." *Smithsonian* 10 (April 1979), 66–74, 76–77.

————, ed. *The Collected Papers of Charles Willson Peale and His Family (1735–1885).* Millwood, NY: Kraus Miscroform, 1980.

Miller, Lillian B., Frederick Voss, and Jeannette M. Hussey. *The Lazzaroni: Science and Scientists in Mid-Nineteenth Century America.* Washington, DC: Smithsonian Institution Press, 1972.

Morley, Grace. "Museums of Anthropology: Their Role in East, South and Southeast Asia." *Eastern Anthropologist* 29 (January-March 1976), 5–19.

Morton, Samuel George. *Notice of the Academy of Natural Sciences of Philadelphia.* 2d ed. Philadelphia: Mifflin & Parry, 1831.

————. "History of the Academy of Natural Sciences of Philadelphia." *American Quarterly Register* 13 (May 1841), 433–38.

Nason, James D., and others. "Finders Keepers?" *Museum News* 51 (March 1973), 20–26.

Nicholson, Thomas D. "NYSAM Policy on the Acquisition and Disposition of Collection Materials." *Curator* 17 (March 1974), 5–9.

Nooter, Gert. "Ethics and the Collection Policy of Anthropological Museums." *Sociologische Gids* 19 (September-December 1972), 5–6, 308–19.

Oleson, Alexandra, and Sanborn C. Brown, eds. *The Pursuit of Knowledge in the Early American Republic: American Scientific and Learned Societies from Colonial Times to the Civil War.* Baltimore: Johns Hopkins University Press, 1976.

Osborn, Henry Fairfield. *The American Museum of Natural History, Its Origin, Its History, The Growth of Its Departments to December 31, 1909.* 2d ed. New York: Irving Press, 1911.

Parr, Albert Eide. *Mostly About Museums, from the Papers of A. E. Parr.* New York: American Museum of Natural History, 1959.

————. "Museums and Museums of Natural History." *Curator* 5 (1962), 137–44.

————. "Civilization and Environment: A Program for Museums." *Canadian Museums Association Bulletin* 14 (Fall 1963), 1–6.

————. "On Museums of Art and Nature." *Museum News* 59 (October 1980), 41–43.

Peale, Charles Willson. *Discourse Introductory to a Course of Lectures on the Science of Nature; with Original Music, Composed for, and Sung On, the Occasion.* Philadelphia: Zachariah Poulson, Jr., 1800.

Peale, Charles Willson, and Ambroise Marie François Joseph Palisot de Beauvois. *A Scientific and Descriptive Catalogue of Peale's Museum.* Philadelphia: Samuel H. Smith, 1796.

Pepper, George H. "The Museum of the American Indian, Heye Foundation." *Geographical Review* 2 (December 1916), 401–18.

Perry, John. "P. T. Barnum's American Museum." *Early American Life* 7 (June 1976), 14–17, 56.

Phillips, Maurice E. "The Academy of Natural Sciences of Philadelphia." *Transactions of the American Philosophical Society,* n.s. 43 (1953), 266–74.

Pickard, Madge E. "Government and Science in the United States: Historical Backgrounds." *Journal of the History of Medicine and Allied Sciences* 1 (April 1946), 254–89; 1 (July 1946), 446–81.

Poesch, Jessie J. *Titian Ramsay Peale, 1799–1885, and His Journals of the Wilkes Expedition.* Memoirs of the American Philosophical Society, vol. 52. Philadelphia: American Philosophical Society, 1961.

Porter, Charlotte M. "The Rise to Parnassus: Henry Fairfield Osborn and the Hall of the Age of Man." *Museum Studies Journal* 1 (Spring 1983), 26–34.

Ragghianti, Carlo Ludovico, and Licia Ragghianti Collobi. *National Museum of Anthropology, Mexico City.* New York: Newsweek, 1970.

Ramírez Vázquez, Pedro, and others. *The National Museum of Anthropology: Mexico: Art, Architecture, Archaeology, Anthropology,* edited by Beatrice Trueblood and translated by Mary Jean Labadie and Aza Zatz. New York: Harry N. Abrams, 1968.

Reichenbach, Herman. "Carl Hagenbeck's Tierpark and Modern Zoological Gardens." *Journal of the Society for the Bibliography of Natural History* 9 (April 1980), 573–85.

Richardson, Edgar P., Brooke Hindle, and Lillian B. Miller. *Charles Willson Peale and His World.* New York: Harry N. Abrams, 1983.

Ripley, S. Dillon. *The Sacred Grove: Essays on Museums.* New York: Simon & Schuster, 1969.

Schwartz, Alvin. *Museum: The Story of America's Treasure Houses.* New York: E. P. Dutton, 1967.

"Scientific Institutions." *Quarterly Review* 34 (June 1826), 153–79.

Sellers, Charles Coleman. *Charles Willson Peale.* 2 vols. Memoirs of the American Philosophical Society, vol. 23, pt. 1–2. Philadelphia: American Philosophical Society, 1947.

———. "Peale's Museum." *Transactions of the American Philosophical Society,* n.s. 43 (1953), 253–59.

———. *Charles Willson Peale.* New York: Charles Scribner's Sons, 1969.

———. "Peale's Museum and 'The New Museum Idea.'" *Proceedings of the American Philosophical Society,* February 29, 1980, 25–34.

———. *Mr. Peale's Museum: Charles Willson Peale and the First Popular Museum of Natural Science and Art.* New York: W. W. Norton, 1980.

Shapiro, Henry D., and Zane L. Miller, eds. *Physician to the West: Selected Writings of Daniel Drake on Science & Society.* Lexington: University Press of Kentucky, 1970.

Shor, Elizabeth Noble. *The Fossil Feud Between E. D. Cope and O. C. Marsh.* Hicksville, NY: Exposition Press, 1974.

Simpson, George Gaylord. "The Beginnings of Vertebrate Paleontology in North America." *Proceedings of the American Philosophical Society,* September 25, 1942, 130–88.

Squires, Donald F. "Schizophrenia: The Plight of the Natural History Curator." *Museum News* 48 (March 1969), 18–21.

Stannard, Jerry. "Early American Botany and Its Sources." In *Bibliography & Natural History,* edited by Thomas R. Buckman. Lawrence: University of Kansas Libraries, 1966.

Stanyukovich, T. V. *The Museum of Anthropology and Ethnography Named After Peter the Great.* Leningrad: Nauka, 1970.

Stearns, Raymond Phineas. *Science in the British Colonies of America.* Urbana: University of Illinois Press, 1970.

Stresemann, Erwin. *Ornithology from Aristotle to the Present*, edited by William Cottrell, and translated by Hans J. Epstein and Cathleen Epstein. Cambridge: Harvard University Press, 1975.

Struik, Dirk Jan. *Yankee Science in the Making*. Rev. ed. New York: Collier Books, 1962.

Sturtevant, William C. "Does Anthropology Need Museums?" *Proceedings of the Biological Society of Washington* 82 (1969), 619–49.

Truettner, William H. *The Natural Man Observed: A Study of Catlin's Indian Gallery*. Washington, DC: Smithsonian Institution Press, 1979.

Vail, Robert William Glenroie. *Knickerbocker Birthday: A Sesquicentennial History of the New-York Historical Society, 1804–1954*. New York: New-York Historical Society, 1954.

Wagstaffe, Reginald, and J. Havelock Fidler, eds. *The Preservation of Natural History Specimens*. 2 vols. New York: Philosophical Library, 1955–1968.

Wilcox, U. Vincent. "The Museum of the American Indian, Heye Foundation." *American Indian Art Magazine* 3 (Spring 1978), 40–49, 78–79, 81.

Wilson, Alexander. *American Ornithology; or, The Natural History of the Birds of the United States*, vol. 1. Philadelphia: Bradford & Inskeep, 1808.

Zusui, Richard L. "The Role of Museum Collections in Ornithological Research." *Proceedings of the Biological Society of Washington* 82 (1969), 651–62.

2

THE ART MUSEUM

Edith A. Tonelli

The history and historiography of the art museum in the West reflect fluctuating definitions of art and changing attitudes toward the role of art in society. These theoretical issues have raised two important questions for museums: "What is fine art and, therefore, appropriate for an art museum collection?" and "What is the relative significance of the preservation of precious objects, as compared to that of the education of the public, within the institution?" Responses to these questions not only have determined the character of the myriad of institutions that now are sanctioned as art museums by the American Association of Museums (AAM) but also have motivated and influenced much of the research and writing on art museums in the United States.

In this chapter, the focus is on institutions that fit the definition of "museum" used for AAM accreditation; that is, an institution that collects, preserves, exhibits, and interprets a permanent collection of art. Therefore, the debate surrounding the categorization of those art institutes, centers, and galleries that do not have permanent collections but do present temporary exhibitions, educational programs, and performances is not covered in any detail, although it is not entirely ignored. In addition, the distinctions that are often made between the applied arts and the fine arts are disregarded here in order to ensure comprehensive coverage. All museums that select and evaluate objects on the basis of their aesthetic quality—however that may be defined—and on their value as single, unique items fall within the purview of this study. The history of these various arguments, however, is explored here within the context of changing attitudes toward the nature of

art museums and through their interpretations in the critical and historical literature.

HISTORIC OUTLINE

The first American art museums were established at precisely the time when the contradictions inherent in the European museum were coming into dramatic conflict. Art historian Linda Nochlin has seen it as a "schizophrenia" resulting from the museum's dual identity as "the shrine of an elitist religion" and "a utilitarian instrument for democratic education." Similarly, Kenneth Clark has traced the source of the conflict to the need to give a public justification for a personal, private activity. In whatever terms it has been stated, this conflict between the two primary justifications for the existence of art museums—the preservation and protection of the objects themselves and the direct edification of society as a whole—has been at the heart of the dilemma of many individual institutions in Western society and has greatly influenced the history of the art museum movement in the United States.

The concept of preserving objects specifically for their ideal qualities of truth and beauty rather than for their curiosity, historical significance, or market value was accepted by the ancient Greeks in their first temple preserves. It is with the Greeks also that the Western distinctions between fine works of art with spiritual significance and the base mechanical arts for daily use began to be formulated. Although Plato and Plotinus made different distinctions than we often make today concerning those objects that are worthy of preservation and contemplation, it was the Hellenic concept of setting aside certain works of art for special viewing that laid the foundation for the first art museums in the West.

Throughout the following centuries, collections of art objects were set aside and kept for the viewing of those who had special knowledge or understanding. Roman imperial palaces, Romanesque and Gothic cathedrals, and private Renaissance villas all provided essentially private settings for the viewing of art. Although Italian merchant princes often arranged their collections in long, grand halls, or gallerias, it was the more eclectic collections of the Northern European royalty of the seventeenth and eighteenth centuries that were to evolve gradually into the first art museums open to the general public. These were the institutions that would find themselves with a conflicting sense of purpose and that, coincidentally, would serve as direct models for American institutions.

In the latter half of the eighteenth century, when public access to museums, although restricted, was being accepted throughout Europe and the new French Republic was declaring the collections of the Louvre to be the property of all citizens, the United States was declaring itself a free and

independent nation with equal opportunity for all. The Enlightenment ideals of the public's right to knowledge and equal opportunity for all were therefore the foundations on which most American cultural institutions were built. American museums started from the novel assumption that these institutions were created for the education and entertainment of the entire citizenry in a democratic society. The American experience was thus almost the reverse of the European. Because the first North American museums and galleries housed eclectic historical and scientific collections, administered in the same spirit as the public libraries, early museum founders struggled to reconcile their institutions with the traditional European concept of a specialized institution with collections of extremely high value, which were removed from the everyday experience and understanding of the average citizen.

Some of the early culture advocates in the colonies, such as De Witt Clinton (New York), Charles Willson Peale (Philadelphia), and John Tudor (Boston), argued that the arts could elevate the masses, as well as improve the design of domestic manufactured items. Such early institutions as Peale's Museum in Philadelphia, the Boston Athenaeum, the New-York Historical Society, and the Maryland Historical Society included portraits and sculpture in their collections, usually to honor Revolutionary heroes or to inspire viewers with the memory of great lives and great deeds. Thus, despite widespread distrust of fine art as the trappings of a corrupt aristocracy, more modest works survived in the new museums, where they were seen as an appeal to national pride, as well as having moral and educational benefits.

By the mid-nineteenth century, popular magazines were carrying articles on the significance of art and art collecting in America, and intellectuals such as James Jackson Jarves, Ralph Waldo Emerson, and others labored to convince their peers that the study, practice, and appreciation of the fine arts were essential to establishing a civilized and powerful nation. Their ideals, however, were not acceptable to a population that still viewed cultural activities as a luxury, which most citizens could not afford. Thus, the first collections to focus exclusively on art objects were formed as part of educational institutions, such as the National Academy of Design and the Pennsylvania Academy of Fine Arts, and comprised primarily plaster casts and copies of paintings from the Louvre that could be used for instruction.

It was not until the 1870s, when the attitude toward art as a separate, valuable, civilizing, and essential human pursuit began to be accepted by schools and colleges, as well as by a growing corps of wealthy, educated, and patriotic individuals, that the European concept of the art museum as temple and treasure house became viable in the United States. Seeking personal recognition, social status, and cultural sophistication, a few prominent Americans with newly made fortunes in the world of industry and finance became interested in the collecting of fine art, which was defined at that time as European painting and sculpture by the new professional art

historians, such as Harvard's Charles Eliot Norton. The attitudes of these
new collectors and the nature of their collections gave form to the nation's
first great museums dedicated to the fine arts.

It was only in the last half of the nineteenth century, when many of these
major urban art museums were founded, that the fine arts were elevated
and distinguished from the mechanical arts, folk arts, and the arts of non-
Western and pre-Columbian cultures. These restricted definitions of art
strongly influenced the character, buildings, programs, and collections of
early American arts institutions. The holdings of these institutions often have
proved to be not only an embarrassment but also a frustration to later mu-
seum professionals who have struggled to correct the obvious bias and omis-
sions in the collections.

The boom of activity in the establishment of art museums, art societies,
and art schools in the last decades of the nineteenth century was due to a
combination of private and public enthusiasm. The Metropolitan Museum
of Art in New York, Boston's Museum of Fine Arts, the Art Institute in
Chicago, and the Philadelphia Museum of Art were each founded by private
groups of wealthy and civic-minded individuals but also received critical gifts
of land and operating funds from public sources. Later, major institutions
in Detroit, St. Louis, Cincinnati, San Francisco, and Pittsburgh were es-
tablished in similar ways. The founding documents of these institutions all
included references to the goal of public education—variously described as
"educating and uplifting," "enlightenment," "popular instruction," and "ad-
vancing general knowledge"—as well as to their mandate for collecting,
preserving, and exhibiting objects. With their narrow definition of art and
dual goals of preservation and education, these large museums acquired
imposing buildings reminiscent of other places and other times, thus setting
both the tone and the image for the art museum in the United States.
Although each of these institutions subsequently developed its own special
character, all of this century's major revolutions in art museum philosophy
and practice have been played out against this ideal, turn-of-the-century
image.

Early protests against this ideal often resulted in the establishment of
entirely new kinds of art museums that attempted to fill in the cultural,
educational, and historical blind spots of these great museum prototypes.
Some wealthy individuals with personal collections preferred to create small,
personal memorials rather than contribute to large, public institutions. To
keep their collections intact, J. Pierpont Morgan, Henry Clay Frick, Isabella
Stewart Gardner, and, later, Albert Barnes preserved intimate personal
settings with limited visitor access and with many conditions restricting their
display and use. In various ways, these patrons placed their emphasis on
the need for the preservation and care of objects and for a specialized,
educated audience who would readily understand and appreciate the gath-

ered treasures. On the other hand, some museums established by educational institutions, civic agencies, and private interests, such as the Toledo Art Museum, the Rochester Memorial Art Gallery, the Brooklyn Museum, the Newark Museum, and many college and university museums, have stressed the educational and community-related aspects of their function.

By the first decade of the twentieth century, specialized art museums began to appear, usually in large cities: the Museum of Modern Art in New York, the Whitney Museum of American Art, and the Boston Institute of Contemporary Art. At the start, these institutions were established because of a lack of attention given to certain areas of art—American and modern, in particular—by the large, generalized art museums. Because of their special interests and non-traditional concerns, they often experimented with architecture, display, programming, and education, as well as with their collections. The Museum of Modern Art, for example, broke precedent in 1939 by installing itself in a commercial-looking building in the middle of a busy Manhattan street and by initiating a constantly changing exhibition schedule, all in order to reflect its modern and progressive mission. Later in the century, museums specializing in Asian, African, and pre-Columbian arts, folk arts, crafts, and industrial arts began to appear, clearly challenging the restrictive definitions of fine art that had prevailed in the nineteenth century.

At the same time, museum professionals in general, and art museum directors in particular, began to articulate concerns that were distinct from those of their counterparts in other cultural and arts organizations. The American Association of Museums, formed in 1905, and the Association of Art Museum Directors (AAMD), which followed soon after in 1916, collectively addressed some of these professional issues. One of the unique features of this growing professionalism was the initiation of an open, public, and at times heated debate about the relative importance of preservation and education in museums. On one side, Benjamin Ives Gilman, secretary of the Museum of Fine Arts in Boston and president of the AAM, and Professor Paul Sachs at Harvard, who taught one of the first and most influential museum courses in the country, were advocates of the unique, inspirational art object that could be understood best by those who possessed refined taste and an education in the arts. The true art museum was the one that kept the sanctity and safety of the object uppermost in its concerns and presented the object as a treasure that was to be appreciated first and foremost for its aesthetic value. On the other side, Philip N. Youtz of the Brooklyn Museum and John Cotton Dana of the Newark Museum and Library saw no reason to collect and preserve objects if they were not to be "used" by the public. By use, Dana meant both the inherent function of the object as created—industrial arts and crafts were therefore often more useful than painting and sculpture—and the presentation of an object in a way that

would make it understandable and relevant to the average citizen. He organized exhibitions and chose objects he thought responded to the needs and desires of the general public.

By the 1920s, some of the oldest art institutions in the United States began to react to this dual demand for higher-quality, more selective collections and exhibitions and for a contextual approach to the display of certain categories of objects. The decorative arts became an acceptable area of collecting, coinciding with the concern for presenting a more educational, historical context for objects. These changes led to the development of "period rooms" in the American Wing of the Metropolitan Museum (1924) and in the Decorative Arts Wing of the Boston Museum of Fine Arts (1928). One new museum that attempted to synthesize these complex curatorial concerns was the National Gallery of Art (1939), which combined the presentation of single, distinct masterworks with the suggestion of historical context in the architectural details and colors of its galleries.

During the 1930s and 1940s, the calls for community-oriented programming and greater public access were intensified in the midst of the crises of financial collapse and world war. John Dewey's theories about the universality of the aesthetic experience and the responsibility of a democracy to build opportunities for creative expression into its educational practice inspired many museum professionals to view the museum as an active environment for public art education. One of those professionals was Francis Henry Taylor, director of the Worcester Art Museum and, later, of the Metropolitan Museum of Art in New York, who repeatedly emphasized the need for responsiveness and realistic personal compromise in the face of a changing society. In 1942, Taylor and the Metropolitan Museum published Theodore Low's critical review of the museum's community function, in which Low urged museums to become "social instruments," effectively disseminating information and communicating values.

This renewed self-evaluation by art museums, which during this period often seemed totally isolated and of little consequence to anyone other than those within the profession, resulted in an intensified dedication to public service. With support from the Exhibition Program of the Works Progress Administration's Federal Art Project, museums began to hold more temporary, thematic, and contemporary exhibitions, reduce storage to make space for larger public galleries, and expand the variety of related activities that they offered to the public. By 1943, when Frank Lloyd Wright was designing the Guggenheim Museum as a continuously spiralling spectator's gallery, the concerns for a building that would be a strong, identifiable contemporary symbol and that would accommodate the circulation of a mass audience through the museum took precedence over the appropriateness of the exhibition spaces for hanging or installing works of art.

Despite the growing interest in public education throughout the country in the postwar years, many institutions resisted sweeping changes and in-

sisted on the necessity for preserving the nation's cultural heritage and expanding the opportunities for special aesthetic experience in an increasingly technological and dehumanized society. In the 1950s, some professionals, such as Walter Pach, Kenneth Clark, and Daniel Catton Rich, warned of the dangers of increasing the quantity of experiences without maintaining or improving the quality. Consequently, it was not until the early 1960s, with challenges from outside as well as inside museums, that the fundamental structure and philosophy of American art museums began to shift.

The social concerns of the 1960s and early 1970s struck directly at the heart of the American art museum contradiction. Questions were asked about the appropriateness, in a democratic society, of an institution that often caters to a small group of knowledgeable individuals—an elite—rather than to the public at large. How could a museum, a basically conservative, elitist institution, have "relevance" in a democratic society? How could the art museum, in particular, serve the disadvantaged, the poorly educated, or the ethnic minorities in the United States? How could the museum reconcile the purchase, preservation, conservation, and presentation of valuable and often esoteric objects with the inability to satisfy the most basic material needs of America's and the rest of the world's expanding populations? Many museum professionals and boards of trustees considered, or were forced to consider, these questions and tried to present exhibitions and programming related to community and social needs. The educational philosophy and public policy of art museum directors became as important to their success as their formal education and experience. Museum educators and education departments became key actors in the restructuring of programs and facilities.

The art museum, more than any other type of museum, became the target of renewed social and political criticism. Internal museum conflicts and policies became front-page news in this era. Thomas Hoving's tenure (1967–1977) at the Metropolitan Museum symbolized the new willingness of museums to respond to social pressures at the same time it suggested the dangers of losing the balance between the museum's roles as a preserver of culture and as an agent for change. His exhibition of 1969, "Harlem on My Mind," sparked a particularly vehement exchange in the press and led to demands for a return to aesthetic, rather than sociological or historical, standards as the principal criteria for the exhibition of artworks. The strikes by museum workers, the big media fund-raising events, and the radical shows of contemporary art happenings also fragmented the museum community into conservatives, moderates, and radicals, to the point of alienating some long-time supporters of museums.

New federal support for the arts and museums during the 1960s and 1970s brought with it the requirement of providing greater public access and the need to attract new audiences. This external pressure caused all art museums

to struggle with the challenge of accommodating the demands of growing education programs and more broadly based public activities, such as blockbuster exhibitions, without losing sight of the more conservative functions of collecting and preserving. By the mid–1970s, art museum directors were being forced to make difficult choices among institutional priorities. During the expansion of the 1960s, trustees and directors often could merely add what was demanded: more female and minority staff appointments, more school programs, broader ethnic representation in collections, a modern art department, or a local artists' gallery. In the late 1970s, it became clear that the seemingly unlimited funds of the postwar years were drying up. In fact, the expenditure of public monies for the arts, both federal and state, began to be questioned and more closely monitored, while private contributions dwindled in a new inflationary crisis, forcing some museums to curtail hours and even close their doors for a time.

The difficult questions concerning goals and purpose, which had been asked by Gilman and Dana and repeated again at mid-century, became the topics for discussion at museum staff meetings and professional conferences. The dramatic reorganization of the financially ailing Pasadena Museum of Modern Art by millionaire collector Norton Simon, who replaced the museum's management with his own staff and supplanted the original holdings of the museum with his own collection in 1974, reflected, in the extreme, the institutional crises of many art museums during this period. The newly endowed and renamed Norton Simon Museum although financially stable, has focused on a private historical collection instead of exhibitions of modern and contemporary art, and has drastically reduced its public access and programming. The Pasadena "takeover" demonstrated the dangers, in the last decades of the twentieth century, of building a facility and committing it to an ideal without sound financial backing and business management, and it has served to inspire greater caution on the part of both art museum trustees and professional staff.

Partly in reaction to the crises and challenges of the 1960s and 1970s, the decade of the 1980s has been a period for balancing cautious expansion and public outreach with stricter ethical and professional standards. With the decade came increased financial constraints, renewed demands from disenfranchised groups, and continued questioning of the nature of the art museum and its collections. More restrictive tax laws and competition with other nonprofits for shrinking government and private dollars have conflicted with the demands for more and larger museums to accommodate increased leisure time and more diverse publics.

Consequently careful audience, research, legal planning, and creative financing have preceded the myriad of renovations and building programs of the last ten years, including those of the Museum of Modern Art in New York, the Museum of Contemporary Art in Los Angeles, the Dallas Museum

of Fine Arts, the Los Angeles County Museum of Art, and many smaller institutions throughout the nation.

As always, however, these new professional concerns have been questioned continually in relationship to the traditional, European raison d'être of the art museum: to collect and preserve the finest examples of art for the benefit of posterity. In addition, museum commentators, concerned about keeping museums conscious of the world around them, have worried about whether there will be a posterity for which to save these treasures and about what kind of values will be passed on with them. Art museums have endured, and perhaps their very survival is linked directly to the fact that they symbolize the great social and cultural dilemma into which the United States was born in the eighteenth century and which continues to engage and challenge the most creative American artists and intellectuals.

HISTORY AND CRITICISM

Although the writing on the art museum in Western society is voluminous, two generalizations are possible. First, the literature can be roughly divided between the attempts at dispassionate, chronological histories of art museums and the explicitly personal or partisan essays of museum professionals and commentators. Second, although the precise arguments concerning the nature, purpose, and role of art museums vary, the conflict between the primary functions of preservation and education remains a central tension throughout the literature. Since few directors, critics, or historians fail to take a stand in the controversy, to review the writing on art museums is also to review the debate on the role of the art museum in a democratic society.

The best brief, basic history of the American art museum is "The Art Museum" in Edward P. Alexander's *Museums in Motion* (1979). Laurence Vail Coleman's *The Museum in America* (1939) is useful for understanding the place of the early art museum in the context of other American museums, while Robert C. Smith's "The Museum of Art in the United States" (1958), James L. Connelly's "Introduction" in *Art Museums of the World* (1987), and Kenneth Hudson's essay, "Temples of Art," in *Museums of Influence* (1987) provide widely divergent commentaries on the role of American art museums in the international art museum community. For a deeper understanding of the unique development of art museums in America, see "The Art Museum in the United States" (1975) by Joshua Taylor. Taylor demonstrates how American art collections, exhibitions, programs, and even the museum buildings themselves, unlike European institutions, reflect the ambiguity of professional and public attitudes toward the art that they house.

The European precedents for American museum practice are covered in Germain Bazin's *The Museum Age* (1967) and Francis Henry Taylor's *The*

Taste of Angels (1948), which present the historical background from the Hellenic period through the eighteenth century in very complete and well-illustrated volumes. The issue of how art was first defined in the early Republic, as distinguished from Europe, and how those definitions influenced American institutions, is carefully delineated by Lillian Miller in *Patrons and Patriotism* (1966).

By the mid-nineteenth century, magazines such as the *Atlantic Monthly*, the *North American Review*, and the *Crayon* were carrying articles on the significance of art and art collecting in America. The arguments of Ralph Waldo Emerson and Charles Eliot Norton on the moral and educational benefits of the arts also helped to mold public opinion and arts institutions. Many of Emerson's essays on the arts and society are collected in *Emerson's Complete Works* (1883–1893), and Kermit Vanderbilt's biography, *Charles Eliot Norton: Apostle of Culture in a Democracy* (1959), discusses Norton's philosophy and influence as an author, teacher, and arts advocate.

The charter documents, published bulletins, and public addresses that marked the founding of America's major art museums in the 1870s were the first official statements to outline the dual function of preservation and education that Americans expected of their art museums. However, these documents reflect the idealism and optimism of the period and rarely reveal anything about the practical compromises that were made to reinforce the power and prestige of the founders, as well as to ensure the financial survival of these new institutions.

In "Museums of Art as a Means of Instruction" (1870), one of the first general commentaries on art museums and an impassioned plea for a great museum of art, Eugene Benson articulated what would become the most common and acceptable justification for art museums in the United States—the art museum as an educational institution. But in 1889, when George Brown Goode, assistant secretary of the Smithsonian Institution, went so far as to define the efficient educational museum as a "collection of instructive labels, each illustrated by a well-selected specimen" in "The Museums of the Future" (1901), he drew strong and repeated criticism from art museum professionals, although he had been primarily directing his comments toward science and natural history museums. In "Art Museums and their Relation to the People" (1896), Ernest Francisco Fenollosa, former curator of Japanese art at the Boston Museum of Fine Arts, responded by clearly outlining, for the first time, the primary functions of an art museum as "collecting, preserving, exhibiting, and educating." Fenollosa, however, also raised the issue of the relative value of preservation and education and came down decidedly on the side of "educational service."

By the first decades of the twentieth century, with the increase in the number and distribution of museums throughout the United States, the functions of American art museums became the subject of book-length anal-

yses and public debates. The organizational meeting of the AAM in 1906 provided the first public forum to discuss the purpose of art museums in American society. A review of the meeting in the *Nation*, entitled "A Selective Art Museum" (1906), described the two positions—one articulated by Benjamin Ives Gilman, secretary of the Boston Museum of Fine Arts, and the other by William Henry Goodyear, curator and head of the Department of Archaeology at the Brooklyn Institute of Arts and Sciences. According to the reviewer, Gilman advocated a selective or "anthological" approach to displaying objects in art museums. Aesthetic judgment would be the deciding factor by which objects were chosen for public viewing, and the rest of the collection would be organized "scientifically," that is, chronologically, for study purposes. The counterargument, by Professor Goodyear, was that aesthetic decisions are arbitrary and not as accurate or enlightening as historical organization, and that the public should be allowed to see everything and make its own judgments. The tone of the review suggests that Gilman is the progressive, revolutionary thinker (which is "good"), while Goodyear is the conservative.

Gilman, later the assistant director of the Boston Museum of Fine Arts, became the primary spokesperson for what has come to be called the "aesthetic" position on the function of art museums. His provocative *Museum Ideals of Purpose and Method* (1923) remains the most comprehensive philosophical statement on the art museum in the United States and a thoughtful defense of its aesthetic function. In response to Goode's early appeal for an educational museum, Gilman argues that because of the special nature of art objects and the significance of their communication at the level of sensation and feeling, they must not be treated as scientific specimens to be dissected, analyzed, and interpreted before they are enjoyed. Gilman concludes that art museums are not primarily educational institutions, but institutions of enjoyment or culture, and that this special character must be reflected in their buildings and their methods—down to the details of lighting and labeling, which he carefully delineated in his book.

Gilman's aesthetic approach to museum work is often contrasted to the educational approach of John Cotton Dana. In fact, sociologist César Graña explicitly identifies Gilman with the "Boston" position and Dana with the "New York" position in "The Private Lives of Public Museums" (1967). Nowhere else was the ideal of a democratic institution more strongly developed and expressed than in Dana's writing and professional career at the Newark Public Library and the Newark Museum in New Jersey. In his four volumes that are known collectively as "The New Museum Series" (1917–1920), Dana carefully delineated not only the fundamental tenets of his philosophy but also his practical suggestions for making the ideas work. Good, brief histories of Dana's philosophy and his influence on the Newark Museum and on the museum profession in general can be found in Karl

Meyer's *The Art Museum* (1979), Barbara Lipton's "John Cotton Dana and the Newark Museum" (1979), and Richard Grove's "Pioneers in American Museums: John Cotton Dana" (1978).

The writing and teaching of Paul J. Sachs at Harvard falls somewhere between the sharp theoretical contrasts presented by Gilman and Dana, although perhaps as a "Bostonian," Sachs tended to favor Gilman's approach. Sachs was assistant director of the Fogg Art Museum and a faculty member in fine arts at Harvard starting in 1915, and, through his museum course, he influenced two generations of directors and curators in the United States. Despite his essentially conservative notions about the museum object, Sachs did advocate the dual function of the twentieth-century art museum as both a treasure house and an educational center, and therefore he molded the thinking of younger museum professionals in that direction. His published writing on museums is limited; however, a useful collection of his papers is available in the Fogg Art Museum Archives, and secondary sources such as Karl Meyer's *The Art Museum* (1979) and Ada Ciniglio's "Pioneers in American Museums: Paul J. Sachs" (1976) give a clear picture of the important role he played.

Increasingly, however, the debate concerning the policies of art museums toward public participation transcended the confines of professional publications. Such popular magazines as the *Saturday Evening Post*, *Century*, and *Scribner's* carried articles on the subject. There were also new publications devoted strictly to the education issue, such as the work of T. R. Adam for the American Association of Adult Education, including *The Civic Value of Museums* (1937) and *The Museum and Popular Culture* (1939). This rising concern for the educational role of art museums paralleled the federal government's focus on public art education in its New Deal cultural programs and an expanding interest in child development and adult education, as well as the dissemination and popularization of John Dewey's art-and-education theories in *Art as Experience* (1934). John Cotton Dana's notion of the museum as an active force in the community was further developed by Philip N. Youtz, Director of the Brooklyn Museum, in "Scientific Basis of the Art Museum" (1936).

The role of the art museum in society became an even more serious issue in the 1940s when such conservative nationalist critics as Thomas Craven, in "Our Decadent Art Museums" (1941), questioned the social and moral value of our institutions and their collections. Related concerns were voiced by some museum professionals in "U.S. Museums Face the Wartime World" (1942) and in "Museum Trends" (1946), a special issue of *Art in America*, as well as by social scientists such as Theodore Low in *The Museum as a Social Instrument* (1942). Francis Henry Taylor, director of the Metropolitan Museum from 1940 to 1954, wrote several articles, many of them included in *Babel's Tower* (1945), admonishing art museums to respond to their times and to their communities. Toward the end of the decade, Low's second

volume on museums, *The Educational Philosophy and Practice of Art Museums in the United States* (1948), broke new ground by combining a theoretical approach to museum education with historical documentation and statistical analysis. Although Low's narrow focus on educational issues limits the usefulness of the volume as art museum history, it does lay the theoretical foundation for the arguments that would explode in the 1960s.

Walter Pach's *The Art Museum in America* (1948), an important reassessment of American art museums, rejected Low's social instrument argument and heralded a renewed concern for "higher values" and an aesthetic approach. Pach's survey and annotated list of more than 110 art museums, both large and small, gave his presentation a comprehensive scope that was lacking in most other art museum histories and demonstrated that the conflict between the goals of preservation and education was present in every American institution, regardless of size.

While acknowledging the dilemma of the art museum in a democratic society, most commentators during the 1950s reiterated the need for art museums to establish aesthetic standards. Kenneth Clark's "The Ideal Museum" (1954) suggested that the art museum could be viewed as a work of art itself, the product of an ongoing creative process to resolve these conflicts and maintain aesthetic quality. James J. Rorimer, director of the Metropolitan Museum in the late 1950s, advocated high aesthetic standards while cautioning against conformity in "Our Motto Should Be: Standards without Standardization" (1958). In "Museums at the Crossroads" (1961), Daniel Catton Rich, director of the Worcester Art Museum, expressed the growing fear among some museum professionals that popularization of the art museum would threaten opportunities for serious scholarship, as well as the quality of the visitor's experience. Furthermore, in "The Museum and the Artist" (1954), Herbert Read noted that in the rush to become popular, museums had neglected the needs of living artists—a theme that reappeared in *The Museum and the Artist* (1958) by the Joint Artists–Museums Committee, James J. Sweeney's "The Artist and the Museum in a Mass Society" (1960), and George Mill's "Art, Artists and Museums" (1960).

The broadening public for art museums and the curiosity about their inner workings and valuable collections also spawned a new genre of books written for a wider audience than scholars and museum professionals. The first major book of this kind was *The Taste of Angels: A History of Art Collecting from Rameses to Napoleon* (1948), by Francis Henry Taylor. Although written by a respected authority in the field, its title, its limited number of footnotes, its illustrations, its focus on personalities, and the author's concern for the general reader make it an enjoyable and entertaining book as well as an informative one. It was soon followed by other books, most of which are less scholarly, but all based on history, written around the personalities and lives of famous and infamous individuals, and titled to intrigue a mass audience, including Russell Lynes's *The Tastemakers* (1954), Aline Saarinen's *The*

Proud Possessors (1958), Elizabeth McFadden's *The Glitter and the Gold* (1971), and John Hess's *The Grand Acquisitors* (1974).

"What Should a Museum Be?" (1961) was the title of a special issue of *Art in America* devoted to a series of articles written by Larry Aldrich, Georges Wildenstein, C. C. Cunningham, and others. It was an appropriate question with which to begin the decade of the 1960s, with an appropriately broad cast of characters—a critic, a dealer, museum professionals, collectors, an architect, a movie star, and contemporary artists. But perhaps the most fitting, and prophetic, part of this analysis was the response by Thomas Messer, director of the Guggenheim Museum, that museums were many things, including "battlefields." Battlefields they were to become—battlefields over almost every social and political issue of the turbulent 1960s and 1970s. Art museums had become popular and visible enough to become themselves targets of public attack. Protests by artists, women, and minority groups, strikes by museum staff, and revelations of financial scandals have been covered regularly by the local and national press, including *The New York Times*, *Time*, and *Newsweek*, and in specialized periodicals serving the art and museum community, such as *Artnews*, *Art in America*, *Museum News*, and *Artforum*.

Increased public activism and demands for new museum services and programs fostered a hot debate over the role of the art museum in the community and in society at large. In "The Museum as a Social Instrument: Twenty Years After" (1962), Theodore Low responded to a critique of his 1942 book given in Wilcomb Washburn's "Scholarship and the Museum" (1961). He apologized for the tone and some of the extreme statements of his earlier book, but he maintained his position that a museum, as an educational institution, is also a social instrument, by which he meant an active force in disseminating information and communicating values. Throughout the 1960s and 1970s, those who believed as Low did continually questioned the role of the museum and, in particular, the place of art and the art museum in the life of the community.

The questioning frame of mind of the 1960s was illustrated by John B. Hightower's public lecture and subsequent article, "Are Art Galleries Obsolete?" (1969). Hightower, soon to have a brief tenure as director of the Museum of Modern Art, insisted that art museums not only needed to continue to expand educational programs but also had to become more actively involved in the social and political life around them. Ann Sutherland Harris and Cindy Nemser examined the role of women in art museums in "Are Museums Relevant to Women?" (1972), while Barry Schwartz, in "Museums: Art for Whose Sake?" (1971), and Ron White, in "Museums Are Poison" (1975), extended the discussion to other disenfranchised groups.

André Malraux's *Museum Without Walls* (1967), echoing Ananda Coomaraswamy's earlier "Why Exhibit Works of Art?" (1956), criticized the art museum for ripping objects out of context and presenting them as isolated

treasures. Related critiques of the "enshrining" of isolated objects in museum sanctuaries, which places them above time and place and erases the circumstances of their creation, can be found in Daniel Buren's "Function of the Museum" (1973) and Carter Ratcliff's "Modernism for the Ages" (1978). In addition, two essays by Carol Duncan and Alan Wallach, "MOMA: Ordeal and Triumph on 53rd Street" (1978) and "The Universal Survey Museum" (1980), examine the way in which the architecture and displays of various model museums in the United States communicate the prevailing values of an established, capitalist society.

Many of the solutions offered to the problems raised in these critiques involved the restructuring of the museum into a more public space. In "The Great Universal Extrasensory Emporium and Display Mart in the Old Curiosity Shop" (1968), Arnold Rockman was convinced that the art museum would have to become something dramatically different from the "old curiosity shop" it often was in order to fulfill its educational function, and the sociologist Rudolph Morris, in "The Art Museum as a Communication Center" (1965), and Edmond Radar, in "Art Centers and Participation" (1976), viewed the museum's proper role as that of a center for information and dialogue. In "The Museum as Forum" (1976), Sir John Pope-Hennessy insisted that the museum has a responsibility to create an environment for the exchange of ideas and new learning as well as to maintain its collections, a position similar to that which Duncan Cameron had taken in "The Museum, A Temple or the Forum" (1971).

The controversial tenure of Thomas P. Hoving at the Metropolitan Museum of Art in New York, began in the midst of these challenges to the profession, is described by Russell Lynes in "The Pilot of the Treasure House" (1967) and by Hoving himself in *The Chase, the Capture: Collecting at the Metropolitan* (1975). Because of the international visibility of his museum, Hoving's extreme responses to public demands for relevant presentations and an active community role, including blockbuster exhibitions and grand media events, brought severe criticism to bear not only on the Metropolitan and himself but also on the entire trend toward the popularization and "politicalization" of art museums. *Newsweek* carried David Shirey and Ann Kay Martin's "Hoving of the Metropolitan" (1968), and Katherine Kuh reacted to Hoving's "Harlem on My Mind" in "What's an Art Museum For?" (1969). Kuh's response to her own question reflected the growing feeling within and without the museum profession that definitions and standards for art were being neglected and needed to be revived.

Museum professionals such as S. Dillon Ripley, in *The Sacred Grove* (1969), and Sherman E. Lee, in "The Idea of an Art Museum" (1968) and "The Art Museum in Today's Society" (1969), began to call for a return to the basic functions of collecting and preserving. Lee placed himself in direct opposition to the theories espoused by Theodore Low and adopted by Thomas Hoving. Grace Glueck described the debate between Lee and Hov-

ing in "The Ivory Tower versus the Discotheque" (1971). Max Kozloff, in his column for the *Nation*, entitled "Art" (1967), Robert Hughes, in "The Museum on Trial" (1973), and E. H. Gombrich, in "Should a Museum Be Active?" (1968) and "The Museum: Past, Present and Future" (1977) also voiced their concerns about the museum's seeming insensitivity to the special nature of art and to its inherent value for the future of American society.

The widespread concern over the future of museums caused a number of forums to be created for the airing of issues. One of the first and also one of the most provocative was the "Special Museum Issue" (1971) edited by Brian O'Doherty for *Art in America*, which was subsequently reprinted as *Museums in Crisis* (1972). This book explores many of the key dilemmas of art museums in essays by historians and critics, thus providing a broad theoretical and historical context for the study of the art museum. The 46th American Assembly, a national bipartisan public affairs forum affiliated with Columbia University, took a similar approach in its 1974 conference, "Art Museums in America." The background material for this meeting was later edited by Sherman Lee and appeared as *On Understanding Art Museums* (1975), perhaps the most comprehensive attempt to date to illuminate the sources of a wide range of problems and conflicts. The recommendations of the assembly were published in *Curator* as "Art Museums in America" (1974) and summarized by Milton Esterow in "The Future of American Museums" (1975). Although the American Assembly and its European sequel, the Ditchley Conference of 1975, encouraged the expansion of many educational functions, critics Grace Glueck, in "Museum Summit in Britain" (1976), and Douglas Davis, in "The Idea of a 21st Century Museum" (1976), felt that the participants were too cautious in choosing their topics for consideration and too hesitant in proposing effective changes and alternatives.

Also of international concern were the issues of the interaction of contemporary art and living artists with museums and the renewed questions about what art is and what art museums should be. Conferences and meetings were held worldwide, such as the seminar at the Art Gallery of Ontario that resulted in Duncan Cameron's edited publication, with John B. Hightower's title, *Are Art Galleries Obsolete?* (1969); the series of discussions among museum professionals in Europe that led to Harald Szeemann's summary, "Problems of the Museum of Contemporary Art in the West" (1972); and the 1975 international symposium in Los Angeles, which was the subject of "Validating Modern Art" (1977) by Maurice Tuchman and others. One important dialogue was created through *Museum in Motion?: The Modern Art Museum at Issue* (1979), edited by Carel Blotkamp and others, which was initiated as a history of Jean Leering's ten years as director of the Van Abbemuseum in Eindhoven but ultimately expanded into a series of comments and responses among artists, critics, and museum professionals on the role and function of the museum of contemporary art. In addition, special issues of magazines devoted to a broad range of museum concerns include

"The Museum World" (1967), a gathering of various general essays for *Arts Yearbook*, and "Modern Art Museums" (1978), a series of articles on individual institutions edited by Richard Cork for *Studio International*. Finally, Tony Rickaby's "Radical Attitudes to the Gallery" (1980), also in *Studio International*, provides a compilation of sixty-six comments by artists on the need for alternatives to showing art in formal gallery and museum spaces.

The desire to understand the issues and to find new solutions stimulated individual scholars to study and write critically about the art museum. In *The New Museum* (1965), Michael Brawne examined the physical spaces and interior design elements in new museum buildings throughout the world that he believed had successfully responded to the social and functional needs of their constituencies. Helmut Seling's "The Genesis of the Museum" (1967) is a historical review of the architectural developments that reflected the changes in art collecting and display from the Renaissance to the early nineteenth century. William Scott Hendon's *Analyzing an Art Museum* (1979) went beyond the examination of a single institution, the Akron Art Museum, and provided a good model for the kind of detailed managerial analysis that can assist in finding practical solutions to problems of organization and administration. Other scholars reexamined the social and philosophical history of museums in articles such as Neil Harris's "The Gilded Age Revisited" (1962), a questioning of the personal motivations traditionally attributed to the founders of America's first museums, and César Graña's "The Private Lives of Public Museums" (1967) and Linda Nochlin's "Museums and Radicals" (1971), both describing the contradictions inherent in the concept of the museum as it evolved in nineteenth-century America.

Although studies of individual art museums certainly appeared before the 1960s, the attempt to understand better the current plight of museums also has resulted in the recent publication of many institutional histories and critiques. Furthermore, the occasion of the U.S. bicentennial and the centennial anniversaries of many large museums in the 1970s coincided with the growing public scrutiny of arts institutions and caused a renewal of interest in historical analyses. For example, to mark the centennial of the Metropolitan Museum of Art, volume 1 of Winifred Howe's *A History of the Metropolitan Museum of Art* (1913–1946) was reprinted in 1974, while Leo Lerman undertook a succinct historical update and pictorial survey in *The Museum* (1969), and Barry Schwartz made suggestions for redirecting the museum's effort to serve better the culturally diverse community of the future in "The Metropolitan Museum of Art: Cultural Power in a Time of Crisis" (1969). Calvin Tomkins provided historical vignettes in *Merchants and Masterpieces* (1970), and *Artnews* published "The Metropolitan Museum, 1870–1970–2001" (1970) by Harold Rosenberg and others.

Many other institutions were treated to retrospectives and reminiscences during this period, including the Museum of Modern Art in Russell Lynes's "unofficial, unsubsidized and unauthorized" history, *Good Old Modern*

(1973), and the Pennsylvania Academy of the Fine Arts in the form of a special bicentennial exhibition catalog with several historical essays, entitled *In This Academy* (1976). David Finley gave his personal account of the founding of the National Gallery of Art in Washington and his eighteen years of directorship in *A Standard of Excellence* (1973), and Paul Oehser's portrait, *The Smithsonian Institution* (1970), was drawn from his thirty-five years as editor and public relations officer there. Walter Whitehill's *Museum of Fine Arts, Boston* (1970) focuses on the personalities that shaped the museum and capitalizes on Whitehill's familiarity with Boston cultural and intellectual history. Smaller art museums have published anniversary catalogues and bulletins that should not be overlooked when researching the history of American art museums. Perhaps the greatest weakness in the literature on art museums is the absence of studies on small and midsized museums. Critic John Canaday, in his essay, "Car-Wash Culture" (1969), made suggestions about how these museums might improve themselves by not competing with the larger institutions, but to date there has been no systematic study of the growth and status of smaller, community-based art museums in the United States.

One of the far-reaching administrative problems of the 1970s and 1980s has been the financial crisis of art museums. In fact, the subtitle of Karl Meyer's *The Art Museum: Power, Money, Ethics* (1979) accurately suggests that central issues were aggravated by the dwindling of internal and private resources and the need to depend more and more on public and corporate subsidies. The increased reliance on public funds—federal, state, and local grants, tax exemptions, and tax deductions for donations—in turn fueled the pressure for art museum programs that were available to a broad public. Such studies as *The Art Museum as Educator* (1978) by the Council on Museums and Education in the Visual Arts, Kenneth Hudson's *Museums for the 1980's* (1977), and hundreds of visitor surveys all have been part of a search for the proper place of the art museum in the midst of its financial constraints, its many publics, and a changing economic and social milieu. For critical analyses of the social and political issues raised by increased public funding of the fine arts in general, and of art museums in particular, see Alvin Toffler's "The Politics of the Impossible—Art and Society" (1968), Dorothy Mariner's "The Museum: A Social Context for Art" (1969), and Edward Banfield's *The Democratic Muse* (1984). In the 1980s, artists such as Daniel Buren and Hans Haacke have used their artwork and their words to critique the market-driven policies of art museums. Haacke's "Museums, Managers of Consciousness" (1984) raises some of the key issues, and Hal Foster's "Subversive Signs" (1985) summarizes the approach of several of these artists. A good analysis of the questions raised from Hoving to Haacke can be found in "The Art of Big Business" (1986) by Brian Wallis.

Increased accountability to the public has expanded and complicated the roles of the trustees and the museum professional in all types of museums.

A sense of this new climate in the art museum can be obtained by reviewing *Professional Practices in Art Museums* (1971), published by the Association of Art Museum Directors; *Conflict in the Arts* (1976), edited by Douglas Schwalbe and Janet Baker-Carr; and "Professional Practices in University Art Museums" (1980) by Muriel B. Christison. Legal and financial concerns over collecting and deaccessioning, balancing budgets, and increasing attendance figures have also raised unique management problems for art museums, as indicated by Walter McQuade in "Management Problems Enter the Picture at Art Museums" (1974), by Thomas W. Leavitt in "The Beleagured Director" (1971), and by Alan Shestack in "The Director: Scholar and Businessman, Educator and Lobbyist" (1978). In "Who Should Manage Museums?" (1977), Phillip Kadis responded to the decision by the trustees of the Metropolitan Museum to create a dual administration with a paid president and a director. This unconventional arrangement brought into question the primacy of aesthetic and educational decisions in the museum and raised concern that trustees might become more interested in business expertise and efficiency than in professional goals or institutional mission. For discussions of the issues of power and authority in art museums, especially as they relate to ethics and the public trust, see Grace Glueck's "Power and Esthetics: The Trustee" (1971) and Daniel Catton Rich's "Management, Power, and Integrity" (1975). Stephen Weil's provocative *Beauty and the Beasts* (1983) and Miriam Horn and Alvin P. Sanoff's "Power Plays in the Galleries" (1988) also suggest the problems inherent in the conflicting interests of the art museum and its benefactors.

In recent years, the building of new museums and the architectural renovation and expansion of existing institutions have been a focus for writing about art museums. Critics such as Joan Vastokas, in "Montreal Museum of Fine Arts and the Issue of Democratization: Building vs. Collections" (1976), Carol Duncan and Alan Wallach, in the "The Universal Survey Museum" (1980), and Douglas Crimp in "The Postmodern Museum" (1987) have analyzed the structure of individual art museums in the context of social philosophy and the communication of established cultural values. Arguing that function and values are directly related to form, Douglas Davis, in "The Museum Impossible" (1983), discusses the conceptual problems inherent in recent American museum architecture, and Michael D. Levin, in *The Modern Museum* (1983) and Thomas Vonier in the title article for a *Museum News* special issue (1988), "Museum Architecture: The Tension Between Function and Form," trace the way that major developments in the concept of art museums have inspired changes in architectural form and museum display in the United States and throughout the rest of the world.

Even articles in specialized architectural periodicals have addressed the unresolved questions of the function of art museums in contemporary society. For example, a special issue of *Progressive Architecture* (1983), "Museums: The Second Round," noted that the increased pressure for accommodating

public access and entertainment often overrode storage and conservation needs and, in some cases, dictated the architectural program. "Museums as Showcases—For Architecture" (1986) in an issue of *Architecture* focused on six new museum buildings representing the notion that in the ten years from 1975 through 1985, museums have been "the glamour buildings of the period" for architects because they have become the symbols of our culture, the "cathedrals of our time."

As cultural symbols, art museums have become, in the last decade, the subject of a diversity and profusion of writing that is unprecedented in American history. Many popular magazines and newspapers carry stories and features on the world of art museums, and recent films and historical fiction have used backdrops of art museum personalities and events. But the mass awareness of the cultural value of these institutions has come out of the social questioning and economic crises of the late 1960s and 1970s. Art museums not only have become of interest to masses of people but also have become the focus for much writing and thinking by sociologists, anthropologists, economists, social philosophers, and political scientists, as well as by artists, art historians, critics, and a new generation of museum professionals. These varied and broadened perspectives on the role of art museums in society are requiring a more comprehensive and interdisciplinary approach to the long-standing dialogue on the primary purpose of these symbols of American culture. The question of the conflicting missions of the preservation of culture and the education of the public within these institutions is being transformed into a questioning of the role and influence of the art museum in the defining of Western culture and a challenging of its traditional approach to the presentation of diverse cultural artifacts to expanding and interdependent world communities.

BIBLIOGRAPHIC CHECKLIST

Adam, Thomas Ritchie. *The Civic Value of Museums*. New York: American Association for Adult Education, 1937.
———. *The Museum and Popular Culture*. New York: American Association for Adult Education, 1939.
Albright, Thomas. "The Contemporary Art Museum: 'Irresponsibility Has Become Most Widespread.' " *Artnews* 79 (January 1980), 42–47.
Alexander, Edward Porter. "The Art Museum." In *Museums in Motion: An Introduction to the History and Functions of Museums*, by Edward Alexander. Nashville, TN: American Association for State and Local History, 1979.
Alloway, Lawrence, and John Coplans. "Talking with William Rubin: 'The Museum Concept Is Not Infinitely Expandable.' " *Artforum* 13 (October 1974), 51–57.
Amon Carter Museum. *Future Directions for Museums of American Art*. Fort Worth: Amon Carter Museum, 1980.
"Art Museums Humanized." *Saturday Evening Post*, March 31, 1928, 26.

"Art Museums in America—Report of the Forty-sixth American Assembly." *Curator* 17 (December 1974), 255–63.

Association of Art Museum Directors. Professional Practices Committee. *Professional Practices in Art Museums; Report*. New York: Association of Art Museum Directors, 1971.

Aulanier, Christiane. *Histoire du Palais et du Musée du Louvre*. 10 vols. Paris: Editions des musées nationaux, 1947–1971.

Banfield, Edward C. *The Democratic Muse: Visual Arts and the Public Interest*. New York: Basic Books, 1984.

Bazin, Germain. *The Museum Age*, translated by Jane van Nuis Cahill. New York: Universe Books, 1967.

Benson, Eugene. "Museums of Art as a Means of Instruction." *Appleton's Journal of Literature, Science, and Art*, January 15, 1870, 80–81.

Blotkamp, Carel, and others, eds. *Museum in Motion: The Modern Art Museum at Issue*. The Hague: Government Printing Office, 1979.

Brawne, Michael. *The New Museum: Architecture and Display*. New York: Praeger, 1965.

Buren, Daniel. "Function of the Museum." *Artforum* 12 (September 1973), 68. Reprinted in *Journal of the Los Angeles Institute of Contemporary Art* 13 (January-February 1977), 19–21.

Burt, Nathaniel. *Palaces for the People: A Social History of the American Art Museum*. Boston: Little, Brown, 1977.

Cameron, Duncan F., ed. *Are Art Galleries Obsolete?* Toronto: Peter Martin Associates, 1969.

———. "The Museum, A Temple or the Forum." *Curator* 14 (March 1971), 11–24.

Canaday, John. "Car-Wash Culture, or, Big Problems Come in Small Museums." In *Culture Gulch: Notes on Art and Its Public in the 1960s*, by John Canaday. New York: Farrar, Straus and Giroux, 1969.

Cauman, Samuel. *The Living Museum, Experiences of an Art Historian and Museum Director: Alexander Dorner*. New York: New York University Press, 1958.

Christensen, Erwin O. "Art Museums for the Public." *Museum Work* 5 (July-August 1922), 36–40.

Christison, Muriel B. "Professional Practices in University Art Museums." *Museum News* 58 (January-February 1980), 30–40.

Ciniglio, Ada V. "Pioneers in American Museums: Paul J. Sachs." *Museum News* 55 (September-October 1976), 48–51, 68–71.

Clark, Kenneth. "The Ideal Museum." *Artnews* 52 (January 1954), 28–31, 83–84.

Coleman, Laurence Vail. *The Museum in America: A Critical Study*. 3 vols. Washington, DC: American Association of Museums, 1939. Reprint (3 vols. in 1). Washington, DC: American Association of Museums, 1970.

Coles, Robert. "The Art Museum and the Pressures of Society." In *On Understanding Art Museums*, edited by Sherman E. Lee. Englewood Cliffs, NJ: Prentice-Hall, 1975. Reprinted in *Artnews* 74 (January 1975), 24–33.

Compton, Michael. "Art Museums: The Concept and the Phenomenon." *Studio International* 189 (May-June 1975), 197–201.

Cooke, Forest H. "Culture and Fatigue: Some Reflections on Museums." *Century* 111 (January 1926), 291–96.

Coolidge, John Phillips. *Patrons and Architects: Designing Art Museums in the Twentieth Century.* Austin, TX: University of Texas Press, 1989.

———. *Some Problems of American Art Museums.* Boston: Club of Odd Volumes, 1953.

———. "The University Art Museum in America." *Art Journal* 26 (Fall 1966), 9–12, 21.

Coomaraswamy, Ananda K. "Why Exhibit Works of Art?" In *Christian and Oriental Philosophy of Art,* by Ananda K. Coomaraswamy. New York: Dover, 1956.

Coplans, John. "Pasadena's Collapse and the Simon Takeover, Diary of a Disaster." *Artforum* 13 (February 1975), 28–45.

Cork, Richard, ed. "Modern Art Museums." *Studio International* 194 (1978), entire issue.

Council on Museums and Education in the Visual Arts. *The Art Museum as Educator: A Collection of Studies as Guides to Practice and Policy,* edited by Barbara Y. Newsom and Adele Z. Silver. Berkeley: University of California Press, 1978.

Crimp, Douglas. "On the Museum' Ruins," *October* 13 (1980), 41–58.

———. "The Postmodern Museum." *Parachute* 46 (1987), 61–69.

Craven, Thomas. "Our Decadent Art Museums." *American Mercury* 53 (December 1941), 682–88.

Cultural Affairs Committee of the Parti Socialiste Unifié. "Beaubourg: The Containing of Culture in France." *Studio International* 194 (1978), 27–36.

Dana, John Cotton. *The New Museum.* Woodstock, VT: Elm Tree Press, 1917.

———. *The Gloom of the Museum.* Woodstock, VT: Elm Tree Press, 1917.

———. *Installation of a Speaker and Accompanying Exhibits.* Woodstock, VT: Elm Tree Press, 1918.

———. *A Plan for a New Museum: The Kind of a Museum It Will Profit a City to Maintain.* Woodstock, VT: Elm Tree Press, 1920.

Davis Douglas. "The Idea of a 21st Century Museum." *Art Journal* 35 (Spring 1976), 253–58.

———. "The Museum Impossible." *Museum News* 61 (June 1983), 32–37.

Dewey, John. *Art as Experience.* New York: Minton, Balch, 1934.

Drohojowska, Hunter. "The Pasadena Case." *Art in America* 69 (May 1981), 11–17.

Duncan, Carol, and Alan Wallach. "MOMA: Ordeal and Triumph on 53rd Street." *Studio International* 194 (1978), 48–57. An earlier version of this article was published as "The Museum of Modern Art as Late Capitalist Ritual: An Iconographical Analysis." *Marxist Perspectives* 1 (Winter 1978), 27–51.

———. "The Universal Survey Museum." *Art History* 3 (December 1980), 448–69.

Eells, Richard. *The Corporation and the Arts.* New York: Macmillan, 1967.

Emerson, Ralph Waldo. *Emerson's Complete Works,* edited by James Elliot Cabot. 12 vols. Boston: Houghton Mifflin, 1883–1893.

Esterow, Milton. "Conversation with E. H. Gombrich: The Museum's Mission, the Enjoyment of Art, the Problem of Critics." *Artnews* 73 (January 1974), 54–57.

———. "The Future of American Museums." *Artnews* 74 (January 1975), 34, 36–37.

Failing, Patricia. "Is the Norton Simon Museum Mismanaged? Or, Are the Former Trustees Misguided?" *Artnews* 79 (October 1980), 136–42.

Fenollosa, Ernest Francisco. "Art Museums and Their Relation to the People." *Lotus* 9 (May 1896), 844.

Finley, David Edward. *A Standard of Excellence: Andrew W. Mellon Founds the National Gallery of Art at Washington*. Washington, DC: Smithsonian Institution Press, 1973.

Forbes, John D. "The Art Museum and the American Scene." *Journal of Aesthetics and Art Criticism* 1 (Winter 1941–1942), 3–11.

Foster, Hal. "Subversive Signs." In *Recodings*. Port Townsend, WA: Bay Press, 1985.

Fowler, Frank. "The Beneficence of Art Museums." *Scribner's Magazine* 40 (October 1906), 509–12.

Gilman, Benjamin Ives. *Museum Ideals of Purpose and Method*. 2d ed. Cambridge: Harvard University Press, 1923.

Glueck, Grace. "The Ivory Tower versus the Discotheque." *Art in America* 59 (May-June 1971), 80–85.

———. "Power and Esthetics: The Trustee." *Art in America* 59 (July-August 1971), 78–83. Reprinted in *Museums in Crisis*, edited by Brian O'Doherty. New York: George Braziller, 1972.

———. "Museum Summit in Britain." *Art in America* 64 (January-February 1976), 19.

Gombrich, Ernst Hans Josef. "Should a Museum Be Active?" *Museum* 21 (1968), 79–86.

———. "The Museum: Past, Present and Future." *Critical Inquiry* 3 (Spring 1977), 449–470. Reprinted in *Ideals and Idols: Essays on Values in History and in Art*, by E. H. J. Gombrich. Oxford, England: Phaidon, 1979.

Goode, George Brown. "The Museums of the Future." In *Annual Report of the Board of Regents of the Smithsonian Institution . . . 1987. Report of the U.S. National Museum*, pt. 2. Washington, DC: Government Printing Office, 1901.

Graña, César. "The Private Lives of Public Museums." *Trans-action* 4 (April 1967), 20–25.

Grove, Richard. "Pioneers in American Museums: John Cotton Dana." *Museum News* 56 (May-June 1978), 32–39, 86–88.

Haacke, Hans. "Museums, Managers of Consciousness." *Art in America* 72 (February 1984), 9–17.

Harris, Ann Sutherland, and Cindy Nemser. "Are Museums Relevant to Women?" *Feminist Art Journal* 1 (April 1972), 7, 18, 27.

Harris, Neil. "The Gilded Age Revisited, Boston and the Museum Movement." *American Quarterly* 14 (Winter 1962), 545–566.

Hellman, Geoffrey T. "Profile of a Museum." *Art in America* 52 (February 1964), 24–64.

Hendon, William Scott. *Analyzing an Art Museum*. New York: Praeger, 1979.

Hess, John L. *The Grand Acquisitors*. Boston: Houghton Mifflin, 1974.

Hightower, John B. "Are Art Galleries Obsolete?" *Curator* 12 (March 1969), 9–13.

Hinter-Reiter, Hermene-Gilda. "Art and the Process of Change: A Study of the Relationship of Art and the Museum." Ph.D. dissertation, Pennsylvania State University, 1970.

Holmes, William H. "Plea for a National Gallery of Art." *Art and Archaeology* 23 (February 1927), 51–69.

Horn, Miriam and Alvin P. Sanoff. "Power Plays in the Galleries." *U.S. News and World Report*, August 1988, 54–55.

Hoving, Thomas. *The Chase, the Capture: Collecting at the Metropolitan*. New York: Metropolitan Museum of Art, 1975.

Howard, Rossiter. "Changing Ideals of the Art Museum." *Scribner's Magazine* 71 (January 1922), 125–28.

Howe, Winifred Eva. *A History of the Metropolitan Museum of Art, with a Chapter on the Early Institutions of Art in New York*. 2 vols. New York: Gilliss Press, 1913–1946. Reprint of vol 1. New York: Arno Press, 1974.

Hudson, Kenneth. *Museums for the 1980's: A Survey of World Trends*. New York: Holmes & Meier, 1977.

————. *Museums of Influence*. Cambridge: Cambridge University Press, 1987.

Hughes, Robert. "The Museum on Trial." *New York Times Magazine*. September 9, 1973, 34, 102–6.

Jackson, Virginia, Marlene A. Palmer, Eric M. Zafran, Ann Stephens Jackson, and James L. Connelly. *Art Museums of the World*. Westport, CT.: Greenwood Press, 1987

Jarves, James Jackson. *The Art Idea: Part Second of Confessions of an Inquirer*. New York: Hurd and Houghton, 1864.

Johnson, Robert Underwood. "The Establishment of Art Museums." In "Supplement to Art and Progress: The Proceedings of the First Annual Convention of the American Federation of Arts." *Art and Progress* 1 (July 1910), 87–89.

Joint Artists-Museums Committee. *The Museum and the Artist: Principles and Procedures Recommended by the Joint Artists-Museums Committee*. New York: American Federation of Arts, 1958.

Kadis, Phillip M. "Who Should Manage Museums?" *Artnews* 76 (October 1977), 46–51.

Kozloff, Max. "Art." *Nation*, November 27, 1967, 570–72.

Kramer, Hilton. "Has Success Spoiled American Museums?" *New York Times*, January 14, 1979, D1, D27.

Kuh, Katherine. "What's an Art Museum For?" *Saturday Review*, February 22, 1969, 58–59.

Leavitt, Thomas W. "The Beleagured Director." *Art in America* 59 (July-August 1971), 66–71. Reprinted in *Museums in Crisis*, edited by Brian O'Doherty. New York: George Braziller, 1972.

Lee, Sherman E. "The Idea of an Art Museum." *Harper's Magazine* 237 (September 1968), 76–79. Reprinted in *Past, President, East and West*, by Sherman E. Lee. New York: George Braziller, 1983.

————. "The Art Museum in Today's Society." *Dayton Art Institute Bulletin* 27 (March 1969), 2–6. Reprinted in *Past, Present, East and West*, by Sherman E. Lee. New York: George Braziller, 1983.

————, ed. *On Understanding Art Museums*. Englewood Cliffs, NJ: Prentice-Hall, 1975.

Lerman, Leo. *The Museum: One Hundred Years and the Metropolitan Museum of Art*. New York: Viking Press, 1969.

Levin, Michael D. *The Modern Museum: Temple or Showroom*. Jerusalem: Dvir Publishing House, 1983.

Lipton, Barbara. "John Cotton Dana and the Newark Museum." *Newark Museum Quarterly* 30 (Spring-Summer 1979), 1–58.

Loomis, Ross J. *"Please! Not Another Visitor Survey."* *Museum News* 52 (October 1973), 21–26.

Low, Theodore Lewis. *The Museum as a Social Instrument.* New York: Metropolitan Museum of Art, 1942.

———. *The Educational Philosophy and Practice of Art Museums in the United States.* New York: Bureau of Publications, Teachers College, Columbia University, 1948.

———. "The Museum as a Social Instrument: Twenty Years After." *Museum News* 40 (January 1962), 28–30.

Lynes, Russell. *The Tastemakers.* New York: Harper, 1954. Reprint. New York: Dover, 1980.

———. "The Pilot of the Treasure House—Mr. Hoving at the Met." *Art in America* 55 (July-August 1967), 22–31.

———. *Good Old Modern: An Intimate Portrait of the Museum of Modern Art.* New York: Atheneum, 1973.

Malraux, André. *Museum Without Walls,* Translated by Stuart Gilbert and Francis Price. London: Secker and Warburg, 1967.

Mariner, Dorothy Anderson. "The Museum: A Social Context for Art," Ph.D. dissertation, University of California, Berkeley, 1969.

Mather, Frank Jewett. "An Art Museum for the People." *Atlantic Monthly* 100 (December 1907), 729–40.

McFadden, Elizabeth. *The Glitter and the Gold: A Spirited Account of the Metropolitan Museum of Art's First Director, the Audacious and High-Handed Luigi Palma di Cesnola.* New York: Dial Press, 1971.

McQuade, Walter. "Management Problems Enter the Picture at Art Museums." *Fortune* 90 (July 1974), 100–3, 169, 173.

Messer, Helaine Ruth. "MOMA: Museum in Search of an Image." Ph.D. dissertation, Columbia University, 1979.

Messer, Thomas M. "Le Musée au coeur des contradictions americaines." *XXme Siècle* 35 (December 1973), 77.

Meyer, Karl Ernst. *The Plundered Past.* New York: Atheneum, 1973.

———. *The Art Museum: Power, Money, Ethics.* New York: William Morrow, 1979.

Michelson, Annette. "Beaubourg: The Museum in the Era of Late Capitalism." *Artforum* 13 (April 1975), 62–67.

Miller, Lillian B. *Patrons and Patriotism: The Encouragement of the Fine Arts in the United States, 1790–1860.* Chicago: University of Chicago Press, 1966.

Mills, George. "Art, Artists and Museums: An Essay on the Politics of Immediacy." *College Art Journal* 19 (Summer 1960), 307–13.

Morris, Rudolph E. "The Art Museum as a Changing Social Institution." *Arts in Society* 2 (1963), 101–7.

———. "The Art Museum as a Communication Center." *Museum News* 43 (January 1965), 26–31.

Morse, John D., ed. *The Artist and His World: The Report of the First Woodstock Art Conference; August 29–30, 1947.* New York: Woodstock Art Association and Artists Equity Association, 1947.

"Museum Trends." *Art in America* 34 (October 1946), entire issue.

"The Museum World." *Arts Yearbook* 9 (1967), entire issue.

"Museums as Showcases—For Architecture." *Architecture* 75 (January 1986), a special issue.

"Museums: The Second Round." *Progressive Architecture* 64 (August 1983), special issue.

Nash, George. "Art Museums as Perceived by the Public." *Curator* 18 (March 1975), 55–67.

National Endowment for the Arts. "Purposes and Functions of Museums." In *Museums USA: A Survey Report*, by National Endowment for the Arts. Washington, DC: U.S. Government Printing Office, 1975.

Neff, John H. "How Contemporary Is Modern?" *Artnews* 78 (October 1979), 172–77.

Newark Museum. *A Survey: Fifty Years*. Newark: Newark Museum, 1959.

Nochlin, Linda. "Museums and Radicals: A History of Emergencies." *Art in America* 59 (July-August 1971), 26–39. Reprinted in *Museums in Crisis*, edited by Brian O'Doherty. New York: George Braziller, 1972.

O'Doherty, Brian, ed. "Special Museum Issue." *Art in America* 59 (July-August 1971), 25–127. Reprinted as *Museums in Crisis*, edited by Brian O'Doherty, New York: George Braziller, 1972.

Oehser, Paul Henry. *The Smithsonian Institution*. New York: Praeger, 1970.

O'Hare, Michael. "The Public's Use of Art—Visitor Behavior in an Art Museum." *Curator* 17 (December 1974), 309–20.

O'Hare, Michael, and Alan L. Feld. "Is Museum Speculation in Art Immoral, Illegal and Insufficiently Fattening?" *Museum News* 53 (May 1975), 24–26, 52.

Pach, Walter. *The Art Museum in America*. New York: Pantheon, 1948.

Pennsylvania Academy of the Fine Arts. *In This Academy: The Pennsylvania Academy of the Fine Arts, 1805–1976: A Special Bicentennial Exhibition*. Philadelphia: Pennsylvania Academy of the Fine Arts, 1976.

Phillips, Gifford. *The Arts in a Democratic Society*. Santa Barbara, CA: Center for the Study of Democratic Institutions, 1966.

———. "A Vote for the Highbrow Museum." *Art in America* 69 (January 1981), 9–11.

Pope-Hennessy, John. "The Museum as Forum." *Expedition* 18 (Summer 1976), 3–10.

Radar, Edmond. "Art Centers and Participation." *Diogenes* 94 (Summer 1976), 94–109.

Ratcliff, Carter. "Modernism for the Ages." *Art in America* 66 (July-August 1978), 50–54.

Read, Herbert. "The Museum and the Artist." *College Art Journal* 13 (Summer 1954), 289–93.

Rich, Daniel Catton. "Museums at the Crossroads." *Museum News* 39 (March 1961), 36–38.

———. "Management, Power, and Integrity." In *On Understanding Art Museums*, edited by Sherman E. Lee. Englewood Cliffs, NJ: Prentice-Hall, 1975.

Richards, Charles Russell. *Industrial Art and the Museum*. New York: Macmillan, 1927.

Rickaby, Tony. "Radical Attitudes to the Gallery." *Studio International* 195 (1980), 20–52.

Ripley, Sidney Dillon. *The Sacred Grove: Essays on Museums.* New York: Simon and Schuster, 1969.

Rockman, Arnold. "The Great Universal Extrasensory Emporium and Display Mart in the Old Curiosity Shop." *Museum News* 47 (November 1968), 9–12.

Rorimer, James J. "Our Motto Should Be: Standards Without Standardization." *Museum News,* June 1, 1958, 3–4.

Rosenberg, Harold, and others. "The Metropolitan Museum, 1870–1970–2001." *Artnews* 68 (January 1970), 27–45, 58–60, 60B.

Saarinen, Aline B. *The Proud Possessors: The Lives, Times and Tastes of Some Adventurous American Art Collectors.* New York: Random House, 1958.

Sachs, Paul J. "Why Is a Museum of Art?" *Architectural Forum* 71 (September 1939), 198.

————. Papers. Columbia University Oral History Research Office, New York.

Schwalbe, Douglas, and Janet Baker-Carr, eds. *Conflict in the Arts: The Relocation of Authority: The Museum.* Cambridge, MA: Arts Administration Research Institute, 1976.

Schwartz, Barry N. "The Metropolitan Museum of Art: Cultural Power in a Time of Crisis." *Metropolitan Museum of Art Bulletin* 27 (January 1969), 262–64.

————. "Museums: Art for Whose Sake?" *Ramparts* 9 (June 1971), 38–49.

Schwartz, Therese. "The Politicalization of the Avant-Garde." *Art in America* 59 (November-December 1971), 97–105; 60 (March-April 1972), 70–79; 61 (March-April 1973), 67–71; 62 (January-February 1974), 80–84.

Searing, Helen. *New American Art Museums.* Berkeley: University of California Press, 1982.

"A Selective Art Museum." *Nation* May 24, 1906, 422–23.

Seling, Helmut. "The Genesis of the Museum." *Architectural Review* 141 (February 1967), 103–14.

Shestack, Alan. "The Director: Scholar and Businessman, Educator and Lobbyist." *Museum News* 57 (November-December 1978), 27–31, 89–91.

Shirey, David L., and Ann Kay Martin. "Hoving of the Metropolitan." *Newsweek,* April 2, 1968, 54–62.

Smith, Robert C. "The Museum of Art in the United States." *Art Quarterly* 21 (Autumn 1958), 297–316.

Swan, Mabel Munson. *The Athenaeum Gallery, 1827–1873: The Boston Athenaeum as an Early Patron of Art.* Boston: Boston Athenaeum, 1940.

Szeemann, Harald. "Problems of the Museum of Contemporary Art in the West: Exchange of Views of a Group of Experts." *Museum* 24 (1972), 1–32.

Taylor, Francis Henry. *Babel's Tower: The Dilemma of the Modern Museum.* New York: Columbia University Press, 1945.

————. *The Taste of Angels: A History of Art Collections from Rameses to Napoleon.* Boston: Little Brown, 1948.

Taylor, Joshua C. "The Art Museum in the United States." In *On Understanding Art Museums,* edited by Sherman E. Lee. Englewood Cliffs, NJ: Prentice-Hall, 1975.

Toffler, Alvin. "The Politics of the Impossible—Art and Society." In *A Great Society?* edited by Bertram Gross. New York: Basic Books, 1968.

Tomkins, Calvin. *Merchants and Masterpieces: The Story of the Metropolitan Museum of Art.* New York: E. P. Dutton, 1970.

———. "Profiles: A Good Monster (Pontus Hulten)." *New Yorker*, January 16, 1978, 37–38, 42–45, 51–56, 58–67.

———. "The Art World: Elitism vs. Mobocracy." *New Yorker* September 15, 1980, 94, 98–101.

Tuchman, Maurice, and others. "Validating Modern Art: The Impact of Museums on Modern Art History." *Artforum* 15 (January 1977), 36–43.

"U.S. Museums Face the Wartime World." *Art News* January 1, 1942, 9, 25–26.

Vanderbilt, Kermit. *Charles Eliot Norton: Apostle of Culture in a Democracy*. Cambridge: Belknap Press of Harvard University Press, 1959.

Vastokas, Joan M. "Montreal Museum of Fine Arts and the Issue of Democratization: Building vs. Collections." *Artscanada* 33 (July-August 1976), 18–27.

Vonier, Thomas. "Museum Architecture: The Tension Between Function and Form," *Museum News* 66 (May-June 1988) 24–29.

Wallis, Brian. "The Art of Big Business." *Art in America* 74 (June 1986), 28–33.

Washburn, Wilcomb E. "Scholarship and the Museum." *Museum News* 40 (October 1961), 16–19.

Weil, Stephen E. *Beauty and the Beasts: On Museums, Art, the Law, and the Market*. Washington, DC: Smithsonian Institution Press, 1983.

"What Should a Museum Be?" *Art in America* 49 (1961), 23–45.

White, Ron. "Museums Are Poison." *Left Curve* 5 (Fall-Winter 1975), 33–39.

Whitehill, Walter Muir. *Museum of Fine Arts, Boston: A Centennial History*. 2 vols. Cambridge: Belknap Press of Harvard University Press, 1970.

Winser, Beatrice, ed. *John Cotton Dana, 1856–1929*. Newark: Newark Museum, 1930.

Wittlin, Alma. *Museums: In Search of a Usable Future*. Cambridge: MIT Press, 1970.

Wittman, Otto. "Museums at the Crossroads." *Museum News* 44 (September 1965), 15–19.

Youtz, Philip N. *Report Upon the Conditions and Progress of the Museums For the Year Ending December 31, 1934*. Brooklyn: Brooklyn Institute of Arts and Sciences, 1935.

———. "Scientific Basis of the Art Museum." *Museum News*, January 1, 1936, 7–8.

This chapter could not have been written without the special research and bibliographic assistance of Robyn Roslak and Margaret Nelson and without the advice and suggestions of many generous art museum colleagues around the country.

THE MUSEUM OF SCIENCE AND TECHNOLOGY

Bernard S. Finn

Museums of science and technology were born during the scientific revolution and came of age after the industrial revolution. In recent years they have changed again, in response to the special needs of a society increasingly dependent on factors that seem largely incomprehensible. The history of these museums provides a particularly focused view of shifting public attitudes toward science and technology.

HISTORIC OUTLINE

In the fifteenth century private "cabinets of curiosities" existed in Europe as combinations of unusual natural and man-made artifacts. In the sixteenth and seventeenth centuries, these became much more numerous and were often made available to casual visitors, to the extent that lists were compiled for travelers. Among them were the extensive collections of musical, scientific, and other instruments assembled by Rudolph II in Prague, the clocks and scientific apparatus brought together by Landgrave Wilhelm IV at Kassel, and the broad spectrum of objects assembled by the Medicis in Florence. Some of these collections (notably the one in Florence) survived through successive generations to form the cores of museums active today.

Later, as the consequences of the industrial revolution began to become apparent, there was increasing interest in using museums to describe these man-made marvels (separate from those of nature) to a larger public. Thus the Conservatoire National des Arts et Métiers, founded in Paris in 1794 to promote the study of applied arts and sciences, acquired Jacques de Vau-

canson's collection of machines and models. To these it added a large variety of scientific and technological instruments, which formed the basis for a substantial museum. The international fairs that celebrated the fruits of industrialization during the latter half of the nineteenth century spawned a series of additional large museums. In 1851 the Royal Society of Arts in London, encouraged by its president, Prince Albert, sponsored the Great Exhibition for the express purpose of promoting British industry. The main building, Joseph Paxton's Crystal Palace, was a pioneering structure of iron and glass that in itself represented a tribute to the new age. The exhibition closed with a surplus of both objects and funds, which were used to found the South Kensington Museum of Industrial Art. Some of these items were removed to the Science Museum when it was constructed as a separate establishment across the road in 1893.

On the other side of the Atlantic, the Smithsonian Institution, founded in 1846, acquired a miscellaneous collection of objects in the course of its encouragement of scientific activities. In 1876 the Smithsonian developed an exhibit on mammal and fish resources for the nation's Centennial Exhibition in Philadelphia. At the close of the exhibition, these and other materials were returned to Washington, where they became an excuse for the construction of a separate Arts and Industries building, which opened in 1881 as a repository of the National Museum. The National Museum, which no longer exists as an administrative entity, later split into a natural history museum, an art museum, and the Museum of History and Technology (now the National Museum of American History). The Arts and Industries building continues to serve as an exhibit hall, most recently housing a re-creation of the centennial exhibits themselves.

In analogous fashion, the Vienna Exhibition of 1873 found permanent expression in the Technische Museum für Industrie und Gewerbe, and Oskar von Miller's activities at the Paris International Electrical Exhibition in 1881 led him to found the Deutsches Museum von Meisterwerken der Naturwissenschaft und Technik in Munich in 1903. This in turn inspired Julius Rosenwald to establish the Museum of Science and Industry in Chicago thirty years later, appropriately in a reconstructed building from the 1893 Columbian Exposition.

It is not surprising, therefore, to find in these museums two characteristics common to the fairs. First, they attempt to appeal to a broad segment of the public. Second, most museums of science and technology reflect an underlying theme of progress. From the beginning, however, these goals were usually sought within a historical context. Even in exhibits explaining contemporary science and technology, the actual instruments (as opposed to models or reproductions) were used for demonstrations and comparisons.

In 1931, in Paris, a new kind of museum appeared. At the Palais de la Découverte, teaching the principles of science took precedence over describing its origins, and historical collections were absent. The Palais stood

alone as an example of this approach until after World War II, when some museums founded on more traditional lines, most notably the Museum of Science and Industry in Chicago, began to adopt the new didactic approach by revising older exhibits. The movement took on the characteristics of a stampede after *Sputnik*, as many new institutions were established. By 1973 the number had increased to the point where a need was felt to form the Association of Science and Technology Centers (ASTC). The absence of the word *museum* from the title is no accident. The founders wanted to shed an image that they perceived as suggesting outmoded and static approaches. There was also the argument that since many of these institutions did not have collections, they should not be called museums. By the early 1980s, ASTC had well over a hundred members worldwide, and it by no means embraced all institutions of this type.

Museums of science and technology have developed through three interrelated types, which remain evident today. Prominent descendants of the "cabinets," like the Museum of the History of Science at Oxford and the Museo di storia della Scienza in Florence, have preserved much from their early collection but use it in new ways, as foundations for historical studies. The Teylers Museum in Haarlem, conversely, looks as if it had been left unchanged from its original form in the eighteenth century. Historical museums that emphasize exhibits with broad public appeal still include all of those already mentioned, matched by similar if smaller institutions in most industrialized nations. A recent addition to the lists, the National Air and Space Museum of the Smithsonian Institution, is also the most popular (as measured by attendance). Among science centers, the Palais de la Découverte remains active, though it is overshadowed even in Paris by the Musée des Sciences, des Techniques et des Industries at Parc de la Villette. The Chicago Museum of Science and Industry, as a converted historical museum, and the Ontario Science Center in Toronto, as one of the first centers specifically built as such, were early on the scene and have served as case studies for others. The Exploratorium in San Francisco has often been cited as a unique example of effective hands-on technique.

Meanwhile, the movement among historians to deal with broader issues in social history has had an impact on these museums. Increasingly, exhibits have gone beyond the confines of a particular development in the history of science or technology to show how it influenced and was influenced by other movements in society. Newer exhibits tend to be organized around social themes rather than simpler notions of technical change, and questions of the impact of science and technology on society are being asked in ways that would not have been considered a decade ago. The trend has even had an effect on science centers. Social statements can often be found in more recent exhibits, and for new museums they can even be part of the central thesis. Thus the conceptual stages for a proposed new (as yet unbuilt) science center in Riyadh focused on the ways in which the exposition of science and

technology would relate to the Saudi experience, and particularly to the principles of Islamic inquiry. And planning activities for the proposed center at Parc de la Villette were interrupted in 1983 for a conference to consider ways in which socially oriented units could be introduced into exhibits that up to that point had been considered only in terms of the exposition of scientific and technological principles.

One consequence of this attempt to interpret science and technology in a cultural setting has been, in many cases, to deemphasize universal characteristics in favor of national influences. This is understandable, and in some ways even desirable, given the strengths of museum collections and the interests of their audiences. If care is not taken, however, such an approach can lack balance and become chauvinistic.

Not only have museums of science and technology responded to changing moods of academic historians, they have also been peculiarly sensitive to museological developments that involve the use of new technical devices. This is due in part to the fact that the techniques fit well with the subject matter of the displays, in part to the emphasis in these museums on operational and interactive exhibits, and in part to the technical orientation of staff members. Large-format film projection such as the Imax or Omnimax theatre is often the first thing to be designed into a new museum (along with its older counterpart, the planetarium); a theatre of this type has proved to be the most popular attraction at the Smithsonian's National Air and Space Museum. Microcomputers have found their way to the exhibit floor as instructional auxiliaries to other displays; the Lawrence Hall of Science in Berkeley and the Franklin Institute in Philadelphia early explored the exhibition possibilities of this new technology. The potential of computers as interactive and audio- visual complements to exhibits would seem to be great. But just as it has taken a long time to determine the proper role of slides and motion pictures, we can expect to see much more testing of computers on exhibition floors.

Museums treating the history of science and technology share with many others problems associated with a rapidly expanding collecting field, compounded by the fact that many of their objects are quite large. The result is that questions related to the expense of storage, transportation, and restoration can dominate what ideally should be purely historical determinations.

The increasing availability of trained museum personnel has not had as great an impact on museums of science and technology as it has elsewhere because of the additional need for technical knowledge. Historical museums of science and technology have, to a limited extent, drawn on the growing pool of graduates from academic programs in the history of science and technology. Otherwise, they, like science centers, have continued to obtain their professional staff members mainly from the ranks of scientists and

engineers, especially teachers. This has made both types of museums largely immune to benefits from museum studies programs.

All of these developments lead to a consideration of museum effectiveness, an important question that has only recently been seriously addressed. Psychologists have studied visitor reactions to determine how well information is being conveyed and as a result have offered a number of ideas for improved exhibition technique. Others, including historians, have directed their attention to exhibit content. The response of museums to both types of criticism has varied, but it seems clear that a healthy debate has begun, which in the end should produce better exhibits.

In sum, today's museums of science and technology have developed in response to a succession of internal and external forces. Their evolution is reflected in a small but rich literature.

SURVEY OF SOURCES

Most of what has been written has appeared in the last two decades. As a result, there has been little time to digest the material, and much of the writing continues to have a tentative quality. The newness of the subject is apparent in Eugene Ferguson's "Contributions to Bibliography in the History of Technology (Part VII)," which appeared in 1965 and concerns itself with technical museums and exhibitions. Ferguson gives only three or four references related to museums, including George Sarton's *A Guide to the History of Science* (1952), which in turn confines the discussion of science and technology museums to a listing of the institutions themselves. In fact, the early literature is somewhat less sparse than Ferguson's and Sarton's treatments would suggest. Almost three dozen pre–1965 citations appear in the bibliographic checklist to this chapter. Still it is clear that the bulk of the interesting material is quite recent.

The issue of *Technology and Culture* in which Ferguson's bibliography appears is devoted to the subject of museums of technology (no real distinction is made between science and technology). Three articles, taken together, provide an excellent overview of their historical development. Silvio Bedini, in "The Evolution of Science Museums" (1965), traces their origins back to the libraries and cabinets of curiosities of the Renaissance, identifying some fifty collections and museums founded prior to the twentieth century. This is a unique source of valuable material, which clearly shows the shift from private to public audiences in the nineteenth century. Ferguson's "Technical Museums and International Exhibitions" (1965) directly relates the beginnings of some of today's great public technical museums to specific exhibitions. He argues that although these exhibitions were not the sole source of inspiration for the museums, they were of primary importance, and their enthusiastic and uncritical spirit "unfortunately most

deeply affected the philosophy of technical museums." Finally, Bernard
Finn, in "The Science Museum Today" (1965), concentrates on more recent
trends, which focus on the teaching of scientific and technological principles
independent of historical context. The author expresses concern that aes-
thetic considerations can, unless properly controlled, do violence to the
purposes of the exhibits in historical museums. An important alternative
perspective, balancing these articles, can be gained from Friedrich Klemm's
"Geschichte der naturwissenschaftlichen und technischen Museen" (1973)
and Mihai Bacescu's "L'Evolution des musées de sciences naturelles" (1972).

A movement toward the inclusion of social messages in museums of science
and technology can be seen clearly in literature from Eastern European and
developing countries. Samar Bagchi and Pradip Bhaumik, in "New Gallery
on Transport in the Birla Industrial and Technological Museum, Calcutta"
(1976), and Niched Suntornpithug, in "Children and the Science Museum,
Bangkok" (1979), consider the role of the museum in developing countries.
C. Budeneau argues that technical museums ought to demonstrate that
technology and nature should be in balance rather than in conflict in "Eco-
technica şi muzeele technice" (1978). Elfriede Rehbein, in a symposium on
technical museums in socialist societies published as "Charakteristische
Merkmale and Aufgaben der teknischen Museen" (1969), makes it clear that
technology must always be related to society. The strong support that his-
torians of technology have given to this movement can be seen in the es-
tablishment of an award, described in "The Dibner Award" (1988) by the
Society for the History of Technology for exhibits that excel in their inter-
pretation of the interactions between technology and culture.

Histories of individual museums, although uneven, provide insight con-
cerning general trends. The unsigned article "Imperial Conservatory of Arts
and Trades" (1870) and R. Tresse's "Le Conservatoire des Arts et Métiers
et la Société d'Encouragement pour l'Industrie nationale au début du XIXe
siècle" (1952) indicate the French interest in promoting industrial devel-
opment through the exhibition of collections of models. Bruce Sinclair, in
Philadelphia's Philosopher-Mechanics (1974), shows how the Franklin In-
stitute from the beginning used exhibits to stimulate an interest in technical
processes among working people.

A Short History of the Science Museum (1959), compiled by Frank Green-
away, is unfortunately just that; however, the author makes clear that not-
withstanding its origins in the Great Exhibition of 1851, many other factors
influenced development after the South Kensington Museum was estab-
lished in 1857 in temporary quarters. In 1876 there was a major exhibit,
"Special Loan Collection of Scientific Apparatus," in South Kensington,
encompassing technology as well as science and including historical as well
as contemporary items. Afterward, any unclaimed objects were left for the
museum. Another major collection came from the Patent Office, including
a number of significant devices, whether patented or not. As the pressure

for a separate science museum mounted prior to World War I, educational goals were increasingly emphasized, though there is no detailed analysis of this important point. The museum opened in its own quarters in a series of steps beginning in the early 1920s. These are dealt with in some depth by David Follett in *The Rise of the Science Museum under Henry Lyons* (1978).

The story of the Deutsches Museum is chronicled in Friedrich Klemm's *Fünfzig Jahre Deutsches Museum, München* (1953), which is largely a photographic album of significant objects but which also contains a short history tracing Oskar von Miller's concept in 1903 through the opening of the separate museum building in 1925 to the damage incurred by the war and the subsequent rebuilding. Conrad Matschoss, in *Das Deutsches Museum* (1933), provides detailed information about the way in which the collections were exhibited during the early years. These works are complemented by the Deutsches Museum's *Chronik des Deutsches Museum von Meisterwerken der Naturwissenschaft und Technik* (1927), by von Miller's account *Technical Museums as Centers of Popular Education* (1929), and more recently by one chapter of Edward Alexander's *Museum Masters* (1983) and, in particular, Maria Osietzki's "Die Grundung des Deutschen Museums: Motive und Kontroversen" (1984). Because of its founder's interest in the technical education of workers, the museum emphasized demonstrations and working models and also housed an extensive technical library. Historical objects were important primarily for inspiration, though in practice they were placed in a context that can be considered historical.

The evolution of the Smithsonian's approach to a museum of science and technology followed the pattern established by London's Science Museum. Initially stimulated by participation in international exhibitions, the institution accumulated scientific and technological objects, which became numerous enough to generate pressure for a separate museum. This story is covered briefly in Robert Multhauf's "A Museum Case History" (1965) and in Frank Taylor's "The Background of the Smithsonian's Museum of Engineering and Industries" (1946). Taylor outlines the concept of parallel galleries, where detailed reference collections are presented in spaces adjacent to more general (and presumably more popular) exhibits. This concept was only partially realized when the museum eventually opened as the Museum of History and Technology. Taylor himself is the central figure in Marilyn Cohen's dissertation, "American Civilization in Three Dimensions" (1980). Cohen tries to place the museum in museological and historiographic perspective, but the result is somewhat flawed by anachronistic references and a lack of detailed knowledge of the museum. Still, there is much good substantive material on the early history of the museum. She reminds us that Taylor's initial concept included a strong emphasis on history, but the story of how the museum came to include cultural history is only lightly touched upon.

Published commentary on developments in other museums is harder to

find, though in some cases limited-circulation accounts are available. Warren Perry's *The Science Museum of Victoria* (1972) makes it clear that around the turn of the century, as now, the thing to do when starting a new museum was to go on a world tour to see at first hand what was happening at other museums. The overriding purpose of this new institution was to promote local industry. Similar sentiments were expressed about the soon-to-be-founded Chicago museum in Waldemar Kaempffert's "The Museum of Science and Industry Founded by Julius Rosenwald" (1929). Richard Hills, in "The Manchester Museum of Science and Technology" (1968), describes the beginnings of a museum located in a center of previous industrial and scientific activity. Making a virtue out of necessity, he suggests that because the founders began to collect after the Science Museum in South Kensington had already acquired the most significant national treasures, they could afford to demonstrate their less significant machines in actual operation. H. W. Dickinson's "Presidential Address: Museums and Their Relation to the History of Engineering and Technology" (1933–1934) provides some specific information on the origins of the British patent model collection.

André Léveillé, in "The Palais de la Découverte" (1948), describes the origins of a new type of museum with no (or very few) original objects, founded to stimulate public interest in science and a feeling for *la culture scientifique*. More recent discussions about a much larger center, expanded to include technology and industry, at Parc de la Villette have focused on a perceived need to deal with *la culture technologique*. Léveillé does not make it clear how this should be done, beyond relying on the excitement generated by an exposition of scientific topics themselves.

Samar K. Bagchi, in "Science and technology Museums in India" (1975), describes the early phases of what has been planned as a complex of museums designed to acquaint the public with some of the details of an engulfing scientific and technological world. The plan contemplates the use of historical objects in museums where the historical tradition is not strong. This unique experiment is now well under way, with major institutions in Calcutta, Bangalore, Bombay, and Delhi and subsidiary museums elsewhere. A unique feature of many of the Indian science museums is the outdoor "science park," explained by S. K. Ghose in "Science Museums Beyond Their Four Walls" (1986).

Some feeling for the development and public perception of science and technology museums can be gleaned from inventories compiled by people searching for inspiration in founding new museums or by organizations surveying their memberships. "Museums of Science and Technology" (1967), a special issue of *Museum* edited by W. D. O'Dea and L. A. West, not only is a useful listing but also includes statements by directors about how they perceive their own institutions. Views from the outside by museum professionals include Archibald Liversidge's *Report on Certain Museums for Tech-*

nology, Science, and Art (1880), Charles Richard's *The Industrial Museum* (1925) and Industrial Art and the Museum (1927), K. H. Wels's "Technik in Museen" (1936), Laurence Coleman's *Company Museums* (1943), Douglas Allan's "The Museum Presentation of Science" (1953), and Robert Multhauf's "European Science Museums" (1958). Lists, some of which contain details but not analysis, include "Museums of Science and Technology" (1963), compiled by Torsten Althin; *A Profile of Science-Technology Centers* (1975) by Eleanor Davis and Richard Barke; *Survey of Education Programs at Science Technology Centers* (1976) by Davis and Lee Kimche; "Hungarian Technical Museums and Collections" by Laszlo Kiss (1983); and *Exploring Science* (1980), published by the Association of Science-Technology Centers. Finally, one might consult Kenneth Hudson and Ann Nicholls's *The Directory of World Museums* (1975), especially through the subject index. These sources provide a body of information that helps to document some twentieth-century trends.

One of those trends has been the development of museums, or "centers," in which space is used not to display historical objects but to demonstrate the principles of science and technology. The movement has been accompanied by a promotional literature that is often messianic in quality. An unsigned article in *Mosaic*, "Museums to Teach By" (1979), proclaims that "the new breed of science museum . . . shakes off the image of science museums as dusty exhibit repositories and scholarly warehouses." Victor Danilov, director of the Chicago Museum of Science and Industry, in "Science for the Masses" (1973), "America's Contemporary Science Museums" (1976), and other articles, has described such centers as the wave of the future. He makes good arguments for the value of dynamic and interactive exhibits but tends to overstate the case when he claims that these museums are unique in the way they work with school systems or act as focal points for community activities. He even suggests that they can be distinguished from other museums in being "dedicated to the belief that museum-going can be enjoyable," a point of view that directors of many object-oriented museums would have difficulty accepting.

Frank Oppenheimer, former director of the Exploratorium, has emphasized the value of interactive exhibits in "A Rationale for a Science Museum" (1968) and "The Role of Science Museums" (1968). He argues that they project the excitement of science and in the process promote it in a period when there is a strong anti-science sentiment. One might then ask the question posed by Pam Gillies and Anthony Wilson in "Participatory Exhibits: Is Fun Educational?" The authors do not provide an adequate answer. Lee Kimche, in "Science Centers: A Potential for Learning" (1978), describes the field as fast-growing and worldwide, with attendance increasing by a factor of two and a half in the short period between 1973 and 1975. John Whitman, in "More Than Buttons, Buzzers and Bells" (1978), thinks the

strength of science centers lies in a process-oriented approach. The article draws mainly on interviews with several science center directors, often capturing both their modes of approach and their personalities.

A few publications treat specific techniques. In *A Stage for Science* (1979), the results of a conference on the use of theatre edited by Sheila Grinell, a survey indicated that use of drama (broadly defined to include everything from puppetry and laser shows to formal theatre) was quite widespread and generally effective though often expensive. An appendix gives a short list of current activities. Eve Van Rennes describes some of the exhibits at the Cranbrook Institute of Science in "Educational Techniques in a Science Museum" (1978); Evelyn Shaw does the same for the Exploratorium in "The Exploratorium" (1972); and F. G. Walton Smith discusses the effectiveness and high cost of employing active methods in an oceanographic museum in "Planet Ocean" (1982). These articles suggest that a large part of the value of interactive (or even just active) exhibits is the involvement of staff members, who are thereby forced to see the reactions of visitors on the floors of the museum.

The movement to build these centers in Third World countries surely has special significance. They are likely to be a major source of information about science and technology for both an older, uneducated population and younger people whose schools lack good demonstration equipment. A great sense of social responsibility is reflected in the literature. Niched Suntorn-pithug's "Children and the Science Museum, Bangkok" (1979) treats this theme, adding that the diversity of schools and their resources suggests the need for a central educational authority, which can be provided by the museum. Kenneth Jackman and R. S. Bhatal are concerned with both audiences in their article, "The Singapore Science Center" (1974). A cross-section of concerns can be found in the proceedings of the *Workshop on the Establishment of Science Museums in Asian Countries* (1980), in which a significant number of participants also express a desire to preserve elements of the past.

Historical, object-oriented museums justify their collecting activity on two related grounds: exhibition and historical evidence. The validity of collecting for exhibits seems clear, and success can be measured in a number of ways, including attendance. But it is not so obvious how a historian can gain from an object information that is not more easily available in other forms. Eugene Ferguson, in his article "Technical Museums and International Exhibitions" (1965), refers to the emotional response one gets from the size or craftsmanship associated with a machine, feelings that can properly be obtained only by direct observation. Similar arguments are made by Peter Molloy in "The Case for Operating Exhibits" (1982). Presumably many historians have had much the same experience, though this is difficult to document.

But objects may also be sources of information that is unavailable in other documentation. Furthermore, if, as Ferguson persuasively argues elsewhere

in "The Mind's Eye" (1977), much of technological innovation has occurred through nonverbal thought, then objects may provide unique clues to an inventor's thinking process. Only a modest number of studies have appeared in the literature. Robert Multhauf cites the need for research in "The Research Museum of the Physical Sciences" (1960), pointing out that a major problem is the lack of appropriate staff and resources. He holds out the hope that development of the academic discipline of history of science may provide the people needed. Carroll Lindsay echoes the same thoughts in "Museums and Research in History and Technology" (1962).

To date, however, the number of studies based on objects is small. Studies of microscopes indicate limits placed on early investigators. For this see Gerard Turner's *Micrographia Historica* (1972) and P. Van der Star's *Descriptive Catalog of the Simple Microscopes in the Rijksmuseum voor de Geschiendenis der Natuurwetenschappen at Leyden* (1953). Richard Hills, in "A One-Third Scale Working Model of the Newcomen Engine of 1712" (1971–1972), describes experiments that, among other things, demonstrate that this could not have been Newcomen's first attempt. Edwin Battison, in "Eli Whitney and the Milling Machine" (1966), makes a detailed examination of surviving muskets produced by Whitney to prove that their parts were definitely not made to be interchangeable and to show further that Whitney did not even have a proper milling machine. David Hounshell also pursues the question of interchangeability when he examines sewing machines from the Smithsonian's collections in an appendix to *From the American System to Mass Production* (1984). Machines from as late as 1873 prove to be visually uniform but unique in their manufacture, whereas a dozen years later, the parts cannot be distinguished.

Bernard Finn, in "Alexander Graham Bell's Experiments with the Variable-Resistance Transmitter" (1966–1967), finds by repeating Bell's experiments that gases given off at the electrodes interfere with reception; this helps to explain the frustration and confusion that Bell expressed in his notebooks. In his "Telegraph Practice in the 19th Century" (1975), Finn shows when it was the operator and when it was the machine that limited speeds of transmission. Still in the electrical area, Brian Bowers, in *A History of Electric Light & Power* (1982), describes measurements on a restored Cruickshank's battery that indicate that Faraday's recommended acid proportions were in fact optimum, since for stronger solutions the gas output becomes intolerable.

John Guilmartin, in articles cited in the bibliographic checklist of this chapter, reaches some surprising conclusions about foundry practice in the sixteenth and seventeenth centuries. John White discovers in *The John Bull* (1981) and in "To Operate or Not to Operate" (1982) that firing up an old locomotive can reveal an unsuspected responsiveness and workability that belie the assumption that this was an awkward and cumbersome machine. Recently Robert Gordon has employed his scientific training as a metallurgist

to help answer historical questions not only about how things were made but also about how they were used, as in his "Sixteenth-Century Metal Working Technology Used in the Manufacture of Two German Astrolabes" (1987) and "Material Evidence of the Manufacturing Methods Used in 'Armory Practice' " (1988).

Probably because they mimic classroom approaches to cognitive teaching, science and technology centers have been especially fruitful testing ground for the evaluation studies discussed in the chapters by Wilcomb Washburn and Ken Yellis in this book. Some object-oriented science museums, especially those with a strong educational mission, have also participated. Joyce Brooks and Philip Vernon conducted an early study in the Children's Gallery of the London Science Museum and reported the results in "A Study of Children's Interests and Comprehension at a Science Museum" (1956). They find that boys spend more time than girls in the gallery, and they record other demographic data that should be useful for future comparisons. The authors conclude, not surprisingly, that the museum could benefit from advice from psychologists.

While C. G. Screven was pursuing his pioneering studies at the Milwaukee Public Museum, Harris Shettel was arriving at similar conclusions in "An Evaluation of Existing Criteria for Judging the Quality of Science Exhibits" (1968). In particular, he finds a pressing need for clearly defined objectives on the part of staff members. At the Lawrence Hall of Science, Laurie Eason and Marcia Linn provide evidence for the value of formative evaluation in their "Evaluation of the Effectiveness of Participatory Exhibits" (1976). Minda Borun has directed a series of studies of the effectiveness of interactive techniques and of the value of labels at the Franklin Institute. Together with Maryanne Miller, in *What's in a Name?* (1980), Borun finds that once visitors are attracted to an exhibit, they will need labels and that they want to learn new information and not just review old facts.

Not only the methods but also the basic assumptions of museums of science and technology have recently come under scrutiny. Eugene Ferguson has expressed concern over the uncritical positivism of many of them, a legacy of nineteenth-century expositions but a viewpoint that was forcefully defended as late as 1951 by Lenox Lohr, director of the Museum of Science and Industry in Chicago. In "Views of Museum Directors" (1951) Lohr emphasized the function of his museum to display the marvels of science and industry and to "interpret the nature of industry." To accomplish this, Lohr sought industrial support and noted that in his museum, "private enterprise is invited to tell the stories of its achievements." Although he does not quote Lohr (he does refer to Ferguson), George Basalla takes issue with this approach in his provocative "Museums and Technological Utopianism" (1974). Basalla argues that too much of what appears in these museums is presented under the banner of technological progress, a practice that not only is bad history but also confuses notions of social and techno-

logical progress. Machines are displayed out of context in a sterile environment, as part of the cornucopia of goods blessing society, as aesthetic objects, or as curiosities. Basalla questions whether modern industrial processes should be shown at all in a museum and recommends that they might be better seen elsewhere in a more appropriate environment (as in a factory) or, if shown, that they be presented in historical and social context.

Howard Learner's *White Paper on Science Museums* (1979) takes a more detailed look at specific exhibits and museums, arriving at similar conclusions. He finds fault with the degree of corporate sponsorship of exhibits and also the degree to which corporate executives dominate boards of trustees. As a result, he says, too many exhibits are frankly promotional in tone and fail to present balanced views. He suggests that alternative funding be found for these museums and that there be broader-based input at all levels.

As part of the problem, Basalla noted that there was no tradition of critical exhibit reviews. Thomas Leavitt has already urged the editor of *Technology and Culture* to assume a leadership role by reviewing exhibits related to the history of science and technology. In "Toward a Standard of Excellence" (1968) he expressed the hope that both exhibit standards and the quality of collections might be raised. In succeeding years several reviews have been published, most of them by academic historians of science or technology and many as a direct result of Leavitt's plea. There is no common structure, but some themes have reappeared often enough to deserve special attention. One is the suggestion that there are considerable advantages in a small, specialized museum. This can be found in David Lewis's "Exhibit Reviews: Corning Museum of Glass" (1969), John White's "Baltimore and Ohio Transportation Museum" (1970), and David Jeremy's "The Textile Machinery Collection" (1977). In "The Smithsonian Institution's '1876' Exhibit" (1977), Lewis points out that design can be useful in creating the proper mood for an exhibit, but both he and Smith (in the "American Precision" review) warn of the dangers of overdesign, where aesthetic considerations can dominate the objects.

The complaint most often expressed, however, is the lack of interpretation, especially interpretation of the social context. It appears in H. J. Eisenman's "The National Museum of Transport" (1976), Larry Lankton's "Something Old, Something New" (1980), Oliver Greer's "Museum of British Road Transport" (1981), Donald Jackson's "Centennial Celebrations: Two Exhibits Commemorating the 100th Anniversary of the Brooklyn Bridge" (1984), Robert Friedel's " 'American Enterprise' at the Cooper-Hewitt: The Patent Models Again" (1985), and Lewis's review of the "1876" exhibit. Michal McMahon, in "The Romance of Technological Progress" (1981), echoes most strongly the points raised by Basalla and Learner when he criticizes the influence that the National Aeronautical and Space Administration and the air-space industry have had on the development of the Smithsonian's National Air and Space Museum. They appear again in "Exhibiting Nuclear

Power" (1984) by Les Levidow and Bob Young, which condemns the narrow
scope of an exhibit at the Science Museum, London, but in a loosely or-
ganized format and argumentative tone that dilute the article's impact.

An exhibit that deals specifically with social problems is criticized for
failures in its treatment of the history of technology in Stuart Leslie's "The
Urban Habitat" (1982). Treatments of social and cultural themes in tech-
nology exhibits are more favorably received in Alan Friedman's "The Clock-
work Universe" (1984), Charles Haines's "The Making of Victorian America:
Henry Ford Museum's 'Mass-Produced Elegance' " (1984), Robert Turner's
" 'The Great CPR Exposition' at the Glenbow-Alberta Institute" (1985),
Patrick Martin's " 'Where Two Worlds Meet: The Great Lakes Fur Trade,'-
Minnesota Historical Society" (1985), and Edward Pershey's " 'Life and
Times in Silk City', an Exhibit in Paterson, New Jersey" (1985).

In general these reviews have failed to provide the measures that Leavitt
envisioned. Merritt Roe Smith's "Toward a Standard of Excellence: The
Second Installment" (1974) suggests that standards may remain elusive be-
cause of the diverse backgrounds of the reviewers. Brooke Hindle, in "Com-
ment: Museum Reviews and the History of Technology" (1982), offers three
loose criteria for exhibit reviews: the degree to which objects are used, the
degree to which history of technology is represented, and the degree to
which the exhibit achieves its potential goal. Bernard Finn reformulates the
argument in "Museum Reviews: Twenty Years After" (1989) and places spe-
cial emphasis on relationships between exhibits and academic scholars. The
article includes references to the large number of reviews published in
Technology and Culture since 1986.

Although the tradition of writing about museums of science and technology
is not very old, the range is broad, and the subjects are often of fundamental
importance. This is no doubt due in large part to a perception that the
museums themselves are responding to significant problems, both in helping
us to understand science and to understand the role of science in society,
and that they have been willing to adjust their techniques accordingly.

BIBLIOGRAPHIC CHECKLIST

Alexander, Edward P. *Museums in Motion: An Introduction to the History and Functions of Museums.* Nashville, TN: American Association for State and Local History, 1979.
———. *Museum Masters: Their Museums and Their Influence.* Nashville, TN: American Association for State and Local History, 1983.
Allan, Douglas A. "The Museum Presentation of Science." *Advancement of Science* 10 (December 1953), 253–58.
Allen, Jon L. *Aviation and Space Museums of America.* New York: Arco Publishing Company, 1975.
Althin, Torsten. "Museums of Science and Technology: A List Compiled by the Committee on Museums of Science and Technology (chairman, Torsten Al-

thin) of the International Council of Museums (UNESCO)." *Technology and Culture* 4 (Winter 1963), 130–47.

Association of Science-Technology Centers. *Exploring Science: A Guide to Contemporary Science and Technology Museums.* Washington, DC: Association of Science-Technology Centers, 1980.

Auer, Hermann. "Problems of Science and Technology Museums: The Experience of the Deutsches Museum, Munich." *Museum* 21 (1968), 135–39.

———. "Museums of the Natural and Exact Sciences." *Museum* 26, (1974), 68–75.

Bacescu, Mihai. "L'Evolution des musées de sciences naturelles." *Cahiers d'histoire mondiale* 14 (1972), 74–102.

Bagchi, Samar K. "A New Gallery on Mining, Birla Industrial and Technological Museum, Calcutta." *Curator* 11 (March 1968), 76–85.

———. "Science and Technology Museums in India." *Technology and Culture* 16 (October 1975), 607–14.

Bagchi, Samar K., and Pradip K. Bhaumik. "New Gallery on Transport in the Birla Industrial and Technological Museum, Calcutta." *Museum* 28 (1976), 51–60.

Balan, S. "Rolul muzeelor in promovarea creației științifice și technice și in schimbul de valori culturale pe plan mondial." [The task of museums in the promotion of scientific and technical creativity and the exchange of cultural values on world scale (with English summary).] *Revista muzeelor și monumetelor Muzee* 15/4 (1978), 33–36.

Balassa, Ivan. "The Agricultural Museum, Budapest." *Museum* 22 (1969), 44–48.

Barbarits, Ludwig. "Gedanken zur künftigen Gestaltung der Sammlungs-und Ausstellungstätigkeit de Museen." [Thoughts on the future development of the collecting and exhibition activity of museums (with English summary).] *Neue Museumkunde* 13 (1970), 104–15.

Basalla, George. "Museums and Technological Utopianism." In *Technological Innovation and the Decorative Arts*, edited by Ian M. G. Quimby and Polly Anne Earl. Charlottesville: University Press of Virginia, 1974. Reprinted in *Curator* 17 (1974), 105–18.

Battison, Edwin A. "Eli Whitney and the Milling Machine." *Smithsonian Journal of History* 1 (Winter 1966), 9–34.

Beatty, Charles J. "Museums of Industry: Role of the Company Museum as Regards Its Presentation of Technology." Ph.D. dissertation, Ohio State University, 1967.

Bedini, Silvio A. "The Evolution of Science Museums." *Technology and Culture* 6 (Winter 1965), 1–29.

Berzi, Annalisa, Curzio Cipriani, and Marta Poggesi. "Muzeei scientifici fiorentini." [Science Museum, Florence.] *Musei e Galleria d'Italia* 23/65 (1978), 3–17.

Birch, Jeffrey. "A Museum for All Seasons." *Museum News* 60 (March-April 1982), 24–28.

Borun, Minda. *Measuring the Immeasurable: A Pilot Study of Museum Effectiveness.* Washington, DC: Association of Science Technology Centers, 1977.

Borun, Minda, Barbara K. Flexner, Alice F. Casey, and Lynn R. Baum. *Planets and Pulleys: Studies of Class Visits to Science Museums.* Philadelphia: Franklin Institute, 1983.

Borun, Minda, and Maryanne Miller. "To Label or Not to Label?" *Museum News* 58 (March-April 1980), 64–67.

———. *What's in a Name? A Study of the Effectiveness of Explanatory Labels in a Science Museum.* Philadelphia: Franklin Institute Science Museum and Planetarium, 1980.

Bose, Amalendu. "Objectives of a Science Museum." *Science and Culture* 44 (May 1978), 193–96.

Bowers, Brian. *A History of Electric Light and Power.* New York: Peter Peregrinus, 1982.

Brooks, Joyce A. M., and Philip E. Vernon. "A Study of Children's Interests and Comprehension at a Science Museum." *British Journal of Psychology* 47 (August 1956), 175–82.

Brown, F. C. "The Museum Can Help Business." *Nation's Business* 16 (May 1928), 50, 52, 85.

Brown, John J. "A Survey of Technology in Canadian Museums." *Technology and Culture* 6 (Winter 1965), 83–98.

Budeneau, C. "Ecotechnica şi muzeele technice." [Ecotechnology and technical museums (with French summary).] *Revista muzeelor si monumentelor-Muzee* 15/6 (1978), 40–46.

Cameron, Duncan F. "The Museum: A Temple or the Forum." *Curator* 14 (March 1971), 11–24.

Carnes, Alice. "Showplace, Playground or Forum? Choice Points for Science Museums." *Museum News* 64 (April 1986), 29–35.

Cohen, Marilyn Sara. "American Civilization in Three Dimensions: The Evolution of the Museum of History and Technology of the Smithsonian Institution." Ph.D. dissertation, George Washington University, 1980.

Coleman, Laurence Vail. *Company Museums.* Washington, DC: American Association of Museums, 1943.

Conservatoire National des Arts et Métiers. "Notice historique sur l'ancien prieuré de St. Martin-des-Champs et sur les collections du Musée Industriel du Conservatoire National des Arts et Métiers." In *Catalogue des collections du Conservatoire National des Arts et Métiers*, vol. 1. 8th ed. Paris: E. Bernard, 1905.

Corn, Joseph J. "Tools, Technologies, and Contexts: Interpreting the History of American Technics," In *History Museums in the United States: A Critical Assessment.* edited by Warren Leon and Roy Rosenzweig. Urbana and Chicago: University of Illinois Press, 1989.

Cossons, Neil. "The National Railway Museum, York." *Museums Journal* 76 (September 1976), 63–65.

Daber, Rudolf. "Zur Frühgeschichte der wissenschaftlichen Sammlungen im Museum für Naturkunde an der Humboldt Universität zu Berlin 1770–1810." [Early history of natural sciences collections in museum of natural history at Humboldt University (with English summary).] *Neue Museumkunde* 13 (1970), 245–56.

Danilov, Victor J. "Science for the Masses." *ICOM News* 26 (1973), 115–16.

———. "Science/Technology Museums Come of Age." *Curator* 16 (September 1973), 183–219.

———. "America's Contemporary Science Museums." *Museums Journal* 75 (March 1976), 145–48.

———. "European Science and Technology Museums." *Museum News* 54 (July-August 1976), 34–37, 71–72.

———. *Science and Technology Centers.* Cambridge: MIT Press, 1982.

———, ed. *Towards the Year 2000: International Perspectives on Museums of Science and Technology.* Washington, DC: Association of Science-Technology Centers, 1981.

Davis, Eleanor Kay, and Richard Barke, comps. *A Profile of Science-Technology Centers.* Washington, DC: Association of Science-Technology Centers, 1975.

Davis, Eleanor Kay, and Lee Kimche, eds. *Survey of Education Programs at Science-Technology Centers.* Washington, DC: Association of Science-Technology Centers, 1976.

DeBorhegyi, Stephan F. "Visual Communication in the Science Museum." *Curator* 6 (1963), 45–57.

Deutsches Museum. *Chronik des Deutsches Museum von Meisterwerken der Naturwissenschaft und Technik.* Munich: Deutsches Museum, 1927.

"The Dibner Award." *Technology and Culture* 29 (July 1988), 633–34.

Dickinson, H. W. "Presidential Address: Museums and Their Relation to the History of Engineering and Technology." *Newcomen Society Transactions* 14 (1933–1934), 1–12.

Dobrescu, I., M. Marcu, and D. Popescu. "Ideea de istorie technico-ştiinţifica—criteriu fundamental în organizarea muzeelor technice." [The idea of technical-scientific history—a fundamental criterion for the organization of technological museums.] *Revista muzeelor* 5 (1968), 563–66.

Dunbar, Nancy Gould, and Minda Borun. *The Science Museum Audience.* Washington, DC: Association of Science-Technology Centers, 1980.

Eason, Laurie P., and Marcia C. Linn. "Evaluation of the Effectiveness of Participatory Exhibits." *Curator* 19 (March 1976), 45–62.

Eisenman, H. J. "The National Museum of Transport." *Technology and Culture* 17 (January 1976), 93–103.

Exner, Wilhelm Franz. *Das technische Museum für Industrie und Gewerbe in Wien.* Vienna: Selbstverlag des Arbeitsausschusses de technischen Museums für Industrie und Gewerbe, 1908.

Ferguson, Eugene S. "Contributions to Bibliography in the History of Technology (Part VII): Technical Museums and Exhibitions." *Technology and Culture* 6 (Winter 1965), 99–107.

———. "Technical Museums and International Exhibitions." *Technology and Culture* 6 (Winter 1965), 30–46.

———. "Hall of Power Machinery, Museum of History and Technology, U.S. National Museum (Smithsonian Institution)." *Technology and Culture* 9 (January 1968), 75–85.

———. "The Mind's Eye: Nonverbal Thought in Technology." *Science*, August 26, 1977, 827–36.

Finn, Bernard S. "Museum Reviews: Twenty Years After." *Technology and Culture* 30 (October 1989).

———. "The New Technical Museums." *Museum News* 43 (November 1964), 22–26.

———. "The Science Museum Today." *Technology and Culture* 6 (Winter 1965), 74–82.

————. "Alexander Graham Bell's Experiments with the Variable Resistance Transmitter." *Smithsonian Journal of History* 1 (Winter 1966–1967), 1–16.

————. "Telegraph Practice in the 19th Century." In *Actes du XIIIe Congrès International d'Histoire des Sciences*, vol. 11. Moscow: Editions Naouka, 1975.

Follett, David. *The Rise of the Science Museum under Henry Lyons*. London: Science Museum, 1978.

Friedel, Robert. " 'American Enterprise' at the Cooper-Hewitt: The Patent Models Again." *Technology and Culture* 26 (January 1985), 69–73.

Friedman, Alan J. "The Clockwork Universe." *Technology and Culture* 25 (April 1984) 280–86.

Friedman, Alan J., Laurie P. Eason, and Cary I. Sneider. "Star Games: A Participatory Astronomy Exhibit." *Planetarian* 8 (December 1979), 3–7.

Fries, Russell. "Firearms and American Technology." In *The History and Sociology of Technology"*, edited by Donald Hoke. Milwaukee: Milwaukee Public Museum, 1982.

Fuller, Melville W., Jr. "The Development and Status of Science Centers and Museums for Children in the United States." Ph.D. dissertation, University of North Carolina, 1970.

Gebhard, Bruno. "Man in a Science Museum of the Future." *Museum* 2 (1949) 162–66.

Ghose, Saroj K. "Science Museums Beyond Their Four Walls." *Museum* (UNESCO) 150 (1986), 100–106.

Gillies, Pam, and Anthony Wilson. "Participatory Exhibits: Is Fun Educational?" *Museums Journal* 82 (December 1982), 131–34.

Gordon, Robert B. "Material Evidence of the Manufacturing Methods Used in 'Armory Practice.' " *Journal of the Society for Industrial Archaeology* 14 (1988), 23–35.

————. "Who Turned Mechanical Ideal into Mechanical Reality?" *Technology and Culture* 29 (1988), 744–78.

————. "Sixteenth-Century Metal Working Technology Used in the Manufacture of Two German Astrolabes." *Annals of Science* 44 (1987), 71–84.

————. "Material Evidence of the Development of Metal Working Technology at the Collins Axe Factory." *Journal of the Society for Industrial Archaeology* 9 (1983), 19–28.

————. "Archaeological Evidence for Metallurgical Innovation at the Eli Whitney Armory." *Journal of the Society for Industrial Archaeology* 8 (1982), 1–12.

————. "Materials for Manufacturing: The Response of the Connecticut Iron Industry to Limited Resources and Technology Change." *Technology and Culture* 24 (July 1983), 602–34.

————. "English Iron for American Arms: Laboratory Evidence on the Source of Iron Used at the Springfield Armory in 1860." *Journal of the Historical Metallurgical Society* 17 (1983), 91–98.

————. "Material Evidence of the Development of Metal Working Technology at the Collins Axe Factory." *Journal of the Society for Industrial Archaeology* 9 (1983), 19–28.

Green, Jeremy N. "The Armament from the 'Batavia?' " *International Journal of Nautical Archaeology and Underwater Exploration* 9 (February 1980), 43–51.

Greenaway, Frank. *A Short History of the Science Museum*. London: Her Majesty's Stationery Office, 1959.

———. *Science Museums in Developing Countries*. Paris: International Council of Museums, 1962.

Greer, Oliver. "Museum of British Road Transport: A Review." *Museums Journal* 81 (December 1981), 156–58.

Grigorescu, I., and others. "Pentru un muzeu technio științific national." [A national museum of technology and science.] *Revista muzeelor și monumentelor* 12/2 (1975), 23–32.

Grinell, Sheila, ed. *A Stage for Science: Dramatic Techniques at Science-Technology Centers*. Washington, DC: Association of Science-Technology Centers, 1979.

Guilmartin, John Francis, Jr. *Gunpowder and Galleys: Changing Technology and Mediterranean Warfare at Sea in the Sixteenth Century*. London: Cambridge University Press, 1974.

———. "The Cannon of the 'Batavia' and the 'Sacramento': Early Modern Cannon Founding Reconsidered." *International Journal of Nautical Archaeology and Under Exploration* 11 (May 1982), 133–44.

———. "The Guns of the 'Santíssimo Sacramento.'" *Technology and Culture* 24 (October 1983), 559–601.

Guthe, Carl E. "The Science Museum—A Definition." *Museum News* 38 (March 1960), 21–23.

Gwynne, Charles T. *Museums of the New Age*. New York: Association for the Establishment and Maintenance in the City of New York of Museums of the Peaceful Arts, 1927.

Habacher, M. "Das Technische Museum für Industrie und Gewerbe in Wien." *Blatter für Technikgeschichte* 30 (1968), 1–71.

Haines, Charles. "The Making of Victorian America: Henry Ford Museum's 'Mass-Produced Elegance.'" *Technology and Culture* 25 (October 1984), 832–39.

Hercko, Ivan. "Niekoľko poznamok ku vzniku najstarších baníckych zbierok a banských múzeí na Slovenska." [Comments on origins of the oldest mining collections and museums in Slovakia (with English summary).] *Museum* 17 (1972), 245–48.

Hills, Richard. "The Manchester Museum of Science and Technology: An Experiment in Education," *Museums Journal* 68 (1968), 16–18.

———. "A One-Third Scale Working Model of the Newcomen Engine of 1712." *Newcomen Society Transactions* 44 (1971–1972), 63–77.

Hindle, Brooke. *Technology in Early America: Needs and Opportunities for Study*. Chapel Hill: University of North Carolina Press, 1966.

———. "Comment. Museum Reviews and the History of Technology." In *The History and Sociology of Technology*, edited by Donald Hoke. Milwaukee: Milwaukee Public Museum, 1982.

———. "Museum Treatment of Industrialization: History, Problems, Opportunities." *Curator* 15 (September 1972), 206–19.

Hippen, James C. "Industrial Textile Machinery: Five North American Museums." *Technology and Culture* 10 (October 1969), 570–86.

Hobusch, Erich. "Zur Geschichte der naturwissenschaftlichen Museen im Norden der DDR." [On the history of science museums in the German Democratic Republic.] *Neue Museumskunde* 9 (1966), 167–86.

Hounshell, David A. *From the American System to Mass Production, 1800–1932: The Development of Manufacturing Technology in the United States.* Baltimore: Johns Hopkins University Press, 1984.

Hudson, Kenneth, and Ann Nichols. *The Directory of World Museums.* New York: Columbia University Press, 1975.

Hummelbrunner, Franz. "Das Webereimuseum Haslach, Oberösterreich, eine Museumsneugründung besonderer Art." [Museum of weaving at Haslach, upper Austria; a new museum of a specific kind.] *Mitteilungsblatt der Museen Oesterreichs (Wien)* 19 (1970), 96–103.

"Imperial Conservatory of Arts and Trades, at Paris." *American Journal of Education* 21 (1870), 439–49.

Impey, Oliver, and Arthur MacGregor, eds. *The Origins of Museums: The Cabinet of Couriosities in Sixteenth- and Seventeenth Century Europe.* Oxford: Clarendon Press, 1985.

Jackman, Kenneth V., and R. S. Bhatal. "The Singapore Science Center." *Museum* 26 (1974), 110–16.

Jackson, Donald D. "Centennial Celebrations: Two Exhibits Commemorating the 100th Anniversary of the Brooklyn Bridge." *Technology and Culture* 25 (April 1984), 287–91.

Jeremy, David J. "The Textile Machinery Collection, Science Museum (London)." *Technology and Culture* 18 (January 1977), 70–89.

Jewell, Andrew, and John Creasey. "The Present Situation of Agricultural Museums or Museum Sections: Results of an International Inquiry." *Museum* 24 (1972), 150–62.

Jurkovič, Miloš. "Z dejin prirodovedneho muzejniclva na Slovensku. [The history of natural science museology in Slovakia.] *Múzeum* 17 (1972), 20–31, 86–97.

Kaempffert, Waldemar. "The Museum of Science and Technology Founded by Julius Rosenwald: An Institution to Reveal the Technical Ascent of Man." *Scientific Monthly* 28 (June 1929), 481–98.

Kimche, Lee. *Discover and Learn at Science and Technology Centers.* Washington, DC: Association of Science-Technology Centers, 1976.

———. "Science Centers: A Potential for Learning." *Science,* January 20, 1978, 270–73.

Kiss, Laszlo. "Technical Museums and Collections." *Museum* 35 (1983), 236–40.

Klemm, Friedrich. *Fünfzig Jahre Deutsches Museum, München.* Munich: Deutsches Museum, 1953.

———. "Les Musée des techniques: aperçu historique." [Technical museums: a historical view.] *Cahiers d'histoire mondiale* 14 (1972), 61–73.

———. "Geschichte der naturwissenschaftlichen und technischen Museen." [History of science and technology museums.] *Deutsches Museum—Abhandlungen und Berichte* 41/2 (1973), 3–59.

Kólodziejowa, Boleslawa. "Miejskie Museum Przemyslowe im. dra Adriana Baranieckiego w Krakowie." [Municipal industrial museum of Dr. Adrian Baranieckiego in Krakow.]' *Rozpravy i Sprawozdania Muzeum Narodowego w Krakowie* 11 (1976), 186–230.

Kondratow, A. "Die Widerspiegelung des wissenschaftlichen Fortschritts in des naturwissenschaftlichen Museen der UdSSR." [The reflection of scientific

progress in science museums in the Soviet Union.] *Neue Museumskunde* 11/4 (1968), 392–97.

Kuba, Josef. "Současné úkoly muzeí vědy a techniky." [Present-day tasks of science and technology museums.] *Sborník Národniho technického múzea* 5 (1968), 5–13.

Kurzel-Runtscheiner, E. "Von der Ambraser Sammlung bis zum Technischen Museum fur Industrie und Gewerbe in Wien." [From the Ambras collection to the Technical Museum for Industry and Trades in Vienna.] *Technikgeschichte* 22 (1933), 142–45.

Laetsch, Watson M., Judy Diamond, Jeffrey L. Gottfried, and Sherman Rosenfeld. "Children and Family Groups in Science Centers." *Science and Children* 17 (March 1980), 14–17.

La Follette, Marcel C. "Science and Technology Museums as Policy Tools—An Overview of the Issues." *Science, Technology, & Human Values* 8 (Winter 1983), 41–46.

Lankton, Larry. "Something Old, Something New: The Reexhibition of the Henry Ford Museum's Hall of Technology." *Technology and Culture* 21 (October 1980), 594–613.

Learner, Howard. *White Paper on Science Museums*. Washington, DC: Center for Science in the Public Interest, 1979.

Leavitt, Thomas W. "Toward a Standard for Excellence: The Nature and Purpose of Exhibit Reviews." *Technology and Culture* 9 (January 1968), 70–75.

Leslie, Stuart W. "The Urban Habitat: The City and Beyond." In *The History and Sociology of Technology*, edited by Donald Hoke. Milwaukee: Milwaukee Public Museum, 1982.

Leuschner, Fritz. "Technische Revolution und Bildung. Über die Notwendigkeit polytechnischer Museen in der DDR." [Technical revolution and erudition. Polytechnic museums are needed in the DDR.] *Schule und Museum im einheitlichen socialistischen Bildungssystem der DDR, Arbeitsgruppe Museumspädagogik* 5 (1970), 49–53.

———. "100 Jahre Polytechnisches Museum Moskau." *Neue Museumskunde* 15 (1972), 180–85.

———. "Das Nationale Technische Museum Prag." [With English summary.] *Neue Museumskunde* 19 (1976), 265–70.

Léveillé, André. "The Palais de la Découverte." *Museum* 1 (July 1948), 80, 116–17.

Levidow, Les and Bob Young. "Exhibiting Nuclear Power: Science Museum Cover-Up." *Radical Science Journal*, 14 (1984), 52–79.

Levy, Shabtay, comp. *Directory of Exhibits at Science-Technology Centers*. Washington, DC: Association of Science-Technology Centers, 1977.

Lewis, W. David. "Corning Museum of Glass." *Technology and Culture* 10 (January 1969), 68–83.

———. "Parrying Perrot." *Technology and Culture* 10 (April 1969), 178–81.

———. "The Smithsonian Institution's '1876' Exhibit." *Technology and Culture* 18 (October 1977), 670–84.

Lindsay, G. Carroll. "Museum and Research in History and Technology." *Curator* 5 (1962), 236–44.

Liversidge, Archibald. *Report upon Certain Museums for Technology, Science, and Art, also upon Scientific, Professional, and Technical Instruction, and Systems*

of Evening Classes in Great Britain and on the Continent of Europe. Sydney: T. Richards, 1880.

Lohr, Lenox, Riley. "Views of Museum Directors." *Museum* 4 (1951), 231–33.

Lugowski, Czeslaw. "Nowa rola muzeów techniki." [The new role of technology museums (with French summary).] *Biuletyn Informacjny Zarzadu Muzeów i Ochronyzabytkow* 85 (1969), 130–39.

———. "15 lat Muzeum Techniki NOT." [15 years of the museum of technology NOT.] *Muzealniclwo* 21 (1973), 36–49.

Martin, Patrick. " 'Where Two Worlds Meet: The Great Lakes Fur Trade,' Minnesota Historical Society, St. Paul, Minnesota." *Technology and Culture* 26 (July 1985), 620–22.

Matschoss, Conrad, ed. *Das Deutsches Museum. Geschichte, Aufgaben, Ziele.* 3d ed. Berlin: VDI-verlag, 1933.

McMahon, Michal. "The Romance of Technological Progress: A Critical Review of the National Air and Space Museum." *Technology and Culture* 22 (April 1981), 281–96.

Mikhaylouskaya, A. I. "Iz istorii promishlennikh muzeev i vistavok kapitalisticheskoi Rossii." [The history of technical museums in capitalist Russia.] *Ocherki istorii muzeinogo dela v SSSR* 6 (1968), 312–79.

Molloy, Peter M. "The Case for Operating Exhibits." In *The History and Sociology of Technology*, edited by Donald Hoke. Milwaukee: Milwaukee Public Museum, 1982.

Morton, Alan. "Tomorrow's Yesterdays: Science Museums and the Future." In *The Museum Time-Machine: Putting Cultures on Display.* edited by Robert Lumley. London and New York: Routledge, 1988.

Multhauf, Robert. "European Science Museums." *Science* September 5, 1958, 512–19.

———. "The Function of the Technical Museum in Engineering Education." *Journal of Engineering Education* 49 (December 1958), 199–203.

———. "The Research Museum of the Physical Sciences." *Curator* 3 (1960), 355–60.

———. "A Museum Case History: The Department of Science and Technology of the United States Museum of History and Technology." *Technology and Culture* 6 (Winter 1965), 47–58.

Musgrave, Anna Phair. "Characteristics of Southeastern Museums That Feature Science Collections." Ph.D. dissertation, University of Southern Mississippi, 1977.

"Museums to Teach By." *Mosaic* 10 (July-August 1979), 17–25.

O'Dea, W. T., and L. A. West, eds. "Museums of Science and Technology." *Museum* 20 (1967), 150–228.

Omand, Douglas N. "The Ontario Science Center, Toronto." *Museum* 26 (1974), 76–85.

Oppenheimer, Frank. "A Rationale for a Science Museum." *Curator* 11 (September 1968), 206–9.

———. "The Role of Science Museums." In *Museums and Education*, edited by Eric Larrabee, Washington, DC: Smithsonian Institution Press, 1968.

Osietzki, Maria. "Die Grundung des Deutschen Museums: Motive and Kontroversen." *Kultur und Technik* 8 (April 1984), 1–8.

Paweski, Franciszek. *Polskie muzealnictwo przyrodnicze.* [Polish museology of natural science (with English summary).] Poznan: Biblioteka Museum Rolnictwa w Szreniawie, 1970.

Penn, Theodore Z. "The Slater Mill Historic Site and the Wilkinson Mill Machine Shop Exhibit." *Technology and Culture* 21 (January 1980), 56–66.

Perrot, Paul N. "Throwing Stones at Glass Museums." *Technology and Culture* 10 (April 1969), 174–77.

Perry, Warren. *The Science Museum of Victoria: A History of Its First Hundred Years.* Melbourne: Science Museum of Victoria, 1972.

Pershey, Edward Jay. " 'Life and Times in Silk City,' an Exhibit in Paterson, New Jersey, at the American Labor Museum, the Paterson Museum, and the Lambert Castle Museum." *Technology and Culture* 26 (July 1985), 623–28.

Petrik, Ottó. "Models in Museums of Science and Technology." *Museum* 23 (1970–1971), 236–73.

———. "Point of View: The Boston Museum of Science." *Science*, October 9, 1970, 145.

Pizzey, Stephen, comp. *Interactive Science and Technology Centres.* London: Science Projects Publishing, 1987.

Rehbein, Elfriede. "Charakteristische Merkmale und Aufgaben der teknischen Museen." [Characteristic features and tasks of technical museums (with English summary).] *Neue Museumskunde* 12 (1969), 309–16.

Richards, Charles Russell. *The Industrial Museum.* New York: Macmillan, 1925.

———. *Industrial Art and the Museum.* New York: Macmillan, 1927.

Richman, Irwin. "Hopewell Village National Historic Site." *Technology and Culture* 9 (April 1968), 213–17.

Sarton, George. *A Guide to the History of Science: A First Guide for the Study of the History of Science with Introductory Essays on Science and Tradition.* New York: Ronald Press, 1952.

Shaw, Evelyn. "The Exploratorium." *Curator* 15 (March 1972), 39–52.

Shettel, Harris H. "An Evaluation of Existing Criteria for Judging the Quality of Science Exhibits." *Curator* 11 (June 1968), 137–53.

Sinclair, Bruce. *Philadelphia's Philosopher-Mechanics: A History of the Franklin Institute, 1824–1865.* Baltimore: Johns Hopkins University Press, 1974.

Smith, F. G. Walton. "Plant Ocean: Applying Disneyland Techniques at a Science Museum." *Curator* 25 (June 1982), 121–30.

Smith, Merritt Roe. "Toward a Standard of Excellence: The Second Installment." *Technology and Culture* 15 (January 1974), 76–79.

———. "The American Precision Museum." *Technology and Culture* 15 (July 1974), 413–37.

Suntornpithug, Niched. "Children and the Science Museum, Bangkok." *Museum* 31 (1979), 189–92.

Taylor, Frank A. "The Background of the Smithsonian's Museum of Engineering and Industries." *Science*, August 9, 1946, 130–32.

———. "A National Museum of Science, Engineering and Industry." *Scientific Monthly* 63 (November 1946), 359–65.

———. "Technik in Museen." *Technikgeschichte* 22 (1933), 142–56.

Thier, Herbert D. and Marcia C. Linn. "The Value of Interactive Learning Experiences." *Curator* 19 (September 1976), 233–45.

Tratz, Eduard Paul. "Zur Frage de Anwendung von Dioramen in naturwissenschaftlichen Museen." [Some problems in the use of the dioramas in science museums.] *Museumskunde* 37 (1968), 5–12.

Tresse, R. "Le Conservatoire des Arts et Métiers et la Société d'Encouragement pour l'Industrie nationale au début de XIXe siècle." *Revue d'histoire des sciences et leurs applications* 5 (July-September 1952), 246–64.

Tressel, George W. "The Role of Museums in Science Education." *Science Education* 64 (April 1980), 257–60.

Turner, Gerard. "An Electron Microscopical Examination of Nobert's Ten-Band Test-Plate." *Journal of the Royal Microscopical Society* 84 (April 1965), 65–75.

———. "An Electron Microscopical Examination of Nobert's Finest Test-Plate of Twenty Bands." *Journal of the Royal Microscopical Society* 85 (August 1966), 435–47.

———. *Micrographia Historica: A Study of the History of the Microscope*. Oxford: Royal Microscopical History, 1972.

Turner, Robert D. " 'The Great CPR Exposition' at the Glenbow- Alberta Institute, Calgary Alberta." *Technology and Culture* 26 (April 1985), 257–61.

Ucko, David A. "Science Literacy and Science Museum Exhibits." *Curator* 28 (December 1985), 287–300.

Ursescu, E. "Rolul Muzeulni politechnic din Lasi in educarea tinerei generatii." [The role of polytechnic museums at Laşi in educating the young generation.] *Revista muzeelor şi monumentelor* 13 (1976), 26–28.

Van der Star, P. *Descriptive Catalog of the Simple Microscopes in the Rijksmuseum voor de Geschiedenis der Natuurwetenschappen at Leyden*. Leyden: Rijksmuseum voor de Geschiedenis der Natuurwetenschappen, 1953.

Van Rennes, Eve C. "Educational Techniques in a Science Museum." *Curator* 21 (1978), 289–302.

Van Riemsdijk, J. T. "Changing Styles in 'Best Practice Museology' " *Technology and Culture* 19 (July 1978), 606–7.

Van't Hoff, J. H. "Das Teyler-Museum in Haarlem und die Bedeutung fur Naturwissenschaft und Technik." *Deutsches Museum, Vorträge und Berichte* 9 (1905).

Vogel, Robert M. "Assembling a New Hall of Civil Engineering." *Technology and Culture* 6 (Winter 1965), 59–73.

Von Miller, Oskar. *Technical Museums as Centers of Popular Education*. Munich: Deutsches Museum, 1929.

Wall, Alexander J. "The Voice of the Artifact." *Museologist* 125 (1972), 7–14.

Wels, K. H. "Technik in Museeun: Handwerk und Industrie in den kurzmarkischen Heimatmuseen." *Technikgeschichte* 25 (1936), 157–64.

White, Dana F. "The Apocalyptic Vision of Paolo Soleri." *Technology and Culture* 12 (January 1971), 75–88.

White, John H., Jr. "(Baltimore and Ohio Transportation Museum)." *Technology and Culture* 11 (January 1970), 70–84.

———. "The Railway Museum: Past, Present, and Future." *Technology and Culture* 14 (October 1973), 599–613.

———. *The John Bull, 150 Years a Locomotive*. Washington, DC: Smithsonian Institution Press, 1981.

————. "To Operate or Not to Operate: The John Bull." In *The History and Sociology Technology*, edited by Donald Hoke. Milwaukee: Milwaukee Public Museum, 1982.

Whitman, John. "More Than Buttons, Buzzers and Bells." *Museum News* 57 (September-October 1978), 43–50.

Workshop on the Establishment of Science Museums in Asian Countries, Training and Exchange. Bangalore: Visvesvaraya Industrial and Technological Museum, 1980.

Zucker, Barbara Fleisher. *Children's Museums, Zoos, and Discovery Rooms: An International Reference Guide*. Westport, CT: Greenwood Press, 1987.

Scott W. Swank. The History
Museum. (Westport, CT:
Greenwood Press, 1990)

4

THE HISTORY
MUSEUM

Scott T. Swank

"You have to begin to lose your memory, if only in bits and pieces, to realize
that memory is what makes our lives. Life without memory is no life at all."
So mused the late surrealist filmmaker Luis Buñuel in his witty autobiog-
raphy, *My Last Sigh* (1983). At age eighty-two, Buñuel struggled to recon-
struct a colorful and controversial life that, in his mind, seemed to have
lasted but an instant. But respect for memory, and recognition of its fragility,
did not lead him to an equal respect for museums. Buñuel saw the "menace"
to memory everywhere, "not only from its traditional enemy, forgetfulness,
but from false memories," which he believed could be conjured up personally
and collectively.

History museums are especially vulnerable to this ideological manipulation
due to their dependency on group acceptance. In contrast to academic his-
tory, or the analysis of change over time by professionally trained historians,
history museums are vital to the process of generating and maintaining
collective memory. Collective memory is the summation of remembrances
most useful to particular social groups, including families, ethnic groups,
social classes, and even nations. Such groups support collective memory
because it helps them to retain their identities and to function more suc-
cessfully in the larger society. National collective memory therefore, is a
sifted past codified in public school education, political ideology, and national
symbols. Although a full discussion of the relationship of academic and mu-
seum history is beyond the scope of this chapter, by focusing on selected
developments in academic history and history museums and by probing

their relationship to one another in memory maintenance, it explores some of the uses of the past in American culture.

HISTORIC OUTLINE

The chief impetus to the founding of history museums in federal America appears to have been the conjunction of political and cultural nationalism. In the decades immediately following the American Revolution, a powerful ambivalence prevailed among political and social elites concerning the role of history in the life of the new Republic. Cultural geographer David Lowenthal notes that part of the Enlightenment's contribution to America's intellectual awareness was a worship of "newness," and this reverence for novelty implied a concomitant distrust of the past. Enlightenment thinking favored a cyclical view of history, with nations proceeding through a natural growth cycle from youth to old age. This interpretation posited America as a youthful nation looking to the present and future rather than to the past. A more extreme view declared America to be outside history, a bold, new human experiment with no allegiance to the European past.

But such thinking soon ran into problems. Rhetorically leaders of the new nation were initially future oriented, but they realized that nation building required selective reliance upon constitutional tradition and the achievements of the recent past. As the Revolutionary generation died, the memory of these personal embodiments of the successful Revolution had to be institutionalized. Recent history had to be promoted self consciously. Landmarks commemorating the great political events, especially those associated with the life and times of George Washington, were selected for preservation. The effort to preserve Washington's headquarters in Newburgh, New York (the Hasbrouck House), as a shrine occurred as early as 1848. But the past was more often invoked in popular biography and historical narrative than in efforts to preserve historic sites or establish history museums. Whether in the popular storytelling of Mason Locke (Parson) Weems or in the sophisticated narratives of Francis Parkman, history became a useful and valued commodity for the dominant political and social groups in American culture in recording their past as the official collective memory.

The earliest historical institutions in America were founded in the twilight years of the Revolutionary era, partly in response to fears that the achievements of the founding fathers might be forgotten. These were the historical societies of Massachusetts (1791), New York (1804), and Pennsylvania (1824). All three collected objects, although the societies functioned more as libraries than museums, a tendency that increased throughout the century. In the inevitable competition for space, library collections were usually victorious, leaving museum displays and collections in a state of neglect and stagnation.

In many historical institutions, the trend was not reversed until late in the twentieth century, often at considerable expense.

Although institutional growth and change were often painfully slow in the nineteenth century, events outside the history museum were dramatically transforming American attitudes about the past. Perhaps the most important event was the Civil War. James B. Jackson, a perceptive observer of the American landscape, has argued that Gettysburg Battlefield Park not only marks the military turning point of the Civil War but also the triumph of the vernacular reinterpretation of the past. The battlefield park is not a traditional monument to an elite or a monument to remind people of future social obligations; rather, to Jackson, it is a collective monument to the common soldier, or in this chapter's terms, an assertion of the common soldier's place in national collective memory. Although efforts to preserve such battlefields by the National Park Service and attempts to fill temples of the collective memory such as the Museum of the Confederacy were not realized until the twentieth century, the Civil War nevertheless marks an important turning point in historical consciousness.

Another benchmark in the reshaping of the collective understanding of the past was the Philadelphia Centennial Exhibition of 1876 with its dual themes of patriotism and progress. Although the vitality of this celebration of American and technological progress stood in sharp contrast to the torpidity of nineteenth-century historical societies, the centennial ironically marked a new beginning for the history museum movement. The theme of the centennial was future-oriented, but exhibits like the New England log kitchen and collateral events, including "eighteenth-century-style" balls and teas held outside the city, heightened historical consciousness and provided an opportunity for many Americans to look to the past for inspiration.

The centennial also provided an unanticipated opportunity for the federal government to enter the museum field. The Smithsonian Institution assigned to George Brown Goode, a youthful but farsighted assistant curator, the task of selecting material from the exposition for inclusion in the national collections. The centennial proved to be a windfall for the government, and the objects eventually filled the entire new Arts and Industries Building, which opened to the public in 1881. Although Goode was not a historian by training, his vision of a great national museum was refined by succeeding generations of Smithsonian officials and curators, culminating in the establishment of the Museum of History and Technology in 1960.

Although the centennial focused popular attention on the past, the professional study of American history was moving in a different direction. Graduate school instruction in history and the formation of the American Historical Association in 1884 marked the emergence of history (including American history) as a distinct discipline and profession. Increasingly, American historical studies within the university passed from the hands of ama-

teurs into the hands of professionals. Although some academic historians saw the utility of the past for promoting progressive social and political values, most academic historians generally distanced themselves from the ideals, methods, and evidence of historical society and museum workers.

The craft of history was thus divided roughly between those interested in the memorialization of the past through the preservation of documents, objects, buildings, and sites and those interested in the "scientific" study of the past, largely through teaching and writing. Historians working in universities and research libraries were able to lay claim to the status of professionals while successfully labeling others interested in history as antiquarians, including those working in historical libraries, societies, and museums, as well as the public school system. The reorientation of historical studies was also reflected in a rough division of subject matter. University-based historians, for the most part, chose to study topics of "national" significance, while collective memory below the national level was left to antiquarians and to a few maverick professionals interested in state and local history.

The division within the community of historians was so deep that individuals and institutions were forced to make difficult decisions by the turn of the century. The American Antiquarian Society, founded in 1812, decided to abandon its museum collections in 1909 after seriously considering whether it could turn its "cemetery of bric-a-brac" into a "nursery of living thoughts." Within the university, professional historians refused to acknowledge that the study of domestic artifacts and social history was worthy of scholarly attention. Princeton historian Thomas J. Wertenbaker stood virtually alone during the 1930s and 1940s in espousing what detractors called "pots and pans history." The lingering impact of these negative connotations has often obscured the antiquarians' significant contributions to the collection, preservation, and interpretation of materials essential to the understanding of the American past.

The motivations of antiquarians have been more complex than academic historians have generally recognized. The antiquarians began their work in the mid-nineteenth century by saving landmark domestic buildings, generally those associated with the Revolutionary generation and often specifically related to the life of Washington. By preserving local and national shrines, the antiquarians were trying to reach a wider audience of like-minded Americans at the same time that they were validating their role in American society. Since the preservation of buildings of national historical significance was deemed praiseworthy, the promoters of such projects were able to create a favorable collective memory for their families and class.

The early development of the historic house movement reflected both the geographic strengths and aesthetic preferences of the antiquarians. Although only a handful of historic house museums were founded prior to 1900, eight house museums were established every year from 1900 to 1925. In 1926 the movement accelerated, with fourteen new openings, followed by even

greater increases in subsequent years, climaxing in the opening of Colonial Williamsburg in 1932. By 1933, eleven states had ten or more historic house museums, including all of New England except Vermont and the entire mid-Atlantic region except for Maryland and Delaware. The vast majority of the houses opened to the public were of the colonial and federal eras, suggesting an overwhelming public preference for the reassuring order and rationality of colonial art, architecture, and landscape design, in contrast to the exuberance of Victorian design and the overstuffing pattern of Victorian consumption.

This antiquarian aesthetic preference, today recognized as part of a larger, complex intellectual and social movement called the colonial revival, helped to establish an officially approved standard of good taste that became an integral part of the general pattern of upper-class American consumption. The buying and selling of art and antiques (historical memory fragments) thus became an important activity for American social elites. Although objects and buildings were collected and preserved for many personal and social reasons, some never articulated by the antiquarians, the collections themselves often contain clues concerning the motivations of the collectors. For example, the antiquarians Irving Lyon and George F. Dow tended to limit their collecting to the houses, tools, and ornaments of domestic life and the accoutrements of personal adornment of their own social class in its pre-industrial era. Buildings and objects, as collected and preserved, served as signifiers of rank and became vital agents of communication in the social ritual of a particular group maintaining its collective memory.

The influence of the colonial revival is also evident in the rise of the period room installations in American art and history museums in the early twentieth century, a distinct episode in American museum history. Though influenced by developments in European ethnographic museums (especially the folklife displays in Sweden's Skansen) and habitat groups in the natural history museums, the impetus for the American period room can be traced to the homes of the early collectors of Americana. George Francis Dow is usually credited with installing the most influential period rooms in the reorganized displays of the Essex Institute in 1907, though Charles Wilcomb was simultaneously experimenting with period rooms in what are now the De Young and Oakland museums in California. The idea quickly spread to countless state and local historical societies over the next several decades. The opening of the Metropolitan Museum of Art's American Wing in 1924, however, ushered in a new period of immense popularity for the period room in American museums.

Though most often located in art museums, the period room had many of the characteristics of a history museum convention. Even the creators of the American Wing at the Metropolitan were fully aware that they were teaching the public a lesson in American history. The planners of the exhibit intuitively recognized that in order to elevate American arts and crafts,

symptomatically termed the "minor arts," to an aesthetic level befitting a world-class museum, the artifacts must be displayed in a context that would evoke a sympathetic response. By placing the artifacts in colonial and federal settings, the public could be told the complementary stories of the rise of the new Republic and the growth of a distinctive American taste. The contrast between "American" and "European" taste was considered an especially important lesson during the 1920s, when foreign ideas appeared to be eroding American principles and traditions.

The period room flashed brilliantly for almost a decade in the art museum, a setting that ultimately could not support the exhibit technique intellectually or financially. From the beginning, cultural history had coexisted tenuously with art history. As professional historians in the progressive era began to debunk the founding fathers, art was initially seen as a more useful tool than history to convey social status. Though period installation did help to validate American art and architecture among certain air historians, the alliance of art history and cultural history was always uneasy. Gradually the period room fell into disfavor as many art museum professionals began to regard this exhibit technique as overly didactic, too expensive, and inflexible. After World War II, most large art museums were no longer installing new period rooms, though there was little or no effort to remove existing rooms, which continue to be popular among visitors.

The period room survived, and in many instances flourished, outside the art museum. As the emphasis in history museum practice steadily shifted from commemoration to interpretation, historic houses, sites, and history museums of all kinds continued to install period rooms long after the technique was abandoned by the art museum. The National Park Service gave official sanction to this exhibit convention after 1932 when it approved the installation of the Assembly Room at Independence Hall. The enormous public appeal of historic period interiors at such museum complexes as Colonial Williamsburg, Old Sturbridge Village, and Winterthur made the period room a permanent element of the exhibit vocabulary of history museums. Finally, the bicentennial celebration gave rise to a wave of reinstallations of earlier period rooms, which temporarily reversed the trend toward neglect even among many major art museums.

By the early twentieth century, the antiquarian view of America's past, already under siege, was in full retreat. The proliferation of museums, their rapid growth in popularity, and the need for full-time workers was dramatically changing the nature of museum work. The entry of large numbers of academically trained historians into the museum and preservation fields during the Great Depression (often supported through government-funded projects) accelerated the pace of change. A new generation of museum historians was sharply critical of exhibitions and programs that looked narrowly backward to an idyllic period in American history unlikely to be repeated. At best, the antiquarian approach seemed nostalgic and superficial. At worst,

it seemed elitist, anti-democratic, and reactionary, a worldview that limited rather than expanded interpretive possibilities. More democratic and future oriented, the new professionals were optimistic about the ability of the nation to solve domestic problems and meet international obligations. The past for them was but a prelude to a glorious present and sparkling future. Nor were history museum professionals afraid of signaling their new independence of judgment within such newly formed associations as the American Association of Museums and the American Association for State and Local History.

Despite the gains of professionalism during the 1930s, antiquarians continued to make major contributions to understanding the American past. Working within privately owned museums, which were becoming institutions of national significance (for example, Historic Deerfield, Old Mystic Seaport, Shelburne Museum, Old Sturbridge Village, Winterthur, Colonial Williamsburg, and Greenfield Village), antiquarians continued to collect and preserve the nation's cultural heritage, although their view of collective memory no longer controlled the interpretive policies of the broad spectrum of history museums.

The massive entry of the federal government into the history museum field during the depression is one of the most significant developments of the modern history museum era. The interest of the National Park Service in historical concerns, initially limited to the maintenance and interpretation of Civil War battlefields, gradually expanded to include a nationwide system of historic sites, even encompassing urban historical parks in eastern cities. Preservation of historical resources came to stand side by side with preservation of natural resources.

Equally significant was the creation of a national Museum of American History as part of the growing complex of museums of the Smithsonian Institution. Though tracing its roots to the centennial collecting spree of George Brown Goode and the subsequent dreams of curator Carl Mitman, the museum's real genesis was with Frank Taylor, a museum administrator originally trained in engineering, who worked with congressmen, government officials, architects, and museum professionals for more than thirty years to bring about the opening of the Museum of History and Technology (MHT) in 1960 (renamed the National Museum of American History in 1980).

Government sponsorship of history museums also shaped official statements of collective memory. In the cold war era, the original concept of a national cultural museum yielded to the concept of a museum that combined history and technology, an idea that ran counter to the prevailing tendency to isolate science and technology from history in museum presentation. The principal justification for this hybrid emphasis was to trumpet American achievements in technology over those of the Soviet Union and to demonstrate to the rest of the world that technology was the hope of the future. As Lyndon Johnson observed, MHT was "the treasure house of our inheritance," a shrine to American progress. Thus, by governmental fiat, the

history of technology was not only added to the panoply of official collective memory but also elevated to front rank, a step confirmed by the creation of the National Air and Space Museum in the 1970s.

The position of the federal government on the proper emphasis for its new history museum was not an isolated phenomenon. All levels of government accelerated their participation in the history museum field in the post-World War II era, and private activity flourished as never before. Strong pride in American accomplishments during World War II, coupled with the need to defend American values worldwide, were obvious contributing factors. This social need, along with the resumption of America's tourist industry, generated unprecedented popular interest in historic sites and museums. New institutions were created to help meet the demand, and older ones entered an expansionist era that lasted until the tumultuous economy of the 1970s slowed the pace of growth.

Partly encouraged by professionalization (which moved many private museums away from the dominance of wealthy antiquarians) and partly due to the increased presence of government history museums (which theoretically made museums responsible to the full electorate), history museums became much more popular civic institutions in postwar America. This tendency toward democratization helped spark many new types of museums and altered the emphasis of existing ones. Emphasis on historic houses of famous individuals yielded to historic sites and districts; static displays were infused with living history; a domestic emphasis was preempted by a broad range of socioeconomic interests that has led to the creation of commercial and industrial museums and the collection and preservation of material ranging from boats to machinery. The late nineteenth century and early twentieth century were adopted as acceptable time frames for museum collection and display, and history museum distribution spread more evenly throughout the nation.

The celebration of the nation's Revolutionary War bicentennial generally had a salutary effect on American history museums, although the need to create popular exhibitions and market new images was often accompanied by an unwelcome commercialism. Private and public funds were poured, sometimes thoughtlessly, into history museums with Revolutionary War associations. New museums were developed, historic sites were refurbished, and exhibition and visitor facilities were upgraded at established museums.

Perhaps most significant, museum and university historians began to collaborate on bicentennial projects. The Smithsonian's pathbreaking "A Nation of Nations" (1976), an exhibit that reflected the ethnic diversity of the United States, represented a departure from the rigid division of professional roles and subject matter specialties that had divided academic and museum historians. Packed from wall to wall with historical artifacts and descriptive information, "A Nation of Nations" for a time set the standard for a new

genre of historical exhibition even though many of its subjects were treated with relatively little visual and intellectual sophistication.

In response to heightened public attention and higher level of public funding, other innovative exhibits followed. For example, "The Afro-American Tradition in Decorative Arts" (1978), organized by the Cleveland Museum of Art and circulated to six sites, and Winterthur's "The Pennsylvania Germans: A Celebration of Their Arts, 1683–1850" (1983) represented a more inclusive approach to museum interpretive exhibits. Just as the object exhibited increased in value by virtue of public exhibition, so too the groups portrayed in these exhibitions derived social benefits. For such groups, the exhibit process itself can be a dramatic moment of introduction into the national memory system, as illustrated by "A More Perfect Union: Japanese-Americans and the United States Constitution" (1988), in which the Smithsonian Institution addressed the complex legal and social issues arising from Japanese-American internment during World War II.

Still, questions remained: "Is it history?" or "Whose history is it?" or "So what?" Such questions only thinly veiled the persistent tension between historical scholarship (which resists efforts to package it for quick visual consumption at anniversaries, holidays, and other celebrations) and history as social memory, which can be presented effectively by museums. But even such questions would not have been possible without the gradual reconciliation of academic and museum history. By 1976 historians in both camps had in common at least a modicum of academic training and shared interests in the new social history and material culture study. Reconciliation was also facilitated by a renewed emphasis on research and interpretation at private institutions and at major historical agencies where academically trained historians made room for research within their demanding administrative schedules. Thus, the enduring legacy of the Revolutionary and constitutional celebrations may lie in the establishment of a dialogue between museum and academic historians. This dialogue, born during high-profile periods of national attention, has been nurtured by other developments within the history museum field.

First, the number of professional historians working in museums is now large enough to form a critical mass, and museum historians are beginning to make their presence felt in organizations other than the American Association for State and Local History (AASLH), long their organizational base.

Second, AASLH is beginning to assume a position of intellectual leadership in the history museum field. One instrument of this change is the Common Agenda project, a leadership initiative aimed at setting the future agenda for history museum collecting (including twentieth-century materials), data management, and communication through exhibitions, publications, and other media.

Third, a growing number of academic historians are specializing in museum history and/or material culture and frequently and easily cross boundaries to serve as peer reviewers for federal grants, consultants for major exhibitions, reviewers of museum exhibitions and catalogs, and cultural critics. Neil Harris, for example, has pointed out that the involvement of academic historians is likely to increase as museums provide an excellent vehicle to communicate with the public on a rapidly expanding range of issues of interest to the history establishment.

Fourth, certain history museums are emerging as institutional leaders, rising above the individual leadership roles played by their directors in the past. These institutions are employing professional historians who are applying academic criteria to their work and inviting dialogue between museum and academic colleagues throughout the country.

Fifth, historians in museums are recognizing that they must move to new levels of sophistication if they want to bridge the communication gap between historical scholars and the public. After an intense examination of the communication potential of the exhibition, museum historians now also hold high expectations for communicating through publications, film, and media. In this regard, many museum workers view future exhibits as "communications events," shows that will engage all the senses. This process is facilitated by the review of exhibitions and catalogs in scholarly journals, itself a significant breakthrough in the dialogue among historians and between historians and interested public.

Finally, the canon of history museum exhibition topics can be expected to conform more closely than ever before to the canon of historical scholarship, although this process will occur unevenly and with some potential for resistance. History museums, as agents of social memory, have been selectively sifting the past, in collections as well as exhibitions. In the process, many historic peoples, objects, events, and issues have been ignored while others have been overemphasized. The redress of this imbalance will tax the skill and energy of the history museum field but is necessary if history museums are to fulfill their obligations as both keepers of social memory and participants in the academic dialogue between past and present. After all is said, as Luis Buñuel reminds us, memory is not just memory; it is a selective principle.

SURVEY OF SOURCES

The literature on America's history museums has been written by museum professionals for their peers, and their enthusiastic commitment to the field simultaneously constitutes the literature's greatest strength and its most significant weakness. Although disputation abounds, the fundamental underpinnings of history museums are rarely explored or challenged.

The intellectual background to the American history museum movement

is treated in several works. Francis Henry Taylor's *The Taste of Angels* (1948) provides a useful survey of the history of the collecting of antiquities, while the English rendition of scientific antiquarianism is wittily delineated in Stuart Piggott's *Ruins in a Land Scape* (1976). David Lowenthal's probing essay, "The Place of the Past in the American Landscape" (1976), relates formal theories of history to popular attitudes toward the past and its preservation, but Lowenthal's masterpiece is *The Past Is a Foreign Country* (1985). A sensitive discussion of the Enlightenment ideal of the museum can be found in Charles Coleman Seller's *Mr. Peale's Museum* (1980), with massive documentation now provided in volume 2 of *The Collected Papers of Charles Willson Peale and His Family* (1988).

Each of the historical societies founded early in U.S. history— Massachusetts, New York, and Pennsylvania—has its institutional history, celebratory in tone and conservative in format. These descriptive institutional histories, like the political histories of their times, slavishly follow a chronological development of the terms of their presidents. Written by respective society leaders to commemorate a major anniversary, they convey a strong sense of orderly continuity. Hampton L. Carson's *A History of the Historical Society of Pennsylvania* (1940), Robert W. G. Vail's study of the New-York Historical Society, *Knickerbocker Birthday* (1954), and Stephen T. Riley's *The Massachusetts Historical Society, 1791–1959* (1959) reflect an insider's perspective. One might be tempted to relegate these histories to the dustbin of antiquarianism, but, together, these accounts and those of the more democratic historical societies of the Midwest, such as Paul Angle's *The Chicago Historical Society, 1856–1956* (1956) and Clifford L. Lord's *Keepers of the Past* (1965), with its emphasis on the Historical Society of Wisconsin, chronicle the efforts of a historically conscious elite to shape the social memories of their regions and nation.

In addition to the institutional histories, there is an important body of analytical literature on the historical societies. Leslie W. Dunlap includes a useful general historical account and brief thumbnail sketches of all the societies founded before 1860 in *American Historical Societies, 1790–1860* (1944). His discussion of the motivations of historical society founders is indispensable to understanding later developments. In *Recording America's Past* (1960), David Van Tassel argues that the historical society "originated as a weapon in the battle to dominate the writing of national history" by competing state and local historical societies since in the federal era "national" history was conceived as the sum total of state histories.

George H. Callcott's *History in the United States, 1800–1860* (1970), building upon the work of Dunlap and Van Tassel, places more emphasis on the intellectual currents in Europe and America that shaped historical writing, the methods employed in historical research, and changes in subject matter. Callcott shows that history, and particularly historical biography, in the first half of the nineteenth century was employed to strengthen moral and political

values. All three of the books, however, generally ignore the museum func-
tion of the historical societies.

The literature on the antiquarian phase of the history museum movement
is plentiful but superficial. Wallace E. Davies's *Patriotism on Parade* (1955)
is a convenient starting point for the analysis of antiquarians as a group.
Davies confirms the view that the antiquarians were predominately a white,
Protestant elite seeking recognition for their ancestors and certification of
their own role in a rapidly changing society. Davies's work lacks sociological
sophistication, and he probably underestimates the contribution of anti-
quarians to the history museum and preservation movements. Elizabeth
Stillinger's *The Antiquers* (1980) provides useful biographical information on
the collectors of Americana and chronicles the shift from historical to aes-
thetic criteria in the collecting of antiques. Charles Hosmer's *Presence of
the Past* (1965) captures the zeal and dedication of pioneer preservationists
up to 1929 and describes comprehensively the architectural preservation
work of the antiquarians, including such groups as the Daughters of the
American Revolution and the Colonial Dames of America.

Though largely superseded by Hosmer's work, Laurence Vail Coleman's
pioneering study, *Historic House Museums* (1933), still contains valuable
information and insights. Coleman, the director of the growing American
Association of Museums and a prolific writer, visited, counted, described,
and mapped almost all of America's historic house museums. Still, Coleman's
provocative thesis that house museums were a product of the automotive
industry (often carelessly repeated in the professional literature) fails to
explain fully this complex, national phenomenon. A more complete and
sophisticated analysis of the intellectual and cultural context of antiquari-
anism is *The Colonial Revival in America* (1985), edited by Alan Axelrod.
For a critique of antiquarian thought, Michael Ettema's essay, "History,
Nostalgia, and American Furniture" (1982), is narrowly focused but broadly
applicable.

Treatments of the results of antiquarian collective memory maintenance
are frequently superficial. However, Dianne H. Pilgrim's study of the period
rooms of the Brooklyn Museum, "Inherited from the Past" (1978), is thor-
oughly documented. The remarkable story of the Metropolitan's American
Wing is told by R. T. H. Halsey and Elizabeth Tower in *The Homes of Our
Ancestors* (1934), the original, illustrated guidebook published by Double-
day. A modern interpretation of Halsey's work is Wendy Kaplan's "R. T. H.
Halsey: An Ideology of Collecting American Decorative Arts" (1982), and
the most recent guide to the wing is Marshall Davidson's *The American
Wing* (1980).

Each of the major private institutions to emerge from the collecting in-
terests of the antiquarians, such as Greenfield Village, Colonial Williams-
burg, Old Sturbridge Village, and Winterthur, has its popular history or
visitor manual. Such publications tend to illustrate the present situation and

present an overview of what the visitor can expect to see. Geoffrey C. Upward's account of Greenfield Village and the Henry Ford Museum, *A Home For Our Heritage* (1979), illustrates some of the shortcomings of this literature. Although one of the best of the "anniversary" histories, the study suffers from a narrow focus, incompleteness, and chronological determinism. The lack of historical narrative is somewhat offset by the book's excellent photographs, rich description of the role of Henry Ford's staff, and the many anecdotes about the museum's founder (for example, Greenfield Village was nicknamed "Henry Ford's Doll House"). By contrast, Jay E. Cantor's *Winterthur* (1985) offers a more balanced assessment of the role of its founder in American cultural history. Charles Hosmer's monumental *Preservation Comes of Age* (1981), which contains a stimulating discussion of Colonial Williamsburg, suggests a productive and insightful approach to writing institutional narratives that illuminate larger historical themes. Unfortunately, too few historians have been able to break out of institutional tunnel vision.

More research and writing are also needed before the entry of the federal government into the museum field can be fully understood. Marilyn Cohen's doctoral dissertation, "American Civilization in Three Dimensions" (1980), is a good start; it traces the painfully slow birth of the Museum of History and Technology (later the National Museum of American History) from the pioneer work of George B. Goode, through Carl W. Mitman, to Frank Taylor. Although the history of the National Park Service is recounted in Freeman Tilden's light and lively *Interpreting Our Heritage* (1977) and in William C. Everhart's *The National Park Service* (1972), the cultural significance of the federal government's increased role in the acquisition, preservation, and interpretation of historical materials remains an open question. Tilden's book is a descriptive, anecdotal, armchair tour of the nation's parks and historic sites, while Everhart's fine institutional biography is fraught with the limitations of that genre, a relentless internal focus that provides no context for understanding the NPS in the light of national intellectual, political, or social trends.

This problem of formulating a historical issue was once suggested to me by the question of a Nigerian teacher during a traveling history seminar. "Why does your country devote so much money and energy to commemorating battles, particularly those of your Civil War?" the visitor asked. "My country has just endured a terrible civil struggle, and we would not want to remember it in this manner." The potential rewards to be gained from adopting new angles of vision are evident in John B. Jackson's cursory but provocative treatment of the battlefield syndrome in *The Necessity for Ruins* (1980).

Nearly every history museum, historic house, and historic site has published a brochure, booklet, or handbook for the general public; a review of this literature reflects not only the substantive concerns of history museums but also the growing importance of the publication function. In general, the

American guides are more poorly written, less informative, and inferior in quality of photography and printing than their European counterparts. Even the publications of such major history museums as Colonial Williamsburg, Mystic Seaport, Old Salem, and Old Sturbridge Village are excessively wordy and fail to convey the rich sensory experience and historical complexity of their respective institutions.

Still, the overall quality of American historical museum publications is improving dramatically in spite of increases in publishing costs. The excellent publication program of the American Association for State and Local History has established high standards for historical agencies and museums. Improvements in the design, layout, and overall quality of history museum handbooks are evident in the revised full-color edition of *The White House* (1973), in Peter Molloy's excellent black-and-white guidebook to the Merrimack Valley Textile Museum, *Homespun to Factory Made* (1977), and in the newest edition of Colonial Williamsburg's official guidebook.

Although in the past National Park Service materials lacked lustre in every category of performance, recent publications, such as John Milley's *Treasures of Independence* (1980), reflect higher standards in both tone and quality. The change in National Park Service publications is perhaps best illustrated by the new handbook series. There is a sharp contrast between Edward M. Riley's *Independence National Historical Park* (1956) and the more recent *Hopewell Furnace* (1983), an example of the new handbook series. Unlike their predecessors, the new handbooks provide readable and attractive historical text heavily illustrated with maps, drawings, and historic and contemporary photographs. With tightly woven visual and verbal essays that operate on more than one sensory level, the new series should be a greater stimulant to attendance, a better complement to the visit, and a substantially more effective memory record of the visitor experience than the old series.

The exhibit catalog, another genre of history museum literature, has also been undergoing a metamorphosis, with many provocative catalogs stemming from Revolutionary War and constitutional bicentennial exhibitions. In the past, the history museum has been an easy mark for critics who argued that catalogs, like the changing exhibits they purported to document, are intellectually disposable. Exhibition catalogs often lacked original and/or significant research. They also failed to document fully the exhibit installation. A series of major catalogs, beginning with Hugh Honour's monumental *The European Vision of America* (1975), the record of a bicentennial exhibit organized by the Cleveland Museum of Art and the Réunion des Museés Nationaux de Paris, challenged the conventional wisdom. Honour captures much of the intellectual excitement of the exhibit, which drew on the resources of European and American collections to portray changing attitudes toward America from its discovery through the mid-nineteenth century. Other fine exhibitions and catalogs that have proved to have value beyond the self-congratulation of the bicentennial celebration include the following:

A Nation of Nations (1976), edited by Peter C. Marzio for the Museum of History and Technology; *The World of Franklin and Jefferson* (1976), written by Charles Eames and Ray Eames for the Metropolitan Museum of Art; *The Eye of Thomas Jefferson* (1976), edited by William Adams for the National Gallery of Art; *1876: A Centennial Exhibition* (1976), edited by Robert C. Post for the Smithsonian Institution; and *Remember the Ladies* (1976), edited by Linda Grant De Pauw and Conover Hunt for the Corcoran Gallery of Art.

The recent gradual reconciliation of academic and antiquarian approaches to the past is reflected in exhibit catalogs. Wendy Cooper's *In Praise of America* (1980) summarizes fifty years of decorative arts scholarship on the occasion of an exhibition that marked the landmark Girl Scouts Loan Exhibition of 1929. Other history exhibit catalogs have contributed fresh ideas and original scholarship, at times prompting academic historians to take notice. Illustrative of this type of catalog are the following: Robert Blair St. George's *The Wrought Covenant* (1979) at the Brockton Art Center—Fuller Memorial, a study of woodworking craftsmen and community in seventeenth century Massachusetts; Robert F. Trent's *Hearts and Crowns* (1977), an excursion into folk culture through chairs made in coastal Connecticut at the New Haven Colony Historical Society; and George Talbot's *At Home* (1976), a photographic study of domestic life in the late nineteenth century, at the State Historical Society of Wisconsin.

Occasionally the history museum field produces an exhibition and catalog that achieves both popular and scholarly acclaim. Such a blockbuster exhibit was "New England Begins," a survey of colonial New England cultural history, organized by the Museum of Fine Arts in Boston. According to historian John Demos, who reviewed the exhibition's three-volume catalog by Jonathan Fairbanks and Robert Trent, entitled *New England Begins* (1982), in his article for the *William and Mary Quarterly*, "Words and Things" (1983), the exhibit successfully broke down the artificial distinction between intellectual and artifactual history. "For some of us, perhaps for many, the study of early New England history will never again be quite the same," Demos concluded. If Demos is correct, the exhibit may mark a turning point not only in the study of early American culture but also in bridging the gulf between academic and museum history.

In the case of "New England Begins" and many other cultural history exhibitions of the 1970s and 1980s, the striking fact is that many of the most memorable history exhibits have been mounted by art museums. Although one might quibble about the percentage of history to art in these exhibits, most fall comfortably within the boundaries of cultural history. For example, *Automobile and Culture*, organized by the Museum of Contemporary Art in Los Angeles in 1984 as an Olympics exhibition, features industrial design intersecting with popular culture. Wendy Kaplan's *The Art That Is Life: The Arts and Crafts Movement in America, 1875–1920* at Boston's Museum of

Fine Arts (1987) documents another example of a cultural history exhibition in an art museum setting. Often these exhibitions are designed for aesthetic impact to highlight objects, whereas the catalog is more intellectually and historically oriented. Perhaps the most critical underlying message of these exhibits and catalogs is that drawing the line of demarcation between art and history is often intellectually indefensible and may even get in the way of understanding and appreciating the subject at hand. Consequently, art museum exhibitions, especially those that feature industrial design, domestic design, decorative arts, ethnic art, and Third World art, are often set in cultural context, and museums such as the Cooper-Hewitt in New York and Winterthur in Delaware move freely over disciplinary borders in their exhibitions, displays, and publications.

Many of the shifts in history museum policies are available only in unpublished speeches and conference proceedings. However, the shift in AASLH policy is documented in *History News* (September-October, 1986), and a preliminary statement of the objectives of the Common Agenda project can be found in Lonn Taylor's *A Common Agenda for History Museums: Conference Proceedings* (1987). Critical reviews of exhibitions and catalogs are available in such scholarly journals as *Technology and Culture*, *Winterthur Portfolio*, *William and Mary Quarterly*, and *Journal of American History*.

BIBLIOGRAPHIC CHECKLIST

Abbott, Shirley. *The National Museum of American History*. New York: Harry N. Abrams, 1981.

Abram, Ruth J., ed. *"Send Us a Lady Physician": Women Doctors in America, 1835–1920*. New York: W. W. Norton and Co., 1985.

Adams, William Howard, ed. *The Eye of Thomas Jefferson*. Washington, DC: National Gallery of Art, 1976.

Addyman, Peter, and Anthony Gaynor. "The Jorvik Viking Center- An Experiment in Archeological Site Interpretation." *International Journal of Museum Management and Curatorship* 3 (March 1984), 7–18.

Alderson, William T. "The American Association for State and Local History." *Western Historical Quarterly* 1 (April 1970), 175–82.

Alderson, William T., and Shirley P. Low. *Interpretation of Historic Sites*. Nashville,TN: American Association for State and Local History, 1976.

Alegre, Mitchell R. *A Guide to Museum Villages: The American Heritage Brought to Life*. New York: Drake Publishers, 1978.

Alexander, Edward P. "Restorations." *In Support of Clio: Essays in Memory of Herbert A. Kellar*, edited by William B. Hesseltine and Donald R. McNeil. Madison: State Historical Society of Wisconsin, 1958.

———. *The Museum: A Living Book of History*. Detroit: Wayne State University Press, 1959.

———. "History Museums: From Curio Cabinets to Cultural Centers." *Wisconsin Magazine of History* 43 (Spring 1960), 173–80.

————. "Artistic and Historical Period Rooms." *Curator* 7 (1964), 263–81.

————. "Sixty Years of Historic Preservation: The Society for the Preservation of New England Antiquities." *Old-Time New England* 61 (Summer 1970), 14–19.

————. *Museums in Motion: An Introduction to the History and Function of Museums*. Nashville, TN: American Association for State and Local History, 1979.

————. *Museum Masters: Their Museums and Their Influence*. Nashville, TN: American Association for State and Local History, 1983.

Anderson, Jay. *The Living History Sourcebook*. Nashville, TN: American Association for State and Local History, 1985.

————. "Living History: Simulating Everyday Life in Living Museums." *American Quarterly* 34 (1982), 290–306.

————. *Time Machines: The World of Living History*. Nashville, TN: American Association for State and Local History, 1984.

Anderson, Jay, and Candace Tangorra Matelic. *Living History Farms: A Pictorial History of Food in Iowa*. Des Moines, IA: Living History Farms Foundation, 1980.

Angle, Paul M. *The Chicago Historical Society, 1856–1956: An Unconventional Chronicle*. New York: Rand McNally, 1956.

Appel, John J. "(Immigrant Historical Societies in the United States, 1880–1950)." Ph.D. dissertation, University of Pennsylvania, 1960.

Appleton, William Sumner. "Destruction and Preservation of Old Buildings in New England." *Art and Archaeology* 8 (May-June 1919), 131–83.

Atkinson, Frank. "New Open-Air Museums." *Museum* 23 (1970–1971), 99–107.

Axelrod, Alan, ed. *The Colonial Revival in America*. New York and London: W. W. Norton and Co., for the Henry Francis du Pont Winterthur Museum, 1985.

Baily, Joshua L., Jr. "Some Early American Museums." *Science*, November 6, 1942, 427.

Baker, Alan, Warren Leon, and John Patterson. "Conflict and Community at Old Sturbridge Village and Connor Prairie." *History News* 41/2 (March 1986), 6–15.

Bancroft, Hubert Howe. *The Book of the Fair: An Historical and Descriptive Presentation of the World's Science, Art, and Industry, As Viewed Through the Columbian Exposition at Chicago in 1893*. Chicago: Bancroft, 1895.

Barendsen, Joyce P. "Wallace Nutting, an American Tastemaker: The Pictures and Beyond." *Winterthur Portfolio* 18 (Summer Autumn 1983), 187–212.

Basalla, George. "Museums and Technological Utopianism." In *Technological Innovation and the Decorative Arts*, edited by Ian M. G. Quimby and Polly Anne Earl. Charlottesville: University Press of Virginia, 1974.

Bather, F. A. "The Triumph of Hazelius." *Museums Journal* 16 (December 1916), 132–36.

Bell, Whitfield J., Jr., Clifford K. Shipton, John C. Ewers, Louis Leonard Tucker, and Wilcomb E. Washburn. *A Cabinet of Curiosities: Five Episodes in the Evolution of American Museums*. Charlottesville: University Press of Virginia, 1967.

Benson, Susan Porter, Stephen Brier, and Roy Rosenzweig, eds. *Presenting the Past:*

Essays on History and the Public. Philadelphia: Temple University Press, 1986.

Blatti, Jo, ed. *Past Meets Present: Essays about Historic Interpretation and Public Audiences*. Washington, DC: Smithsonian Institution Press, 1987.

Borowsky, Caroline M. "The Charleston Museum." *Museum News* 41 (February 1963), 11–21.

Bossom, Alfred C. "Colonial Williamsburg: How Americans Handle a Restoration." *Architect and Building News*, March 27, 1942, 229–30.

Boyd, Julian P. "State and Local Historical Societies in the United States." *American Historical Review* 40 (October 1934), 10–37.

Brown, Alexander Crosby. *The Mariners' Museum, 1930–1950: A History and Guide*. Newport News, VA: Mariners' Museum, 1950.

Bryan, Courtland Dixon Barnes. *The National Air and Space Museum*. New York: Harry N. Abrams, 1979.

Buñuel, Luis. *My Last Sigh*, translated by Abigail Israel. New York: Knopf, 1983.

Burns, Ned J. "The History of Dioramas." *Museum News*, February 15, 1940, 8–12.

———. *Field Manual for Museums*. Washington, DC: Government Printing Office, 1941.

Bushman, Richard. "Regional Material Culture: A Review of 'The Great River': Art and Society of the Connecticut River Valley, 1635–1820." *William and Mary Quarterly* 43 (April 1986), 245–51.

Butterfield, Lyman H. "Draper's Predecessors and Contemporaries." In *The American Collector*, edited by Donald R. McNeil. Madison: State Historical Society of Wisconsin, 1955.

Callcott, George H. *History in the United States, 1800–1860: Its Practice and Purpose*. Baltimore: Johns Hopkins Press, 1970.

Cantor, Jay E. *Winterthur*. New York: Harry N. Abrams, 1985.

———. "When Wine Turns to Vinegar: The Critics' View of 19th Century America." *Winterthur Portfolio* 7 (1972), 1–28.

———. "Art and Industry: Reflections on the Role of the American Museum in Encouraging Innovation in the Decorative Arts." In *Technological Innovation and the Decorative Arts*, edited by Ian M. G. Quimby and Polly Anne Earl. Charlottesville: University Press of Virginia, 1974.

Carson, Barbara G., and Cary Carson. "Things Unspoken: Learning Social History From Artifacts." In *Ordinary People and Everyday Life: Perspectives on the New Social History*, edited by James B. Gardner and George Rollie Adams. Nashville, TN: American Association for State and Local History, 1983.

Carson, Cary. "Doing History with Material Culture." In *Material Culture and the Study of American Life*, edited by Ian M. G. Quimby. New York: W. W. Norton, 1978.

———. "Living Museums of Everyman's History." *Harvard Magazine* 83 (July-August 1981), 22–32.

Carson, Hampton Lawrence. *A History of the Historical Society of Pennsylvania*. 2 vols. Philadelphia: Historical Society of Pennsylvania, 1940.

Catalogue of the Paintings and Other Objects of Interest, Belonging to the Historical Society of Pennsylvania. Philadelphia: Collins, printer, 1872.

Chase, Darryl, ed. *Selected Living Historical Farms, Villages, and Agricultural*

Museums in the United States and Canada. Washington, DC: Association for Living Historical Farms and Agricultural Museums, Smithsonian Institution, 1976.

Cohen, Marilyn Sara. "American Civilization in Three Dimensions: The Evolution of the Museum of History and Technology of the Smithsonian Institution." Ph.D. dissertation, George Washington University, 1980.

Coleman, Laurence Vail. *Historic House Museums; with a Directory*. Washington, DC: American Association of Museums, 1933.

———. *The Museum in America: A Critical Study*. 3 vols. Washington, DC: American Association of Museums, 1939. Reprint (3 vols. in 1). Washington, DC: American Association of Museums. 1970.

Collier-Thomas, Betty. "Field to Factory: An Exhibit Review." *History News* 43 (January-February 1988), 17–18, 28–29.

Comstock, Helen. "A Reconstructed City. Williamsburg: Virginia's Old Capital. Part I—The Historical Background; Part II—The Architectural Aspect; Part III—The Treatment of Detail." *Connoisseur*, 1/101 (May 1938), 227–34; 2/101 (June 1938), 283–90; and 3/102 (July 1938), 3–10.

Cooke, Edward S., Jr. "History and the Art Museum: An Exhibition Review." *Winterthur Portfolio* 22, no. 2/3 (Summer-Autumn 1987), 165–80.

Cooper, Wendy A. *In Praise of America: American Decorative Arts, 1650–1830*. New York: Alfred A. Knopf, 1980.

Cotter, John. "Colonial Williamsburg." *Technology and Culture* 11 (July 1970), 417–27.

Crew, Spencer R. *Field to Factory: Afro-American Migration 1915–1940*. Washington, DC: National Museum of American History, Smithsonian Institution, 1987.

Cummings, Abbott Lowell. "Restoration Villages." *Art in America* 43 (May 1955), 12–13.

Curtis, John O. "The Buildings at Old Sturbridge Village." *Antiques* 116 (October 1979), 896–904.

Davidson, Marshall B. *The American Wing: A Guide*. New York: Metropolitan Museum of Art, 1980.

Davies, Wallace E. *Patriotism on Parade: The Story of Veterans' and Hereditary Organizations in America, 1783–1900*. Cambridge: Harvard University Press, 1955.

Davis, Douglas F. "Logging, Lumbering, and Forestry Museums: A Review." *Forest History* 17 (January 1974), 28–31.

Davis, Thomas. " 'They, Too, Were Here': The Afro-American Experience and History Museums." *American Quarterly* 41 (1989), 328–340.

Dearing, Mary R. *Veterans in Politics: The Story of the G.A.R.* Baton Rouge: Louisiana State University Press, 1952.

De Ber, Paul Jacobus. "The Phenomina Open-Air Museum in Cultural and Historical Perspective." Ph.D. dissertation, University of Pretoria, 1979.

Deetz, James. "The Artifact and Its Context." *Museum News* 62, no. 1 (October 1983).

———. "The Reality of the Pilgrim Fathers." *Natural History* 78 (November 1969), 32–45.

———. "The Changing Historic House Museum: Can It Live?" *Historic Preservation* 23 (January-March 1971), 51–54.

————. *In Small Things Forgotten: The Archaeology of Early American Life*. Garden City, NY: Anchor Press/Doubleday, 1977.

————. "A Sense of Another World: History Museums and Cultural Change." *Museum News* 58 (May-June 1980), 40–45.

Demos, John. "Words and Things: A Review and Discussion of 'New England Begins.' " *William and Mary Quarterly*, 3d ser., 40 (October 1983), 584–97.

De Pauw, Linda Grant, and Conover Hunt. *Remember the Ladies: Women in America, 1750–1815*. New York: Viking Press, 1976.

Douglas, Mary T., and Baron Isherwood. *The World of Goods*. New York: Basic Books, 1979.

Dow, George Francis. "The Colonial Village Built at Salem, Massachusetts, in the Spring of 1930." *Old-Time New England* 22 (July 1931), 3–14.

Dunlap, Leslie Whittaker. *American Historical Societies, 1790–1860*. Madison: private, 1944. Reprint. Philadelphia: Porcupine Press, 1974.

Dunn, John. "Nature Programming and the Outdoor Museum." *Gazette* (Canadian Museums Association) 9 (1976), 39–43.

Eames, Charles, and Ray Eames. *The World of Franklin and Jefferson: The American Revolution Bicentennial Administration Exhibition*. Los Angeles: G. Rice, 1976.

Eaton, Allen H. *Immigrant Gifts to American Life*. New York: Russell Sage Foundation, 1932. Reprint. New York: Arno Press, 1970.

————. *Handicrafts of the Southern Highlands*. New York: Russell Sage Foundation, 1937. Reprint: New York: Dover Publications, 1973.

Edwards, Lee M. *Domestic Bliss: Family Life in American Painting, 1840–1940*. Yonkers, NY: The Hudson River Museum, 1986.

Eleuterio-Comer, Susan K., comp. *Irish-American Material Culture: A Dictionary of Collections, Sites, and Festivals in the United States and Canada*. Westport, CT., Greenwood Press, 1988.

Ellis, Richard P. "The Founding, History, and Significance of Peale's Museum in Philadelphia, 1785–1841." *Curator* 9 (September 1966), 235–58.

Ellsworth, Lucius F., and Maureen A. O'Brien. *Material Culture: Historical Agencies and the Historian*. Philadelphia: Book Reprint Service, 1969.

Ettema, Michael J. "History Museums and the Culture of Materialism." In *Past Meets Present: Essays about Historic Interpretation and Public Audiences*, edited by Jo Blatti. Washington, DC: Smithsonian Institution Press, 1987.

————. "History, Nostalgia, and American Furniture." *Winterthur Portfolio* 17 (Summer-Autumn 1982), 135–44.

Eubanks, Sharon Y. *A Bibliography of Books, Pamphlets, and Films Listed in the Living Historical Farms Bulletin from December 1970 Through May 1976*. Washington, DC: Association for Living Historical Farms and Agricultural Museums, 1976.

Everhart, William C. *The National Park Service*. New York: Praeger Publishers, 1972.

Fairbanks, Jonathan L., and others. *Paul Revere's Boston, 1735–1818: Exhibitions, April 18–October 12, 1975*. Boston: Museum of Fine Arts, 1975.

Fairbanks, Jonathan L., and Robert F. Trent. *New England Begins: The Seventeenth Century*. 3 vols. Boston: Museum of Fine Arts, 1982.

Fennelly, Catherine. "Two Brothers and Their Hobby." *New England Galaxy* 7 (Winter 1966), 56–60.

———. *Old Sturbridge Village: A Guidebook*. 5th ed. Sturbridge: Old Sturbridge Village, 1966.

———. *Life in an Old New England Country Village: An Old Sturbridge Village Book*. New York: T. Y. Crowell, 1969.

Fenton, Alexander. "The Scottish Country Life Museums Trust." *Museums Journal* 72 (June 1972), 7–8.

Fernandez, J. W. "Folklore as an Agent of Nationalism." In *Social Change: The Colonial Situation*, edited by Immanuel Wallerstein. New York: John Wiley and Sons, 1966.

Finley, David E. *History of the National Trust for Historic Preservation*. Washington, DC: National Trust for Historic Preservation, 1965.

Fishel, Leslie H. "The Role of the Historical Society in Contemporary America." Keynote address presented at the American Association for State and Local History, 1975.

Fleming, E. McClung. "The Period Room as a Curatorial Publication." *Museum News* 50 (June 1972), 39–42.

Fortier, John, and Owen Fitzgerald. *Fortress of Louisbourg*. Toronto: Oxford University Press, 1979.

Foss, C. "The Living Village of Kings Landing." *Canadian Antiques and Art Review* 15 (February 1981), 32–37.

Franco, Barbara, and Millie Rahn. "Who's Teaching History?" *History News* 42, no. 5 (September-October 1987), 7–11.

Fridley, Russell W. "Critical Choices for the Minnesota Historical Society." *Minnesota History* 46 (Winter 1978), 130–46.

Frye, Melinda Young. "Pioneers in Museums: Charles P. Wilcomb." *Museum News* 55 (May-June 1977), 55–60.

Gardner, James B., and George Rollie Adams, eds. *Ordinary People and Everyday Life: Perspectives on the New Social History*. Nashville, TN: American Association for State and Local History, 1983.

Garvan, Beatrice B., and Charles F. Hummel. *The Pennsylvania Germans: A Celebration of Their Arts, 1683–1850*. Philadelphia: Philadelphia Museum of Art and the Henry Francis du Pont Winterthur Museum, 1982.

Gilman, Carolyn, and Mary Jane Schneider, with essays by W. Raymond Wood et al. *The Way to Independence: Memories of a Hidatsa Indian Family*. St. Paul: Minnesota Historical Society Press, 1987.

Goode, George Brown. "Museum-History and Museums of History." *Papers of the American Historical Association* 3 (1889), 495–579. Reprinted in *Annual Report of the Board of Regents of the Smithsonian Institution . . . 1897. Report of the U.S. National Museum*, pt. 2. Washington, DC: Government Printing Office, 1901.

Goodwin, W. A. R. "The Restoration of Colonial Williamsburg." *National Geographic Magazine* 71 (April 1937), 402–43.

Grover, Kathryn, ed. *Dining in America, 1850–1900*. Amherst: University of Massachusetts; Rochester: Strong Museum, 1987.

Guthe, Carl Eugen. *The Management of Small History Museums*. 2d ed. Nashville, TN: American Association for State and Local History, 1964.

Haas, Irvin. *America's Historic Villages and Restorations.* New York: Arco Publishing, 1974.

Halbwachs, Maurice. *The Collective Memory,* translated by Francis J. Ditter, Jr., and Vida Yazdi Ditter. New York: Harper & Row, 1980.

Halsey, Richard Townley Haines, and Elizabeth Tower. *The Homes of Our Ancestors, as Shown in the American Wing of the Metropolitan Museum of Art of New York.* Garden City, NY: Doubleday, Doran, 1934.

Hamp, Steven K. "Subject Over Object: Interpreting the Museum as Artifact." *Museum News* 63, no. 2 (December 1984), 33–37.

Harris, Neil. "The Gilded Age Revisited, Boston and the Museum Movement. *American Quarterly* 14 (Winter 1962), 545–66.

———. "Thoughts on the Present State of History." *History News* 43, no. 1 (January-February 1988), 11–16.

———. "Museums: The Hidden Agenda." *Midwestern Museum News* 46, no. 2 (Spring 1987), 17–21.

Hawes, Edward L. "The Living Historical Farm in North America: New Directions in Research and Interpretation." *Proceedings of the Annual Meeting—Association for Living Historical Farms and Agricultural Museums* 2 (1976), 41–60.

Haynes, Elizabeth. *A Guide to the American Rooms of the Brooklyn Museum.* Brooklyn: Brooklyn Museum, 1936.

Heininger, Mary Lynn Stevens. "A Trip Worth Taking: An Exhibition Review." *Winterthur Portfolio* 23, no. 2/3 (Summer-Autumn 1988), 169–82.

Henry Ford Museum and Greenfield Village. *Greenfield Village and the Henry Ford Museum.* New York: Crown Publishers, 1972.

Hesseltine, William B. *Pioneer's Mission: The Story of Lyman Copeland Draper.* Madison: State Historical Society of Wisconsin, 1954. Reprint. Westport, CT: Greenwood Press, 1970.

Higham, John, Leonard Krieger, and Felix Gilbert. *History: The Development of Historical Studies in the United States.* Englewood Cliffs, NJ: Prentice-Hall, 1965.

Hindle, Brooke. *Technology in Early America: Needs and Opportunities for Study.* Chapel Hill: University of North Carolina Press, 1966.

An Historical and Descriptive Account of the Field Columbian Museum. Chicago: Field Columbian Museum, 1894.

Honour, Hugh. *The European Vision of America: A Special Exhibition to Honor the Bicentennial of the United States.* Cleveland: Cleveland Museum of Art, 1975.

Hopewell Furnace: A Guide to Hopewell Village National Historic Site, Pennsylvania. Washington, DC: Division of Publications, National Park Service, United States Department of the Interior, 1983.

Hosmer, Charles B., Jr. *Presence of the Past: A History of the Preservation Movement in the United States Before Williamsburg.* New York: G. P. Putnam's Sons, 1965.

———. *Preservation Comes of Age: From Williamsburg to the National Trust, 1926–1949.* 2 vols. Charlottesville: University Press of Virginia, 1981.

Hudson, Kenneth. *A Social History of Museums: What the Visitors Thought.* Atlantic Highlands, NJ: Humanities Press, 1975.

Hurt, R. Douglas. "Agricultural Museums: A New Frontier for the Social Sciences."
 History Teacher 11 (May 1978), 367–75.
International Congress of Maritime Museums. *Third Conference Proceedings, 1978.*
 Ann Arbor, MI: University Microfilms International, 1979.
Jackson, George, comp. *History of All Centennials, Expositions, and World Fairs
 Ever Held.* Lincoln, NB: Wekesser-Brinkman, 1937.
Jackson, John B. *The Necessity For Ruins, and Other Topics.* Amherst: University
 of Massachusetts Press, 1980.
James, Hunter. *Old Salem Official Guidebook*, edited by Frances Griffin. Winston-
 Salem, NC: Old Salem, 1977.
Johnson, Gerald W. *Mount Vernon: The Story of a Shrine.* New York: Random
 House, 1953.
Jurmain, Claudia K., and James J. Rawls; foreword by L. Thomas Frye. *California:
 A Place, A People, A Dream.* San Francisco: Chronicle Books; Oakland: Oak-
 land Museum, 1986.
Kammen, Michael. *A Season of Youth: The American Revolution and the Historical
 Imagination.* New York: Alfred A. Knopf, 1978.
Kaplan, Wendy. *The Art That Is Life: The Arts and Crafts Movement in America,
 1875–1920.* Boston, MA: Little, Brown for the Museum of Fine Arts, 1987.
————. "R. T. H. Halsey: An Ideology of Collecting American Decorative Arts."
 Winterthur Portfolio 17 (Spring 1982), 43–53.
Karp, Walter. "Greenfield Village." *American Heritage* 32 (December 1980), 98–
 107.
Kelsey, Darwin P., ed. *Farming in the New Nation: Interpreting American Agri-
 culture, 1790–1840.* Washington, DC: Agricultural History Society, 1972.
————. "Outdoor Museums and Historical Agriculture." *Agricultural History* 46
 (January 1972), 105–27.
————. "Historical Farms as Models of the Past." *Proceedings of the Annual
 Meeting—Association for Living Historical Farms and Agricultural Museums*
 1 (1975), 33–38.
————. "Old Sturbridge Village Today." *Antiques* 116 (October 1979), 826–47.
Kettell, Russell Hawes, ed. *Early American Rooms, 1650–1858.* Portland, ME:
 Southworth-Anthoensen Press, 1936. Reprint. New York: Dover, 1967.
Key, Archibald F. *Beyond Four Walls: The Origins and Development of Canadian
 Museums.* Toronto: McClelland and Stewart, 1973.
Kjellberg, Reidar. "Scandinavian Open-Air Museums." *Museum News* 39 (December
 1960–January 1961), 18–22.
Kocher, Alfred Lawrence, and Howard Dearstyne. *Colonial Williamsburg, Its Build-
 ings and Gardens: A Descriptive Tour of the Restored Capital of the British
 Colony of Virginia.* 2d rev. ed. Williamsburg: Colonial Williamsburg Foun-
 dation, 1976.
Kreiswirth, Sandra. "Vancouver Ensemble" *Westways* 73 (April 1981), 30–32.
Lagercrantz, Bo. "A Great Museum Pioneer of the Nineteenth Century." *Curator*
 7 (1964), 179–84.
Leavitt, Thomas W. "The Need for Critical Standards in History Museum Exhibits:
 A Case in Point." *Curator* 10 (1967), 91–94.
Lee, Ronald F. *United States: Historical and Architectural Monuments.* Mexico:
 Instituto Panamericano de Geografía e Historia, 1951.

Leon, Warren and Roy Rosenzweig, eds. *History Museums in the United States: A Critical Assessment*. Urbana and Chicago, IL: University of Illinois Press, 1989.

Leone, Mark P. "Archaeology's Relationship to the Present and the Past." In *Modern Material Culture: The Archaeology of Us*, edited by Richard A. Gould and Michael B. Schiffer. New York: Academic Press (1981).

————. "The Relationship Between Artifacts and the Public in Outdoor History Museums." In *The Research Potential of Anthropological Museums Collections*, edited by Anne-Marie E. Cantwell, James B. Griffin, and Nan A. Rothschild. New York: New York Academy of Sciences (1981).

————. "Method as Message: Interpreting the Past with the Public." *Museum News* 62, no. 1 (October 1983), 35–44.

Lewis, Wilmarth Sheldon. *Horace Walpole*. New York: Pantheon Books, 1960.

Lindsay, G. Carroll. "Museums and Research in History and Technology." *Curator* 5 (1962), 236–44.

Little, Bertram K. "Help from Experience in Creating Period Rooms." In *Winterthur Seminar on Museum Operation and Connoisseurship, June 3–7, 1957*. Winterthur, DE: Winterthur Museum, 1957.

Little, Nina Fletcher. "An Expanding Concept of the Period Room." In *Winterthur Seminar on Museum Operation and Connoisseurship, June 3–7, 1957*. Winterthur, DE: Winterthur Museum, 1957.

Lord, Clifford L., ed. *Keepers of the Past*. Chapel Hill: University of North Carolina Press, 1965.

Lord, Clifford L., and Carl Ubbelohde. *Clio's Servant: The State Historical Society of Wisconsin, 1846–1954*. Madison: State Historical Society of Wisconsin, 1967.

Lowe, John. "The Weald and Downland Open Air Museum." *Museums Journal* 72 (June 1972), 9–12.

Lowenthal, David. *The Past Is a Foreign Country*. Cambridge: Cambridge University Press, 1985.

————. "The Place of the Past in the American Landscape." In *Geographies of the Mind: Essays in Historical Geosophy in Honor of John Kirtland Wright*, edited by David Lowenthal and Martyn J. Bowden. New York: Oxford University Press, 1976.

Lowenthal, David. "The American Way of History." *Columbia University Forum* 9 (Summer 1966), 27–32.

Lowther, G. R. "Perspective and Historical Museums." *Museums Journal* 58 (January 1959), 224–28.

Lubar, Steven D. *Engines of Change: An Exhibition on the American Industrial Revolution at the National Museum of American History*. Washington, DC: Smithsonian Institution, 1986.

Lumley, Robert, ed. *The Museum Time-Machine: Putting Cultures on Display*. London and New York: Routledge, 1988.

Lynes, Russell. *The Tastemakers*. New York: Harper, 1954. Reprint. New York: Dover, 1980.

Marzio, Peter C., ed. *A Nation of Nations: The People Who Came to America as Seen Through Objects and Documents Exhibited at the Smithsonian Institution*. New York: Harper and Row, 1976.

Mayer, Brantz. *History, Possessions and Prospects of the Maryland Historical Society.* Baltimore: J. Murphy, 1867.

McCracken, Jane. "The Role of Oral History in Museums." *Canadian Oral History Association Journal* 1 (1975–1976), 34–36.

Meltzer, David J. "Ideology and Material Culture." In *Modern Material Culture: The Archaeology of Us,* edited by Richard A. Gould and Michael B. Schiffer. New York: Academic Press, 1981.

Merrill, Walter M. *New England Treasury of American Beginnings: Essex Institute.* New York: Newcomen Society in North America, 1957.

Merrimack Valley Textile Museum. *The Housing of a Textile Collection.* Merrimack Valley Textile Museum Occasional Reports, no. 1. North Andover, MA: Merrimack Valley Textile Museum, 1968.

Miller, Lillian B., ed. *The Collected Papers of Charles Willson Peale and His Family.* New Haven: Published for the National Portrait Gallery, Smithsonian Institution, by the Yale University Press, 1983, 1988.

Milley, John C., ed. *Treasures of Independence: Independence National Historical Park and Its Collections.* New York: Mayflower Books, 1980.

Modén, A. "Open Air Museums in Sweden." *American Scandinavian Review* 21 (June-July 1933), 341–50.

Molloy, Peter M. *Homespun to Factory Made: Woolen Textiles in America, 1776–1876.* North Andover, MA: Merrimack Valley Textile Museum, 1977.

Montgomery, Charles F. "The Historic House—A Definition." *Museum News* 38 (September 1959), 12–17.

———. "Classics and Collectibles: American Antiques as History and Art." *Art News* 76 (November 1977), 126–36.

Mumford, Lewis. *The Golden Day: A Study in American Experience and Culture.* New York: Boni and Liveright, 1926.

Mystic Seaport Guide. Mystic, CT: Marine Historical Association, 1972.

"Mystic Seaport Museum: Years of Expansion." *Log of Mystic Seaport* 32 (Spring 1980), 25–35.

"Mystic Seaport Museum: Years of Refinement." *Log of Mystic Seaport* 32 (Summer 1980), 64–76.

Nash, Gary B. "Behind the Velvet Curtain: Academic History, Historical Societies, and the Presentation of the Past." *The Pennsylvania Magazine of History and Biography* 114 (January 1990), 3–36.

National Gallery of Art. *An American Sampler: Folk Art from the Shelburne Museum.* Washington, DC: National Gallery of Art, 1987.

Nelson, David T. "Norwegian-American Museum." *Palimpsest* 6 (December 1965), 609–39.

Nelson, Marion J. *Vesterheim: The Norwegian American Museum, Decorah, Iowa.* Decorah: Norwegian American Museum, 1973.

Newark Museum. *A Museum in Action, Presenting the Museum's Activities.* Newark: Newark Museum, 1944.

———. *A Survey: Fifty Years.* Newark: Newark Museum, 1959.

Nicholson, Thomas D. "The University of Nebraska State Museum—A Century of Growth." *Curator* 14 (1971), 308–24.

Parker, Arthur Caswell. *A Manual for History Museums.* New York: Columbia University Press, 1935. Reprint: New York: AMS Press, 1966.

Parker, Franklin. "George Peabody and the Peabody Museum of Salem." *Curator* 10 (June 1967), 137–53.

Parr, Albert E. "Dimensions, Backgrounds, and Uses of Habitat Groups." *Curator* 4 (1961), 199–215.

———. "Habitat Group and Period Room." *Curator* 6 (1963), 325–36.

Patterson, Jerry E. *The City of New York: A History Illustrated from the Collections of the Museum of the City of New York*. New York: Harry N. Abrams, 1978.

Perrin, Richard W.E. *Outdoor Museums*. Publications in Museology, no. 4. Milwaukee: Milwaukee Public Museum, 1975.

Piggott, Stuart. *Ruins in a Land Scape: Essays in Antiquarianism*. Edinburgh: University Press, 1976.

Pilgrim, Dianne H. "Inherited from the Past: The American Period Room." *American Art Journal* 10 (May 1978), 4–23.

Post, Robert C., ed. *1876: A Centennial Exhibition*. Washington, DC: Smithsonian Institution, 1976.

Pott, Peter. "The Role of Museums of History and Folklore in a Changing World." *Curator* 6 (1963), 157–70.

Priestly, John. "An American Seminar on the Open Site Museum." *"Museums Journal"* 73 (June 1973), 7–10.

Quimby, Ian M. G. "Yankee Ingenuity Is Alive and Well in Maine: An Exhibition Review." *Winterthur Portfolio* 21, no. 2/3 (Summer-Autumn 1986), 185–97.

Quimby, Maureen O'Brien. *Eleutherian Mills*. Greenville, DE: Hagley Museum, 1977.

Rath, Frederick L., Jr., and Merrilyn Rogers O'Connell, eds. *A Bibliography on Historical Organization Practices*, compiled by Rosemary S. Reese. 6 vols. Nashville, TN: American Association for State and Local History, 1975.

Rehnberg, Mats. *The Nordiska Museet and Skansen: An Introduction to the History and Activities of a Famous Swedish Museum*, translated by Alan Tapsell. Stockholm: Nordiska Museet, 1957.

Richards, Charles R. *The Industrial Museum*. New York: Macmillan, 1925.

Riley, Edward Miles. *Independence National Historical Park, Philadelphia, Pa.* Historical Handbook Series, no. 17. Rev. ed. Washington, DC: National Park Service, U.S. Department of the Interior, 1956.

Riley, Stephen T. *The Massachusetts Historical Society, 1791–1959*. Boston: Massachusetts Historical Society, 1959.

Rivière, Georges Henri. "Role of Museums of Art and of Human and Social Sciences." *Museum* 25 (1973), 26–44.

Russell, Loris S. "Problems and Potentialities of the History Museum." *Curator* 6 (1963), 341–49.

Rybicki, Alexander. "Open Air Museums: A Strange Collector." *Poland* 10 (October 1966), 40–45.

St. George, Robert B. *The Wrought Covenant: Source Material for the Study of Craftsmen and Community in Southeastern New England, 1620–1700*. Brockton, MA: Brockton Art Center-Fuller Memorial, 1979.

Schechner, Richard. "Restoration of Behavior." *Studies in Visual Communication* 7 (Summer 1981), 2–45.

Schlebecker, John T. *The Past in Action: Living Historical Farms*. Washington, DC: Living Historical Farms Project, Smithsonian Institution, 1967.

————. *Living Historical Farms: A Walk into the Past*. Washington, DC: Smithsonian Institution, 1968.

Schlebecker, John T., and Gale E. Peterson. *Living Historical Farms Handbook*. Washington, DC: Smithsonian Institution Press, 1972.

Schlereth, Thomas J. *Artifacts and the American Past*. Nashville, TN: American Association for State and Local History (1980).

————. "Causing Conflict, Doing Violence." *Museum News* 63 (October 1984), 45–52.

————. "Contemporary Collecting for Future Recollecting." *Museum Studies Journal* 1 (Spring 1984), 23–30.

————. "Historic Houses as Learning Laboratories: Seven Teaching Strategies." American Association for State and Local History Technical Leaflet, no. 105. *History News* 33 (April 1978), insert.

————. "The Historic Museum Village as a Learning Environment." *Museologist* 141 (June 1977), 10–17.

————. "It Wasn't That Simple." *Museum News* 56 (January February 1978), 36–44.

————. "Material Culture Studies and Social History Research." *Journal of Social History* 16 (Summer 1983), 111–43.

————, ed. *Material Culture Studies in America*. Nashville, TN: American Association for State and Local History, 1982.

————, ed. *Material Culture: A Research Guide*. Lawrence: University of Kansas Press, 1985.

————. *Cultural History and Material Culture: Everyday Life, Landscapes, Museums*. Ann Arbor, MI: UMI Press, 1990.

Schnechner, Richard. "Restoration of Behavior." *Studies in Visual Communication* 7 (Summer 1981), 2–45.

Schwartz, Alvin. *Museum: The Story of America's Treasure Houses*. New York: Dutton, 1967.

Schwartz, Marvin D. *American Interiors, 1675–1885: A Guide to the American Period Rooms in the Brooklyn Museum*. Brooklyn: Brooklyn Institute of Arts and Sciences Museum, 1968.

Seale, William. *Recreating the Historic House Interior*. Nashville, TN: American Association for State and Local History, 1979.

Sellers, Charles Coleman. *Charles Willson Peale*. New York: Charles Scribner's Sons, 1969.

————. *Mr. Peale's Museum: Charles Willson Peale and the First Popular Museum of Natural Science and Art*. New York: W. W. Norton, 1980.

Sherman, Claire Richter, and Adele M. Holcomb, eds. *Women as Interpreters of the Visual Arts, 1820–1979*. Contributions in Women's Studies, no. 18. Westport, CT: Greenwood Press, 1981.

Short, James R. "Comments on Museums and Agricultural History." *Agricultural History* 46 (January 1972), 129–34.

Silk, Gerald, et al. *Automobile and Culture*. New York: Harry N. Abrams, Publishers, 1984.

Skramstad, Harold K., Jr. "Interpreting Material Culture: A View from the Other Side of the Glass." In *Material Culture and the Study of American Life*, edited by Ian M. G. Quimby. New York: W. W. Norton, 1978.

Smith, Barbara Clark. *After the Revolution: The Smithsonian History of Everyday Life in the Eighteenth Century*. New York: Pantheon Books, 1985.

Smith, David C. "From Stump to Ship." *History News* 41, no. 4 (July-August 1986), 25–28.

Smith, James Steel. "The Museum as Historian." *San Jose Studies* 2 (1976), 46–56.

Snyder, B. "Upper Canada Village." *Canadian Antiques and Art Review* 2 (February 1981), 38–41.

Stauffer, Florence S. "Conner Prairie Pioneer Settlement: A Living Museum." *Early American Life* 9 (February 1978), 38–41, 54.

Stevens, Mary Lynn. "Wistful Thinking: The Effect of Nostalgia on Interpretation." *History News* 36 (December 1981), 10–13.

Stillinger, Elizabeth. *The Antiquers: The Lives and Careers, The Deals, The Finds, The Collections of the Men and Women Who Were Responsible for The Changing Taste in American Antiques, 1850–1930.* New York: A. A. Knopf, 1980.

Stone, Lawrence. *The Past and the Present.* Boston and London: Routledge and Kegan Paul, 1981.

Swank, Scott T. "Period Rooms: A Museum Controversy." *The 31st Annual Washington Antiques Study* catalogue (January 1986), 8–12.

Sweeney, John A. H. *The Treasure House of Early American Rooms.* New York: Viking Press, 1963.

———. "The Evolution of Winterthur Rooms." *Winterthur Portfolio* 1 (1964), 106–20.

Talbot, George. *At Home: Domestic Life in the Post-Centennial Era, 1876–1920.* Madison: State Historical Society of Wisconsin, 1976.

Taylor, Francis Henry. *Babel's Tower: The Dilemma of the Modern Museum.* New York: Columbia University Press, 1945.

———. *The Taste of Angels: A History of Art Collecting from Rameses to Napoleon.* Boston: Little, Brown, 1948.

Taylor, Lonn, ed. *A Common Agenda for History Museums: Conference Proceedings.* Nashville, TN: American Association for State and Local History; Washington, DC: Smithsonian Institution, 1987.

Thomas, Samuel W., and James C. Thomas. *The Simple Spirit: A Pictorial Study of the Shaker Community at Pleasant Hill, Kentucky.* Harrodsburg, KY: Pleasant Hill Press, 1973.

Tice, Patricia M. *Gardening in America, 1830–1900.* Rochester, NY: Margaret Woodbury Strong Museum, 1984.

Tilden, Freeman. *Interpreting Our Heritage: Principles and Practices for Visitor Services in Parks, Museums, and Historic Places.* 3d ed. Chapel Hill: University of North Carolina Press, 1977.

Tise, Larry E. "Organizing America's History Business: A New Ethic and Plan of Action." *History News* 43, no. 2 (March-April 1988), 17–27.

Toulson, Shirley. *Discovering Farm Museums and Farm Parks.* Aylesbury, England: Shire Publications, 1977.

Trent, Robert F. *Hearts and Crowns: Folk Chairs of the Connecticut Coast, 1720–1840, as Viewed in the Light of Henri Focillon's Introduction to Art Populaire.* New Haven, CT: New Haven Colony Historical Society, 1977.

Ubbelohde, Carl. "The Threshold of Possibilities—The Society, 1900–1955." *Wisconsin Magazine of History* 39 (Winter 1955–1956), 76–88.

Uldall, Kai. "Open Air Museums." *Museum* 10 (1957), 68–96.

U.S. Commissioner of Education. *Public Libraries in the United States of America:*

Their History, Condition and Management; a Special Report of the U.S. Commissioner of Education, Washington, DC: U.S. Office of Education, 1876. Reprint. Totowa, NJ: Rowman and Littlefield, 1971.

Upward, Geoffrey C. *A Home for Our Heritage: The Building and Growth of Greenfield Village and Henry Ford Museum, 1929-1979*. Dearborn, MI: Henry Ford Museum Press, 1979.

Vail, Robert William Glenroie. *Knickerbocker Birthday: A Sesquicentennial History of the New-York Historical Society, 1804-1954*. New York: New-York Historical Society, 1954.

Van Ravenswaay, Charles. *The Story of Old Sturbridge Village*. New York: Newcomen Society in North America, 1965.

Van Tassel, David D. "From Learned Society to Professional Organization: The American Historical Association, 1884-1900." *American Historical Review* 89 (1984), 929-56.

————. *Recording America's Past: An Interpretation of the Development of Historical Studies in America, 1607-1884*. Chicago: University of Chicago Press, 1960.

Veblen, Thorstein. *The Theory of the Leisure Class: An Economic Study of Institutions*. New York: Mentor, 1953. c. 1912.

Vlach, John Michael. *The Afro-American Tradition in Decorative Arts*. Cleveland: Cleveland Museum of Art, 1978.

Wadsworth Atheneum. *The Great River: Art and Society of the Connecticut Valley, 1635-1820*. Hartford: Atheneum, 1985.

Wainwright, Nicholas B. *One Hundred and Fifty Years of Collecting by the Historical Society of Pennsylvania, 1824-1974*. Philadelphia: Historical Society of Pennsylvania, 1974.

Walden, Ian. "The Large Scale Removal of Museum Specimens." *Museums Journal* 71 (March 1972), 157-60.

Wall, Alexander J. "A Village Anniversary." *New-England Galaxy* 8 (Winter 1967), 53-56.

Wallace, Michael. "Visiting the Past: History Museums in the United States." *Radical History Review* 25 (October 1981), 63-96.

————. "Industrial Museums and the History of Deindustrialization." *Public Historian* 9, no. 1 (Winter 1987).

————. "Mickey-Mouse History: Portraying the Past at Disneyworld." *Radical History Review* 32 (March 1985).

Ward, Barbara McLean. " 'After the Revolution' and 'New and Different'—Exhibitions at the National Museum of American History, Washington, D.C." *Technology and Culture* 29 (July 1988), 613-18.

Way, Ronald L. *The Day of Crysler's Farm, November 11, 1813*. Morrisburg, Ontario: Ontario-St. Lawrence Development Commission, 1968.

Weinland, Thomas P. "Teaching History in Three-D: The History Museum as Educator." *Connecticut Antiquarian* 30 (January 1978), 11-16.

Weyns, Josef. "Bokrijk: The First Open-Air Museum in Belgium." *Museum* 12 (1959), 18-22.

The White House: An Historic Guide. 11th rev. ed. Washington, DC: White House Historical Association, 1973.

Whitehill, Walter Muir. *Independent Historical Societies: An Enquiry Into Their*

114 The Museum

Research and Publication Functions and Their Financial Future. Boston:
 Boston Athenaeum, 1962.
————. *Dumbarton Oaks: The History of a Georgetown House and Gardens, 1800–
 1966.* Cambridge: Belknap Press of Harvard University Press, 1967.
————. *Museum of Fine Arts, Boston: A Centennial History.* 2 vols. Cambridge:
 Belknap Press of Harvard University Press, 1970.
————. "Local History Makes Good—Sometimes." *American Heritage* 23 (August
 1972), 36–41.
Whitehill, Walter Muir, Clifford K. Shipton, Louis Leonard Tucker, and Wilcomb
 E. Washburn. "History of Museums in the United States." *Curator* 8 (1965),
 5–54.
Williams, Susan. *Savory Suppers and Fashionable Feasts: Dining in Victorian Amer-
 ica.* New York: Pantheon Books in association with the Strong Museum, 1985.
Willis, Jill R., and John A. Veverka, eds. *Malabar Farm: An Interpretive Planning
 Process.* Columbus, OH: School of Natural Resources, Ohio State University,
 1977.
Witteborg, Lothar P. "Design Standards in Museum Exhibits." *Curator* 1 (January
 1958), 29–41.
Woodward, Arthur. "Miniature Historical Dioramas: Their Construction and Use."
 Museum News, December 1, 1939, 8–10.
Wroth, Lawrence C. *The Walpole Society: Five Decades.* N.p.: Walpole Society,
 1960.

THE FOLK MUSEUM

Elizabeth M. Adler

HISTORIC OUTLINE

Eighteenth-century Europe underwent vast social changes largely brought
about by the industrial revolution. The upper classes, attempting to escape
from the increasing stresses of industrialization and pressures from a de-
veloping middle class, re-created their view of the "simple peasant life" by
building rustic cottages in their parks. Marie Antoinette (1755–1793) and
her court at Versailles mimicked peasants by creating the Petit Trianon.
Charles von Bonstetten proposed moving a group of rural buildings into a
Danish royal castle's park for study.

 Scandinavian reactions to the industrial evolution combined European
romanticism with northern rationalism in the collection and interpretation
of folk materials. By the nineteenth century, interest in the traditions and
customs of Sweden led to the systematic collection of folksongs and melodies.
Some of the local societies that investigated and preserved antiquities in the
1850s and 1860s evolved into provincial cultural history museums, one as
early as 1867. By 1870, members of special university societies were studying
local languages and oral traditions. One linguist and historian was the Swed-
ish scholar Artur Hazelius (1833–1901). Worried about the uniform, bland
culture apparently resulting from the industrial revolution, Hazelius began
collecting vernacular materials from craftsmen and peasants. His collection
formed the basis of the Museum of Scandinavian Folklore, which opened
in 1873 in Stockholm and six years later changed its name to the Nordiska
Museet. One commentator portrayed this museum pioneer as a patriot who

loved his homeland, a pedagogue who used exhibitions to teach, a pragmatist who saw the need to educate through entertainment and activities, and a publicist who, in instituting ethnological research, built a model system of informants and archival records.

A pioneer in museum exhibition techniques, Hazelius staged traditionally costumed figures in period interiors at the World Exhibition in Paris in 1878 and later expanded the period room concept to an entire house. By 1891, a collection of furnished buildings was opened at Skansen, the open-air section of the Nordiska Museet. The first of its type, Skansen established an important precedent for later open-air folk museums by defining a particular geographic region and all its classes of people. Theoretically the buildings had no particular historical interest but represented all walks of life in the region. Today Skansen's seventy-five acres include a zoo, an amusement park, and a restaurant, in addition to the open-air museum section. The museum hosts concerts, exhibitions, and festivals, as well as craft demonstrations.

A Dane, Bernhard Olsen, met Hazelius and saw his tableaux at the 1878 Paris Exhibition. Olsen modeled the historical section of the 1879 Copenhagen Exhibition on these progressive concepts, including period rooms through which visitors could walk. The enthusiasm aroused at the 1879 exhibition led to the formation of the Danish Folk Museum and encouraged the development of an open-air museum, the Frilandsmuseet, which opened in 1897 and was moved to its current site at Sogenfri in 1901.

Another early Scandinavian museum was founded by a young Norwegian dentist, Anders Sandvig (1861–1950). Disturbed by the disappearing way of life in Norway, Sandvig accepted peasant artifacts as payment for his services. His collection, both donated and purchased, included six houses; by 1904 the Sandvig collection had opened at its current location in Maihaugen.

There are now many other open-air and folklife museums in Europe and Scandinavia, such as the Schleswig-Holstein Open-Air Museum near Kiel and the Den Gamle By ("The Old Town"), the first open-air museum devoted solely to town life, in Aarhus, Denmark. The large Village Museum in Bucharest, based on research done by the Bucharest University beginning in the late 1920, consists of nearly 291 buildings grouped into sixty-two visible units according to their ethnographic and geographic provenance. All of these museums owe their origin to the vision of Arthur Hazelius.

Open-air museums gained acceptance at a much later date in Great Britain than in Scandinavia, although the need for national collections of folklife was mentioned in the Final Report of the Royal Commission on National Museums and Galleries as early as 1929. Two noteworthy pioneer attempts failed. In the late 1800s, Egyptologist Sir Flinders Petrie suggested a museum portraying the natural and cultural history of the British Isles, and in 1912 an effort was made to utilize the Crystal Palace as a British folk museum.

As in Scandinavia, the museums that were eventually founded in Great

Britain were primarily the work of individuals. Scottish historian I. F. Grant collected Highland artifacts and recorded everyday life, efforts that resulted in the opening of a small museum at Iona in 1936. Today, the Highland Folk Museum (now at Kingussie) contains a reconstructed black house from the Isle of Lewis, a farming museum, and arts, crafts, and furniture exhibitions. In 1938, William Cubbon created the Manx Museum on the Isle of Man, using an innovative approach in which buildings remained in situ at one end of a small village rather than being moved to the site.

In 1946, the Welsh Folk Museum (Amgueddfa Werin Cymru) of the National Museum of Wales opened at St. Fagans. Following a now-established pattern for open-air museum layout, it consists of an orientation building displaying the life and culture of Wales and an open-air section presenting the evolution of Welsh society over several hundred years. Numerous other open-air and folklife museums have opened in the British Isles since 1946. Auchindrain, a farming township in Argyll, Scotland, is an in situ example of Scots life and farming techniques. The Ryedale Folk Museum in Yorkshire; the Manor Farm Museum in Cogges, Oxfordshire; the North of England Open Air Museum in Beamish, Durham; and the Weald and Downland Open Air Museum in Sussex are only a few of the open-air folklife museums in the British Isles today.

The theoretical underpinning of folk museums established in Europe was folklife research. These early museums were founded with the backing of solid institutional research programs that examined regional ethnology with an eye to re-creating and representing the totality of traditional cultures of a particular region. Artur Hazelius and other museum founders were also scholars and researchers, the earliest people to advocate the value of studying a culture in its entirety.

The folk museum tradition has been quite different in the United States. Although there is now a multitude of open-air museums in the United States, none has been established on the national scale and few with the commitment to research and scholarship (often with academic ties to universities or scholarly societies) of the Scandinavian museums. There are, however, a number of similarities between the European open-air folklife museum concept and the open-air museums in the United States. While the majority of these museums in America were not founded with the idea of folklife in mind, by their very nature and their attempt to keep history alive, they have touched on the life of the common person. New social history, in fact, advocates what folklife scholars and regional ethnologists have claimed for years: society can be studied from the bottom up, and the average person is (and was) affected as much by windy weather as by windy politicians.

Like their European counterparts, many of the American open-air museums were originally based on the interests and collections of one or two people. Anders Sandvig or Artur Hazelius would certainly meet their equivalents, at least in collecting, in Albert and Cheney Wells, who during the

1920s and 1930s began to collect artifacts reflecting New England's past. As their collection grew, so did the public's interest, until the brothers found they needed a place to display their artifacts. Following their preference for a natural site suggestive of the collection's original environment, the brothers purchased a 200–acre tract of farmland and forest with the Quinebaug River flowing through it. Here, a typical New England village (circa 1790–1840) was laid out, with a common, houses, church, tavern, stores, shops, and outlying farms. Today the collections of the Wells brothers are part of Old Sturbridge Village in Sturbridge, Massachusetts, an open-air history museum where interpreters and craftspeople inhabit the buildings and a small-scale farm is worked according to the practices of the period.

Most of the open-air museums in the United States, like the European museums that inspired them, are composed of buildings that were carefully dismantled, moved to a museum's grounds, and reconstructed on a new site that simulated the native environment. Ideally these buildings, whether they are shops, barns, houses, or schools, are furnished with artifacts chosen on the basis of careful research to represent furnishings typical of the region and time. Guides, interpreters, craftspeople, actors, or curators are located in each building to answer questions and educate or enlighten visitors.

The Farmers' Museum and Village Crossroads of the New-York State Historical Association, as well as the Fenimore House Museum, follow the pattern of the Scandinavian open-air museums. Visitors to the Farmers' Museum and Village Crossroads, located on the shores of Lake Otsego in Cooperstown, New York, enter through an introductory orientation center and exit into the outdoor village. The Farmers' Museum, located in a large stone dairy barn, shows upstate New York life from just after the American Revolution to just before the Civil War. Visitors see period farming equipment, crafts and working craftsmen, and regional social life and work. The Village Crossroads, a composite of structures moved to the site, includes a tavern, offices and shops, a church, a school, and a small farm. Interpreters and craftsmen are available to answer questions.

Perhaps the best known open-air museum in the United States is Colonial Williamsburg in Virginia, which re-creates the environment of eighteenth-century Williamsburg. In 1926, the Reverend W. A. R. Goodwin and John D. Rockefeller, Jr., collaborated on beginning the restoration, renovation, and reconstruction of the decaying buildings of Williamsburg. The city and surrounding tidewater area were scrutinized by historians, archaeologists, architects, and other researchers in search of architectural types, structural details, and furnishings. Today attempts are made to depict all walks of life at Williamsburg, including that of the slaves and servants, who made up a large portion of the population.

While Old Sturbridge Village, the Farmers' Museum and Village Crossroads, and Colonial Williamsburg have closely followed the Scandinavian open-air museum pattern, more recent American museums have added new

dimensions to the open-air museum concept. The older museums typically have an introductory display, often in a separate, modern building, which orients visitors to the museum site and period using exhibitions, maps, or oral presentations. Frequently an adjunct restaurant or eating area, as well as craft and sales shops, are present. Some farm animals are present in most American open-air museums, but none of the museums has a zoological park comparable in scale to Skansen's. The newer outdoor museums, including Old World Wisconsin Living History Farms and Plimoth Plantation, have departed from the European model by presenting more complex historical themes and stressing visitor involvement.

One of the newest and most innovative fold museums is the State Historical Society of Wisconsin's Old World Wisconsin at Eagle. In an effort to represent Wisconsin's diverse ethnic heritage, Old World Wisconsin presents examples of the types of farmsteads developed by Dutch, German, Yankee, Belgian, Irish, Danish, Finnish, Swiss, Norwegian, Scots, Cornish, Welsh, English, and East and Central European groups who settled in the state. An introductory visitors' center and a rural village complete the layout of this ambitious open-air museum.

The Conner Prairie Pioneer Settlement at Noblesville, Indiana, is a single village depicting rural central Indiana life in 1836, including schools, shops, farms, and homes. The interpreters at this museum play the roles of characters who might have lived in a similar village in 1836. Living History Farms, near Des Moines, Iowa, is actually three farm museums (an 1840s homestead and trading post, a turn-of-the-century farm, and a farm of the future), Walnut Hill, a partially reconstructed Iowa town of 1870, and a reconstructed Iowa Indian village of 1700. The museum is particularly interesting for its research in pioneer agriculture.

Plimoth Plantation is a re-creation of Plymouth Colony, established by the Pilgrims in 1620 in Massachusetts. Visitors to Plimoth are encouraged to experience the life of the Pilgrims; the furnishings in the buildings are reproductions rather than actual museum pieces, and people sometimes actually live on the site in the style of the early settlers and Indians.

SURVEY OF SOURCES

Douglas Allen's "Folk Museums at Home and Abroad" (1956), though dated, remains a useful survey of European and American folk museums and contains information on such classic museums as Skansen, Maihaugen, Frilandsmuseet, the Welsh Folk Museum, and the Farmers' Museum, as well as lesser-known museums like the Museum of English Rural Life at Reading and the West Yorkshire Folk Museum at Halifax. In addition to his overview of museums, Allen discusses the emergence of the concept of folk museums and their function and purpose, concluding with a number of photographic plates.

J. W. Y. Higgs's classic work, *Folk Life Collection and Classification* (1963), concentrates on the more technical aspects of the subject but nevertheless contains thoughtful comments on the origins and history of folk museums and folklife collections in Europe. His observations on the efforts of the European nobility to "rusticate and simplify" their lives during the eighteenth century are particularly insightful.

Outdoor Museums (1975) by Richard W. E. Perrin is probably the most recent survey of folk museums. A consolidation of a series of articles originally published in the Milwaukee Public Museum's *Lore*, the work introduces museums in Europe and America and is illustrated with photographs by the author. Written when Old World Wisconsin was being planned, the book devotes an entire chapter to "An Outdoor Museum for Wisconsin." Perrin's style is easy to read, and much of the material is apparently based on his own experiences. Although useful as an introduction to a number of outdoor museums, the book presents no new background concepts or information and suffers from a lack of scholarly annotations.

The best way to learn about folk museums (aside from visiting them) is to study the guides to some of the better-known facilities. Since Scandinavian museums were in the forefront of the outdoor museum movement, almost obligatory mention is made of Skansen in every book or article dealing with outdoor museums. The most useful source is Mats Rehnberg's *The Nordiska Museet and Skansen* (1957). Rehnberg covers not only the background and history of the museums but also the facilities and programs, and he includes photographs of the collections. Several articles discuss the life and work of Artur Hazelius, the founder of the Nordiska Museet and Skansen. The most complete treatment (in English) is Nils-Arvid Bringéus's "Artur Hazelius and the Nordic Museum" (1974). In "A Great Museum Pioneer of the Nineteenth Century (1964)," Bo Lagercrantz discusses the similarities of Hazelius's philosophy to that of John Ruskin an the leaders of the English arts and crafts movement. The author notes that Hazelius's interest in preserving the traditional handcrafts of Sweden paralleled Ruskin and Morris's interest in reviving handcrafts in England. Also useful is Edward P. Alexander's recent biographical portrait of Hazelius in *Museum Masters* (1983).

Norway's first outdoor museum, Maihaugen, is well represented in museum literature. Thale Gjessing's *The Sandvig Collections Guide* (1949) provides a brief introduction to the history of the museum and grounds; *The Sandvig Collections: Guide to the Open Air Museum* (1963) by Fartein Valen-Sendstad updates and completes the study. The entire range of handcrafts is highlighted in *The Sandvig Collections: Guide to the Handicraft Section* (1951) by Sigurd Grieg and G. A. Norman. All three books are primarily descriptive guides.

The Dansk Folkemuseum and the Frilandsmuseet, departments of the National Museum of Denmark established to shed light on 300 years of Danish cultural history to roughly 1650, are described in *Dansk Folkemu-*

seum & *Frilandsmuseet* (1966), edited by Holger Rasmussen. See particularly
the chapter by Rasmussen, "The Origin and Development of the Danish
Folk Museum." *The Dansk Folkemuseum & Frilandsmuseet*, a collection of
scholarly articles by various experts, is a treasure trove of information, and
specific chapters will be referred to in later contexts. The Frilandsmuseet,
the open-air portion of the Danish National Museum, is depicted in *Fri-
landsmuseet: The Danish Museum at Sogenfri: A History of an Open-Air
Museum and Its Old Buildings* (1973) by Peter Michelsen. *Frilandsmuseet*
is a well-executed guide to the museum and its collections, with numerous
color photographs enhancing the text and placing the buildings in a visual
and descriptive context. Michelsen also contributed "The Origin and Aim
of the Open-Air Museum" (1966), an introduction to the Frilandsmuseet,
to *Dansk Folkemuseum & Frilandsmuseet*.

The unique concept of an urban open-air museum such as Den Gamle
By (The Old Town) in Aarhus, Denmark, is mentioned in a number of general
articles, including Allen's, and is featured in Peter Holm's "The Old Town:
A Folk Museum in Denmark" (1937). Regional and local folk museums in
the Netherlands are discussed in "Regional Ethnography Museums" (1962)
by A. J. Bernet Kempers. This survey is not limited to open-air museums
but treats all museums that preserve traditional artifacts. Kempers presents
the museums in a straightforward manner with illustrations, relating the
collections to regional ethnology. "The Open-Air Ethnographic Museums
in Belgium" (1966), an article by K. C. Peeters, illustrates the development
of folk museums in another European nation. Alfred Kamphausen's *Schles-
wig-Holsteinisches Freilichtmuseum: ein Bildband* (1975) contains a thorough
introduction to this open-air museum, which opened in 1965 with thirteen
dwellings. The author gives good explanations and diagrams of the various
types of architecture at the museum, provides information on other open-
air museums, and imparts his philosophy of museum visitation, noting the
importance of experience and creative observation to the visitor. *The Village
Museum in Bucharest* (1967) by Gheorghe Focsa describes an open-air mu-
seum based on research in Rumania's principal areas of ethnographic interest
since 1948. The museum's 291 genuine structures are grouped into sixty-
two units reassembled on the site.

Many of the folk and open-air museums in Great Britain are listed in
Shirley Toulson's *Discovering Farm Museums and Farm Parks* (1977). Toul-
son begins this dandy little compendium by discussing farming in Britain,
including livestock, buildings, tools and implements, and crafts. Pictures
from various museums are included. The information for each museum listed
in the gazetteer includes a statement about the nature of the collection, the
location of the museum, visitation hours, and telephone number. Higgs, in
Folk Life Collection and Classification (1963), devotes two chapters to folklife
museums and collections in Great Britain. One of the best known of these,
the Welsh Folk Museum, St. Fagans, is described and pictured in the

Handbook/National Museum of Wales, Welsh Folk Museum, St. Fagans
(1955) by the National Museum of Wales. Iorwerth C. Peate describes the
background of this museum in "The Welsh Folk Museum" (1965). One of
the more notable but less-known folk museums, the Auchindrain Museum
of Country Life in Argyll, Scotland, is the site of an abandoned farming
village, which is being restored as a living farm museum. In *A Farming
Township: Auchindrain, Argyll* (1979), Scottish folklorist Alexander Fenton
discusses the background of the buildings and farm life in rural Argyll. The
Ulster Folk Museum at Cultra Manor, Ireland, is briefly introduced by E.
Estyn Evans in "Folklife Studies in Northern Ireland" (1965) and by George
B. Thompson in "Estyn Evans and the Development of the Ulster Folk
Museum" (1970). The bibliographic checklist at the end of this chapter
includes references to many other folk and outdoor museums in Great Brit-
ain.

Although the folk and outdoor museum movement got a relatively late
start in the United States, major museums are now well represented in
available literature and guides. Perrin's *Outdoor Museums* (1975) includes
lengthy chapters on museums in the United States, and the Association for
Living Historical Farms and Agricultural Museums' *Selected Living Histor-
ical Farms, Villages, and Agricultural Museums in the United States and
Canada* (1976), edited by Darryl Chase, is a useful list. *Art in America*
devoted an entire issue to restoration villages in May 1955, edited and
introduced by Abbott Cummings, and Nicholas Zook's *Museum Villages,
U.S.A.* (1971) orders museums (including many folk museums) historically,
chronologically, and alphabetically by state.

Like their counterparts overseas, American museums have published il-
lustrated guidebooks describing their history, contents, and goals. The mu-
seum complex at Cooperstown is described in Louis C. Jones's "The
Cooperstown Complex" (1959), an introduction to the special issue of *An-
tiques* illustrating the Cooperstown collection of crafts, buildings, textiles,
sculpture, country furniture, painted decorations, and paintings, including
fine and folk art. The New York State Historical Association edited a more
complete guide, *The New York State Historical Association and Its Museums:
An Informal Guide* (1968), which gives the background of the association,
its programs, and its museums, as well as some of the history and information
found in exhibits in the Farmers' Museum, Fenimore House, and the now
defunct Carriage and Harness Museum.

The history of Old Sturbridge Village is recounted in Catherine Fennelly's
Old Sturbridge Village: A Guidebook (1966), which discusses the individual
buildings and crafts, and in Samuel Chamberlain's *A Tour of Old Sturbridge
Village* (1972), which gives a photographic tour of the museum with a brief
description of the collection. The history, architecture, and plan of Colonial
Williamsburg are summarized in *Colonial Williamsburg, Its Buildings and
Gardens* (1976) by Lawrence Kocher and Howard Dearstyne. A more de-

tailed historical account can be found in Charles Hosmer's *Preservation Comes of Age* 1981. One of the most concise introductions to Williamsburg's outstanding folk art collection is Beatrix Rumford's *The Abby Aldrich Rockefeller Folk Art Collection: A Gallery Guide* (1975), which discusses its background, defines American folk art, and presents various folk art forms contained in the collection through color illustrations. *Greenfield Village and the Henry Ford Museum* (1972) and *Folk Art and the Street of Shops/Henry Ford Museum* (1971), both by the Henry Ford Museum and Greenfield Village, are guides to the Dearborn, Michigan, museum complex.

Perrin's *Outdoor Museums* (1975) devotes an entire chapter to Old World Wisconsin, an outdoor museum representing the ethnic groups that settled in Wisconsin. A prospectus for the museum, *Old World Wisconsin: An Outdoor Ethnic Museum* (1973) by the State Historical Society of Wisconsin, contains information on the background of Wisconsin's pioneers, the birth of the idea for the museum, the site and the plans for the museum, and some of the buildings to be located on the grounds. Such insights may be useful as a guide to the development of other museums of this type. Scott Swank's chapter on the history museum in this book contains additional background information on the outdoor history movement in the United States.

Most outdoor museums may be categorized as folk museums because they use artifacts to represent traditional cultures and ways of life, often in simulated natural contexts. There are, however, a number of museums that display folk art collections in the manner of fine art, installed in a gallery or exhibit hall rather than in a real or contrived natural setting. The Museum of American Folk Art in New York City is an example, and its publication, *The Clarion: America's Folk Art Magazine*, contains scholarly articles on items in the museum's collection and on special exhibitions. Another periodical, *El Palacio*, devoted an entire issue, entitled "Museum of International Folk Art Issue" (1953) and edited by Paul Walter and Arthur Anderson, to the Museum of International Folk Art in Santa Fe, New Mexico. Other museums also publish special exhibition catalogs or catalogs of their collections; some of these are annotated in Elizabeth Mosby Adler's "Collectors and Museums" (1984), a chapter in Simon J. Bronner's *American Folk Art: A Guide to Sources* (1984).

Readers interested in folklife research in the folk museum setting should begin with the writings of Hazelius, Sandvig, and other founders of early European folk museums. Siguard Erixon, in "Regional European Ethnology, I. Main Principles and Aims with Special Reference to Nordic Ethnology" (1937) and in "An Introduction to Folklife Research or Nordic Ethnology" (1950–1951), expounds on the importance of studying the total culture by comparing regional ethnology to other academic disciplines. Erixon implies that the representation of the total culture is the basis of the folklife museum, thus providing a theoretical core of folk museum philosophy.

Similar ideas were also expressed in Great Britain by geographer-anthropologist-zoologist Herbert John Fleure of the University of Wales, Aberystwyth. In his compendium, *A Natural History of Man in Britain* (1951), Fleure stresses that folk museums of national culture must collect and store material before it is lost to future generations. This theme runs throughout the establishment of folk museums beginning with Hazelius's attempt to preserve a disappearing way of life at Skansen and Sandvig's similar attempt at Maihaugen. Fleure's influence is evident in the work of his students, Iorwerth C. Peate of the Welsh Folk Museum, St. Fagans, and E. Estyn Evans of the Ulster Folk Museum. Peate echoes the plea to save culture in "The Study of Folk-Life and Its Part in the Defence of Civilization" (1958–1959), noting that "barbarism" is on the rise and traditions and languages are being lost as Western society disintegrates. He implies that folk museums can rescue "culture" before it is too late.

One of the best summaries of the theory behind folk museums is Don Yoder's "The Folklife Studies Movement" (1963). Yoder traces the European roots of the term *folklife* and discusses the term *folklife research*. He notes that the open-air museum is one of four institutions of folklife research in Europe, and the museum is usually an adjunct to a research library, archives, or institute. The importance of museum-sponsored research is stressed in Norbert F. Riedl's "Folklore and the Study of Material Aspects of Folk Culture" (1966). Riedl questions the emphasis of American folk museums on public education at the expense of solid folk cultural research.

The movement of American outdoor museums toward an emphasis on folklife and regional folk culture is presented in Howard Wight Marshall's "Folklife and the Rise of American Folk Museums" (1977). This article not only summarizes the background of folklife research and the folk museum movement but also discusses the common-man orientation of many modern outdoor museums, stressing the importance of accurate interpretation and presentation. Some of the types of research and presentations done by specific museums in the United States are mentioned in "Folklore Research and Museums" (1983) by Willard B. Moore. Moore lists potential research categories, such as architecture, folk art, and sports traditions, and discusses museums that have already utilized their research in these areas.

There are numerous resources on museum organization available to persons interested in founding a folk museum. Ormond H. Loomis, in "Organizing a Folklore Museum" (1983), succinctly summarizes various areas of concern, including goals, financing, donors, physical form, collections, administrative problems, staffing needs, educational programs, and curatorial concerns. Loomis's extensive bibliography, "Sources on Folk Museums and Living Historical Farms" (1977), is an invaluable guide not only to organization but also to methods, techniques, activities, and descriptive works on museums around the world.

Two general museum works, UNESCO's *The Organization of Museums*

(1960) and G. Ellis Burcaw's *Introduction to Museum Work* (1975), contain valuable practical advice for folklife museum professionals. Kai Uldall's "Open Air Museums" (1957) is particularly useful in its background of outdoor museums and summaries of where to situate the museum, how to move buildings, and other specific problem areas. The technical aspects are also detailed in Holger Rasmussen's *Dansk Folkemuseum & Frilandsmuseet* (1966), which specifically addresses problems related to the expertise of the staff at the Danish museums. The *Living Historical Farms Handbook* (1972) by John T. Schlebecker and Gale E. Peterson is a valuable guide to starting this type of museum; it supplies hints on the type of farm to have, incorporating the museum, selecting the site, the duties of a qualified director, financing, research resources, staff, equipment, visitors and interpretation, capital and operating expenses, and anticipated income. The book also summarizes the living historical farms and museums movement and contains a directory of historical farms and museums by state.

Since folklife research, often based on oral and visual sources, is essential to the folklife museum, the literature on fieldwork may be helpful to museum-based professionals working on the collection, exhibition, and display of folk material. The following sources provide an excellent general introduction to the topic: Kenneth Goldstein's *A Guide for Field Workers in Folklore* (1964); Edward D. Ives' *The Tape-Recorded Interview: A Manual for Field Workers in Folklore and Oral History* (1980); and part 2 of Richard M. Dorson's *Folklore and Folklife, an Introduction* (1972), entitled "The Methods of Folklife Study." Also useful is Barbara Allen and W. Lynwood Montell's *From Memory to History: Using Oral Sources in Local Historical Research* (1981). J. Geraint Jenkins has specifically related folklife research to the museum setting and stresses the need for documentation in "Field-Work and Documentation in Folk-Life Studies" (1960) and in "The Use of Artifacts and Folk Art in the Folk Museum" (1972). In the first article, Jenkins discusses (with examples) the use of questionnaires, emphasizes the importance of fieldwork, suggests a workable classification system, and describes good record-keeping systems. In "The Use of Artifacts and Folk Art in the Folk Museum," Jenkins points out that in addition to collection, preservation, and display, the museum has the responsibility to study and research the collection. He illustrates these "four tasks" with examples from the Welsh Folk Museum and other folk museums. *Folk Life Collection and Classification* (1963) by J. W. Y. Higgs uses the collection and classification system of the Museum of English Rural Life at Reading to explicate collecting and classifying folk culture. The appendixes in Higgs's work are particularly useful since they include specimen questionnaires and examples from a dialect survey at Leeds University.

Folk museums often use the methods of archaeologists to illuminate the period they are researching. Archaeology has successfully been used in the United States at Colonial Williamsburg and in Denmark at the Frilands-

museet. In *Invitation to Archaeology* (1967) archaeologist James Deetz clearly explains the "principles, methods, and problems of the present-day archaeologist, whose responsibility it is to uncover, interpret, and understand man's past." Ivor Noël Hume's *Historical Archaeology* (1975) is a guide to "the techniques and methods of excavating historical sites" from the initial planning of the dig to the final report. Noël Hume's useful annotated bibliography covers subjects from architecture to wells and is particularly strong on ceramics, which are presented by type and country. Deetz shows how historical archaeology can help us understand the lives of ordinary people in *In Small Things Forgotten: The Archaeology of Early American Life* (1977), which discusses Anglo- and Afro-American colonial traditions, particularly emphasizing the Plymouth colony. Details and problems of excavating an entire village are discussed in Svend Nielsen's "Village Archaeology" (1966), which presents the research for the Frilandsmuseet and Dansk Folkemuseum, and in Singleton P. Moorehead's "Problems in Architectural Restoration" (1955), which focuses on archaeological work at Colonial Williamsburg.

One of the primary artifactual concerns of open-air folk museums is architecture, and several good books present detailed information on recording, restoring, and moving buildings. Harley J. McKee's profusely illustrated *Recording Historic Buildings* (1970), a statement of the principles and standards of the Historic American Buildings Survey (HABS), includes chapters on "Organizing a Survey," "Measured Drawings," "Photographs and Graphic Material," "Documentation," "Specialized Recording Techniques," and "Catalogs." While McKee stresses academic rather than folk architecture, he nevertheless includes much useful information on documentation and research. *The Restoration Manual: An Illustrated Guide to the Preservation and Restoration of Old Buildings* (1966) by Orin M. Bullock presents an agenda for restoration, including the selection of architects; historical, architectural, and archaeological research; the actual restoration work; specifications for contractors; and maintenance and interpretation. The manual includes a glossary of terms and an appendix of related pertinent articles on measured drawings, photogrammetry, photographic records, masonry restoration, and climate control. Peter Michelsen's "The Investigation of Old Rural Buildings" (1966) and Frode Kirk and Bjarne Stoklund's "Moving Old Buildings" (1966) outline the architectural research and problems entailed in relocating buildings to new sites at the Frilandsmuseet. An extremely useful architectural resource for folk museums, *American Folk Architecture: A Selected Bibliography* (1981) by Howard Wight Marshall, organizes works into five categories: "Theory and General Works," "Antecedents to American Building," "Regional Works," "Museums and Historic Preservation," and "Field Documentation." Although the bibliography is primarily unannotated, it suggests a variety of valuable printed sources.

Although some of the works cited briefly mention collections' care and

preservation, readers should consult Katherine and Philip Spiess's chapter on collections management in this book. Especially useful in the folk museum setting is George Grotz's *The Furniture Doctor* (1962), which contains sound advice on furniture construction, repair, and finishing. Per E. Guldbeck's *The Care of Historical Collections: A Conservation Handbook for the Nonspecialist* (1972), a handy companion for most folk museum workers, should be supplemented by A. Bruce MacLeish's *The Care of Antiques and Historical Collections* (1987).

One of the tasks of the folk museum, like any other museum, is to interpret its collections to the public in an educational and possibly even entertaining manner. The folk museum, and the outdoor museum in particular, is in a unique position to accomplish these goals. It re-creates the context of a representative life-style of its inhabitants and therefore can easily induce the visiting public to participate. While folk museum professionals may agree on some objectives, there is sharp controversy regarding the methods of interpretation and educational programs. Specifically, there is disagreement concerning the use of docents, guides, and interpreters, the role of crafts, the use and type of signs or labels, the inclusion of participatory activities, the sale of reproductions produced at the museum, and the organization of programs and special events.

One of the major criticisms of folk museums is that their representation of reality simplifies and cleanses the past, making it both physically and mentally tidy and conflict free. Thomas J. Schlereth makes this point in "It Wasn't That Simple" (1978), but Daniel B. Reibel, in "In Defense of Historic Sites" (1978), points out the practical reasons for some less-than-accurate representations of the past.

In "The Outdoor Museum and Its Educational Program" (1966), Peter Michelsen discusses the role of outdoor museums in educating adults and children. In "Folklife Museums: Resource Sites for Teaching" (1976–1977), Willard Moore notes that folk museums can be a useful resource at all levels of education. Holly Sidford, in "Stepping into History" (1974), points out the limitations of role playing when the visitor is not provided with adequate background knowledge. Sidford suggests that a properly prepared visitor can gain a great deal from role playing but believes that guided thematic tours, craft demonstrations, and live-in experiences can be equally effective.

Craft demonstrations are often used by outdoor folk museums to depict the way of life of various groups. Peter W. Cook, in "The Craft of Demonstrations" (1974), points out that craft demonstrations can illuminate more than technology by indicating the social and cultural context of the craft and the usage of the resulting product. Cook identifies an ideal crafts program as one that reflects the purpose of the museum while accounting for accurate representation, preservation, interpretation, and other programs. In "Demonstration Crafts at Old Sturbridge Village" (1955), Frank O. Spinney illustrates the types of crafts portrayed at that museum. In "Education through

the Outdoor Museum . . . The Farmers' Museum at Cooperstown" (1955), Louis C. Jones discusses not only the role of crafts in education but also the other school and educational programs that have been developed by the New York State Historical Association. Carlisle H. Humelsine's *Preserving Our Handcrafts: The President's Report* (1968) introduces some of the contemporary crafts demonstrators at Colonial Williamsburg and discusses their backgrounds.

Live-in experiences are being offered by more and more museums. Roger L. Welsch writes of his experiences as both a teacher and a resident in "Very Didactic Simulation: Workshops in the Plains Pioneer Experience at the Stuhr Museum" (1974). Welsch makes useful comments for those interested in this type of program.

The literature on artifact analysis now includes a growing number of articles on the interpretation of folk collections, an important function of the folk museum. Using a seventeenth-century American court cupboard as an example, E. McClung Fleming notes the five properties of an artifact (history, material, construction, design, and function) and suggests a method for studying them through identification, evaluation, cultural analysis, and interpretation in "Artifact Study: A Proposed Model" (1974). Craig Gilborn's "Pop Iconology: Looking at the Coke Bottle" (1970) uses this modern-day artifact to illustrate a study based on description, classification, and interpretation. Although including the same types of information, Gilborn's study is methodologically less complicated than Fleming's. A more personal view of artifacts is provided by George R. Clay in "The Lightbulb Angel: Towards a Definition of the Folk Museums at Cooperstown" (1960). Peter C. Welsh treats the interpretation of folk art exhibitions from different academic perspectives (art museum curator and history/technology curator) in "Folk Art and the History Museum: The Van Alstyne Collection at the Smithsonian Institution" (1967). Welsh points to the need for cultural interpretation of folk art, illustrating his argument with examples drawn from the Smithsonian exhibition, "Art and Spirit of the People." In "Popular Culture and the European Folk Museum" (1981), Kurt Dewhurst and Marsha MacDowell note that many European folk museums include items of popular culture in their collections since twentieth-century distinctions are "indistinct and fluid." Dewhurst and MacDowell suggest three exhibition models currently popular in European folk museums: the self-directed model, the cultural aesthetic model, and the folkloristic model.

There are a number of professional and ethical concerns peculiar to folk museums. The architectural controversy concerning the relative merits of reconstruction, preservation in situ, or removal to a museum site is also of primary interest to folk museum professionals. In discussing the ethical considerations of moving a building to a museum's grounds, Peter Michelsen notes, "It is better to preserve than to repair, better to repair than to restore, better to restore than to reconstruct." In *Historic Preservation Today* (1966),

edited by the National Trust for Historic Preservation and Colonial Williamsburg, several authors comment on preservation, restoration, and reconstruction, including Jacques Dupont ("Viollet-le-Duc and Restoration in France"), Sir John Summerson ("Ruskin, Morris, and the 'Anti-Scrape' Philosophy"), and Peter Michelsen ("The Outdoor Museum and Its Educational Program"). Robin Austin, in comparing Scandinavian and British folk museums in "Scandinavian Folk Museums" (1958), argues that British museums should be in situ rather than re-created parks, and Bo Lagercrantz firmly states, "There is no need for more open-air museums . . . we should . . . preserve old buildings *in situ*," in "A Great Museum Pioneer of the Nineteenth Century" (1964). Robert D. Ronsheim summarizes many of the problems underlying the living history programs often used at folk museums in "Is the Past Dead?" (1974). He points out that craftsmen, artifacts, or interpreters alone cannot accurately represent the past, which he views as a continuum based on a larger cultural perspective, a viewpoint too frequently ignored by museums. Jay A. Anderson's "Immaterial Material Culture: The Implications of Experimental Research for Folklife Museums" (1976–1977) notes that experimental archaeology can help define past cultures. Two innovative research projects at European folklife museums, Butser Hill in England and Lejre in Denmark, have enlarged scholars' knowledge about premedieval life and inspired similar work in the United States, particularly at Plimoth Plantation and Colonial Pennsylvania Plantation.

Professional and ethical concerns of continuing interest to folk museums include the following: the role of folklife research, the protection of sources and informants, the sale and reproduction of artifacts, the dilution of reality, the tension between collecting and displaying the best and representative artifacts, and inadequate funding. Although these issues will not be easily resolved, they are likely to be addressed responsibly in the growing literature of the folk museum.

BIBLIOGRAPHIC CHECKLIST

Adler, Elizabeth Mosby. "Collectors and Museums." In *American Folk Art: A Guide to Sources*, edited by Simon J. Bronner. New York: Garland Publishing, 1984.

Alexander, Edward P. "Comment." In *Historic Preservation Today: Essays Presented to the Seminar on Preservation and Restoration, Williamsburg, Virginia, September 8–11, 1963*, edited by National Trust for Historic Preservation and Colonial Williamsburg. Charlottesville: University Press of Virginia, 1966.

———. *Museums in Motion: An Introduction to the History and Functions of Museums*. Nashville, TN: American Association for State and Local History, 1979.

———. *Museum Masters: Their Museums and Their Influence*. Nashville, TN: American Association for State and Local History, 1983.

Allen, Barbara, and W. Lynwood Montell. *From Memory to History: Using Oral Sources in Local Historical Research*. Nashville, TN: American Association for State and Local History, 1981.

Allen, Douglas. "Folk Museums at Home and Abroad." *Proceedings of the Scottish Anthropological and Folklore Society* 5 (1956), 91–121.

American Association of Museums. *The Official Museum Directory.* Washington, DC: American Association of Museums and National Register Publishing Company, 1985.

American Museum in Britain. *American Museum, Claverton Manor, Bath.* Norwich, England: American Museum, 1975.

Anderson, Jay A. "Immaterial Material Culture: The Implications of Experimental Research for Folklife Museums." *Keystone Folklore* 21 (1976–1977), 1–11. Reprinted in *Material Culture Studies in America*, edited by Thomas J. Schlereth. Nashville, TN: American Association for State and Local History, 1982.

———. "Living History: Stimulating Everyday Life in Living History Museums." *American Quarterly* 34 (Summer 1982), 289–306.

———. "On the Horns of a Dilemma: Identity, Museum Funding, and Administration at the Colonial Pennsylvania Plantation." *Proceedings of the Annual Meeting—Association for Living Historical Farms and Agricultural Museums* 3 (1977), 18–19.

———. *Time Machines: The World of Living History.* Nashville, TN: American Association for State and Local History, 1984.

———. *The Living History Sourcebook.* Nashville, TN: American Association for State and Local History, 1985.

Anderson, Jean. *Recipes from America's Restored Villages.* Garden City, NY: Doubleday, 1975.

Austin, Robin. "Scandinavian Folk Museums." *Museums Journal* 57 (February 1958), 253–57.

Baron, Robert. "Folklife and the American Museum." *Museum News* 59 (March–April 1981), 46–50, 58, 60, 63–64. Reprinted in *Folklife and Museums: Selected Readings*, edited by Patricia Hall and Charlie Seeman. Nashville, TN: American Association for State and Local History, 1987.

Bath, Gerald Horton. *America's Williamsburg: Why and How the Historic Capital of Virginia, Oldest and Largest of England's Thirteen American Colonies, Has Been Restored to Its Eighteenth Century Appearance by John D. Rockefeller, Jr.* Williamsburg: Colonial Williamsburg, 1946.

Bather, F. A. "The Triumph of Hazelius." *Museums Journal* 16 (December 1916), 132–36.

Berg, Gösta. "Reviews: European Open-Air Museums—Adelhart Zippelius, 'Handbuch de europaischen Freilichtmuseen.'" *Ethnologia Scandinavica* (1975), 165–66.

Blue Ridge Institute. *A Travel Guide to Virginia's Back Country Museums.* Ferrum, VA: Blue Ridge Institute, Ferrum College, 1982.

Borchers, Perry E. "Architectural Photogrammetry in Restoration." *Building Research* 1 (September–October 1964), 18–19. Reprinted in *The Restoration Manual: An Illustrated Guide to the Preservation and Restoration of Old Buildings*, by Orin M. Bullock, Jr. Norwalk, CT: Silvermine Publishers, 1966. Reprint. New York: Van Nostrand Reinhold, 1983.

Boucher, Jack E. "Photographic Records in Restoration." *Building Research* 1 (September–October 1964), 25–26. Reprinted in *The Restoration Manual: An Illustrated Guide to the Preservation and Restoration of Old Buildings*, by

Orin M. Bullock, Jr. Norwalk, CT: Silvermine Publishers, 1966. Reprint. New York: Van Nostrand Reinhold, 1983.

Boynton, Edgar B. "Climatic Control in Restored Buildings." *Building Research* 1 (September–October 1964), 37–39. Reprinted in *The Restoration Manual: An Illustrated Guide to the Preservation and Restoration of Old Buildings*, by Orin M. Bullock, Jr. Norwalk, CT: Silvermine Publishers, 1966. Reprint. New York: Van Nostrand Reinhold, 1983.

Bringéus, Nils-Arvid. "Artur Hazelius and the Nordic Museum." *Ethnologia Scandinavica* (1974), 5–16.

Bronner, Simon J., ed. *American Folk Art: A Guide to Sources*. New York: Garland Publishing, 1984.

Buchanan, Ronald H. "A Decade of Folklife Study." *Ulster Folklife* 11 (1965), 63–75.

Bullock, Orin M., Jr. *The Restoration Manual: An Illustrated Guide to the Preservation and Restoration of Old Buildings*. Norwalk, CT: Silvermine Publishers, 1966. Reprint. New York: Van Nostrand Reinhold, 1983.

Burcaw, George Ellis. *Introduction to Museum Work*. Nashville: American Association for State and Local History, 1975.

Callender, Donald W., Jr. "Reliving the Past: Experiment Archaeology in Pennsylvania." *Archaeology* 29 (July 1976), 173–77.

Chamberlain, Samuel. *A Tour of Old Sturbridge Village*. New York: Hastings House, 1972.

Chase, Darryl, ed. *Selected Living Historical Farms, Villages, and Agricultural Museums in the United States and Canada*. Washington, DC: Association for Living Historical Farms and Agricultural Museums, Smithsonian Institution, 1976.

Clay, George R. "The Lightbulb Angel: Towards a Definition of the Folk Museums at Cooperstown." *Curator* 3 (1960), 43–65.

Coleman, Laurence Vail. *Historic House Museums, with a Directory*. Washington, DC: American Association of Museums, 1933. Reprint. Detroit: Gale Research Company, 1973.

Cook, Peter W. "The Craft of Demonstrations." *Museum News* 53 (November 1974), 10–15, 63.

Corceaghina, V. I. "Methods and Techniques of Organization of Open-Air Ethnographic Museums." In *Organization of Open-Air Ethnographic Museums—Principles and Methods*. Bucharest: International Council of Museums, Rumanian National Committee, 1966.

Cummings, Abbott Lowell. "Restoration Villages." *Art in America* 43 (May 1955), 12–13.

De Borhegyi, Stephan F., and Elba A. Dodson, comps. *A Bibliography of Museums and Museum Work, 1900–1960*. Publications in Museology, no. 1. Milwaukee: Milwaukee Public Museum, 1960.

De Borhegyi, Stephan F., Elba A. Dodson, and Irene A. Hanson, comps. *Bibliography of Museums and Museum Work, 1900–61; Supplementary Volume*. Publications in Museology, no. 2. Milwaukee: Milwaukee Public Museum, 1968.

Deetz, James. *Invitation to Archaeology*. Garden City, NY: Natural History Press, 1967.

————. *In Small Things Forgotten: The Archaeology of Early American Life*. Garden City, NY: Anchor Press/Doubleday, 1977.

Dewhurst, Kurt, and Marsha MacDowell. "Popular Culture and the European Folk Museum." In *Twentieth Century Popular Culture in Museums and Libraries*, edited by Fred E. H. Schroeder. Bowling Green, OH: Bowling Green University Popular Press, 1981.

Dorson, Richard M., ed. *Folklore and Folklife: An Introduction*. Chicago: University of Chicago Press, 1972.

Dupont, Jacques. "Viollet-le-Duc and Restoration in France." In *Historic Preservation Today: Essays Presented to the Seminar on Preservation and Restoration, Williamsburg, Virginia, September 8–11, 1963*, edited by National Trust for Historic Preservation and Colonial Williamsburg. Charlottesville: University Press of Virginia, 1966.

Eleuterio-Comer, Susan K., comp. *Irish-American Material Culture: A Directory of Collections, Sites, and Festivals in the United States and Canada*. Westport, CT: Greenwood Press, 1988.

Erixon, Siguard. "Regional European Ethnology, I. Main Principles and Aims with Special Reference to Nordic Ethnology." *Folk-Liv* 2/3 (1937), 89–108.

————. "An Introduction to Folklife Research or Nordic Ethnology." *Folk-Liv* 14/15 (1950–1951), 5–15.

Eubanks, Sharon Y. *A Bibliography of Books, Pamphlets, and Films Listed in the "Living Historical Farms Bulletin" from December 1970 Through May 1976*. Washington, DC: Association for Living Historical Farms and Agricultural Museums, Smithsonian Institution, 1976.

Evans, E. Estyn. "Folklife Studies in Northern Ireland." *Journal of the Folklore Institute* 2 (December 1965), 355–63.

Favretti, Rudy J., and Joy Putnam Favretti. *Landscapes and Gardens for Historic Buildings: A Handbook for Reproducing and Creating Authentic Landscape Settings*. Nashville, TN: American Association for State and Local History, 1978.

Fennelly, Catherine. *Old Sturbridge Village: A Guidebook*. 5th ed. Sturbridge, MA: Old Sturbridge Village, 1966.

Fenton, Alexander. "An Approach to Folklife Studies." *Keystone Folklore Quarterly* 12 (Spring 1967), 5–21.

————. *A Farming Township: Auchindrain, Argyll*. Perth, Scotland: Countryside Commission for Scotland, 1979.

Fitch, James Marston. *Historic Preservation: Curatorial Management of the Built World*. New York: McGraw-Hill, 1982.

Fleming, E. McClung. "Artifact Study: A Proposed Model." *Winterthur Portfolio* 9 (1974), 153–73. Reprinted in *Material Culture Studies in America*, edited by Thomas J. Schlereth. Nashville, TN: American Association for State and Local History, 1982.

Fleure, Herbert John. *A Natural History of Man in Britain: Conceived as a Study of Changing Relations Between Men and Environments*. London: Collins, 1951.

Focsa, Gheorghe. *The Village Museum in Bucharest*. 2d ed. Bucharest: Meridiane Publishing House, 1967.

Fowler, John. "An Ounce of Prevention." *Museum News* 53 (November 1974), 19, 61.

Gibson, Colin. *Angus Folk Museum.* Glamis: Angus Folk Museum, 1967.

Gilborn, Craig. "Pop Iconology: Looking at the Coke Bottle." In *Icons of Popular Culture,* edited by Marshall Fishwick and Ray B. Browne. Bowling Green, OH: Bowling Green University Popular Press, 1970.

Gjessing, Thale. *The Sandvig Collections Guide.* Lille-hammer, Norway: n.p., 1949.

Glassie, Henry. *The Spirit of Folk Art: The Girard Collection at the Museum of International Folk Art.* New York: Harry N. Abrams, Inc. and Sante Fe Museum of New Mexico, 1989.

————. *Pattern in the Material Folk Culture of the Eastern United States.* Philadelphia: University of Pennsylvania Press, 1968.

Goldstein, Kenneth S. *A Guide for Field Workers in Folklore.* Hatboro, PA: Folklore Associates, 1964.

Goodall, Harrison, and Renee Friedman. *Log Structures, Preservation and Problem-Solving.* Nashville, TN: American Association for State and Local History, 1980.

Graham, Joe S., comp. *Hispanic-American Material Culture: An Annotated Directory of Collections, Sites, Archives, and Festivals in the United States.* Westport, CT: Greenwood Press, 1989.

Grieg, Sigurd, and G. A. Norman. *The Sandvig Collections: Guide to the Handicraft Section,* translated by T. Abrahamsen. Lillehammer, Norway: n.p., 1951.

Grotz, George. *The Furniture Doctor; Being Practical Information for Everybody About the Care, Repair, and Refinishing of Furniture, with Easy to Follow Directions and Tricks of the Trade That Use Commonly Available Materials, All Presented with the Author's Usual Hilarious Anecdotes in the Yankee Manner and More About His Infamous Uncle George.* Garden City, NY: Doubleday, 1962.

Guldbeck, Per Ernst. *The Care of Historical Collections: A Conservation Handbook for the Nonspecialist.* Nashville, TN: American Association for State and Local History, 1972.

Hall, Patricia, and Charlie Seeman, eds. *Folklife and Museums: Selected Readings.* Nashville, TN: American Association for State and Local History, 1987.

Henry Ford Museum and Greenfield Village. *Folk Art and the Street of Shops/Henry Ford Museum.* Dearborn: Edison Institute, 1971.

————. *Greenfield Village and the Henry Ford Museum.* New York: Crown Publishers, 1972.

Higgs, John Walter Yeoman. *Folk Life Collection and Classification.* London: Museums Association, 1963.

Hobbie, Margaret, comp. *Museums, Sites, and Collections of Germanic Culture in North America.* Westport, CT: Greenwood Press, 1980.

Hojrup, Ole. "The Work of the National Museum's Ethnological Surveys Department." In *Dansk Folkemuseum & Frilandsmuseet: History & Activities,* edited by Holger Rasmussen. Copenhagen: Nationalmuseet, 1966.

Holm, Peter. "The Old Town: A Folk Museum in Denmark." *Museums Journal* 37 (April 1937), 1–9.

Hosmer, Charles B., Jr. *Preservation Comes of Age: From Williamsburg to the*

National Trust, 1926–1949. 2 vols. Charlottesville: University Press of Virginia, 1981.

Humelsine, Carlisle H. *Preserving Our Handcrafts: The President's Report, 1968.* Williamsburg: Colonial Williamsburg, 1968.

Hurst, Joseph. *Ryedale Folk Museum Guide.* Hutton le Hole, England: Ryedale Folk Museum, 1976.

Ives, Edward D. *The Tape-Recorded Interview: A Manual for Field Workers in Folklore and Oral History.* Rev. ed. Knoxville: University of Tennessee Press, 1980.

Jenkins, J. Geraint. "Field-Work and Documentation in Folk-Life Studies." *Journal of the Royal Anthropological Institute* 90 (1960), 250–71.

———. "Folk Life Studies and the Museum." *Museums Journal* 61 (December 1961), 186–90.

———. "The Use of Artifacts and Folk Art in the Folk Museum." In *Folklore and Folklife, an Introduction,* edited by Richard M. Dorson. Chicago: University of Chicago Press, 1972.

Jewell, Andrew. "The Museum of English Rural Life, Reading." *Museum* 24 (1972), 168–73.

Jones, Louis C. "Education Through the Outdoor Museum . . . The Farmers' Museum at Cooperstown." *Art in America* 43 (May 1955), 34–39, 71–73.

———. "The Cooperstown Complex." *Antiques* 75 (February 1959), 168–69.

Kamphausen, Alfred. *Schleswig-Holsteinisches Freilicht-museum: ein Bildband.* Neumünster: Karl Wachholtz Verlag, 1975.

Kelsey, Darwin P. "Outdoor Museums and Historical Agriculture." *Agricultural History* 46 (January 1972), 105–27.

———. "Historical Farms as Models of the Past." *Proceedings of the Annual Meeting—Association for Living Historical Farms and Agricultural Museums* 1 (1975), 33–38.

Kempers, A. J. Bernet. "Regional Ethnography Museums." *Museum* 15 (1962), 117–19.

Kirk, Frode, and Bjarne Stoklund. "Moving Old Buildings." In *Dansk Folkemuseum & Frilandsmuseet: History & Activities,* edited by Holger Rasmussen. Copenhagen: Nationalmuseet, 1966.

Kjellberg, Reidar. "Scandinavian Open-Air Museums." *Museum News* 39 (December 1960–January 1961), 18–22.

Kocher, Alfred Lawrence, and Howard Dearstyne. *Colonial Williamsburg, Its Buildings and Gardens: A Descriptive Tour of the Restored Capital of the British Colony of Virginia.* 2d rev. ed. Williamsburg: Colonial Williamsburg Foundation, 1976.

Lagercrantz, Bo. "A Great Museum Pioneer of the Nineteenth Century." *Curator* 7 (1964), 179–84.

Leon, Warren and Margaret Platt, "Living-History Museums," in *History Museums in the United Stats: A Critical Assessment,* edited by Warren Leon and Roy Rosenzweig. Urbana and Chicago: University of Illinois Press, 1989.

Lessig, Charles W. "Measured Drawings in Restoration." *Building Research* 1 (September–October 1964), 20–24. Reprinted in *The Restoration Manual: An Illustrated Guide to the Preservation and Restoration of Old Buildings,* by

Orin M. Bullock, Jr. Norwalk, CT: Silvermine Publishers, 1966. Reprint. New York: Van Nostrand Reinhold, 1983.

Levitas, Gloria. "Living History in Iowa: Outdoor Museum Re-creates Farm Life in the 1840's." *New York Times*, July 17, 1983, XX 19, 35.

Lichten, Frances. "The Pennsylvania-German Arts." *Antiques* 75 (March 1959), 264–71.

Little, Nina Fletcher. *The Abby Aldrich Rockefeller Folk Art Collection: A Descriptive Catalogue*. Williamsburg: Colonial Williamsburg, 1957.

Loomis, Ormond H. "Sources on Folk Museums and Living Historical Farms." *Folklore Forum*, Bibliographic and Special Series, no. 16 (1977), 1–59.

———. "Organizing a Folklore Museum." In *Handbook of American Folklore*, edited by Richard M. Dorson. Bloomington: Indiana University Press, 1983.

Loomis, Ormond H., and Willard B. Moore, eds. *Museum Studies Reader: An Anthology of Journal Articles on Open-Air Museums in America*. Indianapolis: Indiana Committee on the Humanities, 1978.

Lord, Clifford. "The Farmers' Museum: The Museum of the New York Historical Association at Cooperstown." *Agricultural History* 17 (July 1943), 167–71.

MacLeish, A. Bruce. *The Care of Antiques and Historical Collections*. Nashville, TN: American Association for State and Local History, 1987.

Marshall, Howard Wight. "Folklife and the Rise of American Folk Museums." *Journal of American Folklore* 90 (October–December 1977), 391–413. Reprinted in *Folklife and Museums: Selected Readings*, edited by Patricia Hall and Charlie Seeman. Nashville, TN: American Association for State and Local History, 1987.

———. "Material Culture and the Museum." *Proceedings of the Annual Meeting—Association for Living Historical Farms and Agricultural Museums* 3 (1977), 35–38.

———. *American Folk Architecture: A Selected Bibliography*. Publications of the American Folklife Center, no. 8. Washington, DC: American Folklife Center, Library of Congress, 1981.

McGiffin, Robert F., Jr. *Furniture Care and Conservation*. Nashville, TN: American Association for State and Local History, 1983.

McKee, Harley J., comp. *Recording Historic Buildings*. Washington, DC: National Park Service, U.S. Department of the Interior, 1970.

Michelsen, Peter. "The Investigation of Old Rural Buildings." In *Dansk Folkemuseum & Frilandsmuseet: History & Activities*, edited by Holger Rasmussen. Copenhagen: Nationalmuseet, 1966.

———. "The Origin and Aim of the Open-Air Museum." In *Dansk Folkemuseum & Frilandsmuseet: History & Activities*, edited by Holger Rasmussen. Copenhagen: Nationalmuseet, 1966.

———. "The Outdoor Museum and Its Educational Program." In *Historic Preservation Today: Essays Presented to the Seminar on Preservation and Restoration, Williamsburg, Virginia, September 8–11, 1963*, edited by National Trust for Historic Preservation and Colonial Williamsburg. Charlottesville: University Press of Virginia, 1966.

———. *Frilandsmuseet: The Danish Museum at Sogenfri: A History of an Open-Air Museum and Its Old Buildings*, translated by Jean Olsen. Copenhagen: National Museum of Denmark, 1973.

Moore, Willard B. "Folklife Museums: Resource Sites for Teaching." *Indiana English Journal* 11 (Winter 1976–1977), 3–10.

———. "Folklore Research and Museums." In *Handbook of American Folklore*, edited by Richard M. Dorson. Bloomington: Indiana University Press, 1983.

Moorehead, Singleton P. "Problems in Architectural Restoration . . . Colonial Williamsburg." *Art in America* 43 (May 1955), 23–29, 63–66, 68.

Mukherjee, Shyam Chand. *Folklore Museum*. Calcutta: Indian Publications, 1969.

National Museum of Wales. Welsh Folk Museum. *Handbook/National Museum of Wales, Welsh Folk Museum, St. Fagans*. Cardiff, Wales: National Museum of Wales, 1955.

———. *Amgueddfa Werin Cymru, Welsh Folk Museum*. Cardiff, Wales: National Museum of Wales, n.d.

National Trust for Historic Preservation and Colonial Williamsburg, eds. *Historic Preservation Today: Essays Presented to the Seminar on Preservation and Restoration, Williamsburg, Virginia, September 8–11, 1963*. Charlottesville: University Press of Virginia, 1966.

New York State Historical Association. *The New York State Historical Association and Its Museums: An Informal Guide*. Cooperstown, NY: New York State Historical Association, 1968.

Nielsen, Svend. "Village Archaeology." In *Dansk Folkemuseum & Frilandsmuseet: History & Activities*, edited by Holger Rasmussen. Copenhagen: Nationalmuseet, 1966.

Noël Hume, Ivor. *Historical Archaeology*. New York: Knopf, 1969. Reprint. New York: W. W. Norton, 1975.

Peate, Iorwerth C. *Amgueddfeydd Gwerin: Folk Museums*. Cardiff, Wales: University of Wales Press, 1948.

———. "The Study of Folk-Life and Its Part in the Defence of Civilization." *Gwerin* 2 (1958–59), 97–109.

———. "The Welsh Folk Museum." *Journal of the Folklore Institute* 2 (December 1965), 314–16.

———. "Reconstructing the Past." *Folklife* 6 (1968), 113–14.

Peeters, K. C. "The Open-Air Ethnographic Museums in Belgium." In *Organization of Open-Air Ethnographic Museums—Principles and Methods*. Bucharest: International Council of Museums, Roumanian National Committee, 1966.

Perrin, Richard W. E. *Outdoor Museums*. Publications in Museology, no. 4. Milwaukee: Milwaukee Public Museum, 1975.

Peterson, Harold L. *How to Tell If It's A Fake: A Practical Handbook on the Detection of Fakes for the Antique Collector and Curator*. New York: Charles Scribner's Sons, 1979.

Polley, Robert I., ed. *America's Folk Art: Treasures of American Folk Arts and Crafts in Distinguished Museums and Collections*. New York: Putnam, 1968.

Rasmussen, Holger, ed. *Dansk Folkemuseum & Frilandsmuseet: History & Activities*. Copenhagen: Nationalmuseet, 1966.

———. "The Origin and Development of the Danish Folk Museum." In *Dansk Folkemuseum & Frilandsmuseet: History & Activities*, edited by Holger Rasmussen. Copenhagen: Nationalmuseet, 1966.

———. "Classification Systems of European Ethnological Material." *Ethnologia Europaea* 4 (1970), 73–97.

Rehnberg, Mats Erik Adolf. *The Nordiska Museet and Skansen: An Introduction to the History and Activities of a Famous Swedish Museum*, translated by Alan Tapsell. Stockholm: Nordiska Museet, 1957.

Reibel, Daniel B. "In Defense of Historic Sites." *Museum News* 56 (May–June 1978), 11–12.

Riedl, Norbert F. "Folklore and the Study of Material Aspects of Folk Culture." *Journal of American Folklore* 79 (October–December 1966), 557–63.

Roberts, Warren E. "Folk Architecture in Context: The Folk Museum." *Pioneer America Society Proceedings* 1 (1973), 34–50.

Ronsheim, Robert D. "Is the Past Dead?" *Museum News* 53 (November 1974), 16–18, 62.

Roy, Carmen, ed. *An Introduction to the Canadian Centre for Folk Culture Studies*. Canadian Centre for Folk Culture Studies, Paper no. 7. Ottawa: National Museum of Man, National Museums of Canada, 1973.

Rumford, Beatrix T. *The Abby Aldrich Rockefeller Folk Art Collection: A Gallery Guide*. Williamsburg: Colonial Williamsburg, 1975.

———. "Uncommon Art of the Common People: A Review of Trends in the Collecting and Exhibiting of American Folk Art." In *Perspectives in American Folk Art*, edited by Ian M. G. Quimby and Scott T. Swank. New York: W. W. Norton, 1980.

Schlebecker, John T., and Gale E. Peterson. *Living Historical Farms Handbook*. Smithsonian Studies in History and Technology, no. 16. Washington, DC: Smithsonian Institution Press, 1972.

Schlereth, Thomas J. "It Wasn't That Simple." *Museum News* 56 (January–February 1978), 36–44.

———. *Artifacts and the American Past*. Nashville, TN: American Association for State and Local History, 1980.

———, ed. *Material Culture Studies in America*. Nashville, TN: American Association for State and Local History, 1982.

Schroeder, Fred E. H., ed. *Twentieth-Century Popular Culture in Museums and Libraries*. Bowling Green, OH: Bowling Green University Popular Press, 1981.

Seale, William. *Recreating the Historic House Interior*. Nashville, TN: American Association for State and Local History, 1979.

Sidford, Holly. "Stepping into History." *Museum News* 53 (November 1974), 28–35.

Smith, Frank A., III. "Restoration of Masonry." *Building Research* 1 (September–October 1964), 40–43. Reprinted in *The Restoration Manual: An Illustrated Guide to the Preservation and Restoration of Old Buildings*, by Orin M. Bullock, Jr. Norwalk, CT: Silvermine Publishers, 1966. Reprint. New York: Van Nostrand Reinhold, 1983.

Smith, Robert W. *Auchindrain*. Auchindrain, Scotland: n.p., 1979.

———. *Auchindrain Museum of Country Life, Argyll*. Auchindrain, Scotland: n.p., 1980.

Spinney, Frank O. "Demonstration Crafts at Old Sturbridge Village." *Art in America* 43 (May 1955), 30–33, 68, 70–71.

Stackpole, Edouard A. "Mystic Seaport and the Maritime Tradition." *Art in America* 43 (May 1955), 48–52, 75–76.

State Historical Society of Wisconsin, and [Wisconsin] Department of Natural Re-

sources. *Old World Wisconsin: An Outdoor Ethnic Museum*. Madison: State
 Historical Society of Wisconsin, 1973.

Steane, John M., ed. *Cogges: A Museum of Farming in the Oxfordshire Countryside*.
 Woodstock, England: Oxfordshire County Council, Department of Museum
 Services, 1980.

Summerson, John. "Ruskin, Morris, and the 'Anti-Scrape' Philosophy." In *Historic
 Preservation Today: Essays Presented to the Seminar on Preservation and
 Restoration, Williamsburg, Virginia, September 8–11, 1963*, edited by Na-
 tional Trust for Historic Preservation and Colonial Williamsburg. Charlottes-
 ville: University Press of Virginia, 1966.

Thompson, George B. "The Welsh Contribution to the Development of the Ulster
 Folk Museum." In *Studies in Folklife: Essays in Honor of Iorwerth C. Peate*,
 edited by J. Geraint Jenkins. New York: Barnes & Noble, 1969.

————. "Estyn Evans and the Development of the Ulster Folk Museum." *Ulster
 Folklife* 15–16 (1970), 233–38.

Toulson, Shirley. *Discovering Farm Museums and Farm Parks*. Aylesbury, England:
 Shire Publications, 1977.

Tresch, Phillip S. *An Historic Structure Inventory for Wisconsin Including the Old
 World Wisconsin Research Project*, Madison: State Historical Society of Wis-
 consin, 1969.

Uldall, Kai. "Open Air Museums." *Museum* 10 (1957), 68–96.

United Nations Educational, Scientific and Cultural Organization. *The Organization
 of Museums: Practical Advice*. Paris: UNESCO, 1960.

Valen-Sendstad, Fartein Sigurd. *The Sandvig Collections: Guide to the Open Air
 Museum*, translated by Margaret Bautz. Lillehammer, Norway: Gjo/vik, 1963.

Walter, Paul A. F., and Arthur J. O. Anderson, eds. "Museum of International Folk
 Art Issue." *El Palacio* 60 (September 1953), 306–36.

Washburn, Wilcomb E. "Do Museums Educate?" *Curator* 18 (September 1975),
 211–18.

Webb, Electra H. "Folk Art in the Shelburne Museum." *Art in America* 43 (May
 1955), 15–22, 60–63.

Welsch, Roger, L. "Very Didactic Simulation: Workshops in the Plains Pioneer
 Experience at the Stuhr Museum." *History Teacher* 7 (May 1974), 356–64.

Welsh, Peter C. "The Van Alstyne American Folk Art Collection." *Antiques* 88
 (August 1965), 208–11.

————. "Folk Art and the History Museum: The Van Alstyne Collection at the
 Smithsonian Institution." *Curator* 10 (March 1967), 60–78.

Wertkin, Gerard C. "The Museum at Twenty: Challenges and Perspectives." *Clarion*
 (Fall 1981), 22–27.

Wildhaber, Robert. "A Bibliographical Introduction to American Folklife." *New York
 Folklore Quarterly* 21 (December 1965), 259–302.

Winchester, Alice, and the Staff of Antiques Magazine, eds. *The Antiques Treasury
 of Furniture and Other Decorative Arts at Winterthur, Williamsburg, Stur-
 bridge, Ford Museum, Cooperstown, Deerfield, Shelburne*. New York: Dut-
 ton, 1959. Reprint. New York: Galahad Books, 1974.

Wittlin, Alma S. *The Museum: Its History and Its Tasks in Education*. London:
 Routledge & K. Paul, 1949.

Yoder, Don. "The Folklife Studies Movement." *Pennsylvania Folklife* 13 (July 1963), 43–56.
Zippelius, Adelhart. *Handbuch der europaischen Freilichtmuseen.* Fuhrer und Schriften des Rheinischen Freilichtmuseums und Landesmuseums fur Volkskunde in Kommern, nr. 7. Koln: Rheinland-Verlag, 1974.
Zook, Nicholas. *Museum Villages, U.S.A.* Barre, MA: Barre Publishers, 1971.

6

MUSEUM
COLLECTIONS

Katherine Spiess and Philip Spiess

Collecting seems to be an almost innate human activity. If anthropologists are correct, the earliest occupations of humans were hunting and gathering, the latter another word for *collecting*. When it comes to collecting the sorts of things that invariably end up in museums, the hunting aspects can be as exciting as the gathering aspects. It was perhaps just such complex human motivations that prompted Thomas P. Hoving, former director of the Metropolitan Museum of Art, to write: "The chase and the capture of a great work of art is one of the most exciting endeavors in life—as dramatic, emotional, fulfilling as a love affair."

The motives of collectors are diverse and not thoroughly understood. As early as 1921, Dr. Henri Codet speculated that collectors may be motivated by the need for possession, the need for spontaneous activity, the desire for self-advancement, and the tendency to regulate things by classifying them. Douglas Rigby and Elizabeth Rigby subsequently emphasized the human need for distinction, the search for knowledge and aesthetic satisfaction, and the quest for immortality. Whatever the motive, the act of collecting appears to affirm the individualism of the collector—the decisions made when selecting and organizing the collection are personal. In short, collecting may be viewed as the art of self-expression.

Although collecting satisfies individual needs, often private collections exceed the resources of even the most wealthy to continue to acquire, house, and maintain. Today (either during the collector's life or at death), many collectors become donors, and their private assemblages become part of the public trust. If the collector (and the museum) has chosen well, the collector's

influence will continue to be felt in the museum as a result of the myriad of decisions that originally brought the collection into existence. The task of organizing and preserving the collection in a new intellectual environment becomes the sole responsibility of the museum.

When the object or collection enters a museum, there is no single, comprehensive approach guiding its management and use. Rather, each museum, drawing from its own history and the traditions and culture associated with its collections, and the experience of private and public collecting in its field, organizes and manages its collections to meet its own program needs.

HISTORIC OUTLINE

Because of their importance to human existence, ancient collections were often housed in temple complexes under the guardianship of priests, interpreters of divine will and intercessors between God and humanity. The civilizations of ancient Egypt, prehistoric Ireland, and medieval Japan all gave rise to such collections. Individual and communal collections of food, tools, weapons, or precious objects also gradually came to represent economic power and social status in ancient civilizations. For example, the ancient Babylonian rulers Nebuchadrezzar and Nabonidus collected antiquities for what may have been political reasons. Even objects found in ancient tombs appear to have been placed there not only as means to venerate the dead and prepare for their survival in the afterworld but also as a means to establish their social and political status permanently.

Roughly concurrent with the emergence of the concept of an afterlife in antiquity, a deeper understanding of the deterioration of materials developed; the Egyptians were perhaps the first to attempt to preserve cultural materials. Collections storage and security, however, may have posed a greater threat to the survival of ancient collections than natural deterioration, for evidence suggests that the robbing of tomb treasures has existed as long as the tombs themselves. These twin dangers to collections—deterioration and theft—were recognized early in the biblical reference to "treasures upon earth, which moth and rust doth corrupt, and where thieves break through and steal."

As political power gradually passed from spiritual to temporal authorities, a new class of collectors emerged. With the increased importance of commerce after the fourteenth century, the interest in and resources to amass collections of fine objects became centered in wealthy merchants and royalty whose patronage of the arts encouraged the intellectual and artistic currents culminating in the Renaissance. The Medicis and other powerful families of northern Italy and the popes of Rome set a standard and style that was followed by the Valois and Bourbons in France, the Fuggers and Hapsburgs

in Germany, and the Tudors and Stuarts in England. From these regal peaks, the urge to collect descended through the ranks of the aristocracy and bishop-electors to the wealthier bourgeoisie, ultimately reaching collectors of more modest means.

In these great households, precious objects were assembled into private universal collections, or "cabinets of curiosities," a phenomenon that reached its apogee between the sixteenth and seventeenth centuries. Francis Bacon, describing the requisite collections of a gentleman in 1594, listed four essentials: a general library, a garden (botanical and zoological in nature), a still-house (a chemistry and physics laboratory), and a cabinet (museum) for the keeping and sorting of the products of people and nature. Of these, the cabinet was the most encyclopedic, for it was conceived as a place where all reality was symbolized through objects. Perhaps over-optimistically, the Flemish physician Samuel van Quiechberg advised in 1565 that a properly organized collection should represent a systematic classification of all things in the universe.

Conceived as a setting of philosophical contemplation rather than scientific analysis, the arrangement of the gentleman's cabinet of the early sixteenth century was often haphazard at best. Gradually, however, collectors recognized that the arrangement of their collections into storage cases, and the cases into cabinets, was a useful, though primitive, classification system. Cabinets were broadly divided into *naturalia* (natural history specimens) and *artificialia* (man-made objects), and specific types of cabinets were named for their contents. The *Schatzkammer* (treasury) housed jewels, precious gems and metals, bullion, reliquaries, and other religious objects. The *Kunstkammer* (chamber of art) contained fine and decorative art; large or small objects; misshapen or trick items (*mirabilia*); objects from foreign climes and ethnographic items (*exotica*); and souvenirs of persons or events (*memorabilia*). Specialized forms of cabinets included the antiquarium (antiquities collections), the naturalienkabinet (natural history collections), and the armamentarium (arms and weapons collections).

Toward the end of the eighteenth century, private collectors, influenced by Enlightenment ideas, began to apply even more precise standards of systematic classification to their collections. Through examination and methodical comparison of the specimens and artifacts in their cabinets, gentleman-scholars could participate in the scientific movement, which was beginning to amass detailed information about the elements comprising the natural and man-made worlds. The rise of learned societies during this period, each with its own collection, stimulated such investigations, bringing together amateurs and scholars for mutual inquiry, scientific experimentation, and discussion. The exchange of ideas between private collectors and savants through learned societies proved particularly fruitful with respect to the development of early museum classification systems. For example, Cas-

per F. Neickel's *Museographia* (1727), which was widely distributed to keepers in learned societies and of private cabinets, early addressed the dual problems of collections classification and care.

At the same time that savants were amassing great private collections of natural history, the foundations of the modern principles of scientific nomenclature were being laid by the Swedish naturalist Carolus Linnaeus. His comprehensive system for the classification of natural history specimens that organized all plant life into genus, species, and phyla was widely discussed among private collectors and savants. Linnaeus's grand vision of the natural world, as revealed in his *Systema Naturae* (1785), however, contemplated collections on a scale beyond the energies, resources, and ambitions of even the most dedicated private collector, and in the next century private naturalists would make their most important contribution by supplying specimens to public museums rather than by attempting to maintain private, comprehensive collections.

Although acquisition of art objects was always more important than preservation in royal and noble households, it was not uncommon for sculptors to undertake restoration projects. By the beginning of the eighteenth century, the number of "picture repairers" increased dramatically, and encyclopedists attempted to answer many of the new questions of the nobility concerning the cleaning, relining, retouching, and transferring of paintings. Nonetheless, the attempt to prevent the deterioration of even the most precious items in private collections was not systematic, and the preservation of treasures more closely resembled the keeping of secret family recipes than it did the dissemination of scientific information.

Because specimen deterioration could affect observations and conclusions, scientists working with natural history collections also early recognized the need to develop standard preservation techniques for the safe handling, transporting, and storage of collections. For example, as early as 1784, Charles Willson Peale developed his own system of specimen preservation. His airtight cases (used for the exchange of duplicate specimens with London dealers) and his taxidermic techniques were recognized in their day as great innovations. But the progress of preservation of natural history collections in museums was extremely slow.

Increasingly toward the end of the eighteenth century and on into the nineteenth century, private collectors began opening their cabinets to the public (sometimes only the "genteel" public) or donating their collections to the state or to a local municipality to be operated as public museums. These changes marked the beginning of the modern museum movement. Private collections were donated occasionally to learned societies or to colleges or universities; only gradually were such collections made available to the general public.

The emergence of great public museums at the beginning of the nineteenth century demanded a new rationale for maintaining private collections at

public expense. While the private collection of the eighteenth century began as an entertaining diversion, the public museums were premised on the belief in the benefits of research and education. As a public institution, the museum could not merely collect objects; it had to preserve them. As an educational agency, the museum could not merely display objects; it had to invest them with meaning through interpretation. These two broad missions of public museums—preservation and interpretation—became the foundation for the modern principles of collections management, though many of the practices were slow to evolve.

Roughly concurrent with the rise of the public museum, disparate developments focused renewed attention on the need to preserve collections held in public trust. The discovery and excavation of the Roman towns of Pompeii and Herculaneum captured the imagination of the public and focused attention on the inability of museums to ensure the survival of archaeological materials after excavation. In response, scientists began to turn their attention to retarding the rapid deterioration of objects after excavation.

The difficulties of storing and safekeeping the vast collections of natural history specimens gathered as a result of the great scientific exploring expeditions of the nineteenth century also prompted a reevaluation of the environmental conditions surrounding museum objects. Indeed, the virtual destruction of priceless collections from the Wilkes Expedition in the 1840s at the National Institute for the Promotion of Science suggested that the risk to the survival of collections may have been greater inside the walls of museums than outside.

Museums were also occasionally jolted into accepting full responsibility for collections because of the harsh glare of publicity. For example, in England, questionable restoration policies at the National Gallery gave rise to a greater public outcry in the mid-nineteenth century culminating in a parliamentary investigation. In order to identify deficiencies in British museum practice, an investigating committee of Parliament reported on preservation treatments and approaches common among European museums. However, such investigations only briefly focused public attention on the significant deficiencies of nineteenth-century museums and the need to address collections preservation in a more systematic manner.

By the beginning of the twentieth century, however, the central role of conservation of collections was recognized by most museums. The excavation of the tomb of Tutankhamen (1922) again focused public attention on the need to preserve archaeological materials. This time, museum-based scientists like Alfred Lucas, a chemist working in the Department of Antiquities in Egypt, began to urge museums to play a more aggressive role in preserving their collections. Later, Harold Plenderleith, a scientist at the British Museum, was among a generation of museum-based scientists who conducted basic research on the deterioration of art objects and who urged the adoption of procedures and techniques to prevent deterioration. His text on conser-

vation gathered in one place a range of scientific and craft information that
had been accumulating in museums for more than a century.

The experience of conservators during two world wars (in protecting,
stabilizing, and restoring war-damaged cultural materials) also stimulated
international cooperation among conservators in the post–World War II
period. The United Nations Educational Scientific and Cultural Organization
(UNESCO) and the International Council of Museums (ICOM) were in the
forefront of the effort to gather and disseminate information concerning the
deterioration of museum collections. In 1959, UNESCO established the
International Center for the Study of the Preservation of Cultural Property
in Rome (the Rome Center) to explore interdisciplinary approaches to mu-
seum conservation.

One result of such research was the recognition that environmental factors
played a much greater role in the deterioration of museum collections than
had previously been thought. The effects of fluctuations in temperature and
humidity, light, heat, and environmental pollutants were closely studied in
a variety of museum environments, including storage rooms, exhibit galler-
ies, and processing areas. Conservators, working closely with curators and
registrars, began to emphasize the control of the museum environment as
the first step in prolonging the life of museum objects. To stabilize objects
in the museum setting, levels of temperature and humidity were monitored
and controlled, objects were shielded from environmental pollutants, proper
light sources and intensity were selected or adjusted to avoid harmful wave-
lengths, and collection storage and processing areas were fumigated to pre-
vent damage from pests.

By the twentieth century, museum workers gradually came to recognize
both the importance and challenge of managing the rapidly expanding body
of collections-related information. Such information helps the museum to
meet the demands of users, including curators, researchers, and the public.
The size of the body of collections-related information can vary widely be-
cause, as Andrew Roberts and Richard Light have pointed out, museum
collections can range in scale from a few hundred objects to tens of millions
of objects. For example, the Smithsonian's National Museum of Natural
History is estimated to have over 60 million specimens.

There are two broad purposes for recording the information that a museum
creates, possesses, and disseminates, both within and outside the institution.
First, there is the information that allows a museum to account for an object
from the first moment that the institution considers it (registering), and
thereby becomes responsible for documenting the object, to the last moment
that the item is part of the collection (disposal). Thus, registration information
embraces the most basic kind of data regarding the acquisition or borrowing
of the object by the museum.

Registration files typically include information concerning the legal
method of acquisition or terms under which the object has been borrowed,

the name of the source (donor, lender, vendor, etc.), and the costs associated with the transaction (such as purchase price or object valuation). Most museums then assign a registration number to objects to identify discrete groups acquired or borrowed from one source at one time. The registration number is issued to link the object to its related documentation. Between initial registration and disposal, information is recorded to document every activity or movement involving the object, including exhibition, conservation, lending history, insurance appraisals, and photography.

In addition to this continuing history of the object, museums maintain extensive files containing a wide range of scholarly information to support curatorial research, exhibition, and education programs. Documentation files reflect the interpretive perspective of the museum and vary according to the academic disciplines represented in the curatorial staff. For example, the documentation of a fine art museum object typically includes historical information concerning artist-maker, school-style, and subject-iconography. The history of an art object's previous ownership, or its provenance, also constitutes an important documentary element. Information maintained for a natural history specimen includes data related to its scientific classification and information concerning the location and physical description of the geographic area where the specimen were collected. Finally for man-made objects within history museums, museum files may include data on the object's origin or manufacture, physical nature, history of ownership and use, as well as information concerning the other individuals and culture groups, events, dates, locations, and institutions associated with the object.

In addition to satisfying more complex internal demands for information about collections, museums have had to respond to new, external demands for collections-related information. After a number of art objects were sold to or traded by the Metropolitan Museum of Art in the early 1970s, the press persistently raised questions concerning the policies and procedures under which objects could be removed from a museum's collection. Museum trustees, long held accountable only for their general stewardship of the museum, were increasingly asked to account for specific decisions regarding their management of collections. The demand for access to records documenting the history of ownership of museum collections also grew as the right of museums to continue to have custody over certain objects was challenged. For example, native American groups became increasingly more vocal in their criticism of museum treatment of objects regarded as sacred and occasionally demanded the return of these sacred objects. At the same time, there was an increase in claims by foreign governments for the return of cultural property that arguably had been illicitly imported or exported from its place of origin. Collections management expert Marie Malaro has reported that one bemused director noted: "I think they're all out to get me."

By the mid–1970s, many museums found themselves ill prepared to meet

this increased demand for collections-related information. The growth of collections, the nature of the new demands, and the institution-wide strains of greater public programming made an old problem more visible. For decades the management of information about the collections had taken a back seat to collecting and interpretation of the objects themselves. The results of years of neglect were evident in the disarray of museum record systems and the disorganized way in which staff were assigned responsibilities for collections documents. Collections records were scattered throughout the museum, and, as Lenore Sarasan has noted, in many museums, only a handful of curators and registrars knew what the museum had, what the museum was supposed to have, and where the objects were located.

Understaffed and underfunded, the management of collections information was generally regarded by museum directors as a low-priority item. However, a solid documentation system provides the foundation upon which an effective collections management program is built. As one registrar has recently noted, some museum trustees and directors were shocked into recognizing the importance of collections management only after one-fifth of the museums applying for accreditation by the American Association of Museums failed because of inadequate collections care.

To meet the challenges of managing collections information, some museums reorganized their staffs. Traditionally, duties related to the documentation of collections were divided between curators (responsible for creating and maintaining the historical documentation for the class of objects within the curator's area of specialization) and registrars (responsible for maintaining information regarding the movement of and activities involving all objects). However, as collections grew in size and curators became more active in the preparation of exhibit scripts, catalogues, and other publications, curators found little time available for organizing and maintaining the documentation of collections. In response, some museum registrars began to play an increased role in this area of museum work.

Beginning in the 1970s, some museums also responded to the increased pressures to account properly for their holdings by formulating written policies and procedures for managing their collections. This process was often painful, but for most museums the benefits outweighed the burdens, for the exercise of drafting a collections management policy statement forced many museums to confront some of the most basic assumptions of their institutions. What are the purposes of the museum? How does the present scope and use of the collection support the museum's mission? Not until there was a consensus concerning the answers to such fundamental questions could more detailed policies and procedures be developed to govern collection acquisition, access, disposal, lending, documentation, inventory, and risk management.

At times, the drafting of a collections management policy also required museums to review fundamental changes in public and private collecting.

For example, a science museum may hold collections of enormous historical significance dating back to a nineteenth-century exposition. If the museum does not now define its mission as interpreting nineteenth-century science and technology, should it dispose of such collections? Similarly, many art museums hold vast collections assembled by turn-of-the-century tycoons as business investments. Should the museum retain such collections as the record of an individual's taste or selectively dispose of objects in the collection according to current standards of art historical scholarship? Finally, a museum may have to develop new policies to govern the collection of contemporary materials for the benefit of future generations. Each of these questions raises difficult choices regarding museum resources, for acquisition budgets, storage space, and staff resources must be taken into consideration in formulating collections management policy.

Gradually and reluctantly after the mid–1970s, museums adjusted themselves to operating in a much more complex legal and regulatory environment. Legal questions regarding the collections, including proof of clear ownership, current valuation, copyright status, distribution of royalties, and import and export restrictions, among many others, appeared to be increasing in number and complexity each year. Facing a more challenging world, some museum professionals prepared by attending such educational seminars as the Annual Course of Study on the Legal Problems of Museum Administration cosponsored by the Smithsonian Institution and the American Law Institute–American Bar Association.

The management of records documenting the collection has become a significant activity within museums, but professional procedures designed specifically for museum records have emerged only in comparatively recent times. At first, the systems used to organize, store, and make collections information accessible were developed either by the scientific world or adapted from the library and archive world. Those from the scientific world have served natural history museums well; those adapted from the library and archive world have proved insufficient for meeting the needs of museums, especially those with cultural history collections.

In the past twenty years, museums have looked to computer technology for assistance in meeting the growing demand for collections information. Museum staff have undertaken extensive discussions concerning the advisability of the best methods for adapting the computer to meet museum information needs. At first, the debate centered on the issues of proper methods for documenting collections, organizing the resulting information, and using standard terminology. However, these discussions proved unproductive because the specific needs of individual museums were often ignored. Too much attention was paid to the perceived need to develop a standardized name for all objects and too little attention was paid to systematically categorizing collections-related information into pieces of data ("data elements"). Only after each data element is defined and the relationships

among the elements are identified can computer technology be adapted to the information needs of a particular museum. Although it now appears that universally accepted computer systems (hardware and software) are unnecessary and impractical, universally accepted standard data elements are beginning to evolve.

It was also in the mid–1970s that a new distinct position—collections manager—emerged in some museums. Helping to organize, document, and maintain collections, these individuals were assigned certain functions formerly divided between curators and registrars. But even in museums where there is no one position dedicated to collections management, curators, conservators, registrars, and museum administrators have come to recognize the interrelationships of their shared tasks and to view collections management as a complex web of duties and responsibilities related to acquiring, preserving, and documenting museum objects.

SURVEY OF SOURCES

The scope of the literature on collecting and collections management is unusually wide, encompassing the efforts of private persons and public institutions to acquire objects from the entire natural and man-made worlds. Not surprisingly, a vast literature awaits the uninitiated. Reminiscences and biographies of collectors, dealers, directors, and curators abound. Scholarly artifact studies, price guides, government reports, legal primers, and conservation studies are illustrative of the diverse publications that comprise this domain. The literature on museum conservation alone would fill many volumes. This chapter is intended only as a brief introduction to those works on collecting and collections management that will be most useful to museum studies students, interns, or beginning museum professionals.

Any examination of the collection practices of museums must begin with the private collector, for modern museums have their origins in private collecting, and institutional collecting habits also reflect the psychology of collecting. For this reason, the highly individualistic (at times obsessive) drives of the individual collector may be a useful point of departure. Virginia Woolf's short story "Solid Objects," from *A Haunted House and Other Stories* (1944), is the tale of an obsessed collector. The story of New York's Collyer brothers, who literally died because of their collecting habits, is retold in Bill Carmichael's *Incredible Collectors, Weird Antiques, and Odd Hobbies* (1971), which contains additional tales of strange collections formed by otherwise commonplace people.

Though somewhat dated, Douglas Rigby and Elizabeth Rigby's *Lock, Stock and Barrel* (1944) is still the essential introduction to private collecting. The authors cover the varied motivations of the individual collector and provide an extensive history of private collecting. Maurice Rheims's *The*

Strange Life of Objects (1961) offers insights on the psychology of collectors, with examples of behavior that run the gamut from the calculating to the neurotic. His companion work, *The Glorious Obsession* (1980), explores his experiences with collectors as an auctioneer and appraiser in one of the great auction houses of Paris.

Until recently, general histories of collecting have followed a predictable pattern. The development of art collections has been discussed to the exclusion of nonart collections and Western art to the exclusion of non-Western art. The history of collecting has been viewed as the evolution of abstract standards of taste with events in the areas of private and public collecting treated in isolation from one another. Illustrative of this school of writing is Francis Henry Taylor's *The Taste of Angels* (1948) and Pierre Cabanne's *The Great Collectors* (1963). Similar treatment has been accorded art collecting in the United States in Aline B. Saarinen's *The Proud Possessors* (1958) and in William George Constable's *Art Collecting in the United States of America* (1964).

Joseph Alsop's important work, *The Rare Art Traditions* (1982), is a refreshing new departure. For Alsop, art collecting, art history, the art market, art museums, art faking, revaluation of art, antique collecting, and super prices for works of art are "linked phenomena." By this Alsop means reciprocal events that shape the development of museums and in turn are affected by museums. For example, museums, through their collecting and exhibiting activities, indicate to the public which art is worthy of attention—and therefore collectible. Such objects, in turn, may be donated to museums. While Alsop's discussion is focused on fine arts collections, his theories may also have relevance for natural history and history collections.

One of the most interesting aspects of the history of collecting has been its diffusion from the upper to middle classes. As evidence of this trend, a vast literature is now available for the amateur collector whose collecting interests run from tall-case clocks to mechanical banks. Museum professionals meet this literature with some ambivalence. While critical of amateur collecting guides for their lack of scholarly documentation, curators often keep such works handy as a ready source for object identification. Conservators, on the other hand, often deplore the care and conservation practices often recommended in such books. For a reliable source on good collecting guides, see *Documentation of Collections* (1979), volume 4 in Rath and O'Connell's *A Bibliography on Historical Organization Practices* (1975). Examples of well-written guides useful to both amateurs and museum professionals are Carl David's *Collecting and Care of Fine Art* (1981) and Robert Weinstein and Larry Booth's *Collection, Use and Care of Historical Photographs* (1977).

The transition from private collecting to public collections and collections management is introduced in a comprehensive manner in Alma Wittlin's

Museums (1970), which examines the changing role of collections and museums in Western civilization. An excellent companion work is Germain Bazin's *The Museum Age* (1967), a thorough history of private collecting and its relationship to the development of museums. The most recent addition to this literature is *The Origins of Museums*, edited by Oliver Impey and Arthur MacGregor (1985), a collection of essays suggesting that the systematic sorting, study, and classification of private collections is a common theme in the transformation of man royal and noble collections of Europe into public museums.

The origins of several early and seminal American museums are explored in *A Cabinet of Curiosities*, edited by Walter Muir Whitehill (1967), which still provides useful information on the tastes and habits of collectors whose assemblages are reflected in private institutions of the early American republic. *Keepers of the Past*, edited by Clifford Lord (1965), is an excellent collection of sketches of private collectors in America who became the benefactors of museums, libraries, archives, and historic sites. By contrast, Mahonri Sharp Young's *The Golden Eye* (1983) is an exquisitely illustrated volume on private collections, many of which were transformed from private to public museums.

The role of art and antiques dealers in the creation of modern museum collections, especially in America, is now receiving long overdue attention. However, the picture emerging is not a pretty one, at least from an ethical perspective. In his heavily documented *Artful Partners* (1986), Colin Simpson examines the unholy alliance of world-renowned art historian Bernard Berenson and the suave-but-wily art dealer Joseph Duveen; the author concludes that their practices were not always above reproach as they mobilized big money for art, thereby assisting in the creation of some of the twentieth century's greatest art collections. A gentler tale is told of the American art dealer Israel Sack by his son, Harold Sack, with Max Wilk, in *American Treasure Hunt* (1986). The personal story of the Sacks is also the story of the birth of some of America's most important decorative arts museums.

Not all dealers in museum-quality objects are above-board entrepreneurs; not all collectors of cultural property operate within the law. Nor is this a new phenomenon; a brisk business in stolen artifacts has thrived since the first collector offered lucre for loot. Russell Chamberlin reviews the history of burgled booty in *Loot! The Heritage of Plunder* (1983), while Karl E. Meyer, in *The Plundered Past* (1973), emphasizes twentieth-century cultural larceny and cataloguing. Along the way, Meyer explores museum complicity in this trade, and his closing chapter, "Whose Past?" is particularly insightful. Douglas Cole's *Captured Heritage* (1985) exposes the spoliation of the Northwest American Indians' cultural patrimony, and John L. Hess's *The Grand Inquisitors* (1974) is a scathing attack on some of the more highly questionable collecting tactics of the Metropolitan Museum of Art.

In addition to containing good discussions of private collecting, the stan-

dard texts on museum work provide an adequate introduction to the theory
and practice of collecting by museums. Edward P. Alexander's *Museums in
Motion* (1979) and the [British] Museums Association's *Manual of Curator-
ship* (1984), edited by John M. A. Thompson, contain a general treatment
of collecting and a more detailed discussion of curatorial practice. G. Ellis
Burcaw's *Introduction to Museum Work* (1983) is a useful supplement be-
cause the author separately discusses collecting practices for general, science,
history, and art museums. Ralph H. Lewis's *Manual for Museums* (1976),
originally written as a National Park Service manual and currently being
updated, devotes several chapters to collecting practice, but its usefulness
is somewhat limited by its narrow focus on Park Service policies and pro-
cedures.

The Metropolitan Museum of Art's entertaining *The Chase, the Capture*
(1975), with contributions by Thomas P.F. Hoving and others, provides a
rare glimpse into the collecting practices of the curatorial staff of a major
museum. The tone set by the careful institutional routines for acquiring and
disposing of objects is, however, somewhat undercut by Hoving's introduc-
tory comments and by the title of the book itself. One suspects it was written
in response to sharp criticisms of collections practices at the Metropolitan,
as evidenced in such works as Hess's *The Grand Acquisitors*.

Collecting contemporary objects is one of the most stimulating topics in
the collections management literature, for it raises both fundamental phil-
osophical questions (what to select?) and important practical questions (how
to store, document, and handle such collections?). Swedish museums have
been in the forefront of the movement to document twentieth-century cul-
ture, and Goran Rosander's *Today for Tomorrow* (1980) is a fascinating report
on the collaborative efforts of Swedish museums to collect contemporary
objects "that will represent our everyday life and achievements to future
generations." *A Common Agenda for History Museums* (1987), edited by
Lonn W. Taylor, records the initial efforts by American history museums
to coordinate on a national scale their future museum collecting activities
and offers specific recommendations for action. *Twentieth-Century Popular
Culture in Museums and Libraries*, edited by Fred E. H. Schroeder (1981),
contains essays useful to museum professionals interested in collecting and
documenting popular culture.

One of the most important internal developments in modern museum
theory is the emergence of a consensus that a coherent set of principles,
practices, and procedures to manage the museum's collections is necessary
for the effective functioning of museums. Burcaw's *Introduction to Museum
Work* and George MacBeath and S. James Gooding's *Basic Museum Man-
agement* (1969) are good starting points to understand the place of collections
management and its relationship to other functions in the museum. It is
now accepted professional practice that proper collections management re-
quires a formal statement of the museums' policies and procedures governing

its collections. Marie Malaro, in *A Legal Primer on Managing Museum Collections* (1985), already the standard work on the subject, explains in straightforward language the ethical and legal imperatives underlying formal collections management policies and provides step-by-step guidelines for their development, evaluation, and periodic revision.

The American Association of Museum's "Museum Ethics" (1978) provides a general statement outlining the ethical standards that should govern staff and trustee professional behavior. Especially significant for collections management are the specialized codes of conduct developed by various standing committees of the American Association of Museums. In this regard, readers should consult "A Code of Ethics for Registrars" (1985), "A Code of Ethics for Curators" (1983), and "A Code of Ethics for Couriering Museum Objects" (1987).

The monumental *Art Law: Rights and Liabilities of Creators and Collectors* (1986), by Franklin Feldman and Stephen E. Weil, with the collaboration of Susan Duke Biederman, is at once broader and narrower than Marie Malaro's study. Their subject is not museum law, but the authors provide a wide range of information useful to museums, including reproduction rights, moral and resale rights of artists, claims against the museum by third parties, and charitable deductions. Feldman and Weil's work largely supersedes Leonard DuBoff's *The Deskbook of Art Law* (1977), but his *Art Law in a Nutshell* (1984) is still a useful, succinct summary of the law.

As sales and exhibition of objects increasingly require the transportation of cultural property across national borders, museum professionals also must be aware of the international agreements and domestic laws that govern such movements. UNESCO's *The Protection of Movable Cultural Property* (1984) is a convenient collection of foreign and domestic laws, while *Convention and Recommendations of UNESCO Concerning the Protection of the Cultural Heritage* (1985) gathers together international agreements and procedural conventions and identifies countries that have become signatories. *Information on Convention on Cultural Property Implementation Act (P.L. 97–446)* (1984), published by the U.S. Information Agency, and *United States Import Requirements*, put out by the U.S. Department of the Treasury, are useful sources for determining U.S. legal requirements. Finally, Paul Bator offers a lucid analysis of the relevant issues, policy, and law related to the international movement of cultural property in his seminal *The International Trade in Art* (1983).

Dorothy Dudley and Irma Bezold Wilkinson's *Museum Registration Methods* (1979) is the standard compendium of practice on the management of collections. The current edition offers useful guidelines for establishing a collections documentation system and provides basic information regarding the physical control, packing, transportation, handling, and storing of museum collections. While Dudley and Wilkinson is a banquet of information on collections management, *Registrars on Record* (1988), edited by Mary

Case, is a delightful appetizer, offering thirteen "get acquainted" essays by practitioners involved in the everyday world of collections management.

While a full discussion of the literature of conservation is beyond the scope of both this chapter and this book, persons interested in collections management must be sensitive to conservation concerns and must be aware of the important role of the trained conservator. Two standard works in conservation, Robert Organ's *Design for Scientific Conservation of Antiquities* (1968) and Harold Plenderleith and A. E. A. Werner's *The Conservation of Antiquities and Works of Art* (1971), offer a good introduction to the conservation function for nonspecialists. Organ discusses the design, staffing, and equipment of a modern conservation department and includes examples of facility layouts. Plenderleith and Werner is the classic text on museum conservation, containing abundant information on the nature of materials, causes of deterioration, and methods of preservation, repair, and restoration. Modern conservation has evolved into a highly specialized, scientific field, and like other fields of science, materials and methods are constantly changing. The most recent conservation information, from specific treatments to cleaning agents, is available in the quarterly journal *Technology & Conservation of Art, Architecture, and Antiquities*.

Although the treatment of a museum object should never be undertaken without first consulting a conservator or trained collections manager, there are a number of works that nonspecialists can use to become generally familiar with conservation principles and practices. *Caring for Collections* (1984), edited by Susan J. Bandes, provides a good statement of the current status of collection care practice in U.S. museums and outlines steps to take to introduce improvements in this area. Bruce MacLeish's *The Care of Antiques and Historical Collections* (1985), a revision of Per Guldbeck's popular *The Care of Historical Collection* (1972), contains guidelines for the proper handling and maintenance of cultural material.

The physical care of collections includes the complementary activities of proper handling and maintaining safe physical environments. Frieda Kay Fall's *Art Objects* (1973), a general work particularly useful for art collections, gives specific, simple rules for the handling of objects, while Philip Ward's *In Support of Difficult Shapes* (1978) addresses, with helpful illustrations, the tricky problem of adequately supporting objects during storage and during exhibition.

The preparation of reports documenting and recording the physical condition of objects is a basic task in collections management responsibilities. Useful for the preparation of such reports is *A Glossary of Terms Useful in Conservation* (1976), compiled by Elizabeth Phillimore, which provides an excellent list of terms and definitions to describe the condition of cultural materials. Where words fail, Sheldan Collin's *How to Photograph Works of Art* (1986) may be useful, for it provides tips for preparing the object for photography and taking the photograph.

Establishing the proper physical environments (including buildings, storage areas, and climate control systems) for objects is crucial for an effective collections management program. Raymond Harrison's *The Technical Requirements of Small Museums* (1969) discusses the museum physical plant, including both construction and reconstruction. E. V. Werner Johnson and Joanne Horgan's *Handbook for Museum Collection Storage* (1978) is, however, the only book to address all aspects of collections storage. *Collection, Use, and Care of Historical Photographs* (1977), by Robert Weinstein and Larry Booth, is illustrative of the large literature on the needs of specialized collections.

Control of the museum's environment is of central importance to the preservation of collections, and Garry Thompson's *The Museum Environment* (1986) provides the best overall introduction to the topic. Nathan Stolow's discussion of storage systems, examination and reporting procedures, packing techniques, climate control, security, and transportation methods in his recent *Conservation and Exhibitions* (1987) provides a convenient summary of the range of environmental variables, and their interrelationships, which the collections manager must consider when determining when or how to exhibit and transport a museum object.

Because objects and specimens may become a convenient breeding ground, food supply, and habitat for insects, fungi, and rodents, museums are presented with a major pest control challenge. Traditionally, chemical pesticides have been used to control these unwelcome guests, but many museums have reconsidered their pest control programs in the light of the potential dangers of these products. In *Approaches to Pest Management* (1985), Keith Story emphasizes good museum housekeeping as a central tenet of a museum control program and provides practical information on the use of pesticides, including a list of commercially available products.

Museums in the last two decades have become more active in attempting to prevent losses to the collections resulting from illicit trafficking, vandalism, plagiarism, and misuse. Bonnie Burnham's *Art Theft* (1978) was instrumental in alerting the museum community to the rapid growth of art theft in the 1970s and in galvanizing museums to fight back. Partly as a result of Burnham's study, an art theft archive was established, now the source for *Stolen Art Alert*, a monthly newsletter published by the International Foundation for Art Research.

Most major museums have established collections security programs to prevent losses to irreplaceable collections. In *Museum, Archive, and Library Security* (1983), Lawrence J. Fennelly presents the most comprehensive survey of museum security issues and procedures, including detailed information on fire protection, disaster planning, establishing a guard force, and investigating theft. Fennelly's treatment of insurance, security devices, and equipment is also useful. This work supersedes the International Council of Museums' *Museum Security/La Securité dans les musées*, edited by Robert

Tillotson and Diana Menkes (1977). However, Donald L. Mason's *The Fine Art of Art Security* (1979) still provides information useful in assessing the security requirements of museum collections.

Fire continues to pose one of the most serious threats not only to museum collections but also to the historic structures in which they are often housed. *Fire!* (1982) and *On-the-Job Fire Safety* (1982), two booklets published by the Channing L. Bete Company, provide a good introduction to fire safety in the museum. Other helpful sources are the National Fire Protection Association's *Fire Safety Self-Inspection Form for Museums* (1976) and its *Recommended Practice for the Protection of Museum Collections from Fire* (1974).

Partly in response to escalating insurance premiums, many museums have become more skilled at risk management—the practice of identifying risks, controlling losses, defining insurance requirements, structuring insurance policies, and handling losses. Two complementary works, *Insurance and Risk Management for Museums and Historical Societies*, published by the Gallery Association of New York State, (1985) and *Fine Arts Insurance*, by Patricia Nauert and Caroline Black (1979), address the proper role of insurance within a well-planned risk management program.

Because museum collections are at greatest risk when they are in transit, the latest information on packing techniques and transportation services is of critical importance to collections managers, registrars, and curators. Stephen Horne's *Way to Go!* (1985) is the most recent work on packing techniques and contains many excellent illustrations. Although somewhat outdated (especially with respect to packing materials recommendations), Caroline Keck's *Safeguarding Your Collection in Travel* (1970) still contains some helpful hints regarding crating and transporting museum objects.

In addition to discharging its legal and collections care obligations, museums must establish effective systems for managing information in order to support the research and education functions of the institutions. For an excellent introduction to the purpose and content of a proper collections documentation system, see the Museum Documentation Association's *Practical Museum Documentation* (1982). Although the usefulness of this work is somewhat limited by its strict adherence to the standard MDA catalog card, its recommendations are sound. A good survey of contemporary documentation practices in the United States, Canada, and Great Britain is Andrew Roberts's *Planning the Documentation of Museum Collections* (1985). Roberts provides recommendations for documentation procedures and system design, discusses required resources, outlines methods and approaches for evaluating existing systems, and addresses automation issues.

Perhaps no other topic in the literature of collections management has inspired more optimism, yet produced more frustration, than the computerization of collections information. Three books provide a good history of the efforts in this area during the past twenty years. Robert Chenhall's

Museum Cataloging in the Computer Age (1975) contains a good description of the major software packages in use by museums at that time. *Museum Collections and Computers* (1983), compiled by Lenore Sarasan and A. M. Neuner, contains Sarasan's perceptive appraisal of why museum computer projects fail and her guidelines for planning and implementing successful projects. More recent museum computerization projects in the United States and foreign countries are described in *Museum Documentation Systems* (1986), edited by Richard Light, Andrew Roberts, and Jennifer D. Stewart. Automation is also treated in *Registrars on Record*, edited by Mary Case (1988). "Thinking About Museum Information" (1988), by Patricia Reed and Jane Sledge, provides an easy-to-follow introduction to the process of and reasons for defining data elements for museum information.

Computerization projects have also refocused attention on the much older problem of providing access to collections-related information. Traditionally museums have accessed information about collections through indexes related to the physical characteristics of objects and specimens; methods of manufacture; use; and geographic, person, time, and cultural associations. Thus, for example, access to modern natural history collections still, to some extent, depends on the Linnaen system of classification. For a work representative of the use of scientific nomenclature in the management of natural history collections, see J. S. L. Gilmour's "International Code of Nomenclature of Cultivated Plants" (1969).

The indexing of information documenting man-made objects has for long presented greater difficulties than the classification of materials from the natural world. George Brown Goode's "Outline of a Scheme of Museum Classification" was an early attempt to use the premium category lists of nineteenth-century international exhibitions as a model for developing a scheme for industrially produced objects. The results of an attempt to create a comprehensive, cross-cultural classification of cultural materials can be found in George P. Murdock et al.'s *Outline of Cultural Materials* (1971). This work is too general to be of use as the primary index to a museum's collection; however, one of the most recent attempts to devise an indexing scheme for man-made materials is *The Revised Nomenclature for Museum Cataloging* by James Blackaby, Patricia Greeno, and the Nomenclature Committee (1988), which organizes cultural materials by intended use or function. J. W. Y. Higgs's *Folk Life Collection and Classification* (1963) provides for classification according to both actual and intended use and includes useful discussions of topographical, photographic, location, and biographical indexes. The *Social History and Industrial Classification*, prepared by a working group of the University of Sheffield's Centre for English Cultural Tradition and Language (1983), is an example of a system that organizes collections within the social sphere of activities in which they were produced and used.

Andrew Roberts surveys the current status of collections management

programs in a number of countries in *Collections Management for Museums* (1988), which also includes useful discussions of the design of collection information systems and the role of professional groups and consultants in collections management. Although the diverse nature of museum collections makes standardization of collections practices impossible, a consensus is beginning to emerge concerning the broad standards against which individual museums should review their practices. In this regard, the American Association of Museum's "Guide to Accreditation Self Study" (1987) and its *Professional Standards for Museum Accreditation* (1978) are extremely useful when used in conjunction with one another. A new edition of the *Handbook* is in progress.

BIBLIOGRAPHIC CHECKLIST

Alexander, Edward P. *Museums in Motion: An Introduction to the History and Functions of Museums.* Nashville, TN: American Association for State and Local History, 1979.

Alsop, Joseph. *The Rare Art Traditions: The History of Art Collecting and Its Linked Phenomena Wherever These Have Appeared.* New York: Harper & Row, 1982.

American Association of Museums. "Guide to Accreditation Self Study." Final Draft. Washington, DC: American Association of Museums, 1987.

————. *Professional Standards for Museum Accreditation: The Handbook of the Accreditation Program of the American Association of Museums,* edited by Holman J. Swinney. Washington, DC: American Association of Museums, 1978.

————. Committee on Ethics. "Museum Ethics: A Report to the American Association of Museums by Its Committee on Ethics." *Museum News* 56 (March–April, 1978), 21–30. Reprint. Washington, DC: American Association of Museums, 1978.

American Law Institute–American Bar Association. *Course of Studies Materials: Legal Problems of Museum Administration.* Philadelphia, PA: ALI/ABA, 1973– .

Babcock, Phillip H., and Marr T. Haack. *A New Easy Way to Understand Insurance Policy for Museum Collections.* Washington, DC: n.p. [Smithsonian Institution], 1981.

Bandes, Susan J., ed. *Caring for Collections: Strategies for Conservation, Maintenance and Documentation.* Washington, DC: American Association of Museums, 1984.

Bator, Paul M. *The International Trade in Art.* Chicago: University of Chicago Press, 1983.

Bazin, Germain. *The Museum Age,* translated by June van Nuis Cahill. New York: Universe Books, 1967.

Blackaby, James R., Patricia Greeno, and the Nomenclature Committee. *The Revised Nomenclature for Museum Cataloguing: A Revised and Expanded Edition of Robert Chenhall's System for Classifying Man-made Objects.* Nashville, TN: American Association for State and Local History, 1988.

Block, Huntington T. "Insurance Checklist for Museums." Washington, DC: Huntington T. Block Insurance, n.d.

Burcaw, G. Ellis. *Introduction to Museum Work*. 2d ed. Nashville, TN: American Association for State and Local History, 1983.

Burke, Robert, and Sam Adeloye. *Manual for Basic Museum Security*. Leicestershire, England: Leicestershire Museums for the International Council on Museum Security, 1986.

Burnham, Bonnie. *Art Theft: Its Scope, Its Impact, and Its Control*. New York: Publishing Center for Cultural Resources, for the International Foundation for Art Research, 1978.

————. comp. *The Protection of Cultural Property: Handbook of National Legislations*. Paris: International Council of Museums, 1974.

Cabanne, Pierre. *The Great Collectors*. New York: Farrar, Straus, 1963.

Carmichael, William E. *Incredible Collectors, Weird Antiques, and Odd Hobbies*. Englewood Cliffs, NJ: Prentice–Hall, 1971.

Case, Mary, ed. *Registrars on Record: Essays on Museum Collections Management*. Washington, DC: American Association of Museums, 1988.

Chamberlin, Russell. *Loot! The Heritage of Plunder*. New York: Facts on File, 1983.

Channing L. Bete Co. *Fire!* South Deerfield, MA: Channing L. Bete Co., 1982.

————. *On-the-Job Fire Safety*. South Deerfield, MA: Channing L. Bete Co., 1982.

Chenhall, Robert G. *Museum Cataloging in the Computer Age*. Nashville, TN: American Association for State and Local History, 1975.

Cole, Douglas. *Captured Heritage: The Scramble for Northwest Artifacts*. Seattle: University of Washington Press, 1985.

Coleman, Laurence Vail. *The Museum in America: A Critical Study*. 3 vols. Washington, DC: American Association of Museums, 1939. Reprint (3 vols. in 1). Washington, DC: American Association of Museums, 1970.

Collins, Sheldan. *How to Photograph Works of Art*. Nashville, TN: American Association for State and Local History, 1986.

Constable, William George. *Art Collecting in the United States of America: An Outline of a History*. London: T. Nelson and Sons, Ltd., 1964.

David, Carl. *Collecting and Care of Fine Art*. New York: Crown Publishers, 1981.

DuBoff, Leonard D., ed. *Art Law: Domestic and International*. South Hackensack, NJ: Fred B. Rothman and Co., 1975.

————. *Art Law in a Nutshell*. St. Paul, MN: West Publishing Co., 1984.

————. *The Deskbook of Art Law*. Washington, DC: Federal Publications, 1977. *1984 Supplement*. Washington, DC: Federal Publications, 1984.

DuBose, Beverly M., Jr. "Insuring Against Loss." American Association for State and Local History Technical Leaflet 50. *History News* 24 (May 1969).

Dudley, Dorothy H. et al. *Museum Registration Methods*. 3d ed. Washington, DC: American Association of Museums, 1979.

Dunn, Walter S., Jr. "Storing Your Collections: Problems and Solutions." American Association for State and Local History Technical Leaflet 5. Rev. ed. *History News* 25 (June 1970).

Edwards, Stephen R., and Leonard D. Grotta, eds. *Systematics Collections and the Law: The Proceedings of a Symposium*. Lawrence, KS: Association of Systematics Collections, 1976.

Esterow, Milton. *The Art Stealers*. New York: Macmillan, 1973.

Fall, Frieda Kay. *Art Objects: Their Care and Preservation: A Handbook for Museums and Collectors*. La Jolla, CA: Lawrence McGivey, 1973.

Feldman, Franklin;, Stephen E. Weil, and Susan Duke Biederman. *Art Law: Rights and Liabilities of Creators and Collectors*. 2 vols. Boston: Little, Brown, 1986.

Fennelly, Lawrence J. *Museum, Archive, and Library Security*. Boston and London: Butterworths, 1983.

Gallery Association of New York State, with the Metropolitan Museum of Art, Division of Educational Services. *Insurance and Risk Management for Museums and Historical Societies*. Hamilton, NY: Gallery Association of New York State, 1985.

Gavan, James A. *A Classification of the Order Primates*. Columbia, MO: University of Missouri–Columbia, Museum of Anthropology, 1975.

Genoways, Hugh H., and Jerry R. Choate. "Federal Regulation Pertaining to the Collection, Import, Export, and Transport of Scientific Specimens of Mammals." *Journal of Mammalogy* (1976).

Gilmour, J. S. L., et al. "International Code of Nomenclature of Cultivated Plants." *Regnum Vegetabile* 64 (1969).

Goode, George Brown. "Outline of a Scheme of Museum Classification," *Proceedings United States National Museum, 1981*. Washington, DC: Smithsonian Institution, United States National Museum, 1882.

Greene, Candace S. "Storage Techniques for the Conservation of Collections." n.p.: Oklahoma Museums Association, 1977.

———. "Storage Techniques for Ethnology Collections.'" *Curator* 21 (June 1978), 111–28.

Guldbeck, Per Ernst. Revised and expanded by A. Bruce MacLeish. *The Care of Antiques and Historical Collections*. Nashville, TN: American Association for State and Local History, 1985.

Harrison, Raymond O. *The Technical Requirements of Small Museums*. Ottawa: Canadian Museums Association, 1969.

Hess, John L. *The Grand Acquisitors*. Boston: Houghton Mifflin, 1974.

Higgs, John Walters Yeoman. *Folklife Collection and Classification*. London: Museums Association, 1963.

Holmes, William Henry, and Otis Tufton Mason. "Instructions to Collectors of Historical and Anthropological Specimens." *United States National Museum Bulletin 39*, pt. Q, 3–16. Washington, DC: U.S. Government Printing Office, for the Smithsonian Institution, U.S. National Museum, 1902.

Horne, Stephen A. *Way To Go! Crating Artwork for Travel*. Hamilton, NY: Gallery Association of New York State, 1985.

Hoving, Thomas P. *The Chase, the Capture: Collecting at the Metropolitan*. New York: Metropolitan Museum of Art, 1975.

Impey, Oliver, and Arthur MacGregor, eds. *The Origins of Museums: The Cabinet of Curiosities in Sixteenth- and Seventeenth-Century Europe*. Oxford: Clarendon Press, 1985.

International Commission on Zoological Nomenclature. *International Code of Zoological Nomenclature Adopted by the XV International Congress of Zoology, London, July 1958*. London: International Trust for Zoological Nomenclature, 1964.

International Council of Museums. *Museum Security/La Securité dans les musées*, edited by Robert G. Tillotson and Dinah D. Montes and translated by Marthe de Moltke. Paris: International Council of Museums, 1977.

Johnson, E. Verner, and Joanne C. Horgan. *Handbook for Museum Collection Storage*. Boston: E. Verner Johnson and Associates, 1978.

Jones, Susan, and Anne Gray. *Classification: A Beginner's Guide to Some of the Systems of Biological Classification in Use Today*. London: British Museum, 1983.

Keck, Caroline K. *Safeguarding Your Collection in Travel*. Nashville, TN: American Association for State and Local History, 1970.

———, Huntington T. Block, Joseph Chapman, John B. Lawton, and Nathan Stolow. *A Primer on Museum Security*. Cooperstown, NY: New York State Historical Association, 1966.

Lee, Welton, Bruce M. Bell, and John F. Sutton, eds. *Guidelines for Acquisition and Management of Biological Specimens*. Lawrence, KS: Association for Systematics Collections, 1982.

Lester, Joan. "A Code of Ethics for Curators." *Museum News* 61 (February 1983), 36–40.

Lewis, Ralph H. *Manual for Museums*. Washington, DC: U.S. Department of the Interior, National Park Service, 1976. Reissued as *Handbook of Museum Technology*. New York: Research and Education Association, 1982.

Light, Richard B., Andrew D. Roberts, and Jennifer D. Stewart, eds. *Museum Documentation Systems: Developments and Applications*. London and Boston: Butterworths, 1986.

Linnaeus, Carolus [Carl von Linne]. *Species Plantarum*. Stockholm: 1753.

———. *Systema Naturae per Regna Tria Naturae, secundum Classes, Ordines, Genera, Species, cum Characteribus, Differentiis, Synonymis, Locis*. Stockholm: Laurentii Salvii, various editions (1735–).

Lord, Clifford L., ed. *Keepers of the Past*. Chapel Hill, NC: University of North Carolina Press, 1965.

MacBeath, George, and S. James Gooding, eds. *Basic Museum Management*. Ottawa: Canadian Museums Association, 1969.

Malaro, Marie C. "Collections Management Policies." *Museum News* 58 (November–December 1979), 57–61.

———. *A Legal Primer on Managing Museum Collections*. Washington, DC: Smithsonian Institution Press, 1985.

Marriner, Paul C. "Criteria for Packing Works for Art for Traveling Exhibitions." *Canadian Conservation Institute Newsletter* (November 1974), 3–5.

Mason, Donald L. *The Fine Art of Security: Protecting Public and Private Collections Against Theft, Fire and Vandalism*. New York: Van Nostrand Reinhold Co., 1979.

Messenger, Phyllis Mauch, ed. *Ethnics of Collecting Cultural Property*. Albuquerque, NM: University of New Mexico Press, 1989.

Meyer, Karl E. *The Plundered Past: The Story of the Illegal International Traffic in Works of Art*. New York: Atheneum, 1973.

Murdock, George P., Clellan S. Ford, Alfred E. Hudson, Raymond Kennedy, Leo W. Simmons, and John W. M. Whiting. *Outline of Cultural Materials*. 4th rev. ed. New Haven, CT: Human Relations Area Files, 1971.

Museum Documentation Association. *Data Definition Language and Data Standard.* Duxford, England: Museum Documentation Association, 1980.

———. *Practical Museum Documentation.* 2d ed. Duxford, England: Museum Documentation Association, 1982.

National Fire Protection Association. *Fire Safety Self-Inspection Form for Museums.* Boston: National Fire Protection Association, 1976.

———. *Recommended Practice for the Protection of Museum Collections from Fire.* Rev. ed. Boston: National Fire Protection Association, 1974.

Nauert, Patricia, and Caroline M. Black. *Fine Arts Insurance: A Handbook for Art Museums.* Washington, DC: Association of Art Museum Directors, 1979

Nicholson, Thomas D. "NYSAM Policy on the Acquisition and Disposition of Collection Materials." *Curator* 17 (March 1974), 5–9.

Nystrom, Bengt, and Gunilla Cedrenius. *Spread the Responsibility for Museum Documentation: A Programme for Contemporary Documentation at Swedish Museums of Culture History.* Stockholm: Nordiska Museet, SAMDOK Council, 1982.

Organ, Robert M. *Design for Scientific Conservation of Antiquities.* Washington, DC: Smithsonian Institution Press, 1968.

Perry, Kenneth D., ed. *The Museum Forms Book.* Austin, TX: Texas Association of Museums, 1980.

Pfeffer, Irving, and Daniel K. Herrick, eds. *Risk Management Manual for Museums.* New York: Association of Art Museum Directors, 1974.

———. *Risk Management & Manual*, vol. 2. New York: Association of Art Museum Directors, n.d.

Phillimore, Elizabeth, comp. *A Glossary of Terms Useful in Conservation, with a Supplement on Reporting the Condition of Antiquities.* Ottawa: Canadian Museums Association, 1976

Piechota, Dennis V., and Gretta Hansen. "The Care of Cultural Property in Transit: A Case Design for Traveling Exhibitions." *Technology and Conservation* (Winter 1982): 32–46.

Plenderleith, Harold J., and A. E. A. Werner. *The Conservation of Antiquities and Works of Art: Treatment, Repair, and Restoration.* 2d ed. London: Oxford University Press, 1971.

Privacy Protection Study Commission. *The Report of the Privacy Protection Study Commission: Personal Privacy in an Information Society.* Washington, DC: U.S. Government Printing Office, 1977.

Quick, Edward, ed. "A Code of Ethics for Couriering Museum Objects." *Registrar* 4 (June 1984).

Rath, Frederick L., Jr., and Merrilyn Rogers O'Connell, eds. *A Bibliography on Historical Organization Practices*, compiled by Rosemary S. Reese. Nashville, TN: American Association for State and Local History, 1975.

Reed, Patricia Ann, and Jane Sledge. "Thinking about Museum Information." *Library Trends* (Fall 1988), 220–31.

Reibel, Daniel B. *Registration Methods for the Small Museum: A Guide for Historical Collections.* Nashville, TN: American Association for State and Local History, 1978.

Rheims, Maurice. *The Glorious Obsession*, translated by Patrick Evans. New York: St. Martin's Press, 1980.

————. *The Strange Life of Objects: 35 Centuries of Art Collecting and Collectors*, translated by David Pryce-Jones. New York: Atheneum, 1961.

Rigby, Douglas, and Elizabeth Rigby. *Lock, Stock and Barrel: The Story of Collecting*. Philadelphia: J. B. Lippincott, 1944.

Roberts, D. Andres. *Planning the Documentation of Museum Collections*. Duxford, England: Museum Documentation Association, 1985.

————, ed. *Collections Management for Museums*. Cambridge, England: Museum Documentation Association, 1988.

Rosander, Goran. *Today for Tomorrow: Museum Documentation of Contemporary Society in Sweden by Acquisition of Objects*. Stockholm: SAMDOK Council, 1980.

Rose, Cordelia, ed. "A Code of Ethics for Registrars." *Museum News* 63 (February 1985), 42–46. Reprint. *Registrar* 1 (Winter 1984), 1–13.

Saarinen, Aline B. *The Proud Possessors: The Lives, Times and Tastes of Some Adventurous American Art Collectors*. New York: Random House, 1958.

Sack, Harold, with Max Wilk. *American Treasure Hunt: The Lagacy of Israel Sack*. Boston: Little, Brown, 1986.

Sarasan, Lenore, and A. M. Neuner, comps. *Museum Collections and Computers: Report of an ASC Survey*. Lawrence, K. S.: Association of Systematics Collections, 1983.

Schlereth, Thomas J. "Collecting Today for Tomorrow." *Museum News* (March–April 1982), 29–37.

————. "Contemporary Collecting for Future Recollecting." *Museum Studies Journal* 1 (Spring 1984), 23–30.

Schroeder, Fred E. H., ed. *Twentieth-Century Popular Culture in Museums and Libraries*. Bowling Green, OH: Bowling Green University Popular Press, 1981.

SHIC Working Party. *Social History and Industrial Classification*. Sheffield, England: University of Sheffield, Centre for English Cultural Tradition and Language, 1983.

Simpson, Colin. *Artful Partners: Bernard Berenson and Joseph Duveen*. New York: MacMillan, 1986.

Solley, Thomas T., Joan Williams, and Linda Baden. *Planning for Emergencies: A Guide for Museums*. Washington, DC: American Association of Art Museum Directors, 1987

Stafleu, F. A., et al., eds. "International Code of Botanical Nomenclature Adopted by the Eleventh International Botanical Congress, August 1969." *Regnum Vegetabile* 82 (1972).

Stolen Art Alert. New York: International Foundation for Art Research, monthly newsletter.

Stolow, Nathan. *Conservation and Exhibitions: Packing, Transport, Storage and Environmental Considerations*: London and Boston: Butterworths, 1987

Story, Keith O. *Approaches to Pest Management*. Suitland, MD: Smithsonian Institution, Conservation Analytical Laboratory, 1985.

Sugden, Robert P. *Care and Handling of Art Objects*. New York: Metropolitan Museum of Art, 1946.

————. *Safeguarding Works of Art: Storage, Packing, Transportation and Insurance*. New York: Metropolitan Museum of Art, 1948.

Taylor, Francis Henry. *The Taste of Angels: A History of Art Collecting from Rameses to Napoleon*. Boston: Little, Brown, 1948.

Taylor, Lonn W., ed. *A Common Agenda for History Museums: Conference Proceedings*. Nashville, TN: American Association for State and Local History; Washington, DC: Smithsonian Institution, 1987.

Thompson, Garry. *The Museum Environment*. 2d ed. London: Butterworths, 1986.

Thompson, John M. A., ed. *Manual for Curatorship: A Guide to Museum Practice*. London and Boston: Butterworths, 1984.

United Nations. Educational, Scientific and Cultural Organization. *Temporary and Travelling Exhibitions*. Paris: UNESCO, 1963.

———. *The Organization of Museums: Practical Advice*. Paris: UNESCO, 1967.

———. *The Conservation of Cultural Property with Special Reference to Tropical Conditions*. Paris: UNISCO, 1968

———. *The Protection of Movable Cultural Property I: Compendium of Legislative Texts. The Protection of Movable Cultural Property: Compendium of Legislative Texts*, compiled by Hanna Saba and Nabil G. Salame. Paris: UNESCO, 1984.

———. *Convention and Recommendations of UNESCO Concerning the Protection of the Cultural Heritage*. Rev. ed. Paris: UNESCO, 1985.

United States. Department of the Interior, Fish and Wildlife Service. *Museums and Federal Fish and Wildlife Laws*. Washington, DC: U.S. Government Printing Office, 1976.

United Stated Department of the Interior, National Park Service. Curatorial Services Branch. Preservation Assistance Division. *Museum Handbook: Part II: Museum Records*. Rev. ed. Washington, DC: U.S. Government Printing Office, 1984.

United States. Department of the Treasury. Customs Service. *United States Import Requirements*. Washington, DC: U.S. Government Printing Office, 1965. [periodic updates]

United States. Department of the Treasury. Internal Revenue Service. *Charitable Contributions: For Use in Preparing [Yearly] Returns*. Publication 526, rev. Washington, DC: U.S. Government Printing Office, annually.

———. *Determining the Value of Donated Property*. Publication 561, rev. Washington, DC: U.S. Government Printing Office, annually.

United States Information Agency. Cultural Property Advisory Committee. *Information on Convention on Cultural Property Implementation Act (P.L. 97–446)*. Washington, DC: United States Information Agency, Bureau of Education and Cultural Affairs, 1984.

Ward, Philip R. *In Support of Difficult Shapes*. Victoria, B.C.: British Columbia Provincial Museum, 1978

Weinstein, Robert A., and Larry Booth. *Collection, Use, and Care of Historical Photographs*. Nashville, TN: American Association for State and Local History, 1977.

Welsh, Peter H., and Steven A. LeBlanc. "Computer Literacy and Collections Management." *Museum News* 65 (June 1987): 42–51.

Whitehill, Walter Muir, Whitfield J. Bell, Jr., Clifford K. Shipton, John C. Ewers, Louis Leonard Tucker, and Wilcomb E. Washburn. *A Cabinet of Curiosities:*

Five Episodes in the Evolution of American Museums. Charlottesville: University Press of Virginia, 1967.

Wilcox, U. Vincent. "Collections Management With the Computer." *Curator* 23 (1980): 43–54.

Williams, Sharon A. *The International and National Protection of Movable Cultural Property: A Comparative Study.* Dobbs Ferry, NY: Oceana Publications, 1978.

Williams, Stephen L., René Laubach, and Hugh H. Genoways. *A Guide to the Management of Recent Mammal Collections.* Pittsburgh: Carnegie Museum of Natural History, 1977.

Wittlin, Alma S. *Museums: In Search of a Usable Future.* Cambridge, MA: MIT Press, 1970.

Young, Mahonri Sharp. *The Golden Eye: Magnificent Private Museums of American Collections.* New York: Scala Books, 1983.

7

MUSEUM EDUCATION

Kenneth A. Yellis

Despite the sometimes overwhelming public response to American museums
in recent decades, the suspicion persists among museum people that mu-
seums are underutilized and poorly understood by the public at large. Mod-
ern museum educators may well reflect upon the apparent popularity of
competitive leisure activities with something of the wistful envy of Booth
Tarkington's fictional curator surveying the crowded music hall. "We poor
lonely souls wandering about in our big galleries try to make things attractive,
but really we don't compete at all," he concluded. "I doubt if more than a
fifth of this audience have ever visited the museum even once; yet in general
they seem to be rather interesting people. . . . Why don't they know what
they could have from us?"

There is more than anecdotal evidence to support this feeling. Recent
studies have indicated, for example, that despite an aggregate increase in
museum attendance figures over time, the proportion of the public who
might be considered regular or frequent museum goers has remained con-
stant. About one in seven Americans account for the bulk of museum visits,
while the remaining 85 percent of the public is quite evenly divided between
occasional visitors and non-visitors.

Occasional visitors present a markedly different profile from the museum's
core clientele. In terms of the attributes they seek in leisure activities, they
are not, as museum people have tended to assume, prospective candidates
for conversion to the ranks to the frequent visitors. Rather, they more closely
resemble non-visitors who come only often enough to be reminded that
museums represent an unfamiliar cultural system. For four out of five Amer-

icans, museums are alien environments, and the "museum code" is a foreign
tongue.

There is considerable irony in this. The idea that there was a need to
instill visual and scientific literacy in the American public was perhaps the
primary impetus animating the museum movement of the post–Civil War
period. In that great epoch of institution building, the museum's educational
role often preceded the physical existence of either a collection or a structure
in which to house it. As Adele Silver has noted, those who run American
museums have never fully agreed on what museums should teach, to whom,
or for what ends, but from the outset museums have undertaken to teach
someone something.

HISTORIC OUTLINE

Since at least the middle of the nineteenth century, the discussion of
museum education has been unavoidably embroiled in the larger debate
over the museum's role in a democratic, pluralistic society. That discourse
has reverberated with simple-minded dichotomies between elitist preten-
sions and democratic ideals. Frequently the exaggerated posturing seems
to have had far more to do with institutional self-justification and appeals
for public support than with education theories per se. Given the American
tendency to attach a heavy burden of expectation to the role of education,
the zeal that suffused this debate is perhaps not surprising. But once the
husk of rhetoric is stripped away, the remaining kernel of educational theory
is singularly unnourishing. Moreover, not only was the contest unproductive;
very little was ever at stake. As one Smithsonian educator noted bitterly in
the 1970s, the public has often been encouraged to view the Education
Division as "some sort of institutional matrix, controlling and directing the
museum's life purpose. Insiders, on the other hand, quickly learn that 'ed-
ucation' is a term-of-art descriptive of a handful of smallish budget items."

George Brown Goode, the Smithsonian's assistant secretary in the late
1880s, was among the first to lay the foundations for this polemical debate.
In his oft-repeated dictum, the efficient educational museum was little more
than a "collection of instructive labels, each illustrated by a well-selected
specimen." Such puritanical didacticism was anathema to Goode's famous
nemesis, Benjamin Ives Gilman. Secretary and later director of the Boston
Museum of Fine Arts, Gilman found little comfort in Goode's injunctions,
except for the latter's confession that he never organized the museum solely
for the benefit of "people in their larval or school-going stage of existence."

Indeed, for Gilman, museums were altogether different from schools and
thus no place for children. In museums of science, such as those in which
Goode had spent his career, Gilman conceded that the objects on display
were intended to illustrate a general principle or represent an entire class
of natural specimens. But in museums of art, he countered, the objects were

paramount precisely because they were unique. Thus, Gilman heaped scorn upon those who subscribed to what he called the "didactic fallacy," or the belief that art was the means for teaching about something else. Rather, art itself was the subject, and it had no purpose beyond its capacity to cause enjoyment and appreciation.

In contemporary terminology, Gilman's museum was a "free-choice environment." Within its walls, he wrote, the mature viewer "cultivates the powers of observation, and the casual visitor even makes discoveries for himself." Gilman stopped short of claiming that masterpieces speak for themselves. Nonetheless, his ideology had unmistakable elitist implications, and his arguments influenced a whole generation of critics like Frank Jewett Mather, for whom the democratic aspirations of the early museum movement had been naive at best.

Others, however, contended that museums had not gone far enough toward popular education. John Cotton Dana and Henry Watson Kent, both trained as librarians, saw the museum as a powerful instrument of self-improvement. Dana complained that museums had helped to alienate art from daily life by elevating the rare and exotic over the indigenous and commonplace. In prose every bit as mordant as Gilman's, the director of the Newark Free Public Library and Museum aired his contempt for "gazing museums." Probably, he wrote, "no more useless public institution . . . was ever devised than that popular ideal, the classical building of a museum of art, filled with rare and costly objects."

His patrician temperament notwithstanding, Kent wholeheartedly subscribed to Dana's "educational credo." In his own work as the supervisor of museum instruction at the Metropolitan Museum of Art, he greatly expanded the range of instructional services. Such innovations as a Junior Museum, radio programs for the physically handicapped, and even Saturday morning storytelling sessions, complete with costumed clowns, reflected the growing size of his staff in the late 1920s. Whether connoisseur, classroom teacher, or walk-in visitor, Kent boasted, one only had to appear at the information desk, and a specialist would be on the run "in a matter of minutes."

The populist approach Dana and Kent favored—so well expressed in the latter's personal motto, "art for the people's sake"—made them forerunners of what Paul Rea labeled "active interpretation." The notion that museums have a duty to arouse popular interest, rather than simply sit back and wait for it to materialize, struck a resonant chord in the 1930s, when appeals for public funds were often predicated upon community service. Thomas Richie Adam went further, arguing that the museum's role in public education had important political implications in a period when democratic institutions seemed increasingly in jeopardy. "If critical intelligence is to survive in a civilization flooded with propaganda and intellectual authoritarianism," Adam warned, "the longing for first-hand information must be kept alive."

Others agreed, including Brooklyn Museum director Philip Youtz and

Francis Henry Taylor of the Metropolitan. To Youtz, the museum offered adults "who live in a complex civilization where most adventures are secondhand . . . a fresh visual knowledge of the great art of their own and past cultures." And Taylor, succumbing perhaps to the wave of wartime hyperbole, concocted the remarkable, but puzzling, image of the museum as "the midwife of democracy."

From the midst of this enthusiasm came the ideology of Theodore Low, perhaps the most compelling in this age of overconfidence. In the late 1940s, Low offered a seductive vision of the museum as an engine of social change, an opportunity to do good for ordinary people on a massive scale. Since the end of the depression, he wrote, the question had become not whom to serve but how. To Low, the task ahead was a challenging one now that museums had become aware that they existed to serve a public that was willing to be served but nonetheless had definite needs and desires and "refused to be fed nectar of the museum's choosing."

But as postwar exuberance gave way to the complexities of the cold war and the civil rights movement, the old debate lost whatever clarity it once had. The diverse influences upon museum education after 1950, the absence of a sizable scholarly community, and the lack of a stable base of financial support hindered the emergence of an academic discipline along traditional or even hybrid lines and made it increasingly difficult to formulate an adequate response to Low's query.

The most formidable unfinished task in this process was, and remains, the creation of a body of theoretical literature subject to empirical validation. And in this respect there was little to be learned from the battles of the past. More than eighty years of contention among elitists and democrats, populists and purists, had not produced a theoretical framework, not even competing theories, so much as rival and essentially untested ideologies. Despite periodic efforts to rejuvenate the discussion, including most recently the Getty Trust's interest in discipline-based art education, the philosophical debate that began with Gilman and Goode had become an empty exercise.

By contrast, efforts to draw a theoretical framework for museum education from the findings of visitor surveys and leisure-time studies have proved far more promising. Painstakingly accumulated over the course of several decades, this body of research has been marked by ever more sophisticated methodology, some of it extremely well documented and the rest consigned to oblivion.

Inspired by the time-and-motion studies of the scientific management movement of the early twentieth century, the first visitor studies generally focused on physiological phenomena. Gilman, for example, used photography to pinpoint the cause of museum fatigue and other sources of discomfort. He experimented with different combinations of natural and artificial light in an effort to create optimal viewing conditions.

Such work often lacked methodological sophistication, and, as a result, it

came under fire from researchers in the 1920s. Seminal innovators like Edward Robinson and his colleague, Arthur Melton, maintained that psychological factors, as much as the visitor's physical well-being, were of critical importance to the learning process. In a series of studies underwritten by the American Association of Museums, they suggested ways in which floor plans and visual aids could be adapted to common behavioral traits and cognitive functions so as to orient visitors better and increase their retention of meaningful data. This emphasis on orientation carried over into subsequent decades and gave rise to considerable interest in the effects of signage, pamphlets, and the modernization of exhibits on visitor behavior, although again these studies were rarely part of a systematic inquiry.

Only in the 1950s did investigators begin to pay more attention to the mind-set with which visitors came to museums. Profoundly influenced by the social and political climate of the cold war, the new imperative was often based upon a vision of the museum as an instrument of cultural indoctrination. Thus, at the same time the U.S. Information Agency was exploring the use of exhibitions as propaganda in foreign countries, museums began offering visitors interpretive constructs grounded in the era's prevailing consensus ideology. Museum educators enamored by this approach paid closer attention to inducing attitudinal shifts than to facilitating cognitive learning, and researchers like Robert Bower attempted to gauge the affective impact of various exhibition techniques.

For many, the postwar emphasis on indoctrination was too confining. As the civil rights movement gathered momentum, different sectors of the public demanded a more flexible and inclusive approach. And on a formal, programmatic level, many museums responded, initiating art centers, storefront exhibitions, and other outreach efforts designed to convey the ideology and aesthetic of a different set of cultural assumptions. Reassessing the recent trends in museum education, critics like Albert Eide Parr and Kenneth Boulding argued for a new theoretical orientation stressing the importance of mood generation and the transmission of cultural values.

But the debate over theory lagged far behind the increasing refinement in methodology. As studies proliferated, techniques became more polished, from new and unobtrusive methods of observation to multidimensional scaling to gauge reactions to visual elements. Among some researchers, interest grew in understanding museum excursions as social occasions and examining interactions within visitor groups as well as between individual visitors and the exhibit. Too often, however, such studies tested hypotheses drawn from other disciplines, including environmental psychology and communications theory. As a result, they led to the accumulation of data but not of insight, and museum practitioners were never quite sure what they were supposed to do with the findings.

Belatedly attention began to focus on visitor expectations. Many practi-

tioners had long wondered what needs and expectations—if any—visitors attached to museum going, but for the institutions best situated to inquire further, there was little incentive to probe. The main beneficiaries of the near-exponential growth in attendance after World War II took public interest largely for granted. To be sure, this attitude may not have reflected complacency so much as the assumption that the public sought the same benefits museums were offering. Thus, it was argued, museums had to figure out how to deliver those benefits more effectively.

Gradually, however, this preconception came under closer scrutiny. In the 1970s, more sensitive analyses demonstrated the wide array of social variables that had an impact on visitor curiosity and learning. Demographic studies, for example, revealed that adult museum goers tend to be better educated and to work at higher-level occupations than the population at large. In addition, they are younger and more actively engaged in cultural and community activities.

From these discoveries and from similar findings in the new field of leisure science, researchers like Marilyn Hood concluded that museum going is very much a learned behavior pattern. Visitors acquired familiarity with the codes by which curators and exhibit designers communicate with their audience while they were young, generally as a result of family or peer group activities. For such individuals, social class, levels of education, and occupational skills all played a role in stimulating "museum literacy." Conversely, visitors who were less well educated, had experienced little social mobility, or whose work routines were established by others required far more effort to achieve a comparable degree of comprehension.

As construed by Hood and by others, the dilemma for modern museum educators was to make the visiting experience more meaningful for the latter group without detracting from the benefits derived by those who were already museum adept. But the challenge was far more complex than it appeared at first glance. As Nelson Graburn suggested, the two groups were diametrically opposed in the ways in which they assimilated information, the kind of explanatory materials they required, and even the rewards they hoped to attain. "The problem for contemporary museums," he wrote, "is that their visitor publics are looking for different kinds of knowledge and reaffirmation, depending on past experience."

In general, Graburn conjectured that museums, like other tourist experiences, "are part of the modern search for authenticity which is increasingly sought in the non-mundane, the non-ordinary." He further hypothesized that museum visitors participate in what Claude Lévi-Strauss has labeled "magic" or "mythic" thought, deriving both meaning and satisfaction from "a fusion of the debris of past events and the new event of the museum experience itself." Consequently the learning pattern of each visitor is unique, unsystematic, and beyond the power of the museum either to anticipate or respond to effectively.

In the light of Graburn's hypothesis, it became an open question whether the success of museums in attracting larger, more diverse audiences might be self-defeating. Inevitably the new visitors drawn in would seek meaning in terms of their own experiences, which might or might not include conversance with the codes by which museums communicate. And, indeed, many studies revealed a high degree of cognitive dissonance arising from unrealistic or unsatisfied expectations. Such frustration, it was argued, led ultimately to alienation and thus undermined the efforts designed to attract the uninitiated into the gallery.

Responding in part to the contributions of Graburn and Hood, museum educators over the past decade have increasingly sought to understand the museum as part of a wider array of informal learning opportunities. From this panoply of institutions, both individuals and groups can draw upon those best suited to their respective needs. Thus, renewed interest has been directed toward understanding the visitor not only as a learner but as a consumer—someone who spends time, and often money, on leisure activities.

Among other by-products, this increased attention to marketing concepts holds the salutary prospect of modifying somewhat the introspection, bordering on self-absorption, that has traditionally been a characteristic of museum professionals. Indeed, museums and museum educators have not yet awakened to the full implications of recent studies reporting a marked decline in available leisure time from some twenty-six hours per week in 1973 to only slightly more than eighteen in 1984. Given the contemporary climate in which people guard their time more carefully than their money, institutions will have to be able to communicate how the benefits they have to confer correspond to real human needs felt by the public.

Such a task will require a new theoretical framework, one based on the interaction of visitor characteristics, exhibit types, and desired outcomes. Although considerable research remains to be done in this area, particularly on the critical question of differences between visitors and non-visitors, much usable information is already available. As Chandler Screven has observed, the "implementation of behavioral and cognitive research and the principles and applications evolving from this research will require better coordination than now exists between those well acquainted with research and those attempting to apply it in exhibition settings."

Even this mild formulation probably understates the problem. What the situation may require is, first, a more than rhetorical commitment on the part of museum leaders to make the needs of visitors their first concern and the foundation upon which all decisions are based and, second, their willingness to allocate resources to meet those needs. It is far from assured that such a commitment is imminent. In its absence, the uncertainty in the museum education profession, like the frustration of Booth Tarkington's curator, will remain beyond the power of museum educators to resolve.

SURVEY OF SOURCES

Educators in museums have rarely been able to define their objectives except in the most general way, and, as a field, museum education still lacks a coherent body of literature. Elliot Eisner and Stephen Dobbs, authors of *The Uncertain Profession* (1986), have been roundly attacked on both methodological and substantial grounds, but they merely state aloud what museum educators commonly say in private to each other: that they have no clout, that they lack the support, prestige, or critical mass to acquire any, and that to date no towering intellectual leaders have emerged to overcome what the field lacks in numbers and other resources.

As Adele Silver suggests in "Issues in Art Museum Education: A Brief History" (1978), museum education has been influenced by the same shifts in ideas and values that have characterized the museum field as a whole, running the gamut from moral uplift and self-improvement to the elevation of popular taste. Silver offers a succinct and graceful overview of these thematic cycles. A similar point has been made by Elliot Eisner and David Ecker in their *Readings in Art Education* (1966), which summarizes the changing focus of art education in the late nineteenth century.

The interminable discourse in the twentieth century between the disciples of George Brown Goode and the intellectual heirs of Benjamin Ives Gilman is covered in greater detail in Edith Tonelli's chapter in this book. Interested readers may also refer to such primary works as Theodore Low's quasi-historical treatise, *Educational Philosophy and Practice of Art Museums in the United States* (1948).

Ultimately, however, this philosophical debate degenerated into a confusing welter of overlapping credos, a situation reflected, albeit unintentionally, in Eric Larrabee's *Education and the Museum* (1968) and Barbara Newsom and Adele Silver's *The Art Museum as Educator* (1978). These compilations of contemporary thinking about museum education document exemplary practice in the field but reveal little in the way of patterns. As a result they freeze the discussion as it stood at the conclusion of two turbulent decades rich in rhetoric and suggestive insights but no closer to a meaningful theoretical framework.

More recently, Susan Nichols, Mary Alexander, and Ken Yellis resorted to a number of editorial devices in an effort to remedy this problem in their *Museum Education Anthology* (1984). Distilled from the pages of Roundtable Reports and its successor, the *Journal of Museum Education*, the anthology perhaps achieves a greater degree of coherence than one expects of such works, but whether it succeeds in setting the parameters of a constructive debate about theory seems doubtful. Indeed, the cumulative effect of these surveys is hard to discern and even harder to measure. As Thomas Nicholson noted in "The Art Museum as Educator" (1978), they merely confirm "what we have known all along: museum education is anything we say it is."

By far the more rewarding—and less accessible—body of literature is that which relates to audience research. Historically, museum visitor research, like so much else about museums, has worked from the inside out. Relatively few attempts have been made to comprehend the museum from the perspective of the visitor, and still less interest has been shown in the nonvisitor, at least until very recently. Or, to paraphrase Sam Goldwyn, if people did not want to come, there was nothing museums could do to stop them.

The first visitor studies may be said to have been conducted by G. T. Fechner, who attempted to measure reactions to and recall of works of art in *Vorschule der Aesthetik* (1897). Gilman's pioneering use of photography to study the physiological sources of museum fatigue and his experimentation with light can be found in *Museum Ideals of Purpose and Method* (1923). George Brown Goode focused on the physical well-being of the visitor in such essays as "Principles of Museum Administration" (1895).

By contrast, Edward Robinson offered arguments for a psychological, rather than physiological, source of museum fatigue in *The Behavior of the Museum Visitor* (1928). And in an extended series of articles and monographs, including "Psychological Problems of the Science Museum" (1930) and "Psychological Studies of the Public Museum" (1931), he discussed unobtrusive observational methods and naturalistic experiments for testing teaching and exhibition techniques. Arthur Melton, the most well known of Robinson's disciples, pursued many of these same lines of inquiry in *Problems of Installation in Museums of Art* (1935).

The comparatively narrow emphasis on cognitive processes that typified the "Robinson school" was characteristic of such studies for more than a decade. Katharine Gibson, for example, in "An Experiment: Measuring Results of Fifth Grade Class Visits to an Art Museum"(1925), probed the effects of field trips on cognitive retention, as did Nita Goldberg, in "Experiments in Museum Teaching" (1933). A number of writers, including Louis Powell, in "Evaluating Public Interest in Museum Rooms" (1934), Mildred Porter, in *The Behavior of the Average Visitor in the Peabody Museum of Natural History* (1938), and Homer Calver, in "The Exhibit Medium" (1939), attempted to examine the effects of signage, pamphlets, and various orientation techniques on visitor learning. Indeed, the appeal of this approach continued to exercise a strong influence on such later researchers as L. C. Nielson, in "A Technique for Studying the Behavior of Museum Visitors" (1946).

Partly as a result of the cold war, with its accompanying concern with ideology, investigators began to shed this preoccupation and to question more closely the ways in which museums could induce attitude change. Understanding this affective dimension of learning assumed greater importance in works like *The People's Capitalism Exhibit* (1956), in which Robert Bower concentrated on the reactions of foreign visitors to an exhibition supported by the U.S. Information Agency. Both Stanley Bigman's "Art

Exhibit Audiences" (1956) and the joint survey conducted by Alvin Goins and George Griffenhagen, "Psychological Studies of Museum Visitors and Exhibits at the U.S. National Museum" (1957), took a similar interest in the emotional impact of museum exhibits. More focused still was the investigation of William Cooley and Terrence Piper, who tried to gauge the degree to which racial prejudices were affected by an exhibition of African art in "Study of the West African Art Exhibit of the Milwaukee Public Museum and Its Visitors" (1968).

Among others, Albert Eide Parr took exception to what he believed was a rather blunt-edged attempt to manipulate viewers' attitudes and beliefs. In a seminal series of articles, including "Museums of Memories and Expectations—The Communication of History" (1982) and "Marketing the Message" (1969), Parr urged museum educators to impart a certain "mood" or manifestation of basic cultural values. On a practical level, he speculated on the roles played by the various elements in the museum environment and suggested, like John Cotton Dana before him, that museums could learn a great deal from commercial designers. Parr's larger interest in the museum as a transmitter of cultural perceptions was echoed by Kenneth Boulding in "Communications: The Role of the Museum in the Propagation of Developed Images" (1966), while the influence of his concern for minimizing fatigue and aiding viewer concentration could be seen in such reports as *The Design, Development and Testing of a Response Box* (1967) by H. E. White.

Implicit in Parr's thinking and the work that came out of it was the idea that to visitors, the various components of the museum experience are inseparable—hence the pointlessness of attempting to isolate visitor responses to a single element of that experience. This fascination with the effects of *atmospherics* and *dramaturgy* was nowhere more striking than in the inquires conducted by the Milwaukee Public Museum in the early 1960s. The museum's colorful director, Stephan de Borhegyi, set the tone for these studies in a series of articles, including "Museum Exhibits: How to Plan and Evaluate Them" (1963) and "Visual Communication in the Science Museum" (1963). De Borhegyi's colleagues—Walter MacBriar, in "Testing Your Audience" (1964), Frank Dandridge, in "The Value of Design in Visual Communication" (1966), and Thomas Abler, in "Traffic Pattern and Exhibit Design" (1968)—scrutinized certain aspects of the overall effect, such as dramatic lighting, labels, layout, and crowd flow.

During this period, numerous studies coming out of the Royal Ontario Museum took a different approach to the same problem. Borrowing from the insights of communications theory, David S. Abbey and Duncan Cameron brought increased methodological rigor to visitor research in a succession of articles, climaxing in their multi-volume compilation, *The Museum Visitor* (1959–1961).

This trend toward more innovative techniques and cross-disciplinary borrowing accelerated. Scarvia Anderson, for example, in "Nose Prints on the

Glass" (1966), suggested that hitherto untried observational techniques might yield insight into visitor reactions, both intended and unintended. His call was heeded: Margaret Parsons and Ross Loomis employed unobtrusive methods to study visitor attention in *Visitor Traffic Patterns: Then and Now* (1973). P. S. Kimmel and M. J. Maves, in "Public Reaction to Museum Interiors" (1972), resorted to multidimensional scaling to gauge the reactions to visual elements in the museum environment, and Ray Pierotti monitored responses to variant exhibit modes in "Be...See...Touch... Respond" (1973). Chandler Screven, in a lengthy series of studies, explored methods of making museums more effective learning systems, and Harris Shettel and Pamela Reilly proposed plural strategies for the evaluation of exhibitions, in "An Evaluation of Existing Criteria for Judging the Quality of Science Exhibits" (1968), among others.

Most such studies tested hypotheses drawn from other disciplines and, as such, led to the accumulation of data although not necessarily of insight. Increased methodological refinement fell far short of filling the need for a theory of visitor learning. As a result, many museum educators began to express their frustration with the entire process. Ross Loomis offered a methodologist's patient response to their exasperation in "Please! Not Another Visitor Survey!" (1973).

In retrospect, this process of coming to understand the gestalt of the museum seems to have been a necessary pre-condition to efforts to comprehend the museum experience from the visitor's perspective. Slowly museum people began to raise deeper questions. What did the growing bibliography of studies reveal about the needs and expectations visitors attach to museum going? Alma Wittlin, in "Hazards of Communication by Exhibits" (1971), warned that the news might not be at all good, citing the evidence of mismatch between exhibit design and visitors' physical and psychological characteristics.

The social background and context of museum going, argued Lucille Nahemow, had a far greater importance than previously supposed. In "Research in a Novel Environment" (1971), Nahemow hypothesized that both environmental and social variables had an impact on visitors' curiosity and learning, leading them to comprehend the museum setting in both structural and experiential ways. Similarly, Margaret Ramsey, in "Space for Learning" (1974), borrowed from environmental psychology and structural balance theory to interpret visitor behavior. And Frederick Schmid, in "Can Museums Predict Their Future?" (1973), answered his own question by taking a fresh look at the findings of the 1920s and 1930s to probe museum-visitor interaction.

The most common approach to the social aspect of the museum public, however, has been demographic research, introduced in Michael Shapiro's chapter in this book. Increasingly, however, there is widespread agreement among educators that such demographic variables as age, occupation, and

education, as traditionally defined, are likely to be poor predictors of an individual's allocation of leisure time. For example, in their overview of the literature, *The Social Organization of Leisure in Human Society* (1976), Neil Cheek and William Burch found few consistent associations between demographic profiles and existing patterns of free-time usage. Rather, the influence of social bonds was found to be far more significant.

Indeed, in *Leisure and Recreation Places* (1976), Cheek and coauthors Donald Field and Rabel Burdge uncovered an inverse relationship between duration of residence in a community and frequency of participation in recreational activities. An intriguing discovery, this is due presumably to the accumulation of social ties over time. Similarly, there was evidence of a direct relationship between the level of recreational activity and the number of cities lived in, although—conversely—Alan Andreasen and Russell Belk found minimal correlation between length of residence and either symphony or theater attendance in their study of four southern cities, entitled "Predictors of Attendance at the Performing Arts" (1980).

What such findings suggest, and in fact what Rolf Meyersohn argued as early as 1969, in "The Sociology of Leisure in the United States," is that people rarely adopt new leisure habits in the absence of a social support pattern of some kind, since creation generally occurs in the context of individuals' sharing a social bond. A number of authors, including Dean Yoesting and James Christensen, in such works as "Reexamining the Significance of Childhood Recreation Patterns on Adult Leisure Behavior" (1978), have investigated the role of early socialization in stimulating adult participation in recreational activities. Overall, they conclude that the level of childhood immersion in a given activity is a good predictor—in a general way, at least—of adult participation.

In *Leisure and Recreation Places*, the authors stressed the role of the innermost social circle—the family—in socializing children to a particular leisure activity and in providing them with strong feelings of belongingness and solidarity. On the other hand, John Kelly reported in "Leisure Socialization" (1977) and "Family Leisure in Three Communities" (1978) that cultural participation typically occurs at school and that these patterns are the ones more likely to be carried forward into adulthood than those inaugurated with either family or friends.

A more dynamic approach to the issue of socialization was adopted by Rhona Rapoport and Robert Rapoport, who attempted to use the concept of family life cycles to gain a fresh perspective in *Leisure and the Family Life Cycle* (1975). Rapoport and Rapoport observed that a person's lifelong interest in leisure may be fulfilled by different activities at different times; even the same activity may have a different meaning at different stages in the life cycle. Thus, divorce, remarriage, the emergence of multiple and split families, and a host of other variants were found to have an impact on individual decisions. Stephen Bollman, Virginia Moxley, and Nancy Elliott

found similar correlations between the family life cycle and out-of-home activities in "Family and Community Activities of Rural Nonfarm Families with Children" (1975), while John Kelly demonstrated (intuitively enough) that a dramatic change in activities occurs when adults become parents, in "Outdoor Recreation Participation" (1980).

But despite the obvious primacy of the shared experience in all forms of leisure activity, it has largely been ignored in museum planning and research. Over the course of a decade, Rudolph Morris, in "Leisure Time and the Museum" (1962), Manfred Eisenbeis, in "Elements for a Sociology of Museums" (1972), and Alberta Sebolt and Monica Morgan, in "Integrating the Family" (1978), have all deplored the same deficiency, not just in museums but in zoos and historic sites as well.

The failure to take sufficient account of family-related variables in particular has been damaging to the cause of museum education. Deborah Benton, in her dissertation, "Intergenerational Interaction in Museums" (1979), confirmed anecdotal evidence of the degree to which most parents are unprepared to function as mentors for their children, citing frequent misinterpretations of both the museum and its objects. Only a small minority of adults came to the museum, as she put it, "with the kids" and took the time to structure the pace and focus of the visit. More characteristically, the grownups "brought the kids" and acted as authority figures, leading the tour, directing behavior, and otherwise prompting responses.

A separate, although not unrelated, avenue of inquiry from the close attention given to social groupings is the growing interest in so-called psychographic variables. Such researchers as Robert Havighurst and Kenneth Feigenbaum, in "Leisure and Life Style" (1959), and John Neulinger, in *The Psychology of Leisure* (1974), have concentrated on elements of individual life-styles that allow outside observers to understand what values are being expressed when choosing leisure activities.

In general, these investigations suggest that individuals who have an "external locus of control"—that is, who feel themselves at the mercy of fate or circumstance—are less likely to find the museum experience pleasurable. Conversely, individuals with an "internal locus of control" are often better able to deal with a situation that imposes very few constraints and are more likely to find such an experience both stimulating and rewarding. In a similar vein, Cheek and Burch concluded that those whose work involves adherence to routines established by others tend to minimize the arts in favor of leisure activities that are more family oriented and offer a higher degree of stability. For individuals whose occupations reward self-mastery, on the other hand, such activities are intrinsically less desirable than those that maximize change and social mobility.

In many respects, Nelson Graburn's provocative essays, "The Museum and the Visitor Experience" (1977) and "Tourism, Leisure, and Museums" (1982), were attempts to wed the focus on social interaction with the findings

of leisure research. Defining educational needs as a by-product of the visitor's desire for sense-making experiences, Graburn found the museum a kind of "cultural production" from which people expect to learn something about the world at large. To the extent to which it allows individuals and families to relate to each other in their roles as couples, parents, and siblings in a more direct and relaxed way than within the confines of the workaday world, he argued, the museum could become akin to the "tourist site, the spectator sport, the beach, the theme park, and shopping for fun."

Graburn's interest in the process by which visitors extract meaning from their visit underscored the fact that remarkably little is known about how the public regards the museum. Indeed, as a topic of study, visitor adeptness in the language of museums has largely been ignored. William Hendon concluded in *Analyzing an Art Museum* (1979) that art appreciation involves the ability to "crack the codes" that would otherwise prevent the viewer from deciphering the work and gaining a commensurate aesthetic experience. Even for individuals skilled in such interpretation, however, a considerable degree of distortion is inevitable, since only the curator and the exhibit designer really understand the specific code employed in a given exhibition.

A somewhat different angle of approach also has implications for museum education. By applying cost-benefit analysis to museum visitation in "The Museum from an Economic Perspective" (1980), Werner Pommerehne and Bruno Frey demonstrated that low or no attendance was attributable more to the cost of assimilating information and achieving comprehension than to out-of-pocket expenses per se. That is, for those who are less well educated, more effort is required to achieve comprehension in a museum visit than for the well educated, who derive more understanding with less labor.

Another model, even more persuasive, was proposed by Marilyn Hood in "Adult Attitudes toward Leisure Choices in Relation to Museum Participation" (1981), an exhaustive survey of the literature of leisure science and sociology. Hood, who conducted her studies in the Toledo metropolitan area, investigated the attributes sought by adults in their leisure-time decisions and identified six separate variables: being with people (or social interaction), doing something worthwhile, feeling at ease in one's surroundings, meeting the challenge of new experiences, having an opportunity to learn, and participating in an activity.

Using these attributes to categorize individual decisions, she posited three distinct segments of the adult population: frequent museum goers, occasional museum visitors, and non-visitors. Each group had a unique profile in terms of the six attributes. Frequent visitors, who represented only 14 percent of the Toledo community but accounted for almost half the museum's annual patronage, valued having an opportunity to learn, meeting a challenge, and doing something worthwhile. By contrast, the non-visitors, who represented the largest segment of the population (46 percent in Toledo), valued the

other three attributes more highly in their leisure choices. In effect, they were the mirror image of the frequent visitors, prizing the values less prized by the latter, not socialized into museum going early in life, late in coming to cultural activities in general, and finding more satisfaction in other pursuits.

Surprisingly the occasional visitors more closely resembled the non-visitors than the active museum goers. Accounting for 40 percent of the Toledo population, these adults visited the museum once or twice a year at most. Like the non-visitors, argued Hood, "they perceive museums to be formal, formidable places, inaccessible to them because they usually have had little preparation to read the 'museum code' places that invoke restrictions on group social behavior and on active participation."

An outgrowth of the marketing craze that is currently sweeping the profession, Hood's analysis cogently conveys the dilemma confronting museum professionals. Of course, no one, including museum educators, can hope to offer products or services equally interesting to all segments of the market. But a better understanding of the motivations and needs of the public should enable them to serve a broader constituency without eroding the museum's traditional base of support.

Perhaps most agreement can be found on the indubitable fact that there is much yet to learn and much need to organize the process of going about learning it—a conviction recently expressed by John Koran and Mary Lou Koran, in their "A Proposed Framework for Exploring Museum Education Research" (1986), and by Mary Ellen Munley, in "Back to the Future: A Call for Coordinated Research Programs in Museums" (1986). To some extent, however, as Chandler Screven has written in "Exhibitions and Information Centers: Some Principles and Approaches" (1986), the difficulties encountered by so much of the public in deriving rewarding experiences from their museum visits have as much to do with the reluctant implementation of existing knowledge as with insufficient data. That is a concern few museum educators are in any position to address.

BIBLIOGRAPHIC CHECKLIST

Abbey, David S. "Kids, Kulture and Curiosity." *Museum News* 46 (March 1968), 30–33.

Abbey, David S., and Duncan F. Cameron. *The Museum Visitor*. 3 vols. Toronto: Royal Ontario Museum, 1959–1961.

———. "Notes on Audience Research at the Royal Ontario Museum." *Museologist* 80 (1961), 11–16.

Abler, Thomas S. "Traffic Pattern and Exhibit Design: A Study of Learning in the Museum." In *The Museum Visitor*, edited by Stephan F. De Borhegyi and Irene A. Hanson. Publications in Museology, no. 3. Milwaukee: Milwaukee Public Museum, 1968.

Abrahamson, Dan, Eugene Gennaro, and Patricia Heller. "Animal Exhibits: A Na-

turalistic Study." *Roundtable Reports: The Journal of Museum Education* 8 (Winter 1982), 6–8, 14.

Abrahamson, Dan, Patricia Heller, and Andrew Ahlgren. "Visitor Behavior at an Open and Closed Animal Exhibit." *Roundtable Reports: The Journal of Museum Education* 8 (Winter 1982), 10–13.

Adams, G. Donald, and John Boatwright, "The Selling of the Museum 1986." *Museum News* 64 (April 1986), 16–21.

Alderson, William T., and Shirley Payne Low. *Interpretation of Historic Sites*. Nashville, TN: American Association for State and Local History, 1976.

Alexander, Edward P. "A Fourth Dimension for History Museums." *Curator* 11 (December 1968), 263–89.

Alt, M. B. "Evaluating Didactic Exhibits: A Critical Look at Shettel's Work." *Curator* 20 (September 1977), 241–58.

American Museum of Natural History. *A Profile of Consumer Use and Evaluation: The American Museum of Natural History: Based on a Survey of Attendance, July 1981–December 1981*. New York: American Museum of Natural History, 1983.

Anderson, Scarvia B. "Nose Prints on the Glass: Or How Do We Evaluate Museum Programs?" In *Museum and Education*, edited by Eric Larrabee. Washington, DC: Smithsonian Institution Press, 1968.

Andreasen, Alan R., and Russell W. Belk. "Predictors of Attendance at the Performing Arts." *Journal of Consumer Research* 7 (September 1980), 112–19.

Annis, Sheldon. "The Museum as a Staging Ground for Symbolic Action." *Museum* 28 (1986), 168–71.

"Art Museums and Education." Special issue. *Journal of Aesthetic Education* 19 (Summer 1985).

Arth, Malcolm. "Museum Education: A Personal Perspective." *Museologist* 149 (Summer 1979), 4–7.

Arts, Education, and Americans Panel. *Coming to Our Senses: The Significance of the Arts for American Education*. New York: McGraw-Hill, 1977.

Association of Art Museum Directors. *Education in the Art Museum*. New York: Association of Art Museum Directors, 1972.

Balfe, Judith Huggins. "What We Know and Don't Know about Adult Learners in Museums." *Journal of Museum Education* 12 (Summer 1987).

Balling, John D., and John H. Falk. "A Perspective on Field Trips: Environmental Effects on Learning." *Curator* 23 (December 1980), 229–40.

Banks, Pamela M., and David W. Ewing. "A More Certain and Precise Perimeter— An Interview with Sherman E. Lee." *Museum News* 61 (June 1983), 72–81, 109–12.

Barnes, Frank. "Viewpoint: Living History, Clio or Cliopatra." *History News* 29 (September 1974), 202–3.

Bay, Ann. *Museum Programs for Young People*. Washington, DC: Smithsonian Institution, 1973.

Beardsley, Don G. "Helping Teachers to Use Museums." *Curator* 18 (September 1975), 192–200.

Bechtel, Robert B. "Hodometer Research in Museums." *Museum News* 45 (March 1967), 23–26.

Beer, Valorie. "Do Museums Have Curriculum?" *Journal of Museum Education* 12 (Summer 1987).

Benton, Deborah P. "Intergenerational Interaction in Museums." Ph.D. dissertation, Columbia University, 1979.

Biehler, Robert F. *Psychology Applied to Teaching.* Boston: Houghton Mifflin, 1978.

Bigge, Morris. *Learning Theories for Teachers.* New York: Harper & Row, 1982.

Bigman, Stanley K. "Art Exhibit Audiences: Selected Findings on Who Comes? Why? With What Effects?" *Museologist* 59 (June 1956), 6–16; 60 (September 1956), 2–6.

Bishop, D. W. "Stability of the Factor Structure of Leisure Behavior: Analysis of Four Communities." *Journal of Leisure Research* 2 (Summer 1970), 160–70.

Bishop, D. W., and P. A. Witt. "Sources of Behavioral Variance During Leisure Time." *Journal of Personality and Social Psychology* 16 (October 1970), 352–60.

Black, Patricia R. *The Live-In at Old Economy: An Experiment in a Role Playing Educational Program in the Museum.* Ambridge, PA: Harmonie Associates, 1972.

Blake, Jim. *The Great Perpetual Learning Machine.* Boston: Little, Brown, 1976.

Bollman, Stephan R., Virginia M. Moxley, and Nancy C. Elliott. "Family and Community Activities of Rural Nonfarm Families with Children." *Journal of Leisure Research* 7 (1975), 53–62.

Boocock, S. S., and E. O. Schild, eds. *Simulation Games in Learning.* Beverly Hills, CA: Sage Publications, 1968.

Borun, Minda. *Measuring the Immeasurable: A Pilot Study of Museum Effectiveness.* Washington, DC: Association of Science Technology Centers, 1977.

Botein, Stephen, Warren Leon, Michael Novak, Ray Rosenzweig, and G. B. Warden, eds. *Experiments in History Teaching.* Cambridge, MA: Harvard-Danforth Center for Teaching and Learning, 1977.

Boulding, Kenneth E. "Communications: The Role of the Museum in the Propagation of Developed Images." *Technology and Culture* 7 (1966), 64–68.

————. "The Future of Museums." *Museum News* 52 (October 1973), 51–52.

Bower, Robert T. *The People's Capitalism Exhibit: A Study of Reactions of Foreign Visitors to the Washington Preview.* Washington, DC: Bureau of Social Science Research, 1956.

Brown, Henry D. "Intrigue Before You Instruct." *Museum News* 42 (March 1964), 28–33.

Bruner, Jerome S. *On Knowing: Essays for the Left Brain.* Cambridge: Belknap Press of Harvard University Press, 1962.

————. *Toward a Theory of Instruction.* Cambridge: Harvard University Press, 1966.

Bultena, Gordon L., and Donald R. Field. "Visitors to National Parks: A Test of the Elitism Argument." *Leisure Sciences* 1 (1978), 395–409.

————. "Structural Effects in National Parkgoing." *Leisure Sciences* 3 (1980), 221–40.

Bunning, Richard L. "A Perspective on the Museum's Role in Community Adult Education." *Curator* 17 (March 1974), 56–63.

Burdge, Rabel J. "Levels of Occupational Prestige and Leisure Activity." *Journal of Leisure Research* 1 (Summer 1969), 262–74.

Burdge, Rabel J., and Donald R. Field. "Methodological Perspectives for the Study of Outdoor Recreation." *Journal of Leisure Research* 4 (Spring 1972), 63–72.

Burke, James. *Connections*. Boston: Little, Brown, 1978.

Butler, Michael V. "What Are We Teaching?" *Museum News* 46 (March 1968), 33–35.

Buzan, Tony. *Use Both Sides of Your Brain*. New York: E. P. Dutton, 1974.

Calver, Homer N. "The Exhibit Medium." *American Journal of Public Health* 29 (April 1939), 341–46.

Calver, Homer N., Mayhew Derryberry, and Ivan N. Mensh. "Use of Ratings in the Evaluation of Exhibits." *American Journal of Public Health* 33 (June 1943), 709–14.

Cameron, Duncan F. "How Do We Know What Our Visitors Think?" *Museum News* 45 (March 1967), 31–33.

———. "A Viewpoint: The Museum as a Communications System and Implications for Museum Education." *Curator* 11 (March 1968), 33–40.

———. "Problems in the Language of Museum Interpretation." In *The Museum in the Service of Man: Today and Tomorrow*. Paris: International Council of Museums, 1972.

Carlisle, R. W. "What Do School Children Do at a Science Center?" *Curator* 28 (March 1985), 27–33.

Carnegie Commission on Higher Education. *Toward a Learning Society: Alternative Channels to Life, Work, and Service*. New York: McGraw-Hill, 1973.

Carr, S., and K. Lynch. "Where Learning Happens." *Daedalus* 97 (Fall 1968), 1277–91.

Carson, Cary. "Living Museums of Everyman's History." *Harvard Magazine* 83 (July-August 1981), 22–32.

Center for Museum Education. *Lifelong Learning/Adult Audiences*. Sourcebook no. 1. Washington, DC: George Washington University, 1978.

———. *Programs for Historic Sites and Houses*. Sourcebook no. 00003. Washington, DC: George Washington University, 1979.

———. *Volunteers in Museum Education*. Sourcebook no. 2. Washington, DC: George Washington University, 1978.

Chapman, Laura. "The Future and Museum Educators." *Museum News* 60 (July-August 1982), 48–56.

Chase, Richard A. "Museums as Learning Environments." *Museum News* 54 (September-October 1975), 37–45.

Cheek, Neil H., Jr., and William R. Burch, Jr. *The Social Organization of Leisure in Human Society*. New York: Harper & Row, 1976.

Cheek, Neil H., Jr., Donald R. Field, and Rabel J. Burdge. *Leisure and Recreation Places*. Ann Arbor, MI: Ann Arbor Science Publications, 1976.

Clarke, Alfred C. "The Use of Leisure and Its Relation to Levels of Occupational Prestige." *American Sociological Review* 21 (June 1956), 301–7.

Clawson, Marion, and Jack L. Knetsch. *Economics of Outdoor Recreation*. Baltimore: Johns Hopkins University Press, 1966.

Cohen, Lizabeth A. "How to Teach Family History by Using an Historic House." *Social Education* (November-December 1975), 466–69.

Cohen, Marilyn S. *The State of the Art of Museum Visitor Orientation: A Survey of Selected Institutions*. Washington, DC: Smithsonian Institution, 1974.

Cohen, Marilyn S., G. H. Winkel, Richard Olsen, and Fred Wheeler. "Orientation in a Museum: An Experimental Visitor Study." *Curator* 20 (June 1977), 85–97.

Collins, Zipporah W., ed. *Museums, Adults and the Humanities: A Guide to Educational Programming*. Washington, DC: American Association of Museums, 1981.

Conaway, Mary Ellen. "Exhibit Labelling: Another Alternative." *Curator* 15 (June 1972), 161–66.

Cone, Cynthia A., and Keith Kendall. "Space, Time, and Family Interaction: Visitor Behavior at the Science Museum of Minnesota." *Curator* 21 (September 1978), 245–57.

Cooksey, Ray W., T. L. Dickinson, and Ross Loomis. "Preferences for Recreational Environments: Theoretical Considerations and a Comparison of Models." *Journal of Leisure Science* 5 (1982), 19–34.

Cooley, William, and Terrence Piper. "Study of the West African Art Exhibit of the Milwaukee Public Museum and Its Visitors." In *The Museum Visitor*, edited by Stephan F. De Borhegyi and Irene A. Hanson. Publications in Museology, no. 3. Milwaukee: Milwaukee Public Museum, 1968.

Cross, Patricia. *Adults As Learners: Increasing Participation and Facilitating Learning*. San Francisco: Jossey-Bass, 1982.

Cunningham, Kenneth R., and Theodore B. Johannis, Jr. "Research on the Family and Leisure: A Review and Critique of Selected Studies." *Family Life Coordinator* 9 (September-December 1960), 25–32.

Dandridge, Frank. "The Value of Design in Visual Communication." *Curator* 9 (December 1966), 331–36.

Danilov, Victor J. "Science Museums as Education Centers." *Curator* 18 (June 1975), 87–109.

Davis, Kay. *Survey of Education Programs at Science Technology Centers*. Washington, DC: Association of Science Technology Centers, 1976.

De Borhegyi, Stephan F. "Visual Communication in the Science Museum." *Curator* 6 (1963), 45–57.

———. "Museum Exhibits: How to Plan and Evaluate Them." *Midwest Museums Quarterly* 23 (Spring 1963), 48.

De Borhegyi, Stephan F., and Irene A. Hanson, eds. *The Museum Visitor: . . . Visitor Reaction to Exhibits in the Milwaukee Public Museum*. Milwaukee: Milwaukee Public Museum, 1968.

Deetz, James. "The Reality of the Pilgrim Fathers." *Natural-History* 78 (November 1969), 32–45.

———. "A Sense of Another World: History Museums and Cultural Change." *Museum News* 58 (May-June 1980), 40–46.

Diamond, Judy. "Ethology in Museums: Understanding the Learning Process." *Roundtable Reports: The Journal of Museum Education* 7 (Summer 1982), 13–15.

Dierbeck, Robert E. "Television and the Museum." *Curator* 1 (Spring 1958), 34–44.

DiMaggio, Paul, and Michael Useem. "Opinion Polls: A Finger on the Public Pulse." *Museum News* 57 (May-June 1979), 29–33.

———. "Social Class and Arts Consumption: The Origin and Consequences of Class

Differences in Exposure to the Arts in America." *Theory and Society* 5 (1970), 141–61.

DiMaggio, Paul, Michael Useem, and Paula Brown. *Audience Studies of the Performing Arts and Museums: A Critical Review.* New York: Publishing Center for Cultural Resources, 1977.

Dixon, Brian, A. E. Courtney, and R. H. Bailey. *The Museum and the Canadian Public.* Ottawa: Arts and Cultural Branch, Secretary of State, 1974.

Dondis, Donis. *A Primer of Visual Literacy.* Cambridge: MIT Press, 1986.

Downey, Matthew, and Fay Metcalf. "Using Local Architecture as an Historical Resource: Some Teaching Strategies." *History Teacher* 11 (February 1978), 175–92.

Draper, Linda, ed. *The Visitor and the Museum.* Berkeley: Lowie Museum of Anthropology, University of California, 1977.

Droba, D. D. "Effect of Printed Information on Memory for Pictures." *Museum News* 7 (September 1929), 6–8.

Dubos, René. "Sensory Perception and the Museum Experience." *Museum News* 52 (October 1973), 50–51.

Dunbar, Nancy Gould, and Minda Borun. *The Science Museum Audience.* Washington, DC: Association of Science Technology Centers, 1980.

Eisenbeis, Manfred. "Elements for a Sociology of Museums." *Museum* 24 (1972), 110–19.

Eisner, Elliot W., and David W. Ecker. *Readings in Art Education.* Waltham, MA: Blaisdell Publishing Company, 1966.

Eisner, Elliot W., and Stephen M. Dobbs. *The Uncertain Profession: Observations on the State of Museum Education in Twenty American Art Museums.* Los Angeles: Getty Center for Education in the Arts, 1986.

Erikson, Erik H. *Identity and the Life Cycle.* New York: W. W. Norton & Co., 1980.

Erwin, David B. "The Belfast Public and the Ulster Museum: A Statistical Survey." *Museums Journal* 70 (March 1971), 175–79.

Fairley, John A. *History Teaching Through Museums.* London: Longman Group, 1977.

Falk, John H. "The Use of Time as a Measure of Visitor Behavior and Exhibit Effectiveness." *Roundtable Reports: The Journal of Museum Education* 7 (Summer 1982), 10–13.

Falk, John H., and John D. Balling. "The School Field Trip: Where You Go Makes the Difference." *Science and Children* 17 (1980), 6–8.

Falk, John H., W. W. Martin, and John D. Balling. "The Novel Fieldtrip Phenomenon: Adjustment to Novel Settings Interferes with Task Learning." *Journal of Research in Science Teaching,* 15 (March 1978), 127–134.

Fechner, G. T. *Vorschule der Aesthetik.* Leipzig: Breitkopf and Hartel, 1897.

Feher, E., and K. Rice. "Development of Scientific Concepts Through the Use of Interactive Exhibits in a Science Museum." *Curator* 28 (March 1985), 34–46.

Field, Donald R., and Joseph T. O'Leary. "Social Groups as a Basis for Assessing Participation in Selected Water Activities." *Journal of Leisure Research* 5 (Winter 1973), 51–59.

Fines, John. *The Drama of History.* London: New University Education, 1974.

Flanders, Ned A., and Mary P. Flanders. "Evaluating Docent Performance." *Curator* 19 (1976), 198–225.

Fronville, Claire L. "Marketing for Museums: For-Profit Techniques in the Non-Profit World." *Curator* 28 (September 1985), 169–82.

Gardner, Howard. *Art, Mind and Brain: A Cognitive Approach to Creativity.* New York: Basic Books, 1982.

Gennaro, Eugene D. "The Effectiveness of Using Pre-Visit Instructional Materials on Learning for a Museum Fieldtrip Experience." *Journal of Research in Science Teaching* 18 (May 1981), 275–79.

Gennaro, Eugene D., and Patricia Heller. "Parent and Child Learning: A Model for Programs at Informal Science Centers." *Roundtable Reports: The Journal of Museum Education* 8 (Winter 1983), 4–5.

Gennaro, Eugene D., Shirley Ann Stoneberg, and Sandy Tanck. "Chance or the Prepared Mind?" *Roundtable Reports: The Journal of Museum Education* 7 (Summer 1982), 16–18.

Gibson, Katharine. "An Experiment in Measuring Results of Fifth Grade Class Visits to an Art Museum." *School and Society*, 21 (May 1925), 658–62.

Gilman, Benjamin Ives. Museum Ideals of Purpose and Method. Cambridge: Harvard University Press, 1923.

Goins, Alvin, and George Griffenhagen. "Psychological Studies of Museum Visitors and Exhibits at the U.S. National Museum." *Museologist* 64 (September 1957), 1–6.

Goldberg, Nita. "Experiments in Museum Teaching." *Museum News* 10 (February 1933), 6–8.

Goldfield, David R. "Living History: The Physical City as Artifact and Teaching Tool." *History Teacher* 8 (August 1975), 535–56.

Goode, George Brown. "Principles of Museum Administration." In *Annual Report of the Board of Directors of the Smithsonian Institution . . . 1897.* Report of the U.S. National Museum, part 2. Washington, DC: Government Printing Office, 1901.

Graburn, Nelson H. H. "The Museum and the Visitor Experience." *Roundtable Reports* (Fall 1977), 1–5.

———. "Tourism, Leisure, and Museums." Paper presented at the Annual Meeting of the Canadian Museums Association, May 1982.

Griggs, Steven A. "Orienting Visitors with a Thematic Display." *International Journal of Museum Management and Curatorship* 2 (1983), 119–34.

Griggs, Steven A., and K. Hays-Jackson. "Visitors' Perceptions of Cultural Institutions." *Museums Journal* 2 (1983), 121–25.

Griggs, Steven A., and Jane Manning. "The Predictive Value of Formative Evaluation of Exhibits." *Museum Studies Journal* 2 (Fall 1983), 31–41.

Grinder, Alison, and McCoy, Sue. *The Good Guide: A Sourcebook for Interpreters, Docents and Tour Guides.* Scottsdale, AZ: Ironwood Publishing, 1985.

Grinnell, Sheila, ed. *A Stage for Science: Dramatic Techniques at Science Technology Centers.* Washington, DC: Association of Science Technology Centers, 1979.

Gross, Ronald. *The Lifelong Learner.* New York: Simon & Schuster, 1977.

Grove, Richard. *The Museum Community: New Roles and Possibilities for Art Education.* New York: Institute for the Study of Art in Education, 1969.

Hareven, Tamara, ed. "Papers from Old Sturbridge Village." *Journal of Family History* 6 (Spring 1981), 2–56.

Havighurst, Robert J., and Kenneth Feigenbaum. "Leisure and Life-Style." *American Journal of Sociology* 64 (January 1959), 396–404.

Hayes, Bartlett H., Jr. "Education for All Seasons." *Museum* 21 (1968), 38–40.

Hayward, D. Geoffrey, and John W. Larkin. "Evaluating Visitor Experiences and Exhibit Effectiveness at Old Sturbridge Village." *Museum Studies Journal* 1 (Fall 1983), 42–51.

Hein, Hilde. "The Museum as Teacher of Theory: A Case History of the Exploratium Vision Section." *Museum Studies Journal* 2 (Spring-Summer 1987), 30–40.

Heine, Albert. *Museums and the Student.* Corpus Christi, TX: Corpus Christi Museum, 1976.

———. *Museums and the Teacher.* Corpus Christi, TX: Corpus Christi Museum, 1977.

Hendon, William S. *Analyzing an Art Museum.* New York: Praeger, 1979.

Herman, Judy. "Zoo Update." *Roundtable Reports: The Journal of Museum Education* 7 (Winter 1982), 16–18.

Hood, Marilyn G. "Adult Attitudes Toward Leisure Choices in Relation to Museum Participation." Ph.D. dissertation, Ohio State University, 1981.

———. "Staying Away: Why People Choose Not to Visit Museums." *Museum News* 61 (April 1983), 50–57.

Horn, Adrienne. "A Comparative Study of Two Methods of Conducting Docent Tours in Art Museums." *Curator* 23 (June 1980), 105–17.

Housen, Abigail. "Three Methods for Understanding Museum Audiences." *Museum Studies Journal* 2 (Spring-Summer 1987), 41–49.

Jeffrey, Julie Roy. "Buildings In and Out of the Classroom." *Teaching History* 4 (Spring 1979), 18–23.

Jensen, Nina, ed. "Children, Teenagers and Adults in Museums." *Museum News* 60 (May-June 1982), 25–30.

Johannis, Theodore B., Jr., and James M. Rollins. "Teenager Perception of Family Decision-Making About Social Activity." *Family Life Coordinator* 8 (March 1960), 59–60.

Johnson, Alton C., and E. Arthur Prieve. *Older Americans: The Unrealized Audience for the Arts.* Madison: University of Wisconsin, 1977.

Joint Working Party on Museums. *Pterodactyls and Old Lace: Museums in Education.* London: Evans/Methuen Educational, 1972.

Judson, Bay. "Teaching Aesthetics and Art Criticism to School Children in an Art Museum." *Museum Studies Journal* 2 (Spring-Summer 1987), 50–59.

Kearns, William E. "Studies of Visitor Behavior at the Peabody Museum of Natural History, Yale University." *Museum News,* January 15, 1940, 5–8.

Kelly, John R. "Socialization Toward Leisure: A Developmental Approach." *Journal of Leisure Research* 6 (Summer 1974), 181–93.

———. "Leisure Socialization: Replication and Extension." *Journal of Leisure Research* 9 (Second Quarter 1977), 121–32.

———. "Family Leisure in Three Communities." *Journal of Leisure Research* 10 (First Quarter 1978), 47–60.

———. "Outdoor Recreation Participation: A Comparative Analysis." *Leisure Sciences* 3 (1980), 129–54.

Kelsey, Darwin P. "Harvests of History." *Historic Preservation* 28 (July-September 1976), 20–24.

Kenney, Alice P. "Women, History and the Museum." *History Teacher* 7 (August 1974), 511–23.

Kimmel, Peter S., and Mark J. Maves. "Public Reaction to Museum Interiors." *Museum News* 51 (September 1972), 17–19.

Kinard, John. "To Meet the Needs of Today's Audience." *Museum News* 50 (May 1972), 15–16.

Knez, E. I., and A. G. Wright. "The Museum as a Communications System: An Assessment of Cameron's Viewpoint." *Curator* 13 (September 1970), 204–12.

Knowles, Malcolm. *The Audit as Learner: A Neglected Species.* Houston: Gulf Publishing Co., 1984.

Knox, Alan B. "Adults as Learners." *Museum News* 59 (March/April 1981), 24–29.

Kolb, David. *Experiential Learning: Experience as the Source of Learning and Development.* Englewood Cliffs, NJ: Prentice-Hall, 1983.

Koran, John J., Jr., and Mary Lou Koran. "A Proposed Framework for Exploring Museum Education Research." *Journal of Museum Education* 11 (Winter 1986), 12–16.

———. "The Roles of Attention and Curiosity in Museum Learning." *Roundtable Reports: The Journal of Museum Education* 8 (Winter 1983), 14–17, 24.

Krepela, Rick. "To Tell the Story . . . Interpretation on a Nationwide Scale." *Museum News* 48 (March 1970), 42–45.

Laetsch, Watson M. "Taking a Measure of Families in Museums." *Roundtable Reports: The Journal of Museum Education* 7 (Winter 1982), 3, 12–13.

Lakota, R. A. *The National Museum of Natural History as a Behavioral Environment, Part I.* Washington, DC: Office of Museum Programs, Smithsonian Institution, 1975.

Lakota, R. A., and JoAnn Kantner. *Summary and Conclusions: The National Museum of Natural History as a Behavioral Environment, Part II.* Washington DC: Office of Museum Programs, Smithsonian Institution, 1976.

Larrabee, Eric, ed. *Education and the Museum.* Washington, DC: Smithsonian Institution Press, 1968.

Leavitt, Thomas W., and Dennis A. O'Toole. "Two Views on Museum Education." *Museum News* 64 (December 1985), 26–31.

Lehman, Susan Nichols, and Kathryn Igoe, eds. *Museum School Partnerships: Plans and Programs.* Sourcebook 4. Washington, DC: Center for Museum Education, George Washington University, 1981.

Lemieux, Louis. "Canadian Museums and Their Role in Social Issues." *Curator* 18 (December 1975), 50–55.

Lewis, Brian N. "The Museum as an Educational Facility." *Museums Journal* 80 (1980), 151–57.

Linn, Marcia C. "Evaluation in the Museum Setting: Focus on Expectations." *Educational Evaluation and Policy Analysis* 5 (Spring 1983), 119–27.

London, Manuel, Rick Crandall, and Dale Fitzgibbons. "The Psychological Structure of Leisure: Activities, Needs, People." *Journal of Leisure Research* 9 (1977), 252–63.

Loomis, Ross J. "Please! Not Another Visitor Survey!" *Museum News* 52 (October 1973), 20–26.

———. "Museums and Psychology: The Principles of Allometry and Museum Visitor Research." *Museologist* 129 (1973), 17–23.

———. *Museum Visitor Evaluation*. Nashville, TN: American Association for State and Local History, 1987.

Low, Shirley P. "Historic Site Interpretation: The Human Approach." *History News* 20 (November 1985), 233–44.

Low, Theodore. *Educational Philosophy and Practice of Art Museums in the United States*. New York: Columbia University Press, 1948.

MacBriar, Wallace N., Jr. "Testing Your Audience." *Museum News* 42 (April 1964), 15–17.

Madden, Joan C., "Bridge between Research and Exhibits: The Smithsonian Naturalist Center." *Curator* 21 (June 1978), 159–67.

———. "Fine Museum Teaching!" *Roundtable Reports: The Journal of Museum Education* 7 (Winter 1982), 10–11, 22.

Madeja, Stanley S., with Sheila Onuska, *Through the Arts to the Aesthetic: The Cemrel Aesthetic Education Curriculum*. St. Louis: Cemrel, 1977.

Maquet, Jacques. *The Aesthetic Experience: An Anthropologist Looks at the Visual Arts*. New Haven: Yale University Press, 1986.

Marcouse, Renée, ed. "Education in Museums." *Museums* 21 (1968), 2–4.

———. *Using Objects: Visual Learning and Visual Awareness in the Museum and the Classroom*. New York: Van Nostrand Reinhold, 1974.

Marsh, Caryl. "How to Encourage Museum Visitors to Ask Questions: An Experimental Investigation." *Roundtable Reports: The Journal of Museum Education* 8 (Winter 1983), 18–19.

Martin, W. W., John H. Falk, and John D. Balling. "Environment Effects on Learning: The Outdoor Fieldtrip." *Science Education* 65 (1981), 301–9.

Massialas, Byron G., and Jack Zeven. *Creative Encounters in the Classroom*. New York: John Wiley & Sons, 1967.

Mayer, Susan M., ed. "Museum Education: Beyond the Tour." *Art Education* 33 (January 1980), 6–24.

Mayo, Edith, ed. "Focus on Material Culture." *Journal of American Culture* 3 (Winter 1980), 595–600.

McLuhan, Marshall, Jacques Barzun, and Harley Parker. *Exploration of the Ways, Means and Values of Museum Communication with the Visiting Public*. New York: Museum of the City of New York, 1969.

Mehrabian, A. *Public Places and Private Spaces: The Psychology of Work, Play and the Living Environment*. New York: Basic Books, 1976.

Melton, Arthur W. *Problems of Installation in Museums of Art*. Publications of the American Association of Museums, New Series, no. 14, Washington, DC: American Association of Museums, 1935.

———. "Distribution of Attention in Galleries in a Museum of Science and Industry." *Museum News*, June 1, 1936, 68.

———. "Visitor Behavior in Museums: Some Early Research in Environmental Design." *Human Factors* 14 (1972), 393–403.

Melton, Arthur W., Nita G. Feldman, and Charles W. Mason. *Experimental Studies of the Education of Children in a Museum of Science*. Publications of the American Association of Museums, New Series, no. 15. Washington, DC: American Association of Museums, 1936.

Mertz, Greg. *An Object in the Hand: Museum Educational Outreach for the Elderly, Incarcerated and Disabled.* Washington, DC: Smithsonian Institution Collaborative, 1981.

Metropolitan Museum of Art. *Museum Education for Retarded Adults: Reaching Out to a Neglected Audience.* New York: Metropolitan Museum of Art, 1979.

————. *Museums and the Disabled.* New York: Metropolitan Museum of Art, 1979.

Meyersohn, Rolf. "The Sociology of Leisure in the United States: Introduction and Bibliography, 1945–1965." *Journal of Leisure Research* 1 (Winter 1969), 53–68.

Miles, Roger S., in collaboration with M. B. Alt, D. C. Bosling, B. N. Lewis, and A. F. Tout. *The Design of Educational Exhibits.* London: George Allen and Unwin, 1982.

Mims, Sandra K. "A Language of Research for Museum Education." *Roundtable Reports: The Journal of Museum Education* 7 (Summer 1982), 46.

Morris, Rudolph E. "Leisure Time and the Museum." *Museum News* 41 (December 1962), 17–21.

Mouat, Lucia. "The Museum's a Nice Place, But It Will Always Be There: Officials Ponder Ways to Keep Visitors Coming Back for Another View." *Christian Science Monitor*, December 24, 1982, 1.

Munley, Mary Ellen. "Back to the Future: A Call for Coordinated Research Programs in Museums." *Journal of Museum Education* 11 (Winter 1986), 3–6.

————. *Catalysts for Change: The Kellogg Projects in Museum Education.* Washington, Chicago, San Francisco: Kellogg Projects in Museum Education, 1986.

————. "Asking the Right Questions: Evaluation and the Museum Mission." *Museum News* 64 (February 1986), 18–23.

Munro, Thomas. *Art Education: Its Philosophy and Psychology.* New York: Liberal Arts Press, 1956.

Munyer, Edward A., Mary Alexander, and Ken Yellis, eds. "Research on Learning in Museums." Special issue. *Roundtable Reports: The Journal of Museum Education* 7 (Summer 1982).

————. "Visitor Behavior: Studies and Strategies." Special issue. *Roundtable Reports: The Journal of Museum Education* 8 (Winter 1983).

Murphy, Patrick E., and William A. Staples. "A Modernized Family Life Cycle." *Journal of Consumer Research* 6 (June 1979), 12–22.

"Museums and Interpretive Techniques: An Interim Report." *Museums Journal* 75 (September 1975), 71–74.

Museums for a New Century: A Report of the Commission on Museums for a New Century. Washington, DC: American Association of Museums, 1984.

Nahemow, Lucille. "Research in a Novel Environment." *Environment and Behavior* 3 (March 1971), 81–102.

Nash, George. "Art Museums as Perceived by the Public." *Curator* 18 (March 1975), 55–67.

National Endowment for the Arts. *Surveying Your Arts Audience: A Manual.* Washington, DC: National Endowment for the Arts, 1985.

Netting, M. Graham. "Objectives of Museum Research in Natural History." *Museum News* 41 (November 1962), 30–34.

Neulinger, John. *The Psychology of Leisure: Research Approaches to the Study of Leisure.* Springfield, IL: Charles C. Thomas, 1974.

Newsom, Barbara Y. "A Decade of Uncertainty for Museum Educators." *Museum News* 58 (May-June 1980), 46–50.
———. *The Metropolitan Museum as an Educational Institution*. New York: Metropolitan Museum, 1970.
Newsom, Barbara Y., and Adele Z. Silver, eds. *The Art Museum as Educator: A Collection of Studies as Guides to Practice and Policy*. Berkeley: University of California Press (1978).
Nichols, Susan. *Museum Education Anthology*. Washington, DC: Museum Education Roundtable, 1984.
———., ed. *Working Papers: Historians/Artifacts/Learners*. Washington, DC: Museum Reference Center, Smithsonian Institution, 1982.
Nichols, Susan K., Mary Alexander, and Ken Yellis, eds. *Museum Education Anthology: Perspectives on Informal Learning: A Decade of Roundtable Reports*. Washington, DC: Museum Education Roundtable, 1984.
Nicholson, Thomas D. "The Art Museum as Educator." *Curator* 21 (December 1978), 315–21.
———. "A Planetarium Demonstration in the Classroom." *Curator* 4 (1961), 295–303.
———. "A Question of Function." *Curator* 14 (March 1971), 7–10.
Niehoff, Arthur, "Characteristics of the Audience Reaction in the Milwaukee Public Museum." *Midwest Museums Quarterly* 13 (1953), 19–24.
———. "Evening Exhibit Hours for Museums." *Museologist*, 69 (1958), 2–5.
Nielson, L. C. "A Technique for Studying the Behavior of Museum Visitors." *Journal of Education Psychology* 37 (1946), 103–10.
O'Hare, Michael. "The Audience of the Museum of Fine Art." *Curator* 17 (June 1974), 126–58.
———. "The Public's Use of Art: Visitor Behavior in an Art Museum." *Curator* 17 (December 1974), 309–20.
O'Malley, Celia. "Museum Education and the Gifted Child: Thoughts after a Conference." *Museums Journal* 76 (September 1976), 59.
Oppenheimer, Frank. "Museums for the Love of Learning: A Personal Perspective." *Museum Studies Journal* 1 (Spring 1983), 16–18.
Parker, Harley W. "The Museum as a Communication System." *Curator* 6 (1963), 350–60.
Parr, Albert Eide. "Marketing the Message." *Curator* 12 (June 1969), 77–82.
———. *Mostly About Museums*. New York: American Museum of Natural History, 1959.
———. "Museums of Memories and Expectations— The Communication of History." *Museum News* 61 (November-December 1982), 46–47.
Parsons, Margaret, and Ross Loomis. *Visitor Traffic Patterns: Then and Now*. Washington, DC: Office of Museum Programs, Smithsonian Institution, 1973.
Pessino, Catherine. "City Ecology for City Children." *Curator* 18 (March 1975), 47–55.
Pierotti, Ray. "Be . . . See . . . Touch . . . Respond." *Museum News* 52 (December 1973), 43–48.
Pitman-Gelles, Bonnie. *Museum, Magic and Children: Youth Education in Museums*. Washington, DC: Association for Science and Technology Centers, 1981.

Pommerehne, Werner W., and Bruno S. Frey. "The Museum from an Economic Perspective." *International Social Science Journal* 32 (1980), 323–39.

Porter, Mildred C. B. *The Behavior of the Average Visitor in the Peabody Museum of Natural History, Yale University.* Publications of the American Association of Museums, New Series, no. 16, Washington, DC: American Association of Museums, 1938.

Powel, Lydia Bond. *The Art Museum Comes to the School.* New York: Harper & Brothers, 1944.

Powell, Louis H. "Evaluating Public Interest in Museum Rooms." *Museum News* 11 (February 1934), 7.

Provenzo, Eugene F., Jr. "The Educational Museum of the St. Louis Public School." *Missouri Historical Society Bulletin* 35 (1979), 147–53.

Ragheb, Mounir G. "Interrelationships Among Leisure Participation, Leisure Satisfaction, and Leisure Attitudes." *Journal of Leisure Research* 12 (1980), 138–49.

Ramsey, Grace Fisher. *Education Work in Museums of the United States: Development, Methods and Trends.* New York: H. W. Wilson, 1938.

Ramsey, Margaret A. "Space for Learning." *Museum News* 52 (March 1974), 49–51.

Rapoport, Rhona, and Robert N. Rapoport. *Leisure and the Family Life Cycle.* London: Routledge and Kegan Paul, 1975.

Rea, Paul Marshall. *The Museum and the Community, With a Chapter on the Library and the Community: A Study of Social Laws and Consequences.* Lancaster, PA: Science Press, 1932.

Reekie, Gordon. "Toward Well-being for Museum Visitors." *Curator* 1 (January 1958), 92–94.

Reynolds, Sarah S. "How to Unstuff a Museum: A Preschool Teacher's Guide." *Curator* 27 (March 1984), 59–64.

Rice, Danielle. "Making Sense of Art." *Journal of the Washington Academy of Sciences* 76 (June 1986), 106–14.

Riemann, Irving G. "Post-mortem on a Museum Questionnaire." *Museologist* 63 (June 1957), 1–6.

Ripley, S. Dillon. *The Sacred Grove: Essays on Museums.* New York: Simon & Schuster, 1969.

Riznick, Barnes. "Learning Living History." *New England Galaxy* 9 (Fall 1967), 60–64.

Robbins, J. E., and S. S. Robbins. "Museum Marketing: Identification of High, Moderate, and Low Attendee Segments." *Journal of the Academy of Marketing Science* 9 (Winter 1981), 66–76.

Robinson, Edward S. *The Behavior of the Museum Visitor.* Publications of the American Association of Museums, New Series, no. 5. Washington, DC: American Association of Museums, 1928.

———. "Exit the Typical Visitor." *Journal of Adult Education* 3 (October 1931), 418–23.

———. "Experimental Education in the Museum: A Perspective." *Museum News,* February 15, 1933, 6–8.

———. "Psychological Problems of the Science Museum." *Museum News* 8 (September 1930), 9–11.

————. "Psychological Studies of the Public Museum." *School and Society* 33 (January 1931), 121–25.

Ronsheim, Robert, and Mary Lynn Stevens. "Nostalgia vs. History." *History News* 36 (December 1981), 8–17.

Rosenfeld, Sherman. "The Context of Informal Learning in Zoos." *Roundtable Reports* 4 (Winter 1979), 13, 15–16.

Rosenfeld, Sherman, and A. Terkel. "A Naturalistic Study of Visitors at an Interpretive Mini Zoo." *Curator* 25 (September 1982), 187–212.

Royal Ontario Museum. *Hands On: Setting Up a Discovery Room.* Toronto: Royal Ontario Museum, 1979.

Sadler, D. Royce. "Intuitive Data Processing as a Potential Source of Bias in Naturalistic Evaluations." *Educational Evaluation and Policy Analysis* 3 (July-August 1981), 25–31.

Scanlon, Carole. "Interpretation: The Language of the Visitor." *Historic Preservation* 26 (October-December 1974), 34–37.

Schlebecker, John T., and Gale E. Peterson. *Living Historical Farms Handbook.* Washington, DC: Smithsonian Institution Press, 1976.

Schlereth, Thomas J. *Artifacts and the American Past.* Nashville, TN: American Association for State and Local History, 1980.

————. "Historic Houses as Learning Laboratories—Seven Teaching Strategies." *History News* 33 (April 1978), 87–102.

————. "The Historic Museum Village as a Learning Environment." *Museologist* 141 (June 1977), 10–18.

————. "The History Behind, Within, and Outside the History Museum." *Curator* 23 (December 1980), 255–74.

————. "It Wasn't That Simple." *Museum News* 56 (January-February 1978), 36–45.

Schroeder, Fred E. H. "Accountability: A Covenant with the People." *Midwest Museums Quarterly* 40 (Summer-Fall 1980), 4–11.

————. "Over 60 Inches and Under 30 Years: Finding and Serving New Audiences." *Roundtable Reports: The Journal of Museum Education* 8 (Spring 1983), 3–6.

————., ed. *Twentieth Century Popular Culture in Museums and Libraries.* Bowling Green, OH: Bowling Green University Popular Press, 1981.

Screven, Chandler G. *The Application of Programmed Learning and Teaching Systems Procedures for Instruction in a Museum Environment.* Washington, DC: U.S. Department of Health, Education and Welfare, Office of Education, Bureau of Research, 1967.

————. "The Museum as a Responsive Learning Environment." *Museum News* 47 (June 1969), 7–10.

————. "The Effectiveness of Guidance Devices on Visitor Learning." *Curator* 18 (September 1975), 219–43.

————. "Exhibitions and Information Centers: Some Principles and Approaches." *Curator,* 29 (June 1986), 109–137.

————. "Education Evaluation and Research in Museums and Public Exhibits: A Bibliography." *Curator* 27 (June 1984), 147–65.

Sebolt, Alberta P. *Building Collaborative Programs: Museums and Schools.* Sturbridge, MA: Old Sturbridge Village, 1980.

————. *A Guide for the Development of a Curriculum Model*. Sturbridge, MA: Old Sturbridge Village, 1980.

————, ed. "Using the Community to Explore 200 Years of History." *Social Education* 39 (November-December 1975), 454–469.

Sebolt, Alberta P., and Monica J. Morgan. "Integrating the Family." *Museum News* 56 (May-June 1978), 29–31.

Selig, Daniel. "Lifelong Learning and the Historic House Museum." *Museologist* (Winter 1980), 8–11.

Serrell, Beverly A. "Looking at Zoo and Aquarium Visitors." *Museum News* 59 (November-December 1980), 36–41.

Serrell, Beverly A., and Ken Yellis, eds. "Evaluation." *Journal of Museum Education* 12 (Winter 1987), 1–24.

Sharpe, Elizabeth M., ed. "Museums and Older Adults." Special issue. *Roundtable Reports: The Journal of Museum Education* 9 (Fall 1984).

————. *The Senior Series Program: A Case Study with Implications for Adoption*. Washington, DC: National Museum of American History, Smithsonian Institution, 1982.

Sharpe, Grant W. *Interpreting the Environment*. New York: John Wiley & Sons, 1976.

Shaw, Evelyn. "The Exploratorium." *Curator* 15 (March 1972), 39–52.

Shaw, Evelyn, and Bessie M. Hecht. "An Assessment of the Undergraduate Research Participation Program After Five Years." *Curator* 8 (1965), 119–34.

Shettel, Harris H. "A Critical Look at a Critical Look: A Response to Alt's Critique of Shettel's Work." *Curator* 21 (December 1978), 329–45.

————. "Exhibits: Art Form or Educational Medium?" *Museum News* 52 (September 1973), 33–41.

Shettel, Harris H., Margaret Butcher, Timothy S. Catton, Judi Northrup, and Doris Clapp Slough. *Strategies for Determining Exhibit Effectiveness*. Technical Report no. AIR-E95–4168–FR. Pittsburgh, PA: American Institutes for Research in the Behavioral in Sciences, 1968.

Shettel, Harris H., and Pamela C. Reilly. "An Evaluation of Existing Criteria for Judging the Quality of Science Exhibits." *Curator* 11 (June 1968), 137–53.

Silver, Adele Z. "Education in a Museum: A Conservative Adventure." *Curator* 15 (March 1972), 72–85.

————. "Issues in Art Museum Education." In Barbara Newsom and Adele Z. Silver, eds. *The Art Museum as Educator: A Collection of Studies as Guides to Practice and Policy*. Berkeley: University of California Press (1978), 13–20.

Sobol, Marion C. "Do the Blockbusters Change the Audience?" *Museum Journal* 80 (June 1980), 118–90.

"The Sociomoral Dimension of Museum Design: Tenth Anniversary Issue." *Moral Education Forum* 10 (Fall-Winter 1985).

Sofranko, Andrew J., and Michael F. Nolan. "Early Life Experiences and Adult Sports Participation." *Journal of Leisure Research* 4 (Winter 1972), 6–18.

"Special Issue on Art Museums and Education." *Journal of Aesthetics Education* 19 (Summer 1985).

Stake, Robert. *Evaluating the Arts in Education: A Responsive Approach*. Columbus, OH: Charles E. Merrill Publishing House, 1975.

Stapp, Carol B., and Ken Yellis, eds. *Journal of Museum Education* (1984).

Stites, Raymond S. "Leisure Time and the Museum: A Reply." *Museum News* 41 (February 1963), 29–33.

Stocking, George W., ed. *Objects and Others: Essays on Museums and Material Culture.* Madison: University of Wisconsin Press, 1985.

Strauss, Claudia. "Beyond 'Formal' versus 'Informal' Education: Uses of Psychological Theory in Anthropological Research." *Ethos* 12 (Fall 1984), 195–222.

Stronck, D. "The Comparative Effects of Different Museum Tours on Children's Attitudes and Learning." *Journal of Research in Science Teaching* 20 (1983), 290–93.

Szybillo, George J., and Arlene Sosanie. "Family Decision Making: Husband, Wife and Children." *Advances in Consumer Research* 4 (1977), 46–49.

Taylor, Frank A. *Research in Exhibits.* Washington, DC: Smithsonian Institution, 1968.

Taylor, Joshua C. "To Catch the Eye and Hold the Mind: The Museum as Educator." *Art Educator* 24 (October 1971), 18–24.

———. *Learning to Look: A Handbook for the Visual Arts.* Chicago: University of Chicago Press, 1957.

———. *To See Is to Think: Looking at American Art.* Washington, DC: Smithsonian Institution Press, 1975.

Thier, Herbert D., and Marcia C. Linn. "The Value of Interactive Learning Experiences in a Museum." *Curator* 19 (1976), 233–45.

Tilden, Freeman J. *Interpreting Our Heritage.* Chapel Hill: University of North Carolina Press, 1967.

Van Rennes. "Educational Techniques in a Science Museum." *Curator* 21 (1978), 289–302.

Vukelich, Ronald. "The Museum Activity Recording Scale: A Categorical Observation Tool." *Roundtable Reports: The Journal of Museum Education* 7 (Summer 1982), 6–9.

Washburne, Randel F., and J. A. Wagar. "Evaluating Visitor Response to Exhibit Content." *Curator* 15 (September 1972), 248–54.

Weiner, George. "Why Johnny Can't Read Labels." *Curator* 6 (1963), 143–56.

Weiss, R. S., and S. Boutourline. "The Communication Value of Exhibits." *Museum News* 42 (1969), 23–27.

Wells, Carolyn H. *The Smithsonian Visitor: A Survey.* Washington, DC: Smithsonian Institution, 1970.

Wells, William D. "Psychographics: A Critical Review." *Journal of Marketing Research* 12 (May 1975), 196–213.

Wells, William D., and George Gubar. "Life Cycle Concept in Marketing Research." *Journal of Marketing Research* 3 (November 1966), 355–63.

White, H. E. *The Design, Development and Testing of a Response Box, a New Component for Science Museum Exhibits.* Washington, DC: U.S. Office of Education, 1967.

White, Terrence H. "The Relative Importance of Education and Income as Predictors in Outdoor Recreation Participation." *Journal of Leisure Research* 7 (1975), 191–99.

Whitehead, Alfred North. *The Aims of Education.* New York: Mentor, 1929.

Williams, Patterson B. "Education Excellence in Art Museums: An Agenda for Reform." *Museum Studies Journal* 2 (Spring-Summer 1987), 20–29.

————. "Object-Oriented Learning in Art Museums." *Roundtable Reports: The Journal of Museum Education* 7 (Winter 1982), 12–15.

Wittlin, Alma S. "Hazards of Communication by Exhibits." *Curator* 14 (June 1971), 138–50.

————. *Museums: In Search of a Usable Future.* Cambridge: MIT Press, 1970.

Wolf, Robert L. "A Naturalistic View of Evaluation." *Museum News* 58 (July-August 1980), 39–45.

Wolf, Robert L., Mary Ellen Munley, and Barbara L. Tymitz. *The Pause That Refreshes: A Study of the Discovery Corners in the National Museum of History and Technology.* Washington, DC: Office of Museum Programs, Smithsonian Institution, 1979.

Wolf, Robert L., and Barbara L. Tymitz. *Do Giraffes Ever Sit? A Study of Visitor Perceptions at the National Zoological Park.* Washington, DC: Office of Museum Programs, Smithsonian Institution, 1979.

————. *A Preliminary Guide for Conducting Naturalistic Evaluation in Studying Museum Environments.* Washington, DC: Office of Museum Programs, Smithsonian Institution, 1979.

Wright, Emmett L. "Analysis of the Effect of a Museum Experience on the Biology Achievement of Sixth Graders." *Journal of Research in Science Teaching* 17 (1980), 99–104.

Wright, Gilbert. "Some Criteria for Evaluating Displays in Museums of Science and History." *Midwest Museums Quarterly* 18 (Spring 1958), 62–70.

Yoesting, Dean R., and Dan L. Burkhead. "Significance of Childhood Recreation Experience on Adult Leisure Behavior; An Explanatory Analysis." *Journal of Leisure Research* 3 (Fall 1973), 25–36.

Yoesting, Dean R., and James E. Christensen. "Reexamining the Significance of Childhood Recreation Patterns on Adult Leisure Behavior." *Leisure Sciences* 1 (1978), 219–29.

Yoshioka, Joseph G. "A Direction-orientation Study with Visitors at the New York World's Fair." *Journal of General Psychology* 27 (1942), 3–33.

Zetterberg, Hans L. *Museums and Adult Education.* New York: Kelley, 1969.

Zucker, Barbara Fleisher. *Children's Museums, Zoos, and Discovery Rooms: An International Reference Guide.* Westport, CT.: Greenwood Press, 1987.

Zyskowski, Gloria. "A Review of Literature on the Evaluation of Museum Programs." *Curator* 26 (June 1983), 121–28.

MUSEUM EXHIBITION

Wilcomb E. Washburn

American museums and, indeed, museums throughout the rest of the world, have undergone a virtual revolution in the character of their exhibits in the post–World War II period. Even when new buildings have not been built to replace older buildings, exhibitions—the museum's principal form of communication with the public—have been modernized dramatically. Whether the continuing increase in visitation to museums is tied causally to this new emphasis on exhibition is not clear. This chapter will deal with the historical origin and evolution of exhibits as well as with current trends in their installation and evaluation.

HISTORIC OUTLINE

Exhibition, as a function of museums, grew out of the collection phase of early museums. The desire to exhibit was normally implicit in the desire to collect, if only to show one's treasures to a select group of friends. Historian Alma S. Wittlin has classified the collections of classical, medieval, and Renaissance times as economic hoards, social prestige collections, accumulations of magical charms, expressions of group loyalty, and objects for stimulating curiosity and inquiry. Each type of early collection had an exhibit component, however private or specialized it might have been. Visitors to medieval churches in Europe today are still privileged to see the elaborate display cases, often an integral part of the church architecture, in which are reverently displayed the bones and relics of saints and martyrs and perhaps a piece of the "true cross."

With the flowering of the Renaissance and renewed interest in the ancient world of Greece and Rome, collections of sculpture, coins, and precious

stones were assembled by the Medici of Florence and other ruling families, as well as by royalty like the French monarch Francis I (1494–1547). Such individuals as the Dane Ole Worm (1588–1654) and the Tradescants, who established in the early seventeenth century what was later incorporated as the Ashmolean Museum of Oxford, also amassed private collections. As European maritime powers expanded their influence, interest in the New World as well as in the fabled world of the Orient stimulated acquisition of exotic plants, animals, and manufactured goods, including "china." Many of these holdings gravitated to the eclectic *kuntskammeren* of the wealthy, and some collectors became so consumed by the task that they turned their houses into private museums. But the larger collections, and particularly those of the Italian princes, came to be placed in long *gallerias*, such as that built by Bernardo Buontalenti around 1581 on the top floor of the Uffizi Palace in Florence. Access to these collections was restricted, and the "exhibits" were organized in various systems or lack of systems according to the interests and capabilities of the collector.

Public curiosity soon fueled the development of both scientific and popular exhibitions. The physical juxtaposition in the 1740s of London's first popular museum, "Don Saltero's" coffeehouse on Cheyne Walk in Chelsea, and Sir Hans Sloane's scientific collection next door illustrates the close relationship between early exhibitions of popular curiosities and scientific specimens. Only gradually, with the development of public institutions such as the British Museum, which absorbed many of the original private collections, did the exhibition of objects begin to be subjected to new critical standards of authenticity and explication.

Concurrent with the emergence of public institutions came a more sophisticated division of objects according to class. Although the British Museum continued until recent years to combine books, manuscripts, and three-dimensional objects in one administrative unit, in most cases institutions committed themselves to excellence in one or a few categories of collections and encouraged other institutions to specialize in other categories. Thus books, manuscripts, prints, paintings, sculpture, the decorative arts, crafts, architecture, and science and technology were found in separate institutional contexts, each developing specialized forms of exhibition.

Well into the nineteenth century, access to European collections was limited to friends of the owner or carefully screened outsiders, and the form of the exhibit was of little significance. Those gaining access to the collections were, by definition, both qualified and anxious to profit from an examination of the objects, however displayed. But in the United States, a country priding itself on its democratic character, great efforts were devised to communicate through exhibits especially designed to reach a mass audience. Although the American museum tradition dates to the Charleston Museum of South Carolina (usually credited with a 1773 origin), the prototype of the American democratic museum was Peale's Museum in Philadelphia, which opened in

1782. Designed for a broad audience but governed by scientific rigor, Peale's Museum reflected the genius of Charles Willson Peale, who utilized his numerous and talented family members to create what his biographer, Charles Coleman Sellers, has called "the first popular museum of natural science and art."

Because Peale was a skilled artist as well as an educated and talented man, he was able to bring an atmosphere of beauty and wonder to what could have been merely a miscellaneous assemblage of curiosities. Peale pioneered the habitat group exhibition, arranging birds and animals in various attitudes on artificial ponds and trees or suspended in midair. Sometimes he painted appropriate natural backgrounds for his specimens. Because his museum was a private enterprise, he was forced to look carefully to his gate receipts. At an early date, he noticed that an exhibit of mammoth bones caused a considerable increase in the number of visitors, and thereafter he was never unaware of the need to cater to a mass audience.

Despite Peale's recognition of the need to make a museum attractive to the public and thus profitable to the owner, he operated under an ethic that forbade pandering and deception to achieve that goal. Less scrupulous was the individual who bought out the remains of Peale's collection and succeeded him as America's greatest museum entrepreneur. Phineas Taylor Barnum, by his mastery of the technique of public relations and his willingness to engage in practices that Peale would not have countenanced, stamped American museum practice with a character that has never quite left it. Barnum operated under what Neil Harris, his biographer, called an "operational aesthetic," which consisted of presenting a complicated hoax and then allowing the visitor to debate the issue of falsity and even to discover how the deception had been perpetrated. As his own ticket seller put it: "First he humbugs them, and then they pay to hear him tell how he did it. I believe if he should swindle a man out of twenty dollars, the man would give a quarter to hear him tell about it." Barnum himself sometimes wrote letters to the newspaper claiming that one of his exhibits was a hoax for the very purpose of stimulating the curiosity and desires for self-improvement that he found in most Americans.

The continuing American preoccupation with the biggest, the most unusual, and the first derives in large measure from the commercial style of such popular nineteenth-century museums. Some of America's greatest artists were involved in these enterprises, including Hiram Powers, who created terrifying exhibits for the Western Museum of Cincinnati to give the local inhabitants an intimate sense of Hell itself. That the impress of the advertising approach to exhibits is still with us is evident in the penchant of major American museums like the Smithsonian to collect and display objects that have great publicity value, such as the memorabilia of television stars Carroll O'Connor (Archie Bunker) and Tom Selleck (Magnum), although their real significance for the study of American culture may be questionable.

American department stores in the nineteenth century developed side by side with museums and influenced both their character and design. Department stores such as those of John Wannamaker in Philadelphia and Marshall Field and Company in Chicago often provided an alternative to museums. Their merchandising principle called for attractive displays, careful selection and arrangement of objects, and facilitation of visitor movement. John Cotton Dana, director of the Newark Museum, asserted that the public learned more about art from shop windows than from museums.

The national or international exposition, which stood halfway between the independent, commercial "show-shop" and the publicly supported, scholarly museum, provided another model of exhibit design. Such expositions as the Crystal Palace Exposition in London (1851), the World Exhibition in Paris (1867), the World's Exposition in Philadelphia (1876), San Francisco's Panama Pacific International Exposition (1915), and a host of successors were normally one-shot affairs, grandiosely organized to promote a particular theme. Appeals to emotion rather than reason prevailed, and entertainment generally triumphed over instruction. Often the exhibits assumed a frankly commercial character since private industry was instrumental in the creation of the expositions and organizers were eager to celebrate the material achievements of the participating nations.

Yet the expositions were consciously designed, both in their architecture and exhibits, to draw a mass audience, and they frequently produced lasting innovations. Because of their temporary nature and the need for haste in their construction, architectural experimentation was encouraged, resulting in such achievements as the dramatic yet functional glass and iron facade of the Crystal Palace. Popular attractions like the series of period rooms created by Arthur Hazelius, founder of the Nordiska Museet, for the Paris World's Fair of 1878 contributed to changing standards of museum exhibit design.

The complex organization of space in the expositions required the orchestration of visitor movement, which became a subject of increasing interest to museum designers and theorists in subsequent years. Designer Herbert Bayer notes that "the first attempt to organize an exhibition space was made during the World Exhibition of 1867 in Paris." The exhibits were arranged on an oval floor plan with corresponding galleries, and the overall pattern was expressed in the architecture of the building. Nevertheless, despite the fascination of professional designers for unidirectional movement of museum visitors to facilitate transmission of a specific message, most world's fairs and expositions have allowed random movement even within the context of a developed exhibit scheme. The New York World's Fair (1964–1965), for example, was praised by theorist Marshall McLuhan precisely because its visitors "weren't being told anything about the overall pattern or shape of it, but they were free to discover and participate and involve themselves in the total overall thing."

The creation of the great urban museums in America in the late nineteenth

century, although often attributed to wealthy individuals seeking to validate their snobbish investment in European paintings, was, in fact, as Neil Harris has shown with regard to Boston's Museum of Fine Arts, undertaken for opposite purposes. Harris concludes that, though supported by Boston's elite Brahmin class, the Museum of Fine Arts was "founded as a collection of reproductions, intended to have a direct connection with popular culture and the applied arts; its building (whatever contemporary judgment may be) was planned as modest and utilitarian; its pedagogic role was pre-eminent; its founders were talented, interested and concerned about American art and the contents of their museum; and it was consciously a departure from the approved European tradition." The Metropolitan Museum of New York was similarly dedicated to the education of the masses.

As access to these new museums became more open and democratic, the need to separate casual visitors from serious students became apparent. The great natural history museums that were built almost simultaneously in London, Paris, Vienna, and Berlin were designed not only to receive the growing collections of natural history objects but, as Sir William Flower, president of the British Association for the Advancement of Science, put it, to make a "distinct separation of the two objects for which collections are made; the publicly exhibited collection . . . such as the ordinary visitor can understand and profit by, and the collection for students being so arranged as to afford every facility for examination and research." This division of the museum function between educational exhibits for the general public and research facilities for the qualified scholar was also forcefully expressed by George Brown Goode, who emphasized the need for restraint and clarity in fashioning the exhibition series in order to avoid the clutter and incoherence often associated with museum collections.

Nevertheless, such public institutions as the Metropolitan Museum of Art and the Victoria and Albert Museum, while designed as museums, were still essentially great houses in which expanded cabinets of curiosities and objects of "virtu" were meant to be installed. The Victoria and Albert Museum, built in the London district of Kensington, devised the so-called Kensington case, a two-tiered, wood-framed, glass-enclosed fixture that spread throughout the world and was still in use at the Smithsonian in the late 1950s. The rigidity of such vehicles of exhibition may be illustrated by the example of the Smithsonian's display of one of John Brown's pikes from his Harper's Ferry raid: it was sliced in two in order to fit into the case.

It was not until after World War II that museums, which had become backwaters of culture, began to feel the need to modernize. Outside designers, often influenced by such architectural schools as the Bauhaus movement, were brought in to update the exhibits. Some of the greatest designers, such as Charles Eames and Ivan Chermayeff, moved into the museum field after designing popular exhibits for corporate sponsors like IBM and General Motors at the New York World's Fair of 1964. Ironically, the notoriety of

other exhibits at the same fair foreshadowed the controversy that subsequently surrounded the modernization of museum displays. For example, the dramatic, brilliantly lighted setting devised by Broadway stage designer Jo Mielziner for Michelangelo's *Piéta*, which had been loaned by the Vatican for the occasion, was alternately praised and attacked for its good or bad taste.

The urge to modernize, however, proved irresistible to museum directors and boards of trustees. Despite curatorial grumbling that museums were being turned over to artists and designers, many institutions cast out their traditional exhibits, typified by an abundance of objects crowded into closed floor cases containing a plethora of typed labels. In its place the new designer-organized exhibit was frequently characterized by a limited number of objects tastefully mounted on panels featuring dramatic colors and unobtrusive labels. As Herbert Bayer suggested, the importance of graphics as an element in the modern exhibit could scarcely be overestimated. No matter how traditional the architecture of the museum or style of the case, modern graphic design—virtually unaided—put the stamp of modernity upon an exhibit.

Still, the most fundamental aspects of exhibit design were linked to individual creativity. For example, when I was planning the Hall of Historic Americans in 1964, I sought to take the figure of *The Dying Tecumseh* by Ferdinand Pettrich, then on a chest-high pedestal in the National Collection of Fine Arts, and put it flat on the floor. I wanted visitors to empathize with the dying Indian leader by being forced to look down rather than up at him.

In other museums, imaginative individuals who were in a position to implement their ideas gave the revolution in exhibit design its greatest impetus. One of the most influential was Stephan F. De Borhegyi, the Hungarian-born anthropologist who became director of the Milwaukee Public Museum in 1959 and proceeded to shape the character of the new facilities built by the city. As planned by De Borhegyi and a committee of curators and staff members, the new museum would contain "no 'bird hall' or 'mammal hall' or other fief-for-an-ology. . . . The over-all story will flow through a logical, chronological and ecological sequence, and the exhibits and materials used to tell its individual parts will flow together as they are actually related in fact and in history." De Borhegyi did not merely turn over the design of the new museum to professional designers. Indeed, he warned against both the tendency to overemphasize design and the subjective selection of objects and urged greater emphasis on conceptual displays. The Milwaukee Public Museum still bears the imprint of his leadership in exhibit design, even though his life was cut short in a tragic automobile accident in 1969 before the full working out of his vision.

Another aspect of modernization, the participatory exhibit, was illustrated by Exploratorium in San Francisco. Started in 1969 as the brainchild of Dr. Frank Oppenheimer, like his brother Robert a physicist, the Exploratorium

occupied about 85,000 square feet in the Palace of Fine Arts. Exhibits dealt with subjects such as sight, sound, light, optics, color, holography, art, music, and animal behavior. The exhibits, which were constantly changing, fully involved visitors in experiments designed to illuminate fundamental scientific principles, and many directly involved the staff as well.

The great art museums also quickly embraced the revolution in exhibition design. During the directorship of Thomas Hoving from 1967 to 1977, the Metropolitan Museum of New York placed increasing emphasis on the design of exhibitions, and the National Gallery in Washington followed soon after. Extensive resources of money and personnel in each museum were committed to providing installations that would best show off the objects to be exhibited and most effectively communicate their meaning to the target audience.

The celebration of the American bicentennial provided the occasion for a series of new museum exhibits that relied heavily on modern design techniques. One of the most successful was "The Revolution: How It All Began," an element of the Boston 200 exhibition of the Massachusetts bicentennial in 1976. In that exhibit, the visitor was asked to mark on a "ballot" five decisions on where he or she would have stood on the crises leading up to independence. At the end of the exhibit a computer reviewed the visitor's decisions and told the person how he or she would have been classified at the time—Tory or Revolutionary. Such interactive devices have been most frequently used in temporary fairs and remain relatively rare in most permanent American museums.

But, although often successful, the modernization of exhibits also provoked intense opposition from both critics and curators. When the office of Charles and Ray Eames designed "The World of Franklin and Jefferson" under the auspices of the American Revolution Bicentennial Administration, the show, installed in the Metropolitan Museum, was attacked by art critic Hilton Kramer for making "a mockery of the museum function." To Kramer, the Eames show was "designed to 'sell' us something," specifically "an anonymous, immaculate, idealized, unreal glimpse of a never-never land—a world at once cozy and glamorous, without flaws or imperfections, where the light always glows with an amber warmth and all emotions are either noble or picturesque." Kramer was particularly upset at the many photographs, "which truly dominate the exhibition and determine its character." His attack should be seen not as a valid critique of the art form achieved by the Eames studio (which even Kramer acknowledged to be superb in its class) but as a defense of the art museum bastion against a designer's interpretation of an era by means other than displaying original works of art.

More recently, efforts by the British Museum (Natural History) to overhaul its exhibits so as better to attract and educate the public have raised a storm of protest. Appalled that "more than 25 years after Watson and Crick's revolutionary paper on the structure of DNA there is still no exhibition on

molecular biology," C. G. S. Clarke and R. S. Miles of the museum's De-
partment of Public Services sought to change the "tendency for the general
public to regard the Natural History Museum as principally a children's
museum." But in the process of modernizing the halls, and particularly with
the opening of the exhibit "Man's Place in Evolution," they came face to
face with critics who deplored the change from the object-filled cases of the
past to exhibits dominated by fabricated models and slick graphic design.
The museum's plea that it must keep up to date with scientific discovery
and teach theory rather than merely display specimens expresses the evolv-
ing philosophy of museum display but also raises new questions and problems
that must be resolved in the debate that the changes have elicited.

Some of the impetus to the modernization of exhibits has come from the
evidence of the learning (or lack of learning) by museum visitors provided
by psychologists in the 1960s and 1970s. Earlier, museums were the subject
of scholarly examination in the 1920s and 1930s when pioneers like Arthur
W. Melton and Edward S. Robinson conducted tests to measure and analyze
visitor behavior. Melton and others provided useful technical data concern-
ing visitors' tendencies to turn right rather than left when entering an exhibit
hall, their greater willingness to enter a hall when an exit is visible at the
other end, their reluctance to read long labels, and other evidence useful
to museum exhibit designers. Researchers discovered that visitors' explor-
atory behavior resembled the behavior of rats in a maze, even to the extent
of hugging the wall as they passed from one enclosure to the next. But the
example Melton and his associates provided was either lost or ignored in
the following decades, perhaps because of the changing leadership of the
American Association of Museums, which sponsored the early research.

It was not until the late 1960s that psychological studies of museum be-
havior again emerged, and then only hesitantly and intermittently. More-
over, the work of experimental psychologists such as Chandler Screven,
Harris Shettel, and others has evoked pained outcries from many museum
directors and curators. Psychologists have been seen as poaching on terrain
that is not their own and asking impertinent questions of museum directors
such as, "What are you trying to accomplish with your exhibit?" To a profes-
sion convinced that a museum is an educational institution and that exhibits
do teach, the fact that an outsider presumes to question these beliefs, even
hypothetically for the purpose of conducting an experiment, constitutes a
threat. Few directors are willing to have their motives and assumptions
questioned in such a fashion.

At the same time it is true that psychologists often are unable to measure
the visual, aesthetic, and emotional effects of objects and succeed best in
measuring verbal comprehension about objects. Nevertheless, the work of
psychologists has both helped to validate the museum's claim to educational
effectiveness and challenged that claim when it is made indiscriminately
without supporting evidence. The fact that such studies are marginal and

poorly supported within the museum profession reflects the ambiguous feelings museum directors and curators hold about such studies.

Because of the evolving character of museums and the often contradictory purposes they have served, the precise manner in which their collections have been exhibited has varied. In both the earliest museums, merely houses or palaces adapted for museum use, and in the monumental buildings of the nineteenth century, exhibits had to adjust to the configurations and constrictions of structures designed to meet other needs. The twentieth century, however, has seen the erection of numerous specialized museum buildings, often by such outstanding architects as I. M. Pei (East Building of the National Gallery of Art in Washington) and Frank Lloyd Wright (Guggenheim Museum). The work of such architects has sometimes been criticized for subordinating the goals of the museum director to an egotistical display of architectural ingenuity. Detractors have noted that otherwise brilliant buildings, like Kevin Roche's Oakland Museum, fail to facilitate easy expansion in the face of growing collections.

A characteristic of much museum architecture in the 1950s and 1960s (although not of subsequent decades) was the near total exclusion of natural light and its replacement by more readily controlled artificial lighting. Flexibility of interior exhibit spaces was often a prime objective of museum directors and designers. The museum thus became a closed box with endless flexibility as curators acquired the means of moving or removing panels and adjusting the lights along the network of lighting tracks embedded in the ceiling. Even when the resulting museum was designed by a superior architect, the surrender of the architect's vision to the needs of the exhibit designer was often a bad trade.

A category of dramatic exhibit of the nineteenth century that is now being rediscovered in a modern form is the cyclorama, or rolled-up painting that was uncovered to the accompaniment of a narrative. Such paintings depicted scenes as varied as a trip down the Mississippi or a panorama of a Civil War battlefield and clearly anticipated the "moving pictures" that have become such a dominant part of our cultural perception of reality and a fundamental element of contemporary museum experience. Few newly constructed museums lack a theatre for showing in motion the objects that may stand mute in the surrounding halls. Perhaps the best example is the theatre in the Smithsonian Institution's National Air and Space Museum. The popularity of the films shown there, though an admission fee is charged, is scarcely less spectacular than the contents of the films themselves.

The use of films in a museum context raises the theoretical question as to whether the picture of an object, particularly the moving picture of an object in use, is not more educational than the object itself in a traditional museum setting. If so, what does this say about the rationale for a museum? E. V. Gatacre, among others, has urged curators to reassess the value of exhibiting three-dimensional objects and, where appropriate, to relinquish

certain subjects to other media. Such considerations, according to Gatacre, suggest that there are limits to design and that, to some extent, museums have become "victims of the post-war surrender of responsibility to architects and to professional designers." But until more sophisticated evaluation techniques are directed to these concerns within a profession that has a vested interest in keeping pictures of objects subordinate to objects themselves, we will not be able to obtain a scientific answer to this fundamental question.

SURVEY OF SOURCES

Alma S. Wittlin describes the categories of early collections and the manner in which they were often displayed in *Museums: In Search of a Usable Future* (1970). For a glimpse of the prototypical European dilettante who transformed his house into a private museum, see *John Soane* (1983), a collection of biographical essays devoted to the eighteenth-century English architect by Sir John Summerson, David Watkin, and G. Tilman-Mellinghoff. More broadly, Richard D. Altick's *The Shows of London* (1978) provides massive documentation of the character of exhibitions—defined as nontheatrical and nonmusical entertainment—that flourished in London from the late seventeenth century until the Crystal Palace Exposition of 1851. Such diversions, which often served as surrogates for books to the uneducated, struck an uneasy balance between the interests of instruction and entertainment. This same tension between conflicting museum functions is evident in the exhibition styles of American entrepreneurs Charles Willson Peale and P. T. Barnum, as described by Charles Coleman Sellers in *Mr. Peale's Museum* (1980) and by Neil Harris in *Humbug* (1973). Harris also attacks the conventional interpretation of the great urban museums of the late nineteenth century as ostentatious embodiments of upper-class privilege by emphasizing the educational goals of Boston's Museum of Fine Arts in "The Gilded Age Revisited" (1962).

Although Peale normally receives credit for creating the first habitat group in the United States, the origin of this exhibition technique is not entirely clear. The "Second Bulletin of the Proceedings of the National Institution for the Promotion of Science, Washington, D.C., March, 1841, to February, 1842" (n.d.) reported "one hundred and thirty specimens of North American Birds, set up in natural attitudes, and placed on stands, with a list of names, sexes, and habitats." This arrangement at Washington's earliest museum may not have constituted a habitat group as we know it, but it certainly went beyond the mere assembling of skins. A. E. Parr, former director of New York's American Museum of Natural History, speculates further on the precursors to the habitat group in several articles, including "The Habitat Group" (1959) and "Dimensions, Backgrounds, and Uses of Habitat Groups" (1961). In "Habitat Group and Period Room" (1963), for example, Parr con-

siders whether the publishers of early stereoscopic views for commercial purposes played a role in creating habitat groups of birds and beasts.

In the 1890s, Carl Akeley created numerous habitat groups for the Milwaukee Public Museum and the Field Museum of Natural History in Chicago before applying his skills to the American Museum of Natural History in New York after 1909. As William King Gregory notes in his "Biographical Memoir of Frank Michler Chapman, 1864–1945" (1949), the American Museum's Frank Chapman "was able to make a marked advance in the art of bringing into the Museum the illusion of outdoors, at the same time showing the bird in relation to its haunts" in the years between 1898 and 1910. For more information on these innovations, see also George S. Gardner's "A New Habitat Group of Wood Storks" (1978).

The notion of placing objects of both human history and natural history within the contexts in which they were used is conceptually the same, but, like the development of habitat groups, the evolution of period rooms in American museums is obscure. In "Artistic and Historical Period Rooms" (1964), Edward Alexander attributes the "first true period rooms displayed in the United States" to George Francis Dow, curator of the Essex Institute at Salem, Massachusetts, who created a colonial New England kitchen and a bedroom and parlor in three alcoves in the museum in 1907. The idea of a period room stems naturally from the association of objects that constitute a room in a palace or historic house. If the palace or house has been converted into a museum, the period room becomes an inevitable concomitant of the museum. In this way, period rooms became common in Europe, but in America their appearance has usually been the result of individual initiative on the part of museum directors.

Among the earliest exponents of the period room approach was Charles P. Wilcomb, founder of the Oakland Public Museum (now the Oakland Museum), whose exhibition methods are discussed in Melinda Young Frye's "Charles P. Wilcomb, Cultural Historian" (1979). At about the same time Dow was creating period rooms at the Essex Institute, Wilcomb brought colonial furniture from his native New England to arrange in period rooms to show Californians the way of life of their New England forebears.

Other museum theorists turned to the new American palaces of consumption for display innovations. The great department stores of the late nineteenth century inspired John Cotton Dana of the Newark Museum to consider the power of shop windows in "The Use of Museums" (1922). More recently, in *The Americans: The Democratic Experience* (1973), historian Daniel J. Boorstin has discussed the significant impact of these displays, attractively packaged under the influence of such men as R. H. Macy, John Wannamaker, and Jordan Marsh in what came to be called "show windows." In "Museums, Merchandising, and Popular Taste" (1978), Neil Harris has also perceptively probed the relationship between early department stores and museums. And, as suggested by A. E. Parr's address to the Package

Designers' Council of New York, published as "Remarks on Layout, Display, and Response to Design" (1964), contemporary museum practices continue to be influenced by department store practices, not only in technical aspects such as the production of mannequins but also in thematic aspects.

Although enticing store displays attracted customers and sold merchandise without the aid of sales clerks, museum curators discovered that even attractive exhibits did not always teach by themselves. Such turn-of-the-century administrators as George Brown Goode and Benjamin Ives Gilman sought more effective means of instruction, despite their differences over the relative value of labels and documents. At the Smithsonian, Goode raised the importance of labels to its highest point with his dictum that "an efficient educational museum may be described as a collection of instructive labels each illustrated by a well-selected specimen." In "Principles of Museum Administration" (1901), Goode validated the detailed labels, complete with Latin nomenclature, that accompanied the specimens filling the Smithsonian's exhibit cases in the early twentieth century.

Later, with the rise of the design profession within the museum world, the curator was sometimes reduced to supplying raw data to the designer to be converted into appropriate labels. In large museums the ultimate authority for the form of labels was occasionally put into the hands of a label editor who checked all labels for exhibits according to certain standards. As George Weiner noted in "Why Johnny Can't Read Labels" (1963), those standards required labels to be brief and comprehensible to young teenagers. In "A Roman Sarcophagus in a Museum of American History" (1964), Wilcomb E. Washburn observed that some curators resisted the requirement that Smithsonian labels fit a procrustean bed of fixed length and limited sophistication. Recalling Goode's arguments, they asserted that pitching labels to the lowest common denominator would sacrifice richness of detail and discourage highly educated visitors from regarding the museum as a scholarly institution.

The docent movement originated in Boston at the Museum of Fine Arts and expressed the strong New England belief in education and the conviction that the meaning of an exhibit can sometimes be conveyed only by someone trained to communicate that meaning. As Benjamin Ives Gilman argued in his *Museum Ideals of Purpose and Method* (1923), the word *docent* was adopted to refer to those—usually volunteers—who "led" the visitor to an understanding of an exhibit by means of a guided tour or gallery lecture. In "Museum Docentship" (1978) and *The Museum, Its History and Its Tasks in Education* (1949), Alma Wittlin reviewed the docent's function and the educational aspects of museum exhibits.

The techniques of temporary fairs inspired new exhibition practices. Contemporary reactions to the expositions of the late nineteenth century are contained in such publications as *Grounds and Buildings of the Centennial Exhibition, Philadelphia, 1867* (1878), edited by Dorsey Gardner, and *Camp-*

bell's Illustrated History of the World's Columbian Exposition (1894), com-
piled by James Campbell. Such expositions in America frequently reflected
the nation's ideological preconceptions at discrete moments in history and
have attracted the attention of modern cultural historians. See, for example,
Merle Curti's "America at the World Fairs, 1851–1893" (1950), John G.
Cawelti's "America on Display" (1968), Burton Benedict's *The Anthropology
of World's Fairs: San Francisco's Panama Pacific International Exposition
of 1915* (1983), and "Visions of Empire" (1983) and *All the World's Fair*
(1984) by Robert W. Rydell.

The difference in approach between temporary fairs and conventional
museums was the subject of a study authorized in 1937 under a grant from
the Rockefeller Foundation to the Buffalo Museum of Science. A group of
museum scholars surveyed the two major world's fairs of 1939, on the East
and West coasts of the United States, and reported their findings in two
volumes, *Exhibition Techniques* (1940) and *East Is East and West Is West*
(1940) by Carlos Emmons Cummings. Herbert Bayer, a bauhaus designer
who pioneered in exhibits modernization in the 1940s at New York's Museum
of Modern Art, later explored the application of techniques originally devised
for the temporary fair to the museum in "Aspects of Design of Exhibitions
and Museums" (1961).

Although the origins of the "interpretive exhibit"—with its emphasis on
telling a story coherently—can be traced to earlier experiments in architec-
ture, display, and instructional techniques, the great impetus came in the
post–World War II period, and particularly in the 1950s and 1960s. In
"Surprises for the Museum-Going Vacationist" (1959), K. Ross Toole, then
director of the Museum of the City of New York, announced that "there has
been a revolution in the museum world. The tourist today who visits the
indoor or outdoor historical museum is very apt to find himself entranced
rather than entrapped, and he is probably going to be taught something
painlessly."

The importance of graphic design in capturing the viewer's attention was
early recognized by commercial and industrial enterprises, and the principles
of the craft are laid out in such books as F. H. K. Henrion and Alan Parkin's
Design Coordination and Corporate Image (1967). Discussions of design
specifically related to museums are contained in Misha Black's *Exhibition
Design* (1950) and in a wide variety of journal articles.

A compelling example of exhibits modernization occurred at the Milwau-
kee Public Museum under the direction of Stephan De Borhegyi. In "The
New Museum" (1963), Robert Riordan expressed the philosophy developed
by Borhegyi and his staff, who attempted to design a comprehensive exhi-
bition scheme that emphasized the interrelationships of humans, other mam-
mals, birds, fish, and flora. De Borhegyi suggested methods for transplanting
the principles of bionomics into three-dimensional displays in "Visual Com-
munication in the Science Museum" (1963) and "Some Thoughts on An-

thropological Exhibits in Natural History Museums in the United States"
(1964).

Prompted by the discoveries of educational psychologists in the 1960s,
other museum curators focused on the importance of visitor involvement as
an element in the learning process. Generally this entailed interactive de-
vices in which the visitor, often in the form of a game, responded to questions
raised by an exhibit. At Frank Oppenheimer's Exploratorium, visitors were
invited to perform scientific experiments. In "A Rationale for a Science
Museum" (1968), Oppenheimer explained his belief that the laboratory at-
mosphere of an "exploratorium" can replace the hodgepodge of exhibits that
too often have characterized science museums. The genesis of this idea is
recalled in "Exploration and Culture" (1982), Oppenheimer's remarks on
receiving the Award for Distinguished Service to Museums from the Amer-
ican Association of Museums. Like the Lawrence Hall of Science at the
University of California across the bay in Berkeley and the Ontario Museum
of Science in Toronto, the Exploratorium measures its effectiveness by the
learning its exhibits stimulate, as noted by Evelyn Shaw in "The Explora-
torium" (1972). But in contrast to the Exploratorium's success, some mu-
seums have failed to provide adequate maintenance to support the efficient
functioning of interactive devices, and the result is a disquieting panorama
of broken-down machines.

The desire for notoriety and the increasing concern with attendance figures
led many museums to install lavishly designed exhibitions. In "Almost Every-
one Loves a Winner" (1982), designer Stuart Silver gives a revealing glimpse
of the initiation of this trend at the Metropolitan Museum of Art in 1967
under the new director, Thomas Hoving. Critic John Canaday hailed the
Met's first blockbuster exhibition, "In the Presence of Kings," as "kingly,"
and succeeding shows at the Metropolitan, the National Gallery of Art, and
other museums were warmly greeted. More recently there has been a ques-
tioning of such efforts. In an article entitled "When the Size of a Show
Overwhelms Its Content" (1980), Hilton Kramer has asserted that often such
exhibitions overwhelm their contents. An artist's bad work is exhibited with
his or her good work; contextual details overshadow the objects; the non-
essential dominates the essential. Connoisseurship is abandoned in favor of
wholesale documentation. A show like "The World of Franklin and Jeffer-
son," which Kramer attacked in his review for the New York Times, entitled
"What Is This Stuff Doing at the Met?" (1976), may be a blockbuster in
terms of impact on the mass media but lacks the qualities that Kramer
believes distinguish good museum exhibits.

The movement away from traditional museum values to what Jean Baud-
rillard (1982) calls the "Beaubourg-Effect . . . Beaubourg-Machine" has stim-
ulated even more criticism. Paris's massively popular Pompidou Center
(known as Beaubourg because of its location) has caused Baudrillard to com-
pare it to "an incinerator, absorbing and devouring all cultural energy, rather

like the black monolith of *2001*—a mad convection current for the mater-
ialization, absorption, and destruction of all the contents within it." Baud-
rillard notes that "the masses fall on Beaubourg to enjoy this execution, this
dismembering, this operational proposition of a culture that is at last truly
liquidated, including all counterculture, which is nothing but its apotheosis."

Clearly the integration of exhibit design and museums has not always been
harmonious. In "Interpreting Material Culture" (1978), Harold K. Skram-
stad, Jr., perceptively analyzes the hostile reaction by conservative museum
staff to such modern thematic exhibits as "If We're So Good, Why Aren't
We Better?" at the National Museum of History and Technology, an exhi-
bition designed by Ivan Chermayeff and devoted to explaining the concept
of productivity.

Elsewhere the modernization of exhibits in the British Museum (Natural
History) and the controversy that brought forth are discussed by G. C. S.
Clarke and R. S. Miles in "The Natural History Museum and the Public"
(1980). The new exhibits raised some fundamental questions about museum
purpose. In his review, "A Sideways Look at the Natural History Museum"
(1979), Anthony Smith thought the changes so radical that the museum
should be called the "Former Natural History Museum." "Should the natural
history museum," Smith asked, "be a kind of big biology classroom and
three-dimensional textbook?" In "Whither the Natural History Museum?"
(1978), Dr. B. Halstead of the University of Reading charged the museum
with ignoring its unique role as a national collection and repository and
adopting a new role of social engineering and indoctrination of "the more
inarticulate sections of the community" in "concepts that happen to be cur-
rent in the present climate of opinion."

Proponents of the new scheme responded that the act of Parliament cre-
ating the museum in 1753 sanctioned collections not only "for the Inspection
and Entertainment of the learned and the curious, but for the general Use
and Benefit of the public." In addition, supporters like R. S. Miles and
M. B. Alt, in "British Museum (Natural History)" (1979), have been able to
point to a rapid increase in attendance and learning largely attributable to
the new halls to justify the revolution in exhibition policy. Professor Halstead
then renewed his attack in a letter entitled "Museum of Errors" (1980),
making the more serious charge that the new exhibits at the British Museum
(Natural History) were "simply vehicles for the promotion of a system of
working out relationships known as cladistics." Halstead saw sinister impli-
cations in the exhibits in terms of inculcating both Marxist and creationist
approaches to evolutionary history. A minor scandal arose in the European
press as a result of the accusations and rebuttals. Dr. Miles and supporters
of the museum's Department of Public Services have counterattacked, and
such papers as *Visitors' Perceptions and Evaluations of Seven Exhibitions
at the Natural History Museum* (1984), a mimeographed publication of the
British Museum (Natural History) by Steven Griggs, have attempted to show

that the new concept-oriented exhibits are both more popular and effective than the traditional exhibits they replaced.

Partly in response to criticism of modern exhibit trends, E. V. Gatacre suggested "an easy retrospective test" for the suitability of exhibitions like the Eames's Franklin and Jefferson show and other non-traditional museum displays in "The Limits of Professional Design" (1976). For the visitor, the test includes the question, "Would I rather have seen the exhibition or have bought the catalogue?" For the curator, it is, "Would I rather have the catalogue published or the exhibition open to the public?" If the catalogue seems the more desirable, Gatacre concludes, "then the energy, time and money should surely be devoted to publishing."

Gatacre's suggestion that curators consider alternative modes of communication is equally applicable to motion pictures, which are increasingly assimilated to more traditional exhibition techniques. A justly famous film used in a museum context is Charles Eames's *Powers of Ten*, a ten-minute film produced in 1977 utilizing forty-two still photographs descending in scale by a factor of ten at each step from a cosmic range of 10^{25} meters to a subnuclear 10^{-16}. The film has been described in *Powers of Ten* (1982) by Philip Morrison and Phylis Morrison and the Office of Charles and Ray Eames. It is hard to conceive of a static museum exhibit on the subject conveying what Robert H. March calls, in "Book Reviews: Differences of Scale" (1983), "the sense of wonder [in the film] that drives us to transcend the limits imposed by our senses."

Simultaneously with the revolution in exhibition techniques in the 1960s, the Milwaukee Public Museum and other institutions resumed experimental studies of visitor behavior. Few such studies had been conducted since the early publication of works like *The Behavior of the Museum Visitor* (1928) by Edward S. Robinson, Irene Sherman, and Lois Curry and "Some Behavior Characteristics of Museum Visitors" (1933) by Arthur W. Melton. At Milwaukee, Stephan De Borhegyi began an active program of testing the effectiveness of museum exhibits, which is described by Lee A. Parsons in "Systematic Testing of Display Techniques for an Anthropological Exhibit" (1965) and by De Borhegyi in "Testing of Audience Reaction to Museum Exhibits" (1965).

The work of the evaluators has become increasingly sophisticated, as indicated by Harris H. Shettel's "An Evaluation of Existing Criteria for Judging the Quality of Science Exhibits" (1968) and two significant works by Chandler G. Screven, "The Effectiveness of Guidance Devices on Visitor Learning" (1975) and *The Measurement and Facilitation of Learning in the Museum Environment* (1974). The bitterness of the debate between the psychologists and their critics is well expressed in Shettel's "A Critical Look at a Critical Look" (1978), in which he responded to criticism leveled at his work by M. B. Alt in "Evaluating Didactic Exhibits" (1977). One of the points Alt attacked was Shettel's emphasis on the usefulness of doing mock-up vali-

dation, or formative evaluation, prior to constructing an elaborate exhibit. Alt, "in his effort to be cuttingly critical," Shettel notes, had asked why he did not recommend that mock-ups replace the real exhibit if visitors can learn as much from photographs on the wall as from expensive exhibition productions. Shettel turns the tables and notes that "Alt has actually (and inadvertently) made an important point! The fact is that from a learning point of view one does not always need the elaborate kinds of display devices and techniques that one often finds in exhibits."

The *Manual of Curatorship* (1984), edited by John M. A. Thompson and others and published by Butterworths for the Museums Association of Great Britain, recognizes the important work of experimental psychologists in the museum more fully than any of the comparable publications sponsored by the American Association of Museums. The third section of the *Manual*, entitled "Visitor Services," contains a series of articles on evaluating museum exhibits. In particular, the passive observational approach of psychologists like Robert Wolf, sometimes referred to as "naturalistic observation," is increasingly attractive to museum directors. Wolf's studies record visitor reactions and provide non-threatening comments and insights about exhibits to non-threatened directors. Most of his works, usually coauthored with Barbara L. Tymitz, have been published in multilithed form by the Smithsonian's Office of Museum Programs, under such titles as *The Evolution of a Teaching Hall: "You Can Lead a Horse to Water and You 'Can' Help It Drink"* (1981).

The proliferation of psychological consultants reflects a growing fragmentation of the museum exhibition process in the twentieth century. Specialists have emerged in conservation, preparation, interpretation, label editing, design, education, and evaluation. In turn, this division of labor encouraged the development of a team approach toward installation of exhibitions. The Royal Ontario Museum of Toronto has formalized this concept in several of its publications, including *Communicating with the Museum Visitor* (1976) and the first report of the Exhibits Communication Task Force, entitled *Opportunities and Constraints* (1979). The International Laboratory for Visitor Studies, set up in 1987 by Chandler Screven in the Department of Psychology, University of Wisconsin—Milwaukee began publishing a bibliography of visitor studies, to be updated biannually.

Prior to the explosion of interest in imaginative design techniques in the mid–1960s, museum exhibits were rarely if ever reviewed in scholarly journals. Reviews consisted for the most part of newspaper or magazine accounts of openings, with attention focused on who attended and what they wore. Often such reviews were consigned to what used to be called the woman's page. In 1964, in "Letters from Readers: Exhibit Reviews?" Wilcomb E. Washburn and Gordon Gibson urged the museum profession, if it wished to validate its professional status, to review exhibits in scholarly journals as scholarly books are reviewed.

The Washburn-Gibson proposal was quickly challenged by A. E. Parr in "Test and Criticism" (1964) on the grounds that no single individual could possibly assess a museum exhibit. Instead, a team of experts in educational theory, exhibits design, and other fields would be necessary. Such a combination, Parr thought, "should be able to function effectively without striking fear into the heart of anyone, but raising the hopes of all." Despite the reservations of Parr and others, who emphasized the possibility of unfair criticism and the danger of generating hard feelings in a profession unaccustomed to strong internal criticism, the idea of exhibit reviews was taken up, in particular by Thomas W. Leavitt, director of the Merrimack Valley Textile Museum, who pointed out that critical reviews were a way of driving incompetent curators out of museums and encouraging competent curators to work more carefully in preparing exhibitions. After citing three exhibits in the Federal Hall National Memorial in New York that he labeled "disasters" in "The Need for Critical Standards in History Museum Exhibits" (1967), Leavitt urged critical reviews as a way of rescuing the history museum exhibit from its position of inferiority in relation to art and natural history museum exhibits. In "Toward a Standard of Excellence" (1968), Leavitt followed up his expression of concern with a formal proposal that scholarly journals initiate a series of exhibit reviews. The journal *Technology and Culture* was the first to respond, and today exhibit reviews can also be found in *Winterthur Portfolio, Public Historian*, and, beginning in 1989, *American Quarterly* and the *Journal of American History*.

Establishing the same critical standards taken for granted in other scholarly journals has been a slow process in the museum field. When W. David Lewis, professor of history at the State University of New York, reviewed the Corning Museum of Glass in "Exhibit Reviews" (1969), Paul N. Perrot, director of the Corning Museum, replied angrily in "Throwing Stones at Glass Museums" (1969), to which Lewis replied in kind under the heading "Parrying Perrot" (1969). The sharp encounter, in which each participant felt his intellectual integrity had been attacked, illustrates the difficulty of transferring the normal critical scholarly reviewing procedure from academic life into the museum world. Consequently accounts of new museum exhibits in museum journals still tend to be appreciations, descriptions, or celebrations rather than dissections of the strengths and weaknesses of museum exhibits.

The form in which an exhibit review may be undertaken, along with a useful brief bibliography, is contained in "American Material Cultural Technique" (1980), the third appendix to Thomas J. Schlereth's *Artifacts and the American Past*. But as Schlereth has pointed out in his bibliographical essay "Material Culture Studies in America" (1982), reviewers and students alike are hampered by the absence of a bibliographical guide to museum exhibit catalogs. The material culture researcher, Schlereth notes, "must largely depend on his own professional contracts [*sic*] and frequent trips to the

bookstores of the country's major museums and historical agencies if he wants to keep current with this mode of material culture publication." Often the museum will publish its own catalog, and its availability will be limited to visitors to the exhibition.

If one queries the Library of Congress automated catalog under the subject of "Exhibitions," one will be presented with a startling set of 27,151 items (as of August 1, 1988), which begins with the South Kensington Museum's *Catalogue of Machinery, Models, etc., in the Machinery and Inventions Division of the South Kensington Museum* (1891). One must search out more specific subject headings in the Library's Subject Heading Catalogue to begin to obtain bibliographic control of the many items related to exhibitions. The problem of bibliographic control continues to be a severe one, though the Library of Congress has provided the basis on which such control can be achieved with its new automated catalog. It is a far cry from the time (not so long ago) when exhibition catalogs were classified as ephemera.

BIBLIOGRAPHIC CHECKLIST

Alexander, Edward P. "Artistic and Historical Period Rooms." *Curator* 7 (1964), 263–81.

Allan, Douglas A., Norman Cook, and J. W. Y. Higgs. "Display Policy in Museums: A Symposium." *Museums Journal* 61 (December 1961), 191–200.

Alt, M. B. "Evaluating Didactic Exhibits: A Critical Look at Shettel's Work." *Curator* 20 (September 1977), 241–58.

Altick, Richard D. *The Shows of London*. Cambridge: Belknap Press of Harvard University Press, 1978.

Bayer, Herbert. "Aspects of Design of Exhibitions and Museums." *Curator* 4 (1961), 257–87.

———. *Herbert Bayer: Painter, Designer, Architect*. New York: Reinhold, 1967.

Baudrillard, Jean. "The Beaubourg-Effect: Implosion and Deterrence," translated by R. Krauss and A. Michelson. (Spring 1982), 3–13.

Beaver, Patrick. *The Crystal Palace, 1851–1936: A Portrait of Victorian Enterprise*. London: Hugh Evelyn, 1970.

Bechtel, Robert B. "Hodometer Research in Museums." *Museum News* 45 (March 1967), 23–26.

———. "The Study of Man: Human Movement and Architecture." *Trans-action* 4 (May 1967), 53–56.

Benedict, Burton. *The Anthropology of World's Fairs: San Francisco's Panama Pacific International Exposition of 1915*. Berkeley: Scolar Press, 1963.

Bergmann, Eugene. "Exhibits: A Production Checklist." *Curator* 19 (June 1976), 157–237.

———. "Making Exhibits—A Reference File." *Curator* 20 (September 1977), 227–37.

Bernal, Ignacio. "The National Museum of Anthropology of Mexico." *Curator* 9 (March 1966), 7–23.

Bitgood, Stephen, Michael Pierce, Grant Nichols, and Donald Patterson. "Formative Evaluation of a Cave Exhibit." *Curator* 20 (1987), 31–39.

Black, Misha, ed. *Exhibition Design*. London: Architectural Press, 1950.

Blackmore, S., and others. "Exhibitions: An Annotated Bibliography." *Interpretation Canada* 3 (October 1976), 23–31.

Boorstin, Daniel J. *The Americans: The Democratic Experience*. New York: Random House, 1973.

Borun, Minda, and Maryanne Miller. *What's in a Name? A Study of the Effectiveness of Explanatory Labels in a Science Museum*. Philadelphia: Franklin Institute Science Museum and Planetarium, 1980.

Boulding, Kenneth E. "The Role of the Museum in the Propagation of Developed Images." *Technology and Culture* 7 (Winter 1966), 64–66.

Bowditch, George. "Preparing Your Exhibits: Case Arrangement and Design." American Association for State and Local History Technical Leaflet, no. 56. *History News* 26 (February 1971), insert.

Bower, Robert T. *The People's Capitalism Exhibit: A Study of Reactions of Foreign Visitors to the Washington Preview*. Washington, DC: Bureau of Social Science Research, American University, 1956.

Braithwaite, David. *Fairground Architecture: The World of Amusement Parks, Carnivals, and Fairs*. New York: Praeger, 1968.

Brawne, Michael. *The Museum Interior: Temporary and Permanent Display Techniques*. New York: Architectural Book Publishing Company, 1982.

Briggs, Rose T. "Displaying Your Costumes: Some Effective Techniques." American Association for State and Local History Technical Leaflet, no. 33. Rev. ed. *History News* 27 (November 1972), insert.

Bruman, Raymond, *Exploratorium Cookbook: A Construction Manual for Exploratorium Exhibits*. San Francisco: Exploratorium, 1975.

Burns, Ned J. "The History of Dioramas." *Museum News*, February 15, 1940, 8–12.

Cameron, Duncan F. "Measuring Effectiveness: The Evaluator's Viewpoint." *Museum News* 46 (January 1968), 43–45.

Campbell, James B., comp. *Campbell's Illustrated History of the World's Columbian Exposition*. Chicago: N. Juul, 1894.

Carboni, Erberto. *Exhibitions and Displays*. Milan: Silvana, Editoriale d'Arte, 1957.

Carstensen, George Johan, and Charles Gildemeister. *New York Crystal Palace*. New York: Riker, Thorne, 1854.

Cawelti, John G. "America on Display: The World's Fairs of 1876, 1893, 1933." In *The Age of Industrialism in America: Essays in Social Structure and Cultural Values*, edited by Frederic Cople Jaher. New York: Free Press, 1968.

Chermayeff, Ivan, and others. *The Design Necessity: A Casebook of Federally Initiated Projects in Visual Communications, Interiors and Industrial Design, Architecture, Landscaped Environment*. Cambridge: MIT Press, 1973.

Ciulla, Vincent, Charles F. Montgomery, and Gerald W. R. Ward. "Creative Compromise: The Curator and the Designer." *Museum News* 55 (March-April 1977), 31–37.

Clarke, G. C. S., and Roger S. Miles. "The Natural History Museum and the Public." *Biologist* 27 (April 1980), 81–85.

Clasen, Wolfgang. *Expositions, Exhibits, Industrial and Trade Fairs,* translated by
 E. Rockwell. New York: Praeger, 1968.
Cohen, Marilyn S., and others. "Orientation in a Museum—An Experimental Visitor
 Study." *Curator* 20 (June 1977), 85–97.
Coleman, Laurence Vail. *Museum Buildings.* Washington, DC: American Association
 of Museums, 1950.
Cotter, John L. "Exhibit Review: Colonial Williamsburg." *Technology and Culture*
 11 (July 1970), 417–27.
Cummings, Carlos Emmons. *East Is East and West Is West: Some Observations on
 the World's Fairs of 1939 by One Whose Main Interest Is in Museums.* East
 Aurora, NY: Roycrofters, 1940.
Curti, Merle. "America at the World Fairs, 1851–1893." *American Historical Review*
 55 (July 1950), 833–56.
Cypher, Irene Fletcher. "The Development of the Diorama in the Museums of the
 United States." Ph.D. dissertation, New York University, 1942.
Dana, John Cotton. "The Use of Museums." *Nation,* October 11, 1922, 374–76.
Danilov, Victor J. "Early Childhood Exhibits at Science Centers." *Curator* 27 (1984),
 173–88.
———. "Imax/Omnimax: Fad or Trend?" *Museum News* 65 (August 1987), 32–40.
De Borhegyi, Stephan F. "Visual Communication in the Science Museum." *Curator*
 6 (1963), 45–57.
———. "Museum Exhibits: How to Plan and Evaluate Them." *Midwest Museums
 Quarterly* 23 (Spring 1963), 4–8.
———. "Some Thoughts on Anthropological Exhibits in Natural History Museums
 in the United States." *Curator* 7 (1964), 121–27.
———. "Testing of Audience Reaction to Museum Exhibits." *Curator* 8 (1965), 86–
 93.
———. "Testing of Audience Reaction to Scientific and Anthropological Museum
 Exhibits." In *The Museum Visitor,* edited by Stephan F. De Borhegyi and
 Irene A. Hanson. Publication in Museology, no. 3. Milwaukee: Milwaukee
 Public Museum, 1968.
Dow, George Francis. *Domestic Life in New England in the Seventeenth Century:
 A Discourse.* Topsfield, MA: Perkins Press, 1925. Reprint. New York: B.
 Blom, 1972.
Eames, Charles, and Ray Eames. *A Computer Perspective,* edited by Glen Fleck.
 Cambridge: Harvard University Press, 1973.
———. *Connections, the Work of Charles and Ray Eames: Frederick S. Wight Art
 Gallery, University of California, Los Angeles, December 7, 1976–February
 6, 1977.* Los Angeles: UCLA Art Council, 1976.
———. *The World of Franklin and Jefferson: The American Revolution Bicentennial
 Administration Exhibition.* Los Angeles: G. Rice, 1976.
Eason, Laurie P., and Marcia C. Linn. "Evaluation of the Effectiveness of Partici-
 patory Exhibits." *Curator* 19, (March 1976), 45–62.
Elliott, Pamala, and Ross J. Loomis. *Studies of Visitor Behavior in Museums and
 Exhibitions: An Annotated Bibliography of Sources Primarily in the English
 Language.* Washington, DC: Office of Museum Programs, Smithsonian In-
 stitution, 1975.
Exhibition Techniques: A Summary of Exhibition Practice, Based on Surveys Con-

ducted at the New York and San Francisco World's Fairs of 1939. New York: New York Museum of Science and Industry, 1940.

Exhibits Communication Task Force. *Mankind Discovering.* 2 vols. Toronto: Royal Ontario Museum, 1978–1979.

————. *Opportunities and Constraints: The First Report of the Exhibits Communication Task Force, Royal Ontario Museum, as Part of the Development of the Overall Plan for Galleries.* 2d ed. Toronto: Royal Ontario Museum, 1979.

Fagin, Nancy L. "Closed Collections and Open Appeals: The Two Anthropology Exhibits at the Chicago World's Columbian Exposition of 1893." *Curator* 27 (1984), 249–64.

Fazzini, Dan. "The Museum as a Learning Environment: A Self-Motivating, Recycling, Learning System for the Museum Visitor." Ph.D. dissertation, University of Wisconsin-Milwaukee, 1972.

Frankenstein, Alfred. "Is This Exhibition Necessary? A Critic's View." *Museum News* 41 (June 1963), 16–17.

Freeman, Joan E., and H. Charles Fritzemeier. "Preparing Your Exhibits: Figures for Miniature Dioramas." American Association for State and Local History Technical Leaflet, no. 20. *History News* 27 (July 1972), insert.

Frese, H. H. "The Living Museum. Educational Work in the National Museum of Ethnology, Leyden." *Museum* 10 (1957), 297–99.

Frye, Melinda Young. "Charles P. Wilcomb, Cultural Historian (1865–1915)." In *Natives & Settlers: Indian and Yankee Culture in Early California: The Collections of Charles P. Wilcomb, The Great Hall, The Oakland Museum, December 18, 1979 through March 9, 1980,* edited by Melinda Young Frye. Oakland: The Oakland Museum, 1979.

Gardner, Dorsey, ed. *United States Centennial Commission. International Exhibitions, 1876. Grounds and Buildings of the Centennial Exhibitions, Philadelphia, 1876.* Philadelphia: J. B. Lippincott, 1878.

Gardner, George S. "A New Habitat Group of Wood Storks." *Curator* 21 (June 1978), 101–10.

Gardner, James, and Caroline Heller. *Exhibition and Display.* New York: F. W. Dodge, 1960.

Garland, Ken. *Graphic Handbook.* New York: Reinhold, 1966.

Gatacre, E. V. "The Limits of Professional Design." *Museums Journal* 76 (December 1976), 93–99.

Gibbs-Smith, Charles Harvard. *The Great Exhibition of 1851: A Commemorative Album.* London: Her Majesty's Stationery Office, 1964.

Gilman, Benjamin Ives. *Museum Ideals of Purpose and Method.* 2d ed. Cambridge: Harvard University Press, 1923.

Ginsbury, Madeleine. "The Mounting and Display of Fashion and Dress." *Museums Journal* 73 (September 1973), 50–54.

Glazychev, V. "Poetical Atmosphere of the Museum." *Dekorativnoe Iskusstvo SSSR* 215 (October 1975), 40–43.

Gleandowe, Teresa. *Organising Exhibitions: A Manual Outlining the Methods Used to Organise Temporary Exhibitions of Works of Art.* 2d rev. ed. London: Arts Council of Great Britain, 1975.

Goins, Alvin, and George Griffenhagen. "Psychological Studies of Museum Visitors and Exhibits at the U.S. National Museum." *Museologist* 64 (1957), 1–6.

————. "The Effect of Location and a Combination of Color Lighting and Artistic Design on Exhibit Appeal." *Museologist* 67 (1958), 6–10.

Gold, Peter. "The Exhibit as Ritual." *Curator* 21 (March 1978), 55–62.

Goode, George Brown. "Principles of Museum Administration." In *Annual Report of the Board of Regents of the Smithsonian Institution . . . 1897. Report of the U.S. National Museum*, Part 2. Washington, DC: Government Printing Office, 1901.

Green, Martin. "Trends in Display Techniques." *Museum Round-up* 39 (July 1970), 29–33.

Gregory, William King. "Biographical Memoir of Frank Michler Chapman, 1864–1945." *National Academy of Sciences of the United States of America: Biographical Memoirs* 25 (1949), 111–45.

Griggs, Steven. *Visitor's Perception and Evaluations of Seven Exhibitions at the Natural History Museum*. London: British Museum (Natural History), 1984.

Gross, Laurence F., and Robert A. Hauser. "Reducing the Perils of Textile Displays." *Museum News* 58 (September-October 1979), 60–64.

Hall, Pauline. *Display: The Vehicle for the Museum's Message*. Toronto: Historical Branch, Department of Public Records and Archives, 1969.

Halstead, B. "Whither the Natural History Museum?" *Nature*, October 26, 1978, 683.

————. "Museum of Errors." *Nature*, November 20, 1980, 208.

Halvorson, Elmer. "Constructing Life-Size Figures for the Historical Museum." American Association for State and Local History Technical Leaflet, no. 64. *History News* 28 (June 1973), insert.

Harris, Neil. "The Gilded Age Revisited, Boston and the Museum Movement." *American Quarterly* 14 (Winter 1962), 545–66.

————. *Humbug: The Art of P. T. Barnum*. Boston: Little Brown, 1973.

————. "Museums, Merchandising, and Popular Taste: The Struggle for Influence." In *Material Culture and the Study of American Life*, edited by Ian M. G. Quimby. New York: W. W. Norton, 1978.

Harrison, Laurence S. "Esthetics in Lighting—Some Thoughts on Art Gallery Planning." *Illuminating Engineering* 63 (February 1968), 54–58.

Hatt, Robert T. "Seven Lighting Problems; Seven Solutions." *Curator* 3 (1960), 361–70.

Hebditch, Max. "Briefing the Designer." *Museums Journal* 70 (September 1970), 67–68.

Henrion, F. H. K., and Alan Parkin. *Design Coordination and Corporate Image*. New York: Reinhold, 1967.

Hipschman, Ron. *Exploratorium Cookbook II: A Construction Manual for Exploratorium Exhibits*. San Francisco: Exploratorium, 1980.

Holt, Elizabeth Gilmore, ed. *The Triumph of Art for the Public: The Emerging Role of Exhibitions and Critics*. Garden City, NY: Anchor Press, 1979.

————, ed. *The Art of All Nations, 1850–1873: The Emerging Role of Exhibitions and Critics*. Garden City, NY: Anchor Press, 1981.

Howell, Daniel B. "A Network System for the Planning, Designing, Construction, and Installation of Exhibits." *Curator* 14 (June 1971), 100–8.

Hudson, Kenneth. *A Social History of Museums: What the Visitors Thought*. Atlantic Highlands, NJ: Humanities Press, 1975.

Impey, Oliver, and Arthur MacGregor, eds. *The Origins of Museums: The Cabinet of Curiosities in Sixteenth- and Seventeenth-Century Europe*. Oxford: Clarendon Press, 1985.

Jacknis, Ira. "Franz Boas and Exhibits: On the Limitations of the Museum Method of Anthropology." In *History of Anthropology*, vol. 3: *Objects and Others: Essays on Museums and Material Culture*, edited by George W. Stocking, Jr. Madison: University of Wisconsin Press, 1985.

Jones, William K. "The Exhibit of Documents: Preparation, Matting & Display Techniques." American Association for State and Local History Technical Leaflet, no. 75. *History News* 29 (June 1974), insert.

Kearns, William E. "Studies of Visitor Behavior at the Peabody Museum of Natural History, Yale University." *Museum News*, January 15, 1940, 5–8.

Kimche, Lee. "Science Centers: A Potential for Learning." *Science*, January 20, 1978, 270–73.

Kimmell, Peter S., and Mark J. Maves. "Public Reaction to Museum Interiors." *Museum News* 51 (September 1972), 17–19.

King, Mary Elizabeth. "Museums, Archaeology, and the Public." *Curator* 27 (1984), 298–307.

Kissiloff, William. "How to Use Mixed Media in Exhibits." *Curator* 12 (June 1969), 83–95.

Kramer, Hilton. "What Is This Stuff Doing at the Met?" *New York Times*, March 14, 1976, D29.

———. "When the Size of a Show Overwhelms Its Content." *New York Times*, December 7, 1980, D1, D35.

Landay, Janet, and R. Gary Bridge. "Video vs. Wall-Panel Display: An Experiment in Museum Learning." *Curator* 25 (1982), 41–56.

Lawless, Benjamin W. "Museum Installations of a Semi-Permanent Nature." *Curator* 1 (January 1958), 81–90.

Leavitt, Thomas W. "The Need for Critical Standards in History Museum Exhibits: A Case in Point." *Curator* 10 (June 1967), 91–94.

———. "Toward a Standard of Excellence: The Nature and Purpose of Exhibit Reviews." *Technology and Culture* 9 (January 1968), 70–75.

———. "Curators, Collections and Exhibits." *Museum News* 46 (June 1968), 32–34.

Lewis, Jon Noel Claude. *Typography: Basic Principles: Influences and Trends Since the 19th Century*. 2d ed. London: Studio Vista, 1967.

Lewis, Ralph H. *Manual for Museums*. Washington, DC: National Park Service, U.S. Department of the Interior, 1976.

Lewis, W. David. "Exhibit Reviews: Corning Museum of Glass." *Technology and Culture* 10 (January 1969), 68–83.

———. "Parrying Perrot." *Technology and Culture* 10 (April 1969), 178–81.

Linn, Marcia C. "Exhibit Evaluation—Informed Decision Making." *Curator* 19 (December 1976), 291–302.

Lohse, Richard Paul. *New Design in Exhibitions: 75 Examples of the New Form of Exhibitions*. New York: Praeger, 1954.

Loomis, Ross J. "Please! Not Another Visitor Survey." *Museum News* 52 (October 1973), 21–26.

Lowenthal, David. *The Past Is a Foreign Country*. Cambridge: Cambridge University Press, 1985.

Luckhurst, Kenneth W. *The Story of Exhibitions*. New York: Studio Publications, 1951.

Lusk, Carroll B. "Museum Lighting." *Museum News* 49 (November 1970), 20–23; 49 (December 1970), 25–29; 49 (February 1971), 18–22.

Maass, John. *The Glorious Enterprise: The Centennial Exhibition of 1876 and H. J. Schwarzmann, Architect-in-Chief*. Watkins Glen, NY: American Life Foundation, 1973.

March, Robert H. "Book Reviews: Differences of Scale." *Science*, September 23, 1983, 1281.

McDonald, P. M. "Audience Surveys in Australia." *Museums' Annual* 2 (1970), 8.

McLuhan, Marshall. *Understanding Media*. New York: McGraw-Hill, 1964.

McLuhan, Marshall, Harley Parker, and Jacques Barzun. *Exploration of the Ways, Means, and Values of Museum Communication with the Viewing Public*. New York: Museum of the City of New York, 1969.

McMahon, Michal. "The Romance of Technological Progress: A Critical Review of the National Air and Space Museum." *Technology and Culture* 22 (1981), 281–96.

Melton, Arthur W. "Studies of Installation at the Pennsylvania Museum of Art." *Museum News*, January 15, 1933, 5–8.

———. "Some Behavior Characteristics of Museum Visitors." *Psychological Bulletin* 30 (November 1933), 720–21.

———. *Problems of Installation in a Museum of Art*. Publications of the American Association of Museums, New Series, no. 14. Washington, DC: American Association of Museums, 1935.

———. "Distribution of Attention in Galleries in a Museum on Science and Industry." *Museum News* 14 (June 1, 1936), 5, 6–8.

———. "Visitor Behavior in Museums: Some Early Research in Environmental Design." *Human Factors* 14 (October 1972), 393–403.

Melton, Arthur W., Nita Goldberg Feldman, and Charles W. Mason. *Experimental Studies of the Education of Children in a Museum of Science*. Publications of the American Association of Museums, New Series, no. 15. Washington, DC: American Association of Museums, 1936.

Miles, Roger S. "Lessons in Human Biology: Testing a Theory of Exhibition Design." *International Journal of Museum Management and Curatorship* 5 (September 1986), 227–50.

Miles, Roger S., and M. B. Alt. "British Museum (Natural History): A New Approach to the Visiting Public." *Museums Journal* 78 (March 1979), 158–62.

Miles, Roger S., and others, comps. *The Design of Educational Exhibits*. London: George Allen and Unwin, 1982.

Miller, Leon Gordon. "The Industrial Designer: New Member of the Museum Team." *Curator* 6 (1963), 187–90.

Mills, John FitzMaurice. *Treasure Keepers*. Garden City, NY: Doubleday, 1973.

Morrison, Philip, Phylis Morrison, and Office of Charles and Ray Eames. *Powers of Ten: A Book about the Relative Size of Things in the Universe and the Effect of Adding Another Zero*. Redding, CT: Scientific American Library, 1982.

Neal, Arminta. "Gallery and Case Exhibit Design." *Curator* 6 (1963), 77–95. Reprint.

224 The Museum

American Association for State and Local History Technical Leaflet, no. 52. *History News* 24 (August 1969), insert.

———. "Legible Labels: Three-Dimensional Letters." American Association for State and Local History Technical Leaflet, no. 23. *History News* 19 (May 1964), insert.

———. *Help! For the Small Museum: A Handbook of Exhibit Ideas and Methods.* Boulder, CO: Pruett Press, 1969.

———. "Legible Labels: Hand-Lettering." American Association for State and Local History Technical Leaflet, no. 22. Rev. ed. *History News* 26 (July 1971), insert.

———. *Exhibit for the Small Museum: A Handbook.* Nashville, TN: American Association for State and Local History, 1976.

Nelson, George. *Display.* New York: Whitney Publications, 1953.

Nicol, Elizabeth H. *The Development of Validated Museum Exhibits.* Project No. 5–0245, Contract No. OECI–6–050245–1015. Washington, DC: Bureau of Research, U.S. Department of Health, Education, and Welfare, 1969.

Nielsen, L. C. "A Technique for Studying the Behavior of Museum Visitors." *Journal of Educational Psychology* 37 (February 1946), 103–10.

Noble, Joseph Veach. "Museum Thinking." *Curator* 27 (1984), 194–204.

———. "The Megashows Are Coming." *Curator* 30 (1987), 5–10.

O'Doherty, Brian, ed. "Special Museum Issue." *Art in America* 59 (July-August 1971), 25–127. Reprinted as *Museums in Crisis,* edited by Brian O'Doherty. New York: George Braziller, 1972.

Oppenheimer, Frank. "A Rationale for a Science Museum." *Curator* 11 (September 1968), 206–9.

Oppenheimer, Frank, and Kenneth Starr. "Exploration and Culture: Oppenheimer Receives Distinguished Service Award." *Museum News* 61 (November-December 1982), 36–45.

Parr, Albert E. "The Time and Place for Experimentation in Museum Design." *Curator* 1 (Autumn 1958), 36–40.

———. "The Habitat Group." *Curator* 2 (1959), 107–28.

———. "Designed for Display." *Curator* 2 (1959), 313–34.

———. "The Skeletons in the Museum." *Curator* 3 (1960), 293–309.

———. "Mass Medium of Individualism." *Curator* 4 (1961), 39–48.

———. "Packaged Simplicity versus Crowded Complexity: Comments on a Recurrent Theme at Museum Conferences." *Curator* 4 (1961), 91–93.

———. "The Revival of Systematic Exhibits." *Curator* 4 (1961), 117–37.

———. "Dimensions, Backgrounds, and Use of Habitat Groups." *Curator* 4 (1961), 199–215.

———. "Some Basic Problems of Visual Education by Means of Exhibits." *Curator* 5 (1962), 36–44.

———. "The Obsolescence and Amortization of Permanent Exhibits." *Curator* 5 (1962), 258–64.

———. "Pattern of Progress in Exhibition." *Curator* 5 (1962), 329–45.

———. "Realism and Romanticism in Museum Exhibits." *Curator* 6 (1963), 174–86.

———. "Habitat Group and Period Room" *Curator* 6 (1963), 325–36.

————. "Remarks on Layout, Display, and Response to Design." *Curator* 7 (1964), 131–42.

————. "Test and Criticism." *Museum News* 43 (October 1964), 36–38.

Parsons, Lee A. "Systematic Testing of Display Techniques for an Anthropological Exhibit." *Curator* 8 (1965), 167–89.

Peart, Bob. "Impact of Exhibit Type on Knowledge Gain, Attitudes, and Behavior." *Curator* 27 (1984), 220–37.

Perrot, Paul N. "Throwing Stones at Glass Museums." *Technology and Culture* 10 (April 1969), 174–77.

Pierotti, Ray, "Learning and Exhibits: Be, See, Touch, Respond." *Museum News* 52 (December 1973), 43–48.

Plowmann, Allan, and Vhairi Pearson, *Display Techniques*. London: Blandford Press, 1966.

Porter, Mildred C. B. *Behavior of the Average Visitor in the Peabody Museum of Natural History, Yale University*. Publications of the American Association of Museums, New Series, no. 16. Washington, DC: American Association of Museums, 1938.

Price, Ian. *Creative Display*. New York: Van Nostrand Reinhold, 1975.

Randall, Reino, and Edward C. Haines. *Design in Three Dimensions*. Worcester, MA: Davis Publications, 1965.

Riordan, Robert. "The New Museum: A Look at the Future of Our New Museum." *Let's See* 8 (February 1963), 3–17.

Riviere, Georges Henri, and Herman F. E. Visser. "Museum Showcases." *Museum* 13 (1960), 1–55.

Robinson, Edward S. "Psychological Problems of the Science Museum." *Museum News*, September 1, 1930, 9–11.

————. "Psychological Studies of the Public Museum." *School and Society*, January 24, 1931, 121–25.

————. "Exit the Typical Visitor: Museums Take Thought of Real Men and Women." *Journal of Adult Education* 3 (October 1931), 418–23.

————. "Experimental Education in a Museum—A Perspective." *Museum News*, February 15, 1933, 6–8.

Robinson, Edward S., Irene Case Sherman, and Lois E. Curry. *The Behavior of the Museum Visitor*. Publications of the American Association of Museums, New Series, no. 5. Washington, DC: American Association of Museums, 1928.

"The Role of the Designer in the Museum." *Museums Journal* 70 (September 1970), 63–66.

Royal Ontario Museum. Communications Design Team. *Communicating with the Museum Visitor: Guidelines for Planning*. Toronto: Royal Ontario Museum, 1976.

Rubino, Luciano. *Ray & Charles Eames: il Collettivo della Fantasia*. Rome: Kappa, 1981.

Rydell, Robert W. "The Trans-Mississippi and International Exposition: 'To Work Out the Problem of Universal Civilization.' " *American Quarterly* 33 (Winter 1981), 587–607.

————. "Visions of Empire: International Expositions in Portland and Seattle, 1905–1909." *Pacific Historical Review* 52 (February 1983), 37–65.

————. *All the World's a Fair: Visions of Empire at American International Expositions, 1876–1916.* Chicago: University of Chicago Press, 1984.

Salpeter, Bob. "How Nonscientists Design a Highly Scientific Exhibit." *Curator* 18 (June 1975), 130–39.

Schlereth, Thomas J. "American Material Culture Technique: Historical Museum Exhibit Review." In *Artifacts and the American Past*, by Thomas Schlereth. Nashville, TN: American Association for State and Local History, 1980.

————. "Material Culture Studies in America: A Selective Bibliographical Essay." In *Material Culture Studies in America*, edited by Thomas Schlereth. Nashville, TN: American Association for State and Local History, 1982.

Schoener, Allon, "Electronic Participation Theatre: A New Approach to Exhibitions." *Museum* 23 (1970–1971), 218–21.

Schroeder, Fred. "Designing Your Exhibits: Seven Ways to Look at an Artifact." American Association for State History Technical Leaflet, no. 91. *History News* 31 (November 1976), insert.

Screven, Chandler G. "The Museum as a Responsive Learning Environment." *Museum News* 47 (June 1969), 7–10.

————. *The Measurement and Facilitation of Learning in the Museum Environment: An Experimental Analysis.* Washington, DC: Smithsonian Institution Press, 1974.

————. "Learning and Exhibits: Instructional Design." *Museum News* 52 (January-February 1974), 67–75.

————. "The Effectiveness of Guidance Devices on Visitor Learning." *Curator* 18 (September 1975), 219–43.

————. "Exhibit Evaluation: A Goal-Referenced Approach." *Curator* 19 (December 1976), 271–90.

————. "Exhibitions and Information Centers: Some Principles and Approaches." *Curator* 29 (1986), 109–37.

Seale, William. *Recreating the Historic House Interior.* Nashville, TN: American Association for State and Local History, 1979.

"Second Bulletin of the Proceedings of the National Institution for the Promotion of Science, Washington, D.C. March, 1841, to February, 1842." In *Papers Relative to the National Institute*, compiled by Francis Markoe, Jr. Washington, DC: private, n.d.

Sellers, Charles Coleman. *Mr. Peale's Museum: Charles Willson Peale and the First Popular Museum of Natural Science and Art.* New York: W. W. Norton, 1980.

Shapiro, Harry L. "Some Observations on the Function of a Scientific Exhibit." *Curator* 4 (1961), 226–30.

Shaw, Evelyn. "The Exploratorium." *Curator* 15 (March 1972), 39–52.

Sheppard, D. "Methods for Assessing the Value of Exhibitions." *British Journal of Educational Psychology* 30 (November 1960), 259–65.

Shettel, Harris H. *An Evaluation Model for Measuring the Impact of Overseas Exhibits.* Technical Report no. AIR-F28–6/66–FR, Contract no. NY–66–354. Washington, DC: Atomic Energy Commission, 1966.

————. "Exhibits: Art Form or Educational Medium?" *Museum News* 52 (September 1973), 32–41.

———. "A Critical Look at a Critical Look: A Response to Alt's Critique of Shettel's Work." *Curator* 21 (December 1978), 329–45.

Shettel, Harris H., Margaret Butcher, Timothy S. Cotton, Judi Northrup, and Doris Clapp Slough. *Strategies for Determining Exhibit Effectiveness.* Technical Report no. AIR-E95–4/68–FR. Pittsburgh: American Institutes for Research in the Behavioral Sciences, 1968.

Shettel, Harris H., and Pamela C. Reily. "An Evaluation of Existing Criteria for Judging the Quality of Science Exhibits." *Curator* 11 (June 1968), 137, 153.

Silver, Stuart. "Almost Everyone Loves a Winner: A Designer Looks at the Blockbuster Era." *Museum News* 61 (November-December 1982), 24–35.

Skramstad, Harold., Jr. "Interpreting Material Culture: A View from the Other Side of the Glass." In *Material Culture and the Study of American Life*, edited by Ian M. G. Quimby. New York: W. W. Norton, 1978.

Smith, Anthony. "A Sideways Look at the Natural History Museum." *Biologist* 26 (February 1979), 39–41.

Smith, Ruth, ed. *Treasures of the Ashmolean Museum.* Oxford: Ashmolean Museum, 1986.

Spaeth, David A. *Charles Eames Bibliography.* Monticello, IL: Vance Bibliographies, 1979.

Spencer, Herbert, and Linda Reynolds. *Directional Signing and Labelling in Libraries and Museums: A Review of Current Theory and Practice.* London: Readability of Print Research Unit, Royal College of Art, 1977.

Stearn, William T. *The Natural History Museum at South Kensington: A History of the British Museum (Natural History), 1753–1980.* London: Heinemann, 1981.

Stolow, Nathan, "Conservation Policy and the Exhibition of Museum Collections." *Canadian Museums Association Gazette* 9 (Fall 1976), 13–18.

Summerson, Sir John, *et. al. John Soane* New York: St. Martin's Press, 1983.

Sweeney, James Johnson. "Some Ideas of Exhibition Installation." *Curator* 2 (1959), 151–56.

Szemere, Adam, ed. *The Problems of Contents, Didactics and Esthetics of Modern Museum Exhibitions.* Budapest: Istvan Eri, 1978.

Taylor, Frank A. "A National Museum of Science, Engineering and Industry." *Scientific Monthly* 63 (November 1946), 359–65.

Their, Herbert D., and Marcia C. Linn. "The Value of Interactive Learning Experiences." *Curator* 19 (September 1976), 233–45.

Thompson, John M. A., and others, eds. *Manual of Curatorship: A Guide to Museum Practice.* London: Butterworths, 1984.

Toole, K. Ross, "Surprises for the Museum-Going Vacationist." *New York Times*, May 24, 1959, sec. 12, 7.

Tucker, Louis Leonard. "The Western Museum of Cincinnati, 1820–1867." *Curator* 8 (1965), 17–35. Reprinted as ' "Ohio Show-Shop': The Western Museum of Cincinnati, 1820–1867." In *A Cabinet of Curiosities: Five Episodes in the Evolution of American Museums*, by Whitfield J. Bell, Jr., Clifford K. Shipton, John C. Ewers, Louis Leonard Tucker, and Wilcomb E. Washburn. Charlottesville: University of Virginia Press, 1967.

United Nations. Educational, Scientific and Cultural Organization. *The Organization of Museums; Practical Advice.* Paris: UNESCO, 1960.

————. *Temporary and Travelling Exhibitions.* Paris: UNESCO, 1963.

United States Centennial Commission. International Exhibition, 1876. Official Catalogue. 6th rev. ed. Philadelphia: John R. Nagle, 1876.

van Culik, W. R., H. S. van der Straaten, and G. D. van Wengen, eds. *From Field-Case to Show-Case: Research, Acquisition and Presentation in the Rijksmuseum voor Volkenkunde (National Museum of Ethnology), Leiden: In Tribute to Professor P. H. Pott on the 25th Anniversary of His Directorship of the Rijksmuseum voor Volkenkunde, Leiden.* Amsterdam: Gieben, 1980.

Wadsworth Atheneum. *Exhibition as Process: Wadsworth Atheneum, Hartford, Connecticut, Lions Gallery of the Senses, September 14, 1977–January 8, 1978.* Hartford: Wadsworth Atheneum, 1977.

Warren, Jefferson T. *Exhibit Methods.* New York: Sterling Publishing Company, 1972.

Washburn, Wilcomb E. "The Dramatization of American Museums." *Curator* 6 (1963), 109–24.

————. "The Museum's Responsibility in Adult Education." *Curator* 7 (1964), 33–38.

————. "A Roman Sarcophagus in a Museum of American History." *Curator* 7 (1964), 296–99.

————. "Natural Light and the Museum of the Future." *AIA Journal* 43 (January 1965), 60–64.

————. *Defining the Museum's Purpose.* New York State Historical Association Monographic Studies, no. 1. Cooperstown, NY: New York State Historical Association, 1975.

————. "Do Museums Educate?" *Curator* 18 (September 1975), 211–18.

————. "Collecting Information, Not Objects." *Museum News* 62 (February 1984), 5–6, 9–10, 12–15.

————. "A Critical View of Critical Archaeology." *Current Anthropology* 28 (1987), 544–45.

Washburn, Wilcomb E., and Gordon D. Gibson. "Letters from Readers: Exhibit Reviews?" *Museum News* 42 (February 1964), 7.

Webster, Frederic S. "The Birth of Habitat Bird Groups, Reminiscences Written in His Ninety-fifth Year." *Annals of the Carnegie Museum,* September 10, 1945, 97–118.

Weiner, George. "Why Johnny Can't Read Labels." *Curator* 6 (1963), 143–56.

Weiss, Robert S., and Serge Boutourline, Jr. "The Communication Value of Exhibits." *Museum News* 42 (November 1963), 23–27.

Westbrook, Nicholas. "Decisions, Decisions: An Exhibit's Invisible Ingredient," *Minnesota History* 45 (Fall 1977) 292–296.

White, Harvey E. *The Design, Development and Testing of a Response Box, a New Component for Science Museum Exhibits.* HEW Project no. 3148, Contract no. OE6–10–056. Berkeley: University of California, 1967.

Williams, Luther A. "Labels: Writing, Design, and Preparation." *Curator* 3 (1960), 26–42.

Williams, Stephen. "A University Museum Today." *Curator* 12 (December 1969), 293–306.

Wilson, Don W., and Dennis Medina. "Exhibit Labels: A Consideration of Content."

American Association for State Local History Technical Leaflet, no. 60. *History News* 27 (April 1972), insert.

Witteborg, Lothar P. *Good Show! A Practical Guide for Temporary Exhibitions.* Washington, DC: Smithsonian Institution Traveling Exhibition Service, 1981.

Wittlin, Alma S. *The Museum, Its History and Its Tasks in Education.* London: Routledge & K. Paul, 1949.

———. "Exhibits: Interpretive, Under-Interpretive, Misinterpretive—Absolutes and Relative Absolutes in Exhibit Techniques." In *Museums and Education,* edited by Eric Larrabee. Washington, DC: Smithsonian Institution Press, 1968.

———. *Museums: In Search of a Usable Future.* Cambridge: MIT Press, 1970.

———. "Hazards of Communication by Exhibits." *Curator* 14 (June 1971), 138–50.

———. "Museum Docentship: Alternatives to Tradition." *Canadian Museums Association Gazette* 11 (Winter 1978), 8–10.

Wolf, Robert, and Barbara L. Tymitz. *The Evolution of a Teaching Hall: "You Can Lead a Horse to Water And You 'Can' Help It Drink." A Study of the "Dynamics of Evolution" Exhibit.* Washington, DC: National Museum of Natural History, Smithsonian Institution, 1981.

Michael S. Shapiro, ed., The Museum: A Reference Guide (New York: Greenwood Press, 1990)

9

THE PUBLIC AND THE MUSEUM

Michael S. Shapiro

The story of the museum and the public has traditionally been told as a four-act moral drama. The tale begins in the mid-sixteenth century with descriptions of the vulgar crowds who gathered in European cities to gawk in wonder at collections of religious and natural curiosities. Although the ignorance and illiteracy of the mob continues until the end of the eighteenth century, act 2 opens with the optimism of the Enlightenment, as nation-states trumpet the opening of great public museums, which promise to usher in a new age of public participation in the national cultural patrimony.

The plot slows in act 3 as persistent patterns of elite patronage and attitudes frustrate the cultural aspirations of the populace for almost a century. Nonetheless, these lingering aristocratic fears of public disorder are gradually dispelled, principally through the success of the great international exhibitions, paving the way for a second great period of public museum founding. By the turn of the century, museum workers, allied with social reformers, eliminate the last obstacles to the public's full enjoyment of the national patrimony. The ideology of public service and the modern museum audience finally emerge during the twentieth century, developments reinforced by the subsidy of nation-states, which now recognize that affording cultural opportunities to all citizens is within the proper sphere of government.

While this Whiggish account of the rise of an ideology of public service and the correlative growth of a museum constituency captures many of the dramatic moments in museum history, it is nonetheless a seriously flawed and misleading narrative. Without entirely abandoning this historical framework, I have tried to point out its shortcomings both as history and as a

guide to contemporary museum policy. Thus, this chapter is an attempt to reframe historical questions in order to bring past attitudes toward museum visitation and past museum audiences into sharper historical focus, thereby unpacking some of the meanings of the modern ideology of public service.

HISTORIC OUTLINE

The modern notion of the museum public, an audience identifiable primarily through habits of arts consumption, is scarcely imaginable before the social dislocations that accompanied the rise of nation-states and industrial enterprise at the end of the eighteenth century. Prior to these developments, there are infrequent references to gatherings of illiterate peasants, laborers, and artisans who marvelled at the relics exhibited in European cities, the residue of centuries of trade, exploration, and the Crusades. But little is known of such assemblages other than their gullibility and their innate hunger for marvels. Although some evidence suggests that an occasional middle-class tradesman or gentleman joined the crowd, for the most part these groups appear distant and alien rather than the antecedents of the educated, enlightened museum goer.

After 1750 the elements of the museum public appear to come into sharper historical focus. Fueled by the prosperity that accompanied mercantile capitalism, London, Paris, and Rome emerged as centers for the leisure activities of the gentry who flocked to the metropolis to take advantage of the theatre, music, and arts. With the breakdown of an official system of court patronage, these capital cities became the focus of a cosmopolitan public life where the gentry gradually established new networks of sociability. For example, as art historian George Haskell has shown, the vigorous trade in antiquities in Rome foreshadowed a larger public interest in the arts: "Pictures were readily available and within the reach of everybody; no longer confined to the altar or the family palace, they now hung outside the church on family occasions, were propped up against the walls of cloisters on specified days of the year."

Affluence also allowed a small group of aristocrats to begin to amass personal collections of art and natural objects. Convinced that fresh analysis, keen observation, and logical thinking would elicit hidden scientific truths from these objects, these gentlemen-collectors began to open their "cabinets" to like-minded traveling savants. A pervasive fear of public misconduct, however, made most collections inaccessible to all but a narrow circle of collectors. The ill-fated experiment of Sir Horace Walpole who briefly opened his famous collection of antiquities at Strawberry Hill to wider public inspection, served as a warning to other public-spirited collectors who might be tempted to depart from the social conventions of viewing objects. In the face of a growing throng of sightseers, Walpole was forced to restrict visitation severely.

By the end of the eighteenth century, the leisure activities of the gentry

were extended to other classes and given official state sanction. Eager to identify government with the symbols of aristocratic power, nation-states dedicated large, ceremonial spaces for use as public parks, zoological and botanical gardens, and museums. Such public institutions of leisure were patronized by the gentry and the bourgeoisie, prosperous members of the mercantile and administrative classes. For example, in 1753 the British government purchased the private collections of Sir Hans Sloane, a British physician and botanist, "not only for inspection and entertainment of the learned and the curious, but for the general use and benefit of the public." An even more dramatic transformation was the nationalization of the former French royal collections by Louis XVI, creating the Louvre out of a royal art gallery and private cabinet.

The inability of such great institutions to attract a wide audience, despite the announcement of egalitarian ideals, traditionally has been explained as a result of the policies of a small group of autocratic directors who perpetuated attitudes characteristic of the *ancien régime*. Indeed, museum visitors were likely to encounter arrogant and intimidating guides, limited hours of admission, and poorly organized collections. Visitors to the Louvre, for example, could expect to gain entry only three days of every *decade*, the ten-day period that briefly replaced the week in Revolutionary France. At the British Museum, visitors were required to make an application (including name, social rank, and address) for an admission ticket. One German visitor, avoiding delays by buying a ticket from a scalper, felt that the reward was hardly worth the price: "I went out about as wise as I went in... been hackneyed through the rooms with violence, had lost the little share of good humor I brought in, and came away completely disappointed."

But to interpret such episodes as evidence of a widespread campaign by an elitist museum directorate to deprive an emerging middle-class audience of its cultural patrimony is to read history backward, to miss what historian Bernard Bailyn has called in a different context the "true moment of origination." The fragmentary historical evidence, in fact, points to an opposite conclusion. By the beginning of the nineteenth century, the urban bourgeoisie had not yet embraced the museum-going habit, and the norms of behavior that later facilitated their full participation had not yet crystalized. "Genteel people, who can amuse themselves every day throughout the year, do not frequent the Louvre on Sunday," observed William Thackery in 1841. "You can't see the pictures well and are pushed and elbowed by all sorts of low-bred creatures."

Other public places, such as coffeehouses, proprietary museums, print shops, and commercial galleries, afforded the bourgeoisie the opportunity to experience the arts indirectly in less threatening social settings. In fact, as historian Richard Altick has pointed out, London coffeehouses, which were often filled with portraits, natural history specimens, and art objects, served as the city's first truly public museums. But even in such congenial

settings bourgeois arts consumption was always something more than the filtering down of upper-class mores and taste. Vocal, emotive, and expressive, the arts may have facilitated social discourse by allowing the participants to exchange information about trade and occupational status without the requirement of embracing the social customs or cultural values associated with viewing similar collections in museums.

Precisely because the values associated with viewing collections in public places had not yet crystallized, the bourgeoisie could also participate in the vigorous commercial entertainments that flourished in nineteenth-century cities. The circus, the melodrama, sporting events, and waxworks offered recreational alternatives for the working class. Both rural and urban workers were willing to pay the small admission fee to view a waxworks, mechanical display, diorama, or horror show because they promised not only to entertain, enthrall, and frighten but also to enlighten and uplift.

Such petty capitalist entrepreneurs as P. T. Barnum recognized the commercial potential of these new entertainments. Barnum's "American Museum" and his international tour of Tom Thumb illustrated the ease with which members of different social classes crossed the boundaries of nineteenth-century leisure activities. The components of this popular culture were consolidated in the nineteenth century out of the political necessity to defend it. In America, that defense was framed in familiar moral terms. As Barnum's biographer, Neil Harris, concluded, "It took a true democrat to argue that a moral audience made a moral art, that the standards were fixed by the entertained, not the entertainer."

Other civic leaders were not convinced and began to view the museum as an antidote to civic vice, an institution that could define and establish standards of quality that were personal and moral in nature. In this romantic view of the museum, trustees and workers were assigned the role of guardians of the nation's cultural heritage, stewards ideally positioned to abstract certain moral and intellectual activities from the commercial society. The museum visitor was to participate in this process of elevation, initially as a producer and subsequently as a consumer of the products of a new industrial state. By simultaneously instilling habits of discipline and inspiring standards of excellence, the museum and other cultural institutions would serve, in Coleridge's words, as a "court of human appeal" in a socially chaotic world.

This romantic faith in the individual gave rise to a number of experiments aimed at making museums more accessible to the working classes. In one project, Henry Cole, the innovative director of the South Kensington Museum, sought to replace gas with electrical lighting in galleries in order to extend the hours of operation of the museum, thereby making museum visitation cheaper, safer, and easier. After one of the first groups of workers visited the museum in the evening, Cole wrote: "The looks of surprise and pleasure of the whole party when they first observed the brilliant lighting inside the museum show what a new, acceptable and wholesome excitement

this evening entertainment affords them." But Cole's brand of cultural philanthropy shaded imperceptibly into an older strain of urban reform more concerned with the abolition of vice than with the cultural elevation of the working classes. Even Cole added, "Perhaps the evening opening of public museums may furnish a powerful antidote to the gin palace."

Although still enmeshed in an older vocabulary of urban reform, the elements of a new public service ideology of the museum were slowly beginning to emerge by the mid-nineteenth century. This ideology combined elements of a romantic belief in individual fulfillment through the arts with a utilitarian commitment to extend the benefits of culture to the wider population. Moreover, reformers began to think of culture itself less as a static habit of mind than as a complex response to the social and political developments that accompanied industrialization. Cultural planners began to express the view that the museum might better serve the public (and thereby mitigate the harshness of a competitive economy) by illustrating cultural process rather than by merely displaying cultural products. It was precisely this mixture of romanticism and utilitarianism that captured the imagination of the British Parliament, resulting in the enactment of the Museums Act (1845) and the Libraries Act (1850).

A series of international exhibitions during the nineteenth century tested and refined this ideology. The first, and perhaps most protean, was the Crystal Palace Exhibition (1851), a "gathering of the products of all nations." The elegance of its simple glass and steel enclosure addressed museum visitors in a comprehensible architectural vocabulary, which seemed to dispel working-class anxieties about being entombed in a cultural mausoleum. The semiofficial theme of the Crystal Palace Exhibition—like the great international shows that followed in Vienna (1878), Philadelphia (1876), and Chicago (1893)—stressed production over consumption, but the exhibits of manufactured goods were a prophecy of material prosperity.

The crowds themselves were also on display at these shows, and few commentators failed to miss their exemplary behavior, restrained dress, and refined manners. Thus, the international exhibitions were as much experiments in public civility as displays of technological progress. Mass manufacturing not only made possible the bounteous displays but also provided the drab, homogeneous dress that allowed visitors of all social distinctions to blend into the crowd. The social implications of manufactured clothing were startling, for, as Richard Sennett has argued, by simply exchanging the peasant smock for the black broadcloth suit, dress coat, and top hat, new members of the urban bourgeoisie instantly could acquire at least the outward rudiments of social respectability. Fair planners took pride in the vindication of the belief that leisure properly organized could be civilizing.

The transformation of the norms of public conduct was not confined to exhibit spaces but cut across a number of cultural institutions, including the theatre, the concert hall, the library, and the museum. As Lawrence Levine

has put it, this desire to "tame" the audience resulted from the desire of the promoters of the new high culture "to convert audiences into a collection of people reacting individually rather than collectively." As fair planners and museum directors adopted the behavioral codes of the theater to the museum, a silence fell over the exhibition galleries. Middle-class audiences learned that the restraint of emotion was the outward expression of the respect for quality, the deference to the best demanded of those who viewed objects in public places. Exhibitions thus became textbooks in public civility, places where the visitor learned to accord their counterparts recognition while avoiding modes of speech and conduct that intruded upon another's experience.

The habit of viewing collections in public places was later systematically cultivated by dealers and critics. The French national system of exhibition was particularly successful in attracting broader audiences to art exhibitions through publicity in art journals and newspapers. The growing popularity of art exhibition was reinforced by new techniques of reproduction that helped to erode fixed canons of upper-class taste. Also, visitors lacking the skills needed to decipher complex iconography could enjoy a museum outing as the exhibition of grand works based on classical and historical themes gave way to the display of more popular genre pictures. Nonetheless, learning to appreciate the fine arts in public settings was an acquired talent. After spending almost six weeks in England studying the Art Treasures Exhibit (1857), even as perceptive a viewer as Nathaniel Hawthorne could report that he had just begun to "receive some pleasure from looking at pictures."

Not all nineteenth-century visitors were afforded the leisurely opportunity to discover their personal preferences in art. In a period of social fluidity, most museum directors agreed that the fundamental mission of arts institutions was to "instruct rather than to inform, to impose Taste rather than to question its foundations." In matters relating to the cultivation of public taste, then, the museum frequently found itself in a more authoritarian posture than the library or the university. There was a consensus, at least among the directors of major Western art museums, that the central mission of the museum was to reestablish fixed standards of taste and that the competing objectives of artistic innovation, scholarship, and education must be subordinated. According to one museum director, the paramount mission of the museum was "to impose upon society an ethic of respect for quality, an ethic of deference to 'the best.'"

By the mid–1870s, the hope that the museum might play a mediating role between social classes was undermined by economic dislocations and widespread social unrest. Indeed, reformers and cultural stewards appeared to be consumed by a growing fear that industrial nations would be divided permanently into culturally hostile working and middle classes. Matthew Arnold gave this fear its classic expression in *Culture and Anarchy* (1883) when he noted that it was "productive of anarchy, now that the populace

wants to do what it likes to do." The economist W. S. Jevons, alarmed by the rowdiness of the English working classes in public, attacked the laissez-faire attitudes of mid-Victorian directors, favoring government promotion of museums through legislation. Jevons wrote: "A large brilliantly lighted Museum is little or nothing more than a promenade, a bright kind of lounge. . . . The well known fact that the attendance at Museums is greatest on wet days is very instructive."

For other civic reformers the solution to social problems seemed to lie outside the sphere of government. Borrowing from the arts and crafts movement, some museum officials believed that museums could help bridge the gulf between social classes by sponsoring industrial education classes designed to appeal to middle-class consumers interested in the quality of design of consumable goods and laborers seeking to reassert their pride of workmanship. The South Kensington Museum, an outgrowth of the Crystal Palace Exhibition, made the improvement of design of locally manufactured goods its principal objective. Similarly, social settlement worker Jane Addams relied on Ruskin's aesthetic theories when she opened the "Labor Museum" at Hull House, a working display of spinning wheels and textiles of immigrant women that were interpreted as survivals of pre-modern craft traditions.

Educator and philosopher John Dewey argued that broader social objectives being enunciated by museum workers could not be achieved without reformulating the museum's conception of the public. Scorning the abstract, romantic notion of the public as a "great society," Dewey urged the directors of schools, libraries, and museums to identify "scattered, mobile, and manifold" publics rather than to attempt to elevate what Walter Lippmann called the "phantom public." Taking a step beyond the progressive educators, Dewey appealed to municipal officials and urban planners to abandon entirely the concept of the large art museum and instead establish small, centrally located community museums.

Recognizing the potential significance of the museum as a tastemaker, Newark museum founder John Cotton Dana urged his colleagues to imitate department store techniques in the competition for the attention of middle-class consumers: "In a word, a visitor goes to a museum to gaze as a duty, with some hope of uplift; but to a store to enjoy, to compare and to study in sheer delight." Borrowing from Thorstein Veblen, Dana confused the issue somewhat by attacking art museums as institutions of "conspicuous consumption." His entreaties were nonetheless unable to stem the class segmentation of arts consumption in the early twentieth century. Art museums in particular began to target their "cultural products" at managerial, business, and professional elites in ways that reinforced the loyalty of these constituencies.

As the intensely familiar, local world of leisure was replaced by a national, commercialized, popular culture, the museum became the principal insti-

tution entrusted with preserving upper-middle-class canons of taste in the early twentieth century. Arts critic D. L. Duffus was convinced that a pervasive popular culture (evidenced by "the derby hat, the hotdog stand, tabloid newspapers, and the extensive use of chewing gum") posed a significant obstacle to an aesthetic revival in America. The unrelieved attack by museum directors on popular culture and on working-class forms of recreation (the cinema, the amusement park, and the commercial sporting event) as "lowbrow" and the celebration of their collections as "highbrow" then reinforced the emerging class-bound system of leisure and solidified a dual system of popular and high culture in America.

By the 1920s museum directors were more concerned about catering to the social conventions and physical comforts of an established clientele than about identifying new museum audiences. Symptomatic was the museum's mighty struggle against "museum fatigue" in the early twentieth century. At the Boston Museum of Fine Arts, director Benjamin Ives Gilman added seats in the galleries, improved the design of exhibit cases, and devised a "skiascope," a mechanical device that aided visitors in isolating and reducing glare on a single work of art. Yale's noted behavioral psychologist Edward Robinson entered the fray by tracking visitors through the galleries armed with a notebook and stopwatch, though he was never able to isolate a general state of physical or mental exhaustion associated with museum visitation. Other psychologists, like Arthur Melton, documented a century of learned behavior, reporting such details of visitor conduct as the tendency to turn right upon entering a gallery and then to search for the nearest exit.

These efforts did not go unnoticed abroad. British observer Henry Miers, in his report to Parliament on the state of British museums, praised American museums for improving visitor services while condemning the arbitrary hours, minimal advertising, poor labeling, and static exhibits of English museums. Even the smallest details caught his attention. Miers noted that in England the close of the museum was signaled by a "raucous handbell rung with great gusto," while in the United States a "beautifully melodious sound gradually penetrates to the utmost recesses of the building, graciously informing the visitor that he must bring his visit to a close." What Miers could not notice were the non-visitors, the groups who had become alienated by the gentrified museum environment that turn-of-the-century American museum directors had created.

By the beginning of the twentieth century, the transformation of the American museum, and the emergence of its principal constituency, was virtually complete. American art museums, whose eclectic collections once attracted diverse audiences, had become treasuries of artistic "masterpieces," the understanding of which required prior education and cultural experience. Although the doors of the museums were literally open to all, true access to the collections, what French sociologist Pierre Bourdieu has called "the appropriation of cultural wealth," was limited to visitors who

could decipher the complex codes by which museums selected, displayed, and interpreted objects. Well-established codes of public comportment, dress, and speech, moreover, pervaded the museum, serving as subtle but forceful barriers to participation. The result was "to demand of art that it should not be accessible to all, that it should require, not only a certain degree, but also a certain quality of culture, that it should be closed to the vulgar and open to initiates only," wrote sociologist Edmond Goblot. "The bourgeoisie took up art in order to make a barrier of it."

Although the contours of the museum audience had crystalized, museums continued to adjust their policies in response to a range of external pressures, alternately seeking to attract or exclude groups at the margins. For example, the smug complacency of museum officials toward the public was no longer fashionable after the stock market crash of 1929, an event that seemed to signal the end of the period of "extravagant prosperity" for museums. In response, the trustees and directors of some museums favored devoting limited resources to public programs at the expense of amassing ever greater collections and ever larger buildings. Dressing up this conclusion in the vocabulary of popular economics, Charleston Museum director Paul Rea wrote that the "expenditure of steadily mounting millions of dollars" could not be justified for "progressively diminishing increments in attendance."

As the federal government and private foundations assumed a greater role in the support of museums during the depression years, the ideology of public service was stripped of some of the vestiges of aesthetic purism that had attached during the 1920s. Funds from the Works Progress Administration enabled museums to hire more guides, lecturers, and instructors and even to open new community museums. At the same time, the Carnegie, Kress, and Russell Sage foundations began to fund projects specifically aimed at increasing the audience of American museums. In fact, the establishment of branch museums became the darling of some private foundations during the depression, for the results of decentralization could be measured in concrete increases in attendance.

Arguing that such increases were meaningless if visitors remained ignorant of the collections, museum educators appealed for increased support by reasserting the museum's "historic mission" to educate, "what we have been preaching for a quarter of a century." Other museum educators adopted the more strident vocabulary of social change. "The time has come . . . for delicacy . . . to be eliminated from museums, by persuasion if possible, but by force if necessary," wrote an ardent educator at the Metropolitan Museum of Art. "The museums must come down to earth and realize that democracy and popular culture are synonymous."

During World War II, museum officials again adjusted policies toward the public, recognizing the need to reinforce notions of national unity and to downplay the themes that had divided Americans during the depression. Moreover, by sponsoring such patriotic exhibitions as the Museum of Mod-

ern Art's (MOMA) "Road to Victory" and by making museums more accessible to servicemen and workers, museum directors hoped to bring museum policy into conformity with national social policy. The Metropolitan's Henry Francis Taylor flamboyantly urged his colleagues to "meet the man in the street halfway" in order to avoid the dilemma of European museum directors who were reduced to "pimping for ideologies that destroy the very civilization whose finest flowering we are dedicated to preserve."

Not all postwar commentators were so quick to disparage as "cut-rate aestheticism" earlier museum policies. Critics like Walter Pach were concerned with the heavy burden of world leadership that was thrust on American museums at the conclusion of the war. Pach echoed European fears that the popularization of museum programs would lead to the spread of American popular culture and, ineluctably, to the "Americanization" of Europe. In response to Taylor's appeal to the man in the street, Pach questioned: "Must we go into the street and, for example, take part in the battle of the Colas—Pepsi versus Coca—as they scream from the billboard or from magazine covers?"

The fear of a breakdown in Western cultural standards also combined with other anxieties in postwar American society. Sociologists viewed with alarm the rapid rise in income, the spread of suburbia, and the new acquisitiveness of Americans. Thus, while Taylor was proposing to turn the museum into an "informal liberal arts college for a whole generation," others in the museum community greeted with suspicion the coming of age of the children of the immigrants, who were ready to share in the cultural bounty of an affluent society.

Come they did, and by the 1950s, the American museum visitor was viewed as a "status seeker," Vance Packard's phrase for a person eager for cultural experience but essentially impatient and undiscriminating. John Coolidge's impressions of the "average hypothetical visitor" to Harvard's Fogg Museum fit this collective portrait of the American public as shallow and superficial. Coolidge observed that he "is not persnickety about what he sees, and looks quite happily at whatever is displayed. He has come to see the art museum; he is not making a pilgrimage just to study the collection of Indian Sculpture or the Early American Silver."

Other "mass culture critics" saw darker tones in the collective portrait of a socially sleepwalking public. James Johnson Sweeney, the director of MOMA, feared that the "hasty democratization of education" would encourage an "indolent approach" to the visual arts. The real betrayal of the public, Sweeney argued, came not through limited admissions but through open admissions, branch museums, and interpretive techniques that spoon-fed culture to mass audiences, depriving others of an "immediate sensuous contact" with the object. "To catch and hold the attention of the indolent visitor," Sweeney wrote, "elaborate biographical, critical, explanatory labels, even canned lectures on earphones are provided, like aesthetic water wings,

so one may dabble about without getting too deep in the water." Sweeney laid the blame directly on trustees, who he felt had become hostages of attendance figures, and their chosen directors, who were "ambitious to embrace the broadest public." These new American museum directors, Sweeney concluded, lacked the courage to admit that the highest experience of art is reserved to an elite who have "earned in order to possess."

The worst fears of the mass culture critics were realized by the public response to the showing of the *Mona Lisa*, which attracted more than 2 million people. An incredulous John Walker, director of the National Gallery, carefully studied the crowds flocking to see the *Mona Lisa*, distinguishing the merely "superficial" (those who felt presence alone entitled the visitor to an "emanation of culture") from the truly "devout" (those who consumed works of art as sacraments with "profound attention and reverence"). Though Walker was convinced that public behavior might contain some "basic clue" to the significance of museum work, he was nonetheless unable to solve the mystery of "those endless lines of people who waited hours for a quick glimpse of a sinisterly smiling lady."

Part of the answer lay in the aspirations of a newly affluent, educated, and mobile class in the 1960s. In an apt phrase, critic Alvin Toffler called them the "culture consumers" because of their preference to spend their leisure and income on culture and education rather than recreation. In contrast to the image of the conformity-seeking museum audiences of the 1950s, Toffler found highly individualistic arts audiences in the 1960s who were eager to explore personal identity through group cultural experiences.

Hoping to expand audiences without alienating their traditional constituencies, museums sought directors who were youthful, well educated, and well born. Perhaps more than any other director of the decade, Thomas Hoving, the Princeton-educated scion of an upper-class New York family, helped to shift museum policy toward including groups on the periphery of the museum's principal audience. Critic Grace Glueck early observed that Hoving came to the Metropolitan with an implied mandate to reassemble the constituency of the museum by mediating between the "dissident, young artists disillusioned with producing objects for a bourgeois culture" and the "elders eager to find some purchase on a youth dominated milieu that had become baffling, thus threatening."

The extent of that threat became clearer when poor, minority, and disadvantaged Americans briefly formed alliances with youthful museum goers and artists to challenge the basic assumptions of American museums. Combining their critique with a much deeper crisis in national self-confidence and self-respect associated with the Vietnam War and the civil rights movement, radical reformers demanded a reappraisal of the museum as a civic institution. The hidden anger and injury associated with a class-bound system of arts consumption often overwhelmed the debate. At a small seminar on New York's neighborhood museums, for example, museum officials were

charged with ineptness, insensitivity, and cultural imperialism in the op-
eration of branch and neighborhood museums—charges that reverberated
through the museum community and succeeded only in polarizing it.

Making a virtue out of necessity, the American Association of Museums
attempted to mediate the conflict by spotlighting museums that had reached
new audiences through new public programs. In fact, many museums during
the 1960s and early 1970s began dramatically to expand community services,
special classes, and workshops, often using branch museums as a vehicle to
attract the disaffected to the parent museum. Though many of these tech-
niques were not new, the idea that the museum should confront directly
racial injustice and urban poverty was, as Edward Banfield has argued, a
substantial departure from its historic mandate.

The success of museums in attracting new groups of visitors gave rise to
an uneasiness among museum workers. Who attended museums? Who did
not? Did exhibits make an educational difference? This questioning frame
of mind helped to revive the dormant social-scientific study of visitor be-
havior. Too often, however, the importance of such research was honored
in the breach, and many museum directors and curators steadfastly resisted
the intrusive efforts of psychologists who made their entrée into museums
all the more difficult by quarrelling among themselves about research meth-
odologies.

The brief idealism of the 1960s in attracting new groups of visitors gradually
gave way to the cynicism of drawing ever larger museum audiences in the
1970s. The blockbuster exhibit—highly publicized, lavishly installed exhi-
bitions specifically designed to attract mass audiences—became the signature
public program of museums in the 1970s. Caught in an inflationary spiral,
museums were also increasingly reliant on government grants and revenues
from admissions and museum shop sales—sources of support that required
a more detailed understanding of the visiting public. "Research is an infor-
mation-buying business," one museum evaluator wrote. "No one in their
right mind would spend more for information than they expect to gain from
having the information." In response, museums hired large public opinion
survey firms to provide the kind of detailed demographic information re-
quired to support their expansive operations and programs.

The results of these visitor surveys were remarkably consistent, docu-
menting the emergence of an American museum audience that was pre-
dominantly young, educated, and affluent, with relatively little
representation from working-class or ethnic minorities. The underrepresen-
tation of such groups is all the more regrettable because the museum has
emerged as a significant institution in modern American culture still holding
out the promise of giving, in the words of Robert Coles, "sanction to the
thoughtful reveries of many millions of people . . . who, in their own manner,
struggle for coherence, vision, a sense of what obtains in the world."

SURVEY OF SOURCES

While informed discussion of the museum in twentieth-century culture is scarcely imaginable without reference to the public that it serves, remarkably little has been written on the evolution of museum audiences. The literature that does exist has largely been written by museum insiders and sympathetic historians, eager to defend institutions that have become highly valued in liberal, progressive, and enlightened countries. Searching for the earliest roots of the modern concept of public service, these writers have often lost sight of past museum audiences and, anachronistically, have assumed the existence of a museum-going public from the beginning. As Bernard Bailyn has put it in another context, museum historians have lacked the belief that the "elements of their world might not have existed."

The Whiggish interpretation of the growth of a public service ideology is pervasive in the general literature on museums and is particularly well illustrated by Alma Whittlin's *Museums: In Search of a Usable Future* (1970). Kenneth Hudson's *A Social History of Museums: What the Visitors Thought* (1975), which promises but fails to deliver the people missing in standard histories, is an example of the problems facing the historian seeking to reconstruct past museum audiences. Nathaniel Burt's *Palaces for the People* (1977) is a similarly misleading narrative account of American art museums that pays scant attention to museum audiences.

A more useful point of departure is the recent work of British and American social historians of leisure. In general, British historians have associated the growth of a middle-class arts audience with the disappearance of traditional working-class leisure activities, the privatization of leisure space, and the growth of state-subsidized museums. Robert W. Malcolmson's *Popular Recreations in English Society* (1973) and Peter Bailey's *Leisure and Class in Victorian England* (1978) provide convenient introductions to this literature, and *Leisure in Britain* (1983), edited by John K. Walton and James Walvin, is largely a representative collection of local studies. The new social history of leisure may also tend to romanticize the life of ordinary people, neglect the leisure activities of the bourgeoisie, and overstate the influence of social elites.

In his imaginative *The Shows of London* (1978), Richard Altick uses diverse historical materials to focus attention on neglected urban, public entertainments that flourished before the crystalization of "conventional barriers that kept class and class at a distance." Hugh Cunningham, in *Leisure in the Industrial Revolution* (1980), criticizes Altick for his assumption that "what is new starts from high up the social scale and is diffused downwards." Although Cunningham notes in passing that mass entertainments such as P. T. Barnum's traveling shows occasionally attracted diverse audiences, he nevertheless concludes that working-class attendance at museums was a

"poisoned gift" because participation was tied to the acceptance of middle-class values.

American historians have emphasized the role of the museum in shaping shared political values. For example, Charles Coleman Seller's *Mr. Peale's Museum* (1980) presents a cameo portrait of the American Enlightenment museum, an institution where exhibits were designed to teach lessons in reason and morality. Even P. T. Barnum, perhaps in his final performance as the great showman of the nineteenth century, appears not as a petty bourgeois capitalist entrepreneur but rather as a true Jacksonian democrat in Neil Harris's perceptive biography, *Humbug* (1973). Nonetheless, the collective portraits of nineteenth-century American and European museum audiences are not inconsistent. See, for example, the heterogeneous nature of visitors to public entertainments described by Louis L. Tucker in "The Western Museum of Cincinnati" (1965) and by M. H. Dunlop in "Curiosities Too Numerous to Mention" (1984).

Although not much work has been done on reconstructing past art museum audiences, a number of provocative theoretical works make the task especially inviting. Despite a certain anti-middle-class bias, Arnold Hauser's work is the best introduction to the complex relationship between the art museum and the public. In *The Social History of Art* (1952), Hauser suggests that the public art museum is a reflection of the rational ordering of the arts that was more appealing to the bourgeoisie than to the upper or working classes. For a critique of Hauser's thesis, see E. H. J. Gombrich's *Meditations on a Hobby Horse* (1978). Art historians Carol Duncan and Alan Wallach extend Hauser's argument in "The Universal Survey Museum" (1980), an iconographic analysis of the art museum.

The relationship of the artist, museum, and public is best introduced by George Francis Haskell's essay for the *International Encyclopedia of the Social Sciences* entitled "Fine Arts: Art and Society" (1968). In *The Sociology of Art* (1982), Hauser posits a reciprocal relationship between art producers and consumers that is mediated by the museum. Thus, Hauser provides a framework that should allow an inventive historian to avoid retelling the standard romantic tale of the antipathy between artists and bourgeois audiences. In fact, art historian Timothy Clark defines art history as "the history of mediations" in *Image of the People* (1973) but suggests that the artist, and not the museum, plays the most important role. Rejecting the view that the public is an "identifiable 'thing' whose needs the artist notes, satisfies, or rejects," Clark uses the canvases of Courbet to probe the often socially charged relationship between arts producers and arts consumers.

Although the tension between artists and the museum-going public is perhaps better explained by social than by political differences, understanding the involvement of artists in radical politics is helpful. The European background is surveyed in Eugenia W. Herbert's *The Artist and Social Reform* (1961) and James A. Leith's *The Idea of Art as Propaganda in France*

(1965). These works should be supplemented by Timothy Clark's provocative study of artists, art, and politics in revolutionary France, *The Absolute Bourgeois* (1973). Finally, Linda Nochlin attempts a broad-brush coverage of radical politics and museum constituencies in "Museums and Radicals: A History of Emergencies" (1971).

Several works reappraising the place of the artist in the nineteenth century offer some help in understanding early arts audiences. A generally useful collection of essays is *The Sociology of Art and Literature* (1970), edited by Milton Albrecht, James Barnett, and Mason Griff. See also Mason Griff's "Fine Arts: The Recruitment and Socialization of Artists" (1968) in the *International Encyclopedia of the Social Sciences*. Elizabeth Holt documents the interaction of public, critic, and artist in *The Triumph of Art for the Public* (1979) and concludes that at mid-century the opinion of the public "might be disparaged but could never be disregarded." In *The Art of All Nations, 1850–1873* (1981), Holt describes how art journals, newspapers, and international exhibitions reached a seemingly ever-expanding audience.

There is no study of the behavior of early nineteenth-century museum audiences, and more research is needed to understand the emergence of norms governing public conduct in cultural institutions. My account is based on standard museum histories and Richard Sennett's provocative *The Fall of Public Man* (1977). The works of Erving Goffman (the leading contemporary role theorist), *Behavior in Public Places* (1963) and *Relations in Public* (1971), are of use to historians. As Sennett has noted, however, contemporary psychologists have become preoccupied with social conventions while losing sight of the class and moral overtones of public behavior. "Here is a picture of society in which there are scenes but no plot," he writes. Also useful are John Kasson's "Civility and Rudeness: Urban Etiquette and the Bourgeois Social Order in Nineteenth Century America" (1984), and Lawrence Levine's observations in *Highbrow/Lowbrow* (1988).

The history of the transformation of the museum into the principal American institution defining standards of taste also needs to be written. A number of works suggest important lines of research. John Steegman's pioneering *Consort of Taste, 1830–1870* (1950) chronicles the attempt by mid-Victorians to reform their own standards after the public recognized that authority had been too hastily abandoned during the industrial revolution. The official canons of classical taste are the subject of Francis Haskell and Nicholas Penny's excellent *Taste and the Antique* (1981). In *Rediscoveries in Art* (1976), Haskell describes how the massive acquisition of old masters, made possible in part by the rise of mercantile fortunes, subverted established hierarchies, only to be replaced by a rigid new code facilitated by museums.

The response of the mid-Victorian museum to the social dislocations of industrialization has received considerably less attention than its role as tastemaker. Matthew Arnold's enduring *Culture and Anarchy* (1875) is still the best testament to the mid-Victorian preoccupation with the "social prob-

lem." The importance of Arnold's work in establishing hierarchies of taste and culture in nineteenth-century America cannot be overemphasized. The standard work on Arnold's influence in America is John Henry Raleigh's *Mathew Arnold and American Culture* (1957). For a contemporary account of the treatment of social issues by mid-Victorian British museum directors, see William Jevons's biting essay, "The Use and Abuse of Museums" (1883), reprinted in *Methods of Social Reform, and Other Papers* (1965).

Despite Jevons's complaint that "hardly anything has been written about the general principles of [museum] management," there is a rich body of literature on the political economy of nineteenth-century arts. Raymond William's *Culture and Society* (1958) offers the best introduction to liberalism and cultural reform. The early, utilitarian arguments for government support of the arts are conveniently summarized in Daniel M. Fox's "Artists in the Modern State" (1970). The rise of English parliamentary liberalism (including the principal legislation affecting museums) is noted in Cunningham's *Leisure in the Industrial Revolution* (1980) and Kenneth Hudson's *A Social History of Museums* (1975). My account of British museum practice and observations on social questions is based in part on Sir Henry Miers's *A Report on the Public Museums of the British Isles* (1928) and Sir Frederic George Kenyon's *Museums and National Life* (1927).

The implications of mid-Victorian cultural policy have been the subject of several studies of nineteenth-century cities. In "The Gilded Age Revisited, Boston and the Museum Movement" (1962), Neil Harris concludes that museum trustees were engaged in a highly rational attempt to make the fine arts more popular. The more persuasive counterargument is set forth in Paul DiMaggio's "Cultural Entrepreneurship in Nineteenth-Century Boston: The Creation of an Organizational Base for High Culture in America," and his "Cultural Entrepreneurship in Nineteenth-Century Boston, Part II: The Classification and Framing of American Art" (1982).

The question of cultural philanthropy has been a central issue in a number of other insightful urban histories. For example, Helen Horowitz finds evidence of paternalism and racism in the cultural policy formulated by Chicago's cultural stewards in *Culture and the City* (1976) and Kathleen McCarthy concludes in *Noblesse Oblige* (1982) that Chicago's cultural institutions were led by "utterly idealistic and fundamentally democratic" men. Helen Meller's *Leisure and the Changing City* (1976) is a case study of cultural leaders in Bristol who founded an art gallery, library, and university to release the "passions and enthusiasms" of daily work and to allow workers to fit art and music, with its "civilizing effects," into their daily schedules.

By the beginning of the twentieth century, a few commentators questioned the self-congratulatory tradition of private philanthropic support of American museums. Thorstein Veblen, in his classic *The Theory of the Leisure Class* (1899), described the way in which upper-class habits of consumption ("conspicuous consumption") were later reflected in middle-class norms ("pecu-

niary canons of taste"). Although Veblen never specifically mentioned the role of the museum in establishing socially approved standards of taste, museum reformer John Cotton Dana incorporated Veblen's ideas into his *The Gloom of the Museum* (1917), a tract attacking Victorian museum trustees for imposing European cultural standards on a reluctant public.

The assault on the art museum is best understood in the context of conceptions of the public interest during the progressive era. John Dewey's *The Public and Its Problems* (1927), especially his discussion of "The Great Community," provides a useful point of departure. Similarly, Walter Lippmann rejects the notion of the public as a "fixed body" of individuals united by organic laws in *The Phantom Public* (1925). For critical commentary, see Benjamin F. Wright's *Five Public Philosophies of Walter Lippman* (1973). There are a number of sources on the community museum movement. Jane Addams's efforts to establish a neighborhood museum are treated in Karen Cushman's "Jane Addams and the Labor Museum at Hull House" (1983). Dana's appeal to city managers to establish centrally located museums can be found in *A Plan for a New Museum* (1920), while American Association of Museums director Laurence Coleman gave the community museum movement professional sanction in his *Manual for Small Museums* (1927). William Noland Berkeley's *The Small-Community Museum* (1932) is a practical manual for developing a community museum.

The complex relationship between the museum and the emergence of a system of popular and high culture is best introduced by Levine's penetrating *Highbrow/Lowbrow*. Levine poses the most important questions and sketches in the broad contours of a hierarchically organized and socially fragmented public culture in America. My account of the place of the museum in the emergence of a dual system of culture is based on Benjamin Ives Gilman's *Museum Ideals of Purpose and Method* (1923) and Robert L. Duffus's "Dusting Off the Museums" in *The American Renaissance* (1928), works that suggest that museum and arts audiences were becoming increasingly class segregated during the 1920s.

Specific research attention also should be focused on various popular culture forms as leisure alternatives to the museum. Some historical leverage is afforded by several excellent histories of American popular culture institutions. See, for example, John F. Kasson's *Amusing the Million* (1978) (amusement parks), Lary May's *Screening Out the Past* (1980) (the motion picture industry), and Robert Toll's *The Entertainment Machine* (1982) (a general survey).

Leisure should also be understood in the context of choices available in a consumption economy. Neil Harris's "Cultural Institutions and American Modernization" (1981) and his "Museums, Merchandising, and Popular Taste: The Struggle for Influence" (1978) provide good points of departure for understanding the place of the museum in a consumption economy. T. J. Jackson Lears associates museums at the turn of the century with antimod-

ernism in his penetrating *No Place of Grace* (1981), in which he notes that "collections of premodern artifacts became new and striking emblems of upper-class cultural authority." More generally, *The Culture of Consumption* (1983), a collection of essays edited by Richard Wightman Fox and T. J. Jackson Lears, and Alan Trachtenberg's *The Incorporation of America* (1982) provide useful background for understanding the museum's tastemaking function in a culture of consumption.

The atmosphere of liberalism surrounding the New Deal prompted several reappraisals of museum policy. In *The Museum and the Community* (1932), Charleston Museum director Paul Rea developed "social scientific laws" that related museum size and attendance and concluded that large American museums must decentralize, a position AAM director Laurence Coleman echoed in his monumental work, *The Museum in America* (1939). In his general assessment, "The Arts in Social Life" (1933), Frederick Keppel urged American museums to adopt a policy of "educational opportunity almost literally from the cradle to the grave."

Cloaking his argument in a fashionable social egalitarianism, T. R. Adam appealed to museum workers in *The Museum and Popular Culture* (1939) to base programs on the theory that a "democratic society produces customers for aesthetic education capable of receiving direct inspiration without the intervention of any social machinery based on wealth or class." Theodore Low, the most strident of the depression-era museum writers, appealed to museum educators to question the priority of research and to extend educational programs to the "intellectual middle class" in his *The Museum as a Social Instrument* (1942), the manifesto of progressive museum education. Wilcomb Washburn argued in "Scholarship and the Museum" (1961) that Low's mischief (the displacement of research in the museum) was still at work two decades later. In "The Museum as a Social Instrument: Twenty Years After" (1962), Low responded that he would change his tone but not his tune.

During World War II, writers emphasized the common denominators of American museum audiences—"good taste" and a commitment to self-improvement—and downplayed the social differences among museum visitors. Alarmed by the growth of propaganda in totalitarian regimes, T. R. Adam found a new justification for broadening the base of museum audiences and, in *The Civic Value of Museums* (1937), argued that a well-rounded program of adult education in the museum might serve as a "modern weapon" in the struggle for public enlightenment. The Metropolitan's Francis Henry Taylor also sensed among museum visitors a new restlessness with the exhibition of European works of art, which he attributed to the growth of anti-authoritarianism in "Museums in a Changing World" (1939).

With the museums of Europe in shambles, American museum directors hastily struggled to reformulate notions of public service befitting a democratic society charged with world cultural leadership. Perhaps the most far-reaching restatement was Francis Taylor's *Babel's Tower* (1945), in which

he called for making the postwar American museum into an "informal liberal arts college for the whole generation." In arguing for a democratic museum tradition, however, Taylor confused twentieth-century German authoritarianism with eighteenth-century English colonial policy, introducing a persistent anachronism into museum literature. Art historian Meyer Schapiro, in his review of Taylor's book in the *Art Bulletin* (1945), called his treatment of German art history inaccurate, his polarization of the museum and university communities unfortunate, and his ideal of a popular museum tradition disingenuous. By contrast, Walter Pach's *The Art Museum in America* (1948) was a naive appeal to museum directors to return to prewar aestheticism.

The rediscovery in postwar America of middle-class standards of taste gave additional support to those who argued for an expansion of public programs. In *Made in America* (1948), John Kouwenhoven urged Americans not to be "hesitant or apologetic" about their tradition of vernacular design, while Russell Lynes, in *The Tastemakers* (1954), written at a time when Americans were peculiarly sensitive to characterizations of the public as a "dreadful mass of insensible back-slappers," stripped taste of all social trappings. "Unless I completely misunderstand the real reason for having taste, it is to increase one's faculties for enjoyment," Lynes concluded. "Taste in itself is nothing." Reversing the anti-Victorianism of the early twentieth century, these works placed the American museum into a tradition of popular, democratic institutions, linking them to other "custodians of culture," as Henry May described in *The End of American Innocence* (1959).

The question of museum policy toward the public in the 1950s is tied to mass culture criticism. An excellent, short introduction to this literature is Daniel Bell's "Modernity and Mass Society: On the Varieties of Cultural Experience" (1963). *Mass Culture: The Popular Arts in America* (1957), edited by Bernard Rosenberg and David White, is also a useful collection of essays. The collective portrait of the American public as a shallow, superficial people preoccupied with material success that emerged during this period is based on such popular works as David Riesman's *The Lonely Crowd* (1950), William Whyte's *The Organization Man* (1956), and Vance Packard's The Status Seekers (1959). My use of John Coolidge's portrait of the "average hypothetical visitor" to illuminate these themes is taken from his *Some Problems of American Art Museums* (1953).

The American museum was not the principal target of the mass culture critics who, rather, took aim at enterprises where high production costs demanded mass audiences. In a disquieting essay, "Society and Culture" (1961), Hannah Arendt attacked the tendency of mass culture industries literally to make culture into a consumer good. Although primarily a discussion of the movies, radio, and television, Gilbert Seldes's *The Great Audience* (1950) contains observations useful in understanding the application of mass culture criticism to the museum. His provocative "The People and the Arts" is reprinted in Rosenberg and White's *Mass Culture* (1957).

For a particularly sharp attack on the mass media, see Max Horkheimer and Theodor Adorno's "The Culture Industry" in their joint work, *Dialectic of Enlightenment* (1972). A general introduction to the "Frankfort school," including the works of Herbert Marcuse and Erich Fromm, is contained in Dave Laing's *The Marxist Theory of Art* (1978).

Mass culture criticism of the museum also requires an understanding of the changes in the relationship of artists and the public. By the 1950s the phrase "art public" no longer stood for an undifferentiated and potentially hostile bourgeois audience. Just the opposite connotation is suggested by Read Bain's definition of an "appreciate public," in *A Dictionary of the Social Sciences* (1964), edited by Julius Gould and William Kolb, and by Alfred Barr's *Matisse, His Art and His Public* (1951). The loss of this creative tension is also the theme of James Sweeney, who blames the "hasty democratization of education," in "The Artist and the Museum in a Mass Society" (1960).

In *The Vanguard Artist* (1965), Bernard Rosenberg and Norris Fliegel suggest abandoning the artist-public dichotomy entirely and replacing it with four types of "publics"—friends, buyers and collectors, viewers, and critics. This typology is refined by Bruce Watson in "On the Nature of Art Publics" (1968), a sociological study of the audience of the Armory Show. Watson characterizes the museum-going public not as a single, permanent group but as amorphous, temporary social structures produced by impersonal communication and contact. Historian James Ackerman argues in "The Demise of the *Avant Garde* (1969) that the rise of "professional manufacturers of opinion" (commercial galleries and the news media) partly explains the abrupt end to middle-class hostility to experimentation in contemporary art. Daniel Bell expands this argument in *The Cultural Contradictions of Capitalism* (1976), declaring that there is "no longer an avant-garde, because no one in our post modern culture is on the side of order or tradition. There exists only a desire for the new."

Defining the exact contours of the new class of arts consumers has attracted considerable interest. John Kenneth Galbraith first suggested the emergence of an educated, prosperous, and largely professional class in *The Affluent Society* (1958), and Alvin Toffler described 1960s arts audiences in *The Culture Consumers* (1964). "The sense of exclusivity is gone," Toffler wrote. "The museum is crowded with 'other Americans' and there may well be hundreds more queued up outside waiting to enter." My account of the perplexed response of one museum director, John Walker, is based on his witty *Self-Portrait with Donors* (1974).

The growth of mass arts audiences can be traced through the separate literature on the finances of cultural institutions. William J. Baumol and William G. Bowen's *Performing Arts, the Economic Dilemma* (1966) and the Ford Foundation's *The Finances for the Performing Arts* (1974) detail the gap between earned income and expenses of cultural institutions. *America's*

Museums: The Belmont Report (1969), a report of the American Association of Museums, is an appeal for direct federal support of museums.

The growth of federal and private foundation support for the arts prompted several important cross-sectional studies of arts audiences. The most influential reports are the National Endowment for the Arts's *Museums USA* (1974), the National Committee for Cultural Resources's *National Report on the Arts* (1975), and the National Research Center of the Arts's *Americans and the Arts* (1975). A useful, though somewhat dated, digest of more than 270 audience studies is *Audience Studies of the Performing Arts and Museums* (1978) by Paul DiMaggio, Michael Useem, and Paula Brown. The authors organize the results of the surveys by age, education, occupation, gender, income, and race. More recent survey data are included in Lynne Fitzhugh's "An Analysis of Audience Studies for the Performing Arts" (1983). Representative publications from this largely unpublished literature include the following: Carolyn Wells's *Smithsonian Visitor* (1969); Michael O'Hare's "The Audience of the Museum of Fine Arts" (1974); Yankelovich, Skelly, and White's *A Study of Visitors to the Smithsonian* (1976); and the American Museum of Natural History's *A Profile of Consumer Use and Evaluation* (1977).

The growth of national museum audience surveys has not been limited to the United States. Canadian museum audience research was stimulated by D. S. Abbey and Duncan Cameron's three-part study of visitation at the Royal Ontario Museum, *The Museum Visitor* (1959–1961), the results of which were summarized in their article, "Visits Versus Visitors" (1960). The principal reports on cross-sectional audience research in Canada are contained in *The Museum and the Canadian Public* (1974) by Bryan Dixon, A. E. Courtney, and R. H. Bailey and in *Patterns of Museum Participation* (1974). The survey concludes that education is the most significant variable, distinguishing visitors from non-visitors.

Perhaps the most influential survey of European attitudes toward museum visitation is Pierre Bourdieu and Alain Darbel's, *L'Amour de l'art: les musées d'art européens et leur public* (1969). In his "Outline of a Sociological Theory of Art Perception" (1968), Bourdieu argues that class and educational background systematically guide the choices necessary to take advantage of cultural opportunity, a process he calls the "appropriation of cultural wealth." Departing from the classical Marxist view that reduces the issue of cultural advantage to its material preconditions, Bourdieu emphasizes the "deeply interiorized values" that help to define attitudes toward education and cultural experience.

American sociologists Paul DiMaggio and Michael Useem also find evidence of unequal consumption of the arts among various socioeconomic strata in "Social Class and Arts Consumption" (1978), which is based on their exhaustive review of the post-1961 survey literature. Although they argue

that the wealthy and well educated continue to dominate the American museum-going public, they concede that the survey evidence suggests an "inexact fit" between class predictors and actual cultural participation. The recent literature on museum evaluation, which reveals a psychological community deeply divided over the purpose, methods, and use of audience research, is surveyed in the chapter by Ken Yellis in this book.

The subsidization of museums by private foundations and federal funding agencies has given rise to a lively and important literature. Robert F. Arnove's *Philanthropy and Cultural Imperialism* (1980) is a convenient collection of essays setting forth the Marxist-Gramscian critique of philanthropy. For general background and a discussion of the concept of hegemony, see also Robert Simon's *Gramsci's Political Thought* (1982) and Martin Carnoy's *The State and Political Theory* (1984). Barry D. Karl and Stanley N. Katz discuss, among other things, the applicability of Gramsci's ideas to American foundations in their incisive and balanced article, "Foundations and Ruling Class Elites" (1987).

Gary Larson's *The Reluctant Patron: The United States Government and the Arts, 1943–1965* (1983) is the best historical overview of state funding in the United States. Economist Dick Netzer challenges many of the arguments for direct public subsidy of the arts in *The Subsidized Muse* (1978), while Alan L. Feld, Michael O'Hare, and J. Mark Davidson Schuster examine the implications of indirect government subsidies of the arts through the tax system in *Patrons Despite Themselves* (1983). Edward C. Banfield, rejecting utilitarian arguments, argues that state subsidy of the visual arts lies outside the proper sphere of government in *The Democratic Muse: Visual Arts and the Public Interest* (1984). The pronouncements of arts administrators, museum officials, academics, benefactors, and government officials are collected in *The Arts and Public Policy in the United States* (1984), edited by McNeil Lowry, and in "Symposium on the Public Benefits of the Arts and Humanities" (1985).

BIBLIOGRAPHIC CHECKLIST

Abbey, D. S., and Duncan F. Cameron. *The Museum Visitor*. 3 vols. Toronto: Royal Ontario Museum, 1959–1961.

———. "Visits Versus Visitors: An Analysis." *Museum News* 39 (November 1960), 34–35.

Ackerman, James S. "The Demise of the *Avant Garde*: Notes on the Sociology of Recent American Art." *Comparative Studies in Society and History* 11 (October 1969), 371–84.

Adam, Thomas Ritchie. *The Civic Value of Museums*. New York: American Association for Adult Education, 1937.

———. *The Museum and Popular Culture*. New York: American Association for Adult Education, 1939.

Albrecht, Milton C., James H. Barnett, and Mason Griff, eds. *The Sociology of Art and Literature: A Reader.* New York: Praeger, 1970.

Altick, Richard D. *The Shows of London.* Cambridge: Belknap Press of Harvard University Press, 1978.

American Association of Museums. *America's Museums: The Belmont Report: A Report to the Federal Council on the Arts and the Humanities by a Special Committee of the American Association of Museums.* Washington, DC: American Association of Museums, 1969.

————. *Museums: Their New Audience.* Washington, DC: American Association of Museums, 1972.

American Museum of Natural History. *A Profile of Consumer Use and Evaluation.* New York: American Museum of Natural History, 1977.

Arendt, Hannah. "Society and Culture." In *Culture for the Millions? Mass Media in Modern Society,* edited by Norman Jacobs. Princeton, NJ: D. Van Nostrand, 1961.

Arnold, Matthew. *Culture and Anarchy, an Essay in Political and Social Criticism.* 2d ed. London: Smith, Elder, 1875. Reprint. Indianapolis: Bobbs-Merrill, 1971.

Arnove, Robert F. *Philanthropy and Cultural Imperialism: The Foundations at Home and Abroad.* Bloomington, IN, Indiana University Press, 1982.

Bailey, Peter. *Leisure and Class in Victorian England: Rational Recreation and the Contest for Control, 1830–1855.* London: Routledge & Kegan Paul, 1978.

Bailyn, Bernard. *Education in the Forming of American Society: Needs and Opportunities for Study.* Chapel Hill: University of North Carolina Press, 1960.

Bain, Read. "Public." In *A Dictionary of the Social Sciences,* edited by Julius Gould and William L. Kolb. New York: Free Press, 1964.

Banfield, Edward C. *The Democratic Muse: Visual Arts and the Public Interest.* New York: Basic Books, 1984.

Barbier-Bouvet, Jean Francois: *Nouveaux éléments sur le public des musées: le public du musée de peinture et de sculpture de Grenoble: fréquentation, comportement, attitudes.* Paris: Documentation française, 1977.

Barbier-Bouvet, Jean Francois and M. Poulain. *Publics à L'ouvre-culturelles à la Bibliothèque publique d'information du Centre Pompidou:* Paris: La Documentation francaise, 1986.

Barr, Alfred H., Jr. *Mattisse, His Art and His Public.* New York: Museum of Modern Art, 1951. Reprint. New York: Arno Press, 1966.

Baumol, William J., and William G. Bowen. "The Audience." In *Performing Arts, the Economic Dilemma: A Study of Problems Common to Theater, Opera, Music, and Dance,* edited by William J. Baumol and William G. Bowen. New York: Twentieth Century Fund, 1966.

Bell, Daniel. "Modernity and Mass Society: On the Varieties of Cultural Experience." In *Paths of American Thought,* edited by Arthur M. Schlesinger, Jr., and Morton White. Boston: Houghton Mifflin, 1963.

————. *The Cultural Contradictions of Capitalism.* New York: Basic Books, 1976.

Berkeley, William Noland. *The Small-Community Museum: Why It Is Entirely Feasible; Why It Is Extremely Desirable.* Lynchburg, VA: J. P. Bell, 1932.

Bitgood, Stephen, James T. Roper, Jr., and Arlene Benefield, eds., *Visitor Studies–*

1988: Theory, Research, and Practice. Jacksonville, AL: The Center for Social Design, 1988.

Bourdieu, Pierre. "Outline of a Sociological Theory of Art Perception." *International Social Science Journal* 20 (1968), 589–612.

———. "Cultural Reproduction and Social Reproduction." In *Knowledge, Education, and Cultural Change: Papers in the Sociology of Education*, edited by Richard Brown. Explorations in Sociology, no. 2. London: Tavistock Publications, 1973.

———. *Outline of a Theory of Practice.* Cambridge: Cambridge University Press, 1977.

———. *Distinction: A Social Critique of the Judgement of Taste*, translated by Richard Nice. Cambridge: Harvard University Press, 1984.

Bourdieu, Pierre, and Alain Darbel, with Dominique Schnapper. *L'Amour de l'art, les musées d'art européens et leur public.* 2d ed. Paris: Les Editions de minuit, 1969.

Brooks, Van Wyck. *Three Essays on America.* New York: E. P. Dutton, 1934. Reprint. New York: Dutton, 1970.

Burt, Nathaniel. *Palaces for the People: A Social History of the American Art Museum.* Boston: Little, Brown, 1977.

Cameron, Duncan F. "The Museum, A Temple or the Forum." *Curator* 14 (March 1971), 11–24.

Cameron, Duncan F., and D. S. Abbey. "Museum Audience Research." *Museum News* 40 (October 1961), 34–38.

Carnoy, Martin. *The State and Political Theory.* Princeton, NJ: Princeton University Press, 1984.

Clark, Timothy J. *The Absolute Bourgeois: Artists and Politics in France, 1848–1851.* Greenwich, CT: New York Graphic Society, 1973.

———. *Image of the People: Gustave Courbet and the 1848 Revolution.* London: Thames and Hudson, 1973.

Coleman, Laurence Vail. *Manual for Small Museums.* New York: G. P. Putnam's Sons, 1927.

———. *The Museum in America: A Critical Study.* 3 vols. Washington, DC: American Association of Museums, 1939. Reprint (3 vols. in 1). Washington, DC: American Association of Museums, 1970.

Coles, Robert. "The Art Museum and the Pressures of Society." In *On Understanding Art Museums*, edited by Sherman E. Lee. Englewood Cliffs, NJ: Prentice-Hall, 1975. Reprinted in *Artnews* 74 (January 1975), 24–33.

Coolidge, John Phillips. *Some Problems of American Art Museums.* Boston: Club of Odd Volumes, 1953.

Craven, Thomas. "Our Decadent Art Museums." *American Mercury* 53 (December 1941), 682–88.

Cunningham, Hugh. *Leisure in the Industrial Revolution.* New York: St. Martin's Press, 1980.

Cushman, Karen. "Jane Addams and the Labor Museum at Hull House." *Museum Studies Journal* 1 (Spring 1983), 20–25.

Dana, John Cotton. *The Gloom of the Museum.* Woodstock, VT: Elm Tree Press, 1917.

———. *The New Museum.* Woodstock, VT: Elm Tree Press, 1917.

————. *A Plan for a New Museum, The Kind of a Museum It Will Profit a City to Maintain*. Woodstock, VT: Elm Tree Press, 1920.

Davis, Douglas. "The Idea of a 21st Century Museum." *Art Journal* 35 (Spring 1976), 253–58.

De Borhegyi, Stephan F., and Irene A. Hanson, eds. *The Museum Visitor*. Publications in Museology, no. 3. Milwaukee: Milwaukee Public Museum, 1968.

————. "Chronological Bibliography of Museum Visitor Surveys." In *Museums and Education*, edited by Eric Larrabee. Washington, DC: Smithsonian Institution Press, 1968.

Dewey, John. *The Public and Its Problems*. New York: Henry Holt, 1927.

DiMaggio, Paul. "Cultural Entrepreneurship in Nineteenth-Century Boston: The Creation of an Organizational Base for High Culture in America," and "Cultural Entrepreneurship in Nineteenth-Century Boston, Part II: The Classification and Framing of American Art." *Media, Culture and Society* 4 (1982) 33–50, 303–22.

DiMaggio, Paul, and Michael Useem. "Social Class and Arts Consumption: The Origins and Consequences of Class Differences in Exposure to the Arts in America." *Theory and Society* 5 (March 1978), 141–61.

————. "Cultural Property and Public Policy: Emerging Tensions in Government Support for the Arts." *Social Research* 45 (Summer 1978), 356–89.

DiMaggio, Paul, Michael Useem, and Paula Brown. *Audience Studies of the Performing Arts and Museums: A Critical Review*. Research Division Report, no. 9. Washington, DC: National Endowment for the Arts, 1978.

Dixon, Bryan, A. E. Courtney, and R. H. Bailey. *The Museum and the Canadian Public*. Ottawa: Arts and Cultural Branch, Secretary of State, 1974.

Draper, Linda, ed. *The Visitor and the Museum*. Washington, DC: Museum Educators of the American Association of Museums, 1977.

Duffus, Robert L. *The American Renaissance*. New York: Alfred A. Knopf, 1928.

Dulles, Foster Rhea. *Americans Abroad: Two Centuries of European Travel*. Ann Arbor: University of Michigan Press, 1964.

Duncan, Carol, and Alan Wallach. "The Universal Survey Museum." *Art History* 3 (December 1980), 448–69.

Dunlop, M. H. "Curiosities Too Numerous to Mention: Early Regionalism and Cincinnati's Western Museum." *American Quarterly* 36 (Fall 1984), 524–48.

Eisenbeis, Manfred. "Elements for a Sociology of Museums." *Museum* 24 (1972), 110–19.

Elliott, Pamela, and Ross J. Loomis. *Studies of Visitor Behavior in Museums and Exhibitions: An Annotated Bibliography of Sources Primarily in the English Language*. Washington, DC: Office of Museum Programs, Smithsonian Institution, 1975.

Feld, Alan L., Michael O'Hare, and J. Mark Davidson Schuster. *Patrons Despite Themselves: Taxpayers and Arts Policy*. New York: New York University Press, 1983.

Fitzhugh, Lynne. "An Analysis of Audience Studies for the Performing Arts." *Journal of Arts Management and the Law* 13 (Summer 1983), 49–85.

Ford Foundation. *The Finances of the Performing Arts*. New York: Ford Foundation, 1974.

Fox, Daniel M. *Engines of Culture: Philanthropy and Art Museums*. Madison: State Historical Society of Wisconsin, 1963.

———. "Artists in the Modern State: The Nineteenth-Century Background." In *The Sociology of Art and Literature*, edited by Milton C. Albrecht, James H. Barnett, and Mason Griff. New York: Praeger, 1970.

Fox, Richard W., and T. J. Jackson Lears, eds. *The Culture of Consumption: Critical Essays in American History, 1880–1980*. New York: Pantheon Books, 1983.

Galbraith, John Kenneth. *The Affluent Society*. Boston: Houghton Mifflin, 1958.

Gans, Herbert J. *Popular Culture and High Culture: An Analysis and Evaluation of Taste*. New York: Basic Books, 1974.

Gilman, Benjamin Ives. *Museum Ideals of Purpose and Method*. 2d ed. Cambridge, MA: Harvard University Press, 1923.

Glueck, Grace. "The Ivory Tower versus the Discotheque." *Art in America* 59 (May-June 1971), 80–85.

Goblot, Edmond. "Cultural Education as a Middle-Class Enclave." In *Sociology of Literature and Drama*, edited by Elizabeth Burns and Tom Burns. Baltimore: Penguin Books, 1973.

Goffman, Erving. *Behavior in Public Places: Notes on the Social Organization of Gatherings*. Glencoe, IL: Free Press, 1963.

———. *Relations in Public: Microstudies of the Public Order*. New York: Basic Books, 1971.

Gombrich, Ernst Hans Josef. "The Museum: Past, Present and Future." *Critical Inquiry* 3 (Spring 1977), 449–70. Reprinted in *Ideals and Idols: Essays on Values in History and in Art*, by E.H.J. Gombrich. Oxford, England: Phaidon, 1979.

———. *Meditations on a Hobby Horse, and Other Essays on the Theory of Art*. 3d ed. New York: Phaidon, 1978.

Goode, George Brown. "Museums of the Future." In *Annual Report of the Board of Regents of the Smithsonian Institution . . . 1897. Report of the U.S. National Museum*, Pt. 2. Washington, DC: Government Printing Office, 1901.

Graburn, Nelson. "The Museum and the Visitor Experience." In *The Visitor and the Museum*, edited by Linda Draper. Washington, DC: Museum Educators of the American Association of Museums, 1977.

———. "The Anthropology of Tourism." *Annals of Tourism Research* 10 (1983), 9–33.

Graña, César. *Fact and Symbol: Essays in the Sociology of Art and Literature*. New York: Oxford University Press, 1971.

Griff, Mason. "Fine Arts: The Recruitment and Socialization of Artists." In *International Encyclopedia of the Social Sciences*, edited by David L. Sills. New York: Macmillan and Free Press, 1968.

Harris, Neil. "The Gilded Age Revisited, Boston and the Museum Movement." *American Quarterly* 14 (Winter 1962), 545–66.

———. *Humbug: The Art of P. T. Barnum*. Boston: Little, Brown, 1973.

———. "Museums, Merchandising, and Popular Taste: The Struggle for Influence." In *Material Culture and the Study of American Life*, edited by Ian M. G. Quimby. New York: W. W. Norton, 1978.

———. "A Historical Perspective on Museum Advocacy." *Museum News* 59 (November-December 1980), 60–63, 65–66, 69–70, 73–75, 77–78, 81–82, 85–86.

———. "Cultural Institutions and American Modernization." *Journal of Library History* 16 (Winter 1981), 28–47.

Harvey, Emily Dennis, and Bernard Friedberg, eds. *A Museum for the People: A Report of Proceedings at the Seminar on Neighborhood Museums, held November 20, 21 and 22, 1969, at MUSE, the Bedford Lincoln Neighborhood Museum in Brooklyn, New York*. New York: Arno Press, 1971.

Haskell, Francis. *Patrons and Painters: A Study in the Relations Between Italian Art and Society in the Age of the Baroque*. New York: Knopf, 1963.

———. "Fine Arts: Art and Society." In *International Encyclopedia of the Social Sciences*, edited by David L. Sills. New York: Macmillan and Free Press, 1968.

———. *Rediscoveries in Art: Some Aspects of Taste, Fashion, and Collecting in England and France*. Ithaca: Cornell University Press, 1976.

Haskell, Francis, and Nicholas Penny. *Taste and the Antique: The Lure of Classical Sculpture, 1500–1900*. New Haven: Yale University Press, 1981.

Hauser, Arnold. *The Social History of Art*, translated by Stanley Godman. New York: Alfred A. Knopf, 1952.

———. *The Sociology of Art*, translated by Kenneth J. Northcott. London: Routledge & Kegan Paul, 1982.

Herbert, Eugenia W. *The Artist and Social Reform: France and Belgium, 1885–1898*. New Haven: Yale University Press, 1961.

Holt, Elizabeth Gilmore, ed. *The Triumph of Art for the Public: The Emerging Role of Exhibitions and Critics*. Garden City, NY: Anchor Press, 1979.

———, ed. *The Art of All Nations, 1850–1873: The Emerging Role of Exhibitions and Critics*. Garden City, NY: Anchor Press, 1981.

Hood, Marilyn G. "Staying Away: Why People Choose Not to Visit Museums." *Museum News* 61 (April 1983), 50–57.

Horkheimer, Max, and Theodor W. Adorno. *Dialectic of Enlightenment*, translated by John Cumming. New York: Herder and Herder, 1972.

Horne, Donald. *The Great Museum: The Re-Presentation of History*. London: Pluto Press, 1984.

Horowitz, Helen Lefkowitz. *Culture and the City: Cultural Philanthropy in Chicago from the 1880s to 1917*. Lexington: University Press of Kentucky, 1976.

Hudson, Kenneth. *A Social History of Museums: What the Visitors Thought*. Atlantic Highlands, NJ: Humanities Press, 1975.

Jevons, William Stanley. "The Use and Abuse of Museums." In *Methods of Social Reform, and Other Papers*. London: Macmillan, 1883. Reprint. New York: A. M. Kelley, 1965.

Karl, Barry D., and Stanley N. Katz. "Foundations and Ruling Class Elites." *Daedalus* (Winter 1987), 1–40.

Kasson, John F. *Amusing the Million: Coney Island at the Turn of the Century*. New York: Hill and Wang, 1978.

———. "Civility and Rudeness: Urban Etiquette and the Bourgeois Social Order in Nineteenth-Century America." *Prospects* 9 (1984), 143–67.

Kenyon, Sir Frederic George. *Museums & National Life*. Oxford: Clarendon Press, 1927.

Keppel, Frederick P. "The Arts in Social Life." In *Recent Social Trends in the United*

States; Report of the President's Research Committee on Social Trends. New York: McGraw-Hill, 1933. Reprint. Westport, CT: Greenwood Press, 1970.

Kinard, John R., and Esther Nighbert. "The Anacostia Neighborhood Museum, Smithsonian Institution, Washington, DC." *Museum* 24 (1972), 102–9.

Kouwenhoven, John A. *Made in America: The Arts in Modern Civilization.* Garden City, NY: Doubleday, 1948. Reprinted as *The Arts in Modern American Civilization.* New York: W. W. Norton, 1967.

Laing, Dave. *The Marxist Theory of Art.* Atlantic Highlands, NJ: Humanities Press, 1978.

Larson, Gary O. *The Reluctant Patron: The United States Government and the Arts, 1943–1965.* Philadelphia: University of Pennsylvania Press, 1983.

Lears, T. J. Jackson. *No Place of Grace: Antimodernism and the Transformation of American Culture, 1880–1920.* New York: Pantheon Books, 1981.

Leith, James A. *The Idea of Art as Propaganda in France, 1750–1799: A Study in the History of Ideas.* Toronto: University of Toronto Press, 1965.

Levine, Lawrence W. *Highbrow/Lowbrow: The Emergence of Cultural Hierarchy in America.* Cambridge: Harvard University Press, 1988.

Lilla, Mark. "Art and Anxiety: The Writing on the Museum Wall." *Public Interest* 66 (Winter 1982), 37–54.

Lippmann, Walter. *The Phantom Public.* New York: Harcourt, Brace, 1925.

Low, Theodore Lewis. *The Museum as a Social Instrument.* New York: Metropolitan Museum of Art, 1942.

———. "The Museum as a Social Instrument: Twenty Years After." *Museum News* 40 (January 1962), 28–30.

Lowry, W. McNeil, ed. *The Arts and Public Policy in the United States.* Englewood Cliffs, NJ: Prentice-Hall, 1984.

Lynes, Russell. *The Tastemakers.* New York: Harper, 1954. Reprint. New York: Dover, 1980.

MacCannell, Dean. *The Tourist: A New Theory of the Leisure Class.* New York: Schocken Books, 1976.

McCarthy, Kathleen D. *Noblesse Oblige: Charity & Cultural Philanthropy in Chicago, 1849–1929.* Chicago: University of Chicago Press, 1982.

———. "From Cold War to Cultural Development: The International Cultural Activities of the Ford Foundation, 1950–1980." *Daedalus* (Winter 1987), 93–118.

Mailey, Thomas F. "A Public Opinion Survey of the Attitudes of Nonusers of the Carnegie Museum of Natural History in Pittsburgh, Pa." Ph.D. dissertation, University of Pittsburgh, 1975.

Malcolmson, Robert W. *Popular Recreations in English Society, 1700–1850.* Cambridge, England: Cambridge University Press, 1973.

Mather, Frank Jewett. "An Art Museum for the People." *Atlantic Monthly* 100 (December 1907), 729–40.

May, Henry. *The End of American Innocence: A Study of the First Years of Our Own Time, 1912–1917.* New York: Alfred A. Knopf, 1959.

May, Lary. *Screening Out the Past: The Birth of Mass Culture and the Motion Picture Industry.* New York: Oxford University Press, 1980.

Meller, Helen Elizabeth. *Leisure and the Changing City, 1870–1914.* London: Routledge & Kegan Paul, 1976.

Miers, Sir Henry Alexander. *A Report on the Public Museums of the British Isles (Other Than the National Museums)*. Edinburgh: T. and A. Constable, 1928.

Miller, Lillian B. *Patrons and Patriotism: The Encouragement of the Fine Arts in the United States, 1790–1860*. Chicago: University of Chicago Press, 1966.

Morris, Rudolph E. "Leisure Time and the Museum." *Museum News* 41 (December 1962), 17–21.

Nash, George. "Art Museums as Perceived by the Public." *Curator* 18 (March 1975), 55–67.

National Center for Education Statistics. *Museum Program Survey, 1979*. Washington, DC: National Center for Education Statistics, 1981.

National Committee for Cultural Resources. *National Report on the Arts: A Research Report on the Economic and Social Importance of Arts Organizations and Their Activities in the United States, with Recommendations for a National Policy of Public and Private Support*. New York: National Committee for Cultural Resources, 1975.

National Endowment for the Arts. *Museums USA: Art, History, Science, and Others*. Washington, DC: U.S. Government Printing Office, 1974.

National Research Center of the Arts. *Americans and the Arts: A Survey of Public Opinion*. New York: Associated Councils of the Arts, 1975.

Netzer, Dick. *The Subsidized Muse: Public Support for the Arts in the United States*. New York: Cambridge University Press, 1978.

Nochlin, Linda. "Museums and Radicals: A History of Emergencies." *Art in America* 59 (July-August 1971), 26–39. Reprinted in *Museums in Crisis*, edited by Brian O'Doherty. New York: George Braziller, 1972.

O'Doherty, Brian, ed. "Special Museum Issue." *Art in America* 59 (July-August 1971), 25–127. Reprinted as *Museums in Crisis*, edited by Brian O'Doherty. New York: George Braziller, 1972.

O'Hare, Michael. "The Audience of the Museum of Fine Arts." *Curator* 17 (June 1974), 126–58.

————. "Why Do People Go to Museums? The Effect of Prices and Hours on Museum Utilization." *Museum* 27 (1975), 134–46.

Pach, Walter. *The Art Museum in America*. New York: Pantheon, 1948.

Packard, Vance. *The Status Seekers: An Exploration of Class Behavior in America and the Hidden Barriers That Affect You, Your Community, Your Future*. New York: David McKay, 1959.

Plumb, John Harold. *The Commercialisation of Leisure in Eighteenth-Century England*. Reading: University of Reading, 1973.

Raleigh, John Henry. *Mathew Arnold and American Culture*. Berkeley, CA: University of California Press, 1957.

Rea, Paul Marshall. *The Museum and the Community, With a Chapter on the Library and the Community: A Study of Social Laws and Consequences*. Lancaster, PA: Science Press, 1932.

Riesman, David. *The Lonely Crowd: A Study of the Changing American Character*. Studies in National Policy, no. 3. New Haven: Yale University Press, 1950.

Robinson, Edwards S., Irene Case Sherman, and Lois E. Curry. *The Behavior of the Museum Visitor*. Publications of the American Association of Museums, New Series, no. 5. Washington, DC: American Association of Museums, 1928.

Rosenberg, Bernard, and David Manning White, eds. *Mass Culture: The Popular Arts in America.* Glencoe, IL: Free Press, 1957.

Rosenberg, Bernard, and Norris Fliegel. *The Vanguard Artist, Portrait and Self-Portrait.* Chicago: Quadrangle Books, 1965.

Royal Ontario Museum. Communications Design Team. *Communicating with the Museum Visitor: Guidelines for Planning.* Toronto: Royal Ontario Museum, 1976.

Schapiro, Meyer. "Book Reviews: Francis H. Taylor, *Babel's Tower. The Dilemma of the Modern Museum.*" *Art Bulletin* 27 (December 1945), 272–76.

Schlereth, Thomas J. "The History Behind, Within, and Outside the History Museum." *Curator* 23 (December 1980), 255–74.

Schwartz, Barry N. "Museums: Art for Whose Sake?" *Ramparts* 9 (June 1971), 38–49.

Seldes, Gilbert. *The Great Audience.* New York: Viking Press, 1950. Reprint. Westport, CT: Greenwood Press, 1970.

————. *The Public Arts.* New York: Simon and Schuster, 1956.

Sellers, Charles Coleman. *Mr. Peale's Museum: Charles Willson Peale and the First Popular Museum of Natural Science and Art.* New York: Norton, 1980.

Sennett, Richard. *The Fall of Public Man.* New York: Alfred A. Knopf, 1977.

Simon, Robert. *Gramsci's Political Thought: An Introduction.* London: Lawrence and Wishart Ltd., 1982.

Smith, Valene I., ed. *Hosts and Guests: The Anthropology of Tourism.* Philadelphia: University of Pennsylvania Press, 1977.

Smithsonian Institution. *Proceedings, 1977 Museum Evaluation Conference.* Washington, DC: Office of Museum Programs, Smithsonian Institution, 1979.

Steegman, John. *Consort of Taste, 1830–1870.* London: Sidgwick and Jackson, 1950. Reprinted as *Victorian Taste: A Study of the Arts and Architecture from 1830 to 1870.* Cambridge: MIT Press, 1971.

Sweeney, James Johnson. "The Artist and the Museum in a Mass Society." *Daedalus* 89 (Spring 1960), 354–58.

"Symposium on the Public Benefits of the Arts & Humanities." *Art & The Law* 9 (1985), 123–251.

Taylor, Francis Henry. "Museums in a Changing World." *Atlantic Monthly* 164 (December 1939), 785–92.

————. *Babel's Tower: The Dilemma of the Modern Museum.* New York: Columbia University Press, 1945.

Toffler, Alvin. *The Culture Consumers: A Study of Art and Affluence in America.* New York: St. Martin's Press, 1964.

Toll, Robert C. *The Entertainment Machine: American Show Business in the Twentieth Century.* New York: Oxford University Press, 1982.

Trachtenberg, Alan. *The Incorporation of America: Culture and Society in the Gilded Age.* New York: Hill and Wang, 1982.

Trondsen, Norman. "Social Control in the Art Museum." *Urban Life* 5 (April 1976), 105–19.

Tucker, Louis Leonard. "The Western Museum of Cincinnati, 1820–1867." *Curator* 8 (1965), 17–35. Reprinted as " 'Ohio Show-Shop': The Western Museum of Cincinnati, 1820–1867." In *A Cabinet of Curiosities: Five Episodes in the Evolution of American Museums,* by Whitfield J. Bell, Jr., Clifford K. Shipton,

John C. Ewers, Louis Leonard Tucker, and Wilcomb E. Washburn. Char-
lottesville: University Press of Virginia, 1967.

Veblen, Thorstein. *The Theory of the Leisure Class: An Economic Study in the
Evolution of Institutions.* New York: Macmillan, 1899. Reprint. Boston:
Houghton Mifflin, 1973.

Walker, John. *Self-Portrait with Donors: Confessions of an Art Collector.* Boston:
Little, Brown, 1974.

Walton, John K., and James Walvin, eds. *Leisure in Britain, 1780–1939.* Manchester:
Manchester University Press, 1983.

Washburn, Wilcomb E. "Scholarship and the Museum." *Museum News* 40 (October
1961), 16–19.

———. "The Museum's Responsibility in Adult Education." *Curator* 7 (1964), 33–
38.

Watson, Bruce. "On the Nature of Art Publics." *International Social Science Journal*
20 (1968), 667–80.

Weil, Stephen E. *Beauty and the Beasts: On Museums, Art, the Law, and the Market.*
Washington, DC: Smithsonian Institution Press, 1983.

———. *Rethinking the Museum and other Meditations*: Washington, DC: Smith-
sonian Institution Press, 1990.

Wells, Carolyn H. *Smithsonian Visitor.* Washington, DC: Smithsonian Institution,
1969.

Whyte William H. *The Organization Man.* New York: Simon and Schuster, 1956.

Williams, Raymond. *Culture and Society, 1780–1950.* New York: Columbia Univer-
sity Press, 1958.

Wittlin, Alma. *Museums: In Search of a Usable Future.* Cambridge: MIT Press, 1970.

Wright, Benjamin F. *5 Public Philosophies of Walter Lippmann.* Austin: University of
Texas Press, 1973.

Yankelovich, Daniel, Inc. *A Study of Visitors to the Metropolitan Museum of Art.* n.p.,
1973.

Yankelovich, Skelly and White, Inc. *A Study of Visitors to the Smithsonian.* n.p.,
1976.

10

BIOGRAPHY AND THE MUSEUM

Louis W. Kemp

Pilgrims to Donald Barthelme's fictional "Tolstoy Museum" enter a building resembling a series of stacked boxes about to fall on them, which the architects attribute to Tolstoy's moral authority. They gape at a mounted overcoat several stories high and discover that Tolstoy shaved off his eyebrows to make them grow back bushier. At last, teary-eyed, they resort to the handkerchiefs circulated in buckets by the guards. Although Barthelme lampoons the institutionalization of a literary giant, his metaphor also suggests an alternative approach to museum history. Like an exaggerated Tolstoy, the imprint of individual collectors and administrators looms over many gallery walls, and it can be profitable to examine each museum as the product of interactions among a forceful personality, the surrounding community, and prevailing intellectual trends.

HISTORIC OUTLINE

"I am just come from Sir Hans Sloane's," wrote the duchess of Portland in 1742, "where I have beheld many odder things than himself, though none so inconsistent." She would not have had to walk far to patronize the coffee house of Don Saltero, where such oddities as "A Piece of Queen Catherine's skin" amused a less refined clientele. Although each was the creation of a distinctive personality, defined by gradations of class, background, and associations, the collections of Sloane and Saltero were both reflections of the eighteenth-century London community.

Sloane, the fashionable physician and amateur botanist, perpetuated a tradition of aristocratic collecting that could be traced from Lorenzo the Magnificent to the Hapsburgs, Louis XIV, and Britain's own Charles I, who accumulated artworks, bird skins, dried plants, and minerals as a form of self-aggrandizement. The diffusion of wealth and interest in exotica generated by Elizabethan England's expanding maritime empire also encouraged men of more modest means like John Tradescant the Elder to assemble artificial and natural wonders for the edification of the country's idle rich. The seizure of the Tradescants' "Ark" in 1678 by Lady Mainwaring's grasping husband, Elias Ashmole, who used his prestigious contacts in the Court of Chancery to harass the widow of John the Younger until she drowned herself, suggests the intensely personal manner in which such early institutions as the Ashmolean Museum emerged from London's private hoards.

The center of world trade by the early 1700s, the city was ideal for dilettantes like James Pettiver and William Charleton, whose curiosities were incorporated into Sloane's growing collection. Inspired by the empiricism of Francis Bacon, whose depiction of "Solomon's House" equated knowledge with encyclopedic accumulation, Sloane, Sir Joseph Banks, John Hunter, and other eighteenth-century gentlemen-scholars stocked their cabinets with specimens gleaned from an extensive network of correspondents, including Americans Cadwallader Colden and Thomas Jefferson.

Sloane recognized the significance of London's "great confluence of people" and hoped to have his Chelsea collections housed there permanently. But despite his desire for public access, London remained a city with no police and few means of controlling its enormous population. Instead, the British Museum created from Sloane's holdings institutionalized the mistrust of the mob expressed by Hunter and by Sloane himself, who restricted admission to knowledgeable and genteel patrons during his lifetime.

In a different context, the castoffs from Sloane's collection had already created a public museum for Chelsea residents through the entrepreneurial skill of his barber, James Salter. The latter reinvigorated a lower-class tradition of informal exhibitions that flourished in the reliquaries of medieval cathedrals and amid the animal prodigies and automata of London's fairs and street shows. Known as "Spanish Don Saltero," he capitalized on popular superstitions that compelled even Sloane to scurry after cocks' bills and folk remedies against mad dogs while combining witty exhibitions with the coffeehouse forum, where his customers were entertained with fine punch, the fiddle, and a bleeding if they desired. Saltero's success created opportunities for a variety of commercial attractions intended for tradesmen and laborers, including Robert Barker's panoramas, Jacques de Loutherbourg's "Eidophusikon," and William Bullock's ersatz Egyptian Hall.

A closely knit city of extreme contrasts, where economic and social ranks were sharply differentiated by income, costume, pastimes, and daily routines, the London of Sloane and Saltero easily supported conflicting museum

styles. Like Sloane himself, the gentlemen's cabinets and the British Museum they created were elitist, scholarly, and cosmopolitan, while Saltero's coffeehouse suggested an egalitarian, popular, and provincial alternative.

The Enlightenment revolutions of the late eighteenth century transformed the climate in which museums were conceived. Nowhere was the change more apparent than in post-Revolutionary Philadelphia where Eugène Du Simitière, a Swiss immigrant who importuned political leaders to support his "American Museum" of historical ephemera, in vain, discovered that the war had disrupted patterns of aristocratic patronage. In 1784, Charles Willson Peale, a veteran of the battle of Princeton, opened a museum of portraits and natural specimens for the general public. Peale's conception of popular education was inspired by Rousseau's "chain of flowers" and emphasized alluring exhibition techniques to lead the public into new realms of knowledge. Although he sometimes imitated London's showmen, his realistic taxidermy was the product of his own inventive mind and his previous experience as an itinerant painter. Such devices as the perpetual motion machine tapped a local tradition of technological inquiry inherited from Franklin and Rittenhouse, while the museum's Oriental curiosities reflected Philadelphia's role in the China trade before the War of 1812.

Like Franklin, Peale was a deist who believed that natural laws expressed divine will and were accessible to reason. Thus, the wax replica of himself that startled visitors in the gallery was intended to sharpen the viewer's perceptions, and specimens with brightly painted backdrops illustrating their natural habitats were arranged after the Linnaean system in rows as relentlessly rational as the city's distinctive gridiron of streets. This holistic approach to the arts and sciences was shared by Peale's scholarly correspondents like Baron von Humboldt and excited his peers at the American Philosophical Society, a non-academic body of artisans, lawyers, and bankers that leased its hall to his museum and supplied the leadership for the Pennsylvania Academy of Fine Arts, the Franklin Institute, and the Historical Society of Pennsylvania.

But Peale overestimated the attraction of his rational amusement. In a community plagued by unruly mobs, his refusal to countenance popular tastes for five-legged cows or the magic shows introduced by his son Rubens contributed to his commercial failure. Reflecting his enthusiasm for the French Musée d'Histoire Naturelle, and perhaps his memories of the patronage of colonial Maryland's Governor Sharpe, Peale's vision of a publicly subsidized institution ignored Philadelphia's political instability and its tendency to relegate municipal services to voluntary associations. The federal government was equally disinclined to augment its minor responsibilities. Indeed, as late as the 1830s, congressmen would consider rejecting the bequest of England's James Smithson for a national institute of science. Already in decline by 1810, Peale's museum had thrived in the brief flowering of federal Philadelphia by appealing to both the lay public and a scientific

community still characterized by amateurism and the absence of specialization.

Symptomatic of the widening gulf between scholarly and popular museums were the efforts of Cincinnati physician Daniel Drake to transplant Philadelphia's cultural institutions on the frontier. Famous for his regional surveys and civic improvements, Drake tied his fortune to the merchants who dominated Cincinnati's local affairs. Together with businessman William Steele, he established the Western Museum Society in 1820 to endow the community with cultural refinement and to uplift the public. But Drake and his subscribers were nearly destroyed by depression, and in 1823 Joseph Dorfeuille took control of the bankrupt museum in an era of fast-paced urban transformations.

Discredited by the financial disaster, the old mercantile elite withdrew into isolated residential enclaves and lost their political and cultural hegemony to a boisterous class of wage earners attracted by the meat-packing plants of the emerging "porkopolis." New steamboats revolutionized trading networks and inundated the city with boatmen, canal laborers, and immigrants, many of whom sought entertainment in the smoky maze of grogshops and brothels along the waterfront. At the public landing, Dorfeuille and his assistants Hiram Powers and Frances Trollope lightened the Western Museum of its educational mandate and hawked such wonders as the "Invisible Girl" with the flamboyance of western land promoters. Customers enjoyed the new museum's relaxed atmosphere and laughed at its harmless hoaxes to relieve deeper anxieties generated by a fluctuating antebellum economy.

City after city discarded well-meaning amateurs like Drake as relics of the pre-industrial Jeffersonian order. In New York, Luman Reed and Thomas Jefferson Bryan presided over empty art galleries, awaiting an occasional visitor in search of moral edification, while showman John Scudder revived the entertainments of Gardiner Baker and achieved notoriety with Apollo the Card-Playing Dog. In 1841, P. T. Barnum opened his American Museum in the City Hall district deserted by genteel residents and given over to hotels and services for a transient population conducting commercial transactions.

Barnum's New York had far outstripped Philadelphia as a trading port, although its mercantile community was shattered by a string of panics and recoveries after 1837, creating a complex, turbulent, and intensely competitive society. As a store clerk and an unsuccessful investor, Barnum early absorbed both the cynicism and craving for spectacle of the new bourgeoisie and emphasized packaging and publicity to promote such dubious products as a model of Niagara Falls. Once lured inside, curious crowds were entertained with an endless array of freaks, inventions, and theatrical displays. Unlike Peale's optical illusions, Barnum's fantastic shams appealed to the romanticism of Americans increasingly accustomed to startling scientific rev-

elations and technological change. But by offering a simplified standard of evaluation that required visitors only to distinguish the genuine from the humbug, Barnum democraticized the museum for restless and uneducated customers. As New York's financiers were knitting disparate markets into a national network of exchange, Barnum, his Boston partner Mosel Kimball, and his myriad imitators nurtured a mass museum culture that widely diffused sensationalistic techniques.

Louis Agassiz, the Swiss naturalist who descended on Harvard University in 1846 "like a meteor out of a clear sky," demonstrated that the popular currents Barnum exploited could be harnessed for scientific institutions. The charismatic scholar who earned his reputation in Europe's prestigious seats of learning was immediately absorbed by an urban gentry that had escaped the fragmentation of New York elites. By contrast, Boston's old mercantile families had been infused with the wealth of its textile manufacturers; many had gone on to reinforce their economic and political leadership with cultural attainments.

Agassiz married the daughter of Thomas Cary, treasurer of the Hamilton and Appleton Mills, and was installed in a Harvard chair endowed by Abbott Lawrence, where he accumulated an enormous collection in a bathhouse and persuaded Francis Calley Gray to finance his new Museum of Comparative Zoology (MCZ). Although Agassiz manipulated Brahmin sensibilities by periodically leaking bids for his services from the Jardin des Plantes, the MCZ was only partly a product of class aspirations. No amount of comparison between native provincialism and European sophistication by Charles Eliot Norton could convince Brahmin patrons to purchase the James Jackson Jarves collection of Italian primitives, but Agassiz reaped where Norton could not as a result of his ebullient personality and his distinctive philosophy of the natural sciences.

Although originally inspired by the *naturphilosophie* of Ignatius Dollinger, Agassiz rejected his assumption that every form of life shared a common unity. Possessing visual acuity that permitted him to discern the smallest anomalies in a collection of specimens, he encountered discontinuity rather than continuity in nature and instead attempted to prove the validity of special creationism and Cuvier's four kingdoms. Agassiz retained only the romantic tenor of the *naturphilosophistes*, who attributed cosmic significance to aspects of the natural world, and he brought to the United States a unique mixture of idealism and empiricism.

His determination to discover God's plan by analyzing the New World's "zoological provinces" excited the Brahmins as the perfect union of moral inspiration and intellectual achievement. It also captured the imagination of a wider public stimulated by his lecture tours, correspondence, and appeals for specimens. No less popular than Barnum's Mud Iguana, Agassiz's discoveries of new species fueled national pride and deluged the MCZ with barrels of fish and dried skins. The museum itself was tangible expression

of his philosophy from its "synoptic room," in which visitors familiarized themselves with the characteristics of Cuvier's four types, to its perpetual disorder as a result of his revelations in the field. After 1859, it also became a refuge for its beleaguered director, who resisted Darwinism as the heretical reduction of divine order to random physical forces.

Agassiz's accomplishment spurred Othniel Marsh to seek George Peabody's endowment for a similar institution at Yale University. Later, his students Frederic Ward Putnam and Albert Bickmore encouraged the growth of natural history museums in New York, Chicago, and Berkeley. But Agassiz's larger ambitions transcended the concerns of specific localities. With Alexander Dallas Bache, physicist Joseph Henry, and other "Lazzaroni," he attempted to direct the course of American research and propel colleagues into positions of scientific leadership.

Motivated by personal interactions, Agassiz and his associates were often accused of advancing their own self-interests. Henry, who resented the praise bestowed on Michael Faraday by Europeans who ignored his own work, reluctantly became the first secretary of the Smithsonian Institution but largely confined its research to laboratory investigation and resisted the taxonomic collections of his curator and eventual successor, Spencer Baird. Henry's insistence that a museum was for local amusement reflected the cosmopolitan perspective of the Lazzaroni, who were attracted to Washington by the patronage of an expanding federal bureaucracy. Reinforcing the capital's existing dichotomy between "resident" and "official" societies, naturalists like John Wesley Powell, whose Colorado expeditions exhausted the resources of the Illinois Natural History Society in the late 1860s, lived in the city primarily to lobby politicians. Powell's success in carving out the Bureau of American Ethnology in 1879 not only legitimized his personal interest in collecting Indian artifacts under Smithsonian auspices but represented the culmination of Agassiz's campaign to spin out a national scientific network from local foundations in antebellum Boston.

By the mid-nineteenth century, showmen and scientists had extended the possibilities first explored by Sloane and Saltero to create a variety of commercial museums and research institutes in the major cities of the North Atlantic World. But in the undeveloped or decaying interstices of rural New England, the western backcountry, and the plantation South, scattered collectors rejected the progressive visions of both Barnum and Agassiz and reacted apprehensively to urbanization, the rise of manufacturing, and the deterioration of national unity. Antiquarian Cummings Davis of Concord, Massachusetts, filled his house with the writing chairs, lanterns, and coffeepots used by his ancestors or by legendary personalities, while Lyman Draper scoured the Middle Border for broadsides and letters pertaining to "Western heroism." Presenting herself as the "Southern Matron," Ann Pamela Cunningham rallied women's associations in 1853 to preserve Mount Vernon from an ignoble fate as a beer garden. In each case, individual efforts

created or enriched museums, but Davis demonstrated no concern for exhibition and Draper was notorious for mutilating documents in the course of compiling his unfinished biography of Daniel Boone. Seeking reassurance from objects associated with a less disturbing past, the antiquarians produced idiosyncratic shrines rather than distinctive museum styles, and they shared Cunningham's determination to stem the tide of change.

The arcadian age celebrated by the Mount Vernon Ladies' Association was fast being obliterated. Amid the sprawling slums of cities like London, the scale and pace of the industrial revolution obliged collectors and administrators to see museums in a new context. Coal, iron, and cotton generated fortunes for the manufacturers of the Midlands, who flocked to London to rub elbows with the gentility. Socially ambiguous but uneducated, they sought the status of fine art and were often victimized by charlatans among the picture framers and curio dealers who claimed access to aristocrats liquidating their Old Masters. In 1840, the Belgian immigrant Ernest Gambart entered this informal exchange as a printseller hawking his wares in the street. By 1854 he had forged the role of the modern art dealer.

Gambart, who witnessed the Durand-Ruels performing a similar function in Paris, purchased artworks on the auction block or commissioned them directly from popular academics and then sold them to the public in well-publicized exhibitions. Replacing an inefficient trade as cumbersome as the city's medieval food markets with a streamlined distribution system, he assured customers of consistent quality by persuading Ruskin and other experts to review his selections. The dealer-critic system was engineered for middle-class consumers, and Nathan Wildenstein later extended it to the United States, where it accelerated the accumulation of art by potential museum donors and removed the necessity for collectors to retain foreign agents like Samuel Avery and George Lucas.

When fused with the utilitarian philosophies of Jeremy Bentham and John Stuart Mill, the middle-class aspirations underlying Gambart's success galvanized political efforts to restructure archaic institutions for greater efficiency. Appalled by the squalor of the city's manufacturing districts, parliamentary reformers like Henry Brougham raised a paternalistic state on the framework of new legislation devoted to child labor, sanitation, prison conditions, and other areas, including the British Museum, which had been quietly stagnating since the eighteenth century as a source of sinecures for elderly clergymen.

As a museum trustee, Brougham secured a librarian's appointment for Antonio Panizzi, an Italian liberal forced into exile after plotting to overthrow Austrian monarchical rule in his native Brescello. Panizzi infuriated genteel colleagues with his brusque efficiency and insistence on professional standards but won public approbation for his cataloguing reforms in the course of two government inquiries in 1835 and 1847. His vow to provide poor students the same means of indulging "rational pursuits" enjoyed by the rich

helped to catapult him into the museum's chief administrative post. At heart, however, he remained a librarian, and his eagerness to divorce the library from its natural history collections resulted in a separate museum under Sir Richard Owen in 1883.

By leveling restrictions to public access and heightening opportunities for self-improvement, Panizzi expressed a reform credo shared by his contemporaries William Jackson Hooker and Sir Henry Cole. Under Hooker's guidance, the brick walls of Kew came crashing down to admit crowds eager for respite from a city in which open spaces were rapidly disappearing, while a new Museum of Economic Botany instructed visitors in the commercial applications of the native flora. Cole, an associate of Mill and a former civil servant who forced a parliamentary investigation of Record Commission practices, embedded himself in the English bureaucracy. He soon became the lieutenant of Prince Albert, who admired his devotion to refining domestic manufactures through popular instruction in the arts. And after organizing the Crystal Palace Exhibition of 1851, Cole became the first director of the Victoria and Albert Museum at the exhibition's South Kensington site. There he stimulated attendance with such innovations as gas lighting, evening hours, and improved labels. His "chamber of horrors," an exhibition of contemporary wares illustrating shoddy design, reflected the essence of bourgeois efforts to make the museum an instrument of reform.

But despite his branch museum in the deteriorating industrial district of Bethnal Green, Cole's programs and those of his peers were less genuinely democratic than symptomatic of Victorian middle-class radicalism. Regardless of their middling origins, Panizzi, Hooker, and Cole were firmly tied to the upper-class political establishment. To the disgust of his son, Hooker frequently interrupted his work to trot visiting aristocrats about the garden while plying them with models of proposed facilities and urging them to keep the directorship in the family. Cole's legendary bureaucratic intrigues were reflected in his design for the South Kensington museum as a series of sheet-metal modules that could be expanded under sympathetic administrations. On a deeper level, his popular art classes emphasized the precision prized by local manufacturers and subordinated creativity to reverence for the models of the past.

Just as London Benthamites recoiled from Chartist rebellion, the museum reformers stopped short of advocating sweeping social changes. Instead they inculcated frugality, respect for authority, and the values of middle-class, industrial culture implicit in Cole's hope that Sunday hours would lure the working class out of the gin palace and into the museum. Still, the bourgeois world of Henry Cole established precedents for the museum personalities of the next century. While Gambart initiated the cluster of private institutions that served middle-class collectors and established a transatlantic community in which art functioned as a status commodity, Cole linked the public museum to utilitarian standards and local constituencies.

In the latter half of the nineteenth century, the new industrial order celebrated at South Kensington erupted in the drab labyrinth of tenements, foundries, and shantytowns spilling down the hills of Pittsburgh. As a visitor to the city in 1882, Herbert Spencer shrank from the bedlam of the rolling mills beneath its thick pall of smoke and disowned the exclamations of his disciple Andrew Carnegie, who proclaimed the arrival of the philosopher's industrial utopia. Beneath Spencer's very nose, the Carnegie Institute rising in Schenley Park was a colossal reminder of Carnegie's apostasy from orthodox social Darwinism. Despite the dinosaur fossils with which Carnegie illustrated evolutionary development, his museum was dedicated to uplifting the weak. It owed little to Spencerian philosophy amd much to the philanthropic tradition of George Peabody. Carnegie himself insisted that the museum's entablature of great men include Franklin, the patron saint of self-improvement.

The Scottish immigrant and former bobbin boy who became the largest steel producer in the country was a living symbol of Pittsburgh's vitality and a model for middle-class ambitions. But Carnegie wrestled with conflicting emotions. In his migrations to England, he dabbled with the Chartist faith of his father and contributed funds to Cole's nemesis, the Radical Liberal William Gladstone. At home he resisted populist reforms and argued that American political institutions were above reproach. Carnegie's "gospel of wealth" was intended to remedy inequalities of distribution without destroying individual initiative, but beneath his extravagant praise for stewardship, frugality, and "triumphant democracy" lurked deep doubts concerning his own role in consigning thte common man to a plutocratic stranglehold.

As if to allay his fears, Carnegie's museum promised millhands that the America of his youth, an open society of limitless possibilities, was compatible with unfettered capitalism. In thirty years, another self-made manufacturer seized by similar doubts would stock a school house with McGuffey's *Readers* and reassemble the shingled houses and barns of the pre-industrial past in the shadow of one of the world's largest automobile plants. Elevating Edison's workshop on the altar of individualism, Henry Ford's Greenfield Village became the mythic community of Carnegie's democratic ideals—a syntehtic construction that existed only in the industrialist's imagination.

In reality, Carnegie's Pittsburgh was an urban nightmare jocosely described as "hell with the lid taken off." Like its counterparts throughout industrial Europe and America, its ring politicians, poverty, and profusion of immigrants horrified many observers. While Carnegie and Ford desperately denied the loss of opportunities inherent in the small towns of a youthful democracy, the English designer William Morris inspired other collectors to infuse this dehumanizing industrial society with the integrity of traditional craft processes. Edwin Atlee Barber, an archaeologist awed by the purity of early ceramic forms, carried his discoveries into the Pennsylvania Museum to reeducate contemporary manufacturers, while in Bucks County Henry

Chapman Mercer accumulated a museum of hand tools and duplicated Pennsylvania German pottery techniques. At its best, the arts and crafts movement nourished the sympathies shared by Artur Hazelius and Jane Addams for the human costs of modernization. Both the Swedish founder of Skansen and the Chicago settlement-house pioneer, whose Labor Museum encouraged immigrant women to demonstrate Old World crafts to their children, reunited traditional objects and rootless craftsmen in an effort to regenerate the communal bonds of village society.

Too often this social stability seemed on the brink of violent collapse. In the aftermath of the Homestead Strike, the forbidding figure of Henry Clay Frick momentarily eclipsed that of his senior partner in the popular mind. Pittsburgh's leading coke supplier, who survived an assassin's bullet and precipitated the carnage on the banks of the Monongahela while Carnegie took refuge in his English working-class politics, had risen from the loading dock of his grandfather's distillery to the chairmanship of Carnegie Steel by 1892. Seemingly unperturbed by Carnegie's self-recriminations, Frick constructed neither an elaborate philosophy nor a monument of philanthropy to insulate himself from the ramifications of his success. A prototype for the ham-fisted collector of the Gilded Age, he lavishly acquired French paintings after a continental tour with Andrew Mellon and impressed art dealer René Gimpel as a rich child playing with his toys. Frick and his peers chafed under Carnegie's straitlaced austerity and demonstrated little loyalty to a city where, as Gimpel protested, "one's nostrils spew out as much smut as does the subsoil." In 1899, he angrily severed ties with Carnegie and left the cradle of his industrial fortune for the less suffocating atmosphere of New York, where he raised a museum in tribute to himself.

Frick's destination was a dealer's paradise in which Charles Knoedler, Paul Durand-Ruel, and the Duveen brothers fiercely pursued the wealthy industrialists gravitating to New York between 1880 and 1910. Joseph Duveen, the son of a produce exporter who exchanged his low-quality hams for Delft ware and objets d'art, emerged from the fray as the leading art dealer of the twentieth century. Deceptively clownish, Duveen capitalized on his clientele's sensitive pride and virtually dictated the design of Frick's Fifth Avenue home by convincing him to purchase furnishings commensurate with his social standing. The exorbitant sums Duveen and his imitators expended for paintings and, in turn, demanded from their customers aroused the competitive spirit of collectors like Henry O. Havemeyer, the sugar trust plunger who ran up prices at the auction block and purchased Rembrandts in wholesale quantities. But lawyer John Quinn and others of more modest income journeyed instead to the Parisian flat of Ambroise Vollard in search of undiscovered contemporary masters. A companion to Yeats and an Irish partisan, Quinn relished his role as a patron of the avant-garde and contributed to the Armory Show in 1913.

New York's multifaceted art market reflected an urban society fragmented

by industrialists like Havemeyer, who were attracted to the city's credit facilities and its pool of legal talent. Corporate directors establishing headquarters in Manhattan hailed from diverse backgrounds and espoused civic policies in conflict with those of investment bankers and merchants, contributing to the disintegration of the upper class and liberating professionals like Quinn from compulsions to defend the interests of the elites. The splintered elite produced by New York's modern industrial economy tolerated a broader range of cultural initiatives than other communities, as the transplanted native Isabella Gardner discovered among Boston scions outraged by her conspicuous consumption. And in the city's major museums, the divergent cultural agendas of Morris Jesup and Pierpont Morgan underscored the necessity for competing elites to bolster their positions with professional expertise.

A retired merchant, Jesup feared that the venality of the submerged tenth would erode the city's moral fiber and alienate potential clientele. His cultural leadership was suffused with Protestant millenialism and enthusiasm for blue laws, the Society for the Suppression of Vice, and self-improvement agencies for the poor. Bringing a mixture of Carnegie's local philanthropy and Cole's concern for regulating behavior to his presidency of the American Museum of Natural History, Jesup infused the institution with his mandate for popular instruction at a critical moment when the appeal of Bickmore's scientific research was waning among upper-class patrons. In Henry Fairfield Osborn, his curator of paleontology and eventual successor, Jesup found the ideal combination of professional prestige, moral zeal, and public benevolence. Osborn, a prolific scholar who mined the Eocene beds of Wyoming for fossils with the Carnegie Institute's O. A. Peterson, rejected the materialism of Darwinian natural selection and instead accepted the modified theology of James McCosh, for whom evolution was a manifestation of predestination. Osborn believed that mammalian paleontology would verify his theory that human racial stocks were separate species with different evolutionary potentials, and after 1908 he convinced New York's elite to underwrite ambitious collecting expeditions and museum expansion.

Driven by his personal interpretation of evolution, Osborn insisted on the museum's responsibility to instruct the public in social hygiene. It was nothing less, he believed, than a campaign to eliminate such sinks of depravity as New York's Lower East Side and to protect the collective destiny of the Anglo-Saxon race. To increase the museum's didactic effectiveness, he overrode the objections of researchers like Joel Allen to assemble fully articulated dinosaur skeletons and enticing habitat groups while recruiting artists and taxidermists like Frederic Lucas, Carl Akeley, and Frank Chapman.

Lucas, who boasted that he had never read a scientific text, was a former curator at the National Museum, where he absorbed the philosophy of his idol, George Brown Goode. Before his premature death in 1896, Goode experimented with labeling, display cases, and floor-plan arrangements de-

signed to stimulate visitor interest and impart useful information, but his innovations were thwarted by insufficient space and a meager budget. As the director of the American Museum from 1911 to 1923, Lucas enjoyed the resources to realize Goode's concept of a museum as a "house full of ideas and a nursery of living thought," although the nursemaids were now a set of urban elites anxious to impose social restrictions and the ideas were interjected with notions of racial supremacy.

Pierpont Morgan, who transformed the Metropolitan Museum of Art from an instrument of popular education modeled on the South Kensington prototype into a repository of masterpieces, pursued a different approach to cultural leadership. The son of a wealthy and urbane financier, Morgan wore the trappings of aristocracy more gracefully than the millionaire parvenus, and his domestic treasure trove moved Bishop Lawrence to exclaim that "everything in the house was a part of the house, and the house was the home of its master." New York's most powerful investment banker, he perceived that the city's prosperity owed less to working-class mores than to the perceptions of European financiers, whose determination to locate branch offices in the nation's leading metropolis might easily be deflected to Chicago. With his personal control limited by the multiplicity of his investments, Morgan himself trusted the force of his reputation, supplemented by the imposing tapestries and Renaissance oils of his library, to enforce agreements between feuding businessmen. Both the city and the man relied on projecting an image that was larger than life, and, as the Metropolitan's president from 1904 until his death in 1913, Morgan subordinated all other goals to the creation of a world-class museum.

The barnlike Metropolitan of the 1880s had been adequately directed by Luigi Palma di Cesnola, who battled heroically against noseblowing and spitting and invited the public to inspect suspected forgeries with fingers and files. But Morgan's program required a palatial facade and new forms of expertise. Although he transferred entire collections from Europe to New York through dealer Jacques Seligmann, Morgan mistrusted the chicanery of salesmen like Duveen and sought the professional services of Edward Warren and Roger Fry.

Warren had combined exhaustive research and commercial acumen to acquire antiquities for Boston's Museum of Fine Arts (MFA), and his insistence on the MFA's primary obligation to collect objects of beauty culminated in the policies of its secretary, Benjamin Ives Gilman. Stung by the trustees' decision to erect a new building at the expense of his acquisition funds, Warren accepted Morgan's offer to collect for the Metropolitan. Fry, who detected forgeries on his first visit to the museum, impressed Morgan as an academic prodigy capable of adding lustre to the staff, although he never delved into the critic's aesthetic philosophy. An English Quaker harboring ambivalent attitudes toward ostentatious display, Fry could not understand Morgan's motivations and found the Metropolitan's millionaires

insensitive. Critical of Morgan for intertwining museum holdings with his personal collections, he retreated to London in 1909.

Fry's departure typified the efforts of critics like Ernest Fenollosa, Bernard Berenson, and the Steins to extricate themselves from the web of dealers and museums and elevate impartial standards of aesthetic judgment. Prompted by such diverse intellectual currents as Fenollosa's Hegelian constructs and the radical empiricism of Gertrude Stein, each staked out a distinctive field of expertise. Fenollosa, who fled to New York from an unseemly marriage to his assistant at the MFA, introduced Charles Lang Freer to Japanese art, while Berenson dazzled Isabella Gardner with attributions based on his psychological profiles of the Renaissance painters. The Steins plastered their Parisian studio with the raucous nudes of the French modernists and titillated the Cone sisters with their scandals and sexual innuendos.

Like Berenson, who suffered the wrath of aggrieved collectors when he retracted his "discovery" of an unknown master, they struck an uneasy balance between intellectual purity and commercial influence. Fenollosa's "cosmopolis," the flat in the rue de Fleurus, and Berenson's *I Tatti* were disembodied temples of culture reflecting their owners' self-perceptions as arbiters of taste, although in reality the hilltop villa in which Berenson relived the classical ideals of Matthew Arnold was financed by his collaborations with Duveen. Paradoxically, the critics insured the investments of Morgan and his fellow collectors at the same time they divorced themselves from active roles within the modern art museum. Wistfully, Berenson agreed with his wife that the directorship of the Metropolitan "would be a waste of a man who could think."

The critical community sharpened public sensibilities to accurate labeling, conservation, and display. Simply sorting out the avalanche of acquisitions demanded new skills. William Milliken, the future director of the Cleveland Museum of Art, began his professional career by cataloguing the Morgan bequest. Henry Watson Kent, a librarian who brought the systematic approach of Melvil Dewey to the Metropolitan in 1905, not only revamped its registration procedures but imitated Wilhelm Bode's "mixed" galleries at the Kaiser Friedrich Museum. Although placating trustees like R. T. H. Halsey, who were anxious to revive the spirit of a romanticized past, Kent's period rooms also expressed his personal quest for effective exhibitions. His mandate for instruction in cultural history, as well as his interaction with sympathetic innovators like Oakland's Charles Wilcomb in the infant American Association of Museums, suggested that new museum professionals could organize and pursue objectives of their own.

But like Lucas, Kent and his counterparts functioned within the parameters imposed by elites, by the likes of Jesup and Morgan. They achieved their limited autonomy on the basis of expertise that was increasingly drained of either social relevance or academic distinction. Art history had already

become the domain of independent critics. And after 1905 many scholars in the social and natural sciences followed Osborn's rebellious curator of anthropology, Franz Boas, out of the museum and into the university, while the remaining librarians, taxidermists, and designers cultivated a technical idiom devoted to habitat groups and period rooms and referred vaguely to their responsibilities as popular educators.

Ironically, an alternative to this narrow professionalism flourished along the Passaic River in New Jersey. There dredgeboats had carved a channel through the swamplands, known by their bucolic misnomer as the "Meadows," to create Port Newark. Completed in 1915, the waterway capped two decades of civic improvements promoted by the local elites who, in contrast to their Manhattan counterparts, forged an economic, political, and cultural consensus. In a city less than one-tenth the size of New York, upper-class leaders dominated municipal government and clustered around a compact commercial district where skyscrapers towered over the outlying ethnic enclaves. Local librarian John Cotton Dana recognized that a central location was critical to his new museum and persuaded department store owner Louis Bamberger to endow a functional edifice on grounds once reserved for a market. A sharp-tongued agnostic who admonished colleagues that no collection justified itself by its mere existence, Dana sliced through the rhetoric of Jesup and Morgan to insist that museums meet the needs of their urban constituents. Like Bamberger, Newark's elites responded enthusiastically to his plans to refine workmanship and consumer tastes with exhibitions of regional manufacture.

Shaped by past experience and a planner's grasp of the community, Dana's utilitarian approach recalled the innovations of Wisconsin's Reuben Gold Thwaites, who laced together museums, libraries, and schools in a network of public education. But Dana injected his galleries of plumbing fixtures and dime-store pottery with the atmosphere of the county fairs in his native Vermont while at the same time he imitated the advertising and displays of Newark's department stores. Like the downtown emporiums, his museum solicited the city's self-contained neighborhoods and attempted to diffuse tolerance and civic pride through its circulating loans and special exhibitions of ethnic cultures. By 1929, Dana had defined relationships between museum techniques and popular instruction that were unclear to New York's early professionals, although his achievements relied on a core of sympathetic elites that disintegrated two decades after his death. As Paul Rea speculated in Charleston and social worker John Kinard later demonstrated in the Anacostia Neighborhood Museum of the 1960s, Dana's ideals were more effective in small communities where the museum faced fewer competing attractions.

But in complex urban settings like Washington, where a transient and cosmopolitan upper class rarely interacted with local residents, few collectors shared Dana's contempt for "mausoleums of curios." At the height of the

Great Depression, Andrew Mellon acquired masterpieces from the Hermitage with characteristic secrecy and concealed them in a vault under the Corcoran Gallery. Heir to a Pittsburgh banking dynasty with nationwide investments, Mellon had little interest in municipal politics or philanthropy and instead sought to control tariffs as the secretary of the treasury from 1921 to 1932. In his financial speculations and in the political arena, where his wealth invited Democratic diatribes, he relied on anonymity and delegation of authority. Accusations of tax fraud and the cynicism with which the public responded to his National Gallery of Art reinforced Mellon's reticence, and neither temperament nor reputation compelled him to emulate Duncan Phillips, the son of a Pittsburgh glassmaker who mounted a small collection in his home off Dupont Circle. Mellon's corporate monolith on the Mall resembled his personal empire at its zenith as he receded into the background, leaving its daily operations to his former cabinet aide, David Finley.

Troubled by the realization of their unearned wealth, second-generation industrialists like Edsel Ford and John D. Rockefeller, Jr., were equally vulnerable to public criticism. Hastening to justify their acquisitive habits, they retreated from the gallery to the boardroom and in the process heightened the visibility of their directors. Like Mellon, they sought new personnel who combined administrative competence with a flair for entertaining the powerful. Despite his lack of technical experience, John Walker graduated from *I Tatti* to the National Gallery in 1938 and succeeded Finley on the strength of prerequisites he candidly described as charm, sophistication, and savoir-faire. European precedents for Walker's position included Bode's apprentice William Valentiner and Kenneth Clark, his predecessor under Berenson's tutelage, but he was also a product of Paul Sachs, the financier who joined Edward Forbes in cultivating future directors like Alfred Barr and James Rorimer at Harvard's Fogg Art Museum. Although Forbes and Sachs emphasized conservation and art historical expertise, their program chiefly prepared promising candidates for the Rockefellers and other prominent trustees and was sometimes cynically described as a course in "making the right sort of noises in front of pictures."

Worldly and erudite, the Fogg alumni romanticized the acquisition of original works with such episodes as Walker's descent into a Liechtenstein dungeon in search of Renaissance treasures. Their deceptive aura of professional autonomy was maintained by the deference of trustees like Abby Aldrich Rockefeller, although Walker's contention that museums existed for connoisseurs cut to the heart of his role as an ambassador for the reclusive elites. As Clark boasted, the modern director relied less on scholarship than panache and his ability to insinuate himself into symbiotic relationships with upper-class patrons. Thus, Rorimer rose to power in the Metropolitan by fulfilling the cultural aspirations of John D. Rockefeller, Jr., while Alfred H. Barr was recruited by Abby Aldrich Rockefeller to become the first

director of New York's Museum of Modern Art. Fiske Kimball's failure to nurture similar ties with Philadelphia elites contributed to the tragic quality of his career, which culminated in a nervous breakdown despite his academic achievements.

That Mellon and his contemporaries recruited their new directors to dispel personal insecurities was also suggested by collectors who made no pretense at relinquishing their authority to professional expertise. Confident in their own taste, Henry Francis du Pont and Peggy Guggenheim dominated their museums with the omnipotence once exercised by Isabella Gardner. And Albert Barnes, the self-made manufacturer of argyrol who correctly identified the directors from an upper class he bitterly detested, literally barred them from his collection.

While Dana's successors in the municipal museum perpetuated the self-help philosophy of Henry Cole, Walker's elitism reflected another permutation of the art market pioneered by Ernest Gambart. In Thomas Hoving, both strains of museological thought converged dramatically at the Metropolitan in 1966, only two years after the accumulated pressures of poverty and discrimination had erupted in the Harlem race riots. The son of a merchandising genius at Tiffany's and an art historian with Princeton credentials, Hoving captivated Rorimer, who overlooked his penchant for rash actions. To Rorimer's delight, Hoving's highly embellished "discovery" of the Bury St. Edmonds Cross rejuvenated the slumbering Cloisters Museum by exploiting the glamorous dimensions of the modern director. But unlike Rorimer, Hoving realized that the Metropolitan's deteriorating image as a bastion of upper-class privilege was linked to a volatile political climate in which elites were increasingly compelled to accommodate local demands.

Abruptly departing from the Cloisters in 1965 to become Mayor Lindsay's commissioner of parks, Hoving pursued his own path to the director's chair amid a deluge of publicity surrounding his popular "happenings." Immersed in Lindsay's crusade to "rehumanize" obsolescent institutions, by the time of Rorimer's sudden death, he emerged as an ideal solution for trustees eager to enter the mainstream of the mayor's urban renaissance. But Hoving also shared his mentor's arrogant impatience and a tendency to alienate supporters with sweeping changes. Although intended to stimulate pride in a troubled neighborhood, his hastily contrived exhibition "Harlem on My Mind" raised a storm of protest over anti-Semitic remarks inadvertently published in its catalogue. Besieged by trustees and conflicting interest groups, Hoving retreated from social activism to more traditional collecting pursuits by 1970, although scandals continued to plague his career.

Momentarily, the political atmosphere had encouraged an ambitious personality to mix scholarly and popular styles in a single museum, but Hoving's appeal to cosmopolitan and local constituencies was destabilized by his own character flaws and simply blew apart, leaving the task of reassembling the fragments to other communities and new museum people.

SURVEY OF SOURCES

In his *Aspects of Biography* (1930), André Maurois observed that biographers select and interpret subjects according to idiosyncratic needs and in the context of their own age. This condition is particularly relevant to the biographies of museum people, which represent a variety of disciplinary perspectives that often bear little connection to museology. Authors of diverse interests are attracted to figures who were primarily businessmen, politicians, scientists, or literati, and only secondarily men and women for whom the accumulation of objects fulfilled personal desires. Although Edward Alexander demonstrates the impact of twelve museum leaders on institutional evolution, his attempt to trace a "professional tradition" in *Museum Masters* (1983) frequently reduces the multifaceted nature of such early reformers as Sir Henry Cole to a one-dimensional existence. Like portraits in a hall of fame, his collective biography is a useful introduction to a larger and more complex body of literature.

Amid debates surrounding the British Museum's reorganization in the late nineteenth century, keeper Edward Edwards reexamined its early contributors in *Lives of the Founders of the British Museum* (1870). He concluded that the holistic conception of knowledge shared by collectors like Sir Robert Cotton, who used his antiquities to document Queen Elizabeth's precedence over the Spanish throne, had created a unique institution still worthy of preservation a century later. Both *The Tradescants* (1964) by Mea Allan and "James Petiver" (1952) by Raymond Stearns capture the atmosphere of imperial expansion that excited the fashionable collectors of the 1600s. Indiscriminately mixing natural and artificial specimens, the Tradescants sought pleasing combinations, but Stearns notes that Petiver functioned in a network of botanists eager to develop a comprehensive taxonomic system. In *Sir Hans Sloane* (1954), Eric Brooks characterizes Petiver's patron as a cautious innovator who was restrained from original discoveries by his adherence to classical theories. Gavin De Beer's *Sir Hans Sloane and the British Museum* (1953) is less critical but cites contemporary reactions to Sloane's cabinet, while *Sir Hans Sloane and Ethnography* (1970) by Hermann Braunholtz briefly describes his anthropological collections, which later attracted additional artifacts to the British Museum.

By procuring fresh material from the hangman, the surgical instructor John Hunter assembled a museum of dissected organs that not only revolutionized the methods of London's collectors but, as Jessie Dobson argues in *John Hunter* (1969), served as a reference collection for his investigations into pathological structures. While Hunter aroused the public's prurient interests in a manner suggested by Garet Rogers, whose fictional biography *Lancet* (1956) dwells on his bloodstained fingernails, his emphasis on research typified gentlemen-scholars of the late eighteenth century. Hector Cameron's *Sir Joseph Banks, K.B., P.R.S.* (1952) and Charles Lyte's *Sir Joseph*

Banks (1980) follow the career of a Lincolnshire peer and an expert botanist who was encouraged by the Linnaean system to reorient Kew as a laboratory for agricultural experimentation and a clearinghouse for imperial exchanges.

In *A Species of Eternity* (1977), Joseph Kastner examines Cadwallader Colden and the international community of naturalists who supplied their English counterparts with foreign specimens. But of the many scholars influenced by Banks, few have attracted more attention than the obscure geologist James Smithson. Leonard Carmichael and J. C. Long reconstruct Smithson's life with moderation in *James Smithson and the Smithsonian Story* (1965), but the romance surrounding his bags of gold and ambiguous testament spurred others to speculate on the significance of his illegitimate birth, supposed republican sympathies, and estrangement from the Royal Society. As William Bird notes in "A Suggestion Concerning James Smithson's Concept of 'Increase and Diffusion' " (1983), such works as *A Memoir on the Scientific Character and Researches of the Late James Smithson* (1844) by Walter Johnson, *James Smithson and His Bequest* (1880) by William Rhees, and especially Louise Hackney's novel *Wing of Fame* (1934) are more useful as popular conceptions of the Smithsonian mandate at different intervals in its institutional growth than as accurate assessments of Smithson's motivations. Bird restores Smithson's bequest to the context of English educational philosophy in the 1820s, when the increase and diffusion of knowledge were seen as reciprocal functions rather than the conflicting objectives later perceived by Joseph Henry and his successors.

Paul Sifton's "A Disordered Life" (1973) and Hans Huth's "Pierre Eugène Du Simitière and the Beginnings of the American Historical Museum" (1945) portray an inflexible collector embedded in the tradition of Sloane's private museum who vexed congressmen with his pleas for funds during the American Revolution. By contrast, the French botanist Jean-Baptiste Lamarck, who was under suspicion as the son of nobility, realized the expediency of adapting the naturalist's cabinet to revolutionary ideology. In *The Spirit of System* (1977), Richard Burkhardt demonstrates his role in the transformation of the Jardin et Cabinet du Roi to a new Musée d'Histoire Naturelle devoted to utilitarian goals.

Although Lamarck's grand theoretical synthesis of physical and chemical phenomena was rendered obsolete among French naturalists by the rising popularity of Georges Cuvier's empiricism, many of his ideas were duplicated by his correspondent Charles Willson Peale. As Charles Sellers argues in *Charles Willson Peale* (1969) and in *Mr. Peale's Museum* (1980), Peale found Lamarck's educational programs and comprehensive philosophy congenial to his own concept of the public museum, although his enthusiasm for the Linnaean system was infused with religious overtones that were lacking among the faculty of the Musée. The different form assumed by Peale's museum owed much to the local political and social setting described in Russell Weigley's *Philadelphia* (1982). Though primarily concerned with

Daniel Drake's medical innovations, Emmet Horine's *Daniel Drake* (1961) suggests the similarity of Peale's techniques to the early Western Museum's popular lectures and exhibitions of indigenous wildlife, while *The Urban Frontier* (1959) by Richard Wade illustrates the economic conditions that ensured its collapse.

Although little is known of James Salter and his commercial alternative to the gentleman's cabinet, Bryant Lillywhite consolidates references to the "Chelsea Knackatory" in his *London Coffee Houses* (1963). *Patience Wright* (1976) by Charles Sellers and *The Great Belzoni* (1961) by Stanley Mayes examine not only London's boisterous entertainments but also the avenues available to entrepreneurs in search of more polished clientele. Billing her waxworks as portraiture, Wright divorced herself from the East End shows of Mrs. Salmon and solicited private commissions, while Giovanni Belzoni, who formerly upheld the "Human Pyramid" in Bartholomew Fair, parlayed his Egyptian antiquities into social acclaim and an exhibition at William Bullock's showplace. Bullock himself, as depicted in Wilbur Shepperson's "William Bullock" (1961), amused a popular audience for more than a decade before promoting land speculation in Ohio, where he inspired Mrs. Trollope's Infernal Regions for the rejuvenated institution described by Louis Tucker in "The Western Museum of Cincinnati" (1965). The most recent treatment is Edward Alexander's "William Bullock: Little-Remembered Museologist and Showman" (1985).

Showmen like Rubens Peale and Gardiner Baker were forced to improvise increasingly sensational attractions, which offended upper-class patrons and serious scientists, as suggested in "The Tribulations of a Museum Director in the 1820's" (1954) by Wilbur Hunter and "Tammany's Remarkable Gardiner Baker" (1958) by Robert McClung and Gale McClung. In "The American Museum from Baker to Barnum" (1959), Loyd Haberly illustrates the vulgarization of Baker's collection by his widow and the Scudders, who were hard pressed by New York's proliferating diversions. Both M. R. Werner's *Barnum* (1923) and Irving Wallace's *The Fabulous Showman* (1959) adequately represent the impresario who overcame the limitations of his trade through his genius for publicity, while Edward Spann's *The New Metropolis* (1981) analyzes the urban transformations that reinforced Barnum's success. But *Humbug* (1973) by Neil Harris elevates Barnum as a Jacksonian hero who stimulated the common man to shun classically trained experts and nurture his own "operational aesthetic."

When Charles Holder recalled in *Louis Agassiz* (1893) the childish enthusiasm with which he collected coral for the MCZ and the encouraging letters he received from its founder, he contributed to a reservoir of works like Alice Gould's *Louis Agassiz* (1901), which captured Boston's fascination for Agassiz's alpine exploits, his "picturesque" poverty, and the high moral calibre of his museum. Colleagues praised his "exquisite sense of form" in Arnold Guyot's *Memoir of Louis Agassiz* (1883) and Jules Marcou's conde-

scending *Life, Letters, and Works of Louis Agassiz* (1895), while the reactions of students to his museum pedagogy were later encapsulated in Lane Cooper's *Louis Agassiz as a Teacher* (1917) and James Teller's *Louis Agassiz, Scientist and Teacher* (1947). Elizabeth Agassiz's affectionate memoir, *Louis Agassiz* (1885), contains autobiographical fragments penned by her husband and remains a wellspring of popular myths, but only Edward Lurie's *Louis Agassiz* (1960) unravels the skein of self-confidence and European experience that led Agassiz to see himself as a master naturalist capable of synthesizing knowledge in diverse fields. In his biography and in *Nature and the American Mind* (1974), Lurie argues that New England businessmen were intellectually attracted to Agassiz's peculiar fusion of scientific rationalism and metaphysics, although less cerebral motives can also be surmised from Frederic Jaher's "The Politics of the Boston Brahmins" (1984).

George Kunz's "Memoir of Albert Smith Bickmore" (1915) and Ralph Dexter's "Frederic Ward Putnam" (1966) describe two of Agassiz's students, but Paul Oehser's *Sons of Science* (1949) extends his vision of a national scientific establishment into the Smithsonian by suggesting that secretaries Samuel Langley and Charles Abbot periodically rekindled the passion for pure research first ignited by Henry and the Lazzaronis. In *Joseph Henry* (1950), Thomas Coulson claims that Agassiz's friend suppressed both his craving for recognition and assaults on his budget to preserve the institution's role as a sponsor of original investigations, while William Dall's *Spencer Fullerton Baird* (1915) reveals his assistant's covert encouragement of collectors in anticipation of a new national museum. The interplay of ambitions among Agassiz, Henry, and Baird enlivens the letters assembled by Charles Herber in *Correspondence Between Spencer Fullerton Baird and Louis Agassiz* (1963), in which Agassiz routinely waves aside requests that he return specimens borrowed from Washington with entreaties to respect Henry's objectives. As a proviso to the often exaggerated disparity between Henry and Baird, Wilcomb Washburn notes in "The Museum and Joseph Henry" (1965) that neither rejected research, although Henry's experimental inquiries required different facilities from Baird's classificatory pursuits. Thus, the skill with which John Wesley Powell simultaneously portrayed his expeditions as topographical surveys and ethnographic collecting junkets, as illustrated in William Darrah's *Powell of the Colorado* (1951), excited both men for different reasons.

Ironically, none of the Smithsonian naturalists trumpeted the lonely rewards of museum research more fervently than Henry Fairfield Osborn in his *Fifty-two Years of Research, Observation and Publication* (1930), although, as William Gregory notes in his "Biographical Memoir of Henry Fairfield Osborn" (1937), his associate rarely reported findings without expounding upon their significance for the general public. Moreover, "The Rise to Parnassus" (1983) by Charlotte Porter demonstrates the impact of Osborn's unfounded theories of racial hygiene on permanent museum ex-

hibitions. Melville Herskovits argues in *Franz Boas* (1953) that Osborn's curator rejected the application of evolutionary principles to cultural phenomena, and, while Boas devised ethnographic displays to express his concept of culture-areas, Curtis Hinsley and Bill Holm conclude in "A Cannibal in the National Museum" (1976) that his holistic culture studies were ultimately unsuited to the institutional realities of American museums.

At his grandfather's feet, Lyman Draper absorbed the romanticized past of his ancestors, which William Hesseltine identifies in *Pioneer's Mission* (1954) as an overriding obsession of his collecting career at the Wisconsin Historical Society. Draper's zeal for extracting historical material from dying frontiersmen was rivaled only by Ann Pamela Cunningham's response to the moonlit visions of her mother, as described by the Mount Vernon Ladies' Association in its *Historical Sketch of Ann Pamela Cunningham* (1929). Charles Wall's "Ann Pamela Cunningham" (1975), which credits her treasurer, George Riggs, with hammering out a practical restoration program, speculates on Cunningham's desire to dissolve sectional hostilities amid a wave of patriotic nostalgia.

Tracing the antiquarian impulse through the lives of prominent collectors in *The Antiquers* (1980), Elizabeth Stillinger argues that the sentimentalism of Cummings Davis and his contemporaries was superseded in the 1890s by Clarence Cook's appreciation of antiques for their artistic qualities. The international arts and crafts movement inspired not only New England connoisseurs but also museum founders discussed in other works, including Ronald Pilling's "Henry Chapman Mercer and the Moravian Tile Works" (1979), Karen Cushman's "Jane Addams and the Labor Museum at Hull House" (1983), and "A Great Museum Pioneer of the Nineteenth Century" (1964), in which Bo Lagercrantz places Artur Hazelius in the context of Ruskinian philosophy. For Stillinger, twentieth-century collectors like R. T. H. Halsey were attempting to indoctrinate immigrants and the laboring class in acceptable American values by institutionalizing antiques with the aid of art museum curators. Against this critical framework, her portraits of Henry Francis du Pont and Henry Ford recall Keith Sward's slashing attack on Ford's genteel pretensions in *The Legend of Henry Ford* (1948). Neither John Sweeney's celebratory *Henry Francis du Pont* (1980) nor the mildly disparaging view of Ford's historical inaccuracies taken by Alan Nevins and Frank Hill in *Ford* (1957) is so sharply focused.

While stalking state secrets through the bedchambers of Europe's courtesans, the royal ambassador Dominique Vivant Denon honed his skills as a courtier and imbibed the aesthetic credo of the French *philosophes* that art existed to elevate the viewer's mores. Both lessons, together with a pragmatic acceptance of his own limitations, enabled him to survive the Revolution, and, as Judith Nowinski demonstrates in *Baron Dominique Vivant Denon* (1970), Napoleon's new imperial art administrator recast the Louvre in the image of his patron's overweening ambitions. Vivant's utili-

tarian goals and instinctive feel for manipulating the aristocracy were later characteristic of English reformers like William Hooker, whose schemes to coax emoluments from the royal family are recited by Joseph Hooker in *A Sketch of the Life and Labours of Sir William Jackson Hooker* (1903). Although Hooker never joined his son in diffusing Darwinism, F. O. Bower's "Sir William Hooker" (1913) commends his reorganization of Kew for facilitating subsequent research. The elder Hooker's timely blend of traditional taxonomic expertise, artistic imagination, and bureaucratic cunning permitted him to revolutionize the Royal Gardens, argues Mea Allan in *The Hookers of Kew* (1967), while Joseph Hooker's scientific professionalism simply obstructed his effectiveness as an administrator.

In the letters collected by Louis Fagan for *The Life and Correspondence of Sir Anthony Panizzi* (1881), the principal librarian bluntly protests that scholars are unfit to direct museums. But although Panizzi also equated privilege with inefficiency, Edward Miller argues in *Prince of Librarians* (1967) that his enthusiastic performance as a public-spirited Englishman impressed influential allies like Lady Dacre and Lord Chancellor Brougham.

The application of improved exhibition techniques to popular instruction is a recurrent theme in both *The Life of Richard Owen* (1894) by Owen's grandson R. S. Owen and Henry Cole's *Fifty Years of Public Work of Sir Henry Cole* (1884). Illustrating his respect for universally accepted principles of taste and behavior, Cole's reform campaigns ran the gamut from uniform penny postage to the standard rail gauge, while his rationale for schools of design was suffused with the Victorian gospel of self-help and a contemporary political ideology described in Francis Sheppard's *London* (1971).

American philanthropists who shared Cole's concerns are analyzed in Franklin Parker's *George Peabody* (1971), Joseph Wall's *Andrew Carnegie* (1970), and William Brown's *Morris Ketchum Jesup* (1910). Although Parker discovers neither religious motivations nor a guilt-ridden conscience behind Peabody's secular stewardship, Carnegie's troubled mind found no solace in ostentation and was driven instead to justify his life as a symbol of the democratic process. Brown does little more than commemorate his subject's largesse, and only David Hammack's *Power and Society* (1982) provides a critical perspective on Jesup's response to the fragmentation of New York elites.

Inspired by Thomas Jefferson Bryan's "Gallery of Christian Art," Edith Wharton's fictional *False Dawn* (1924) portrays a New York dilettante whose acquisition of Italian primitives literally gives his father apoplexy. Such eccentricities have proved irresistible to biographers of the major art collectors, as suggested by Aline Saarinen's *The Proud Possessors* (1958) and Pierre Cabanne's *The Great Collectors* (1963), which survey personalities dating predominantly from the late nineteenth century. Although Saarinen's subjects pursue their collections as a means of self-expression, modified by the communities in which they function and by tastemakers like Mary Cassatt,

Cabanne concentrates on the collector's neurotic compulsion to possess art objects. Likewise, individual biographies are often characterized by either Saarinen's "sociological" interpretation or Cabanne's "psychoanalytical" approach, although neither method precludes the other. In "A Forgotten New Englander" (1933), Theodore Sizer argues that James Jarves alienated Americans by urging the importation of European aesthetic traditions to combat cultural ignorance, while *The Two Lives of James Jackson Jarves* (1951) by Francis Steegmuller depicts his search for artistic ideals as the culmination of lifelong aversions to his father's industrial career. Louise Tharp's *Mrs. Jack* (1965) emphasizes the impact of Isabella Gardner's collections on a chaste Boston society, but Gardner's director Morris Carter tentatively justifies her acquisition of Old Masters and young men as manifestations of a private longing "to own fine things" in *Isabella Gardner and Fenway Court* (1925).

Forgiving, or at best timidly critical, George Harvey's *Henry Clay Frick* (1928), Louisine Havemeyer's *Sixteen to Sixty* (1961), and Francis Henry Taylor's *Pierpont Morgan as Collector and Patron* (1957) celebrate the prudent tastes of relatives or institutional benefactors. Havemeyer insists that her husband's silk-swaddled Rembrandt Room enhanced his purchases without advertising their market value, while Taylor vindicates Morgan's penchant for purchasing entire collections as a calculated risk. By contrast, Cass Canfield observes in *The Incredible Pierpont Morgan* (1974) that he was motivated by a mixture of sentiment and greed, but Frederick Lewis Allen stands alone in restoring Morgan's collecting habits to the context of his financial affairs and his conceptions of leadership in *The Great Pierpont Morgan* (1949). Allen's balanced assessment is conspicuously absent in the biographies of Andrew Mellon, which range from David Finley's bowdlerized portrait in *A Standard of Excellence* (1973) to Harvey O'Connor's muckraking gibes in *Mellon's Millions* (1933). Raymond Fosdick's *John D. Rockefeller, Jr.* (1956) and Mary Chase's *Abby Aldrich Rockefeller* (1950) illustrate the new trustees' reverence for professional competence, which Fosdick attributes to Rockefeller's low self-esteem and Chase to his wife's sunny disposition. Milton Lomask's *Seed Money* (1964) is less charitable to Solomon Guggenheim, whose scrupulous observance of his director's prerogatives apparently derived from his personal affection for the Baroness Hilla Rebay.

"An Appreciation of Charles Lang Freer" (1957) by Katharine Rhoades and *The Man From New York* (1968) by Benjamin Reid typify the dilemma of American businessmen who sublimated artistic creativity to their drive for financial security. Like Freer, who shaped his collection of Oriental paintings as a work of art in itself, John Quinn recognized that Morgan's masterpieces had become commodities akin to pork bellies and corn futures. With his contemporary Albert Barnes, whose personal frustrations are exposed by William Schack in *Art and Argyrol* (1960), he sought out modern art as he longed to attack an empty canvas. Still undiscovered and unassessed, the post-impressionists beckoned not only wealthy collectors but original

thinkers, and, as Marjorie Phillips notes in *Duncan Phillips and His Collection* (1970), her husband eagerly joined Quinn in his mission to interpret abstract art to the public.

Speculating on the margins of accepted taste and often with limited budgets, the modern art enthusiasts produced subjective collections that were not easily institutionalized. In *The Collectors* (1962), Barbara Pollack traces the complications surrounding the Cone bequest to the Baltimore Museum of Art to the conflicting personalities of Claribel and Etta Cone, who charged their collection with such dynamic tension that its vitality seemed to ebb away outside the confines of their apartment. Both Peggy Guggenheim's *Confessions of an Art Addict* (1960) and *Hirshhorn* (1979) by Barry Hyams capture the determination of Quinn's successors to create their own standards of aesthetic criticism outside the framework of established museums.

As Jeremy Maas demonstrates in *Gambart* (1975), the modern art market owed its commercial atmosphere to devices first employed by Ernest Gambart to accelerate the dispersal of aristocratic holdings. Gambart manifested a talent for exploiting the bourgeoisie that was later perfected by Ambroise Vollard, who handily concocted new titles for his unsigned paintings as the need arose. Like Vollard's *Recollections of a Picture Dealer* (1978), René Gimpel's *Diary of an Art Dealer* (1966), and Julien Levy's more recent *Memoir of an Art Gallery* (1977) are not only firsthand accounts of the marketplace but also unvarnished observations of prominent collectors in action. In *Merchants of Art* (1961), Germain Seligman credits his father with recognizing the museum's potential for encouraging new collectors, although the confidence he cultivated in Morgan was surpassed by the elaborate ruses with which Joseph Duveen "upgraded" his clientele. Samuel Behrman's *Duveen* (1952) examines the dealer's insatiable desire to become the sole conduit for every significant purchase of his age and argues that he transformed American tastes, but James Henry Duveen, a victim of his cousin's machinations to steal his customers, accuses him of destroying the family business in *The Rise of the House of Duveen* (1957).

Another casualty of Duveen's aggressive tactics was Bernard Berenson, who protested in his *Sketch for a Self-Portrait* (1949) that their partnership consigned him to the ranks of fortune-tellers and charlatans. As Sylvia Sprigge discovered in her conversations with the aging aesthete, the Lithuanian emigrant who once shaved his sidelocks and confessed his conversion to Boston's fashionable Phillips Brooks was determined to become a worldly epicure and found Duveen's transactions demeaning. Both Sprigge's *Berenson* (1960) and Nicky Mariano's *Forty Years with Berenson* (1966) suffer from a housebound perspective that obscures Berenson's significance beyond *I Tatti*, but Ernest Samuels explores the impact of his scholarship on collectors who, like himself, were spellbound by the artistic philosophy described in Kermit Vanderbilt's *Charles Eliot Norton* (1959). The critical role that Samuels defines in *Bernard Berenson* (1979) is equally prominent in

James Mellow's *Charmed Circle* (1974), in which the Steins' atelier functions as a "cultural halfway house" for Americans seeking their first exposure to the French avant-garde. Monolithic in her brown corduroy suit, Gertrude Stein was an ideal guide to the exotic world of modern art, for, as John Brinnin demonstrates in *The Third Rose* (1959), both her outlandish prose and her critical theories were rooted in the familiar rationalism of the nineteenth century. Frances Spalding's *Roger Fry* (1980) and Lawrence Chisolm's *Fenollosa* (1963) suggest similar motivations for each critic's flight from the museum by focusing on aesthetic credos that were better suited to the *Burlington Magazine* and the Chautauqua circuit.

Symbolically, George Brown Goode's postgraduate studies under Louis Agassiz were cancelled by his mentor's demise and, as his Smithsonian colleagues later implied in "A Memorial of George Brown Goode" (1901), his skills were channeled instead into museum administration. Reiterated by his contemporaries in Carl Hagenbeck's *Beasts and Men* (1911) and Charles Currelly's *I Brought the Ages Home* (1956), Goode's creative approach to conservation and display inspired subsequent workers to formulate a body of professional expertise. Thus, William Hornaday pauses with his finger on the trigger to remind himself of his educational mandate in *Two Years in the Jungle* (1910), a chronicle of the museum's "ceaseless warfare for specimens" and a collection of his observations on competent taxidermy. In *Fifty Years of Museum Work* (1933), Frederic Lucas defines his occupation as translating facts into attractive exhibits, although he insists that curatorial skill derives less from professional training than natural aptitude.

Both Frederick Jackson Turner's *Reuben Gold Thwaites* (1914) and Melinda Frye's "Charles P. Wilcomb" (1977) celebrate early professionals who tied the museum to complementary public agencies. Likewise, Henry Watson Kent initiated school programs and radio broadcasts while warning his peers in *What I Am Pleased to Call My Education* (1949) that obsolescent notions of aesthetic purity were reducing the museum to a meaningless "mausoleum." As Stephen Dobbs suggests in "Dana and Kent and Early Museum Education" (1971), the perennial exchange of philippics between the spokesmen of the Metropolitan and the Newark Museum obscured their similar attitudes toward the profession's social obligations. Although Dana's career was characterized by an iconoclastic rejection of institutional routines, Frank Kingdon associates his ethic of community service with the village traditions he inherited from his father in *John Cotton Dana* (1940). Kingdon's analysis, which glorifies Dana's role as a progressive reformer, is extended by Chalmers Hadley in *John Cotton Dana* (1943) and Holger Cahill in "John Cotton Dana and the Newark Museum" (1944), but Richard Grove's "John Cotton Dana" (1978) attempts to place him in the community museum movement Goode initiated. If few other professionals exercised the formative influence of Dana or Kent, many were responsible for significant methodological innovations. "Pioneers in American Museums," an irregular feature

of *Museum News*, often explores less prominent personalities in articles like Joyce Stoner's "George L. Stout" (1978), Gwendolyn Owen's "Bryson Burroughs" (1979), and Claire Sherman's "Dorothy Miner" (1981).

Fastidious and formal to the point of pomposity, Paul Sachs emphasized connoisseurship as the hallmark of professionalism, although as Ada Ciniglio notes in "Paul J. Sachs" (1976), the Harvard graduate who once failed his entrance exam was never an integral member of the academic community. Unlike Forbes, whose sound knowledge of the chemical properties of artworks is portrayed in the Fogg Museum's *Edward Waldo Forbes* (1971), Sachs was only familiar with the social dimensions of the art market, and, in "Paul Joseph Sachs" (1965), Agnes Mongan remembers his course as an extended discussion of his personal collection. But Sachs realized that trustees with a taste for discretion had outgrown such opportunists as Luigi Palma di Cesnola, whose devious route to the directorship as a mercenary and a smuggler of antiquities is examined by Elizabeth McFadden in *The Glitter and the Gold* (1971). As Margaret Sterne suggests in *The Passionate Eye* (1980), upper-class cultural aspirations were fulfilled after 1920 by European scholars like William Valentiner, the high-strung genius of the Kaiser Friedrich Museum who astounded Edsel Ford with his discoveries of unknown masterpieces.

Valentiner's career at the Detroit Institute of Arts, which he often characterized as an outpost on the edge of "nothingness," personifies the obsession with intellectual daring and disdain for provincialism that suffuses John Walker's *Self-Portrait with Donors* (1974) and Kenneth Clark's *Another Part of the Wood* (1974). Both directors portray themselves as intuitive performers wielding tact and "weasel words" to manipulate trustees, and, although witty and seemingly self-deprecating, they project an arrogant satisfaction with a profession that Clark describes as a "long, harmless confidence trick." Nonetheless, Walker and Clark presented a compelling prototype for art museum directors like William Milliken, who accents his glamorous acquisitions and his cosmopolitan life-style in *Born Under the Sign of Libra* (1977), while ignoring the exhibitions of Cleveland artists and local industrial wares that Karal Ann Marling describes in "William M. Milliken and Federal Art Patronage of the Depression Decade" (1974). As George Roberts and Mary Roberts demonstrate in their biography of Fiske Kimball, *Triumph on Fairmount* (1959), such community programs could complicate the director's primary obligation to satisfy his elite patrons. In *Alfred H. Barr* (1989), Alice Marquis portrays the first director of New York's Museum of Modern Art as an urbane flatterer who shaped MOMA's direction for more than a half century by jockeying collectors, dealers and artists.

No one romanticized the director's role more diligently than Thomas Hoving in *The Chase, The Capture* (1975), and his loquacious depictions of the Metropolitan's future apparently infected Russell Lynes in his early interview for "The Pilot of the Treasure House" (1967). More perceptive,

John McPhee shades an otherwise sympathetic portrait in *A Roomful of Hovings* (1968) with the lingering uncertainties surrounding Hoving's penchant for entering new ventures with a relish and quickly casting them aside. John Hess is left to bring Hoving's tempestuous regime into critical perspective in *The Grand Acquisitors* (1974). Noting his weakness for confusing reality with the products of his imagination, Hess attributes Hoving's power to translate personal foibles into institutional policies to the museum itself and to the ambivalent relationships between its trustee and its professionals.

BIBLIOGRAPHIC CHECKLIST

Agassiz, Elizabeth Cabot, ed. *Louis Agassiz, His Life and Correspondence.* Boston: Houghton Mifflin, 1885.

Alexander, Edward. *Museum Masters: Their Museums and Their Influence.* Nashville, TN: American Association for State and Local History, 1983.

———. "William Bullock: Little-Remembered Museologist and Showman." *Curator* 28 (1985), 117–47.

Allan, Mea. *The Tradescants: Their Plants, Gardens and Museum, 1570–1662.* London: Michael Joseph, 1964.

———. *The Hookers of Kew, 1785–1911.* London: Michael Joseph, 1967.

Allen, Frederick Lewis. *The Great Pierpont Morgan.* New York: Harper, 1949.

Altick, Richard D. "Snake Was Fake But Egyptian Hall Wowed London: Cagey Impresario William Bullock Filled His Museum with Everything from Napoleon's Bulletproof Carriage to Mexican Loot." *Smithsonian* 9 (April 1978), 68–72, 74, 76–77.

Ashton, Dore. "Sweeney Revisited." *Studio International Art* 166 (September 1963), 110–13.

Barnum, Phineas Taylor. *The Life of P. T. Barnum, Written by Himself.* New York: Redfield, 1855.

Barthelme, Donald. "At the Tolstoy Museum." In *City Life,* by Donald Barthelme. New York: Farrar, Straus & Giroux, 1970.

Bather, F. A. "The Triumph of Hazelius." *Museums Journal* 16 (December 1916), 132–36.

Battiata, Mary. "Carter Brown & the Shining Heritage: The Gallery Director and His Treasured Country House Show." *Washington Post,* November 7, 1985, C1–C2.

Bayer, Herbert. *Herbert Bayer: Painter, Designer, Architect.* New York: Reinhold, 1967.

Behrman, Samuel Nathaniel. *Duveen.* New York: Random House, 1952. Reprint. Boston: Little, Brown, 1972.

Berenson, Bernhard. *Sketch for a Self-Portrait.* New York: Pantheon, 1949.

Berman, Avis. "Pioneers in American Museums: Juliana Force." *Museum News* 55 (November-December 1976), 45–49, 59–62.

———. *Rebels on Eighth Street: Juliana Force and the Whitney Museum of American Art.* New York: Atheneum, 1990.

Bird, William L., Jr. "A Suggestion Concerning James Smithson's Concept of 'Increase and Diffusion.' " *Technology and Culture* 24 (April 1983), 246–55.

"Bode." *Burlington Magazine* 54 (April 1929), 165–66.

Bode, Wilhelm von. *Mein Leben*. 2 vols. Berlin: H. Reckendorf, 1930.

Bower, F. O. "Sir William Hooker, 1785–1865." In *Makers of British Botany: A Collection of Biographies by Living Botanists*, edited by Francis Wall Oliver. Cambridge: University Press, 1913.

————. "Sir Joseph Dalton Hooker, 1817–1911." In *Makers of British Botany: A Collection of Biographies by Living Botanists*, edited by Francis Wall Oliver. Cambridge: University Press, 1913.

Braunholtz, Hermann Justus. *Sir Hans Sloane and Ethnography*. London: British Museum, 1970.

Brenson, Michael. "De Montebello Pursues a 'Universal Museum.'" *New York Times*, January 1, 1983, 7.

Bringeus, Nils-Arvid. "Artur Hazelius and the Nordic Museum." *Ethnologia Scandinavica* (1974), 5–16.

Brinnin, John Malcomb. *The Third Rose: Gertrude Stein and Her World*. Boston: Little, Brown, 1959.

Brooks, Eric St. John. *Sir Hans Sloane, the Great Collector and His Circle*. London: Batchworth Press, 1954.

Brown, Sanborn Conner. *Benjamin Thompson, Count Rumford*. Cambridge: MIT Press, 1979.

Brown, William Adams. *Morris Ketchum Jesup, a Character Sketch*. New York: Charles Scribner's Sons, 1910.

Burkhardt, Richard Wellington, Jr. *The Spirit of System: Lamarck and Evolutionary Biology*. Cambridge: Harvard University Press, 1977.

Cabanne, Pierre. *The Great Collectors*. New York: Farrar, Straus, 1963.

Cahill, Holger. "John Cotton Dana and the Newark Museum." In *A Museum in Action, Presenting the Museum's Activities. Catalogue of an Exhibition of American Paintings and Sculpture from the Museum's Collections, with an Introduction by Holger Cahill. October 31, 1944, to January 31, 1945. The Newark Museum*. Newark: Newark Museum, 1944.

Cameron, Hector Charles. *Sir Joseph Banks, K.B., P.R.S.* London: Batchworth Press, 1952. Reprint. Sydney: Angus & Robertson, 1966.

Canfield, Cass. *The Incredible Pierpont Morgan: Financier and Art Collector*. New York: Harper & Row, 1974.

"The Career of Charles R. Knight." *Curator* 4 (1961), 352–67.

Carmichael, Leonard. *Joseph Henry (1797–1878) and His Smithsonian Institution*. New York: Newcomen Society in North America, 1956.

Carmichael, Leonard, and Long, J. C. *James Smithson and the Smithsonian Story*. New York: G. P. Putnam's Sons, 1965.

Carter, Morris. *Isabella Stewart Gardner and Fenway Court*. Boston: Houghton Mifflin, 1925. Reprint. Freeport, NY: Books for Libraries Press, 1972.

Castile, Rand. "'The Dean' Departs." *Art News* 82 (April 1983), 102–5.

Cauman, Samuel. *The Living Museum, Experiences of an Art Historian and Museum Director: Alexander Dorner*. New York: New York University Press, 1958.

Chase, Mary Ellen. *Abby Aldrich Rockefeller*. New York: Macmillan, 1950.

Chatelain, Jean. *Dominique Vivant Denon et le Louvre de Napoléon*. Paris: Librairie Académique Perrin, 1973.

Chisolm, Lawrence W. *Fenollosa: The Far East and American Culture*. Yale Publications in American Studies, no. 8. New Haven: Yale University Press, 1963.

Choate, Joseph H., Henry Fairfield Osborn, George Frederick Kunz, and Louis Pope Gratacap. "J. Pierpont Morgan and the American Museum." *American Museum Journal* 13 (April 1913), 154–71.

Ciniglio, Ada V. *Pioneers in American Museums: Paul J. Sachs." Museum News* 55 (September-October 1976), 48–51, 68–71.

Clark, Kenneth McKenzie. *Another Part of the Wood: A Self-Portrait.* London: William Clowes and Sons, 1974.

Cole, Henry. *Fifty Years of Public Work of Sir Henry Cole, K.C.B., Accounted for in His Deeds, Speeches and Writings,* edited by Alan Summerly Cole and Henrietta Cole. 2 vols. London: George Bell & Sons, 1884.

Coleman, William R. *Georges Cuvier, Zoologist: A Study in the History of Evolution Theory.* Cambridge: Harvard University Press, 1964.

Cooper, Lane. *Louis Agassiz as a Teacher.* Ithaca, NY: Comstock Publishing Company, 1917. Reprint. Ithaca, NY: Comstock Publishing Company, 1945.

Coulson, Thomas. *Joseph Henry, His Life and Work.* Princeton: Princeton University Press, 1950.

Cunningham, John T. *Newark.* Newark: New Jersey Historical Society, 1966.

Currelly, Charles Trick. *I Brought the Ages Home.* Toronto: Ryerson Press, 1956. Reprint. Toronto: Royal Ontario Museum, 1976.

Cushman, Karen. "Jane Addams and the Labor Museum at Hull House." *Museum Studies Journal* 1 (Spring 1983), 20–25.

Dall, William Healey. *Spencer Fullerton Baird: A Biography.* Philadelphia: J. B. Lippincott Company, 1915.

Darrah, William Culp. *Powell of the Colorado.* Princeton: Princeton University Press, 1951.

De Beer, Gavin Rylands. *Sir Hans Sloane and the British Museum.* London: Oxford University Press, 1953.

Dexter, Ralph W. "Frederic Ward Putnam and the Development of Museums of Natural History and Anthropology in the United States." *Curator* 9 (June 1966), 151–55.

Dobbs, Stephen Mark. "Dana and Kent and Early Museum Education." *Museum News* 50 (October 1971), 38–41.

Dobson, Jessie. *John Hunter.* Edinburgh: E. & S. Livingstone, 1969.

Dolph, James Andrew. "Bringing Wildlife to Millions: William Temple Hornaday, The Early Years: 1854–1896." Ph.D. dissertation, University of Massachusetts, 1975.

Duveen, James Henry. *The Rise of the House of Duveen.* London: Longmans, Green, 1957.

Eckardt, Wolf von. "High on Tech: Roger Kennedy's Aim." *Washington Post,* March 1, 1980, B1–B2.

Edwards, Edward. *Lives of the Founders of the British Museum; With Notices of Its Chief Augmentors and Other Benefactors 1570–1870.* London: Trübner, 1870.

Eliot, Samuel. *Memoir of Charles Callahan Perkins.* Cambridge, MA: John Wilson and Son, 1887.

Fagan, Louis. *The Life and Correspondence of Sir Anthony Panizzi.* 2 vols. Boston: Houghton Mifflin, 1881.

Finley, David Edward. *A Standard of Excellence: Andrew W. Mellon Founds the National Gallery of Art at Washington.* Washington, DC: Smithsonian Institution Press, 1973.

Fogg Art Museum. *Edward Waldo Forbes, Yankee Visionary.* Cambridge: Fogg Art Museum, Harvard University, 1971.

Fosdick, Raymond Blaine. *John D. Rockefeller, Jr., a Portrait.* New York: Harper, 1956.

Frankfurter, Alfred. "Editorial: Uncloistering Rorimer." *Art News* 54 (September 1955), 17.

Frye, Melinda Young. "Pioneers in American Museums: Charles P. Wilcomb." *Museum News* 55 (May-June 1977), 55–60.

Gimpel, Rene. *Diary of an Art Dealer,* translated by John Rosenberg. New York: Farrar, Straus and Giroux, 1966.

Goode, George Brown. "The Three Secretaries." In *The Smithsonian Institution 1846–1896: The History of Its First Half Century,* edited by George Brown Goode. Washington, DC: n.p., 1897. Reprint. New York: Arno Press, 1980.

Gould, Alice Bache. *Louis Agassiz.* Boston: Small, Maynard, 1901.

Green, Constance McLaughlin. *Washington: Capital City, 1879–1950.* Princeton: Princeton University Press, 1963.

Gregory, William King. "Bashford Dean, 1867–1928." *Science,* December 28, 1928, 635–38.

———. "Biographical Memoir of Henry Fairfield Osborn, 1857–1935." *National Academy of Sciences of the United States of America Biographical Memoir* 19 (1937), 53–119.

———. "Biographical Memoir of Frank Michler Champan, 1864–1945." *National Academy of Sciences of the United States of America Biographical Memoirs* 25 (1949), 111–45.

Grosvenor, Melville Bell. "How James Smithson Came to Rest in the Institution He Never Knew." *Smithsonian* 6 (January 1976), 30–37.

Grove, Richard. "Pioneers in American Museums: John Cotton Dana." *Museum News* 56 (May-June 1978), 32–39, 86–88.

Guggenheim, Marguerite. *Confessions of an Art Addict.* New York: Macmillan, 1960.

Gusdorf, Georges. "Conditions and Limits of Autobiography." In *Autobiography, Essays Theoretical and Critical,* edited by James Olney. Princeton: Princeton University Press, 1980.

Guyot, Arnold Henry. *Memoir of Louis Agassiz, 1807–1873.* Princeton: C. S. Robinson, 1883.

Haberly, Loyd. "The American Museum from Baker to Barnum." *New-York Historical Society Quarterly* 43 (July 1959), 273–87.

Hackney, Louise Wallace. *Wing of Fame, a Novel Based on the Life of James Smithson.* New York: D. Appleton-Century, 1934.

Hadley, Chalmers. *John Cotton Dana, a Sketch.* American Library Pioneers, no. 5. Chicago: American Library Association, 1943. Reprint. Boston: Gregg Press, 1972.

Hagenbeck, Carl. *Beasts and Men, Being Carl Hagenbeck's Experiences for Half a Century Among Wild Animals,* translated by Hugh S. R. Elliot and A. G. Thacker. London: Longmans, Green, 1911.

Hammack, David C. *Power and Society: Greater New York at the Turn of the Century.* New York: Russell Sage Foundation, 1982.

Harris, Neil. *Humbug: The Art of P. T. Barnum.* Boston: Little, Brown, 1973.

Harvey, George Brinton McClellan. *Henry Clay Frick, the Man*. New York: Charles
 Scribner's Sons, 1928.
Havemeyer, Louisine W. *Sixteen to Sixty: Memoirs of a Collector*. New York: private,
 1961.
Herber, Elmer Charles, ed. *Correspondence Between Spencer Fullerton Baird and
 Louis Agassiz—Two Pioneer American Naturalists*. Washington, DC: Smith-
 sonian Institution, 1963.
Herskovits, Melville. *Franz Boas: The Science of Man in the Making*. New York:
 Charles Scribner's Sons, 1953.
Hess, John L. *The Grand Acquisitors*. Boston: Houghton Mifflin, 1974.
Hesseltine, William B. *Pioneer's Mission: The Story of Lyman Copeland Draper*.
 Madison: State Historical Society of Wisconsin, 1954. Reprint. Westport, CT:
 Greenwood Press, 1970.
Hinsley, Curtis M., Jr., and Bill Holm. "A Cannibal in the National Museum: The
 Early Career of Franz Boas in America." *American Anthropologist* 78 (June
 1976), 306–16.
Holder, Charles Frederick. *Louis Agassiz: His Life and Work*. New York: G. P.
 Putnam's Sons, 1893.
Hooker, Joseph Dalton. *A Sketch of the Life and Labours of Sir William Jackson
 Hooker . . . Late Director of the Royal Gardens of Kew*. Oxford: Clarendon
 Press, 1903.
Hooker, Joseph Dalton, and Leonard Huxley. *Life and Letters of Sir Joseph Dalton
 Hooker*. 2 vols. London: John Murray, 1918. Reprint. New York: Arno Press,
 1978.
Horine, Emmet Field. *Daniel Drake, 1785–1852: Pioneer Physician of the Midwest*.
 Philadelphia: University of Pennsylvania Press, 1961.
Hornaday, William Temple. *Two Years in the Jungle: The Experiences of a Hunter
 and Naturalist in India, Ceylon, the Malay Peninsula and Borneo*. 9th ed.
 New York: Charles Scribner's Son's, 1910.
Houghton, Arthur A., Jr., Theodore Rousseau, Edouard Morot-Sir, and Sherman
 E. Lee. "James J. Rorimer." *The Metropolitan Museum of Art Bulletin*, n.s.
 25 (Summer 1966), 38–45.
Hoving, Thomas. *The Chase, the Capture: Collecting at the Metropolitan*. New York:
 Metropolitan Museum of Art, 1975.
Hunter, Wilbur H., Jr. "The Tribulations of a Museum Director in the 1820's."
 Maryland Historical Magazine 49 (September 1954), 214–22.
Huth, Hans. "Pierre Eugène Du Simitière and the Beginnings of the American
 Historical Museum." *Pennsylvania Magazine of History and Biography* 69
 (October 1945), 315–25.
Hyams, Barry. *Hirshhorn, Medici from Brooklyn: A Biography*. New York: E. P.
 Dutton, 1979.
Irby, John Robin McDaniel. *On the Works and Character of James Smithson*. Wash-
 ington, DC: Smithsonian Institution, 1878.
Jaher, Frederic Cople. "The Politics of the Boston Brahmins: 1800–1860." In *Boston,
 1700–1980: The Evolution of Urban Politics*, edited by Ronald P. Formisano
 and Constance K. Burns. Contributions in American History, no. 106. West-
 port, CT: Greenwood Press, 1984.

Johnson, Walter R. *A Memoir on the Scientific Character and Researches of the Late James Smithson, Esq., F.R.S.* Philadelphia: Barrett and Jones, 1844.

Kaempffert, Waldemar. "Oskar von Miller." *Scientific Monthly* 38 (May 1934), 489–91.

Kastner, Joseph. *A Species of Eternity.* New York: Knopf, 1977.

Kent, Henry Watson. *What I Am Pleased to Call My Education*, edited by Lois Leighton Comings. New York: Grolier Club, 1949.

Kingdon, Frank. *John Cotton Dana: A Life.* Boston: Merrymount Press, 1940.

Klein, Woody. *Lindsay's Promise: The Dream That Failed: A Personal Account.* New York: Macmillan, 1970.

Kunz, George Frederick. "Memoir of Albert Smith Bickmore." *Bulletin of the Geological Society of America* 26 (March 1915), 18–21.

Lagercrantz, Bo. "A Great Museum Pioneer of the Nineteenth Century." *Curator* 7 (1964), 179–84.

Levy, Julien. *Memoir of an Art Gallery.* New York: G. P. Putnam's Sons, 1977.

Lillywhite, Bryant. *London Coffee Houses: A Reference Book of Coffee Houses of the Seventeenth, Eighteenth, and Nineteenth Centuries.* London: George Allen and Unwin, 1963.

Lipton, Barbara. "John Cotton Dana and the Newark Museum." *Newark Museum Quarterly* 30 (Spring-Summer 1979), 1–58.

Lomask, Milton. *Seed Money: The Guggenheim Story.* New York: Farrar, Straus, 1964.

Lorant, Stefan, ed. *Pittsburgh: The Story of an American City.* Garden City, NY: Doubleday, 1964.

Lord, Clifford L., ed. *Keepers of the Past.* Chapel Hill: University of North Carolina Press, 1965.

Lucas, Frederic Augustus. *Fifty Years of Museum Work: Autobiography, Unpublished Papers, and Bibliography of Frederic A. Lucas.* New York: American Museum of Natural History, 1933.

Lucas, George A. *The Diary of George A. Lucas: An American Art Agent in Paris, 1857–1909.* 2 vols. Princeton: Princeton University Press, 1979.

Lukach, Joan M. *Hilla Rebay: In Search of the Spirit of Art.* New York: G. Braziller, 1983.

Lurie, Edward. *Louis Agassiz: A Life in Science.* Chicago: University of Chicago Press, 1960.

———. *Nature and the American Mind: Louis Agassiz and the Culture of Science.* New York: Science History Publications, 1974.

Lynes, Russell. "The Pilot of the Treasure House—Mr. Hoving at the Met." *Art in America* 55 (July-August 1967), 22–31.

———. "A Square Peg in a Square Hole: Conversations with Carter Brown." *Art in America* 58 (March-April 1970), 80–85.

Lyte, Charles. *Sir Joseph Banks: 18th Century Explorer, Botanist, and Entrepreneur.* Newton Abbot, England: David & Charles, 1980.

Maas, Jeremy. *Gambart: Prince of the Victorian Art World.* London: Barrie & Jenkins, 1975.

Marcou, Jules. *Life, Letters, and Works of Louis Agassiz.* 2 vols. New York: Macmillan, 1895.

Marquis, Alice G. *Alfred H. Barr, Jr.: Missionary for the Modern.* Chicago, IL: Contemporary Books, 1989.

Mariano, Nicky. *Forty Years with Berenson.* New York: Alfred A. Knopf, 1966.

Marling, Karal Ann. "William M. Milliken and Federal Art Patronage of the Depression Decade." *Bulletin of the Cleveland Museum of Art* 61 (December 1974), 319–20.

Maurois, André. *Aspects of Biography,* translated by Sydney Castle Roberts. New York: D. Appleton, 1930.

Mayes, Stanley. *The Great Belzoni, Archeologist Extraordinary.* New York: Walker, 1961.

McClung, Robert M., and Gale S. McClung. "Tammany's Remarkable Gardiner Baker: New York's First Museum Proprietor, Menagerie Keeper, and Promoter Extraordinary." *New-York Historical Society Quarterly* 42 (April 1958), 142–69.

McFadden, Elizabeth. *The Glitter and the Gold: A Spirited Account of the Metropolitan Museum of Art's First Director, the Audacious and High-Handed Luigi Palma di Cesnola.* New York: Dial Press, 1971.

McPhee, John. *A Roomful of Hovings and Other Profiles.* New York: Farrar, Straus and Giroux, 1968.

Mellow, James R. *Charmed Circle: Gertrude Stein & Company.* New York: Praeger, 1974.

Mill, Anna J. "Some Notes on Mill's Early Friendship with Henry Cole." *Mill News Letter* 4 (Spring 1969), 2–8.

Miller, Edward. *Prince of Librarians: The Life and Times of Antonio Panizzi of the British Museum.* Athens: Ohio University Press, 1967.

Milliken, William Mathewson. *Born Under the Sign of Libra: An Autobiography.* Cleveland: Western Reserve Historical Society, 1977.

Mitchell, Henry. "The Kingdom of Theodore Reed: The Softness of an Okapi's Kiss & Other Memories of the Zoo Director." *Washington Post,* March 11, 1983, D1–D2.

Mongan, Agnes. "Paul Joseph Sachs (1879–1965)." *Art Journal* 25 (Fall 1965), 50, 52.

Morse, Edward Sylvester. "Jean Louis Rudolphe Agassiz." *Popular Science Monthly* 71 (December 1907), 542–49.

Mount Vernon Ladies' Association of the Union. *Historical Sketch of Ann Pamela Cunningham.* Jamaica, NY: Marion Press, 1929.

Murphy, Robert Cushman. "Carl Ethan Akeley, 1864–1926." *Curator* 7 (1964), 307–20.

Nevins, Alan, and Frank Ernest Hill. *Ford.* Vol. 2: *Expansion and Challenge, 1915–1933.* New York: Charles Scribner's Sons, 1957.

Newark Museum. *Louis Bamberger, Honorary President of the Newark Museum: A Tribute to His Memory by His Fellow Trustees.* Newark: Newark Museum, 1944.

Newhall, Beaumont. "Alfred H. Barr, Jr.: He Set the Pace and Shaped the Style." *Art News* 78 (October 1979), 134–37.

Noël Hume, Ivor. *All the Best Rubbish.* New York: Harper & Row, 1974.

Nowinski, Judith. *Baron Dominique Vivant Denon (1747–1825): Hedonist and Scholar in a Period of Transition.* Rutherford: Fairleigh Dickinson University Press, 1970.

O'Connor, Harvey. *Mellon's Millions, the Biograpy of a Fortune: The Life and Times of Andrew W. Mellon.* New York: John Day, 1933.

Oehser, Paul Henry. *Sons of Science: The Story of the Smithsonian Institution and Its Leaders.* New York: Henry Schuman, 1949.

Oldenburg, Richard E., Robert Rosenblum, Dorothy C. Miller, and Hellmut Wohl. "Alfred H. Barr, Jr.—'The Conscientious, Continuous, Resolute Distinction of Quality from Mediocrity.' " *Art News* 80 (November 1981), 166–67.

Orosz, Joel J. "Pierre Eugène Du Simitière: Museum Pioneer in America." *Museum Studies Journal* 1 (Spring 1985), 8–18.

Osborn, Henry Fairfield. *Fifty-two Years of Research, Observation and Publication, 1877–1929: A Life Adventure in Breadth and Depth*, edited by Florence Milligan. New York: Charles Scribner's Sons, 1930.

———. *Cope: Master Naturalist: The Life and Letters of Edward Drinker Cope, With a Bibliography of His Writings Classified by Subject*. Princeton: Princeton University Press, 1931. Reprint. New York: Arno Press, 1978.

Owen, Richard S. *The Life of Richard Owen*. 2 vols. New York: D. Appleton, 1894. Reprint. New York: AMS Press, 1975.

Owens, Gwendolyn. "Pioneers in American Museums: Bryson Burroughs." *Museum News* 57 (May-June 1979), 46–53, 84.

Parker, Franklin. "George Peabody and the Peabody Museum of Salem." *Curator* 10 (1967), 137–53.

———. *George Peabody: A Biography*. Nashville, TN: Vanderbilt University Press, 1971.

Phillips, Marjorie. *Duncan Phillips and His Collection*. Boston: Little, Brown, 1970.

Pilling, Ronald W. "Henry Chapman Mercer and the Moravian Tile Works." *American Art & Antiques* 2 (November-December 1979), 78–83.

Pollack, Barbara. *The Collectors: Dr. Claribel and Miss Etta Cone*. Indianapolis: Bobbs-Merrill, 1962.

Porter, Charlotte M. "The Rise to Parnassus: Henry Fairfield Osborn and the Hall of the Age of Man." *Museum Studies Journal* 1 (Spring 1983), 26–34.

"Profile: John Pope-Hennessy." *Apollo* 77 (March 1963), 242–43.

Reid, Benjamin Lawrence. *The Man From New York: John Quinn and his Friends*. New York: Oxford University Press, 1968.

Rhees, William J. *James Smithson and His Bequest*. Smithsonian Miscellaneous Collections, vol. 21. Washington, DC: Smithsonian Institution, 1880. Reprinted in *William J. Rhees on James Smithson*. New York: Arno Press, 1980.

Rhoades, Katherine Nash. "An Appreciation of Charles Lang Freer (1856–1919)." *Ars Orientalis* 2 (1957), 1–4.

Roberts, George, and Mary Roberts. *Triumph on Fairmount: Fiske Kimball and the Philadelphia Museum of Art*. Philadelphia: J. B. Lippincott, 1959.

Rogers, Garet [pseud.]. *Lancet, a Novel*. New York: G. P. Putnam's Sons, 1956.

Saarinen, Aline B. *The Proud Possessors: The Lives, Times and Tastes of Some Adventurous American Art Collectors*. New York: Random House, 1958.

Samuels, Ernest. *Bernard Berenson: The Making of a Connoisseur*. Cambridge: Belknap Press of Harvard University Press, 1979.

Schack, William. *Art and Argyrol: The Life and Career of Dr. Albert C. Barnes*. New York: Thomas Yoseloff, 1960.

Schwartz, Richard B. *Daily Life in Johnson's London*. Madison: University of Wisconsin Press, 1983.

Seligman, Germain. *Merchants of Art: 1880–1960: Eighty Years of Professional Collecting*. New York: Appleton-Century-Crofts, 1961.

Sellers, Charles Coleman. *Charles Willson Peale*. New York: Charles Scribner's Sons, 1969.

————. *Patience Wright, American Artist and Spy in George III's London*. Middleton, CT: Wesleyan University Press, 1976.

————. *Mr. Peale's Museum: Charles Willson Peale and the First Popular Museum of Natural Science and Art*. New York: W. W. Norton, 1980.

Shaw, Elizabeth. "René d'Harnoncourt: A Belief in 'Things We Can't Conceive of Yet.' " *Art News* 78 (October 1979), 138–40.

Sheppard, Francis Henry. *London, 1808–1870: The Infernal Wen*. Berkeley: University of California Press, 1971.

Shepperson, Wilbur S. "William Bullock—An American Failure." *Bulletin of the Historical and Philosophical Society of Ohio* 19 (April 1961), 144–52.

Sherman, Claire Richter. "Pioneers in American Museums: Dorothy Miner." *Museum News* 59 (March-April 1981), 36–41, 54, 57.

Sifton, Paul G. "A Disordered Life: The American Career of Pierre Eugène Du Simitière." *Manuscripts* 25 (Fall 1973), 235–53.

Sizer, Theodore. "James Jackson Jarves: A Forgotten New Englander." *New England Quarterly* 6 (June 1933), 328–52.

Smithsonian Institution, ed. "A Memorial of George Brown Goode, Together with a Selection of His Papers on Museums and on the History of Science in America." In *Annual Report of the Board of Regents of the Smithsonian Institution . . . 1897. Report of the U.S. National Museum*, Pt. 2. Washington, DC: Government Printing Office, 1901.

Spalding, Frances. *Roger Fry, Art and Life*. London: Granada Publishing, 1980.

Spann, Edward K. *The New Metropolis: New York City, 1840–1857*. New York: Columbia University Press, 1981.

Sprigge, Sylvia. *Berenson: A Biography*. Boston: Houghton Mifflin, 1960.

Stearns, Raymond Phineas. "James Petiver: Promoter of Natural Science, c. 1663–1718." *Proceedings of the American Antiquarian Society* 62 (October 1952), 243–365.

Steegmuller, Francis. *The Two Lives of James Jackson Jarves*. New Haven: Yale University Press, 1951.

Sterne, Margaret. *The Passionate Eye: The Life of William R. Valentiner*. Detroit: Wayne State University Press, 1980.

Stillinger, Elizabeth. *The Antiquers: The Lives and Careers, The Deals, The Finds, The Collections of the Men and Women Who Were Responsible for The Changing Taste in American Antiques, 1850–1930*. New York: A. Knopf, 1980.

Stoner, Joyce Hill. "Pioneers in American Museums: George L. Stout." *Museum News* 56 (July/August 1978), 16–18.

Sward, Keith. *The Legend of Henry Ford*. New York: Rinehart, 1948. Reprint. New York: Atheneum, 1968.

Sweeney, John A. H. *Henry Francis du Pont: Observations on the Occasion of the 100th Anniversary of His Birth, May 27, 1980*. Winterthur: Henry Francis du Pont Winterthur Museum, 1980.

Taylor, Francis Henry. *Pierpont Morgan as Collector and Patron, 1837–1913*. New York: Pierpont Morgan Library, 1957.

Taylor, Tom. *Leicester Square: Its Associations and Its Worthies. With a Sketch of*

Hunter's Scientific Character and Works, by Richard Owen. London: Bickers and Son, 1874.

Teller, James David. *Louis Agassiz, Scientist and Teacher*. Graduate School Studies, Education Series, no. 2. Columbus: Ohio State University Press, 1947.

Tharp, Louise Hall. *Mrs. Jack: A Biography of Isabella Stewart Gardner*. Boston: Little, Brown, 1965.

Thomson, Peggy. *Museum People: Collectors and Keepers at the Smithsonian*. Englewood Cliffs, NJ: Prentice Hall, 1977.

Towner, Wesley. *The Elegant Auctioneers*. New York: Hill & Wang, 1970.

Tucker, Louis Leonard. "The Western Museum of Cincinnati, 1820–1867." *Curator* 8 (1965), 17–35. Reprinted as " 'Ohio Show-Shop': The Western Museum of Cincinnati, 1820–1867." In *A Cabinet of Curiosities: Five Episodes in the Evolution of American Museums*, by Whitfield J. Bell, Jr., Clifford K. Shipton, John C. Ewers, Louis Leonard Tucker, and Wilcomb E. Washburn. Charlottesville: University Press of Virginia, 1967.

Turner, Frederick Jackson. *Reuben Gold Thwaites: A Memorial Address*. Madison: State Historical Society of Wisconsin, 1914.

Turrill, William Bertram. *Joseph Dalton Hooker: Botanist, Explorer, and Administrator*. London: Thomas Nelson and Sons, 1963.

Vanderbilt, Kermit. *Charles Eliot Norton: Apostle of Culture in a Democracy*. Cambridge: Belknap Press of Harvard University Press, 1959.

Vollard, Ambroise. *Recollections of a Picture Dealer*, translated by Violet M. MacDonald. New York: Hacker Art Books, 1978.

Wade, Richard C. *The Urban Frontier: Pioneer Life in Early Pittsburgh, Cincinnati, Lexington, Louisville, and St. Louis*. Chicago: University of Chicago Press, 1959.

Walker, John. *Self-Portrait with Donors: Confessions of an Art Collector*. Boston: Little, Brown, 1974.

Wall, Charles C. "Ann Pamela Cunningham: First Lady of Preservation." *Mount Vernon Ladies' Association of the Union Annual Report* (1975), 10–17.

Wall, Joseph Frazier. *Andrew Carnegie*. New York: Oxford University Press, 1970.

Wallace, Irving. *The Fabulous Showman: The Life and Times of P. T. Barnum*. New York: Alfred A. Knopf, 1959.

Washburn, Wilcomb E. "The Museum and Joseph Henry." *Curator* 8 (1965), 35–54. Revised and reprinted as "Joseph Henry's Conception of the Purpose of the Smithsonian Institution." In *A Cabinet of Curiosities: Five Episodes in the Evolution of American Museums*, by Whitfield J. Bell, Jr., Clifford K. Shipton, John C. Ewers, Louis Leonard Tucker, and Wilcomb E. Washburn. Charlottesville: University Press of Virginia, 1967.

Weigley, Russell F., ed. *Philadelphia: A 300–Year History*. New York: W. W. Norton, 1982.

Werner, Morris Robert. *Barnum*. New York: Harcourt Brace, 1923.

Wescher, Paul. "Vivant Denon and the Musée Napoléon." *Apollo* 80 (September 1964), 178–86.

Wharton, Edith. *False Dawn*. New York: D. Appleton, 1924.

Woolf, Virginia. *Roger Fry, and Biography*. New York: Harcourt, Brace, 1940. Reprint. New York: Harcourt Brace Jovanovich, 1976.

11

PROFESSIONALISM AND THE MUSEUM

J. Lynne Teather

Like a bad penny, the question of whether museum work is a profession keeps turning up in museum writings but with few conclusive results. The problem defies easy solution, largely because the concept of professionalism has been subject to multiple definitions and interpretations not easily applied to the museum. An examination of commonly accepted sociological criteria for professionalism, such as a discrete field of expertise, occupational associations, formal systems of training, standards, and a code of ethics, suggests that museum work is at best a semi- or pseudo-profession. But the degree to which the museum occupation corresponds to this abstract model should not divert attention from larger considerations of the social role of the museum staff. To understand better the current dynamics of professionalism in the museum setting, museum workers must also be seen in terms of their past efforts to generate public acceptance of their autonomy as an occupational group.

HISTORIC OUTLINE

The complexities of the museum workplace have both fostered and limited the development of a professional consciousness for museum workers. In sharp contrast to lawyers, physicians, and clergy, persons attached to museums in the eighteenth and nineteenth centuries had no uniform background and shared few duties, as suggested by the variety of titles from curator and keeper to director and conservator. Sometimes the worker was the original collector who was familiar with his or her materials and the

characteristics of the collection. At other times, personnel were recruited from the ranks of amateur assistants, servants, technicians, and artists (including such masters as Bellini and Donatello) whose abilities were deemed suitable for curating museum collections.

In many museums, the delegation of responsibility from the original creators to others in an honorary or paid capacity was accelerated by legal incorporation, transfer to government control, or maintaining longer visitation hours. The transition to a permanent staff could occur at any time, and it is important to note that many museums, especially those organized as private societies, continued to be run by members in the amateur tradition. Thus, the process was often ambiguous, and the degree of authority delegated among the collector, the trustees, and the staff was unclear, resulting in a legacy of frequent management problems.

Despite the emergence of the permanent staff, there remained many different ways of entering museum work. Amateur enthusiasts, collectors, and men and women of means who helped to found museums often became honorary curators or members of governing boards. Alternatively, technicians and craftsmen entered the museum by means of apprenticeship and worked their way up through the organization. Still others acquired museum positions by virtue of family ties or the correct liberal education. As a result of these diverse avenues of entry, museum workers did not adhere to a single ideological view of the museum and its place in society. Early articles by museum leaders indicate that the heterogeneous characteristics of museums themselves contributed to the rise of divergent professional ideologies. On one hand, curatorship was increasingly associated with research abilities, particularly in the leading national, university, and regional museums. In these large institutions, scientific scholarship paralleled the growing concentration of collections and proliferation of organizational subdivisions. Curators who emphasized the museum's research function formulated an object-oriented ideology that justified the existence of the museum in terms of its unique role in acquiring, studying, and preserving collections of cultural objects and scientific specimens.

On the other hand, the growing popularity of the museum as a public institution created new pressures for museum education and community programs. Although large institutions could respond to public demands with greater specialization in staff functions, smaller museums frequently relied on generalist curators who had little opportunity for original research. James Bailey of the British Museum (Natural History) observed in 1922 that such personnel were at the opposite end of the scale from the research curators and directors of the state museums. "In some cases," Bailey added, "the curator is the whole staff and in addition to dealing with the collections has to clean the building." More intimately involved with the museum visitors, these workers espoused a public-oriented ideology that was both missionary in nature and democratic in spirit, presenting the museum as a beneficial

instrument for public education, scientific development, community well-being, and the refinement of industrial design and consumer tastes.

These competing ideologies, which exist to the present day, presented recurrent obstacles to professionalization. Because they projected conflicting messages to those outside the museum occupation, they helped to undermine the validation of museum work by the public, whose acknowledgment is required to maintain professional authority. Yet, taken alone, neither ideological alternative provided a viable basis for professionalization. The object-oriented ideology reinforced the uniqueness of museum work, but to the extent that it appeared undemocratic, it was politically or financially untenable. By contrast, the public-oriented ideology, while a successful strategy for creating and funding museums, challenged the exclusivity of museum workers, whose professional status depended on special expertise grounded in training or experience. This last point is critical, since the persistent failure to articulate a distinctive "body of knowledge" as a basis for an ideology impeded the development of a professional social structure.

Latent ideological conflicts stemming from disagreements over the nature of museum work were first revealed in the late nineteenth century when an enthusiastic cadre of personnel attempted to create occupational associations as an initial step toward professionalization. In Britain, curators and museum critics modeled the Museums Association (1889), the first organization devoted to museum issues, on precedents established by librarians, including the American Library Association (1876) and the British Library Association (1877). The objectives of this body were clearly directed at museum reform, and British museum leader H. M. Platnauer of York perhaps best captured the spirit of the early associations when he urged his colleagues to "depart from their traditional lines of action," while recognizing that "amateurism would have to give way to what could best be described as professionalism." The Museums Association assumed responsibility for helping museums to exchange duplicates and surplus specimens, as well as to share information concerning the production of labels, illustrations, and other exhibit devices. Its founders recognized the need to improve classification schemes and develop uniform plans for the arrangement of natural history collections. Significantly, they hoped to influence legislation governing the establishment of museums and improve communication within the occupational group by means of a printed journal.

By the turn of the century, professional museum associations, each supporting annual conferences and periodical publications, were being founded in other countries as part of a broad international movement. In the United States, an organizational meeting of nine museum directors in Washington, D.C., led to the first annual meeting of the American Association of Museums (AAM) in 1906, which was attended by seventy-one delegates from major institutions across the country. The AAM adopted a more assertive organizational posture than its British predecessor, and delegates to its 1909 meet-

ing argued that museum work—described as "the care of art and other collections"—should develop along lines similar to those of the "new profession of librarians." Other national museum associations followed the AAM, including the Scandinavian Museiforbundet (1915), the German Deutscher Museumsbund (1917), and the Association Syndicale des Conservateurs des collections publiques de France (1918). Associations have since been created in Czechoslovakia, the Netherlands, Austria, Switzerland, Poland, Japan, New Zealand, and Canada.

Membership in the associations grew in size as the number of employees working in museums increased, and in the 1920s several organizations established permanent secretariats to provide continuous service to their members and promote the museum occupation through public relations and research projects. The AAM opened an office in Washington, D.C., with a grant from the Laura Spelman Rockefeller Memorial Foundation in 1923. A grant from the Carnegie United Kingdom Trust underwrote a permanent office for the British Museums Association. In 1927, at the suggestion of the French art historian Henri Focillon, the International Museums Office was established in Paris under the auspices of the League of Nations Committee of Intellectual Cooperation. After World War II, this organization was superseded by the International Council of Museums (ICOM), initiated by Chauncey Hamlin of the Buffalo Museum of Natural Sciences.

Through meetings, publications, and central office activities, the associations that coalesced around the concerns of museum workers provided a useful forum for the occupation. But from the beginning, their professionalizing influence has been limited. Like the occupational group itself, association members represent a broad spectrum of interests, to the detriment of organizational unity. In Britain, for example, membership in the Museums Association was patterned after the library associations and allowed for both museums and museum personnel, thereby compromising the ability of the association to act as a purely professional body simply because it represented both employers and employees. Furthermore, membership was not confined to a specific group of individuals but was open to anyone interested in the goals of the association, including board members, volunteers, and enthusiastic supporters, as well as the paid museum staff. The reluctance of personnel from the large national museums to join the association complicated the situation by creating disproportionate representation.

For many associations, the inability to accommodate the wide variety of institutions, jobs, and philosophical emphases in a single organization led to a loss of cohesion, marked by acrimonious debates on the proper balance between collecting and education. In some cases, ideological differences forced an early decision on whether to separate art and science museum workers, as was done in France and Scandinavia, or to attempt to represent all disciplines in a single body, as was done in Britain and the United States. The threat of fragmentation was recognized as early as 1913, when British

museum commentators decried the "constant tendency" toward differentiation and specialization in museum work. A single association, they hoped, would foster professional unity by bringing together "those who might otherwise find themselves isolated, ploughing a lonely furrow, and liable therefore under the pressure of circumstances to produce something considerably less than their best work."

Nonetheless, increasing specialization generated a multitude of suborganizational groups. In the AAM, regional conferences were soon created in addition to section meetings, and in the 1960s they evolved into standing professional committees. Special interest groups emerging within British, American, and Canadian associations, as well as within ICOM, sometimes retained their allegiance to the parent organization but often sought independence. Thus, in the United States there are several professional bodies in addition to the AAM and its regional conferences, including the American Association of State and Local History, the Association of College Art Museum Directors, and the Association of Science-Technology Centers, to name only a few. This movement toward multiple organizations for the various occupational constituencies has had a damaging impact on the professionalization of museum work since associations are an important means to define occupational jurisdictions. Museum workers in many countries are currently represented not by a single but by a multitude of organizations, each devoted to specific types of museums, museum jobs, and geographic regions, and none of which is the occupation's sole voice to the public regarding matters of training, performance, promotion, or pay levels.

From the early years of the associations, the improvement of training procedures has been a central issue. Concern for the education of museum workers was partly generated by a sense of the growing complexities of collections, exhibition techniques, and interpretive functions, as well as by the rising number of specialized positions for which few museum personnel were adequately prepared. But as early as 1894, Britain's James Paton recognized the difficulties in designing a curriculum for students who would ultimately be expected to fill a variety of openings, ranging from the specialized post in the large national museum to the curatorship of the small local collection. Beyond the problem of the content of the curriculum, the balance of training methods—apprenticeship and classroom instruction—as well as the relative roles of the university and museum communities in controlling the training process remained open questions. In short, the very mechanism by which museum workers transmitted the knowledge and expertise of their occupation was at issue.

It soon became obvious that some control by the association over preparation for museum work, as an alternative to the antiquated apprenticeship system, would be a precondition to improved occupational status. Thus, the AAM and the College Art Association sponsored a Committee on the Training for Art Museum Workers as early as 1917. The committee turned its attention

to the interrelationship between training and the labor market and recommended a survey of "the outlook for museum workers, including rates of pay, possible openings and the prevailing tendencies for future development of the museums field." Although a detailed job study along these lines would not be undertaken for several decades, the committee's discussions suggested an early awareness of the potential role of formal, academically based systems of education as a means of controlling entry into the workplace.

In the meantime, several universities and colleges independently developed museum curricula, one of the first being the University of Iowa, where Homer R. Dill provided training in taxidermy and exhibition techniques after 1908. By 1939, training programs were operating in seventeen American schools and museums, including Wellesley College, Harvard University, the Newark Museum, the Buffalo Museum of Science, and the Brooklyn Museum. In Britain, intermittent discussions preceded the creation of a diploma of the Museums Association, which was first offered on a trial basis in 1930 and formally instituted in 1932. At the same time, degree and diploma courses were established in academic specialties for art museum curators at the University of London's Courtauld Institute (1932) and for archaeologists at the Institute of Archaeology (1934).

The proliferation of university departments devoted to museum studies accelerated in the decades after World War II, producing a large number of programs of widely differing types, content, and quality. In cooperation with the Museums Association, the University of Leicester began offering a graduate certificate in museum studies in 1966, and a similar professional school was subsequently created at the University of Manchester, with special emphasis on the arts and decorative arts. In North America, particularly strong commitments to museum training were expressed through new programs at the Bank Street College of Education, The George Washington University, the University of Delaware, and the University of Toronto. University-based training in museology rapidly became an international phenomenon with the appearance of notable courses at the University of Paris, the University of Calcutta, and the Centre for the Study of Librarianship, Documentation and Information Sciences at the University of Zagreb in Yugoslavia.

But despite the widespread growth of training opportunities and the efforts of associations to upgrade museum work, the question regarding the expertise that such training programs should be imparting to aspiring museum workers remained unresolved. The way in which this underlying tension in museum training could suddenly erupt into open discord is dramatically illustrated by the important debates of the 1930s that pitted Alexander Ruthven against Laurence Coleman, museum leaders whose careers reflected the tension between the conception of museum work as a congeries of sub-disciplines, each with its own requirements, and a more holistic philosophy of museology as a unique discipline in its own right. A scientist and curator

at the University of Michigan, Ruthven argued that museum work consisted of nothing more than "a group of techniques, which must be determined, guided, and used by those skilled in the several fields of knowledge best cultivated in these institutions." Because it was "only incidental to the recognized disciplines," museum work possessed no basis for professionalization, and, as Ruthven observed, there could be no such thing as a museum professional. At best, the museum worker was a "professional zoologist, botanist, geologist, archaeologist, businessman, teacher, editor, taxidermist, or some other kind of specialist, working in a museum and having a knowledge of methods of gathering, preserving, demonstrating, and otherwise using data which should be saved."

Laurence Vail Coleman, the former director of the American Museum of Natural History and energetic leader of the AAM, challenged Ruthven's assertions in 1939 by defining professionalism as the application of both learning and skill to pursuits that redounded, at least in part, to the benefit of society. For Coleman, museum work, like engineering and architecture, could approach the status of such recognized professions as medicine, law, and theology. Just as medicine embraced more than the specialized methods of anatomy or pathology, museum work implied something larger than pure technique. But few directors and curators had successfully combined a competency in traditional museum techniques with an internally consistent system of theory, and Coleman admitted that museum work was still in a state of partial development. He concluded that the key to future professionalization was to link training to improved standards. "When museum people collectively get a firmer hold of their training and set standards of attainment, the next long step will be taken," Coleman predicted. "In law, medicine, and theology, it is the professional school that has created the profession."

Though inconclusive, the Ruthven-Coleman debate underscored the importance of creating a strong theoretical base and subjecting it to critical refinement. More than the occupational group's self-image was at stake, for all aspects of museum work, including certification and accreditation standards, methods of preparation, and entry into the work force, were influenced by this essential philosophical question. Museum educator Henry Watson Kent recognized the problems posed by poorly defined theories of museum work. In 1949, he reflected on the role of occupational associations in disseminating "knowledge of museum management," promoting cooperation among museums, and encouraging people to enter the field. Still, he sensed the absence of a defined body of knowledge analogous to what he had encountered in library school. Recalling the lectures of Melvyn Dewey at the Columbia Library School, Kent suddenly understood why his former mentor "devoted himself to the 'economy' side of his subject, leaving the other sort of lectures to the professors of the colleges."

Like Coleman and Kent, museum workers concerned with the issue of professionalism increasingly turned to education and explored ways of tying

the multitude of existing training programs more closely to the museum workplace. For example, ICOM's International Committee for Administration and Personnel, which conducted a worldwide survey of the museum occupation from 1956 to 1965, was renamed the International Committee for the Training of Museum Personnel in 1968 and began focusing its investigations on educational preparation.

In the United States, several critics pointed to the growing shortage of adequately trained personnel as museums expanded to meet postwar demands. Carl Guthe charged that museum workers had failed to articulate "acceptable standards of professional competence," with the result that neither boards of trustees nor the general public could "distinguish between amateur and professional performance." Although referring specifically to smaller institutions, Guthe argued that too many museums were poorly managed and represented a major "detriment to the museum movement." Noting similar work done by the American Library Association, he urged the Education Section of the AAM in 1957 to survey large and small museums for "job analyses" of actual positions in an effort to distill minimum requirements for training, experience, and ability. A few such studies were conducted in response, but most involved only limited samples.

In 1968, the AAM and the Federal Council on the Arts and Humanities again directed attention to the need for qualified museum workers in the *Belmont Report*, which concluded that "if the staffing needs of museums are to be met, a very substantial expansion of training programs will be essential." At the same time, private philanthropies such as the Ford and Rockefeller foundations began subsidizing museum training, as did governmental agencies like the National Endowment for the Humanities and the National Science Foundation. Nonetheless, the ambiguous status of museum training was amply illustrated in such job studies as a two-year investigation conducted by Susan Stitt into the relationships of institutionalized preparation, the employment process, and frequency of job openings. Working under a grant from the National Endowment for the Humanities, Stitt discovered that professional personnel employed by museums shared only a "modest level of education," that hiring was infrequent and the flow of job information imperfect, and that women and minorities suffered discriminatory treatment. Based on the extremely low level of trained workers, the obstacles facing museum training programs, and the difficulty of recent graduates in finding employment, Stitt concluded that formal training in museum work was not yet a priority of the museum community.

In fact, more than three decades after Ruthven's controversial attack, some prominent museum workers of the late 1960s continued to challenge the notion of a distinctive museum expertise. A. E. Parr, noted senior scientist at the American Museum of Natural History, rejected the attempts of Guthe and others to compare museum work to library science because he believed

the latter did not demand a wide variety of skills while the former entailed more professional talents than one individual could possibly master. Warning that its tasks and prerequisites were too variegated, Parr criticized efforts to mold museum work into a single professional guild. Parr's position was well publicized, but, like many of his predecessors, Parr himself was strongly influenced by the nature of the museum with which he was most familiar. In sharp contrast to the small general history museums that attracted Guthe's attention, the American Museum of Natural History was a large institution with highly diversified jobs, many with scholarly requirements. More important, despite Parr's misgivings, there were indications of an emerging consensus within the museum field that some means of controlling and improving museum work was sorely needed. What remained unclear was whether a system of certification should be aimed at training programs, individuals, institutions, or all three.

Concerned by the growing number of programs that seemingly adhered to few common assumptions or procedures, the AAM began a survey of ninety-one training courses in 1970 that ultimately provided the basis for a model curriculum. Moreover, in response to the concerns of museum workers and educators, such as those expressed at the Belmont Conference on Museum Training in 1976, the AAM appointed a Museum Studies Committee to examine the fundamental problems of museum training. The committee was charged with analyzing and assessing current training techniques in relation to the professional needs of the museum community and the public it served and to recommend minimum standards for training programs. The committee completed its work with the publication of a series of reports, and, in 1981, the AAM Professional Practices Committee began to examine the possibility of accrediting graduate programs in museum studies. While the committee concluded that a scheme of certification for training was not economically feasible, it did prepare a set of guidelines for self-monitoring of educational bodies. In a similar fashion, the Canadian Museums Association sponsored a ten-month study of museum jobs and training programs in 1978 that resulted in a curriculum guide, a directory of museum positions, and an individual certification scheme. More recently, the ICOM Committee on Training and Professional Development has released its own curriculum and guide to museum posts.

But despite high expectations among museum leaders, the new training programs have not proved universally successful in augmenting occupational jurisdiction or controlling entry into the workplace. Although ICOM has been conducting a survey on the subject since 1977, the current state of museum studies instruction around the world is unclear. The significance of formalized training as a mark of professionalism appears to vary widely from country to country. At one end of the spectrum, Japan's museum community supports a closely monitored system of preparation and certifi-

cation in which every museum worker must enter a four-year museology program at one of sixty-seven approved universities and pass a national examination in order to achieve the rank of professional curator.

The British system of preparation, though far less rigidly controlled, has also produced promising results. Through the Diploma Program of the Museums Association, students registered at the Universities of Leicester and Manchester are eligible to receive a postgraduate professional qualification, known as an Associateship in the Museums Association (AMA), in a number of technical and curatorial specialties. In addition to museological theory and practice, the curriculum at Leicester and Manchester emphasizes the application of an outside discipline to the museum setting. By 1977, it was estimated that 15 percent of the country's museum professionals had graduated from one of these two programs, and together they have produced half of the entrants into the profession in recent years. Thus, while it is still possible to secure a museum post without exposure to training courses recommended by the Museums Association, it has become increasingly unlikely.

At the other end of the spectrum, however, museum workers in many countries continue to enter the field through a variety of routes, relying on a combination of on-the-job preparation and loosely administered certification programs. In particular, North American occupational associations have been limited to recommending academic curricula and training standards on a voluntary basis. Most workers currently employed in American museums have had no formal preparation, and many contend that museological training is an unnecessary adjunct to their expertise in a recognized discipline.

Indeed, efforts to gain occupational control in the United States have followed a different course altogether by focusing on the institution rather than the individual. In the 1950s, the Southeastern Museum Conference of the AAM made an early appeal for museum accreditation and recommended either the association or a publicly chartered authority as the accrediting agency. The idea initially evoked little enthusiasm, and when Aalbert Heine again raised the argument for institutional accreditation in 1967, no such scheme was yet in operation. But in the changing climate of the late 1960s, accreditation gained new support in the context of greatly increased state and federal spending for museum programs. In response to a sharp rise in operating costs and a dramatic increase in attendance, which contributed to the belief that there was a funding crisis for museums, the Kennedy and Johnson administrations approved federal subsidies for museums and the arts. But neither the passage of the National Museum Act (1966) nor the creation of the National Endowment for the Humanities immediately directed funds to museums, at least in part because the basis for awarding federal grants remained uncertain. To resolve this difficulty, AAM president Charles Parkhurst appointed a committee to study accreditation under a grant from the Smithsonian Institution. The committee report, issued in

1970, led to the establishment of an accreditation program under AAM auspicies, which had accredited 484 museums by 1981.

While there have been predictable problems in the supervision of such a new and ambitious program, the accreditation scheme has also encountered surprising resistance from museum workers themselves. Perhaps more important, some funding bodies have been reluctant to accept accreditation as a criterion for disbursal, despite the fact that this contingency was a primary objective of the program from its inception. Largely an artificial response to the requirements of government funding agencies, the accreditation program now runs the risk of being reduced to a meaningless list unless greater commitment from the museum community is forthcoming.

The failure of professional associations to ensure the autonomy of museum workers through training programs or institutional accreditation, combined with the rising expectations of a new generation of museum employees, has resulted in sporadic attempts at unionization in the past decade. At New York's Museum of Modern Art, for example, the newly created Professional and Administrative Staff Association (PASTA/MOMA) went on strike in 1971. The organization, which represented 200 employees, including curators, conservators, registrars, and clerical personnel, protested the lack of job descriptions, fluctuating pay scales, and unfavorable working conditions. A central issue, however, was occupational autonomy; striking workers challenged the authority of the board of trustees and demanded a right to participate in policy decisions.

Although few of PASTA/MOMA's demands were met, employees of other institutions occasionally resorted to unionization, generally by delegating representatives to bargain with the museum management. In a few cases, difficulties arose when external unions attempted to organize the museum staff, creating bitter divisions between personnel who advocated the union model and those who still aspired to an occupation characterized by professional-client relationships. While it experienced only mixed success, the unionization movement graphically illustrated an underlying reality of the museum workplace. Despite occupational claims to professional autonomy, the emergence of groups like PASTA/MOMA suggests that museum workers ultimately derive their power from lay boards or government bodies that effectively regulate their employment and validate their expertise.

Another means by which some museum workers have attempted to maintain a common occupational tradition has been the creation of a code of ethics. Traditionally such professions as medicine and law have codified principles of conduct governing their individual practitioners in order to maintain standards of competency. As early as 1925, Laurence Coleman drafted a code of ethics for museums that was approved by the AAM and permitted to stand unchallenged for five decades. But by the 1970s, the growing concern for public accountability coincided with a new awareness of the illicit traffic in cultural properties, compelling museums to reexamine

the ethical basis of their operations, including acquisitions, governance, staff conduct, and museum management. An AAM committee responsible for studying the issue in 1978 concluded, after long debate, that no one code of ethics could meet the complexities of all museums, and it recommended a statement of ethical principles rather than a single regulatory code. Shortly after, in a decision reminiscent of the fragmentation that had plagued efforts to achieve an occupational consensus in the past, the Association of Art Museum Directors developed its own code of professional practices. To compound the problems posed by multiple codes of ethics, none of the associations sponsoring new codes possessed enforcement mechanisms to ensure that they were applied.

After a century of development, museology is still an emerging field, the existence of which is occasionally denied by its own practitioners. The variety of terms used to describe the field itself, running the gamut from *museology* to *museography* and *museum studies*, illustrates the underlying problem. Though publications and conferences abound, the impression remains that there is still a lack of critical thought. Like nursing, social work, and librarianship, museology has a strong basis in the ideals of public service. Unlike these semiprofessions, however, the museum field lacks a strong theoretical knowledge base.

The philosophical concerns reflected in the early literature have been lost to current practitioners, most of whom have entered the work force without exposure to existing professional schools. For them, museum work is a set of techniques applied to a particular job rather than a field of study for all museum positions. Even attendance at a graduate program does not guarantee familiarity with museum theory and practice because courses vary in length, content, and quality. Moreover, many programs emphasize museum techniques appropriate to a particular discipline, such as art history or zoology.

The museum field today suffers from contradictory pressures, at once encouraging and discouraging professionalization. On one hand, there have been remarkable efforts by museum workers to form associations, share work experiences, publish reports, conduct training programs, establish accreditation procedures, and codify ethics. The result has been the formation of a notable occupational society that shares many common values regarding at least some of the tasks in which museum workers are engaged. On the other hand, complicated forces rooted in the nature of the workplace itself, the inherent contradictions in the occupational group's professional ideology, and an ill-defined body of knowledge have mitigated against such efforts. Today this occupational group is represented not by one single organization but by a multitude, none of which can claim the exclusive loyalty of its members. There is considerable variation in training programs and the certification for individuals and institutions remains voluntary in character. Nor has a single body of knowledge emerged. Finally, while there are a number

of written codes of ethics, there is no enforcement mechanism within the associations. A review of the current literature and practices suggests the semiprofessional character of museum work.

SURVEY OF SOURCES

The growth of the museum occupation has been accompanied by intermittent discussions of the status of museum work, although most treatments of the issue are based on opinion rather than objective analysis. For example, the history of efforts to professionalize the museum field is rarely examined in any depth outside graduate dissertations like Charles Schwefel's "Museum Work as a Profession" (1980) and Lynn Teather's "Museology and its Traditions" (1984). The exception to the rule is the commemorative issue of *Museum News*, entitled "60 Years of Museum News" (1984) and edited by Ellen Hicks. In addition, training, as a subtheme of professionalization, attracted historical treatment in such works as "The Training of Museum Personnel in the United Kingdom" (1983) by Geoffrey Lewis and "A Companion to Change" (1984), William Tramposch's analysis of the Seminar for Historical Administration sponsored by the American Association for State and Local History since 1959, and Raymond Singleton's "Is Training Really Necessary?" (1983).

In general, however, works dealing with professionalism have been written by museum personnel whose use of the term *profession* is ambiguous and based on personalized definitions, ranging from the basic criterion of salaried work to such intangibles as a professional ethos. Because this literature relies heavily on conceptions of the ideal profession (usually described by an inventory of occupational characteristics), it is instructive to examine briefly the various abstract models developed by sociologists of professions. As Morris Cogan notes in "The Problem of Defining a Profession" (1955), sociologists cannot agree on a single definition of professionalism, although most recognize such primary traits as a common body of knowledge and a professional social structure characterized by associations, systems of education, and mechanisms for exercising jurisdiction over the performance of practitioners. For a general introduction to the debates over which elements best characterize a profession, see *The Sociology of the Professions* (1972) by Philip Elliott or *Professionalization* (1966), a collection of essays edited by Howard Vollmer and Donald Mills. The limits to professionalization and the need to establish standard criteria for gauging the status of occupational groups are discussed by Harold Wilensky in "The Professionalization of Everyone?" (1964).

Until recently, sociologists have been primarily concerned with testing a particular occupational group by comparing its attributes to a general model. Classic examples of this approach, sometimes referred to as analysis for goodness of fit, are William Goode's "The Librarian" (1961) and Abraham

Flexner's "Is Social Work a Profession?" (1915). For occupations that fail to measure up to the model in certain key respects, sociologists like Amitai Etzioni, in *The Semi-Professions and Their Organization* (1969), coin the terms *semi-professions, pseudo-professions,* or *partial professions.* In order to distinguish semiprofessions from the categories of "new" or "would-be" professions identified several decades ago by A. M. Carr-Saunders and P. A. Wilson in *The Professions* (1933), Nina Toren emphasizes the inherent factors that prevent some occupational groups from ever achieving full professionalism. In "Semi-Professionalism and Social Work" (1969), an essay with arresting implications for the museum occupation, Toren concludes that social workers lack a systematic body of knowledge with which they might demonstrate to the public's satisfaction that they are something more than enthusiastic amateurs.

At some point, the complex discussion of whether an occupation is or is not a profession can become a red herring, fraught with ambiguities not yet settled by the majority of sociologists. We can be sure that occupations like museum work are at least semi-professions, but as Everett Hughes argues in "Professions" (1965), it is perhaps more important to look beyond the definitional issue to examine how workers attempt to acquire some control over their own work. An additional school of sociologists emphasizes the functional relationships between the occupational group and the surrounding society. For example, in *The Profession* (1970), Wilbert Moore suggests that autonomy is the most important objective of any occupational group and the chief prerequisite to professionalism. Terence Johnson goes further in *Professions and Power* (1972) to analyze the ways in which an occupational group will acquire power to achieve its goals and aims.

Although lessons from the field of sociology of professions are not always clear, several writers endeavor to apply them to the museum setting. Such critical reviews as Stephen Weil's "The Ongoing Pursuit of Professional Status" (1988), Raymond August's essay, "So You Want to Start Your Own Profession! Fable, Fulfillment or Fallacy?" (1983), and "Professionalizing the Museum Worker" (1972) by Dorothy Mariner clearly follow the pattern established by William Goode and other sociologists concerned with the goodness of fit. Mariner, in particular, discovers that the museum occupation falls short of achieving several important criteria of professionalism. First, in the area of training, Mariner suggests that the haphazard state of museum studies programs is indicative of improper "socialization into the profession and inconsistent standards for its practice." Second, the uneven delegation of authority between lay boards, directors, and curators undermines professional jurisdiction in the workplace. Mariner concludes that because genuine professional status is ultimately dependent on the kind of public validation that the museum occupation has failed to elicit, overt claims by museum workers to professional legitimacy ring hollow.

By contrast, Raymond August weighs the benefits and detriments of

professionalism and suggests that the enhanced status and economic rewards that might result from more closely adhering to the professional model would not compensate for the loss of flexibility. Rather than tighten its standards through new testing procedures, August argues that the museum field should preserve its unique attributes, including its volunteer base and mixed routes of entry, regardless of whether such traits ultimately impede professionalization. Functional analyses of museum work in the manner suggested by Wilbert Moore or Terence Johnson are far less numerous than attempts to compare the occupation to a particular sociological model and are limited to occasional pieces such as "The Development of the Museum Professional" (1976) by Daniel Robbins.

Most commentators, in fact, are not firmly committed to any sociological theory and instead attempt to elaborate on the arguments expressed in the Ruthven-Coleman debate of the 1930s. In *A Naturalist in a University Museum* (1931), a philosophical discussion of museum methods and types of museums, Alexander Ruthven maintained that museum work could not be a profession because it consisted of the efforts of diverse "specialists in particular fields of knowledge." A. E. Parr pursues this line of reasoning in "Is There a Museum Profession?" (1960) and "A Plurality of Professions" (1964). For Parr, the multitude of suboccupational groups within the museum community suggests the existence of several professions rather than a single one. Still others extend the implications of Parr's work in order to plead for the professionalization of separate museum specialities, such as education, curatorship, and conservation. Robert Matthai argues in "In Quest of Professional Status" (1974) that museum educators should clearly distinguish themselves from curators and seek professional status by familiarizing themselves with educational theories and methods.

More frequently, writers echo Laurence Vail Coleman, who countered Ruthven's position in *The Museum in America* (1939), or Carl Guthe, who summarized his views in "Correlation of Museum Positions and Standards" (1958). Like Coleman and Guthe, these critics locate the museum occupation somewhere along the road to professionalism, although they may disagree as to whether it is an emerging profession or an established profession suffering from serious problems. Robin Inglis, former director of the Canadian Museums Association, is typical of many who refer to the "immature state" of museum work. In "Canadian Museums: Looking Ahead" (1978), Inglis concludes that despite a recognizable body of knowledge articulated in professional journals, university curricula, and codes of ethics, the process of professionalization is still incomplete. By contrast, Raymond Singleton, in such articles as "Professional Education and Training" (1971) and "The Future of the Profession" (1977), contends that a museum profession is already in existence, but it is one beset by shortcomings, including multiple areas of research and an "incoherent" role in the workplace. Though generally in agreement with Singleton, Edward Alexander suggests in his text-

book, *Museums in Motion* (1979), that occupational fragmentation is adequately overcome by a strong sense of the profession's "common cause and goals."

Much of the literature that is relevant to professionalization does not deal directly with the issue but rather concentrates on the specific conditions of museum work. In the 1970s several agencies conducted surveys of museum salaries and benefits, but methodological flaws tended to limit the utility of their results. The absence of common job titles and tasks, an inherent attribute of the idiosyncratic organizational structures of most museums, rendered comparative data difficult to obtain. Moreover, no standardized survey models were developed to permit comparisons between reports that would illustrate conditions over time or according to museum type and geographic region. One study prepared by the National Endowment for the Arts, *Museums USA* (1974), provided some useful data on pay levels, and David Hamilton classified fifty institutions in the Pittsburgh area in his noteworthy, detailed analysis, "Salary and Fringe Benefit Survey of Selected Museums" (1976). But generally museum associations have been the primary producers of such reports. The AAM, for example, published the *1971 Financial and Salary Survey* (1971) by Kyran McGrath and, more recently, "Survey of Hiring Practices and Salary and Fringe Benefits," which was compiled by its Museum Studies Committee as part of the ongoing investigation described in "Museum Studies: A Second Report" (1980). In a welcome effort to transcend nagging methodological problems, the New England Conference of the AAM and the Texas Association of Museums began sharing the same model for collecting salary data in 1978. As a whole, however, these surveys can only reflect a general sense of the complexities of the museum workplace; the outstanding exception is Charles Philips and Patricia Hogan's *The Wages of History* (1984), which stands as a model for the genre.

Closely related to the status of salaries and benefits in museum work is the issue of unionization. In the 1970s, several articles were devoted to specific cases, such as Eileen Dribin's "Museums Get a Taste of PASTA" (1972). For a general overview, Lawrence Alloway's "Museums and Unionization" (1975) has proved to be one of the best analyses of the phenomenon. Partly in response to unionization, other writers addressed the museum's obligations and responsibilities as an employer. For example, Ronald L. Miller, in such essays as "Developing a Personnel Policy Manual" (1979), recommended coherent policies for museum pay scales, job security, collective bargaining, grievance procedures, employee morale, and other critical issues of human resource management.

A number of works have focused on the interrelationship between recruitment and training. One of the most influential is *America's Museums: The Belmont Report* (1969), a report prepared by a special committee of the AAM that emphasized the connection between adequately trained personnel and museum performance. The AAM has continued to contribute to this

field of interest through such publications as *Museum Studies: A Curriculum Guide for Universities and Museums* (1973), compiled by the Museum Studies Curriculum Committee, and "Museum Studies" (1978). Those reports generally stress the necessity for standardized entry-level requirements and the overall improvement of graduate and mid-professional preparation. In addition, the critical review of university training courses by AAM's Professional Practices Committee, entitled "Criteria for Examining Professional Museum Studies Programs" (1983), suggests suitable guidelines for curriculum, faculty, students, administration, financial support, and physical facilities. A provocative investigation of professional training and its impact on job placement is *The Museum Labor Market* (1976) by Susan Stitt and Linda Silun, which was sponsored by Old Sturbridge Village, and similar studies have been conducted in other countries, including Lynne Teather's *Professional Directions for Museum Work in Canada* (1978).

Perhaps the most significant report of the last decade on museum training is *Museum Professional Training and Career Structure* (1987) by a committee of the Museums and Galleries Commission of Great Britain. The authors argue that the high rate of growth of museums and jobs and the increasing pressures for accountability in the operation of museums create a need for more training, including access to management training. The authors argue for the creation of a museum training council, an independent national coordinating body for museum training, and for the continuation of the Museum Association, which would be responsible for the accreditation of training courses. Thus, the authors favor a healthy separation of evaluation and training. The result would resemble the variety of professional development opportunities available in North America, but, under a unique coordinated professional body, standards and curriculum suitability for the profession would be ensured. Also, in 1989, the Museum Management Institute was set up to move toward this ideal.

Many sociologists have emphasized that a critical factor for any occupational group is the existence of an underlying theoretical base that informs and conditions professional practice. In *Adventures of Ideas* (1942), Alfred Whitehead illustrated the role of theory in elevating an avocation to a profession when he argued that theoretical analysis refines and enhances practice by adding an element of predictability. Demonstrating an impressive understanding of the dynamics of professionalization, Laurence Vail Coleman advocated gleaning practical insights from museum surveys and studies and then refining them into an advanced museum theory. Coleman argued that practical demonstrations and association activities would help to disseminate the new principles, and museums would be stimulated to seek closer working relationships by cooperative undertakings in which workers shared ideas and information. Ultimately, through improved training of personnel, standards for the museum profession could evolve. Coleman's ideas are outlined in articles in the early AAM journal, *Museum Work* (1918–1926).

But despite Coleman's detailed blueprint for professionalization, subsequent discussions have frequently taken the form of perennial laments over the continued absence of museum theory. Thus, Raymond Singleton and A. J. Duggan wrote in "What Should We Train Our Curators to Do?" (1969) that "curatorship still lacks a professional ritual, a defined canon of knowledge and skills." The concept of museum studies, though nurtured in the university setting, has been too diffuse and too specific to European institutions to clarify the occupation's body of knowledge.

Since World War II, efforts to conceptualize a museological discipline have centered in Paris, at the ICOM and UNESCO headquarters, and in the leading museum studies programs of England and Eastern Europe. New approaches to defining museology have been particularly encouraged by ICOM, which sponsors the work of Georges Henri-Rivière and the Training Unit in such publications as *Training of Museum Personnel* (1970) and *Professional Training of Museum Personnel in the World* (1972). The ICOM Committee on Museology, created in 1977, has taken the initiative in the study of museum theory in recent years, largely through its annual meetings and its journal, *MuWop*. Most of the articles in *MuWop* tend to be conference reports or short presentations made to the committee and suffer accordingly from superficiality; by far the most significant work is that of Villy Toft Jensen, who classifies the various approaches to museology in "Museological Points of View" (1980). Toft Jensen reveals the diversity of professional schools, ranging from those that characterize museum studies as a multidisciplinary field of study to those that insist that museology is an independent science.

One of the major theorists of museology in the past ten years is Z. Z. Stransky of the University of Brno in Czechoslovakia, whose works include *Brno: Education in Museology* (1974) and numerous articles in *MuWop*. Stransky cleverly evades the debate about the existence of museology as a science, which he sees as insoluble, by arguing that the museum's problems cannot be resolved in the realm of technique alone. For Stransky, museology pertains fundamentally to specific relationships between people and the material world. In this respect, he touches closely on the work done in material culture theory by Thomas Schlereth for *Artifacts and the American Past* (1980). Other individuals have also been instrumental in developing definitions of the field of study. The Czechoslovakian archaeologist Jiří Neustupný, in *Museum and Research* (1968) and in "What is Museology?" (1971), presents two definitive analyses of museum studies. A second author is Raymond Singleton, former director of the Museum Studies Department at the University of Leicester from 1966 to 1977. Although most of Singleton's work is directed toward appropriate guidelines for museum training, he contributes to the discussion of museum theory in "Museum Studies: The Theory and Practice of Curatorial Training" (1977).

In North America, the theoretical base of museum work is seldom discussed. In 1967, Ellis Burcaw of the University of Idaho circulated a ques-

tionnaire to training courses in the United States and Canada. The results led him to conclude, in "Graduate Training in Museology" (1969), that "most museum training is just that, training in techniques, not a broad, theoretical and philosophical introduction to museology." At the same time, in "Grand-motherology and Museology" (1967), Wilcomb Washburn criticized the existing state of theoretical development among American museum workers, who tend to equate museology with museum administration. Although Washburn offered no alternatives, Burcaw promoted the existence of museum theory and the use of ICOM definitions for the study of museums in his textbook, *Introduction to Museum Work* (1983).

Some critics who have discussed the need for theoretical development in museum studies have suggested that museum workers begin by examining the historical roots of their own occupation. Indeed, the elements of a tradition in museum work can easily be traced back several centuries through such important writings as *Museographia* (1727) by Caspar Neickel, Sir William Henry Flower's *Essays on Museums* (1898), David Murray's *Museums: Their History and Their Use* (1904), and such twentieth-century works as the various AAM publications of the 1920s and 1930s by Laurence Vail Coleman. Still, few writers have attempted to chronicle the evolution of museum functions such as collecting, documentation, exhibition, and education. By contrast, semi-professions like library science have produced a relatively rich body of historical literature devoted to library operations, philosophy, training, and institutional growth, as evidenced in the textbook by Jean Key Gates, *Introduction to Librarianship* (1968). Recently Edward Alexander has endeavored to remedy this condition in *Museum Masters* (1983), which analyzes the lasting contributions of Sir Hans Sloane, Sir Henry Cole, and other early figures in museum work.

Nonetheless, despite some noteworthy efforts, the greatest area for future development in the professionalization of the museum occupation remains the knowledge and skills underpinning the workplace—the theories and principles behind the museum idea, as well as their application to museum operations. Whether a heterogeneous discipline or an interdisciplinary field with certain unique methods, museology is clearly a growing field of study. In the end, the name given to the study of museums—discipline, body of knowledge, or skill base—may be less important than the continuation of the study itself. This is particularly true if museum studies is systematically pursued within the framework of the occupation's social structure and mission.

BIBLIOGRAPHIC CHECKLIST

"The AAMD Takes a Stand." *Museum News* 51 (May 1973), 49.
Adam, Thomas Ritchie. *The Civic Value of Museums.* New York: American Association for Adult Education, 1937.

Alderson, William T., and others. "Beyond the Beginning: Accreditation After 10 Years." *Museum News*, 60 (September-October 1981), 34–39.

Alexander, Edward P. "Museum Studies at Delaware." *Curator* 15 (March 1972), 34–38.

———. "A Handhold on the Curatorial Ladder." *Museum News*, 52 (May 1974), 23–25.

———. *Museums in Motion: An Introduction to the History and Functions of Museums.* Nashville, TN: American Association for State and Local History, 1979.

———. *Museum Masters: Their Museums and Their Influence.* Nashville, TN: American Association for State and Local History, 1983.

Alloway, Lawrence. "Museums and Unionization." *Artforum* 13 (February 1975), 46–48.

———. "The Great Curatorial Dim-Out." *Artforum* 13 (May 1975), 32–34.

American Association of Museums. *Code of Ethics for Museum Workers.* New York: American Association of Museums, 1925. Reprinted in *Museum News* 52 (June 1974), 26–28.

———. *A Statistical Survey of Museums in the United States and Canada.* Washington, DC: American Association of Museums, 1965.

———. *America's Museums: The Belmont Report. A Report to the Federal Council on the Arts and the Humanities by a Special Committee of the American Association of Museums.* Washington, DC: American Association of Museums, 1969.

———. *Museum Accreditation: A Report to the Profession.* Washington, DC: American Association of Museums, 1970.

American Association of Museums. Committee on Ethics. "Museum Ethics: A Report to the American Association of Museums by its Committee on Ethics." *Museum News* 56 (March-April 1978), 21–30. Reprint. Washington, DC: American Association of Museums, 1978.

American Association of Museums. Museum Studies Committee. "Museum Studies." *Museum News* 57 (November-December 1978), 19–26.

———. "Museum Studies: A Second Report." *Museum News* 59 (October 1980), 26–40.

American Association of Museums. Museum Studies Curriculum Committee. *Museum Studies: A Curriculum Guide for Universities and Museums.* Washington, DC: American Association of Museums, 1973.

American Association of Museums. Professional Practices Committee. "Criteria for Examining Professional Museum Studies Programs." *Museum News* 61 (June 1983), 70–71, 99.

American Institute for Conservation. "A Code of Ethics for Conservators." *Museum News* 58 (March-April 1980), 27–34.

American Law Institute–American Bar Association Committee on Continuing Professional Education. *ALI-ABA Course of Study on Legal Problems of Museum Administration.* Philadelphia: Joint Committee on Continuing Legal Education of the American Law Institute and the American Bar Association, 1973.

Art Galleries and Museums Association of New Zealand. "Art Gallery and Museum Officer's Code of Ethics." *AGMANZ News* 9 (August 1978), 9–12.

Association of Art Museum Directors. Committee on Professional Practices. *Profes-*

sional Practices in Art Museums. New York: Association of Art Museum Directors, 1971. Reprinted in *Museum News* 51 (October 1972), 15–20.

August, Raymond S. "So You Want To Start Your Own Profession! Fable, Fulfillment or Fallacy?" *Museum Studies Journal* 1 (Fall 1983), 16–24.

Australian National Commission for the United Nations Educational, Scientific and Cultural Organization. *Training for the Museum Professional/Australian UNESCO Seminar, University of Melbourne, 20–22 August 1973*. Canberra: Australian Government Publishing Service, 1975.

Bethel, David. "The Training of Museum Personnel: The Contribution of Colleges of Art." *ICOM News* 25 (June 1972), 103–5.

Bingham, Judith. "Giving Your Interns a Piece of the Action." *Museum News* 52 (December 1973), 33–39.

Blaine, John. "Accountability to the Hand That Feeds You." *Museum News* 57 (May-June 1979), 34–36.

Bostick, William A. "The Ethics of Museum Acquisitions." *Museum* 26 (1974), 26–33.

Boylan, Patrick J. "Museum Ethics: Museums Association Policies." *Museums Journal* 77 (December 1977), 106–11.

Burcaw, George Ellis. "Museum Training: The Responsibility of College and University Museums." *Museum News* 47 (April 1969), 15–16.

———. "Graduate Training in Museology." *Museum News* 47 (April 1969), 17–18.

———. *Museum Training Courses in the United States and Canada*. Rev. ed. Washington, DC: American Association of Museums, 1971.

———. *Introduction to Museum Work*. 2d ed. Nashville, TN: American Association for State and Local History, 1983.

Burns, William A. "The Curator-as-Canary." *Curator* 14 (September 1971), 213–20.

Canadian Art Museum Directors Organization. *Ethics and Professional Practices*. n.p.: Canadian Art Museum Directors Organization, 1977.

———. *Ethics and Practices for Governing Body of an Art Museum*. n.p.: Canadian Art Museum Directors Organization, 1979.

Canadian Museums Association. *A Curriculum for Museum Studies Training Programmes*. Ottawa: Canadian Museums Association, 1979.

———. *The Ethical Behavior of Museum Professionals*. Ottawa: Canadian Museums Association, 1979.

———. *A Guide to Museum Positions: Including a Statement on the Ethical Behaviour of Museum Professionals*. Ottawa: Canadian Museums Association, 1979.

———. *National Salary Survey*. Ottawa: Canadian Museums Association, 1983.

Capstick, Brenda. "The Museum Profession in the United Kingdom." *Museum* 23 (1970–1971), 154–57.

Carr-Saunders, Sir Alexander Morris. "The Emergence of Professions." In *Man, Work, and Society: A Reader in the Sociology of Occupations*, edited by Sigmund Nosow and William H. Form. New York: Basic Books, 1962.

Carr-Saunders, Sir Alexander Morris, and Paul Alexander Wilson. *The Professions*. Oxford: Clarendon Press, 1933.

Clifford, William, comp. *Bibliography of Museums and Museology*. New York: Metropolitan Museum of Art, 1923.

Cogan, Morris I. "The Problem of Defining a Profession." *Annals of the American Academy of Political and Social Science* 297 (January 1955), 105–11.

Colbert, Edwin H. "On Being a Curator." *Curator* 1 (January 1958), 7–12.

———. "What Is a Museum?" *Curator* 4 (1961), 138–46.

Coleman, Laurence Vail. "Accomplishments of the American Association of Museums, 1923–25." *Museum Work* 8 (November-December 1925), 101–12.

———. *Manual for Small Museums.* New York: G. P. Putnam's Sons, 1927.

———. *The Museum in America: A Critical Study.* 3 vols. Washington, DC: American Association of Museums, 1939. Reprint (3 vols. in 1). Washington, DC: American Association of Museums, 1970.

Committee to Survey Standards for Curatorial Positions. "Standards for Curatorial Positions." *Clearinghouse for Western Museums Newsletter* 217–18 (March-April 1958), 2032–51.

Compton, Mildred S. "Accreditation: What It Can and Cannot Do." *Museum News* 55 (November-December 1976), 34–37.

Conaway, Mary Ellen. "The Roles of the Curator in Natural History Museums." *Curator* 21 (December 1978), 321–28.

Conger, John, Ronald Egherman, and Gail Mallard. "The Museum as Employer." *Museum News* 57 (July-August 1979), 22–28.

De Borhegyi, Stephan F. "A Museum Training Programme." *Museums Journal* 58 (July 1958), 78–80.

De Borgehyi, Stephan F., and Elba A. Dodson, comps. *A Bibliography of Museums and Museum Work, 1900–1960.* Publications in Museology, no. 1. Milwaukee: Milwaukee Public Museum, 1960.

Dodds, Gordon. "The Compleat Archivist." *Archivaria* 1 (Winter 1975–1976), 80–85.

Dong, Margaret, comp. *Museum Studies Programs in the United States and Abroad.* Washington, DC: Office of Museum Programs, Smithsonian Institution, 1982.

———. *Museum Studies, International, 1984.* Washington, DC: Office of Museum Programs, Smithsonian Institution; and International Council of Museums, Committee for the Training of Personnel, 1985.

Donson, Jerome Allan. "Current Trends in Professional Standards for Museums." *Curator* 2 (1959), 157–61.

Douglas, R. Alan. "Museum Ethics: Practice and Policy." *Museum News* 45 (January 1967), 18–21.

Dribin, Eileen. "Museums Get a Taste of PASTA." *Museum News* 50 (June 1972), 21–26.

Eisler, Colin. "Curatorial Training for Today's Art Museum." *Curator* 9 (March 1966), 51–61.

Elliott, Philip. *The Sociology of the Professions.* London: Macmillan, 1972.

Etzioni, Amitai, ed. *The Semi-Professions and Their Organization.* New York: Free Press, 1969.

Fitzgerald, Marilyn Hicks. *Museum Accreditation: Professional Standards.* Washington, DC: American Association of Museums, 1973.

Flexner, Abraham. "Is Social Work a Profession?" In *Studies in Social Work,* no. 4. New York: New York School of Philanthropy, 1915.

Flower, Sir William Henry. *Essays on Museums and Other Subjects Connected with Natural History.* New York: Macmillan, 1898. Reprint. Freeport, NY: Books for Libraries Press, 1972.

Friedmann, Herbert. "The Curator: Introduction." *Curator* 6 (1963), 280–81.

Gallacher, Daniel T. "Curatorial vs. Exhibits and Extension: Definitions." In *History Division Paper*, no. 15. National Museum of Man Mercury Series [pilot issue of *Material History Bulletin*]. Ottawa: National Museums of Canada, National Museum of Man, 1976.

Gates, Jean Key. *Introduction to Librarianship*. New York: McGraw-Hill, 1968.

Gilman, Benjamin Ives. *Museum Ideals of Purpose and Method*. 2d ed. Cambridge: Harvard University Press, 1923.

Gladstone, Myron J. *A Report on Professional Salaries in New York State Museums*. n.p.: New York State Association of Museums, 1972.

Glover, Wilbur H. "Toward a Profession." *Museum News* 42 (January 1964), 11–14.

Goode, George Brown. "Principles of Museum Administration." In *Annual Report of the Board of Regents of the Smithsonian Institution . . . 1897. Report of the U.S. National Museum*, pt. 2. Washington, DC: Government Printing Office, 1901.

Goode, William J. "The Librarian: From Occupation to Profession?" *Library Quarterly* 31 (October 1961), 306–20.

———. "The Theoretical Limits of Professionalization." In *The Semi-Professions and Their Organization*, edited by Amitai Etzioni. New York: Free Press, 1969.

Grant, Alicia. "How Good Is MOMA's PASTA?" *Museum News* 52 (June 1974), 43–44.

Greenwood, Ernest. "Attributes of a Profession." In *Man, Work, and Society: A Reader in the Sociology of Occupation*, edited by Sigmund Nosow and William H. Form. New York: Basic Books, 1962.

Greenwood, Thomas. *Museums and Art Galleries*. London: Simpkin, Marshall, 1888.

Grove, Richard. "You Don't Need a Weatherman to Tell Which Way the Wind's Blowing." *Museum News* 52 (June 1974), 33–34.

Guthe, Carl. "Correlation of Museum Positions and Standards." *Curator* 1 (Spring 1958), 5–12.

Hamilton, David K. "Salary and Fringe Benefit Survey of Selected Museums." *Curator* 19 (September 1976), 183–92.

Hecken, Dorothea. "The Ethics of Acquisition: Recent Developments." *Ontario Museum Association Newsletter* 6 (January 1977), 17–23.

Heine, Albert. "Ours a Profession?" *Museum News* 45 (March 1967), 33–34.

Hicks, Ellen Cochran, ed. "60 Years of Museum News." *Museum News* 62 (February 1984), 19–74.

Hoachlander, Marjorie E. *Profile of a Museum Registrar*. Washington, DC: Academy for Educational Development, 1979.

Hodge, John. "Professionalism in Relation to Museums and Its Implications for Training; or the Education of the Museum Professional." Paper presented at the triennial meeting of the Training Committee of the International Council of Museums, Mexico City, 1980.

Hogan, Patricia, and Carol B. Stapp. "The Best of All Possible Internships." *Museum News* 57 (November-December 1978), 59–63.

Hopkins, Kenneth R. "Is Confrontation in Your Future?" *Curator* 13 (June 1970), 120–24.

Howard, Hildegarde. "Job Analysis of Curatorial Positions." *Clearinghouse for Western Museums Newsletter* 189 (November 1955), 877–80.

Hoyle, W. E. "The Education of the Curator." *Museum Journal* 6 (July 1906), 4–24.

Hughes, Everett C. "Professions." In *The Professions in America*, edited by Kenneth S. Lynn and the editors of Daedalus. Boston: Houghton Mifflin, 1965.

Illg, Paul L. "The Recruitment and Training of Curators for Natural Science Museums." *Curator* 6 (1963), 296–302.

Inglis, Robin. "Canadian Museums: Looking Ahead." Paper presented at the annual meeting of the Western Association of Art Museums/Western Regional Conference, American Association of Museums, Victoria, BC, October 1978.

Institute of Conservation and Methodology of Museums. Working Group on Terminology. *Dictionarium Museologicum: Museological Classification System and Word Index*. 2d ed. Budapest: Muzeumi Restaurator-es Modszertani Kozpont, 1979.

International Council of Museums. *Training of Museum Personnel*. London: Hugh Evelyn, 1970.

International Council of Museums. International Committee for the Training of Personnel, and International Committee for Museology. *Professional Training of Museum Personnel in the World. Actual State of the Problem*. Paris: International Council of Museums, 1972.

———. *International Council of Museums, "Resolutions": Museum Training at University Level. A Symposium Organized by the International Committee of I.C.O.M. for the Training of Personnel, Belgium, 1978*. Tervuren, Belgium: Musée Royal de l'Afrique Centrale, 1980.

———. *Joint Colloquium: Methodology of Museology and Professional Training, London, July 1983*. Stockholm: Museum of National Antiquities, 1983.

International Institute for Conservation of Historic and Artistic Works. American Group. *The Murray Pease Report: Code of Ethics for Art Conservators*. New York: ICC–American Group, 1968.

Jackson, John A., ed. *Professions and Professionalization*. London: Cambridge University Press, 1970.

Jackson, Margaret Talbot. *The Museum: A Manual of the Housing and Care of Art Collections*. New York: Longmans, Green, 1917.

Johnson, Terence J. *Professions and Power*. London: Macmillan, 1972.

Katzive, David. "Up Against the Waldorf-Astoria." *Museum News* 49 (September 1970), 12–17.

Keck, Sheldon. "A Little Training Can Be a Dangerous Thing." *Museum News* 52 (December 1973), 40–42.

King, Mary Elizabeth. "Curators: Ethics and Obligations." *Curator* 23 (March 1980), 10–18.

Kort, Michele, and Jacquelyn Maguire. "Tenure." *Museum News* 53 (December 1974), 26–27, 49–52.

Leavitt, Thomas W. "Reaccreditation: Learning from Experience." *Museum News* 60 (September-October 1981), 40–41.

Lewis, Geoffrey. "A Survey of Staff Movement in Yorkshire and Humberside 1950–71." *Museums Journal* 73 (September 1973), 67–71.

———. "The Training of Museum Personnel in the United Kingdom." *Museums Journal* 83 (June-July 1983), 65–70.

Lewis, Ralph H. "Museum Training in the National Park Service," *Curator* 6 (1963), 7–13.

———. *Manual for Museums*. Washington, DC: National Park Service, United States Department of the Interior, 1976.

Lowe, Edwin Ernest. *A Report on American Museum Work*. Edinburgh: T. and A. Constable, 1928.

Mariner, Dorothy A. "The Museum: A Social Context for Art." Ph.D. dissertation, University of California, Berkeley, 1969.

———. "Professionalizing the Museum Worker." *Museum News* 50 (June 1972), 14–20.

Markham, Sydney Frank. *A Report on the Museums and Art Galleries of the British Isles (Other Than the National Museums)*. Edinburgh: T. and A. Constable, 1938.

Matthai, Robert A. "In Quest of Professional Status." *Museum News* 52 (April 1974), 10–13.

Mayer, Martin. " 'A Way to Clear the Air': The New Code of Ethics for Art Historians." *Artnews* 73 (Summer 1974), 34–36.

McAlee, James R. "The *McClain* Decision: A New Legal Wrinkle for Museums." *Museum News* 57 (July-August 1979), 37–41.

McDonnell, Patricia Joan. "Professional Development and Training in Museums." *Museum News* 60 (July-August 1982), 36–47.

McGrath, Kyran M. *1971 Financial and Salary Survey*. Washington, DC: American Association of Museums, 1971.

———. *1973 Museum Salary and Financial Survey*. Washington, DC: American Association of Museums, 1973.

Meyer, Karl E. *The Art Museum: Power, Money, Ethics*. New York: William Morrow, 1979.

Miers, Sir Henry Alexander. *A Report on the Public Museums of the British Isles (Other Than the National Museums)*. Edinburgh: T. and A. Constable, 1928.

Miller, Alden H. "The Curator as a Research Worker." *Curator* 6 (1963), 282–86.

Miller, Ronald L. "Developing a Personnel Policy Manual." *Museum News* 57 (July-August 1979), 29–32.

"The Model of a Modern Museum Professional." *Museum News* 58 (May-June 1980), 58–59.

Moore, Wilbert E. *The Professions: Roles and Rules*. New York: Russell Sage Foundation, 1970.

Murray, David. *Museums: Their History and Their Use*. 3 vols. Glasgow: James MacLehose and Sons, 1904.

Muséographie, architecture et aménagement des musées d'art. Conférence internationale d'études, Madrid, 1934. 2 vols. Paris: Société des nations, Office international des musées, Institut international de coopération intellectuelle, 1935.

"Museum Staff Members: Are We Neglected?" *Museologist* 118 (March 1971), 6–13.

"Museum Workers Unite." *Museum News* 52 (June 1974), 46–48.

Museums Association. "Guidelines for Professional Conduct Adopted at the 1977 AGM." In *Museums Yearbook 1983*, edited by Jane Jenkins. London: Museums Association, 1983.

Museums and Galleries Commission of Great Britain. *Museum Professional Training and Career Structure. Report by a Working Party, 1987*. London: HMSO, 1987.

National Endowment for the Arts. *Museums USA: Art, History, Science, and Others*. Washington, DC: U.S. Government Printing Office, 1974.

Naumer, Helmuth J. *Of Mutual Respect and Other Things: An Essay on Museum Trusteeship*. Washington, DC: American Association of Museums, 1977.

Neickel, Caspar F. [pseud.]. *Museographia oder Anleitung zum rechten begriff und nutzlicher anlegung der museorum, oder raritaten-kammeren*. Leipzig: M. Hubert, 1727.

Neustupný, Jiří. *Museum and Research*, translated by B. Vančura. Prague: Národní Muzeum, 1968.

———. "What Is Museology?" *Museums Journal* 71 (September 1971), 67–68.

Nicholson, Thomas D. "Commentary: Why Accreditation Doesn't Work." *Museum News* 60 (September-October 1981), 5, 7–8, 10.

Norman, Joy Youmans. "How Museums Benefit." *Museum News* 60 (September-October 1981), 42–47.

Nosow, Sigmund, and William H. Form, eds. *Man, Work, and Society: A Reader in the Sociology of Occupations*. New York: Basic Books, 1962.

Papageorge, Maria. "A World View of Museum Studies." *Museum News* 57 (November-December 1978), 7–9.

Parker, Arthur Caswell. *A Manual for History Museums*. New York: Columbia University Press, 1935.

Parr, Albert Eide. "Policies and Salaries for Museum Faculties." *Curator* 1 (January 1958), 13–17.

———. "Is There a Museum Profession?" *Curator* 3 (1960), 101–6.

———. "Curatorial Functions in Education." *Curator* 6 (1963), 287–91.

———. "A Plurality of Professions." *Curator* 7 (1964), 287–95.

Platnauer, H. M., and E. Howarth, eds. *Proceedings of the First Annual Conference of the Museums Association*. London: Museums Association, 1890.

Philips, Charles, and Patricia Hogan. *The Wages of History: The AASLH Employment Trends and Salary Survey*. Nashville, TN: American Association of State and Local History, 1984.

Ramsey, Grace Fisher. *Educational Work in Museums of the United States: Development, Methods and Trends*. New York: H. W. Wilson Co., 1938.

Rea, Paul Marshall, ed. *Proceedings of the American Association of Museums*. 11 vols. Pittsburgh, PA, and Charleston, SC: American Association of Museums, 1907–1917.

———. *The Museum and the Community, with a Chapter on the Library and the Community: A Study of Social Laws and Consequences*. Lancaster, PA: Science Press, 1932.

Réau, Louis. *L'Organisation des musées*. Paris: Louis Cerf, 1909.

Reimann, Irving G. "Training Museum Personnel in a University." *Curator* 1 (Spring 1958), 63–70.

———. "Preparation for Professional Museum Careers." *Curator* 3 (1960), 279–85.

Robbins, Daniel. "The Development of the Museum Professional." In *Conference Proceedings for 2001: The Museum and the Canadian Public*, edited by Ted Poulos. Ottawa: Canadian Museums Association, 1976.

Rodeck, Hugo G. "The Role of the University in Education Towards Museum Careers." *Curator* 4 (1961), 69–75.

Rogers, Lola Eriksen. *Museums and Related Institutions: A Basic Program Survey.* Washington, DC: U.S. Government Printing Office, 1969.

Ruthven, Alexander G. *A Naturalist in a University Museum.* Ann Arbor, MI: Alumni Press, 1931.

Sage, Diane. *Salary and Benefits Survey of Art Gallery Employees in Ontario in 1975: A Preliminary Report.* Toronto: Ontario Association of Art Galleries, 1976.

————. *Job Study: An Investigation of Work and Workers in Ontario's Public Art Galleries in 1977.* Toronto: Ontario Association of Art Galleries, 1978.

Saunders, John R. "One Hundred Curators: A Quantitative Study." *Curator* 1 (Spring 1958), 17–24.

Schlereth, Thomas J. *Artifacts and the American Past.* Nashville, TN: American Association for State and Local History, 1980.

Schwalbe, Douglas. "Are You an Amateur Administrator?" *Museum News* 51 (January 1973), 26–27.

Schwefel, Charles Albert. "Museum Work as a Profession: An Introduction." M.A. thesis, George Washington University, 1980.

Segger, Martin. *Report on Training Opportunities for Museum Workers in Canada.* Ottawa: Museum Assistance Programmes, National Programmes Branch, National Museums of Canada, 1976.

Seldes, Lee. "Museums and Corruption." *Saturday Review* 8 (July 1981), 10–14.

Shestack, Alan. "The Director: Scholar and Businessman, Educator and Lobbyist." *Museum News* 57 (November-December 1978), 27–31, 89–91.

Singleton, H. Raymond. "University Training for Museum Personnel." In *Museum and Research: Papers from the Eighth General Conference of ICOM*, by International Council of Museums. Munich: Deutsches Museum, 1970.

————. "Professional Education and Training." *Museums Journal* 71 (December 1971), 99–101.

————. "Museum Studies: The Theory and Practice of Curatorial Training." Paper presented at a meeting on museum training, Oslo, Norway, May 2–3, 1977.

————. "The Future of the Profession." *Museums Journal* 77 (December 1977), 121–22.

Singleton, H. Raymond, and A. J. Duggan. "What Should We Train Our Curators to Do?" *Museums Journal* 69 (December 1969), 133–35.

Smith, Ralph Clifton. *A Bibliography of Museums and Museum Work.* Washington, DC: American Association of Museums, 1928.

Sofka, Vinoš, ed. "Museology—Science or Just Practical Museum Work?" *MuWoP: Museological Working Papers* 1 (1980), entire issue.

————. "Interdisciplinarity in Museology." *MuWoP: Museological Working Papers* 2 (1981), entire issue.

Starr, Kenneth. "A Perspective on Our Profession." *Museum News* 58 (May-June 1980), 21–23.

————. "Commentary: In Defense of Accreditation: A Response to Thomas D. Nicholson." *Museum News* 60 (January-February 1982), 5–6, 9–11, 13, 15–18, 20–21.

Stitt, Susan, and Linda Silun. *A Survey of Training Needs of American Historical Agencies*. Sturbridge, MA: Old Sturbridge Village, 1974.

———. *The Museum Labor Market: A Survey of American Historical Agency Placement Opportunities*. Sturbridge, MA: Old Sturbridge Village, 1976.

Stransky, Zbynek Zbyslav. *Brno: Education in Museology*. Brno: J. E. Purkyně University and Moravian Museum, 1974.

Straus, Ellen S. "Volunteer Professionalism." *Museum News* 56 (September-October 1977), 24–26.

Swinney, H. J. "Looking at Accreditation: It Is Ours." *Museum News* 55 (November-December 1976), 15–17.

———. "Our Emerging Professionalism." *Army Museum Newsletter* 16 (April 1978), 2–28.

———, ed. *Professional Standards for Museum Accreditation: The Handbook of the Accreditation Program of the American Association of Museums*. Washington, DC: American Association of Museums, 1978.

Swinton, William Elgin. "Museum Standards." *Curator* 1 (January 1958), 61–65.

Teather, Lynne. *Professional Directions for Museum Work in Canada: An Analysis of Museum Jobs and Museum Studies Training Curricula*. Ottawa: Canadian Museums Association, 1978.

———. "Museology and Its Traditions." Ph.D. dissertation, University of Leicester, 1984.

Thompson, John M. A. "The Accreditation Scheme of the Museums Association 1974–82: A Review." *Museums Journal* 82 (September 1982), 67–69.

Thompson, John M. A., and others, eds. *Manual of Curatorship: A Guide to Museum Practice*. London: Butterworth, 1984.

Toft Jensen, Villy. "Museological Points of View—Europe 1975." *MuWoP: Museological Working Papers* 1 (1980), 6–10.

Toren, Nina. "Semi-Professionalism and Social Work: A Theoretical Perspective." In *The Semi-Professions and Their Organization*, edited by Amitai Etzioni. New York: Free Press, 1969.

Training Arts Administrators: Report of the Committee of Enquiry into Arts Administration Training. London: Arts Council of Great Britain, 1971.

Tramposch, William J. "A Companion to Change: The Seminar for Historical Administration, 1959–1984." *Museum Studies Journal* 1 (Fall 1984), 8–18.

Ullberg, Alan D. "Some Conflict of Interest Questions for Curators and Other Museum Personnel." In *ALI-ABA Course of Study on Legal Problems of Museum Administration—II*. Philadelphia: Joint Committee on Continuing Legal Education of the American Law Institute and the American Bar Association, 1974.

———. *Museum Trusteeship*. Washington, DC: American Association of Museums, 1981.

Ullberg, Alan, and Patricia Ullberg. "A Proposed Curatorial Code of Ethics." *Museum News* 52 (May 1974), 18–22.

Ullberg, Patricia. "Naked in the Garden: Museum Practices after *Museum Ethics*." *Museum News* 57 (July-August 1979), 33–36.

———. "What Happened in Greenville: The Need for Museum Codes of Ethics." *Museum News* 60 (November-December 1981), 26–29.

United Nations Educational, Scientific and Cultural Organization. *The Organization of Museums; Practical Advice*. Paris: UNESCO, 1960.

————. "Recommendations Concerning the Protection at National Level, of the Cultural and Natural Heritage." Adopted by the General Conference at Its Seventeenth Session, Paris, November 16, 1972.

University of Leicester. Department of Museum Studies. *Learning Goals in Museum Studies Training*. Leicester: Department of Museum Studies, 1982.

Vaughan, Thomas. "A Simple Matter of Standards." *Museum News* 55 (January-February 1977), 32–34, 45.

Vollmer, Howard M., and Donald L. Mills, eds. *Professionalization*. Englewood Cliffs, NJ: Prentice-Hall, 1966.

Wall, Alexander J. "Demystifying the Accreditation Process." *Museum News* 60 (September-October 1981), 48–51.

Waller, Bret. "Museum Training: Who Needs It?" *Museum News* 52 (May 1974), 26–28.

Ward, Philip R. "A Profession—." *Museum Round-Up* 67 (Summer 1977), 46–48.

Washburn, Wilcomb E. "Grandmotherology and Museology." *Curator* 10 (March 1967), 43–48.

————. "Professionalizing the Muses." *Museum News* 64 (December 1985), 18–25, 70–71.

Weil, Stephen E. "The Ongoing Pursuit of Professional Status." *Museum News* 67 (November-December 1988), 30–34.

Whitehead, Alfred North. *Adventures of Ideas*. Harmondsworth, England: Penguin Books, 1942.

Wilensky, Harold L. "The Professionalization of Everyone?" *American Journal of Sociology* 70 (September 1964), 137–58.

Appendix A

MUSEUM DIRECTORIES

In his introduction to *The Irish Museums Guide* (1983), Kenneth Hudson writes that the distinguishing mark of a directory is its capacity to consider the museum not solely as a collection of objects but as a package comprised of its management, appearance, and attention paid to visitors' physical comfort. Ideally museum guides, like restaurant guides, should use their unique perspective to encourage a more discriminating attitude among museum professionals and the public at large, to help define standards, and to generate beneficial competition among institutions.

Few directories approach this ambitious agenda. The majority, in fact, address the more fundamental need of compiling inventories of basic data. In Hudson's words, they are designed to "map out the ground, to discover and describe what exists." Written for a variety of audiences, they constitute a diverse and poorly organized body of literature, which suffers from problems of definition and accessibility.

For the purpose of this bibliography, directories are defined as reference works devoted primarily, if not exclusively, to museums and public displays, and listing information pertaining to five or more separate institutions.

Key to Abbreviations

(CA) Catalan	(FR) French	(PO) Polish
(CZ) Czech	(GE) German	(PR) Portuguese
(DA) Danish	(HE) Hebrew	(RU) Russian
(DU) Dutch	(IT) Italian	(SP) Spanish
(EN) English	(JA) Japanese	

If no abbreviation appears, the work is primarily in English.

Entries are divided into three sections: A—International directories, B—Single-country directories, and C—Directories pertaining to a state or region within a country. In each section, directories are listed alphabetically by author's last name and assigned a number for purposes of cross-referencing.

WORLD DIRECTORIES

A–1 Cooper, Barbara, and Maureen Matheson, eds. *The World Museums Guide*. London: Threshold/Sotheby Parke Bernet, 1973.
 This popular guide is oriented toward overseas tourists without the time to sort through an entire collection. Selecting a cross-section of art museums of worldwide, national, or regional significance, the editors asked the curators of each institution included in the book to compile a list of the twenty-five most important treasures in their collection and pay particular attention not only to the museum's "artistic, historical and architectural importance, but to its ambience and to the facilities, amenities and specialized services it offers to the visitor."

A–2 Fahl, Kathryn A., comp. *Forest History Museums of the World*. Guides to Forest and Conservation History of North America, no. 6. Santa Cruz, CA: Forest History Society, 1983.
 Hoping to stimulate intermuseum communication, research, and collection development, the Forest History Society sponsored this directory of museums and collections devoted either wholly or in part to the history of human use of the forest and its products. Entries, arranged by country, vary widely in scope, but most contain data on location, hours, admission, collections, and officers to contact for further information. Thirty-three countries are represented, although the bulk of the directory is devoted to North America.

A–3 Hudson, Kenneth, and Ann Nicholls, eds. *The Directory of World Museums*. 2d ed. New York: Facts on File Publications, 1981.
 Although excluding zoos, botanical gardens, and historic houses without interpretive programs, Hudson and Nicholls still present entries for 25,000 museums. They briefly describe the nature of an institution's holdings and discriminate broadly between museums of greater and lesser importance by listing exceptional or specialized collections in a classified index at the end of the book.

A–4 International Association of Arms and Military History. *Directory of Museums of Arms and Military History*. Copenhagen: IAMAH, 1970.
 This publication provides an inventory of 214 collections in forty-four countries and distinguishes between chronological periods of interest. Entries feature visiting information, collections summaries, and administrative data.

A–5 International Council of Museums. *International Repertory of Glass Museums and Glass Collections.* Liege, Belgium: ICOM, 1966.
 Organized alphabetically by continent and country, the ICOM guide describes museum glass collections and provides the names of curators to contact for further information.

A–6 International Council of Museums. International Committee of Museums of Science and Technology. *Guide-Book of Museums of Science and Technology.* 2d ed. Prague. Národní Technické Museum, 1980. (EN, FR)
 In this revised edition, the International Committee of Museums of Science and Technology has compiled the results of its worldwide survey of science and technology museums. Little has been done to refine the raw data; in fact, the survey questionnaires are simply reproduced as they were completed by the responding museums. Arranged by country, the questionnaires supply information on museum facilities, collections, operations, activities, and staff.

A–7 *International Directory of Arts.* 2 vols. 16th ed. Frankfurt: Art Address Verlag Muller GMBH & Company KG, 1983.
 Volume 1 of this directory, which catalogs more than 100,000 addresses relevant to all spheres of the international art trade, lists museums and staff members available for contact in 136 nations. Volume 2 is devoted to dealers, commercial gallery owners, restorers, and other professionals affiliated with the art market.

A–8 International Federation of Library Associations. Section for Theatrical Libraries and Museums. *Performing Arts Libraries and Museums of the World.* Paris: Editions du Centre National de la Recherche Scientifique, 1967.
 An introductory essay on the nature of contemporary theatrical collections by Rosamund Gilder is supplemented by a directory to museums and libraries in thirty nations. Entries summarize the holdings and generally note hours and admission fees.

A–9 *Museums of the World.* 3d ed. Munich: K. G. Saur, 1981.
 Now in its third edition, this guide covers 163 countries and provides such particulars as location, category of museum, description of collections, and occasionally the founding date for each institution. A list of national and international museums associations, as well as an index to names, places, and collections, accompany the text.

A–10 Nicholson, T. R. *The World's Motor Museums.* Philadelphia: J. B. Lippincott, 1970.
 Nicholson examines museums in twenty-six countries and notes their institutional history, as well as their current operating schedule. The motor museum impresario Montagu of Beaulieu provides a prefatory essay on the problems of automobile display.

A–11 Omura, Marian, Spencer Tinker, and John Tayless. *Directory of the Public Aquaria of the World*. 2d ed. Honolulu: Waikiki Aquarium, 1967.
Intended to aid in coordinating the activities of public aquaria throughout the world, this directory lists hundreds of organizations by continent. Entries contain addresses, the names of owners and directors, number of staff, date of opening, yearly attendance, and specimens available for sale, exchange, or donation to other aquaria.

A–12 Van Beylen, Jules. *Repertory of Maritime Museums and Collections*. Antwerp: National Maritime Museum, 1966–1969.
Van Beylen's compendious book is intended to provide complete profiles of the maritime museums of thirty countries. Entries containing administrative and operating details are equally of interest to travelers and museum professionals.

NATIONAL AND MULTINATIONAL DIRECTORIES

B–1 Abse, Joan. *The Art Galleries of Britain and Ireland: A Guide to Their Collections*. Rutherford, NJ: Fairleigh Dickinson University Press, 1975.
Attempting to make her guide as comprehensive as possible, Abse categorizes the art galleries of Great Britain and Ireland by city and provides instructions to visitors and essays outlining institutional history, collections policy, and works on display. With few pretensions to connoisseurship, the description of what hangs on the walls is generally accompanied by the bare minimum of critical comment.

B–2 Agrawal, Usha, comp. *Brief Directory of Museums in India*. 2d ed. New Delhi: Museums Association of India, 1977.
Organized by state and within states by city, the entries cover more than 350 Indian museums, zoos, and herbariums. Agrawal's pamphlet represents the most recent and most thorough source of information, including policies on photography and the availability of museum publications and guide services. Descriptions of the collections are cryptic but adequate.

B–3 *Aircraft Museum Directory*. New York: Quadrant Press, 1976.
This pamphlet lists aircraft museums of the United States and Canada by locality. Entries are brief but provide the necessary visiting information for tourists. They also feature illustrations and tabulations of specific aircraft of note.

B–4 Alegre, Mitchell R. *A Guide to Museum Villages: The American Heritage Brought to Life*. New York: Drake, 1978.
More sympathetic to the needs of sightseers than Irvin Haas (B–42), Alegre lists American museum villages by state and in each case covers visiting information and the nature of the collections. In a brief introduction, he examines the museum village as a laboratory for new social history and

discusses the problems posed by outdoor exhibitions and incipient commercialism.

B–5 Allen, Jon L. *Aviation and Space Museums in America*. New York: Arco Publishing Company, 1975.
This substantial directory focuses on a select number of permanent, public facilities that represent the most important aviation museums in the United States and Canada. While Allen provides visiting information for each museum, his summaries of institutional history and the significance of the items on display approach a higher plane of sophistication than comparable entries in the Quadrant Press guide devoted to the same subject (B–3). An appendix cites publications and national organizations to contact for more specific information.

B–6 American Association of Museums. *The Official Museum Directory*. Washington, DC: American Association of Museums and National Register Publishing Company. Annual.
Intended to serve as an objective listing of museums and related organizations, ranging the broad spectrum from historic houses to herbariums, the AAM's hefty directory catalogs more than 5,000 North American institutions and is divided into four parts. The first part provides an alphabetical inventory of entries, organized by state or by province and containing full visiting information and administrative details. Subsequent sections list museums by name and by subject.

B–7 Aoki, Kunio, and others, eds. *Directory of Museums in Japan*. Tokyo: Japanese Association of Museums, 1980.
Less critical and more comprehensive than the Laurance Roberts (B–78) guide, the editors list some 240 major Japanese museums and 167 smaller institutions. All are classified broadly according to geographical region. Written especially for foreigners, entries are indexed to a guidebook map and supply visiting information and descriptions of the viewing conditions. The directory is prefaced by a brief historical overview of the evolution of Japanese museology.

B–8 Arinze, E. N. *Museums and Monuments in Nigeria*. n.p., 1978.
This short pamphlet describes the activities of the Nigerian Federal Department of Antiquities and lists museums affiliated with that agency. For each museum, Arinze covers institutional history, collections, and highlights of the exhibition galleries.

B–9 *Art in America Annual Guide to Galleries, Museums, Artists*. New York: Neal-Schuman Publishers. Annual.
This annual guide, compiled by the editors of *Art in America*, contains a comprehensive alphabetical listing of U.S. museums, galleries, and alternative spaces. Entries supply location, telephone number, director's name, and a brief survey of the solo artist shows on view during the previous year. Exhibition catalogs are indicated where available.

B–10 *Automobile Museum Directory.* 3d ed. New York: Quadrant Press, 1973.
 This slim pamphlet is an ideal guide for sightseers to North American
 automobile collections. Complete visiting information is noted for each
 attraction, and the editors focus on the facilities open to the public.

B–11 Barnard, Germaine, and Jean-Pierre Samoyault. *Repertoire des Musées et
 Collections Publiques de France.* Paris: Ministère de la Culture, Editions
 de la Réunion des Musées Nationaux, 1982. (FR)
 Barnard and Samoyault arrange a broadly defined assemblage of museums,
 cathedrals, and other collections by city. For each institution, they provide
 visiting information, a brief historical background, and a description of the
 collections. All entries are indexed according to ICOM's museum classifi-
 cations.

B–12 Belot, Victor R. *Guide des petits trains touristiques en France.* Paris: Pierre
 Horay, 1979. (FR)
 The "Musées" list on page 51 provides the names and locations of fifteen
 public museums in France with important collections pertaining to rail-
 roads. Complete descriptions of each, with visiting information and insti-
 tutional history, are located in the directory to scenic trains and museums,
 which is organized by department and takes up the bulk of the guide.

B–13 Birgit-Kloster, Gudrun. *Handbook of Museums.* 2 vols. New York: R. R.
 Bowker, 1971; Munich: Verlag Dokumentation, 1971. (EN, GE)
 A comprehensive directory to more than 3,000 museums in the principal
 German-speaking nations of Europe, Birgit-Kloster's handbook is arranged
 by country. Volume 1 is devoted to the Federal Republic of Germany; the
 German Democratic Republic, Austria, and Switzerland are treated in vol-
 ume 2. Entries cover a broad spectrum of collections from natural science
 to regional history and offer commentary on the historical and architectural
 significance of each institution, the condition of its archives or library, and
 any restoration work it may be sponsoring, in addition to detailed visiting
 information.

B–14 Boesen, Gudmund. *Danish Museums.* Copenhagen: Committee for Danish
 Cultural Activities Abroad, 1966.
 An overview of Danish museum history precedes a listing of institutions
 by city and region. Boesen devotes photographs and essays to the collections
 of each museum in the text. The appendix provides single-phrase descrip-
 tions and operating details for sightseers.

B–15 Brascoupé, Simon, ed. *Directory of North American Indian Museums and Cultural Centers, 1981.* Niagara Falls, NY: North American Indian Museums Association, 1980.
 Dedicated to tribal museums (as distinguished from museums that contain only artifacts of Indian culture) this soft-cover guide lists more than one hundred institutions operated by North American Indians. Entries are organized alphabetically by name and include complete visiting information, together with comments on community programs, research facilities, and institutional history. The preface reviews the origins and objectives of the North American Indian Museums Association, and the appendix suggests guidelines for museums facing requests for the restitution of native American materials.

B–16 Brzostowski, Stanislaw, and Stanislaw Orysiak. *Muzea w Polsce; przewodnik-informator.* Warsaw: Związkowe CRZZ, 1971. (PO)
 The authoritative guide to Polish museums, this lengthy book directs visitors to more than a hundred public institutions.

B–17 Butler, Patricia. *A Guide to Art Galleries in Ireland.* Dublin: Gill and Macmillan, 1978.
 A short directory to eighty-three private and public art galleries in Northern Ireland and the Irish Republic, Butler's guide is broken down into geographic regions. Entries contain visiting information, brief descriptions of the collections, and indications of publications, community services, programs, and other promotional activities. For more exhaustive listings, see the directories by Joan Abse (B–1) and Séan Popplewell (B–72).

B–18 Canadian Museums Association. *The Official Directory of Canadian Museums and Related Institutions, 1984–85.* Ottawa: Canadian Museums Association, 1984.
 Organized by province and municipality, profiles of 1,702 Canadian museums and related institutions contain brief descriptions of collections and activities, visiting information, and administrative details. All museums are indexed by name and by subject; additional features are a list of museum associations and an index of personnel.

B–19 Cary, Norman Miller, Jr., comp. *Guide to U.S. Army Museums and Historic Sites*. Washington, DC: Center of Military History, Department of the Army, 1975.
Cary's guide to the sixty-four museums of the U.S. Army Museum System and historic sites on army property was compiled from a questionnaire survey. Part I lists registered army and army national guard museums by state; subsequent parts note Department of Defense museums, other federa museums with military collections, and selected private, state, and municipal military museums. All entries include directions, visiting information, and relatively full descriptions of the collections.

B–20 Christensen, Erwin O. *A Guide to Art Museums in the United States*. New York: Dodd, Mead, 1968.
Designed to complement similar works by Aubrey Cartwright (C–10) and Lane Faison (C–16), which are also devoted to U.S. art museums but limited to a regional scope, Christensen's directory omits the small and medium-sized institutions of New England, New York, and the southeast coastal states. Entries for art museums in the East, Midwest, and Pacific Coast regions contain visiting information and comments on the ambiance of the galleries that should "be accepted by the reader like program notes, which put the concert-goer in the mood of listening to music."

B–21 Crotty, Michael, ed. *Zoos and Aquariums in the Americas*. Wheeling, WV: American Association of Zoological Parks and Aquariums, 1974.
The AAZP guide is a reference work for zoo professionals that provides collection statistics and administrative data for all member institutions in North and South America. (See also B–40.)

B–22 Da Costa, Beverley, ed. *An American Heritage Guide: Historic Houses of America Open to the Public*. New York: American Heritage Publishing Company, 1971.
American historic houses, classified by state, are briefly described in terms of their historic significance, displays, governing authority, and operating schedules.

B–23 Denfield, Duane. *World War II Museums and Relics of Europe*. Manhattan, KS: MAIAH Publishing, 1980.
Considering not only museums but abandoned military installations, battlefields, and related sites throughout Europe, Denfield provides visiting information and a description of the material artifacts relating to World War II.

B–24 Directory Hotel's [*sic*]. *Museums and Archaeological Zones of Mexico*. Mexico: Editorial Nueva America, 1968.
The guide reviews eighty-nine Mexican museums, organized by state. Entries vary but generally provide the necessary details for visitors, in addition to descriptions of the collections and institutional history.

B–25 *Directory of Historical Societies and Agencies in the United States and
 Canada.* Nashville, TN: American Association for State and Local History,
 1982.
 The twelfth edition of the AASLH directory to North America contains
 5,865 entries and is intended to help historical researchers and the public
 utilize the resources of local historical societies. Each entry provides an
 address, telephone number, and the name of an officer to contact, as well
 as a brief summary of programs. Included are museums, libraries, archives,
 oral history projects, and publications. The editors single out the organi-
 zations best prepared to answer questions about the history of their state
 or province.

B–26 Dussan de Reichel, Alicia. *Guía de los Museos de Colombia.* Bogotá: In-
 stituto Colombiano de Coltura, Division de Museos y Restauracion, 1973.
 (SP)
 In the first guide to Colombian museums, entries for more than one hundred
 institutions, complete with visiting details and descriptions of the holdings,
 are listed alphabetically in part I. Subsequent sections supply statistics on
 Colombian collections and museum employees.

B–27 Eastman, John. *Who Lived Where: A Biographical Guide to Homes and
 Museums.* New York: Facts on File Publications, 1983.
 Primarily a directory to historic houses and house museums in the United
 States, Eastman's unusual volume differs from other directories devoted to
 the same subject by virtue of its organizational scheme, which arranges
 entries according to the names of more than 600 historic figures. Each
 personage is succinctly identified, and entries contain visiting information
 for the historic houses with which he or she is most closely associated, as
 well as citations for museums housing personal possessions or other relevant
 artifacts.

B–28 Eiffers, Joost, and Mike Schuyt. *Groot Museumboek.* Amsterdam: Meu-
 lenhoff/Landshoff, 1980. (DU)
 Some 660 Dutch museums are strikingly laid out in this illustrated book.
 Every entry includes hours, fees, and telephone numbers, as well as de-
 scriptions of the facilities.

B–29 Fensome, Joan, ed. *Stately Homes, Museums, Castles, and Gardens in
 Britain.* Basingstoke: Automobile Association, 1981.
 Exhaustive in scope, Fensome's directory covers all of the British Isles and
 supplies sightseeing motorists with directions, maps, hours, fees, telephone
 numbers, and terse descriptions of the collections.

B–30 Fitzgerald, W. H., Roland W. Force, and Adrienne L. Kaeppler, comps.
 Directory of Asian-Pacific Museums. Honolulu: Bishop Museum Press,
 1969.
 Harvesting the results of questionnaires distributed to institutions in more
 than twenty Asian and Pacific nations, the editors have compiled brief
 descriptions of each museum. Although the data provided vary from mu-
 seum to museum, entries usually cover staff composition, governing au-
 thority, sources of financial support, and publication programs, in addition
 to standard visiting information. Regional museums associations are listed
 in the appendix, and a 1971 supplement to the directory has been issued
 in pamphlet format.

B–31 Folsom, Franklin. *America's Ancient Treasures: A Guide to Archeological
 Sites and Museums in the United States and Canada.* Albuquerque: Uni-
 versity of New Mexico Press, 1983.
 Folsom catalogs the archaeological sites and museum collections open to
 the public that pertain to prehistoric North American aboriginal cultures.
 Facilities are listed by region, and entries contain directions, opening hours,
 and descriptions of the artifacts on view. Readers will also find essays on
 aspects of Indian life.

B–32 Fransen, Hans. *Guide to the Museums of Southern Africa.* Cape Town:
 Museums Association, 1969.
 Fransen's illustrated guidebook, although somewhat dated, features a tour-
 ist map and thorough descriptions of South Africa's museums.

B–33 Freudenheim, Tom L., ed. *American Museum Guides: Fine Arts.* New
 York: Macmillan, 1983.
 Designed to assist nonspecialists in appreciating the finest art museums in
 the United States on the basis of their specific collection strengths, this
 book is divided into seven sections: American art, ancient art, Asian art,
 European art, modern/postmodern Art, photography, and primitive art. In
 each section, contributing scholars have selected and discussed a limited
 number of the most significant collections in their field of expertise. Entries
 summarize visiting information and describe both the museums' holdings
 and their methods of display. Appendixes list museums cited in the text
 by location and by name.

B–34 Fromme, Babbette Brandt. *Curators Choice: An Introduction to the Art
 Museums of the U.S.* New York: Crown Publishers, 1981.
 The distinguishing feature of Fromme's directory to U.S. art museums,
 which is published in four regional editions, is that it invites museum
 curators themselves to assess their collections and create a list of "don't
 miss" items. Tourists are provided with extensive data on museum facilities,
 special events, and operating policies.

B–35 Galitskii, Vladimir Aleksandrovich, and Feliks Veniaminovich Zalmanov. *Moĭa Rodina—SSSR: Putevoditelʹ: (Po vsesoiuz. temat. marshrutam turist. ėkspedit̄sii sov. molodezhi).* 3 vols. Moscow: Mol. gvardiia, 1978–1980. (RU)
 Several hundred attractions are arranged according to geographic region in this thorough guide to the museums and monuments of the Soviet Union. All entries include visiting information, brief descriptions of the collections, and often a photograph.

B–36 Garvey, Jude. *A Guide to the Transport Museums of Great Britain.* London: Pelham Books, 1982.
 Garvey, the former director of Britain's Transport Trust, thoroughly describes fifty-two museums devoted to all means of transportation, from bicycles to aircraft. These summaries, which are organized by geographical region, cover institutional history, activities, and collections. Visiting information is available in brief notations in the gazetteer, which also lists an additional fifty-four museums awaiting more extensive description.

B–37 Gavzeh-Braverman, Nurit., and Yeho'ash Biber. *Madrikh le-muze'onim be-Yisrael.* 3d ed. Jerusalem: n.p., 1975. (HE)
 More than 150 Israeli museums, zoos, and historic sites are cataloged in this museum guide, which generally provides visiting information and a brief summary of the collections. Occasional illustrations highlight the more important displays, and the 1966 edition indexes entries in English as well as Hebrew.

B–38 Gažo, Josef, comp. *Slovenské Múzea.* Translated by Rajsa Husárová, Eva Gerlická, and Lýdia Oppitzova. Bratislava: Pallas, 1975. (CZ, RU, GE, EN)
 A colorful volume designed to introduce foreigners to the treasures of selected Czech museums, Gažo's amply illustrated guide describes the highlights of nearly eighty collections in greater depth than the directory by Václav Pubal (B–73). Entries are arranged alphabetically by location and contain visiting information, and an introductory essay by Milan Rybecký traces the history of Slovak museology.

B–39 German Africa Society, and Gundolf Seidenspinner, comps. *Museums in Africa: A Directory.* New York: Africana Publications, 1970.
 An excellent directory to the museums of fifty nations, this book provides a broad treatment of open-air museums, botanical gardens, zoos, and libraries, in addition to more traditional categories. All institutions are classified by subject in the appendix, and entries, although not always complete, contain detailed information on management and visitor facilities.

B–40 Gersh, Harry. *The Animals Next Door: A Guide to Zoos and Aquariums of the Americas*. New York: Fleet Academe Editions, 1971.
 Intended for tourists, Gersh's directory features introductory essays on the history, goals, and practices of zoological parks in North and South America. Entries carry more extensive data on hours, facilities, and activities than does the AAZP guide (B–21).

B–41 *Glass Collections in Museums in the United States and Canada*. Corning, NY: Corning Museum of Glass and the American National Committee of the International Association for the History of Glass, 1982.
 Compiled by the Corning Museum of Glass, this specialized directory to North American glass collections, which collectively chronicles the history of glassmaking, supplies both sightseers and researchers with the necessary specifics regarding institutional operations and the strengths of the collections.

B–42 Haas, Irving. *America's Historic Villages and Restorations*. New York: Arco Publishing, 1974.
 In contrast to Mitchell Alegre (B–4), Haas divides his volume into regional sections and endows the same museum villages with a more sophisticated treatment, concentrating on the history of the site itself rather than its tourist facilities.

B–43 Hamarneh, Sami K., and Ernst W. Stieb. *Pharmacy Museums and Historical Collections on Public View in the United States and Canada*. Madison: American Institute of the History of Pharmacy, 1981.
 Intended to supersede several earlier directories of North American pharmacy museums, apothecary shop restorations, and historical collections of pharmacological artifacts, this guide arranges entries by state for the United States and by province for Canada. Collections are briefly described and pertinent visiting information provided. In the preface, Hamarneh and Stieb sketch the historical emergence of health museums.

B–44 Hobbie, Margaret. *Museums, Sites, and Collections of Germanic Culture in North America*. Westport, CT: Greenwood Press, 1980.
 Hobbie, who includes an introductory essay on German-American history, surveys 152 collections of ethnic material. Her guide serves both researchers and tourists by providing visitors' information and tips on how to use the collections.

B–45 Hoffman, Paul, ed. *American Museum Guides: Sciences*. New York: Macmillan, 1983.
 This book covers ninety-three science museum collections in the United States and Canada and is organized in four chapters devoted to air and space, natural history, science and technology, and special topics. Each chapter is written by a specialist who has selected major collections worthy of extended discussion and smaller institutions deserving of "honorable mention." All entries include visiting information and detailed descriptions

of the most striking exhibition halls and best artifacts. Museums cited in the text are listed by geographical region and by name in the appendixes.

B–46 Hogg, Garry. *Museums of England*. Newton Abbot: David A. Charles, 1973. Hogg eschews London's prestigious and encyclopedic museums known to tourists everywhere in favor of fifty English institutions that are specialized, geographically diverse, and of relatively recent origin. Each entry is documented with photographs and descriptions of the collections and facilities.

B–47 Horna, Jorge. *Museos de Panama*. Panama City: Instituto Nacional de Cultura de Panama, 1980. (SP)
This unusually valuable source contains essays on cultural protection laws, museums and Panamanian life, and a chronology of national museum history. A directory to contemporary museums provides information of interest to sightseers.

B–48 Hudson, Kenneth. *The Shell Guide to Country Museums*. London: Heinemann, 1980.
"Museums are one of the things the British are good at," writes Hudson, who, like Garry Hogg (B–46), moves beyond the British Museum, the Victoria and Albert, and other London fixtures to concentrate on small collections with a local rather than national flavor. Hudson argues that such museums, intimate in scale and closely allied with community roots, are natural havens for those interested in social history and offer "a way into the past that makes sense."

B–49 ———. *The Cambridge Guide to the Museums of Britain and Ireland*. New York and Cambridge: Cambridge University Press, 1987.
Hudson's covers over 2,000 well-established and lesser-known museums and art galleries in Britain and Ireland and contains lively entries on topics ranging from the collections to access for the handicapped. This guide largely supercedes Abse (B–1).

B–50 Huovinen, Anja-Tuulikki, ed. *Finnish Museum*. Helsinki: Suomen museoliitto, 1979.
More than 150 museums are treated in this compilation, which lists institutions by geographical location and provides photographs, administrative particulars, historical details, and current operating information. In the index, museums are listed according to topic of collection.

B–51 Jones, Kenneth Westcott. *Railways for Pleasure: The Complete Guide to Steam and Scenic Lines in Great Britain and Ireland*. Guildford: Lutterworth Press, 1980.
Although predominantly devoted to operating scenic lines in England, Scotland, Wales, and Ireland, Jones's well-illustrated guide also contains entries for some nineteen railroad museums. Entries are designed to provide complete visiting information and good summaries of the exhibits and their current condition. The introduction contains a brief overview of the railroad preservation movement in Britain.

B–52 Kean, Randolph, comp. *The Railfan's Guide to Museums & Park Displays*.
 Forty Fort, PA: Harold E. Cox, 1973.
 Intended to permit railroad aficionados ready access to locomotives and
 rolling stock on public display in the United States, Canada, Mexico, Central
 America, and the Caribbean, Kean's directory is organized by state or
 province. For each museum, all rolling stock is listed, and, where known,
 the builder and date built are noted. Entries briefly indicate directions,
 general operating schedules, and addresses for mail inquiries. The book
 contains numerous photographs, a bibliography, and an index for quick
 reference.

B–53 Kirby-Smith, Henry Tompkins. "A Catalog of U.S. Observatories and Some
 Important Museums and Planetariums." In *U.S. Observatories: A Directory
 and Travel Guide*, by Henry Tompkins Kirby-Smith. New York: Van Nos-
 trand Reinhold, 1976.
 One part of a larger survey of observatories in the United States that
 describes in depth fifteen major installations and their work, this catalog is
 arranged by state and attempts to list all institutions of importance to as-
 tronomy. For the museums cited, Kirby-Smith provides short descriptions
 of their relevant exhibits, as well as information regarding their special
 programs and daily schedule. An introductory essay offers advice for pro-
 spective visitors to observatories and some basic information about astron-
 omy.

B–54 Korek, J., and I. Kovrig. *The Archaeological Collections of the Hungarian
 Museums*. Budapest: Vizy Otto, 1969.
 The authors briefly describe thirty-nine Hungarian museums with archae-
 ological collections and their sponsorship of fieldwork but do not address
 the practical demands of tourists.

B–55 Lapaire, Claude. *Museen und Sammlungender Schweiz*. Bern: Paul Haupt,
 1965. (GE)
 An introduction to the history of Swiss museums is printed in both French
 and German, although entries are generally in the latter. Descriptions of
 the museum facilities and collections supplement visiting information in
 every case, and all museums are indexed by subject.

B–56 Lewis, Guy, and Gerald Redmond. *Sporting Heritage: A Guide to Halls
 of Fame, Special Collections and Museums in the United States and Canada*.
 South Brunswick: A. S. Barnes, 1974.
 Divided into geographical regions, Lewis and Redmond's guide lists fifty
 halls of fame and museums of sport in the United States and Canada, running
 the gamut from cricket collections to the National Ski Museum of Ottawa.
 Short summaries of the holdings and the history of the facilities are sup-
 plemented with information on hours, fees, and yearly schedules.

B–57 Lloyd, Clem, and Peter Sekuless. *Australia's National Collections*. North
 Melbourne: Cassell Australia, 1980.
 Excluding local collections, the authors concentrate on museums of national
 importance and devote well-illustrated chapters to the Australian National
 Gallery, the Museums of Science and History, the Nicholson Museum, and
 the Tasmanian Museum and Art Gallery. In their introduction, they develop
 a historical framework that periodizes Australian museum growth into four
 great eras of institutional emergence.

B–58 Lubell, Cecil. *France: An Illustrated Guide to Textile Collections in French
 Museums*. New York: Van Nostrand Reinhold, 1977.
 Lubell reviews the textile collections of twenty-three French museums in
 depth to provide professional textile designers and students of the textile
 industry with potential design ideas and a guide to sources of information.

B–59 Mapatuna, Padma, Marcus Fernando, and L. K. Karunaratne, comps. *Reg-
 ister of Museums and Collections in Sri Lanka*. Colombo: Ministry of Cul-
 tural Affairs, 1978.
 Sri Lankan museums are classified according to location and type of col-
 lection. Each listing contains information for tourists and a description of
 collections highlights.

B–60 McLanathan, Richard. *World Art in American Museums: A Personal Guide*.
 Garden City, NY: Anchor Press, 1983.
 McLanathan evaluates more than 700 museums with the intention of en-
 couraging "the indulgence, and enlargement through experience, of indi-
 vidual taste and curiosity." A geographical inventory providing general
 information and directions to nearby attractions is succeeded by a chron-
 ological discussion of North American collections representing all major
 epochs in art history and introductory essays to the stylistic characteristics
 of individual artists.

B–61 Mohamed Zulkifli bin Abdul Aziz. *Directory of Museums in Malaysia*. Kuala
 Lumpur: Muzium Negara, 1977.
 Arranged under the categories of Malay national museums, state museums,
 departmental museums, art galleries, and zoos and aquariums, each mu-
 seum is accorded full visiting information in addition to a photograph and
 descriptions of institutional history, goals, staff, special facilities, publica-
 tions, and educational activities.

B–62 Molegraaf, Rudi, comp. *De Nederlandse Museumgids*. The Hague: Staat-
 suitgeverij Enkhuizen, Nederlandse Museum Vereniging, 1980. (DU)
 This guide lists 588 museums of the Netherlands by geographic region.
 Entries are composed of visiting information, short summaries of the col-
 lections, and abbreviated designations for certain kinds of facilities, such
 as restaurants, libraries, and movie theaters. At the beginning of each
 regional section, the editors provide a short overview in which they discuss
 and compare the museums more generally by topical area. All entries are
 indexed by museum name and by subject.

B–63 Mostny, Grete. *Los Museos de Chile*. Santiago de Chile: Editora Nacional
 Gabriela Mistral, 1975. (SP)
 An excellent Spanish directory, Mostny's volume contains an introductory
 essay on Chilean museums, which were largely a manifestation of the drive
 for cultural and political independence after 1813. Entries describe the
 ambiance, history, and collections of sixty-nine facilities, and an appendix
 provides operating details for tourists.

B–64 *Museums and Art Galleries in Great Britain and Ireland*. Bedfordshire,
 England: ABC Travel Guides. Annual.
 Something akin to the telephone directory of British and Irish museums,
 this periodical consists of an alphabetical list of abbreviated entries (address,
 single-sentence description of the collections, and hours) punctuated by
 commercial advertisements for museum attractions. All museums are in-
 dexed by subject and location.

B–65 *Museums and Art Treasures in Austria*. Vienna: Josef Gerstmayer, 1968.
 A booklet designed to assist English-speaking visitors locate Austria's less
 well-known art museums, collections, and buildings of architectural inter-
 est, this guide emphasizes facilities outside Vienna and the provincial cap-
 itals. Sites selected for mention have been chosen partly for their
 geographical proximity in order to facilitate tours by foot or by car to several
 points on a single trip. Museums in every city (including Vienna) are listed
 in a chart format that briefly describes collections and indicates opening
 hours.

B–66 *Museums and Galleries in Scotland*. n.p.: Council for Museums and Gal-
 leries in Scotland and Scottish Tourist Board, 1981.
 Nearly 350 Scottish museums and art galleries are listed in alphabetical
 order by town. Designed for visitors, this compact guide provides complete
 visiting information and brief descriptions of the collections. A battery of
 symbols indicates the presence of special facilities and activities.

B–67 *Museums in the Federal Republic of Germany*, translated by B. S. Hughes. Munich: Heinz Moos Verlag, 1976.
This compact guide attempts to give readers an impression of West Germany's various museums and art galleries, their range of exhibits, the "functions they fulfill and the problems they face, even if this has meant that some old established and important museums have been given less attention than smaller, less well-known ones." Classified by genre, museums are generally designated only by their location and cited for the ways in which they typify the goals and achievements of institutions in their category.

B–68 "Museums of Negro History." In *A Guide to Facts About the Negro*. New York: National Association for the Advancement of Colored People, 1970.
A chapter within the NAACP's reference guide to Afro-American history and culture, this museum directory categorizes twenty-three institutions according to subject concentration, such as abolition and Afro-American art and music. Each museum is described in terms of address, hours of operation, and date of founding.

B–69 National Standards Council of American Embroiderers. Museum Information Service Committee. *A Directory of Where to Find Embroidery and Other Textile Treasures in the U.S.A.* Tulsa, OK: Jody's Letter Service, 1977.
This concise directory to American collections of needlework is arranged alphabetically by state and contains visiting information for a variety of museums and historic houses.

B–70 *Nautical Museum Directory*. 5th ed. New York: Quadrant Press, 1978.
Compiled at regular intervals, this directory to nautical museums is short but thorough. Entries are arranged by locality and note operating schedules, fees, and special attractions.

B–71 Peraza Sarausa, Fermin. *Directorio de Archivos y Museos de Cuba*. 2d ed. Coral Gables, FL: University of Miami Branch, 1968. (SP)
Peraza Sarausa compiles a brief listing of Cuban museums by province, with details on date of founding, location, and occasionally the nature of the collections.

B–72 Popplewell, Séan, ed. *The Irish Museums Guide*. Dublin: Ward River Press and Irish Museums Trust, 1983.
In an effort to bring Ireland's museum resources to the attention of a larger audience, the Irish Museums Trust lists 148 institutions regardless of size, scope, or standard of excellence. Entries are organized according to Ireland's four provinces and contain short descriptions of the collections and, in most cases, complete visiting information. All museums are indexed by location and subject, and supplementary appendixes note historic houses, gardens, and libraries with unusual collections open to the public.

B–73 Pubal, Václav. *Muzea, Galerie a Památkové Objekty v. ČSR.* Prague: Ná-
 rodni Muzeum, 1973. (CZ)
 Although not available in English, Vaclav Pubal's directory to more than
 140 Czech museums is considerably more comprehensive than the guide
 compiled by Jozef Gažo (B–38). Museums are listed by location, and entries
 briefly indicate visiting information, institutional history, and the size of
 the collections.

B–74 Read, Neil, and Tom Wilson, comps. *Guide to Art Galleries in Scotland.*
 Edinburgh: Paul Harris Publishing, 1981.
 This pocket guide arranges more than one hundred Scottish art museums
 and commercial galleries in alphabetical order by name. Entries supply
 visiting information and brief but informative descriptions that cover in-
 stitutional history, the focus of the collections, and special programs or
 services.

B–75 Remootere, Julien Van. *Guide des Musees Belges.* Brussels: Meddens, 1979.
 (FR)
 Van Remootere organizes 499 Belgian museums by city. For each, he lists
 careful instructions for tourists and either a brief essay or a room-by-room
 commentary on the collections. All entries are indexed according to the
 major topic represented by the museum holdings.

B–76 Riley, Gordon, comp. *Aircraft Museums Directory.* London: Battle of Brit-
 ain Prints International, 1975.
 A short pamphlet intended to provide quick and easy reference to Great
 Britain's forty aircraft museums, Riley's guide lists attractions alphabetically
 by name. In every instance, locations are identified, admission fees cited,
 and the collections listed in a chart format that notes the types of aircraft
 on display, their condition and current status, and alternate locations where
 they can be seen.

B–77 Riveros Ramírez, Francisca Gladys. *Guía Descriptiva de Bibliotecas, Mu-
 seos y Archivos del Paraguay.* Asunción, Paraguay: Universidad Nacional
 de Asunción, Escuela de Bibliotecologia, 1983. (SP)
 This lengthy monograph provides individual profiles of Paraguayan cultural
 institutions, including forty-four public and private museums. Entries,
 which are indexed by name, offer a brief overview of the collections and
 indicate governing authority, means of financial support, director's name,
 hours, date of founding, size of staff, and type of audience.

B–78 Roberts, Laurance P. *Roberts' Guide to Japanese Museums.* Tokyo: Ko-
 dansha International, 1978.
 A revision of Roberts's earlier *Connoisseur's Guide to Japanese Museums*
 that cites many recently opened institutions, this outstanding directory

represents the personal selections of the author. More than 300 museums of art and archaeology are listed alphabetically by their English names, and each entry contains visiting information, director's name, and a succinct overview of the collections. In his preface, Roberts provides helpful pointers for visiting Japanese museums and a short summary of the art periods of Japan, Korea, and China. A glossary of terms and proper names is provided at the end of the guide. Museums are cross-referenced in the indexes by Japanese names, prefectures, and types of collections.

B–79 Rosenberg, Sam, and Donna M. Hull, eds. *Travel Historic Rural America: A Guide to Agricultural Museums and Events in the U.S. and Canada*. St. Joseph, MI: American Society of Agricultural Engineers, 1980.
Organized by state and province, this directory cites hundreds of agricultural museums, historical societies, and other institutions preserving examples of agricultural structures, machinery, or processes in the United States and Canada. Entries are brief but include directions, hours, telephone numbers, fees, and indications of the holdings.

B–80 Saifur Rahman Dar. *Archaeology and Museums in Pakistan*. Lahore: Lahore Museum, 1975.
Although excluding zoos and botanical gardens, the director of the Lahore Museum lists forty-one museums in appendix A, each with location, date of founding, and a brief description of the collections. Most of the book is devoted to an extended historical essay treating the major Pakistani museums.

B–81 Sakai, Michio, Shin'ichi Nagai, and Ryūkai Etani. *Kankoku shiseki busseki gaido* Tokyo: Higashi, 1977. (JA)
The comprehensive *Guide to South Korean Cultural and Historical Sites* provides visitors with an illustrated listing of museums, galleries, and Buddhist temples.

B–82 Sanz-Pastor y Fernández de Piérola, Consuelo. *Museos y Colecciones de España*. Madrid: Ministerio de Cultura, Dirección General de Bellas Artes, Archivos y Bibliotecas, 1980. (SP)
Conceived by the Ministerio de Cultura as a complete survey of the Spanish museum community, this compendious directory concentrates heavily on the institutional history and operating characteristics of hundreds of museums, galleries, historic houses, zoos, and public gardens. All entries are arranged by province and contain complete visiting information and an abbreviated designation of the collections. Museums are indexed by location and by name, and Sanz-Pastor y Fernández de Piérola, the director of the Museo Cerralbo, supplies a bibliography of works on Spanish museology and chronologies of important legislation relating to museums and cultural policy.

B–83 Serner, Gudrud, ed. *A Key to the Museums of Sweden.* Stockholm: Rabén
 & Sjögren, 1960.
 Intended to aid foreign visitors, Serner's guide briefly summarizes the
 collections and institutional history of some 170 Swedish museums. A list
 of museums at the end of the directory designates locations and hours of
 opening for all institutions cited in the text. The index permits readers to
 locate the museums relevant to their particular areas of interest.

B–84 Sherman, Lila. *Art Museums of America: A Guide to Collections in the
 United States and Canada.* New York: Morrow, 1980.
 Unlike McLanathan's directory (B–60), Sherman's excellent guide is less
 concerned with evaluating the variety of artworks available for public con-
 sumption than with directing Americans participating in the "cultural ex-
 plosion" to the appropriate facility. Entries are categorized by state or
 province, and each contains full particulars for the tourist.

B–85 Simmons, Jack. *Transportation: A Tour of Museums.* South Brunswick, NJ:
 A. S. Barnes, 1970.
 An excellent discussion of thirty-four transport museums in Great Britain
 and Western Europe, Simmons's guide is not comprehensive but is, rather,
 intended to illustrate what can be learned about the evolution of transport
 from museum artifacts. Simmons concentrates on railroads to a greater
 degree than automobiles, ships, or airplanes because he feels that they are
 best handled in the museum setting. Although specific visiting information
 is sketchy, the chapters dedicated to each museum are valuable sources of
 institutional history, criticism of exhibition techniques, and analyses of the
 collections.

B–86 Spaeth, Eloise. *American Art Museums and Galleries: An Introduction to
 Looking.* New York: Harper and Brothers, 1960.
 Intended for new or latent art connoisseurs, Spaeth's classic directory to
 American art museums eschews major metropolitan institutions in favor of
 smaller collections of unusual quality, for which readers are provided vis-
 iting information and subjective analyses of the works on display. Artists
 and artworks are indexed.

B–87 Stepan, Peter, ed. *Die Deutschen Museen.* Braunschweig: Georg Wester-
 mann Verlag, 1983. (GE)
 A beautifully illustrated and compendious guide to more than 1,500 mu-
 seums in both the German Democratic Republic and the Federal Republic
 of Germany, Stepan's book arranges entries alphabetically by city and pro-
 vides visiting information and lengthy descriptions of the collections. All
 museums are indexed by subject, and Norbert Wolf has contributed a
 review of German museum history for the foreword.

B–88 Stobbs, William. *Motor Museums of Europe*. London: Arthur Barker, 1983.
 A well-illustrated book covering 166 automobile and carriage collections in
 Western European museums, this directory provides opening hours, tele-
 phone numbers, and addresses (each museum location is keyed to outline
 maps of Great Britain and the Continent). Stobbs briefly discusses insti-
 tutional history and offers an overall impression of the museum's quality,
 atmosphere, and value to students of road transport.

B–89 Sullivan, Dick. *Old Ships, Boats and Maritime Museums*. London: Coracle
 Books, 1978.
 Sullivan has packed his directory to 130 British maritime museums and 300
 old ships open to the public with extensive descriptions of the collections,
 historical details, and anecdotes pertaining to British naval achievements.
 An introductory essay provides a brief chronology of significant advances
 in shipbuilding.

B–90 Svendsen, Af Poul. *Museet i. undervisningen*. Roskilde: Amtscentralen for
 Undervisningsmidler, 1979. (DA)
 This lengthy directory organizes Denmark's museums according to geo-
 graphical region.

B–91 Sweeney, James B. *A Pictorial Guide to the Military Museums, Forts, and
 Historic Sites of the United States*. New York: Crown Publishers, 1981.
 A lavishly illustrated guide to military museums, forts, and related sites in
 the United States, Sweeney's book is divided into three parts devoted to
 collections dealing with ground action, nautical matters, and aviation com-
 bat. Within each section, entries are arranged alphabetically by state, and
 all entries provide visiting information and short descriptions, in addition
 to photographs. Unlike Norman Cary's guide to U.S. Army museums (B–
 19), Sweeney's directory covers private as well as public institutions.

B–92 Taylor, William R. *Auto Museum Directory USA*. Butte, MT: Editorial
 Review Press, 1983.
 Organized by geographical region and by state, Taylor's guide lists more
 than 140 automobile collections in American museums. Entries contain
 complete visiting information, including details about available tours and
 policies on photography. Each museum receives a short description cov-
 ering institutional history and notable displays.

B–93 Thomson, Keith W. *Art Galleries and Museums of New Zealand*. Welling-
 ton: A. H. & A. W. Reed, 1981.
 Thomson devotes four chapters to some twenty-eight major art galleries,
 art museums, natural history museums, and open-air museums in New
 Zealand. Entries in these chapters contain unusually detailed descriptions
 of the collections, illustrations, and overviews of institutional history, and
 an index provides visiting information and more cryptic summaries for 130
 museums of all kinds, arranged by geographic region. A substantial com-

pilation of data, Thomson's directory indicates important private collections and institutions under development, and an introductory chapter reflects the author's research on the evolution of New Zealand museums and their public.

B–94 Tofayell, Z. A. *Bangladesh: Antiquities and Museum*. Dacca: Atikullah, 1973.
Although ostensibly intended to describe the collections and institutional history of such major facilities as the Shirz Institute and the Varendra and Tagore museums of Bangladesh, this directory incidentally supplies a considerable amount of extraneous material. The tone is sometimes overly nationalistic, and the entries are not always informative.

B–95 Torres, Heloisa Alberto. *Museums of Brazil*, translated by John Knox. Rio de Janeiro: Ministry of Foreign Affairs, Cultural Division, Publications Office, 1953.
Torres classifies some 150 museums according to governing authority and lists locations, collections summaries, and museum publications. The introduction provides a brief overview of Brazilian museum history.

B–96 Toulson, Shirley. "Gazetteer of Farm Museums and Farm Parks." In *Discovering Farm Museums and Farm Parks*, by Shirley Toulson. Aylesbury, England: Shire Publications, 1977.
Written for both historians and tourists with an interest in traditional agricultural processes, Toulson's short book surveys the history of farming in Britain and examines the evolution of livestock, buildings, implements, and rural crafts. The gazetteer lists more than 140 farm museums, folklife centers, and restored buildings in England, Scotland, Northern Ireland, and Wales. Entries provide visiting information and descriptions of the collections.

B–97 Trowell, Kathleen Margaret. *A Handbook of the Museums and Libraries of Uganda*. Occasional Paper, no. 3. Kampala: Uganda Museum, 1957.
Intended to aid both scholars and visitors with more general interests, Trowell's brief directory to Uganda's museums, libraries, herbariums, and aquariums provides the location, telephone number, and hours of each facility. Entries also describe the museum displays and the focus and size of the collections.

B–98 Truesdell, Bill, ed. *Directory of Unique Museums*. Kalamazoo, MI: Creative Communications, 1979.
Truesdell's quirky directory is designed to offer curious sightseers the wherewithal to track down such highly specialized or offbeat American museums as the Dizzy Dean Museum of Jackson, Mississippi, and the St. Louis National Museum of Medical Quackery.

B–99 United Nations Educational, Scientific and Cultural Organization. *Guía de Museos de la América Latina*. Havana: Centro Regional de la UNESCO en el Hemisferio Occidental, 1963.
Designed to offer information on Latin American museums for interested researchers, this UNESCO guide is the result of a questionnaire survey of eighteen nations (not including Brazil). Entries for more than 140 museums are organized by country and provide complete visiting information, short descriptions of the collections, and such historical and administrative details as the date of founding and nature of the governing authority.

B–100 United Nationsl Educational, Scientific and Cultural Organization–International Council of Museums Documentation Centre. *Directory of African Museums 1981*. Paris: UNESCO, 1981. (EN,FR)
Forty-four African countries are covered in this directory, which provides terse information on museum location, staff, opening hours, publications, and services. Although it is a more current publication than the German Africa Society's directory (B–39), many entries are incomplete in this compilation. Full entries include details of institutional history and a summary of the collections.

B–101 ———. *Directory of Asian Museums 1983*. Paris: UNESCO, 1983.
A softback guide to museums in twenty-three Asian nations, this directory was compiled from UNESCO-ICOM data and indicates founding dates, addresses, directors' names, opening hours, governing authorities, and titles of available publications. Collections are summarized briefly.

B–102 Welle-Strand, Erling. *Museums in Norway*. Oslo: Royal Ministry of Foreign Affairs, 1974.
Welle-Strand offers an introduction to some of the more than 320 museums of Norway and outlines Norwegian museum history and the various goals and methods of contemporary institutions. Museums are categorized according to subject, and tourists are provided visiting information, as well as succinct summaries of the collections.

B–103 Wise, Terrence. *A Guide to Military Museums*. Berkshire, England: Bellona Publications, 1969.
Reductions in the British armed forces throughout the decade preceding publication of this pamphlet helped to create a rich array of new regimental museums. Like national army museums and armories, they are arranged in this guide according to location. The entries vary widely in the amount of information provided.

B–104 Wurlitzer, Bernd. *Museen, Galerien, Sammlungen, Gedenkstätten*. Berlin: VEB Tourist Verlag, 1983. (GE)
A comprehensive guide to hundreds of museums and collections in East Germany, this directory is organized by geographic region. Entries provide opening hours and summaries of the collections. All sites are keyed to maps at the end of the book.

B–105 Wynar, Lubomyr R., and Lois Buttlar. *Guide to Ethnic Museums, Librar-
 ies, and Archives in the United States.* Kent, OH: Program for the Study
 of Ethnic Publications, School of Library Science, Kent State University,
 1978.
 In response to "the new emphasis on cultural pluralism in American ed-
 ucation," Wynar and Buttlar provide an alphabetical listing of museum
 collections pertaining to seventy ethnic groups in the United States. Where
 applicable, visiting information is included with a brief description of the
 holdings.

B–106 Young, Andrew D. *Trolley to the Past: A Brief History and Companion to
 the Operating Trolley Museums of North America.* Glendale, CA: Inter-
 urban Press, 1983.
 In an effort to chronicle the rise of operating trolley museums in the United
 States and Canada, Young devotes several chapters to the history of pres-
 ervation, interpretation, and documentation of interurban transport. The
 second part of the book cites twenty-six trolley museums alphabetically by
 state or province. Each entry provides visiting directions (hours and ad-
 mission fees are omitted) and an extensive description of the facilities, as
 well as a tentative roster of the collections. A third part is devoted to defunct
 museums and discusses the possible reasons for their demise.

B–107 Zocca, Emma, ed. *Repertorio dei Musei e delle Racolte di Archeologia,
 Arte e Storia in Italia.* Rome: Ministero della Pubblica Istruzione, Direzione
 Generale delle Antichita e Belle Arti, 1961. (IT)
 Hundreds of Italian museums of art, history, and archaeology are organized
 by city. Although entries do not indicate visiting information other than
 location, they invariably contain some details of institutional history and
 the nature of the collections. In some cases, bibliographic references cite
 museum publications.

REGIONAL, STATE, AND LOCAL DIRECTORIES

C–1 Alabama State Council on the Arts and Humanities and National Endow-
 ment for the Arts. *Alabama Museums; a State Directory.* n.p.: Brown
 Printing Company, 1980.
 Separate listings are provided for Alabama's art museums, art galleries and
 centers, history museums, house museums, military museums, natural his-
 tory and science museums, and museums under development. Essentially
 an inventory of basic information, individual entries designate governing
 authorities, areas of research, activities, publications, hours, and admission
 fees but contain only brief descriptions of the collections.

C-2 Alexander, Mary, ed. *The Directory: A Guide to Museums, Nature Centers, Parks, Historic Sites, and Other Resources in the Washington Area.* Washington, DC: Museum Education Roundtable, 1973.
This pamphlet is intended to aid teachers in planning trips and activities with children in greater Washington, D.C. Museums and other sites of interest are organized by name, and their facilities are described in meticulous detail, with additional information on tours, programs, and staff members to contact.

C-3 Ary, Noel. *Museums of Southwest Kansas.* Dodge City: Cultural Heritage and Arts Center, 1969.
Ary's unusual regional guide to southwest Kansas lists museums by city. Entries, usually accompanied by a photograph, contain complete collections and permanent displays.

C-4 Ashin, Deborah. *Inside L.A. Art: A Guide to Museums and Galleries from Santa Barbara to San Diego.* San Francisco: Chronicle Books, 1980.
Bored by the stereotype of southern California as a cultural wasteland, Ashin sets out to portray it as an "impressive cultural force" and argues that its art community, "from venerable museums to avant-garde galleries, benefits from that special exhilaration which comes from being young and fresh and, perhaps, just a little crazy." She describes 140 museums and galleries in the greater Los Angeles area, and each entry contains voluminous visiting information, including details on parking, mass transit, access for the handicapped, and the range of special facilities. In addition, she offers an overview of the museums' goals, policies, recent exhibitions, atmosphere, and annoying habits, such as the Norton Simon Museum's penchant for covering paintings with glass.

C-5 Bergada, Evangelina, and others. *Guía de Museos.* La Plata: Direccion de Museos, Reservas e investigaciones culturales, 1958. (SP)
Five museums in the Buenos Aires region are described in depth, with full visiting information and summaries of collections highlights, institutional history, and long-term goals.

C-6 Bernard-Foillot, Denise. *Guide to the Museums of Paris and Suburbs.* Paris: Les Guides Bleus-Hachette, 1979.
While covering 124 museums of "exceptional quality and abundance" in greater Paris, Bernard-Foillot has compiled voluminous data for every entry, including all that a tourist could desire and a room-by-room description of the collections. A topical guide to the listings can be found in the "pick your museum" section, and Pierre Quonian, inspector-general of French museums and former director of the Louvre, has contributed an introduction to the history of Parisian museums.

C–7 Boulizon, Guy. *Les Musées du Québec.* 2 vols. Montreal: Fides, 1976. (FR)
 Boulizon's guide suggests eight museum tours of Quebec, and all entries
 describe the facilities, their institutional history, their collections, opening
 hours, and the evaluations of visitors and expert critics. (See also C–22.)

C–8 Butkovic, Ivo, and Vera Vejvoda, eds. *Museums and Galleries in Zagreb.*
 Zagreb, Yugoslavia: Society of Museum Members of the City of Zagreb,
 1976.
 In celebration of the 140th anniversary of the National Museum, this di-
 rectory cites the institutional history and describes both the collections and
 visiting policies of twenty-six museums in Zagreb, Yugoslavia. A reference
 map is enclosed for tourists.

C–9 Cadwalader, Kathryn, and Amy Flowerman, eds. *The Educator's Guide to
 Museum Resources in the Philadelphia Area.* Philadelphia: Museum Council
 of Philadelphia, 1978.
 Designed to offer teachers a concise listing of education program infor-
 mation, this guide to thirty-five museums and related institutions in the
 greater Philadelphia area is organized alphabetically by name of facility.
 Education programs are described in detail, and the editors make sugges-
 tions for enhancing school trips. Each entry provides telephone numbers
 and complete visiting information, supplemented by symbols indicating
 parking, access for the handicapped, cafeteria, library, and other special
 features.

C–10 Cartwright, W. Aubrey. *Guide to Art Museums in the United States. East
 Coast—Washington to Miami.* New York: Duell, Sloan and Pearce, 1958.
 Sorely dated but still valuable for its careful room-by-room analysis of col-
 lections in the existing galleries of Washington, D.C., and the southeastern
 United States, Cartwright's directory alerts readers to special facilities,
 seasonal activities, and works of stylistic or historical significance.

C–11 Cramer, Nancy, and Laurie Gearhart. *Guide to Museums in the Delaware
 Valley.* New York: A. S. Barnes, 1976; Philadelphia: Art Alliance Press,
 1976.
 Encompassing the tristate area of New Jersey, Delaware, and Pennsylvania
 near the Lower Delaware River, Cramer and Gearhart's guide provides
 visiting information and collections summaries for more than 100 museums.
 The book includes maps and photographs.

C–12 *Directory of Civil War Museums in Virginia.* Richmond: Virginia Civil War
 Commission, 1965.
 Virginia museums housing Civil War artifacts are organized by county.
 Hours, admission fees, director's name, and a brief description of the col-
 lections are provided for each.

C-13 *Directory of Ontario Museums, Art Galleries, Archives & Related Institutions.* Toronto: Ontario Museums Association, 1982.
A fine, concise guide to Ontario museums, galleries, and historic houses, this pamphlet lists more than 200 institutions alphabetically by name. Sightseers will find hours of operation listed and a short description of the collections. All museums are indexed by geographical location and by subject.

C-14 *Dirección General de Bibliotecas, Archivos y Museos.* Santiago de Chile: La Dirección, 1972. (SP)
This short pamphlet is dedicated to five museums in Santiago de Chile and describes them in depth, while merely noting the names and locations of lesser museums in the immediate vicinity.

C-15 Evans, D. Kay, comp. *Directory of Louisiana Museums and Exhibition Spaces.* Baton Rouge: Louisiana Association of Museums, 1984.
An excellent looseleaf guide to ninety-five museums and related nonprofit cultural institutions in Louisiana, this directory is intended to serve as a statewide clearinghouse for museum resources and provides information about museum associations and traveling exhibitions. Entries make use of symbols to indicate institutional disciplines and provide visiting information, directors' names, descriptions, and titles of available publications.

C-16 Faison, S. Lane, Jr. *Art Tours and Detours in New York State.* New York: Random House, 1964.
By far the best guide to art museums in New York State, Faison's directory concentrates on some seventy-eight museums and historical landmarks outside New York City. Designed to accompany the museum visitor, it selects more than 400 artworks on display, ranging from Corot to carriages, for their quality of execution and frequently refers readers to other works in nearby collections that illustrate a stylistic or historical argument.

C-17 ———. *The Art Museums of New England.* Boston: David R. Godine, 1982.
The director emeritus of Williams College Museum of Art has organized "an excursion into art criticism" by selecting 550 works of art from more than one hundred museums and galleries for illustration and critical discussion. Selected art museums and other institutions housing artworks are listed alphabetically by town, and many works are cross-referenced to others in the region by the same artist or school, thus allowing tourists to place a particular piece "in a larger critical and historical context." This thorough guide not only treats the collections and operating policies but notes institutional history as well.

C–18 Fein, Cheri. *New York: Open to the Public. A Comprehensive Guide to Museums, Collections, Exhibition Spaces, Historic Houses, Botanical Gardens and Zoos*. New York: Stewart, Tabori and Chang, 1982.
Fein's book is a lavishly illustrated guide to more than 150 museums and collections in New York City. The author thoroughly documents the nature of the facilities and their hours for visitors, while endeavoring to locate offbeat attractions as well as established institutions and to describe their individual ambience colorfully.

C–19 Fernandez de Villegas, A., and Lucas Vidal. *Guía de los Museos de Madrid*. Bilbao: Ediciones Deusto, 1964. (SP)
The authors catalog more than sixty museums in Madrid and provide a map and complete visiting information.

C–20 Fischer, Mildred, and Al Fischer. *Arizona Museums*. Pheonix: Golden West Publishers, 1985.
More than 175 Arizona museums, many of them house museums or small collections of historical memorabilia, are classified according to geographical region and indexed by name, subject, and locality. For tourists, Fischer and Fischer provide maps and directions in addition to visiting information. Each entry contains a photograph of the museum and several paragraphs summarizing the exhibits.

C–21 *Fundação Estadual de Musues*. Rio de Janeiro: FEMURJ, 1977. (PR)
Ostensibly an assessment of museums and community needs in the state of Rio de Janeiro, Brazil, this agency publication lists visiting particulars for eleven area museums.

C–22 Gagné-Kriber, Thérèse, ed. *Les Musées du Québec*. Québec: Ministère des Affaires Culturelles, 1982. (FR)
The Ministry of Cultural Affairs, desiring to acquaint the public with seventy state and private museums and exhibition centers in Quebec, divides its directory into administrative regions, each with separate maps designating museum locations. Entries under each region are intended to give readers a general idea of the museum's collections, activities, and hours of operation. Appendixes list museums alphabetically by name and by town and offer brief summaries of the Société des musées québéçois and the museological programs of the Ministry of Cultural Affairs. (See also C–7).

C–23 Gayle, Nancy, comp. *Texas Museum Directory*. Rev. ed. Austin: Texas Historical Commission, 1978.
Gayle's directory is an authoritative source for Texas museums, although readers may also consult the newer state directory by Tyler and Tyler (C–51). Detailed visiting and mailing instructions, accompanied by a brief description of the collections, characterize each entry. Museums are organized by city.

C–24 Getlein, Frank, and Jo Ann Lewis. *The Washington D.C. Art Review: Explorer's Guide to Washington*. New York: Vanguard Press, 1980.
Perhaps the most useful directory to Washington's art museums, Getlein and Lewis's guide is breezy in style and laced with humor. It covers not only the basic details for visitors to the city's sixteen museums and seventy galleries but assesses the collections and identifies their strengths and weaknesses.

C–25 Groff, Sibyl. *New Jersey's Historic Houses: A Guide to Homes Open to the Public*. New York: A. S. Barnes, 1971.
For readers interested in architectural history, Groff isolates New Jersey communities in which noteworthy but relatively unknown historic houses are open to the public. Entries contain directions, hours, and fees.

C–26 *Guía dels museus de Catalonya*. Barcelona: Caixa de Pensions, 1979. (CA)
A thorough guide to Catalonia for sightseers, this work contains information on museum administration, facilities, and operations. All institutions are indexed by name.

C–27 *Guide to Museums in Wyoming*. Cheyenne: Wyoming State Archives, Museums and Historical Department, 1982.
Primarily oriented toward the needs of teachers, the Wyoming state guide provides information on museum activities, programs, and available audiovisual materials. Fees, schedules, and the names of personnel to contact are also included.

C–28 Hanson, Sharon Kenney, comp. *Art Museums and Galleries in Missouri: A Directory*. Jefferson City, MO: Sheba Review, 1983.
Art museums and commercial galleries are listed by city and indexed by name. Entries for museums provide visiting information and a summary of the collections, the most significant works on display, and sometimes the history of the facilities. A few historical museums that contain collections of artistic interest are also included.

C–29 *Historical Societies and Museums of Ohio*. n.p.: Ohio Association of Historical Societies and Museums, 1976.
Several hundred Ohio art museums, community museums, historical societies, and state memorials are listed in this pamphlet. The guide concentrates on visiting and mailing details; collections summaries range from terse to nonexistent.

C–30 Hunt, David C. *Guide to Oklahoma Museums*. Norman: University of
 Oklahoma Press, 1981.
 One of the nation's best museum guides, Hunt's book offers casual tourists
 directions, visiting information, photographs, and descriptions of both mu-
 seum highlights and special events. Collections summaries are intended to
 introduce students to the state's cultural resources, and a foreword by Alvin
 O. Turner of the Oklahoma Historical Society presents the "connoisseur's
 guide" to the best art, science, and history museums.

C–31 Kent Museums Group. *Thirty Museums and Galleries in Kent*. Deal, Eng-
 land: Kent Museums Group, 1976.
 The Kent, England, regional directory treats twenty-nine museums in me-
 ticulous detail, offering information on museum administration, operations,
 and visitor services. Historical details are brief, and collections are sum-
 marized in paragraphs that enumerate the principal artifacts on display.

C–32 Lopez Jiménez, José. *Museos de Pintura en Madrid*. Madrid: Editorial
 MayFe, 1961. (SP)
 Concentrating on eight art museums in Madrid—including the Prado, Mu-
 seo Nacional de Arte Moderno, and Museo Romantico—Lopez Jiménez's
 directory features weighty descriptions of the collections that analyze prom-
 inent works of art on display from a stylistic perspective. For more detailed
 visiting information, see C–19.

C–33 Lucas, John. *What to See in London's Museums: A Descriptive Guide to
 Museums, Houses and Galleries*. London: Elm Tree Books, 1975.
 Lucas describes the collections and visiting policies of some ninety London
 museums and historic houses from a tourist's perspective and provides a
 reference map. A far more thorough directory of the same subject has been
 compiled by Malcomb Rogers (C–46).

C–34 McDarrah, Fred W. *Museums in New York*. 3d ed. New York: Quick Fox,
 1978.
 McDarrah's comprehensive guide to ninety-five museums in New York
 City provides in each case detailed data on museum operations and gov-
 erning authority and an essay devoted to the building and collections.

C–35 Meredith, Michael, and Anna Meredith. *The Midlands: Museums and His-
 toric Houses*. London: Wayland Publishers, 1973.
 Guiding sightseers through the special features of museum collections in
 the English counties of Derbyshire, Leicestershire, Northamptonshire,
 Warwickshire, and Worcestershire, the Merediths' handbook also contains
 short introductory essays on the history of exhibition and contemporary
 museum practices.

C–36 Mueller, Kimberly J., and Karen L. Hertzberg, eds. *California Museum Directory: A Guide to Museums, Zoos, Botanic Gardens, and Similar Institutions in the Golden State*. Claremont: California Institute of Public Affairs, 1980.
In their valuable guide to 500 California museums, Mueller and Hertzberg have applied no selective criteria and note that "many of the places listed are very small and only of local interest, and some contain what can only be called junk." In two sections, one an alphabetical listing of entries by city and the other an inventory of university museums, a broad range of institutions is thoroughly described for both casual tourists and readers interested in the extent of the state's collections.

C–37 *Museums & Art Galleries in British Columbia*. Victora: Museums' Advisor, British Columbia Provincial Museum, 1974.
More than 120 museums, galleries, nature centers, and restored ships are listed by location in this pamphlet directory to British Columbia. Short entries offer visiting information, general descriptions of the collections, and an indication of governing authority.

C–38 *Museums and Sites of Historical Interest in Oregon*. Portland: Oregon Historical Society, 1980.
Organized alphabetically by county, entries cover museums, art galleries, landmarks and markers, ghost towns and historic districts, and other historical sites. Collections are briefly summarized, and directions, opening hours, and admission fees are noted. All sites are keyed to county maps in a center section of the guide.

C–39 *Museums in Nova Scotia 1984: A Directory of Museums, Archives, Public Galleries, Historical and Heritage Organizations*. Halifax: Nova Scotia Museum, Department of Education, 1984.
More than 150 museums, art galleries, and historic houses and sites are listed alphabetically by town, within county divisions. Entries offer short overviews of the facilities and relevant services, while noting visiting information, governing authorities, and the names of officers to contact for further details. All institutions are indexed by name.

C–40 *Museums of the State of Washington*. Olympia: Washington State Library, 1971.
Washington State museums of every variety are listed in this publication, which, in addition to tourist information, provides data on institutional history, governing authority, and collections.

C–41 Nakamura, Phillip. *Museum Directory, New Mexico, 1979–80*. Santa Fe:
 Museum of New Mexico, 1979.
 Brief but comprehensive, Nakamura's guide to New Mexico museums,
 historical and archeological agencies, and museum service organizations is
 arranged according to city. Museum entries contain short summaries of the
 collections, in addition to visiting and mailing information.

C–42 Oberg, Paul Chancy, ed. *Kansas Museum Directory*. Wichita: Office of
 Museum Programs, Curriculum Services Division, Wichita Public Schools,
 1984.
 Nearly 200 Kansas museums, zoos, historic houses, and herbariums are
 listed in alphabetical order by city. Entries include visiting information and
 brief descriptions of major exhibits and collections. All museums are indexed
 by name.

C–43 Ostrum, Meg, comp. *Vermont's Museums, Galleries, & Exhibition Spaces*.
 Montpelier, VT: Vermont Council on the Arts, 1980.
 Ostrum's comprehensive statewide reference guide, which is based pri-
 marily on field interviews and questionnaires, describes some 150 Vermont
 museums, galleries, and alternative spaces devoted to history, art, or sci-
 ence and technology. Entries are organized by type of facility and in most
 cases provide a short overview of the collections, the size of exhibition
 space, exhibition policy, activities, and publications, in addition to visiting
 information and an institutional profile.

C–44 Perry, Michael L., and Richard E. Kebbey, comps. *Directory of Museums
 and Galleries in Utah*. n.p.: Utah State Division of Fine Arts, Utah Arts
 Institute, and Utah Museums Association, 1977.
 Compiled largely from information supplied by members of the Utah Mu-
 seums Association, entries for 101 museums of all varieties are organized
 by geographic region in this looseleaf directory. The data for each institution
 include director's name, governing authority, visiting information, indica-
 tions of special services, and a terse summary of the holdings.

C–45 Restle, Marcell. *Reclams Kunstführer Istanbul: Bursa, Edirne, Iznik: Buad-
 enkmäler und Museen*. Stuttgart: Philipp Reclam Jun., 1976. (GE)
 An outstanding guidebook for visitors to Istanbul's museums and monu-
 ments, Restle's directory describes a half-dozen museums of archaeology
 and fine arts in great detail. Entries include some institutional history and
 extended commentary on the highlights of the collections as they appear
 in the exhibition halls.

C–46 Rogers, Malcomb. *Blue Guide: Museums and Galleries of London*. New
 York: W. W. Norton, 1983.
 Designed to travel with London museum visitors, this excellent handbook
 is arranged according to the city's principal quarters, with an aggregate of
 160 museums of all kinds listed alphabetically in the various sections. Major

institutions are treated at greater length here than in any other guidebook to London. Every entry provides complete information, including bus and subway directions. In his descriptions of the collections, Rogers circumnavigates the galleries with a ready wit and running commentary reminiscent of the travel literature of nineteenth-century connoisseurs. All museums are indexed by subject.

C-47 Rubin, Jerome, and Cynthia Rubin. *Guide to Massachusetts Museums, Historic Houses, and Points of Interest.* Newton, MA: Emporium Publications, 1972.
 A current and informative source describing such special offerings as tours and educational programs, this guide is organized according to region and indexed by museum type. For visitors, complete information is provided, with short summaries of the collections.

C-48 Ruff, Ann. *Amazing Texas Monuments & Museums.* Houston: Lone Star Books, 1984.
 Considerably less serious than either C-23 or C-51, Ruff's directory ferrets out an eclectic assortment of little-known Texas monuments and museums, which are listed here under subject categories. Although concentrating on unusual collections, ranging from the Permian Basin Petroleum Museum to the World's Largest Pecan, entries provide visiting information and complete descriptions of each attraction. Many of the museums are privately owned, and Ruff's impressions of their owners offer an interesting insight into the habits and eccentricities of collectors.

C-49 Smith, Lester, ed. *Museums and Galleries in Saskatchewan.* 2 vols. Saskatchewan: Department of Culture and Youth, 1974.
 Intended to serve as a reference work for museum policymakers, volume 1 of the Saskatchewan report nevertheless offers all readers an extensive range of data on operations, facilities, public relations, and tourist accommodations in the museums directory of table 15.

C-50 Tennessee Association of Museums. *List of Museums in the State of Tennessee.* n.p. Triannual.
 A short mimeographed pamphlet of limited utility, this list of nearly 100 Tennessee museums denotes locations, directors' names, and status of membership in the Tennessee Association of Museums.

C-51 Tyler, Paula Eyrich, and Ron Tyler. *Texas Museums: A Guidebook.* Austin: University of Texas Press, 1983.
 In order to capture the explosive increase in new Texas museums since the publication of Nancy Gayle's directory (C-23), Tyler and Tyler have compiled data for more than 540 institutions housing public exhibitions. Organized according to town, entries contain complete visiting information and brief descriptions of the collections, the facilities, and their history. Appendixes list museums by subject concentration and provide ten regional maps to assist visitors.

C-52 *Virginia Cultural Facilities and Historic Landmarks: An Inventory.* Rich-
 mond: Division of State Planning and Community Affairs, Education Sec-
 tion, 1976.
 This exhaustive inventory of Virginia cultural institutions is divided into
 twenty-two regional and local planning districts and covers art galleries,
 historic houses, science centers, planetariums, and arboretums. All facilities
 are indexed, and museums are described completely for potential visitors.

C53 Waddell, Carol, ed. *Directory of Indiana Museums.* n.p.: Association of
 Indiana Museums, 1980.
 This revised pamphlet directory contains 182 complete entries and 28 in-
 complete entries for Indiana museums, historic houses, art galleries, zoos,
 and museum villages. Entries are organized alphabetically by county and
 offer visiting information and names of staff members but few details con-
 cerning collections and displays.

C-54 Whittaker, Mary Jo. *Museums of Illinois.* Salem, IL: Weekends, 1974.
 Whittaker's guide to more than 100 Illinois museums is one of the best
 state directories available. Organized by region, museums are described in
 essays emphasizing institutional history and quality of the collections. All
 museums are indexed by name.

C-55 Zagury, Ana, coordinator. *Museos de la Ciudad de Mexico: Directorio Graf-
 ico,* translated by Juan A. Brennan and Antoine Esteban. Mexico City:
 Centro de Investigación y Servicios Museologicos, Universidad Nacional
 Autónoma de México, 1980. (EN, FR, SP)
 Fifty-five art, history, and science museums in Mexico City are described
 in this illustrated directory, which is an outgrowth of an exhibition con-
 ducted by the Center of Museological Research and Services devoted to
 the city's cultural institutions. Entries contain visiting information and short
 descriptions of the collections. All facilities are indexed by subject and keyed
 to street maps.

INDEX

Appendix B

MUSEUM ARCHIVES AND SPECIAL COLLECTIONS

When the staff of the Philadelphia Museum of Art began assembling the papers of former director Fiske Kimball in 1975, they were unpleasantly surprised to find them tossed into open cartons and, in one instance, sitting in a pool of water under the air-conditioning unit. There experience was not unique. In other museums, archivists have uncovered documents in odd corners of a loft, in unmarked shoeboxes, and even wedged behind radiators. Historian Robert Rydell, whose research on nineteenth-century expositions has led him into numerous museums, concludes that few other institutions are more indifferent to their own history. The paradox has not been lost on curators like Helen Hutchison, who marvels in "The Role of Archives in Museums" (1977) that institutions so adept at collecting and preserving artifacts should be so careless with their records. While a lack of funds, floor space, and personnel are contributing factors, the remarks of Rydell and Hutchison suggest that poorly maintained records are often symptomatic of the absence of self-reflection.

A renewed interest in institutional history, occasionally coinciding with centennial celebrations, has provided the impetus for creating new archives in many museums within the past decade. The bicentennial exhibitions of the mid–1970s, which used manuscript materials as often as three-dimensional objects, also helped to bring archivists and archival skills into the museum, and grants for archival projects were generated by the National Endowment for the Humanities and the National Historical Publications and Records Commission. One of the best known of these projects, at the Detroit Institute of Arts, is described by Claudia Hommell in "A Model Museum Archives" (1979).

The rationale for a museum archives is threefold. As William Deiss argues in *Museum Archives* (1984), an introductory manual of archival procedures, accessible records function as a collective memory essential to day-to-day operation. Beyond their immediate utility as a guide to past policies for present-day administrators,

museum records are of potential interest to scholars. In their remarks at a conference sponsored by the Society of American Archivists and subsequently edited by Carole Schwartz for "Keeping Our House in Order" (1983), Robert Rydell and Michelle Aldrich emphasize the value of museum holdings for cultural historians and historians of science. Finally, the archives can provide a rich source of material for exhibition. The literature on this aspect of archival collections is broad and includes such works as "Exhibiting Archival Material" (1979) and *Archives & Manuscripts: Exhibits* (1980) by Gail Casterline and "The Exhibit of Documents" (1974) by William Jones.

As a short guide to some prominent museum archives and special collections, the following list is not meant to be all-inclusive. For a more exhaustive selection, readers should consult the *Directory of Archives and Manuscript Repositories in the United States* (1978), compiled by the U.S. National Historical Publications and Records Commission.

AMERICAN MUSEUM OF NATURAL HISTORY
Department of Library Sciences
Archives
Rare Book and Manuscript Collection
Central Park West and 79th Street
New York, NY 10024
(212) 769–5000
OPEN: M–F, 11:00 A.M.–4:00 P.M.
ACCESS: Permission must be requested in advance from the reference librarian and a "request for access" form, available from the reference librarian, must be completed.
REFERENCE LIBRARIAN: Linda L. Reichert
HOLDINGS: Two special collections maintained by the Department of Library Sciences—the Archives and the Rare Book and Manuscript Collection—offer researchers one of the most detailed records of the history and development of an American scientific institution. The archives contain letters dating from the museum's first hundred years, in addition to its charter, leases, committee and board reports, studies, and architectural plans. Important correspondents represented in the collections include J. P. Morgan, Edward Drinker Cope, O. C. Marsh, and Roy Chapman Andrews. The papers of Henry Fairfield Osborn and the manuscripts of Albert Bickmore and Louis Gratacap are deposited in the Rare Book and Manuscript Collection.

ARCHIVES OF AMERICAN ART
Smithsonian Institution
National Museum of American Art Building
8th and F Streets, NW
Washington, DC 20560
(202) 357–4251
OPEN: M–F, 10:00 A.M.–5:00 P.M.
ACCESS: Open to the public
DIRECTOR: Richard Murray

HOLDINGS: An extensive collection of more than 5 million manuscripts, letters, notebooks, sketchbooks, clippings, and rare publications, and archives is devoted to collecting materials that pertain to all facets of American art. Collections and interviews are maintained for such diverse figures as artists, craftsmen, collectors, dealers, and critics and include the diaries of Samuel Avery, the correspondence of Holger Cahill, the scrapbook of Solomon Guggenheim, and the letters of George Catlin, Pierre du Smitiere, René Gimpel, William Milliken, Walter Pach, and Charles Willson Peale. In addition, records are collected for several art museums, such as the Allen Memorial Art Museum, the Brooklyn Museum, the Carnegie Institute, the Hudson River Museum, the University of Michigan Museum of Art, the Boston Museum of Fine Arts, and the Newark Museum Association. Microfilms of the holdings are available at the archives' regional offices in New York, Detroit, Boston, San Francisco, and Los Angeles.

GUIDES: Archives of American Art. *A Checklist of the Collection* (1977).

BALTIMORE MUSEUM OF ART

Cone Collection, Archives

Art Museum Drive Baltimore, MD 21218

(301) 396–6317

OPEN: Contact librarian

ACCESS: Open to researchers by appointment

LIBRARIAN: Anita Gilden

HOLDINGS: Materials consist of correspondence and photographs related to Etta and Claribel Cone and their art collection. Some documents pertain to the Cones' association with Gertrude and Leo Stein in Paris.

CLEVELAND MUSEUM OF NATURAL HISTORY

Museum Archives

Wade Oval–University Circle

Cleveland, OH 44106

(216) 231–4600

OPEN: By appointment only

ACCESS: By appointment with the archivist

ARCHIVIST: Mary Elizabeth Flahive

HOLDINGS: Established in 1982, the Museum Archives contain historical records of the museum from 1915 to the present and a newspaper clippings file dating to 1920. Other major holdings pertain to the activities of local natural history groups.

CORCORAN GALLERY OF ART

Corcoran Archives

17th Street and New York Avenue, NW

Washington, DC 20006

(202) 638–3211, ext. 208

OPEN: M—F, 10:00 A.M.–4:30 P.M.

ACCESS: By appointment only
ARCHIVIST: Katherine M. Kovacs
HOLDINGS: Created in 1980, the Archives of the Corcoran Gallery and School of
 Art afford a unique insight into the operations of a private museum from the
 nineteenth century to the present. Holdings are divided into thirteen record
 groups, which concentrate primarily on specific administrative units or museum
 activities like the board of trustees, director's office, Curatorial Department,
 Museum Service Department, School of Art, and affiliated membership orga-
 nizations. Correspondence, memoranda, reports, and financial records docu-
 ment such institutional decisions as gallery modernization, collection and
 exhibition policies, and relationships with contemporary artists, donors, dealers,
 and the public. The journal kept by the Corcoran's first director, William
 MacLeod, and the personal papers of its fourth director, C. Powell Minnigerode,
 are examples of useful research tools for museum history and the evolution of
 museum practice.
GUIDES: Katherine M. Kovacs and others. *A Guide to the Corcoran Archives* (1985).

DETROIT INSTITUTE OF ARTS
Museum Archives and Records Center
5200 Woodward Avenue
Detroit, MI 48202
(313), 833–1462
OPEN: M–F, 9:30 A.M.–5:00P.M.
ACCESS: Qualified researchers by appointment
ARCHIVES DIRECTOR: Cheriyl Wagner
HOLDINGS: Archival materials are divided into seven record groups arranged
 around specific administrative entities like the Founders Society, the directors,
 the City of Detroit Arts Commission, the curatorial departments, the admin-
 istrative and service departments, the physical plant, and related institutions.
 Major holdings include the minutes of the board of trustees (dating back to
 1883), the donor files, and correspondence, papers, and reports generated by
 the institute's directors, including William Valentiner and Edgar Richardson.
 Records illustrate the full spectrum of museological activities from gallery design
 and exhibition to conservation, education, and public relations. Collectively the
 holdings represent evidence of the relationship between cultural activities and
 urban economic conditions and the functional role of the museum in Detroit's
 social and political network.
GUIDES: Claudia Hommel and others. *The Museum Archives of the Detroit Institute
 of Arts: Summary Inventory* (1979).

FOGG ART MUSEUM
Fogg Museum Archives
Harvard University
32 Quincy Street
Cambridge, MA 02138
(617) 495–2384

OPEN: M–F, 1:30 P.M.–4:30 P.M.
ACCESS: Open to all qualified scholars by appointment
ASSISTANT ARCHIVIST: Abigail G. Smith
HOLDINGS: The archives maintain materials pertaining to the history of the Fogg
 Art Museum, including the files of former directors Charles H. Moore, Edward
 Waldo Forbes, Paul J. Sachs, Arthur Pope, John P. Coolidge, Agnes Mongan,
 and Daniel Robbins. In addition, scrapbooks, memorabilia, plans and blueprints,
 notes, and records of past exhibitions document the museum's development.

FRANKLIN INSTITUTE SCIENCE MUSEUM
Archives of the Franklin Institute
20th Street and Benjamin Franklin Parkway
Philadelphia, PA 19103
(215) 448–1200, ext. 1181
OPEN: M–F, 9:30 A.M.–4:30 P.M., Sat–Sun, 10:00 A.M.–5:00 P.M.
ACCESS: By appointment

CURATORIAL ASSOCIATE, DEPARTMENT OF COLLECTIONS AND
SPECIAL EXHIBITIONS:
Gladys I. Breuer
HOLDINGS: Materials are relevant to both the history of the Franklin Institute and
 the role of science and technology in American society. Examples of the holdings
 include reports of exhibitions committees, records of the museum's ad hoc
 committees, and minutes dating from the establishment of the institute.

ISABELLA STEWART GARDNER MUSEUM
2 Palace Road
Boston, MA 02115
(617) 566–1401
OPEN: Tu, noon–6:30 P.M., W–Sun, 10:00 A.M.–5:00 P.M.
ACCESS: By appointment only
ARCHIVIST: Susan Sinclair
HOLDINGS: The principal archival holdings are composed of Isabella Stewart Gard-
 ner's extensive personal correspondence with more than 1,000 contemporary
 figures between 1859 and 1924, including artists, writers, musicians, actors,
 politicians, and art historians like Charles Eliot Norton and Bernard Berenson.
 In addition to Gardner's correspondence, which is also available on microfilm
 through the Archives of American Art, the museum is the repository for Gard-
 ner's papers, notebooks, travel journals, museum accounts, diary, dealers' in-
 voices, and photographs. The collected records of the museum from 1924 until
 the present contain the correspondence of directors Morris Carter, George
 Stout, and Rollin van N. Hadley.
GUIDES: An unpublished guide to Gardner's correspondence and papers is available
 at nominal cost from the museum office.

METROPOLITAN MUSEUM OF ART
Library and Archives
Fifth Avenue at 82d Street
New York, NY 10028
(212) 879–5500
OPEN: Tu, 9:30 A.M.–8:45P.M., W–Sun, 9:30 A.M.–5:15 P.M.
ACCESS: Qualified researchers must make appointments in advance.
ARCHIVIST: Jeanie James
HOLDINGS: As the repository for the Metropolitan Museum's administrative rec-
 ords, the archives contain correspondence and other papers documenting the
 museum's history and operations.

MUSEUM OF COMPARATIVE ZOOLOGY
Archives
Harvard University
Oxford Street
Cambridge, MA 02138
(617) 495–2475/3686
OPEN: M–F, 9:30 A.M.–12:30 P.M., 2:00 P.M.–4:30 P.M. (closed on official university
 holidays)
ACCESS: Appointments should be made in advance for extensive research.
SPECIAL COLLECTIONS LIBRARIAN: Sharon S. Regen
HOLDINGS: Archival materials are arranged in three series, consisting of depart-
 ment records since 1859, the papers of curatorial and teaching staff (dating
 primarily from the nineteenth century), and the papers of more recent curators
 and research associates. The departmental series includes administrative and
 financial records, collections documentation, curatorial correspondence, and
 photographs of the museum. Important materials pertaining to the MCZ's found-
 ing and development can be found in the papers of the Agassiz family (1817–
 1910) and in the papers of William Brewster (1865–1919), who was the museum's
 curator of mammals and birds from 1885 to 1900.
GUIDES: Unpublished finding aids available at the archives.

MUSEUM OF SCIENCE AND NATURAL HISTORY
Oak Knoll Park
St. Louis, MO 63105
(314) 726–2888
OPEN: Call for hours of operation
ACCESS: By appointment
CURATOR: Carol Hudlow
HOLDINGS: Archival materials relating to the history of the museum include min-
 utes of the meetings of the board of directors and Council of the St. Louis
 Academy of Science (1856–1959), which are on microfiche, and the transactions
 of the St. Louis Academy of Science.

MUSEUM REFERENCE CENTER

Smithsonian Institution
Office of Museum Programs
Room 2235
Arts and Industries Building
900 Jefferson Drive, SW
Washington, DC 20560
(202) 357-3101
OPEN: M–F, 9:00 A.M.–5:00 P.M.
ACCESS: Open to the public
CHIEF LIBRARIAN: Sylvia J. Churgin
HOLDINGS: The only central source of museological information in the United States, the Museum Reference Center offers researchers a rich array of published and unpublished materials. More than 2,000 books and monographs devoted to all facets of museum history, theory, and practice comprise the core of the collection. In addition, the center contains dissertations, museological periodicals, conference proceedings and audiotapes, research reports, evaluation studies, visitor surveys, and ninety running feet of subject files. Museum professionals and students may contact the center for bibliographic and reference assistance.

PHILADELPHIA MUSEUM OF ART

Archives
P.O. Box 7646
Philadelphia, PA 19101
(215) 787-5419 or (215) 763-8100, ext. 259
OPEN: Th–F, 10:00 A.M.–4:00 P.M.
ACCESS: By appointment to scholars and researchers who can demonstrate a justifiable interest in the materials
ARCHIVIST: Alice Lefton
HOLDINGS: Holdings are divided into six record groups designed to reflect the museum's major administrative units and activities: Records of the Corporation, Records of the Director, Records of the Curatorial Departments, Records of the Administrative Services, Records of the School of Industrial Arts and the Textile School, and Records of Related Organizations, such as the Rodin Museum. Collectively, these record groups contain minutes, correspondence, and reports dating back to 1875 and pertaining to all aspects of museum operation from finance and construction to conservation, exhibition, and education. Moreover, the archives' special collections contain architectural drawings, scrapbooks, photographs, and the Edwin Atlee Barber Papers (1885–1916) and Fiske Kimball Papers (1908–1955). The Kimball Papers contain not only considerable documentation of a biographical nature but a separate series on museum planning (1925–1940) composed of papers collected by Kimball on a wide range of practical and theoretical museum issues.
GUIDES: Philadelphia Museum of Art. *Inventory of the Archives* (1983); Merle Chamberlain, comp. *A Guide to the Fiske Kimball Papers* (1982).

ST. LOUIS ART MUSEUM
Archives
Forest Park
St. Louis, MO 63110
(314) 721–0067, ext. 252
OPEN: Tu–F, 10:00 A.M.–5:00 P.M.
ACCESS: Primarily for use by museum staff, but researchers of college age and older
 are welcome and should contact the archivist.
ARCHIVIST: Norma Sindelar
HOLDINGS: Archival materials consist primarily of departmental records of the St.
 Louis Art Museum and its precursors, the St. Louis School and Museum of
 Fine Arts and the City Art Museum. Correspondence is also on file from various
 museum offices, as are exhibition records, newspaper clipping scrapbooks, plans
 and blueprints, and photographs. Major collections include the Director's Office
 Records, dating from the 1880s to the present, and the Morton D. May Papers
 (1928–1983), which document the purchases, gifts, loans, and exhibits of May's
 art collection.

SMITHSONIAN INSTITUTION
Smithsonian Archives
Room 2135
Arts and Industries Building
900 Jefferson Drive, SW
Washington, DC 20560
(202) 357–1420
OPEN: M–F, 9:00 A.M.–5:00 P.M.
ACCESS: Researchers should make arrangements in advance to ensure service from
 the archivist best acquainted with the records to be consulted.
ARCHIVIST: William A. Deiss
HOLDINGS: The archives are primarily devoted to collecting and processing official
 records of the Smithsonian and papers of the Smithsonian staff. Official records
 include minutes of the board of regents since 1846 and correspondence generated
 by the Office of the Secretary (1863–1964), the assistant secretaries, and the
 director of the U.S. National Museum. In addition, extensive administrative
 correspondence is maintained for the National Museum of Natural History,
 National Museum of History and Technology, National Museum of American
 Art, National Portrait Gallery, National Air and Space Museum, National Zo-
 ological Park, Cooper-Hewitt Museum, and Anacostia Neighborhood Museum.
 The special collections feature the private papers of Smithsonian secretaries
 from Joseph Henry to S. Dillon Ripley and the papers of many scientists and
 curators associated with the Smithsonian like George Brown Goode and George
 Frederick Kunz. Researchers may also refer to interviews recorded for the Oral
 History Project with such twentieth-century museum professionals as John Ew-
 ers, Robert Multhauf, and Frank Taylor.
GUIDES: Smithsonian Archives. *Guide to the Smithsonian Archives* (1983).

UNIVERSITY MUSEUM
University Museum Archives
University of Pennsylvania
33d and Spruce Streets
Philadelphia, PA 19104
(215) 898–8304
OPEN: M–F, 9:00 A.M.–5:00 P.M.
ACCESS: Available to University of Pennsylvania staff and students and to other
 researchers who can demonstrate a genuine need to use the documents
ARCHIVIST: Irene Romano (acting)
HOLDINGS: The archives' broad holdings document a century of anthropological
 and archaeological activities sponsored by the University Museum and are de-
 voted to preserving the records of expeditions, research projects, and ethno-
 graphic studies. In addition, the archives is the repository for the museum's
 administrative records, which are broken down by department or office of origin.
 Most of the administrative records describe the programs of the Office of the
 Director from 1887 to the present, but correspondence, reports, lecture notes,
 photographs, and plans on file pertain to all aspects of museum operation from
 collecting and construction to joint projects undertaken with the Works Progress
 Administration between 1935 and 1943.
GUIDES: Mary Elizabeth Ruwell and the Staff of the University Museum Archives.
 A Guide to the University Museum Archives of the University of Pennsylvania
 (1984).

BIBLIOGRAPHIC CHECKLIST

Archives of American Art. *A Checklist of the Collection.* 2d rev. ed. Washington,
 DC: Archives of American Art, Smithsonian Institution, 1977.
Bolton, Robin. "Historical Records in Community Museums." *Museum Round-Up*
 55 (July 1974), 24–28.
Casterline, Gail Farr. "Historians at the Drawing Board: Organizing 'Chicago: Cre-
 ating New Traditions.' " *Chicago History* 6 (1977), 130–42.
————. "Exhibiting Archival Material: Many-Faceted Manuscripts." *Museum News*
 58 (September-October 1979), 50–54.
————. *Archives & Manuscripts: Exhibits.* Chicago: Society of American Archivists,
 1980.
Chamberlain, Merle, comp. *A Guide to the Fiske Kimball Papers.* Philadelphia:
 Archives, Philadelphia Museum of Art, 1982.
Clapp, Anne F. *Curatorial Care of Works of Art on Paper.* 3d rev. ed. Oberlin,
 OH: Intermuseum Conservation Association, 1978.
Deiss, William A. *Museum Archives: An Introduction.* Chicago: Society of American
 Archivists, 1984.
DeLauzier, Len. "Archival Collections." *Museum Round-Up* 60 (October 1977), 13–
 16.
*Draft Guidelines for Botanical Gardens and Aboretum Archives and for Plant Science
 Society Archives.* New York: New York Botanical Garden Library, 1980.

Franco, Barbara. "Exhibiting Archival Material: A Method of Interpretation." *Museum News* 58 (September-October 1979), 55–59.

Hamer, Philip M., ed. *A Guide to Archives and Manuscripts in the United States.* Compiled for U.S. National Historical Publications Commission. New Haven: Yale University Press, 1961.

Hommel, Claudia. "A Model Museum Archives." *Museum News* 58 (November-December 1979), 62–69.

Hommel, Claudia, and others. *The Museum Archives of the Detroit Institute of Arts: Summary Inventory.* Detroit: Museum Archives and Records Center, Detroit Institute of Arts, 1979.

Hutchison, Helen. "The Role of Archives in Museums: Holdings of Prime Importance, or Expendable?" *Ontario Museums Association Newsletter* 6 (Spring 1977), 37–40.

Jones, William K. "The Exhibit of Documents: Preparation, Matting and Display Techniques." American Association for State and Local History Technical Leaflet, no. 75. *History News* 29 (June 1974), insert.

Kane, Lucile M. "The Exhibition of Manuscripts at the Minnesota Historical Society." *American Archivist* 15 (January 1952), 39–45.

Kovacs, Katherine M., and others. *A Guide to the Corcoran Archives.* Washington, DC: Corcoran Gallery of Art, 1985.

Leisinger, Albert H., Jr. "The Exhibit of Documents." *American Archivist* 26 (January 1963), 75–86.

Ormond, Richard L. "The National Portrait Gallery Archives." *Journal of the Society of Archivists* 4 (October 1970), 130–36.

Philadelphia Museum of Art. *Inventory of the Archives.* Philadelphia: Philadelphia Museum of Art, 1983.

Ruwell, Mary Elizabeth, and the Staff of the University Museum Archives. *A Guide to the University Museum Archives of the University of Pennsylvania.* Philadelphia: University Museum, University of Pennsylvania, 1984.

Schwartz, Carole, ed. "Keeping Our House in Order: The Importance of Museum Records." *Museum News* 61 (April 1983), 38–49.

Smithsonian Archives. *Guide to the Smithsonian Archives.* Archives and Special Collections of the Smithsonian Institution, no. 4. Washington, DC: Smithsonian Institution Press.

United States. National Historical Publications and Records Commission. *Directory of Archives and Manuscript Repositories in the United States.* Washington, DC: National Archives and Records Service, General Services Administration, 1978.

Appendix C

MUSEUM-RELATED PERIODICALS

AIC Newsletter. Washington, DC: American Institute for Conservation of Historic and Artistic Works. Bimonthly newsletter (1976–).

American Anthropologist. Washington, DC: American Anthropological Association. Quarterly journal (1899–).

American Association of Zoological Parks and Aquariums Newsletter. Wheeling, WV: American Association of Zoological Parks and Aquariums. Monthly newsletter (1960–).

ARTnews. New York: ARTnews Associates. Monthly journal (1902–).

ASC Newsletter. Washington, DC: Association of Systematics Collections. Bimonthly newsletter (1973–).

ASTC Newsletter. Washington, DC: Association of Science-Technology Centers. Bimonthly newsletter (1973–).

AVISO [formerly *Bulletin*]. Washington, DC: American Association of Museums. Monthly newsletter (1975 [as *AVISO*]–).

Council for Museum Anthropology Newsletter. Flagstaff, AZ: Council for Museum Anthropology. Quarterly newsletter (1977–).

Curator. New York: American Museum of Natural History. Quarterly journal (1958–).

Historic Preservation. Washington, DC: National Trust for Historic Preservation. Bimonthly journal (1949–).

History News. Nashville, TN: American Association for State and Local History. Bimonthly journal (1946–).

History News Dispatch. Nashville, TN: American Association for State and Local History. Monthly newsletter (1986–).

International Journal of Museum Management and Curatorship. Guildford, England: Butterworth Scientific Ltd. Quarterly journal (1982–).

Journal of Museum Education [formerly *Roundtable Reports*]. Rockville, MD: Museum Education Roundtable. Quarterly journal (1976–).

Muse. Ottawa, Canada: Canadian Museums Association, (1966–).

Museum. Paris: United Nations Educational, Scientific and Cultural Organization. Quarterly journal (1949–).

Museum News. Washington, DC: American Association of Museums. Bimonthly journal (1923–).

Museum Studies Journal. San Francisco: Center for Museum Studies, John F. Kennedy University. Biannual journal (1983–1988).

Museums Journal. London, England: The Museums Association. Quarterly journal (1901–).

Preservation News. Washington, DC: National Trust for Historic Preservation. Monthly newspaper (1961–).

Science Museum News. Pittsburgh: Association of Science Museum Directors. Biannual newsletter (1976–).

Stolen Art Alert. New York: International Foundation for Art Research. Monthly newsletter (ten issues per year) (1980–). [Formerly *Art Theft Archive Newsletter*.]

Technology & Conservation of Art, Architecture, and Antiquities: The Magazine for Analysis/Preservation/Restoration/Protection/Documentation. Boston: Technology Organization. Quarterly journal (1977–).

INDEX

This index covers significant personalities, institutions, and events in museum history and contemporary practice.

Lawrence Hall of Science, 62, 70, 212
Linnaeus, Carolus, 4, 144
London Science Museum, 65, 70, 72
Los Angeles County Museum of Art, 39
Louvre, 32, 33, 233
Low, Theodore, 36, 42–43, 44, 170, 174, 248
Lucas, Frederick, 6, 273, 274, 287

Maihaugen, 120, 124
Marsh, Othniel C., 8, 268
Maryland Historical Society, 33
Massachusetts Historical Society, 86, 95
Mayr, Ernst, 7, 16, 21
Mellon, Andrew, 272, 277, 285
Melton, Arthur, 171, 206, 214, 238
Metropolitan Museum of Art, 8, 34, 36, 37, 43, 45, 47, 49, 89, 96, 141, 147, 169, 203, 205, 240, 241
Milliken, William, 275, 288
Milwaukee Public Museum, 10, 70, 176, 204, 209, 211
Morgan, J. Pierpont, 8, 9, 34, 273, 274, 285
Museum of American Folk Art, 123
Museum of Comparative Zoology, 3, 6, 267
Museum of Contemporary Art (Los Angeles), 38, 99
Museum of Modern Art, 35, 38, 45, 47, 240
Museum of Science and Industry, 60, 61, 66, 67, 70

National Air and Space Museum (Smithsonian Institution), 61, 62, 71, 92, 207
National Gallery of Art (Washington), 36, 48, 205, 212, 241
National Gallery (London), 145
National Museum of American History (Smithsonian Institution), 60, 65, 91, 97
National Museum of Natural History (Smithsonian Institution), 7, 146

National Park Service, 11, 87, 90, 97, 98
Natural History Museum of Los Angeles County, 10
New York Historical Society, 5, 33, 86, 95
New York State Historical Association (Cooperstown, New York), 118, 122, 127–28
New York State Museum (Albany), 5
New York World's Fair, 202, 203
Newark Museum, 35, 41, 169, 202, 237
Nordiska Museet, 115, 116, 120, 202
Norton, Charles Eliot, 34, 40, 267, 286
Norton Simon Museum (Pasadena), 38

Oakland Museum, 207
Old Mystic Seaport, 91
Old Sturbridge Village, 90, 91, 96, 118, 122, 127
Old World Wisconsin Living History Farms, 119, 120, 123
Ontario Museum of Science, 212
Oppenheimer, Frank, 204, 212
Osborn, Henry Fairfield, 9, 11, 12, 19, 20, 273, 282

Pach, Walter, 37, 43, 240, 249
Palais de la Découverte, 60, 61
Panama Pacific International Exposition (1915), 202, 211
Panizzi, Antonio, 269–70, 284
Parr, Albert Eide, 13, 171, 176, 208, 216
Peabody Museum of Archeology and Ethnology, 11, 12
Peabody Museum of Natural History, 8, 9
Peale, Charles Willson, 2, 3, 11, 14, 33, 95, 144, 200, 201, 208, 244, 265, 280
Pennsylvania Historical Society, 86, 95, 265
Pennsylvania Academy of Fine Arts, 33, 265
Philadelphia Centennial Exposition (1876), 7, 60, 87, 99, 202, 210, 235
Phillips, Duncan, 277, 286

CONTRIBUTORS

Elizabeth M. Adler, assistant director for resources and publications, Kentucky Humanities Council, has a special interest in the use of folk and history museums to interpret regional folk cultures. Adler holds a master of arts degree in museum studies from the Cooperstown Graduate Program and received the Ph. D in folklore and American studies from Indiana University.

Bernard S. Finn, a curator in the Division of Electricity in the Smithsonian's National Museum of American History, has long advocated the use of museum collections for both research and interpretation. Finn holds the Ph. D in the history of science from the University of Wisconsin and has consulted internationally on science and technology museums.

Louis W. Kemp has been a student in the museum studies program at the George Washington University, where he received the doctorate degree in American studies in 1989. He has worked at the National Museum of Natural History and is currently an archivist at the Communications Satellite Corporation in Washington, D. C.

Charlotte M. Porter is an associate curator at the Florida Museum of Natural History and an associate professor of history at the University of Florida. Trained as a historian of science at Harvard University, where she received her Ph. D., Porter has lectured and written extensively on the history of natural history museums.

Michael S. Shapiro, a museum director, professor, and attorney, has considered museum practice and policy from a range of vantage points. Formerly the director of the Graduate Program in Museum Studies at the George Washington University, Shapiro holds the Ph. D. in American civilization from Brown University and the J. D. from the George Washington University. He is associated with the law firm of Weil, Gotshal & Manges, where, among other things, he counsels nonprofit organizations and museums.

Katherine Spiess, assistant registrar at the Smithsonian's National Museum of American History, has lectured widely on the management of museum collections, including the use of computers. Spiess has an M. A. in museum studies from the Cooperstown Graduate Programs and a B. A. in mathematics/computer sciences from the University of New Hampshire.

Philip Spiess has worked on a number of projects at both the New York State Historical Association and later at the National Trust for Historic Preservation, aimed at gaining bibliographic control in museum studies. A Hagley Fellow at the Eleutherian Mills-Hagley Foundation, Spiess holds the master of arts in history from the University of Delaware and is working on a doctoral degree in nineteenth-century studies at Drew University.

Scott T. Swank, deputy director for interpretation, Winterthur Museum and Gardens, is responsible for a wide range of programs aimed at interpreting American history through architecture, decorative arts, and material culture. A leader in the history museum movement, Swank lectures widely on the functions of history museums. He received his Ph. D. in history from the University of Pennsylvania.

J. Lynne Teather is graduate coordinator and assistant professor of museum studies in the University of Toronto's Museum Studies Program. Active in the Canadian museum community, Teather has consulted on topics ranging from museum collections and bibliographic research to museum policy analysis. Teather holds the Ph. D. in museum studies from the University of Leicester, England.

Edith A. Tonelli is the director of art museums and collections at the University of California at Los Angeles, where she also teaches a course in the history and practice of art museums. Tonelli, who received the Ph. D. in American studies from Boston University, specializes in twentieth-century American art.

Wilcomb E. Washburn, a historian with almost four decades of museum experience, has written extensively on museum history and theory. Wash-

burn began his career at the Smithsonian Institution as a curator in the Division of Political History and currently directs the Smithsonian's Office of American Studies. Washburn was awarded the Ph. D by Harvard University.

Kenneth A. Yellis, an innovator in museum education, directed the educational programs at the National Portrait Gallery, including the highly acclaimed performance series "Portraits in Motion." Yellis, currently director of public programs at the National Portrait Gallery, holds master's degrees in history from University of Rochester and in public administration from the George Washington University.